The traditional landscap rmed in the 1960s when
many artists stopped m nd made their mark
directly in the environm ercultural impulses of that
decade, artists rejected onomic system. They were
drawn instead to entrop or to the vast, uncultivated
spaces of desert or mou e earth to create colossal
primal symbols while of with man-made signposts.
Although primarily scul ompasses performance
and Conceptualism. For chic experience of the land
became works of art. In phic documentation and/or
text-based accounts are

This book fully docu s and 1970s Land Art
phenomenon, and its cc ontemporary
environmentally-based ts, performances and
actions are all illustrate phs.

A survey text by cultural critic and curator Brian Wallis discusses the
manifold works and issues that define Land and Environmental Art within
a broader art historical context, tracing its aesthetic, conceptual and socio-
political meanings and manifestations.

Editor Jeffrey Kastner has brought together over 250 works of art, spanning
a period of five decades. He has also compiled an invaluable archive of
statements by all the featured artists alongside related texts by art historians,
critics, philosophers and cultural theorists. These key works and key
documents are structured chronologically within a series of themes that define
prevailing tendencies within Land and Environmental Art.

THEMES AND
MOVEMENTS

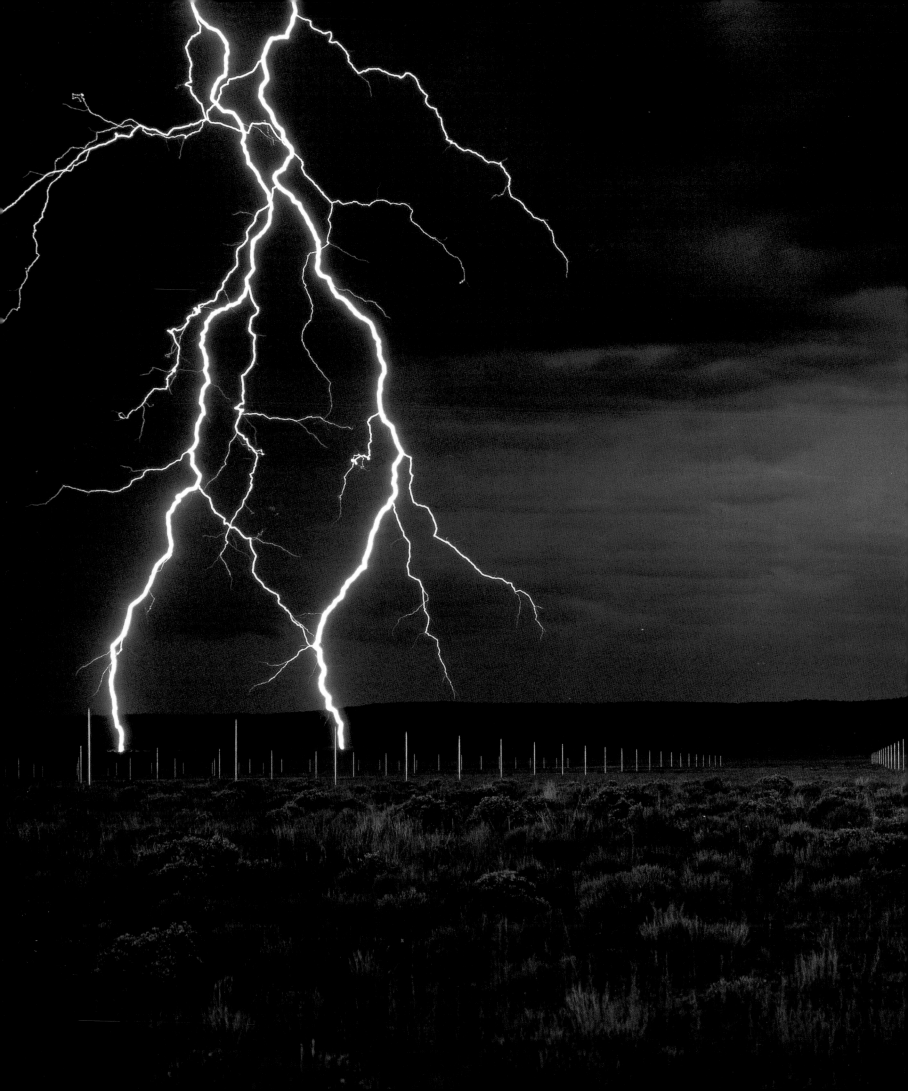

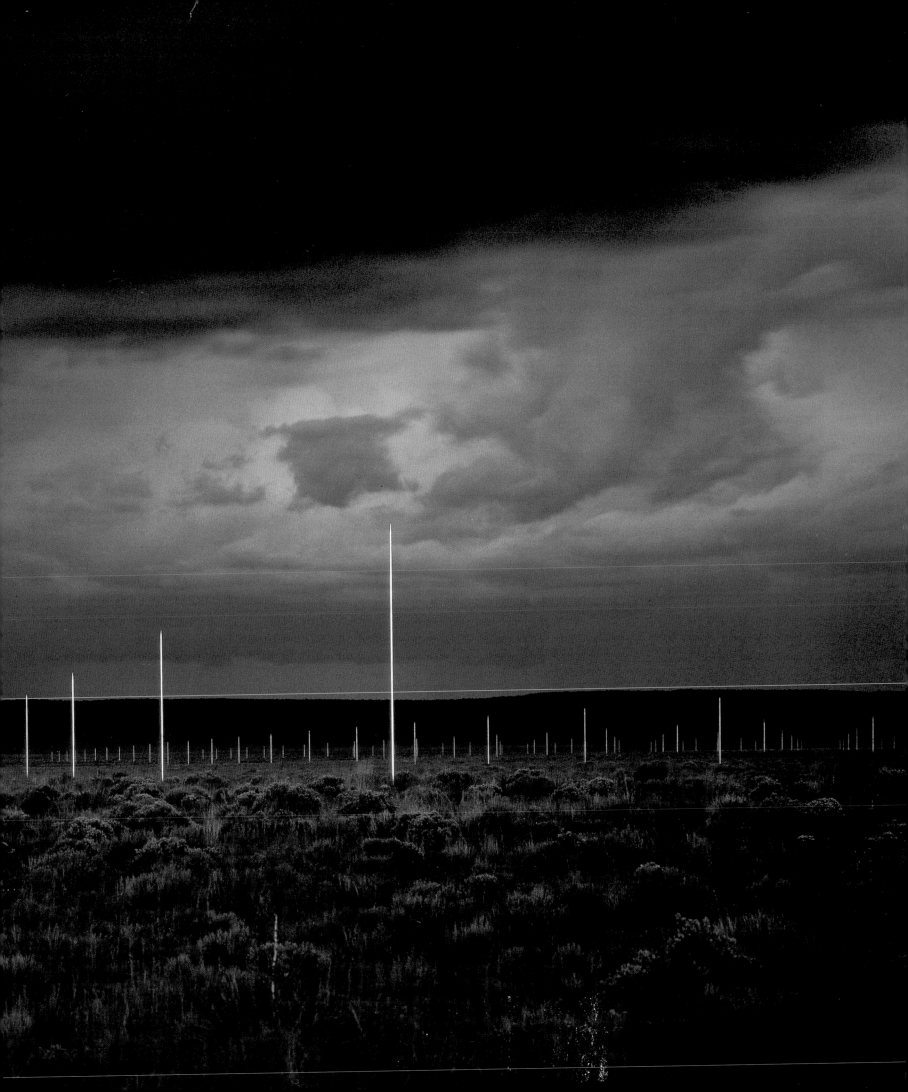

Phaidon Press Limited
Regent's Wharf
All Saints Street
London N1 9PA

First published 1998
© Phaidon Press Limited 1998
All works are © the artists

Printed in Hong Kong

cover, Michael Heizer
Detail of the artist's photographs of the
works Windows and Matchdrop
1986
Städtische Kunsthalle, Dusseldorf

pages 2-3, Walter De Maria
The Lightning Field
1977
New Mexico

page 4, Robert Smithson photographing
Michael Heizer
1968
Monolake, California

back cover, Robert Smithson
Spiral Jetty
1970
Great Salt Lake, Utah

EDITED BY JEFFREY KASTNER
SURVEY BY BRIAN WALLIS

LAND AND ENVIRONMENTAL ART

WORKS

INTEGRATION

INTERRUPTION

INVOLVEMENT

INTERRUPTION page 223

INVOLVEMENT page 235

IMPLEMENTATION page 250

IMAGINING page 272

ILLUMINATION page 279

PRE-FACE

BY JEFFREY KASTNER

MAN IS A SINGULAR CREATURE. HE HAS A SET OF GIFTS WHICH MAKE HIM UNIQUE AMONG THE ANIMALS: SO THAT, UNLIKE THEM, HE IS NOT A FIGURE IN THE LAND-SCAPE - HE IS A SHAPER OF THE LANDSCAPE. IN BODY AND IN MIND HE IS THE EXPLORER OF NATURE, THE UBIQUITOUS ANIMAL WHO DID NOT FIND BUT HAS MADE HIS HOME IN EVERY CONTINENT.

Jacob BRONOWSKI The Ascent of Man, 1973

Among the many relationships that define the human condition, the individual's connection to the environment is primary. The elemental background against which all our activity is played out, nature is the biggest of the big pictures. We worship and loathe it, sanctify and destroy it. Birth, death and all that is graceful and vicious between, sit comfortably within the natural web. We 'singular creatures' also bloom and rot on its vast matrix, but the combination of our ambition and our gifts makes us want more than simply to survive. We aspire to leave our mark, inscribing our observations and gestures within the landscape, attempting to translate and transgress the space within which we find ourselves.

If our culture is the manifestation of this drive, then its continuing fascination with the land is testament to both the potential and the strictures of our terrestrial condition. Subject both of science and art, the landscape functions as a mirror and a lens: in it we see the space we occupy and ourselves as we occupy it. And we have consistently sought to connect on some level with the landscape. Humans have created forms in honour of the land and as an act of defiance against it. They have made objects to place within the sweeping vista and recreated its patterns in isolation from it; invented images variously designed to document, idealize and vilify the sometimes gentle, sometimes violent and always oblivious charms of the natural environment.

Among the most complex and fascinating of these artistic responses to the earth are the works that have come to be called Land Art. What began in the mid 1960s with a small number of committed conceptualists – disenchanted with the modernist endgame and animated by a desire to measure the power of the artwork isolated from the cosmopolitan com-

modifications of the white cube – has grown over the last thirty years to include a widely diverging collection of forms, approaches and theoretical positions.

Like the work that it embraces, the term Land Art is variable, complex and fraught. In many ways a quintessentially American art form, the first manifestations of what came to be known as Land Art and grew to encompass earth, eco and Environmental Art, began in the American cultural crucible of New York and the open spaces of its western deserts. Yet its formulation involved artists from around the world, who brought very different approaches to bear. Never a movement in the traditional sense, encompassing a range of artists who might be at odds with each other's conceptions and executions, Land Art is an imperfect hyponym for a slippery and widely interconnected brand of conceptual kinship. Yet whether seen to be engaged in the interrogations of Modernism, Minimalism or Conceptualism, as a purposefully romantic quest for reconnection with a kind of atavistic inspiration or as a serious-minded programme for the practical conditions of the late-industrial biosphere, all the work included here has as its pivot the land and the individual's responses to and activity within it.

These projects are fundamentally sculptural (in the sense of creating in three dimensions) and/or performance-based (in terms of their orientations towards process, site and temporality). They are concerned with the way both time and natural forces impact on objects and gestures; at once critical of and nostalgic for the notion of 'the garden'; alternately aggressive and nurturing towards the landscape.

The range of work referred to as Land Art and Environmental Art encompasses a wide variety of post-war artmaking. It includes site-specific sculptural projects that utilize the materials of the environment to create new forms or to adjust our impressions of the panorama; programmes that import new, unnatural objects into the natural setting with similar goals; time-sensitive individual activities in the landscape; collaborative, socially aware interventions. By exploring these approaches through examples of artworks and parallel texts, this anthology is intended to expand, rather than circum-scribe, traditional definitions of the genre.

The interventions of the Land Artists – working the resources of antiquity with the tools of mechanized modernity, exporting the cool cultural discourse of the city to industrial wastelands or the unacculturated desert – embodied the dis-sonance of the contemporary age. The decade of the 1960s that spawned Land Art was a period of longing – for a future that broke with a complacent present and for a past that transcended both. An awakening of ecological and feminist con-sciousness; the rapid integration of technology with everyday life and the resultant nostalgia for a simpler, more natural existence; a recognition of the personal and political power of the individual to intervene, for good or ill, within natural systems – all of these demonstrate an ambivalence about the direction of socio-cultural progress. The political strife of the times, and the increasingly decentralized, grass-roots political attacks on the 'institution' that contributed to it, were echoed in the art world's increasing ambivalence towards its own institutional traditions.

Land Art emerged from a mid 1960s art world that was seeking to break with the cult of personalized, transcendental expression embodied in American post-war abstraction. In its celebration of mass produced cultural debris, like home

furnishings, soap boxes and comic strips, Pop Art represented the antithesis of the pristine, uninflected environment of the modernist canvas. Similarly, process art, systems art and ultimately Land Art propose their own kind of sculptural analogue for this re-examination of the presumptions for isolation and purity made on behalf of the artistic gesture. The conceptual approaches then emerging questioned established notions of the artistic object, as well as the authority of its context. Artists found alternatives to the gallery or museum by co-opting other urban building types or by working in the open air.

'A dissatisfaction with the current social and political system results in an unwillingness to produce commodities which gratify and perpetuate that system', wrote critic Barbara Rose in a 1969 *Artforum* article. 'Here the sphere of ethics and aesthetics merge.'[1] Rose's location of an increasingly anti-canonical aesthetic programme within the context of the prevailing social, political and economic system provides a touchstone for examination of the Land Art phenomenon. The rise of contemporary environmentalist, feminist and de-centralized political strategies encouraged intensely political art forms. The broad range of works executed in the landscape participated in a programmatic challenge to social orthodoxy through the agency of the artistic object virtually unparalleled in the twentieth century.

The late 1960s was the time of the Vietnam war, of the assassinations of Martin Luther King Jr. and Robert Kennedy, of civil rights marches and student uprisings in Europe and the US. As Irving Sandler notes in his *Art of the Postmodern Era*, the chaos of the moment derived from and reiterated an essential crisis of faith in the Western body politic. In the denouement of the Second World War, the State, which was still viewed as the primary instrument of social action, began to lose stature. The grand industrialist matrix of early twentieth-century social life started to fray and give way to the more intricate dynamics of consumerism and new technologies. This shift was liberating but also fraught, and one price paid for this autonomy from established institutions was an inevitable sense of alienation. For all the sound and fury of the counter-culture attacks on the notion of the institution, practical change was limited. The effect on sensibilities generated by the efforts to remake, and sometimes even make from scratch, an idea of society did, however, have a dramatic impact on our view of ourselves and the world around us.

Quoting the historian Jonathan Miles, Sandler relates the impact of this sociological revolution, both despite and as a result of its failure, with the 'birth of a generalized concept of revolution – a concept that was seemingly endless in terms of what could be incorporated into it. Political emancipation, spiritual regeneration, sexual liberation … alternative lifestyles, grass-roots and community democracy … ecologically-based production, holistic therapies, anti-institutional "institutions" […]' All of these, Miles writes, 'could refer back to one generalized concept'.[2] And this concept, adds Sandler, 'would spawn artistic movement after movement' in its wake. Few were so fully-formed and dramatic as Land Art.

Although resistant to being seen as part of any distinct movement, the artists who first began to work in the landscape – Michael Heizer, Robert Smithson, Robert Morris, Dennis Oppenheim, Walter De Maria – all seem to have been dramatically influenced by the socio-cultural currents of the time. They shared a conviction that sculptural gestures could have a life away from the institution, out in the world, inflected by a variable and 'organic' location.

Precedents do exist for their formal investigations – as early as 1955 Herbert Bayer had constructed his *Earth Mound* at Aspen, Colorado. And the artists themselves had intermittently presaged what would come to be their defining programmes. De Maria had already suggested the idea of using artworks to activate an empty urban space in 1961. Carl Andre was beginning to question the notion of sculptural verticality by the middle of the decade, responding to the horizontality of the land. But what began as a few scattered expressions or plans for working within the landscape began to coalesce as the decade moved forward. Morris and Smithson were both proposing projects in 1966 that involved 'earthwork'. In 1967 Heizer began to execute works in the Nevada desert – he and De Maria worked together in 1968 on De Maria's *Mile Long Drawing* in California's Mojave Desert. When Heizer created his seminal *Nine Nevada Depressions* in 1968 – commissioned by New York collector Robert Scull – he was joined by Smithson and his wife Nancy Holt. Dennis Oppenheim moved from San Francisco to New York in 1966; having hung out with these artists at the famous downtown Manhattan bar, Max's Kansas City, he returned to the Bay Area to produce his *Oakland Cut* in 1967. The next year he executed a series of snow projects in Maine, including *Annual Rings*, *Time Pocket* and *One Hour Run*.

It was also in 1968 that the first of several important exhibitions dealing explicitly with earthworks was mounted at the Dwan Gallery in New York. Alongside the Americans were artists such as Richard Long from England, Jan Dibbets from the Netherlands and Germans Günther Uecker and Hans Haacke (who had been producing works incorporating and sited within the land for several years). They all participated in the 1969 show, 'Earth Art', at the Andrew Dickson White Museum at Cornell University in Ithaca, New York, curated by Willoughby Sharp.

If the appearance of this work in the galleries and museums began to give shape to a 'movement' of sorts and to a growing critical framework, it was still the work executed outside the exhibition spaces that drove the genre's progress. The counter-culture project to dismantle existing socio-political authority necessarily implicated the authority of the art world. 'The museums and collections are stuffed, the floors are sagging', wrote Michael Heizer, 'but the real space exists'.[3] Leaving the gallery did imply a kind of anti-authoritarian gesture, a break with tradition, but not an unproblematic one. Many of these artists were established figures, represented by galleries, supported by patrons, with access to the resources of the contemporary art world. Relocating an intricate conceptual programme into physical spaces traditionally characterized by a kind of anti-intellectual work ethic, one that spurned high-toned debate in favour of vigorous labour, the early earthworkers both continued the progression of long-established art historical legacies and broke dramatically from them.

Another important aspect of this thematic in post-war art was the increasing involvement of women artists and the impact of Feminism. 'Because women's traditional arts have always been considered utilitarian', Lucy R. Lippard argued in a 1980 *Art Journal* essay on 'The Contribution of Feminism to the Art of the 1970s', 'feminists are more willing than others to accept the notion that art can be aesthetically and socially effective at the same time'.[4] And this entrance of utilitarian ambitions into the sphere of contemporary artistic practice finds many of its earliest and most profound examples in work involving the natural world. A constellation of related vocabularies – among them performance, the critique of domestic-

ity and work, and a synthetic yet interventionist stance towards social concerns in forms as various as ecology, agriculture and waste treatment – were taken and consciously placed within the landscape. This environment – with all its historic and mythic maternal identity – produced a brand of artmaking tied to the social and cultural resonances of the land in a parallel yet markedly different way than its male analogue.

It is often said that Land Art is – perhaps along with the brawling days of Abstract Expressionism – the most macho of post-war art programmes. In its first manifestations, the genre was one of diesel and dust, populated by hard-hat-minded men, finding their identities away from the comforts of the cultural centre, digging holes and blasting cuts through cliff sides, recasting the land with 'masculine' disregard for the longer term. Yet if this is seen to be a visceral reaction to existing art world power structures, it must be remembered that its mythic qualities have to do at least in part with an appreciation of the 'denial' implicit in the choice to leave a largely friendly and accommodating art world circuit behind. Yet, for a number of groups – especially women – such a distancing from power was hardly something that required effort. Indeed, the marginalization of women that was intrinsic to the art world may have, in fact, better equipped them to face the challenges and take advantage of the potential opportunities presented by the definitive shift away from the influence of institutional forces. A foray outside the boundaries of the art world proper was no great liberating adventure for most women artists of the day – the margin was already their home.

Land Art represented an apotheosis of formalism and the evolution of Minimalism, just as the feminist critique which began to emerge in the late 1960s must be recognized as a primary force behind the decline of modernist canons. As Sandler notes, 'Postminimalism was ushered in by a show called "Eccentric Abstraction", curated by Lucy R. Lippard in the fall of 1966. She decided to organize the show because the rigors of Minimalism, of which she had been an early champion, had made her aware of what was precluded, namely "any aberrations towards the exotic". She also recognized that a significant number of artists "evolved a ... style that has a good deal in common with the primary [or minimal] structure as well as, surprisingly, with aspects of Surrealism. [These artists] refuse to eschew ... sensuous experience while they also refuse to sacrifice the solid formal basis demanded of the best in current non-objective art" [...]'[5]

A number of female artists were reconfiguring the limits of Performance Art by establishing new modes of address for it. From Dada through Happenings and Aktionism, up to contemporary practitioners like Bruce Nauman, Vito Acconci and Chris Burden, Performance Art is fundamentally anarchic, pointedly non-productive and ultimately pessimistic in its origins. Women artists such as Ana Mendieta or Mierle Laderman Ukeles, as well as notable male exceptions such as Joseph Beuys, began to turn away from dead-ended behavourial critique and narcissistic tests of physiology, towards practically affecting changes in the realms of cultural identity, community, co-operation and personal realization.

Because women's work had always been regarded as existing apart from the kinds of momentous activities – wars, conquest, exploration – that conventional readings of history placed at the forefront of social evolution, it provided a powerful basis for a subversive new practice that would be at home outside structures of power. When women artists began to query, contextualize and purposefully incorporate the potential and limitations of traditional female roles into their prac-

tice – rather than repudiate them as a kind of nostalgic, prosaic, theatrical clutter as Modernism would have had it – they began to change the very essence of art practice. Modernism defeated Classicism because it opened the door of the academy to the vibrance of the everyday. Yet, even in its embrace of the quotidian, it too eschewed certain kinds of activity as too banal. With its mythos of heroic creators and brave individualists, Modernism remained attached to the notion that artwork might transcend the prosaic. But in the work of the women artists who turned their attentions to the land – Ukeles, Betty Beaumont, Helen Mayer Harrison, Agnes Denes and others – it was precisely the everyday (washing, cleaning, gardening, nurturing) that held the raw material for artistic investigation. Dovetailing with a generalized reawakening of environmental interest, linked to notions of caretaking conventionally associated with the feminine, the works of leading female figures in the avant-garde of the time profoundly altered the course of post-war cultural discourse and practice, changing our expectations of what a work of art could be.

The variable, non-conventional kinds of projects that came to be produced in the landscape also challenged formal canons. As manipulations of three-dimensional materials in physical space, many of the first projects are sculptures. Yet, executed and sited in a specific location on which they depend for their power, they have the ability to melt and spread beyond the limits of their individual materiality, confusing the traditional sculptural scheme in which the experience begins and ends with the object.

With its growing emphasis on personal meditative gestures and integration with daily aspects of social interest, Land Art evolved into one of the most egalitarian of post-war art movements. Formally, the works demonstrated what the modernist critic Michael Fried referred to, famously and pejoratively, as a kind of 'theatricality' – that which 'lies between the arts'.[6] They also expanded into the contextual spaces between previously delimited boundaries of sociology, science, history and art by conflating all of them into a messy and frequently exuberant expression of 'postmodernist' twentieth-century life.

Resituating the site of the aesthetic epiphany from the object to the beholder and the surroundings in which the object was perceived – or generating an aesthetic experience without the object at all – dramatically alters the terrain of art-making tradition. The opposition implicit in the early Land works – between the modernist ideal of traditional aesthetic resources marshalled within the privileged blank space of the gallery and the conceptualist insistence on the contributions to perception made by siting, temporality and material unconventionality – was one that sought to relocate the artist and viewer from observer of nature to participant in it.

This participation went far beyond simple issues of sensory appreciation. The rise of environmentalism, born in the US with Thoreau and raised by Muir, came to a kind of proactive maturity in the 1960s. Between Rachel Carson's ecological call to arms, *Silent Spring*, published in 1962 and the first Earth Day celebration in 1970, environmental consciousness was forever changed. The development of Land Art in many ways mirrored the post-war evolution of eco-thought. The early wilderness-colonizing efforts of the first generation American Land Artists actually paralleled the ideas of conquest and exploitation that characterized the industrial era. At the same time many artists experienced a nostalgia for a pre-

industrial Eden, which precipitated, first, a critique of these conditions and, ultimately, a proactive stance in which the individual began to feel empowered to intervene in the problems that had been identified. The great earthmovers who worked to forcibly rearrange the stuff of the natural world in an effort to mediate our sensory relationship with the landscape were succeeded by artists who sought to change our emotional and spiritual relationship with it. They, in turn, spawned a third approach, that of the literally 'environmental' artist, a practice which turned back to the terrain, but this time with an activity meant to remedy damage rather than poeticize it.

The book is divided into three sections: a survey text which charts the most significant aesthetic and critical characteristics of Land and Environmental Art; a compilation of key works accompanied by extended captions; and documents which encompass artists' statements, key critical commentaries and essays from philosophical, literary, scientific or cultural sources which provide a broader context. The plates and the documents are themselves structured around a series of themes: Inception, Integration, Interruption, Involvement, Implementation, Imagining and Illumination. These themes are not intended to provide comprehensive documentation of a particular style or movement within the overall genre. Rather, they are designed to sketch a tendency, an area of interest and practice, which in its art historical, social or poetic meaning forms part of the larger picture of Land and Environmental Art. This book is not in itself designed to generate new specific criticism of Land and Environmental Art, but rather to bring together an array of observations, meditations, explications and calls to action in a contextual orbit around a strongly gravitational cultural body. It is in this interplay within a loose editorial framework, rather than in any explicit authorial inscription, where readers will be able to build bridges between what might seem distant locations in the socio-cultural landscape.

Our relationship with the land is complex. We see stability in its mute permanence and flux in its unending variances. We exploit and attack nature, wrestling from it the things we need to survive. Yet we are also aware of its transcendent imperturbability, its awesome uncontrollable power. Making the home for ourselves in nature that Bronowski describes is, wrote Wendell Berry, 'the forever unfinished lifework of our species ... The only thing we have to preserve nature with is culture; the only thing we have to preserve wildness with is domesticity'.[7] This fundamental human predicament – like our entire relationship to the environment and our legacy within it – is animated by profound connections and insurmountable divisions. The best Land and Environmental Art highlights this contradiction, probing the limits of artistic activity with the limitless tools of the artistic imagination.

1 Barbara Rose, 'Problems of Criticism VI: The Politics of Art Part III', *Artforum*, New York, May 1969. Reprinted in Irving Sandler, *Art of the Postmodern Era: From the Late 60s to the Early 90s*, Icon Editions, New York, 1996

2 Irving Sandler quoting Jonathan Miles, op. cit. Sandler, from Miles, '68 to '84: What Happened to the Revolution?', *ZG*, London, Summer 1984

3 Michael Heizer, 'The Art of Michael Heizer', *Artforum*, New York, December 1969

4 Lucy R. Lippard, 'The Contribution of Feminism to the Art of the 1970s', *Art Journal*, New York, Fall/Winter 1980. Reprinted in *Pink Glass Swan: Selected Feminist Essays on Art*, New Press, New York, 1995

5 Sandler, op. cit.

6 Michael Fried, 'Art and Objecthood', *Artforum*, New York, June 1967

7 Wendell Berry, *Home Economics*, North Point, San Francisco, 1987. Reprinted in William Cronon, 'The Trouble with Wilderness; or, Getting Back to the Wrong Nature', *Uncommon Ground: Toward Reinventing Nature*, ed. William Cronon, W.W. Norton & Co., New York and London, 1995

SUR-VEY

BY BRIAN WALLIS

Instead of using a paintbrush to make his art, Robert Morris would like to use a bulldozer.

Robert SMITHSON Towards the Development of an Air Terminal Site, 1967

In 1992, delegates from 179 nations came together at the Earth Summit in Rio de Janeiro for the United Nations' first-ever attempt to develop a coherent international policy on the environment. If international observers of this widely publicized event watched with a mixture of cautious optimism and frank scepticism, such a response was due in part to the insanely overambitious and fundamentally divisive goals of the conference: to stem environmental destruction while improving the economic condition of all peoples. The viewpoints of the various nations involved were so diverse that consensus seemed impossible; further, any policy generated would likely wind up being disappointingly centrist.[1]

To many, the Summit seemed like no more than a vast public-relations effort with little hope of curbing the true villains in a worsening global eco-crisis: the major industrial and corporate polluters. This position was only bolstered by the lavish promotional materials produced and disseminated at the Summit, which subsumed the apparently unattainable aims under the upbeat catchphrase 'sustainable development', and offered endless, blithely optimistic images of one world united by a common goal.

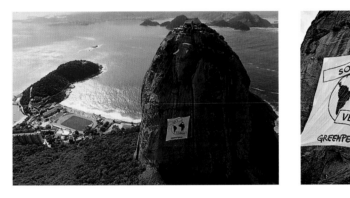

Greenpeace banner Sugar Loaf Mountain, Rio de Janeiro, 1992

While delegates to the conference were debating various geopolitical and spatial remappings, outside the meeting halls two very different 'images of ecology' were being presented.[2] The first gained considerable attention from a photo-op-starved media that had descended on the otherwise sombre summit, particularly since it inverted in spectacular fashion the rosy emblem of the summit itself. From high atop Sugar Loaf Mountain, the promontory that dominates Rio's harbour, Greenpeace activists unfurled a banner that featured the globe depicting solely the Southern Hemisphere overstamped with the words 'Sold' and '*Vendido*'. In a canny,

succinct way, the banner summarized one of the key debates of the conference: that Northern nations with far greater economic power were exploiting the non-reneweable resources of impoverished Southern nations. As environmental groups critical of the conference noted, the economic and political norm being promoted was based upon a late-capitalist American-style model of development, with all its attendant notions of wealth and progress. The crucial question was not so much *how* to manage the environment, but *who* would manage it.

One presumably unintentional result of the Earth Summit was precisely this reorientation of antagonisms from the old East-West alignment of the Cold War to a new North-South opposition. The Greenpeace banner also echoed a widespread post-colonial rethinking of global mapping itself and its relation to the project of domination. The year 1992 was, after all, the 500th anniversary of Columbus' 'discovery' of North America, and many non-white intellectuals were seizing upon the occasion to challenge the

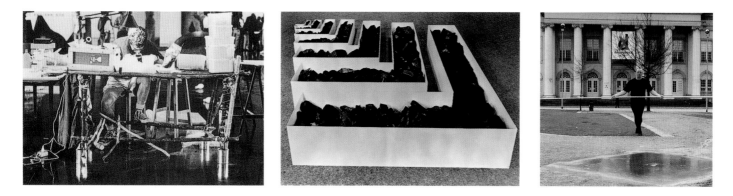

Mark DION A Meter of Jungle, 1992
Robert SMITHSON Non-site, 1968
Christian Philipp MÜLLER A Balancing Act, 1997

Eurocentrism of Western art and thought. As Latino artist Guillermo Gómez-Peña said at the time, 'Artists and writers throughout the continent are currently involved in a … redefinition of our continental topography. We imagine either a map of the Americas without borders, a map turned upside down, or one in which … borders are organically drawn by geography, culture and immigration, not by the capricious fingers of economic domination'.[3]

Less visible but equally incisive was a work by US artist Mark Dion, created as a part of 'Arté Amazonas', a contemporary exhibition staged by the Museu de Arte Moderna in Rio to coincide with the Earth Summit. For his installation *A Meter of Jungle*, Dion adopted the guise of the expeditionary naturalist and literally removed a section of the jungle floor, transporting it to the gallery for dissection and classification. This physical displacement replicated the principal operation of Robert Smithson's *Non-sites*, although in Dion's case, the change in context from the original locale to the museum was meant self-

Earthworks by Brian W. Aldiss, 1980. Originally published 1968 Earth Art Exhibition Andrew Dickson White Museum, Cornell University, Ithaca, New York, 1969; l. to r. Tom Leavitt, Neil Jenney, Dennis Oppenheim, Günther Uecker, Jan Dibbets, Richard Long, Robert Smithson

consciously to mimic the imperialistic basis of natural history itself.[4]

Both of these alternative approaches to the environment – that of the eco-activist and the eco-artist – trace their origins to the agitations of the 1960s, most particularly to the long-deprecated phenomenon known as Earth or Land Art, and more generally to the fundamental reordering of critical and representational practices conceived at that time. Both also unite certain themes, crudely construed as 'politics' and 'art', in a form of communication that embraces both performance and theory, aesthetics and activism. By locating the sources of these strategies in political developments of the 1960s, one can not only provide a historical point of origin, but also reveal how both currents responded to a need to develop what French urbanist Henri Lefebvre called a 'critique of everyday life' – a form of quotidien-based analysis that many would identify with the emergence of Postmodernism in the 1980s.

This historical recuperation is especially relevant in light

of the fact that many contemporary artists, like Dion, have recently found in the work of earlier Environmental Artists unresolved dilemmas, abandoned practices and distorted histories – in short, ripe possibilities for creating an art practice that engages both materially and critically with the past. To cite just a few recent examples: Renée Green's *Partially Buried* (1996) takes a multi-faceted look back at Smithson's *Partially Buried Woodshed* (1970); Christian Philipp Müller's contribution to the 1997 Documenta examines the current state of earlier site-specific works by Joseph Beuys and Walter De Maria; and Peter Fend's Ocean Earth company now builds earthworks originally designed by Dennis Oppenheim and Michael Heizer in the 1960s. Why this pronounced contemporary return to the prior examples of land-based work?

The exercises of a few 'earth artists' in the deserts of the western United States in the late 1960s may seem almost trivial when compared to the grand, if unrealizable, ambitions of the 1992 Earth Summit. But sometimes scale, rather than

size, changes the magnitude and importance of things. Robert Smithson once remarked, 'Look closely at a crack in the wall and it might as well be the Grand Canyon'.[5] In the same way, political or historical events sometimes gain prominence only through a change in optic. Such is the case with Land Art, which, although flamboyantly boostered in the heady, back-to-the earth 1960s, has since largely fallen off the map of canonical art histories. Such delays and repressions in the reception or history of ideas have their own mechanisms; sometimes it is necessary to uncover those earlier moments, not to establish some false pedigree, but to reconnect with and even celebrate what was previously overlooked.

The whole Land Art movement was, according to early accounts, a scrappy and faddish set of pranks carried out by a small group of self-described nature nuts. But in retrospect, it seems to have presaged – or at least participated in – the abrupt shift from Modernism to Postmodernism, particularly in the way that Postmodernism bracketed both 'nature' and 'culture' as socially constructed or fictional ideas. Postmodernists see a thorough interpenetration of culture and nature, regarding both as discursive fields not fully apprehendable as 'fact'. The critical application of this view suggests, in the words of primatologist Donna Haraway, that 'love of nature could be part of the solution rather than the imposition of colonial domination and cultural destruction'.[6]

Earthworks

In October 1968, at the height of the Vietnam war, six months after the student riots of Paris, and just weeks before the election of Richard Nixon as President of the United States, artist Robert Smithson organized an exhibition at Dwan Gallery in New York titled simply 'Earthworks'. Included in the show were large-scale outdoor works by fourteen artists, mostly young and little-known, but also including Herbert Bayer and Claes Oldenburg. All of the works posed an explicit challenge to conventional notions of exhibition and sales, in that they were either too large or too unwieldy to be collected; most were represented only by photographs, further emphasizing their resistance to acquisition. Named after a dystopian science-fiction novel by Brian W. Aldiss about a future in which even soil has become a precious commodity, the 'Earthworks' show delivered a pointedly pessimistic comment on the current state of America's environment and its future.

This perspective was congruent with the general political atmosphere of the time, in which the ecological movement was growing rapidly, and political activism, particularly in opposition to the war in Vietnam, was regarded as virtually mandatory among artists. Although not political in any conventional sense, the 'Earthworks' exhibition was clearly oppositional in that it demonstrated an intention to move the conception of art beyond the spatial confinements of the studio and the gallery.[7] In addition, the various works included in the show all overturned stereotypical versions of landscape and its meaning; the contributing artists joined up, however awkwardly, with pioneering ecologists in turning attention to the land and people's relationship to it.

Like many political currents of the 1960s, the ecology movement was a millennialist reaction to both the successes and failures of Modernism. It was not simply a moral campaign against the corporate depredation of the environment, but also an anxious response to the globalization of electronic

and cultural technologies. Mass war, nuclear threats, population explosions, repressive economies and polluted rivers all suggested that the utopian promises of progress had failed. From this followed what the geographer David Pepper calls the 'ecocentric catechism': 'anti-materialism; love and respect for the land; the land as one organism; the extension of "natural rights" from humans to the rest of nature; the need for an ecological conscience rather than mere agronomic management; the plea to return to an outdoor holistic science of natural history'.[8] Such views often tended to be translated into nationalistic versions of the pastoral based on such cliched examples as John Constable's often reproduced painting *The Haywain* (1821) or Eliot Porter's colour photographs of pristine nature.

Against this iconography of ecology, the dispirited sense of place echoed in the 'Earthworks' was clearly dysfunctional. In the centre of the exhibition, and also bearing the title *Earthwork*, was a small mound of dirt, twenty-five feet in diam-

eter, collected by Robert Morris and laced with steel rods and pipes, bands of felt, scraps of wood and coils of barbed wire. This work, typical of Morris' anti-form installations, was a kind of emblem, suggesting the provisional, anti-romantic view of nature typical of the works in the show. Such apparently casual spills and scatter pieces also challenged the static and fetishized character of modernist sculpture, including the rigid Gestalts of Morris' own earlier minimal sculptures, as well as idealized concepts of landscape. Shortly after the 'Earthworks' exhibition, Morris wrote, 'What art now has in its hands is mutable stuff which need not arrive at a point of being finalized with respect to time or space. The notion that work is an irreversible process ending in a static icon-object no longer has much relevance.'[9]

An equally striking aspect of the 'Earthworks' exhibition was that much of it consisted solely of photographic documentation of works that were either permanently sited in distant locations or destroyed. This not only frustrated conventional market expectations in the gallery, but established a strange sense of absence, even loss, and posed a peculiarly disorienting problem about what constituted the 'real' work of art. As critic Craig Owens later noted, the key shift marked by these works was 'a radical dislocation of the notion of point-of-view, which is no longer a function of physical position, but of *mode* (photographic, cinematic, textual) of confrontation with the work of art'.[10] This dislocation was only amplified by the bizarre nature of many of the projects shown: a room filled with earth and mile-long drawings in the desert by Walter De Maria; rings cut into a wheat field by Dennis Oppenheim; a line of wood blocks placed in a forest by Carl Andre; and various trenches gouged through forests and mud flats by Michael Heizer. Oldenburg showed what was perhaps the most unusual work: a hole in Central Park that he had hired professional gravediggers to dig and then fill in. (The work was represented in the exhibition by photographs and a plastic bag full of dirt.)

Just one month previous, Smithson, the acknowledged polemicist for the budding Earth Art movement, had published an essay titled 'A Sedimentation of the Mind: Earth Projects', which served as a kind of manifesto for the exhibition.[11] In that meandering text, Smithson offered at least three

propositions regarding the meaning and relevance of recent Earth Art. First, he proposed the work as a challenge to formalist views of sculpture's 'proper' role recently pronounced by critic Michael Fried; Smithson asserted that both studio-based art and the concept of the autonomous or timeless art object that Fried so adamantly defended were essentially finished. Secondly, Smithson argued that despite their apparent subject, earthworks had little to do with conventional notions of landscape or nature. 'The desert', he wrote, 'is less "nature" than concept, a place that swallows up boundaries'.[12] Finally, Smithson claimed that 'the more compelling artists today are concerned with "place" or "site" '.[13] By this Smithson meant not only specific overlooked locations, but also a conceptual relation between viewers and boundaries, inside and outside, centre and periphery.

In his essay 'Art and Objecthood' (1967), Fried accurately perceived that for the flagging modernist art movement of the mid 1960s, the major artistic problem was what to do with

Kenneth NOLAND Gift, 1962

sculpture.[14] How could its history be rewritten, how could its dominant terms be evaluated? This crisis, which would continue to haunt formalist critics for decades, stemmed from the rigid critical dictums that had been laid down in the previous decade by the influential American critic Clement Greenberg. Best-known for his strong defence of Abstract Expressionism in the 1940s, Greenberg had, by the end of the 1950s, developed a very compelling, though highly personal, theory of the logic of Modern Art.

Greenberg's principal rule was this: 'The essence of Modernism lies, as I see it, in the use of the characteristic methods of a discipline to criticize the discipline itself – not in order to subvert it, but to entrench it more firmly in its area of competence'.[15] This view presupposed an allegiance to the conventional aesthetic categories of high Modernism – painting, sculpture, drawing and architecture – and a commitment to reinforcing the boundaries that separated them. Indeed, the measure of quality in any particular work of art was gauged by the degree to which it criticized, defined and upheld that medium and eliminated elements from other disciplines. In painting, for example, the inherent qualities of the medium (which Greenberg identified as colour, flatness, edge and

scale) formed both the ground for refined experimentation and the basis for determinations of success. Thus, works like Kenneth Noland's *Targets* (1958–62) and *Chevrons* (1962–65), bold emblems of colour stained onto unprimed canvas, were considered exemplary modernist works. Characteristics considered extrinsic to the medium, particularly literary or theatrical qualities such as narrative, realism, description, subject matter or drama, were regarded by Greenberg as detrimental impurities. Thus, he stated, 'Three-dimensionality is the province of sculpture, and for the sake of its own autonomy painting has had above all to divest itself of everything it might share with sculpture'.[16]

For Greenberg and his followers (who included Fried, Sidney Tillim and Rosalind Krauss), Modernism was constantly bound to an almost tautological and formally reductive system, based on rational principles but prohibiting traffic with the 'real world'. Transgression or critique could take place only within the established terms of artistic creation. Change was defined by stylistic or technical innovation, and it followed that formal advancements would increase the degree of visual pleasure. Greenberg's Modernism excluded any consideration of extra-artistic factors, explicitly denying that artworks were themselves bound by a web of connections to specific historical and social contexts. Indeed, in the aesthetic economy of Modernism, the amount of pure pleasure provided by a work of art was often measured by how effectively that work separated itself from everyday time and space to provide an imaginary oasis of ideal reflection.

In his own text, Fried used Greenberg's critical model to attack the dramatic installations of early Minimalism, which he called 'Literalism'. In disparaging the works of Donald Judd and Robert Morris, Fried wrote, 'The concepts of quality and value – and to the extent that these are central to art, to the concept of art itself – are meaningful or wholly meaningful, only within the individual arts. What lies between the arts is theatre'.[17] Fried's notion of theatricality was typified by the invasion of the static art of sculpture by duration, temporality. This created a dramatic situation in which minimalist works – unlike conventional modernist sculptures – were no longer to be viewed as autonomous, self-contained objects in an atemporal state of grace. Rather they referred directly to the architectural space of the gallery and to the viewer passing through and participating in that space.

Greenberg himself summarized the stakes in the debate

when he stressed, 'The borderline between art and non-art had to be sought in the three-dimensional, where sculpture was and where everything material that was not art, also was'.[18] The question involved in debating Fried's concept of theatricality, then, was not simply what constituted sculpture, but what constituted art itself. As it turned out, much of the groundbreaking work of the late 1950s and early 1960s was characterized precisely by its 'theatricality' and its tendency to operate between traditional categories. This is obvious in the dance, performance, film and gallery-filling installation work of Robert Rauschenberg, Yvonne Rainer, Yayoi Kusama, Andy Warhol, Fluxus and others. But a similar argument can be made for the interdisciplinary aspects of other intellectual currents of the period that are generally considered in strictly political terms. Thus, one might consider the 'theatrical' aspects of the feminist critique of representation, the counter-culture's revolt against authority, the situationist remapping of urban spaces, the conceptualists' attention to the institu-

tional frames of art, the civil rights movement's strategies to re-assert cultural self-definition and the critical reappro-priation of popular cul-ture in a wide range of subcultural styles.

The second part of Smithson's argument addressed the ways in which earthworks differed from conventional approaches to landscape then being held up as a standard by formalist critics like Greenberg. Smithson aligned Greenberg's view of landscape with that of popular garden magazines that favour 'memory traces of tranquil gardens as "ideal nature" – jejune Edens that suggest an idea of banal "quality" '.[19] In a lengthy review of the 'Earthworks' exhibition in *Artforum* titled 'Earthworks and the New Picturesque', Greenbergian critic Sidney Tillim assailed what he perceived as the prevailing Romanticism of the Land Art movement.[20] He complained that the new earthworks were simply an updated form of the 'picturesque' – that is, landscape seen in a pictorial way. Like Minimalism, he suggested, earthworks were useless artefacts that created a setting more than a space and, like the eighteenth-century picturesque, served largely to define the observer as a 'man of taste'. Here, Tillim accepted Fried's central idea: the fact that when the observer

is situated within the artwork's spatial parameter, the experi-ence becomes 'theatrical'. And, as if to suggest that the Earth Artists were somehow taking advantage of modernist art's debilitated state, Tillim wrote that earthworks were, like Pop Art, a 'precious primitivism seeking revitalization through willful banality ... [that] arrive at a moment when Modernism is at the lowest ebb in its history'.[21]

Tillim was not alone in considering Land Art a return to the landscape tradition, and other critics also began to assert his-torical precedents for it in eighteenth-century aesthetic theo-ries of the sublime and the picturesque as well as other Mayan, Egyptian and Native American sources. But Land Art had virtually nothing to do with such conventional notions of landscape as gardening, open prairies, natural rock forma-tions, or John Ford's Monument Valley. Nor were these works ritual landforms in the sense of the Great Serpent Mound in Ohio or the Egyptian pyramids. For the most part they were impermanent anti-monuments, formed with the aid of gravity by the removal or addition of natural materials. Although often vast in scale, they were intended to be inclusive, partici-patory, even intimate. Quite unlike manifestations of the sub-lime, as defined by Edmund Burke in the eighteenth century, earthworks made no attempt to overwhelm or intimidate the viewer. Burke suggested that the sublime, a mood prompted by some overwhelming or awe-inspiring natural feature, would create in the viewer an unsettling fear or astonishment, similar to what Sigmund Freud later called 'the uncanny'. In Burke's catalogue of comparisons, sublime objects are vast and painful, beautiful objects are small and produce pleasure in the observer. Contrasting the open prairie with the expanse of ocean, for instance, Burke proclaimed that the ocean was infinitely greater because, as he said, 'the ocean is an object of no small terror ... [and] terror is in all cases whatsoever, either more openly or lately, the ruling principle of the sublime'.[22] Beauty, on the other hand, evokes feelings of love and compla-cency, according to Burke.

A generation after Burke, English philosopher Uvedale Price proposed the picturesque as more than simply a middle ground between beauty and sublimity, albeit one with a 'more general influence'. Rather, he felt that both beauty and the sublime were weighted down by an extremism that produced uniformity and stasis ('that general equal gloom which is spread over all nature before a storm'); the picturesque, he said, requires greater variety.[23] As an example, Price offered

Pyramids Dynasty IV, Giza, Egypt

this argument (quoted approvingly by Smithson in his 1973 essay 'Frederick Law Olmsted and the Dialectical Landscape'):

'The side of a smooth green hill, torn by floods, may at first very properly be called deformed; and on the same principle, though not with the same impression, as a gash on an animal. When a rawness of such a gash in the ground is softened, and in part concealed and ornamented by the effects of time, and the progress of vegetation, deformity, by this usual process, is converted into picturesqueness; and this is the case with quarries, gravel pits, etc., which at first are deformities, and which in their most picturesque state, are often considered as such by a leveling improver.'[24]

The picturesque, Price claimed, 'by its variety, its intricacy, its partial concealments ... excites that active curiosity which gives play to the mind, loosening those iron bonds with which astonishment chains up its faculties'.[25] In other words, Price accepted the ongoing changes and disasters of nature and attempted to develop a more practical and pragmatic view of the landscape, based on actual experience and real land rather than the brooding visions of idealists like Burke. Price's idea of the picturesque, as Smithson recognized, was based on 'chance and change in the material order of nature'.[26] Thus, Smithson concluded, 'Price seems to have accepted a side of nature that the "formalists" of his times would rather have excluded'.[27]

Smithson saw Price's theories in light of his own notion of the dialectical landscape as 'a process of ongoing relationships existing in a physical region'.[28] Then, speaking of Olmsted (but obviously referring to contemporary debates about Earth Art), he added, 'Dialectics of this type are a way of seeing things in a manifold of relations, not as isolated objects. Nature for the dialectician is *indifferent* to any formal ideal'.[29] Smithson's notion of the dialectical landscape presupposes the idea that the landscape is a culturally constructed entity. Not only is the landscape bounded by a political culture – either developed or *allowed* to remain wilderness – but it is invented in advance in the form of representations, including maps, photographs, engineering plans, etc. For Smithson, those representations were not the end product but the beginning of a long line of corruption and devolution, developments that he saw as exciting and generative. In fact, in his series of 'site selections' of 1967, he once designated the unfinished pilings of a dam as 'an abstract work of art that vanishes as it develops'.[30]

Thus, when Smithson made his third claim, that the more compelling artists of his day were concerned with 'place' or 'site', he was invoking an altogether new concept of these terms. The spots that Smithson preferred were artificial, marginalized or downright banal. The type of landscape he sought was embodied in fellow sculptor Tony Smith's famous description of a night drive on an abandoned highway:

'This drive was a revealing experience. The road and much of the landscape was artificial, and yet it couldn't be called a work of art. On the other hand, it did something for me that art had never done. [Its] effect was to liberate me from many of the views I had about art. It seemed that there had been a reality there which had not had any expression in art. The experience of the road was something mapped out but not socially recognized. I thought to myself, it ought to be clear that's the end of art. Most paintings looks pretty pictorial after that. There is no way you can frame it, you just have to experience it'.[31]

Although many critics were struck by Smith's visionary words (including Michael Fried, who used Smith's quotation as the starting point for his argument about the theatricality of minimalist sculpture), Smithson saw in this description an echo of his own fascination for useless spaces and for the meanings to be found in a landscape that was understood to be geographically, historically and socially *situated*. As Smithson wrote in the 'Sedimentation' essay, 'A bleached and fractured world surrounds the artist. To organize this mess of corrosion into patterns, grids and subdivisions is an aesthetic process that has scarcely been touched'.[32] What Smithson meant by 'earthworks', then, was both pre-existing sites on the land and artistic interventions that marked, traversed, constructed or demarcated territory. In other words, both operations involved actions or processes – pointing or mapping – that might be called 'spatial practices'.

A Radical Dislocation

Although conventional art histories chart the sudden emergence of Land Art in 1968 as a sort of footnote to the triumph of Minimalism, a more quantifiable and gallery-bound movement, it is more useful to see it as part of a wider practice of spatial concerns, what Owens calls 'a radical dislocation of art'.[33] This involved not only the physical dematerialization of the art object (as described by much Conceptual Art, in which artworks were often reduced to propositions or ideas involving no material form) but also various conceptual projects

based on geographical or economic decentring (often including a shift in the conventional relation between centre and periphery). These included certain manifestations of Happenings, Fluxus, Conceptual Art and Situationism that were mostly urban oriented and were concerned with patterns of everyday life as well as the social organization of space.

Early conceptual examples of such spatial practices include Yoko Ono's *Map Pieces* (1962–64), one of which instructed participants to 'Draw a map to get lost'; Stanley Brouwn's *This Way Brouwn* (1961–62), in which passers-by in Amsterdam were asked to draw maps to various locations; Douglas Huebler's *Variable Piece #1* (1968), a 'site sculpture' in which four corners of a square were mapped randomly in various vertical and horizontal directions by placing pieces of tape on elevators, cars and trucks, and permanent sites.[34] Huebler later described the sorts of social processes he meant to set in motion, 'I always felt that the work was meant to launch the person viewing into a "real-life" experience … I

took a road map [and] I just drew random trips with a magic marker as on an AAA map, and I wrote on those things and gave a number of them out'.[35]

Such projects enacted what geographer Edward Soja refers to as a 'spatialization of cultural politics', a radical rethinking of the intersections between social relations, space and the body. This rethinking, he claims, can lead to a kind of in-between or third space, a 'lived space of radical openness and unlimited scope, where all histories and geographies, all times and places, are immanently presented and represented, a strategic space of power and domination, empowerment and resistance'.[36] Soja cites, in particular, French sociologist Michel de Certeau's notion of 'spatial practices' to describe the way a physical place is embodied through social actions, such as people's movements through it. Against the totalizing space of the grid or the government survey, de Certeau sees a whole rhetoric of pathways, such as those proposed by Conceptual Artists, spreading out like a 'story jerry-built out of

elements taken from common sayings, an allusive fragmentary story whose gaps mesh with the social practices it symbolizes'.[37]

While de Certeau's examples are based on urban street culture, the practice and its analysis allow one to recognize in the work of 1960s Conceptual Artists 'the clandestine forms taken by the dispersed, tactical and makeshift creativity of groups or individuals already caught in the nets of "discipline"'.[38] Further clarifying the ways such social spaces are activated, art historian Rosalyn Deutsche distinguishes between two key factors: difference and use. She notes, 'Differentiation from other sites, rather than intrinsic characteristic, endows social spaces with distinct identities and values. In addition, members of particular social groups perceive and use these spaces: they visit them regularly, carry on interrelations there, and interpret reality in their cultural settings.'[39]

These social activations of spatial conditions were crucial to the first generation of Land Artists whose works often addressed the specific histories and social uses of their environmental context even as they transformed that space. Frequently the works addressed the history and representation of nature, the patterns and process of growth or decay, as well as the complex historical and social issues pertaining to the site's ecology. A central idea was that of nature as defined and shaped by culture or, more specifically, the history and phenomenology of man's inhabitation of the landscape – what geographer John Brinckerhoff Jackson calls the 'vernacular landscape' and identifies with 'local custom, pragmatic adaptation to circumstances and unpredictable mobility'.[40]

If these terms seem a far cry from the monumental earthworks for which the Land Artists are best known, that is in part because the documentation of these works has focused attention on their sculptural forms and deflected it away from their spatial settings and social interconnections. Viewers of photographs of the distant desert earthworks by Smithson, Heizer or De Maria were often struck by the isolation and barren character of the landscape and tended to see the works as large-scale versions of minimal sculptures. But such aesthetic descriptions failed to acknowledge the complex rela-

tionships between the earthworks and the social and biological context of the desert. As critic Elizabeth Baker noted after visiting several of the earthworks, '[There is an] unexpected sense one gets of their connection with ordinary, everyday life … [requiring] encounters at every level of society, with federal and state land officials through local industrialists, ranch owners and bankers to suppliers of all kinds, technicians workmen and even watchmen'.[41]

Heizer, as the son of a noted archaeologist and authority on Native American tribes, was familiar with the cliff dwellings, rock drawings and other archaeological features, as well as the various ethnic cultures that thrived in the American Southwest. Smithson was also acutely aware of the history of specific sites and sought to incorporate both ancient myths and present-day banalities into the work. In part because Heizer and Smithson were interested in the anthropological and archaeological testimonies of the land, they were 'not involved with landscape in any pictorial sense

 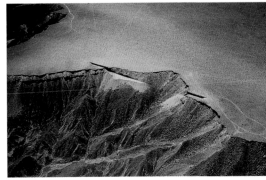

… their spaces tend to be rather neutral, although very vast'.[42] Yet, as film theorist Jane Tomkins notes, even this apparently neutral desert has a meaning, 'The blankness of the plain serves a political function that remains below the level of consciousness. It implies – without ever stating – that this is a field where a certain kind of mastery is possible, where a person can remain completely autonomous, alone and in control of himself, while controlling the external world through brute force and sheer force of will'.[43]

When Michael Heizer made his first earthworks in 1967 he was a twenty-three-year old painter living in New York and apparently searching for just this sort of mastery. His early Land Art projects were temporary 'drawings' or trenches made on rented land in the desert. In one case he hired professional motorcycle racers to create vast designs on the desert surface by riding in circles. For another work, Heizer dug short trenches in a pattern determined by dropping matches onto a piece of paper.[44] By the time of the

'Earthworks' show in 1968, Heizer had already created at least ten temporary land works in the western US desert, including *Isolated Mass, Circumflex* (1968), made with the assistance of Robert Smithson and one of *Nine Nevada Depressions* (1968), a series of craters funded by collector Robert Scull that stretched 520 miles across the Nevada desert.

Despite the apparent literalization of the drawing practice onto a massive scale, Heizer's work was both subtle and complex. For one thing, he accepted the temporary nature of the work, and even took pleasure in publishing photographs of the deterioration of pieces years after they were made. He also focused on negative space both within and beyond the actual work. Along with Smithson, Oppenheim and De Maria, Heizer was involved in a whole host of practices designed to break down the object, including negation (cuts, holes, removals); duration (space as a factor of time); decay (decomposition of organic and inorganic materials); replacement (transfer of materials from one context to another); dispersion (patterns produced by gravity in the form of spills, pours, slides, etc.); growth (seeding, harvesting); marking (temporary random patterns on public surfaces); and transfer of energy (decomposing, sterilizing).

Heizer's most noted work, *Double Negative* (1969–70), created for his 1969 show at Dwan Gallery, is a monument to displacement. Heizer said, 'The title *Double Negative* is impossible. There is nothing there, yet it is still a sculpture'.[45] Heizer had a team of bulldozers cut two massive sloping trenches fifty feet (15 m) deep on either side of a narrow canyon on the edge of Virgin River Mesa, near Overton, Nevada. This created an imaginary line thirteen metres wide and 457 metres long, bridging the chasm and displacing over 244,800 tonnes of sandstone and rhyolite. Heizer's dealer, Virginia Dwan, funded the work, which cost approximately $10,000 (and she later donated it to the Los Angeles Museum of Contemporary Art).

Heizer's exhibition at Dwan, a series of panoramic photographs from inside the trench, was controversial in that it symbolized for many critics the dangers of such monumental projects. One critic argued that it only succeeded in 'marring the very land, which is what we have just learned to stop

doing'.[46] Heizer himself later claimed that he 'started making this stuff in the middle of the Vietnam war. It looked like the world was coming to an end, at least for me. That's why I went out in the desert and started making things in dirt.'[47] But Heizer, like many artists working outside gallery spaces in the 1960s, was also intent on making a political statement about art-world economics. In an interview with the editors of *Avalanche* magazine he said, 'One aspect of earth orientation is that the works circumvent the galleries and the artist has no sense of the commercial or the utilitarian ... One of the implications of Earth Art might be to remove completely the commodity status of a work of art'.[48]

If Heizer's 'drawings' in the desert seemed immaterial yet meaningful, those made by Walter De Maria were even more charged. De Maria had traveled west with Heizer in April 1968 to make several large works in the desert. One of these was *Mile Long Drawing* (1968), which consisted simply of two mile-long chalk lines in the Mojave Desert in California.

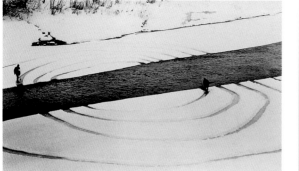

Photographs show the artist standing or lying down between the lines. And a visitor to one of De Maria's later works, *Las Vegas Piece* (1969), reported that it was important to walk the four miles of the work to gain 'an experience of a specific place, random apprehension of surroundings, and an intensified sense of self that seem to transcend visual apprehension alone'.[49] But like many early earthworks, *Las Vegas Piece* is seen most clearly from the air.

The political difference in meaning between the view from above and the view from below has been greatly debated.[50] The view from above, it is argued, constitutes a totalizing, panoptic gaze, a sense of looking at something, while the view from ground level suggests participation and community, the phenomenological effect of walking through space. When Robert Morris visited Peru to see the famous Nazca Lines, massive effigies scribed into the desert surface by the Pre-Columbian Nazca tribe, he said, 'Everyone I spoke to in Peru advised me to ... see the lines from the air ... Aerial photogra-

phy returns us to our expected viewpoint. Looking down, the earth becomes a wall at 90° to our vision'.[51] In the late 1960s, however, Americans had one association with aerial photographs: views of the earth taken from the Mercury and Gemini spacecraft (and often published in colour in *Life* magazine). That these same images of the earth from above had the salutary effect of reinforcing an ecologically friendly image of the planet was not overlooked. Satellite photography also displaced Cold War aerial images of missile emplacements with more benign view of weather formations. For his part, De Maria proposed a *Three Continent Piece* to be generated by satellite: three superimposed images of massive earthworks in India, Australia and North America.

This sense of geopolitical boundaries and border crossings was central to the thinking of many of the early Land Artists, though their works had little to do with overt considerations of nationalism, identity or displacement. Dennis Oppenheim's *Annual Rings* (1968), for instance, used the US-Canadian border as a median line for the schematic inscription of annual tree rings in the snow.[52] In that case the border, an indistinguishable feature on the land, served as a conceptual element in an arbitrary and abstract design and lent the work a distinctly political resonance. At a time when young American draftees were routinely slipping across the border into Canada to avoid serving in Vietnam, the annual growth rings suddenly connoted youthful age and potential destruction.

The sense of socially defined place that Oppenheim was exploring in his various Canadian border pieces of 1968 had been suggested earlier in a project he called *Site Markers*. These were simply stakes which the artist drove into the ground at various locations to designate or 'claim sites'. Oppenheim later said, '[In my site markers of 1967] the notion of travel was coupled with a sense of place. Place kind of took the place of the object ... My simple act of issuing a stake and taking up a photograph of the piece and claiming, pointing out where it was the map and describing it on the document was sufficient ... The need to replicate, duplicate or manipulate form was no longer an issue.'[53]

Smithson himself, in describing the genesis of his own Non-sites, says something quite similar, 'I began to question very seriously the whole notion of Gestalt, the thing in itself, specific objects. I began to see the world in a more relational

Dennis OPPENHEIM Annual Rings, 1968
View of the Earth from Apollo 17, December 1972

way. In other words, I had to question where the works were, what they were about … So it became a preoccupation with place'.[54] Smithson's Non-sites were presented as crib-like minimalist containers of painted or galvanized steel that contained raw material – rocks, gravel, salt – salvaged from distant mines, excavations or quarries. Crucial to these Non-sites were the maps that were exhibited with the more sculptural containers, since the maps both directed the viewer to the original site and established the 'dialectic' between site and non-site. This relational aspect, this in-betweeness, not only destablized the site itself but also foregrounded the whole concept of process or performance. The passage between the two locations, even if simply implied, threw new emphasis on time, duration, physical participation and a whole range of spatial practices.

Aside from the formal paradigms elicited by the site/Non-site, the conceptual and spatial issues are as crucial to the theoretical consideration of contemporary art as Marcel Duchamp's notion of the readymade. Like the readymade, the key to the Non-site is the concept of displacement, how the meaning of an object is changed by removal to another site. But unlike the readymade, the Non-site retains a connection to its original site (through the negative impression it leaves as well as the documentation that accompanies it), thereby setting up a dialogue about context, removal and recombination that echoes the very terms of the collecting or archiving project that underlies the museum itself. As Smithson noted in his own comparison of site and Non-site, a site is about scattered information ('The site is a place you can visit and it involves travel as an aspect too'), a Non-site is about contained information, 'Instead of putting something on the landscape, I decided it would be interesting to transfer the land indoors, to the Non-site, which is an abstract container'.[55]

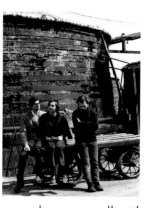

Robert SMITHSON, Nancy HOLT and Carl ANDRE New Jersey, 1967

For Smithson the great issue was studying conditions of cultural confinement, for which the Non-site was a metaphor. But at the same time, his view of 'sites' or specific locations was expansive, even kaleidoscopic. Smithson's *Spiral Jetty* (1970) is probably the best-known of the earthworks in part because of its stark minimalist form but also because of its complex appeal to the imaginary projections of the land itself.

In Smithson's own description of the work, and his process of creating it, the materialist base of the land blends with the fantasmatic readings of the site:

'This site was a rotary that enclosed itself in an immense round-ness. From that gyrating space emerged the possibility of the Spiral Jetty. No ideas, no concepts, no systems, no structures, no abstractions could hold themselves together in the actuality of that evidence. My dialectics of site and Non-site whirled into an indeterminate state, where solid and liquid lost themselves in each other. It was as if the mainland oscillated with waves and pulsations, and the lake remained rock still. The shore of the lake became the edge of the sun, a boiling curve, an explosion rising into a fiery prominence. Matter collapsing into the lake mirrored the shape of the spiral. No sense wondering about classification and categories, there were none.'[56]

The sense of not only desolation and decay but of collapsing categories perfectly encapsulated Smithson's sense of space and time.

To create the work it was necessary to plot and move over 6,500 tonnes of material, which was shaped to form a spiral or coil-shaped jetty 1,500 feet (450 m) long, duplicating the length of Heizer's imaginary line but curling it into a multidimensional work. Smithson drew on mythology, biology, geology and history of the region, an area of the Great Salt Lake not far from Promontory Point where the continental railroads met and the Golden Spike was driven. In his essay on the work, Smithson notes how the landscape was ravaged by prospectors, miners and oil drillers, all trying to extract something of value from the site. In describing some of their dilapidated shacks near the site of *Spiral Jetty*, Smithson wrote, 'A great pleasure arose from seeing all those incoherent structures. This site gave evidence of a succession of man-made systems mired in abandoned hopes.'[57]

Smithson's desire to revive or make useful what was once abandoned revealed both his allegorical penchant for ruins and his attraction to entropy, the tendency of all things to tend towards disintegration. The spectacular culmination of these interests was his *Partially Buried Woodshed* (1970), a metaphorical anti-monument constructed on the campus of Kent State University. Earth was piled on the roof of an abandoned woodshed until its main roof beam cracked, and Smithson stipulated that the work should be allowed to deteriorate naturally, the decay being part of the work (after several acts of vandalism, school authorities ordered the work razed

in 1984). The work acquired additional meaning four months after its creation when four student protesters were killed by National Guardsmen on the Kent State campus in May 1970. When someone spraypainted 'May 4 Kent 70' on the side of Smithson's earthwork, it became an inadvertent memorial to that event. Smithson later accepted that added meaning and even made an anti-war poster incorporating an image of this work for the *Collage of Indignation*.

Earthworks rarely engaged so directly with political matters, though. As Smithson said, 'The artist does not have to will a response to the deepening political crisis in America. Sooner or later the artist is implicated and/or devoured by politics without even trying.'[58] Smithson may have been referring to the patterns of activism then preoccupying much of the United States and the world: student strikes and campus takeovers to protest the war in Vietnam, urban riots to protest racial inequality, non-violent marches to highlight poverty and unemployment, factory shutdowns to fight for fair working

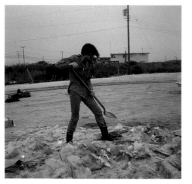

conditions, site occupations to inhibit destruction of the land. Many artist collectives were, as Smithson suggests, devoured by politics, particularly imperialism and the bourgeois institutions including museums that supported it. While Fluxus artists tried to circumvent the commercial art context by creating an alternate visual culture based on Eastern notions of chance and Dadaistic opposition, the Artworkers Coalition and the Guerrilla Art Action Group flagrantly challenged the unspoken political attitudes of museums by staging activist demonstrations inside the museums themselves, in one case spilling vials of blood on the floor of The Museum of Modern Art in New York to protest against the war in Vietnam.

However, artists themselves were sometimes the object of protests and the politics of the growing environmental awareness often posed a more direct conflict with projects on the land. Smithson's proposal for *Island of Broken Glass* (1970), near Vancouver, caused a major ecological controversy when opponents claimed that the two tons of glass shards to be dropped on a rock outcropping would harm nesting birds and seals; ultimately, the project was halted by the Canadian Society for Pollution and Environmental Control.[59] And incidents like this, as well as the massive earth moving involved in

operations like Heizer's *Double Negative*, made many viewers in the early 1970s regard earthworks as environmentally destructive. As one critic argued, 'Earth Art, with very few exceptions, not only doesn't improve upon the natural environment, it destroys it'.[60]

Smithson, for one, was sensitive to such criticism since he had earlier tried to revitalize the landscape itself and to direct the attention of observers to its spatial, historical, geological and cultural dimensions. He often spoke of *Spiral Jetty* as an ecological work of reclamation, and he envisioned a widespread movement to involve artists in the reclamation and improvement of devastated industrial sites. 'Across the country there are many mining areas, disused quarries and polluted lakes and rivers', he wrote. 'One practical solution for the utilization of such devastated places would be land and water re-cycling in terms of "Earth Art" ... Art can become a resource that mediates between the ecologist and the industrialist. Ecology and industry are not one-way streets, rather they should be crossroads. Art can help to provide the needed dialectic between them. A lesson can be learned from the Indian cliff dwelling and earthworks mounds. Here we see nature and necessity in consort.'[61]

Towards the end of his life, Smithson sent packets to dozens of mining companies proposing various unsolicited solutions for the reclamation of strip-mining pits and for the disposal of tailings (the waste minerals left after the ore has been extracted). 'The artist must come out of the isolation of galleries and museums and provide a concrete consciousness for the present as it really exists, and not simply present abstractions or utopias. The artist must accept and enter into all of the real problems that confront the ecologist and industrialist', Smithson wrote in a 1972 proposal for the reuse of a strip-mining pit near Ohio State University campus. 'Art should not be considered as merely a luxury, but should work within the processes of actual production and reclamation. We should begin to develop an art education based on relationships to specific sites. How we *see* things and places is not a secondary concern, but primary.'[62] Smithson's ambitious plans for the reclamation of a three-mile-wide mining pit worked by the Kennecott Copper Corporation near Bingham, Utah, and a massive tailing pond for waste generated by the Minerals Engineering Company in Creede, Colorado, were cut short by his untimely death in a plane crash in June 1973. After Smithson's death, his widow, Nancy Holt, continued to

Robert SMITHSON The Map of Broken Glass (Atlantis), 1969

pursue the project for the Creede site, saying, 'I see it as functional or necessary aesthetics, not art cut off from society, but rather an integral part of it'.[63]

Necessary Aesthetics

These twin ideas – necessary aesthetics and an art that was integral to society – became the hallmarks of much subsequent work on the land and in the tradition of the early Earth Artists.

Some of the controversies generated by the massive earthworks of Smithson and Heizer were addressed in quite different forms of ecological art by artists who focused on such natural forces as light, energy, growth and gravity. In these works, the natural sites or forces were left uninterrupted or unimpeded; there was no earth moving, there were no scars on the land. For the 'Earth Art' show at Cornell University in 1969, for instance, Hans Haacke exhibited a small mound of soil laced with grass seed; the work was titled simply *Grass Grows*. Other

early works by Haacke involved even less intervention, and were often focused on spatial determinates as mapped by random or natural motions. Some of these works, such as the self-describing *Ten Turtles Set Free* (1970) and *Spray of Ithaca Falls, Freezing and Melting on a Rope* (1969), involved only observations of natural processes and echoed an early manifesto in which Haacke had written, 'make something which experiences, reacts to its environment, changes, is nonstable ... make something sensitive to light and temperature changes, that is subject to air currents and depends, in its functioning, on the forces of gravity ... articulate something natural'.[64]

In a similar vein, New York artist Alan Sonfist sought to articulate something natural and to create a more harmonious and ecologically responsible form of Land Art based on a particular type of spatial and historical intervention. His *Time Landscape*™ (1965–present) was a massive project intended to convert anonymous urban sites throughout the five boroughs of New York City into reconstruction of the seventeenth-century, pre-colonial landscape. Implicit in this proposal was the juxtaposition of natural and urban, contempo-

rary and ancient, and developed and authentic, distinctions that were themselves highly debatable. The most visible section of Sonfist's project, at the corner of La Guardia Place and Houston Street, just north of SoHo, took ten years of research and negotiations with the city. But ultimately he was able to restore the damaged soil, replant native vegetation and reconstruct the original elevations. Although visible on four sides through a tall fence, this permanent, eight-thousand square-foot installation has a metaphorical impact and a moralizing intent that makes its function far different from other city parks.

For some critics, however, Sonfist's attempt to recreate a 'primitive wilderness' was misguided precisely because it echoed the preservationist strain of 1960s ecological thought. In this view, certain areas of wilderness should be protected as parks or preserves and should be returned, as much as possible, to their natural state. In the famous Leopold Committee report on the national parks in the United States in 1963 the government-appointed committee wrote, 'As a primary goal we would recommend that the biotic associations within each park be maintained, or where necessary recreated, as nearly as possible in the condition that prevailed when the area was first visited by the white man. A national park should represent a vignette of primitive America.'[65] But such measures simply disguise the actual problems of modern-day environmentalism by fixing an image of the landscape frozen in the past, privileging one moment in ecological history over all others, and precluding more complex interactions with various inhabitants, native or other. Critics have raised other questions about the symbolic and utilitarian values of such a living monument. At a panel discussion in 1978, for instance, a participant challenged the efficacy of Sonfist's blocklong forest in stemming pollution. Sonfist replied, 'Everyone here has their own responsibility to their environment. Everyone here has a certain role. I'm not trying to say that everyone should go out and deal with pollution. I think the issue is to create a more heightened awareness of our circumstances, whether they be political, or social. The forest is one of many answers.'[66]

Since 1970, at least, the symbolic consolidation of the environmental movement around the annual celebration of Earth Day had suggested that Sonfist's political metaphor – one forest among many – was an apt one. Robert Rauschenberg's famous *Earth Day Poster* (1970) summarized

Alan SONFIST Time Landscape™, 1965–78

this theme by representing the endangered bald eagle in the centre surrounded by a black-and-white constellation of other environmental disasters, and suggesting that the movement had to operate on many fronts. Even official environmental lobbyists had moved from a univocal preservationist position characterized by the Sierra Club to the variety of programmes comprised by the Group of Ten, a coalition of major environmental lobbying groups representing multiple compromise positions between government and industry interests in resource development and those Deep Ecologists who favoured a policy of minimal impact on the environment. In addition, following environmental disasters at Love Canal, Chernobyl, the Alaska Oil Spill and Three Mile Island, the citizens of many countries were looking to their national governments for leadership, regulation and answers to their anxieties about the global ecology.

Among the answers posed by a wide variety of artists throughout the 1970s were a range of solutions that, in keep-

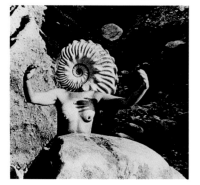

ing with the increasingly popular environmental movement, specifically avoided damaging or altering the earth. Some of these approaches involved spatial practices in the city rather than in distant landscapes, but the conceptual approaches were similar. Three strategies in particular governed many works of the early 1970s: feminist-inspired ritual activity that regarded the earth as an intimate extension of the human body; simpler gestural works that involved walking, pointing or the gentle and temporary displacements of some natural elements; and, finally, what might be called organizational projects that utilized or studied large social groups or political formations while creating works that emphasized the land or environmentally conscious actions.

After the first generation of predominantly male earthworks artists (when women such as Nancy Holt and Jeanne-Claude, though working alongside their artist husbands, received little recognition), female artists began to build projects on the land. Inspired by second-wave feminist theory and politics, which sought to define a distinctly female world apart from the conventions of patriarchy, these artworks were often related to specific struggles to define gender and identity. One way in which feminists sought to delineate the uniqueness of

women was to reconstruct a separate history that could be traced to prehistoric matriarchies and goddess cults. These mythological genealogies were based in part on the ancient belief in the earth as the mother of all living things, and a social attitude stemming from that tradition that identified women with passivity and nature and associated men with the active making of culture. This view was summarized in the title of feminist author Sherry Ortner's controversial essay 'Is Female to Male as Nature Is to Culture?' (1972), which argued for an elimination of such stereotypical views. Art critic Lucy R. Lippard, on the other hand, echoed the view of many 1970s radical feminists when she said, '[I see] no reason why all distinctly female qualities should be discarded in favour of an unattainable, overrated (and undesirable) androgyny'.[67]

Embracing the stereotype, many feminist artists drew an explicit link between the land and the female body, tying women's liberation directly to ecology and enacting communal or ritualistic performances at sites with historical connections to matriarchal religions. In this way, they created a far more self-conscious relationship between space and gender than had earlier male Land Artists. Artist Mary Beth Edelson typifies the impulse among some feminist artists of the 1970s to combine myths, dreams and spiritual images in rituals that referred to nature and earth goddesses. Implicit in her work was a belief that such pagan forms of nature worship offered an alternative union between the human and natural spheres that superceded both conventional religion and rationalism. Travelling to distant sites in Eastern Europe and Scandinavia, Edelson sought locations with strong supernatural associations. Her performances, such as *See for Yourself: Pilgrimage to a Neolithic Cave* (1977), enacted in a cave in Yugoslavia, used a traditional vocabulary of ritual, including chants, rings of fire, mandalas and a woman's body, to highlight the universal character of the female world that was being conjured. Despite their nostalgic claims to authenticity and their mystical appeals to Jungian notions of the collective unconscious, such early feminist projects were important steps in an effort to clarify a separatist space and a geography of difference.[68]

'If ecology is the syntax of Nature', writes critic Jack Burnham, 'then ritual is its daily, procedural counterpart in Culture. While ecology is simply the way of Nature, ritual has to be learned and adhered to.'[69] Burnham's definition, while overturning the rigid distinction of nature and culture, also removes ritual from the atemporal realm of the vaguely mythi-

Mary Beth EDELSON Goddess Head, 1975

cal to the more everyday context of any social practice that is 'learned and adhered to'. Thus when the nineteenth-century American writer Henry David Thoreau spoke of 'the art of Walking', he was describing a ritual to which he attached great political significance. 'We are but faint-hearted crusaders, even the walkers, nowadays, who undertake no persevering, never-ending enterprises', Thoreau complained. He wanted activist walkers who would sally forth 'in the spirit of undying adventure, never to return, prepared to send back our embalmed hearts only as relics'.[70] But when he contrasted this absolute freedom in nature with the constrained civil freedom of society, which required negotiation and compromise, he was advocating the romantic strain of transcendentalism that many American Land Artists of the 1970s – like Smithson and Morris – despised. Thoreau thought of man as 'part and parcel of Nature', but he still saw Nature with a capital N, and regarded most human improvements (such as the locomotive) as unwelcome intrusions.

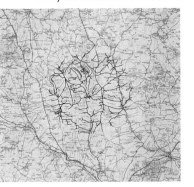
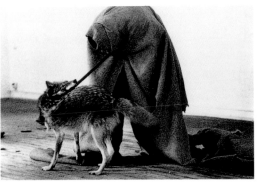

Richard LONG A six day walk over all roads and double tracks inside a six mile wide circle centred on the Giant of Cerne Abbas. 1975

Joseph BEUYS Coyote: I Like America and America Likes Me. 1974

If American artists of the 1970s were suspicious of the ideal lyricism of Thoreau's image of the walker in the forest, many British artists of the same period saw this activity as an engagement with authenticity itself. Richard Long, whose works document his solitary walks across the English landscape, has said, 'My work is real not illusory or conceptual. It is about real stones, real time, real actions.'[71] In early pieces such as *A Line Made by Walking* (1967), made while he was still a student at London's Saint Martin's School of Art, Long mapped straight lines across the landscape by displacing small stones or twigs along arbitarily selected stretches of ground. These solitary walks, which were re-presented either as books of photographs or as individual photographs with captions recording the time and place of the hike, were meant in part as a minimalist challenge to the Greenbergian model of formalist, welded-steel sculpture then being produced in England by Anthony Caro. All of Long's 'ephemeral gestures on the land' were equally simplified; as art historian Carol Hall

recounts, 'One work was the making of a path in a field of grass by walking back and forth for several hours, another consisted of snipping off the heads of flowers in a meadow, thus inscribing a giant X'.[72] Some even engaged with the historical or political meaning of the sites, such as his six-day walk around the Cerne Abbas Giant (1975) or his *Power Line Walk: From a Water Wheel to a Nuclear Power Station* (1980), though the principal significance of Long's work was neither their primitivizing ritual nor their attention to the specific meaning of a place.[73] Rather than the defined place, the key to Long's work was the notion of travel. Passing through a contemporary space with all its own accumulated history and everyday rituals, Long enacted a specific temporal activity that scarcely left a mark but which communicated through the fundamental integers of a language of transitivity itself.

Other conceptualists, notably the messianic German artist Joseph Beuys, used natural processes as metaphors for the spatial structure of social systems and often blurred the line between artmaking and organized political action. Beuys, in an effort to spread his 'green' ecological philosophy (which saw every citizen as an artist and linked all animate and inanimate things in one ecosystem), even ran twice for the German Parliament (but lost). From his early involvement with Fluxus, Beuys had perfected a ritual form of perfor-mance or 'action' that utilized dramatic spaces and symbols, such as a dead hare or stag, as metaphors of German political trauma. In his famous New York action *Coyote: I Like America and America Likes Me* (1974), a felt-wrapped Beuys stayed in a cage installed at the René Block Gallery with a live coyote for three days, as both a direct allusion to endangered species (the coyote and, by extension, the Native American for whom the animal was sacred) and the imperialism of American involvement in Vietnam (likened to the near extermination of Native American tribes). When Beuys referred to his actions as 'my so-called spatial doings in so-called environments', he was alluding to the fact that despite their universalizing overtones his performances were always rooted in the specific spatial practices of a particular political context.[74]

The complex rituals of contemporary social institutions and networks articulate a constant exchange of materials and representations between a specific site and its environment or context. A major task for the first generation of Conceptual

Artists (including Marcel Broodthaers, whose work simulated museum exhibitions; Bernd and Hilla Becher, who photographed typologies of vernacular architecture, such as water towers; Ed Ruscha, whose deadpan photo books, like *Every Building Along Sunset Strip* [1966], created arbitary collections of public networks and spaces; and Dan Graham, whose *Homes for America* [1966] organized the permutations of suburban tract housing) was to catalogue the components of this exchange. But beyond that structuralist project, they engaged in a form of institutional critique that examined the microcosmic economic and political preconditions that were channelled through the art-world container and inflected the meaning of all artworks.

Many of their site-specific installations consisted of small interventions or alterations in the exhibition space. Daniel Buren , for instance, underscored the meaning of certain environments or sites by plastering them with posters reduced to a standard programme of stripes, alternating white and

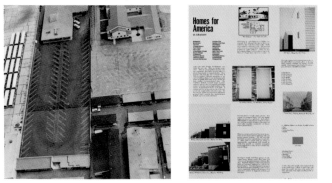

another colour. At various key locales these seemingly formalist stripes drew attention to ways in which the ideological and psychological preferences of capitalist economy were being reinforced or produced through elements of architecture or decoration. In particular, this type of institutional critique stressed the effects on the audience of certain naturalizing codes within the museum or gallery. But, at the same time, the emphasis on public space and vernacular forms of architecture as subject matter in the conceptual works of Graham, Oldenburg, the Bechers and Ruscha, as art historian Benjamin H.D. Buchloh has pointed out, 'foregrounded the absence of a developed artistic reflection on the problematic of the contemporary public'.[75]

This was specifically the problem taken up in the early 1970s by Hans Haacke, who had earlier documented various natural systems. In an extended series of works of 'systems analysis', Haacke polled museum visitors about the political views of the trustees, charted the interlocking fiscal connec-

tions of a museum's board, traced the tenement holdings of a single New York landlord, and chronicled the provenance of certain paintings.[76] These investigations revealed the systematic networks that always connect art to other forms of political influence.

For various ecological artists of the 1970s it was important to make clear links between natural and political systems, both within the context of the museum or gallery and outside. One collaborative team, Helen Mayer Harrison and Newton Harrison, focused almost exclusively on environmental policy and the powers that shape it. In the ten-year long *Lagoon Cycle* (1972–82), for example, the Harrisons present their research into the history and function of watersheds of various cultures, focusing in particular on the Pacific Coast ecosystem. *The Lagoon Cycle* has no tangible form as an earthwork (though some of their ecological alternatives have been adopted by local planners in Los Angeles); rather, it consists of a narrative of drawings, maps and conversational dialogue between a fictional witness and the lagoon keeper. In part this form replicates the nature of the Harrisons' research which entails speaking with dozens of scientists, ecologists, politicians and sociologists. So, the text of *The Lagoon Cycle* in part represents the Harrisons' own increasing involvement in ecological issues and contains their argument for both restoration of the original water systems and a greater integration of natural and human needs. Towards this end, their 'ecopoetry' has a didactic function, proposing practical solutions to existing food production and irrigation systems while also looking at the language of ecological discourse. 'Likening their process to the flow of a river', notes art critic Eleanor Heartney, '[The Harrisons] talk about "conversational drift" and suggest that their ultimate goal is to "change the conversation"'.[77]

The Bulgarian artist known simply as Christo has, along with his wife and collaborator Jeanne-Claude, extended the notion of site-specificity to buildings and landscapes alike by wrapping them in cloth or curtains. One of their earliest projects, *Valley Curtain* (1970–72) in Rifle, Colorado, consisted of a vast orange curtain (1,250 feet wide and 182 feet high) hung between two cliffs in the western US desert. The political significance of their work lies not only in the subjects that they select – key buildings like the Reichstag in Berlin or monumental natural forms like the Cayman Islands – but also in the rigorous political negotiations necessary to accomplish these

Ed RUSCHA Thirty-four Parking Lots in Los Angeles: State Board of Equalization, 14601 Sherman Way, Van Nuys, 1967
Dan GRAHAM Homes for America, 1966

works. In the documentary film that the Maysles Brothers created about the making of *Running Fence* (1972–76), Christo and his wife are seen jammed into a telephone booth somewhere on the California coastline pleading with a private landowner to allow the fence to cross their land. In other meetings with banks, landowners, community groups and planners, Christo and Jeanne-Claude hammered out the details of that complicated project. As critic Jeffrey Deitch has observed, '*Running Fence* was approached in much the same way as a highway authority would approach building a road or a developer would plan an industrial park. Thousands of hours had to be spent structuring financing, preparing environmental impact reports, and testifying before zoning boards.'[78] Although quite different from the sorts of ideological machinations highlighted by Hans Haacke, the Artworkers Coalition and other artists, the practical, on-the-ground politics of Christo and Jeanne-Claude demonstrates the everyday negotiations necessary to any social transaction.

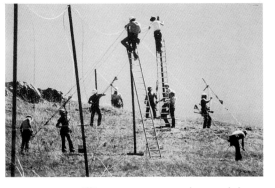

Postmodernism

One thing that united these very diverse efforts by feminists, systems theorists and eco-artists in the 1970s was a willingness to move beyond the conventions of artmaking and to engage with the ways that political meanings are shaped in a complex field of social interactions. In an important essay titled 'Sculpture in the Expanded Field' in 1979, American art historian Rosalind Krauss returned to the troubled nature of the modernist category of sculpture.[79] Twelve years after Michael Fried's 'Art and Objecthood', Krauss found that the word 'sculpture' no longer meant simply a homeless and largely self-referential object as it had in the modernist canon. The basic definition of sculpture as 'not landscape' and 'not architecture' had been vastly complicated by the wide range of site-specific structures and processes produced by artists in the 1970s. These new liberties taken by artists seemed to return Krauss to the conundrum outlined by Greenberg in 1968, 'The borderline between art and non-art had to be sought in the three-dimensional, where sculpture was and where everything material that was not art, also was'.[80] But how was one to map such a broadly conceived category?

Utilizing a structuralist diagram borrowed from linguistics, Krauss charted an 'expanded field' that included the new, in-between categories, which she called 'marked sites' (any physical manipulation or impermanent stamp on the spot), 'site constructions' (structures built into the landscape) and 'axiomatic structures' (interventions within architecture). This logical expansion of Modernism's categories, Krauss claimed, provided 'both for an expanded but finite set of related positions for a given artist to occupy and explore and for an organization of work that is not dictated by the conditions of a particular medium'.[81] And, most significantly, this structural transformation of the cultural field signalled, according to Krauss, the advent of Postmodernism.

But in a direct response to Krauss' essay, critic Craig Owens offered a strikingly different version of postmodern spatial practices in his essay 'Earthwords' (1979), a review of Robert Smithson's collected writings.[82] Owens shared with Krauss the view that language is central to postmodern philosophy, which regards culture as a system of socially constructed signs that can be read as text. But Owens argued that Postmodernism in the arts was signalled not by a multiplication of its forms but by the eruption of language into the aesthetic, and was therefore far more profound in its implications than Krauss acknowledged; it entailed 'a transgression of entire aesthetic categories (the visual versus the verbal, the spatial versus the temporal)'.[83] This radical decentring, which Owens found in Smithson's writings, reflected the poststructuralist view that discourse destabilizes all spatial categories based on logic and disrupts the closure implicit in common-sense definitions (such as those plotted by Krauss). Smithson himself reflected on the new conditions of postmodern space when he said:

'There is no hope for logic. If you try to come up with a logical reason then you might as well forget it, because it doesn't deal with any kind of namable, measurable situation. All dimension seems lost in the process. In other words, you are really going from some place to some place, which is to say, nowhere in particular. To be located between those two points puts you in a position of elsewhere, so there's no focus. This outer edge and this centre constantly subvert each other, cancel each other out. There is a suspension of destination.'[84]

This 'suspension of destination' is an apt characterization of the philosophical basis of Postmodernism as well as its spatialization. Critical and theoretical work in the early 1980s,

responding to the breakdown of modernist discourse in literary theory, psychoanalysis and the social sciences, shifted attention in art away from the autonomous modern masterworks towards the operations of Modernism itself, and from the established divisions of traditional culture towards an interdisciplinary examination of the dynamics of discourse. Specifically, Postmodernism studied the construction and perpetuation of the subject, or individual socialized person, through discourse, social fields made up of representations which do not refer back to an 'original' nature or reality but only to the language of one another. The very existence of the real or something 'outside' discourse was questioned. The means by which such representations could be critically apprehended by visual artists were specified by Owens, 'appropriation, site-specificity, impermanence, accumulation, discursivity, hybridization'.[85]

One specific direction for postmodern artists who were attempting to move beyond the strictures of Modernism was

the exploration of issues surrounding public space and public art. Postmodern space, as defined by cultural critic Fredric Jameson and others, was understood to be fragmented, insufficient and confounding. In a much-debated essay 'Postmodernism, or the Cultural Logic of Late Capitalism' (1984), Jameson described a new kind of disorienting, postmodern space symbolized by the mirrored-glass surfaces of John Portman's Bonaventure Hotel in Los Angeles. The reflective panels of the hotel's exterior produce in the viewer, according to Jameson, 'a sense of immersion and dislocation; the hotel transcends the capacities of the individual human body to locate itself, to organize its immediate surroundings perceptually, and cognitively to map its position in a mappable external world'.[86] In other words, the modernist conception of the logical, fully integrated self was superseded by a postmodern individual seen as psychically fragmented, schizophrenic and superficial, trapped in a maze of competing signs. For Jameson and others, the postmodern subject was, in a sense, placeless.[87]

But, as Susan Bordo and other feminist critics of Jameson have pointed out, this geographical metaphor suggests a too-easy move from a modernist 'view from nowhere' (objectivism) to an equally problematic postmodernist 'view from everywhere' (relativism). And, in the process, there is consid-

erable room for glossing over specific issues of gender, colour and location.[88] In general, feminist and postcolonial critics have preferred to use the metaphor of the body and to consider the issues around what has been called 'the politics of location', which calls for a specific attention to the way specific situations or contexts shape particular political practices. This view clashes with Jameson's idea that postmodern perception of space produces a sort of schizophrenic sensation that 'tends to demobilize us and to surrender us to passivity and helplessness, by systematically obliterating possibilities of action under the impenetrable fog of historical inevitability'.[89] Although it is worth retaining the sense of dislocation and decentredness in Jameson's model, his universalizing description of spatial conditions overrides the very different experiences of space one might have based on one's gender or ethnicity. Moreover, the political helplessness that Jameson's disorienting Postmodernism predicts is contradicted by the practical ecological endeavours of many contemporary artists.

Certainly, the decentring of postmodern space has undercut the authority of site-specific public monuments, a particularly ironic legacy of early Land Art. In fact, it was the sheer incompatibility of postminimal site-specificity and postmodern placelessness that formed the subtext of the celebrated debate in the United States over Richard Serra's sculpture, *Tilted Arc* (1981). That curving rusted steel wall bisecting a forlorn public plaza in New York City was opposed by over 1,300 workers in the adjacent office buildings who signed a petition against the work claiming that it violated *their* public space, that is, their easy access to work. In March 1985, a public hearing was held in the District Court of Lower Manhattan, and it was decided that the work should be removed. The destruction of Serra's monument signaled a rejection of his intention to 'involve the viewer both rationally and emotionally'[90] by a large portion of his audience, but it also sounded the death knell for a version of site-specific art that insisted by its sheer bulk in remaining rooted to its location.

Against the permanence and monumentality of *Tilted Arc* and the heroic individualism of artists such as Serra are postmodern practices that are mobile, adaptable to a wide variety of spaces, and attendant to the intersection of various social discourses rather than to the importance of one restrictive spot. Art critic James Meyer has referred to the spatial arena of such projects as 'the functional site', which he defines as 'a

process, an operation occurring between sites, a mapping of institutional and textual filiations and the bodies that move between them (the artist's above all) ... an informational site, a locus of overlap'.[91] In so far as such works are ambulatory, involving movement and impermanence, two prototypically 'functional' works are *Flow City* (1983–present) by the American artist Mierle Laderman Ukeles, an enormous walk-through viewing station that allows visitors to observe the massive and ongoing process of urban garbage disposal, and *Still Waters* (1992) by the British collective PLATFORM, an exploration of the damaged ecosystem of London's lost rivers, ancient tributaries of the Thames that have now been channelled through sewer pipes and underground diversions. Both works temporarily claim certain sites but, more importantly, they also generate a kind of grass-roots activism that is directed towards involving community members in representing and constructing meaning for environmental issues that are generally invisible.

Mierle Laderman UKELES at Flow City, 1992
PLATFORM Still Waters, publicity material
PLATFORM schoolchildren from Hatland Primary School, Merton Island

Provisionality is central to this idea of the functional site and this often entails the artist's ability to adopt alternate professional roles or to engage the services of non-art specialists. Ukeles, for example, serves as artist-in-residence for the New York Sanitation Department, a unpaid pseudo-bureaucratic post that nevertheless accords her status as an expert or insider. Being part of the system makes possible many of her works that focus on the labour involved in waste management, such as *Touch Sanitation: Handshake Ritual* (1978–79), in which she shook the hand of every garbage collector in New York City. Being part of the system also allowed her to participate in the planning and design of the New York City Sanitation Department's Marine Transfer Facility, a vast pier in the Hudson River where huge garbage trucks continually rumble through to dump tons of urban trash onto barges headed for landfill dumping sites. Within this switching place, a geographical passage between use and disuse, Ukeles has built a kind of visitors' centre that allows tourists to observe

and understand this process. Her design includes three parts: a long arcade-like entry ramp made of recyclables, the clear glass bridge that passes over the dumping stages, and a video wall that shows various operations and provides information on environmental topics. 'By creating a point of access', art critic Patricia C. Phillips argues, 'Ukeles enables members of the public to make more incisive connections with the physical dimensions of their urban and natural worlds. Both the city and the river are seen as relational; *Flow City* serves as the suture that draws the extremes of the nature culture dialectic into visible coexistence.'[92] Ukeles suggests that 'if people can directly observe how the city works, they can then direct their actions and ideas towards the construction of a meaningful public life'.[93]

In a similar way, PLATFORM's project uses a spatial and environmental project to alter perceptions of social life. Working collaboratively since 1983, PLATFORM has incoporated a flexible membership of specialists and non-specialists alike. In general, they work with local communities to restore environments that have been destroyed or damaged by human intervention and to use alternative energy production, waste management, information distribution and other schemes to re-educate the public about their ecosystem. In one statement, the members of PLATFORM stated their goals in rather utopian terms: to '[provoke] desire for a democratic and ecological society ... [and to] create an imagined reality which is different from the present reality'.[94]

Like Ukeles' *Flow City*, PLATFORM's *Still Waters* project involved specialists from a variety of disciplines as well as members of the community as observers and participants. In attempting to draw attention to the lost history of the London's watershed, *Still Waters* incorporated four major projects at specific sites within the city. For one section, 'Unearthing the Effra', a performance artist and a publicist developed a massive publicity campaign urging the public simply to dig up the River Effra, buried since the late nineteenth century under urban South London, and to restore its natural forms. Using the language of modern advertising, PLATFORM wrote, 'The unearthing of the Effra will be Europe's most important and exciting urban renewal project,

and it is happening on your doorstep'.[95] Part of another project on Merton Island involved restoring the abandoned Merton Abbey Mills wheelhouse and using it to generate electricity to illuminate the nearby Hatland Primary School.

Increasingly, artists have taken it upon themselves to initiate such covertly oppositional readings in the public realm. Combining a new awareness of the vitalism of public sites, an interest in reclaiming lost or suppressed histories, and an investment in contributing to social change, these artists have often formed alliances with other public interest groups. Intervening in the pre-existing spaces of communication, transportation, waste treatment and environmental reclamation, these artists have taken over public spaces. Their works are deliberately not like *Tilted Arc*, abstract monuments erected on permanent sites. Rather these are temporary responses, more akin to political action, responding to immediate situations and current causes. Sometimes these interventions have taken the form of education and direct action

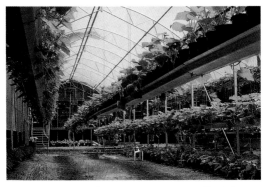

united not by stylistic features but by common strategies or modes of address. Israeli artist Avital Geva, for example, active since the 1970s, has been working on a project called the *Greenhouse* since 1977. This project, which is part of the Kibbutz Metzer, near the town of Messer in Israel, is a collective social experiment designed not only to produce new plants and food but also to teach horticultural skills and to foster a communal living and working situation, what Geva calls a 'social learning environment'. For Geva, who quit the art world in 1980, there is no distinction between the political or ecological work of the kibbutz and his art.

For those artists who continue to work within the more conventional spaces of the contemporary art world, a similar interest in instigating particular social or political practices for particular regions is facilitated (or exacerbated) by the new condition of exhibitions staged at widely dispersed locations that require the presence of the artist to create topical and site-specific installations. Unlike Geva's work on the kibbutz, however, these new site-specific projects are often temporary and involve only brief encounters with the local community. As a

consequence, art historian Hal Foster has complained that this 'quasi-anthropological work' constitutes a kind of amateur fieldwork that attempts to reconcile theory and practice but often ends up in a cul-de-sac of 'self-othering'.[96] Against this tendency, post-colonial theory has focused on diasporic and hybrid cultures, encouraging the study of migrations of people and cultural practices. Cultural theorist Homi K Bhabha notes:

'Anxiety is created by enjoining the local and the global; the dilemma of projecting an international space on the trace of a decentred, fragmented subject. Cultural globality is figured in the in-between spaces of double frames its historical originality marked by a cognitive obscurity; its decentred "subject" signified in the nervous temporality of the transnational, or the emergent provisionality of the present.'[97]

The dislocations of the postmodern subject in space referred to in Bhabha's notion of in-betweenness suggests a new attention to travel and mobility. Against the rootedness to a particular site, these artists emphasize a multiplicity of sites and the mobility of the artist. The very notion of travel also signals the possibility of the liminal sites as a position, what Smithson called 'dialectical' space. The work of Swiss artist Christian Philipp Müller provides a good example of an oeuvre based almost exclusively on travel, both in terms of its subject and its form. Many of his works involve hikes, tours and excursions, often with the specific intention of challenging politically invested boundaries. As part of *Green Border* (1993), his contribution to the 45th Venice Biennale (with the theme 'Nomadism and Multiculturalism'), Müller posed as an Alpine hiker and surreptitiously crossed the border of Austria into eight neighbouring countries. While humourously tweaking the attentiveness of the Austrian border patrol, Müller says, he 'experienced the difference between the border as an artistic concept and a political reality'.[98] He and his assistant were seized in Czechia and forbidden to re-enter the country for three years, an event that immediately recast the humour of the piece into a harrowing recreation of the circumstances of thousands of illegal immigrants and other border-crossers. For philosopher Michel Foucault, the hope of such symbolic artistic actions is to:

'Develop action, thought and desires by proliferation, juxtaposition and disjunction [and] to prefer what is positive and multiple, difference over uniformity, flows over unities, mobile arrangements over systems. Believe what is productive is not sedentary

Avital GEVA *Greenhouse*, 1977-present

but nomadic.'[99]

As part of this mobile positioning many recent artists have developed their own companies, programmes, organizations and solutions. American artist Peter Fend, for example, heads Ocean Earth, a company that was the first to sell high-quality satellite images to news organizations and is now involved in massive ecological projects based on early earthworks. In so far as Fend seeks to use satellite imagery to highlight global ecological disaster areas such as Chernobyl and the Persian Gulf, there is an activist element to this otherwise conventional professional work of consulting, teaching, networking and building new structures. Another example is the work of Viet Ngo, a Vietnamese-American artist and civil engineer, who started his own business in 1983 using his patented 'Lemna System', which employs duckweed (*lemnaceae*), a small floating aquatic plant, to transform waste into protein-rich feed for animals. Ngo's *Devil's Lake Wastewater Treatment Plant* (1991), in Devil's Lake, North Dakota, is a sixty-acre sewage treatment plant in the form of a snake-shaped earthwork. The plant doubles as a waterpark for the community, tells visitors about the environment and soil, and 'adds beauty and meaning to the communities they serve while purifying the water'.[100]

Using these models of spatial and environmental engagement, many activist coalitions – not necessarily involving artists – have applied postmodern visual techniques to critical public issues. Thus in addition to 1960s-style means of protest such as demonstrations, sit-ins, roadblocks or monkeywrenching (spiking trees slated for logging), many environmental coalitions have developed sophisticated means of intervening in or 'zapping' the media. Notable among these efforts are the vivid images of Greenpeace protesters rappelling from bridges to stop ships carrying hazardous materials or PETA's animal-rights advertisements showing celebrities preferring to go naked rather than wear fur. In a similar way, international gay and lesbian rights groups, including ACT UP, Gran Fury and WHAM!, have used vivid graphic design styles for posters that question social attitudes towards biological and medical issues around AIDS ('US spends more in five hours on defense than in five years on healthcare' or 'Men, use condoms or beat it'). Again, exploiting formal techniques developed by earlier postmodern artists – appropriation, montage, use of advertising style graphics – these artists use their art as political propaganda. Needless to say, the purpose of this work has little to do with the commodity-based requirements of the commercial art world. As video artist and AIDS activist Gregg Bordowitz says, 'What seems useful to me now is to go out and do work that is directly engaged, that is productive – to produce work that enables people to see what they are doing, that enables them to criticize what they are doing, and moves on'.[101]

Redefining cultural production as a political activity that is collaborative, multicultural and engaged with a community in an active way, these issue-oriented collectives (including the artist groups Border Arts Workshop, PAAD and Group Material) extend the lessons of the early Land Artists. Their 'non-art' manifestations suggest a way beyond the frame of Modernism to a true 'Postmodernism of resistance'. But they also make clear that there is not one Postmodernism, but many; not one voice, but many. Postmodern spatial practices cannot be confined to a fixed set of theories but form an ongoing experiment, costantly shifting and evolving. In particular they address the crucial issue of border crossings and limits as they pertain to nationalisms, local cultures, class, race, gender and sexuality. So the questions that are pertinent include: From what position do we speak? And for whom? What will this change? And for whom?

Such interrogatives suggest that the project of understanding our relation to nature and the environment has changed drastically in the past thirty years. The banner unfurled by Greenpeace at the 1992 Earth Summit showed a different view of the world, alluding to a poststructuralism where meaning and power are not determined by a single dominant viewpoint. Yet, even as we are confronted with a world that is increasingly multifaceted, intertextual and relativistic, certain material tasks remain. Among these are the need to remain suspicious of the ideological freight and the constructedness of the concept of nature and calls for its preservation; and to continue to call attention to the fragility of our environment and organized threats to it. This means not only protesting violations of specific physical spaces and negotiating the complex issues raised by difference but also paying attention to the everyday, that local social site 'where ideology and its resistance are lived out in all their messy contingency'.[102]

1 Coming just twenty-two years after the first Earth Day, the 1992 Earth Summit was envisioned as a crowning moment for the environmental movement. But as they sought to reconcile the tension between expanding international economic development and fragile and finite natural resources on the one hand and deepening Third World poverty on the other, hopes for concrete achievements diminished. Five years later, many question the accomplishments of the Rio Summit. The head of Greenpeace in Rio said in 1997, 'The Earth Summit made big noise, then few things happened, but I think it will take time to identify the outcome'.

2 On the relationship between Susan Sontag's 'ecology of images' and 'images of ecology', see Andrew Ross, *The Chicago Gangster Theory of Life: Nature's Debt to Society*, Verso, New York, 1994, pp. 170-73.

3 Guillermo Gómez-Peña, quoted in Suzanne Lacy, 'Cultural Pilgrimages and Metaphoric Journeys', in *Mapping the Terrain: New Genre Public Art*, ed. Lacy, Bay Press, Seattle, 1995, p. 19.

4 On Dion's *A Meter of Jungle* see Miwon Kwon, 'Unnatural Tendencies: Scientific Guises of Mark Dion', *Forum International*, Antwerp, May-August 1993. In an event unrelated to the 'Arté Amazonas' exhibition, the Finnish government chose the occasion of the Earth Summit to announce the sponsorship of Agnes Denes' *Tree Mountain* (1992-95), a forest preserve of 10,000 trees planted by 10,000 individuals, as part of its national campaign for environmental awareness.

5 Robert Smithson, unpublished interview.

6 Donna Haraway, 'A Cyborg Manifesto', in *Simians, Cyborgs, and Women: The Reinvention of Nature*, Routledge, New York, 1991, pp. 164-65.

7 By contrast, another exhibition in New York in October 1968 had more overtly political ends, though the work shown was more mainstream. The exhibition 'Art for Peace', organized by critic Lucy R. Lippard, painter Robert Huot and peace activist Ron Wolin at the Paula Cooper Gallery was designed to use the commercial gallery system for political ends. Works by major minimalist artists such as Carl Andre, Sol LeWitt, Robert Morris and Donald Judd were sold to benefit the Student Mobilization Committee to End the War in Vietnam. Over $30,000 was raised. See Lucy R. Lippard, *A Different War: Vietnam in Art*, Real Comet Press, Seattle, 1990, pp. 18-20.

8 David Pepper, *Modern Environmentalism: An Introduction*, Routledge, New York, 1996, p. 220.

9 Robert Morris, 'Notes on Sculpture, Part 4: Beyond Objects', *Artforum* 7, no 8, New York, April 1969, p. 54. See also Robert Morris, 'Anti-Form', *Artforum* 6, no 8, New York, April 1968, pp. 33-35. And for a discussion of Morris' own anti-form works, see Maurice Berger, *Labyrinths: Robert Morris, Minimalism, and the 1960s*, Harper and Row, New York, 1989. An exhibition titled 'Anti-Form', and including works by Eva Hesse, Panamarenko, Robert Ryman, Alan Saret, Richard Serra, Keith Sonnier and Richard Tuttle, was presented at the John Gibson Gallery during the same month as the 'Earthworks' exhibition at Dwan Gallery. The exhibition '9 at Leo Castelli', organized by Robert Morris during the month of December 1968 at Castelli's warehouse, included a large cast of artists and marked the clearest expression of the antiform tendencies.

10 Craig Owens, 'Earthwords', in *Beyond Recognition: Representation, Power, and Culture*, ed. Barbara Kruger et. al., University of California Press, Berkeley, 1992, p. 47. [See in this volume pp. 281-82]

11 Robert Smithson, 'A Sedimentation of the Mind: Earth Projects', *Artforum* 7, no 1, New York, September 1968; reprinted in *The Writings of Robert Smithson*, ed. Nancy Holt, New York University Press, New York, 1979, pp. 82-91. [See in this volume pp. 211-15]

12 Ibid., p. 89. [See in this volume pp. 211-15]

13 Ibid., p. 85. [See in this volume pp. 211-15]

14 Michael Fried, 'Art and Objecthood', *Artforum* 5, no 10, New York, June 1967; reprinted in *Minimal Art: A Critical Anthology*, ed. Gregory Battcock, E. P. Dutton & Co., New York, 1968, pp. 116-47. [See in this volume pp. 223-24]

15 Clement Greenberg, 'Modernist Painting', *Arts Yearbook IV*, New York, 1961; reprinted in *Minimal Art: A Critical Anthology*, op. cit., p. 70.

16 Ibid.

17 Fried, 'Art and Objecthood', in *Minimal Art: A Critical Anthology*, op. cit., pp. 19-20. [See in this volume pp. 223-24]

18 Clement Greenberg, 'The Recentness of Sculpture', in *Minimal Art: A Critical Anthology*, op. cit., pp. 180-81.

19 Smithson, 'A Sedimentation of the Mind: Earth Projects', op. cit., p. 85.

20 Sidney Tillim, 'Earthworks and the New Picturesque', *Artforum* 7, no 4, New York, December 1968, pp. 42-45. [See in this volume pp. 221-22]

21 Ibid. [See in this volume pp. 221-22]

22 Edmund Burke, 'A Philosophical Enquiry into the Origin of Our Ideas of the Sublime and Beautiful', R. and J. Dodsley, London, 1757; reprinted in *The Philosophy of Edmund Burke: A Selection of his Speeches and Writings*, ed. Louis I. Dredvold and Ralph G. Ross, University of Michigan Press, Ann Arbor, 1967, pp. 256-57; 262. [See in this volume p. 193]

23 Uvedale Price, 'An Essay on the Picturesque', J. Robson, London, 1796; reprinted in *The Genius of the Place: The English Landscape Garden 1620–1820*, ed. John Dixon Hunt and Peter Willis, Harper and Row, New York, 1975, pp. 354-57. [See in this volume pp. 193-94]

24 Uvedale Price, 'Three Essays on the Picturesque', 1810, quoted in Robert Smithson, 'Frederick Law Olmsted and the Dialectical Landscape', *Artforum* 11, no 6, New York, February 1973; reprinted in *The Writings of Robert Smithson*, op. cit., pp. 118-19.

25 Price, 'An Essay on the Picturesque', in 'Frederick Law Olmsted and the Dialectical Landscape', op. cit.

26 Smithson, 'Frederick Law Olmsted and the Dialectical Landscape', op. cit., p. 119.

27 Ibid., p. 118. This remark undoubtedly referred to the formalist critics of Smithson's own time, such as Tillim and Fried, who dismissed Earth Art as 'picturesque'. [See in this volume pp. 223–24]

28 Ibid., p. 119.

29 Ibid.

30 Robert Smithson, 'Towards the Development of an Air Terminal Site', *Artforum* 5, no 10, New York, June 1967; reprinted in *The Writings of Robert Smithson*, op. cit., p. 43.

31 Samuel Wagstaff, Jr., 'Talking to Tony Smith', *Artforum* 4, no 4, New York, December 1966, p. 19. A contemporary artist in sympathy with Smith's view is James Turrell, who has said, 'The places that most command my attention are large civic spaces that are no longer used, such as Monte Albán (the temple city of the Zapotecs situated on a mountain near Oaxaca in Mexico). The experience of entering such a space is just the experience of the space itself ... I'm interested in making spaces that we're familiar with in dreams and in imagination.' 'James Turrell: Painting with Light and Space, Interview by Clare Farrow', *Art & Design*, no 30, London, 1993, p. 46.

32 Smithson, 'A Sedimentation of the Mind: Earth Projects', op. cit., p. 82.

33 Owens, 'Earthwords', op. cit., p. 41.

34 See Christel Hollevoet, 'Wandering in the City: *Flânerie* to *Dérive* and After: The Cognitive Mapping of Urban Space', in *The Power of the City/ The City of Power*, ISP Papers, no 1, Whitney Museum of American Art, New York, 1992, pp. 25-55.

35 Douglas Huebler, quoted in 'Symposium', 1970, in Lucy R. Lippard, *Six Years*, Praeger, New York, 1973, p. 128.

36 Edward Soja, *Thirdspace: Journeys to Los Angeles and other Real-and-Imagined Places*, Blackwell, Oxford, 1996, p. 311.

37 Michel de Certeau, *The Practice of Everyday Life*, University of California Press, Berkeley, 1984, p. XX.

38 Ibid., pp. XIV - XV.

39 Rosalyn Deutsche, 'Alternative Spaces', in *If You Lived Here: A Project by Martha Rosler*, ed. Brian Wallis, Bay Press, Seattle, 1988, p. 45.

40 John Brinckerhoff Jackson, *Discovering the Vernacular Landscape*, Yale University Press, New Haven, 1984, p. xii. [See in this volume pp. 194-95]

41 Elizabeth C. Baker, 'Artworks on the Land', *Art in America*, vol 64, New York, January-February 1976; reprinted in *Art in the Land: A Critical Anthology of Environmental Art*, ed. Alan Sonfist, E.P. Dutton & Co., New York, 1983, p. 84.

42 Ibid., p. 75.

43 Jane Tomkins, 'Language and Landscape: An Ontology for the Western', *Artforum* 28, no 6, New York, February 1990, pp. 96-99. [See in this volume pp. 247-48]

44 On Heizer's early works, see 'The Art of Michael Heizer', *Artforum* 8, no 4, New York, December 1969, pp. 32-39.

45 Michael Heizer, 'Interview with Julia Brown', *Sculpture in Reverse*, ed. Julia Brown, The Museum of Contemporary Art, Los Angeles, 1984. [See in this volume pp. 228-29]

46 Joseph Masheck, 'The Panama Canal and Some Other Works of Art', *Artforum* 9, no 9, New York, May 1971, p. 41.

47 Michael Heizer, quoted in Douglas C. McGill, 'Michael Heizer's *Effigy Tumuli*', in *Michael Heizer's Effigy Tumuli: The Reemergence of Ancient Mound Building*, Harry N. Abrams, New York, 1990, p. 11. Heizer's huge quasi-architectural work *Complex One/City* (1972-76) was built next to a nuclear test site in Nevada, and Heizer said, 'Part of my art is based on an awareness that we live in a nuclear era. We're probably living at the end of civilization'. Such Eve of Destruction themes were echoed in the negative cast of many works, not only literal holes dug into the earth but also cancellations, destructions, craters, self-destroying works, disintegrating works, ruins and displacements.

48 Michael Heizer, quoted in 'Michael Heizer, Dennis Oppenheim, and Robert Smithson; Interview with *Avalanche*', 1970, New York, Autumn 1970, pp. 48-71. [See in this volume pp. 202-5] A few years later, however, Heizer told a reporter from *Newsweek*, 'I was never out to destroy the gallery system or the aesthetic object ... I'm not a radical.' See Douglas Davis, 'The Earth Mover', *Newsweek* 84, New York, November 18, 1974, p. 113.

49 Baker, 'Artworks on the Land', op. cit., p. 80.

50 See in particular, Michel de Certeau, 'Walking in the City', in *The Practice of Everyday Life*, op. cit., pp. 91-110.

51 Robert Morris, 'Aligned with Nazca', *Artforum* 14, no 2, New York, October 1975, pp. 26-39.

52 Oppenheim made several other important works near Fort Kent, Maine, during the same winter, including *Time Line* (1968), *Time Pocket* (1968), *Boundary Split* (1968), *Garage Extension* (1968) and *Negative Board* (1968). See *Dennis Oppenheim: Retrospective — Works, 1967-77*, Musée d'Art Contemporain, Montreal, 1978, pp. 40-42.

53 Ibid., Dennis Oppenheim, quoted in interview with Alain Parent, p. 16.

54 Robert Smithson, quoted in Paul Cummings, 'Interview with Robert Smithson for the Archives of American Art/Smithsonian Institute', 1972; reprinted in *The Writings of Robert Smithson*, op. cit., pp. 155-56.

55 Robert Smithson, quoted in 'Symposium', in *Earth Art*, ed. Nina Jager, Andrew Dickson White Museum of Art, Ithaca, New York, 1970, n.p.; reprinted in *The Writings of Robert Smithson*, op. cit., p. 160; 162.

56 Robert Smithson, 'The Spiral Jetty', in Gyorgy Kepes, *Arts of the Environment*, George Braziller, New York, 1972; reprinted in *The Writings of Robert Smithson*, op. cit., p. 111. [See in this volume pp. 215-18]

57 Ibid.

58 Robert Smithson, in 'The Artist and Politics: A Symposium', *Artforum* 9, no 1, New York, September 1970, p. 39.

59 On the proposed *Vancouver Project: Island of Broken Glass* (1970), see Robert Hobbs, *Robert Smithson: Sculpture*, Cornell University Press, Ithaca, 1981, pp. 185-86.

60 Michael Auping, 'Michael Heizer: The Ecology and Economics of 'Earth Art'', *Artweek*, New York, June 18, 1977, p. 1.

61 Robert Smithson, 'Untitled 1971', in *The Writings of Robert Smithson*, op. cit., p. 220. For more on art as reclamation, see Robert Morris, 'Notes on Art as/and Land Reclamation', *October*, no 12, Cambridge, Massachusetts, Spring 1980, pp. 87-102. [See in this volume pp. 254-56] Perhaps the most disastrous example of this type of reclamation is Michael Hiezer's *Effigy Tumuli* (1985-86) in Ottawa, Illinois, an attempt to make a park on the site of a forest destroyed by the Ottawa Silica Company. Intended to replicate the effigy mounds of prehistoric Native American moundbuilders, the work consists of five massive mounds in the abstract forms of a spider, a frog, a snake, a fish and a turtle. Originally, there was strong local

opposition to the project since the abandoned building site had become a popular dirtbike track and since it also seemed to trivialize the function of the original mounds. Once built, the mounds failed to grow grass as planned since the soil was contaminated. After several years of neglect the site was closed. One local opponent offered a useful summary of the cycles of public use of the land when he said, 'They might reopen it, but nobody is going to come see it anyway. There is still nothing to it but a few dirt hills. We took a wasteland and we used it. They ruined it so nobody uses it'. See Erika Doss, *Spirit Poles and Flying Pigs: Public Art and Cultural Democracy in American Communities*, Smithsonian Institution Press, Washington, DC, 1995. For a promotional gloss on the project, see McGill, 'Michael Heizer's *Effigy Tumuli*', cited in 47.

62 Robert Smithson, 'Proposal 1972', in *The Writings of Robert Smithson*, op. cit., p. 221.

63 Nancy Holt, letter to Timothy Collins, 2 October, 1973, *Smithson's Papers*, Archives of American Art, Washington, DC.

64 Hans Haacke, quoted in Jack Burnham, 'Hans Haacke: Wind and Water Sculpture', *Tri-Quarterly*, no 1, Northwestern University, Evanston, Illinois, Spring 1967, pp. 1-24; reprinted in *Art in the Land*, op. cit., pp. 106-24.

65 A.S. Leopold, et al., *Wildlife Management in the National Parks*, US Department of the Interior, Advisory Board on Wildlife Management, Report to the Secretary, 4 March, 1963.

66 Alan Sonfist, quoted in Harold Rosenberg, 'Time and Space Concepts in Environmental Art', in *Art in the Land*, op. cit., pp. 211-12.

67 Lucy R. Lippard, *Overlay: Contemporary Art and the Art of Prehistory*, Pantheon Books, New York, 1983, p. 44.

68 Other feminist artists developed structures which reiterated spaces with personal meanings, such as Alice Aycock's *Williams College Project* (1974), a small earth mound with a chamber in which one could crawl, and which refers to Hopi *kivas*, the caves of Kor, the subterranean vaults of the Federal Reserve Bank, and the circular pits of the Matmaris of Tunisia.

69 Jack Burnham, 'Contemporary Ritual: A Search for Meaning in Post-Historical Terms', in *Great Western Salt Works: Essays on the Meaning of Post-Formalist Art*, George Braziller, New York, 1974, p. 161.

70 Henry David Thoreau, 'Walking', *The Atlantic Monthly*, Boston, 1861; reprinted in *The Portable Thoreau*, ed. Carl Bode, Viking, New York, 1980, pp. 592-93. [See in this volume p. 235]

71 Richard Long, excerpt from leaflet printed on the occasion of the Richard Long exhibition, Anthony d'Offay, September 1980; reprinted in *Richard Long: Books Prints Printed Matter*, New York Public Library, New York, 1994.

72 Both the quote from Carol Hall and the apt phrase 'ephemeral gestures on the landscape' are borrowed from Stephanie Ross, 'Gardens, Earthworks, and Environmental Art', *Landscape, Natural Beauty and the Arts*, ed. Salim Kemal and Ivan Gaskell, Cambridge University Press, Cambridge, 1993, p. 171.

73 On Richard Long's work, in particular the *Cerne Abbas Walk*, see Stephen Bann, 'The Map as the Index of the Real: Land Art and the Authentication of Travel', *Imago Mundi*, no 46, British Library, London, 1994, pp. 9-18. [See in this volume pp. 243-45]

74 Joseph Beuys and Richard Demarco, 'Interview', 1982, *Energy Plan for the Western Man, Joseph Beuys in America, Writings by and Interviews With The Artist*, compiled by Canin Kuoni, Four Walls Eight Windows, New York, 1990, pp.109-16. [See in this volume pp. 266-68]

75 Benjamin H.D. Buchloh, 'From the Aesthetic of Administration to Institutional Critique (Some Aspects of Conceptual Art, 1962-1969)', in *L'art Conceptuel, une perspective*, Musée national d'art moderne de la ville de Paris, Paris, 1989, p. 49.

76 Haacke's importance to the whole idea of 'environmental art' can be judged from the fact that his cancelled retrospective at the Solomon R. Guggenheim Museum, New York, in 1971 was to have been divided into three sections: Physical Systems, Biological Systems and Social Systems. On Haacke's early systems works, see Hans Haacke, *Framing and Being Framed: 7 Works 1970-75*, ed. Kaspar Koenig, New York University Press, New York, 1975.

77 Eleanor Heartney, 'Ecopolitics/Ecopoetry: Helen Mayer Harrison and Newton Harrison's Environmental Talking Cure', in *But Is It Art?: The Spirit of Art as Activism*, ed. Nina Felshin, Bay Press, Seattle, 1995, p. 148.

78 Jeffrey Deitch, in *Art in the Land*, op. cit., p. 87.

79 Rosalind Krauss, 'Sculpture in the Expanded Field', *October*, no 8, Cambridge, Massachusetts, Spring 1979. [See in this volume pp. 233-34]

80 Clement Greenberg, 'Recentness of Sculpture', reprinted in *Minimal Art: A Critical Anthology*, op. cit., pp. 180-81.

81 Ibid.

82 Craig Owens, 'Earthwords', op. cit.

83 Ibid. According to Owens, this linguistic eruption was 'signalled by, but by no means limited to, the writings of Smithson, Morris, Andre, Judd, Flavin, Rainer, LeWitt [and was] coincident with, if not the definitive index of the emergence of Postmodernism'. The gloss on Owens' essay is from Hal Foster, *The Return of the Real*, MIT Press, Cambridge, Massachusetts, 1996, p. 86.

84 Robert Smithson, 'Fragments of an Interview with P.A. Norvell, April 1969', in Lippard, *Six Years*, op. cit., p. 89.

85 Craig Owens, 'The Allegorical Impulse: Toward a Theory of Postmodernism', in *Art After Modernism: Rethinking Representation*, ed. Brian Wallis, David Godine, Boston and New Museum of Contemporary Art, New York, 1984, p. 209.

86 Fredric Jameson, 'Postmodernism, or the Cultural Logic of Late Capitalism', *New Left Review*, no 146, London, 1984, p. 83. Jameson describes his purpose as: 'A model of political culture appropriate to our own situation will necessarily have to raise spatial issues as the fundamental organizing concern. I will therefore provisionally define ... an aesthetic of cognitive mapping.' The concept of cognitive mapping is more explicitly discussed in Jameson, 'Cognitive Mapping', in *Marxism and the Interpretation of Culture*, ed. Cary Nelson and Lawrence Grossberg, University of Illinois, Urbana, 1988, pp. 347-60.

87 For a succinct summary of these debates, see David Harvey, *The Postmodern Condition*, Basil Blackwell, London, 1992. For feminist correctives to the 'masculinist' spatial theories of Fredric Jameson, David Harvey, Edward Soja, and others, see these important works: Rosalyn Deutsche, *Evictions*, MIT Press, Cambridge, Massachusetts, 1997; Gillian Rose, *Feminism & Geography: The Limits of Geographical Knowledge*, University of Minnesota Press, Minneapolis, 1993; S. Pile and Gillian Rose, 'All or Nothing? Politics and Critique in the Modernism-Postmodernism Debate', *Environment and Planning D: Society and Space*, no 10, Pion, London, 1992, pp. 123-36; and Doreen Massey, 'Flexible Sexism', *Environment and Planning D: Society and Space*, no 9, Pion, London, 1991, pp. 31-57.

88 Susan Bordo, 'Feminism, Postmodernism, and Gender Skepticism', in *Feminism/Postmodernism*, ed. Linda J. Nicholson, Routledge, New York, 1990, pp. 133-56.

89 Frederic Jameson, op. cit., p. 86.

90 Richard Serra, quoted in Robert Storr, '*Tilted Arc*: Enemy of the People?' *Art in America*, vol 73, no 9, New York, September 1985, p. 93.

91 James Meyer, 'The Functional Site', *Documents*, no 7, New York, Fall 1996, p. 21.

92 Patricia C. Phillips, 'Maintenance Activity: Creating a Climate for Change', in *But Is It Art?*, op. cit., p. 188.

93 Ibid. For more on Ukeles' work, see Mierle Laderman Ukeles, 'Maintenance Art Activity (1973)', responses by Miwon Kwon and Helen Molesworth, and a conversation between Ukeles and Doug Ashford titled 'Democracy Is Empty', *Documents*, no 10, New York, Fall 1997, op. cit., pp. 5-30.

94 PLATFORM, *Still Waters*, exhibition brochure, 1992, n.p.

95 Ibid.

96 For Foster, this whole line of argument is part of a larger skepticism about the anthropological pretensions of cultural studies, new historicism, visual studies, and transdisciplinary studies in general. See Hal Foster, *The Return of the Real*, op. cit.

97 Homi K Bhabha, *The Location of Culture*, Routledge, New York, 1994, p. 216.

98 Christian Philipp Müller, 'Green Border', in *Stellvertreter, Representatives, Rappresentanti* [cat.], Austrian Pavilion, Venice, 1993, n.p.

99 Michel Foucault, *The Foucault Reader*, ed. Paul Rainbow, Pantheon, New York, 1984, p. xiii.

100 Cheryl Miller, 'Viet Ngo: Infrastructure as Art', *Public Art Review*, Minneapolis, Minnesota, Spring-Summer 1990.

101 'A Conversation Between Douglas Crimp and Gregg Bordowitz, 9 January, 1989', in Jan Zita Grover, *AIDS: The Artists Response*, exhibition catalogue, Ohio State University, Columbus, 1989, p. 8.

102 John Roberts, 'Mad For It!', *Third Text*, no 35, London, Summer 1996, p. 30.

WORK-S

CARL ANDRE
ANT FARM
ART & LANGUAGE
ALICE AYCOCK
JOHN BALDESSARI
LOTHAR BAUMGARTEN
HERBERT BAYER
BETTY BEAUMONT
JOSEPH BEUYS
DORIS BLOOM
ALIGHIERO BOETTI
CAI GUO QIANG
MEL CHIN
CHRISTO AND JEANNE-
CLAUDE
WALTER DE MARIA
HERMAN DE VRIES
AGNES DENES
JAN DIBBETS
MARK DION
TOSHIKATSU ENDO
HARRIET FEIGENBAUM

PETER FEND
IAN HAMILTON FINLAY
RICHARD FLEISCHNER
HAMISH FULTON
WILLIAM FURLONG
AVITAL GEVA
ANDY GOLDSWORTHY
HANS HAACKE
HELEN MAYER HARRISON
AND NEWTON HARRISON
MICHAEL HEIZER
NANCY HOLT
DOUGLAS HUEBLER
PETER HUTCHINSON
PATRICIA JOHANSON
WILLIAM KENTRIDGE
RICHARD LONG
GORDON MATTA-CLARK
ANA MENDIETA
CILDO MEIRELES
MARY MISS
ROBERT MORRIS

CHRISTIAN PHILIPP
MÜLLER
VIET NGO
ISAMU NOGUCHI
DENNIS OPPENHEIM
PLATFORM
RICHARD SERRA
BONNIE SHERK
KAZUO SHIRAGA
CHARLES SIMONDS
BUSTER SIMPSON
ROBERT SMITHSON
ALAN SONFIST
JAMES TURRELL
MIERLE LADERMAN
UKELES
MEG WEBSTER

INTEGRATION

The works grouped here manipulate the landscape as a material in its own right. The artists add, remove or displace local natural materials to create a form of sculpture that reflects the ethos of Minimalism in its emphasis on materiality, elemental geometries and siting. Their work draws out the relationship between the existing characteristics of a site and evidence of human intervention. Often monumental in scale, they simulate the spatial expanses in which they are located. These works introduce the foundational expressions of the Land Art phenomenon. The performative, process-based nature of Land Art's formal strategies developed throughout the 1960s are based on mark-making, cutting, agglomeration or relocation. Later practitioners inflect these methods with lyrical, and/or political intent.

Isamu NOGUCHI
Sculpture to Be Seen from Mars
(unrealized)
1947
Model in sand on board
30.5 × 30.5 cm

Noguchi started designing works for public spaces between 1933 and 1937. *Sculpture to Be Seen from Mars* was initially entitled *Memorial to Man* and conceived as a massive earthwork. The maquette was an impression of an abstract face in sand, photographed to create the illusion of massive scale. The nose was to have been a mile (1.6 km) long, and when seen from space, was intended to show that a civilized life form had once existed on Earth. Noguchi's pessimism about the future of the planet resulted in part from his experiences as a Japanese-American during the Second World War and the development of atomic weapons.

Walter DE MARIA
Las Vegas Piece
1969
Four cuts in the earth
2 cuts, 244 cm × 1.6 km each
2 cuts, 244 cm × 804 m each
Desert Valley, Nevada

Las Vegas Piece consists of four trenches, two one mile (1.6 km) long, and two half a
mile (804 m) long, all set at right angles to form a square. The straight lines are
trenches in the earth 244 cm wide, oriented N-S and E-W. Overlapping this artificial
grid are the curved patterns of natural streams. The piece is meant to be experienced
at ground level. It explores ideas of measurement and orientation of the body in the
landscape. By digging into the earth, De Maria also comments on how map-making
devices are imposed on the natural landscape.

INTEGRATION

Walter DE MARIA 47
Desert Cross (destroyed)
1969
White chalk lines
2 parts, w. 8 cm each
150 × 300 cm overall
El Mirage Dry Lake, Nevada

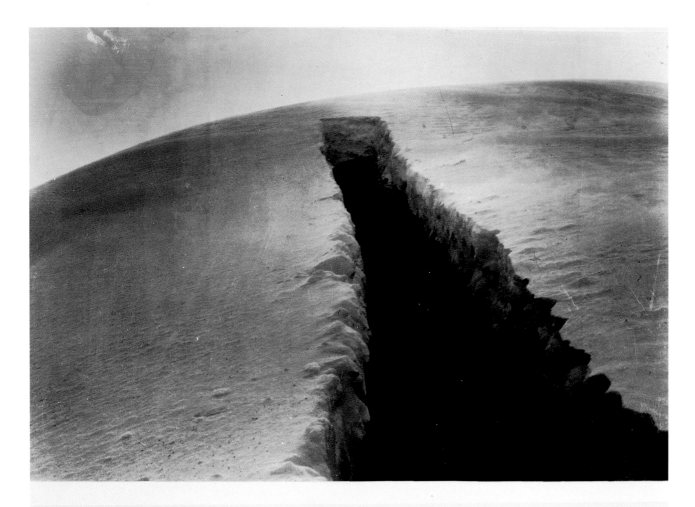

Dennis OPPENHEIM
Negative Board
1968
Colour photograph, black and
white photograph, hand-stamped
topographic map
152 × 102 cm
St Francis, Maine

Oppenheim cut through deep layers of snow and ice, lining the path with sawdust to create a dark seam (91 × 122 × 1,500 cm) through the snow. The work was exhibited as a photograph accompanied by a map showing the location of the temporary mark in the landscape. The mapping of the artist's gesture on the land and on a map created two very different visual experiences of the work. This work makes evident the symbolic function of maps.

NEGATIVE BOARD. 1968. St. Francis, Maine. 3' x 4' x 50'. Snow and sawdust.

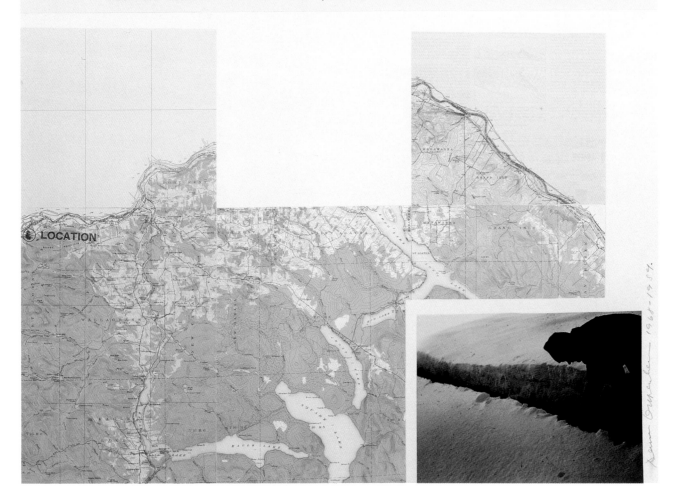

Dennis OPPENHEIM
Accumulation Cut
1969
Black and white photograph,
hand-stamped topographic map
152 × 102 cm
Ithaca, New York

Perpendicular to a frozen waterfall, Oppenheim cut a 122 × 300 centimetre channel in ice with a chainsaw. Within twenty-four hours the channel in the ice had refrozen; the forces of nature had erased man's intervention in the natural environment.

Oppenheim exhibited documentation of this work in the form of a map and photographs at the seminal 'Earth Art' exhibition at Andrew Dickson White Museum, Cornell University, Ithaca, 1969.

ACCUMULATION CUT. 1969.
Location: Ithaca, New York. 4' X 100' cut made perpendicular to frozen waterfall.
Equipment: Gasoline powered chain saw. 24 hours required to refreeze.

Dennis OPPENHEIM

Time Line

1968

Snow, snowmobile

2 lines, 30 × 91 cm × 4.827 km
each

Boundary between Fort Kent, Maine
(US) and Clair, New Brunswick
(Canada) on the frozen St. John
River

Following the lines of the boundary between Fort Kent, Maine (US) and Clair, New Brunswick (Canada) on the frozen St John River, Oppenheim cut two parallel lines in the ice with a snow-mobile, travelling at 35 m.p.h. The work took ten minutes to execute. The boundary also marks the intersection between two different time zones. Oppenheim is exploring the relationship between time and space; the time is simultaneously the same and different on each side of the time line. This makes clear the contrast between time as an abstract concept and time as it is experienced by moving through space. Oppenheim's gesture illustrates how human mapping systems are imposed on the natural environment, reiterating the artificiality of man's mapping of space.

Dennis OPPENHEIM
Cancelled Crop
1969
Wheatfield, harvester
267 × 154 m
Finisterwolde, Holland

A field was seeded and then the grain was harvested in the form of an X; the grain was kept from processing and never sold. Oppenheim explained, 'Planting and cultivating my own material is like mining one's own pigment (for paint) ... Isolating this grain from further processing becomes like stopping raw pigment from becoming an illusionistic force on canvas'
– Dennis Oppenheim in *Dennis Oppenheim: Selected Works 1967–90*, 1992
 The X is a symbol of cancellation and economic negation. The crop was not released into the food chain and remained exclusively part of an artistic act.

Jan DIBBETS
A Trace in the Woods in the Form
of an Angle of 30° Crossing a Path
1969
Overturned turf
300 × 152 cm
Ithaca, New York

Dibbets found a large clearing in a forest where a path crossed a creek. A clothesline attached to large rocks was used to mark out a large V on the ground, each arm of which was approximately 152 cm wide and 3 m long. The turf within each arm of the V was turned over with pickaxes and shovels, except where the V was intersected by the path. The long walk through the woods to the site of the work was part of the piece.

The work was made for the 'Earth Art' exhibition at Andrew Dickson White Museum, Cornell University, Ithaca, 1969.

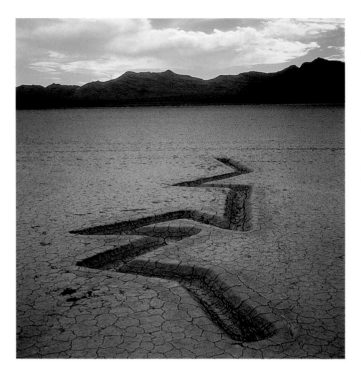

Michael <u>HEIZER</u>
Rift (deteriorated)
1 of Nine Nevada Depressions
1968
1.5 tonne displacement on the bottom of a dry lake bed
158 × 4.5 × 3 m
Massacre Dry Lake, Nevada

The transformative powers of nature are examined through the natural deterioration of Heizer's excavations. The artist creates a dynamic relationship between time and space. The forms which have been dug into the desert floor gradually disappear over time as they are eroded and the site is reclaimed by nature. Time is set in relation to human scale, which seems miniscule in proportion to the immensity of nature.

In his photographs of the *Nine Nevada Depressions* Heizer plays with conventions governing perspective vision; seen from different angles the depressions appear to take on a different form.

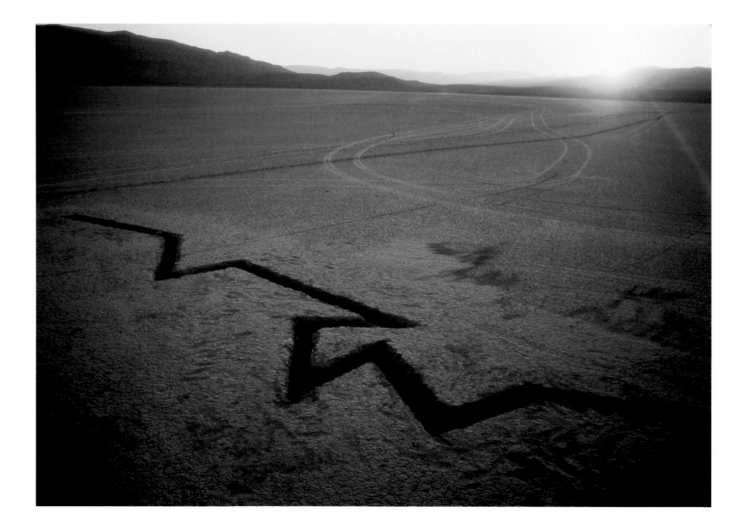

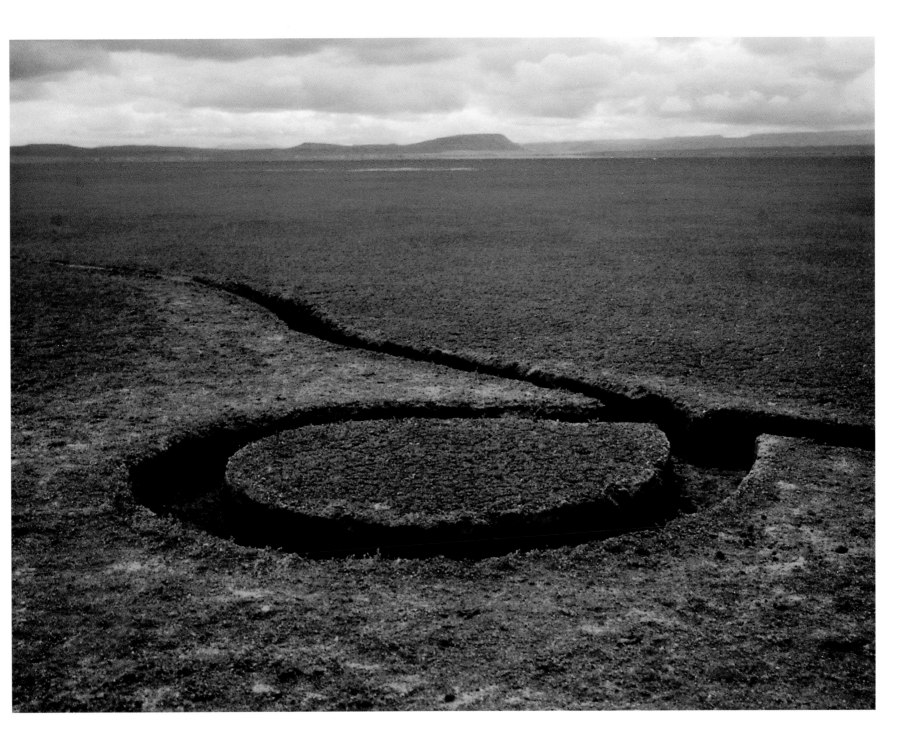

Michael HEIZER
Isolated Mass, Circumflex
9 of Nine Nevada Depressions
1968
1.5 tonne displacement on the
bottom of a dry lake bed
366 × 36 × 3 m
Massacre Dry Lake, Nevada

Michael <u>HEIZER</u>
Double Negative
1969-70
244,800 tonne displacement
Rhyolite, sandstone
457 × 15 × 9 m
Mormon Mesa, Overton, Nevada

A massive 240,000 tons (244,800 tonnes) of earth was moved with the help of
bulldozers which excavated from two sides of a valley wall. The displaced earth was
banked up in front of the bulldozers to form two horizontal ramps. Commenting on
the title, the artist stated, 'In order to create this sculpture material was removed
rather than accumulated … There is nothing there, yet it is still a sculpture'.
– Michael Heizer, 'Interview with Julia Brown', 1984

 The sculpture is created from the void rather than from the solid. Heizer's concerns
with the direct physical experience of our bodies in relation to the landscape are
particularly evident in *Double Negative*. The vastness of the work itself competes with
the immense scale of the natural world. The viewer can walk through the sculpture as
if it was a building; thus a connection is also made between sculpture and
architecture.

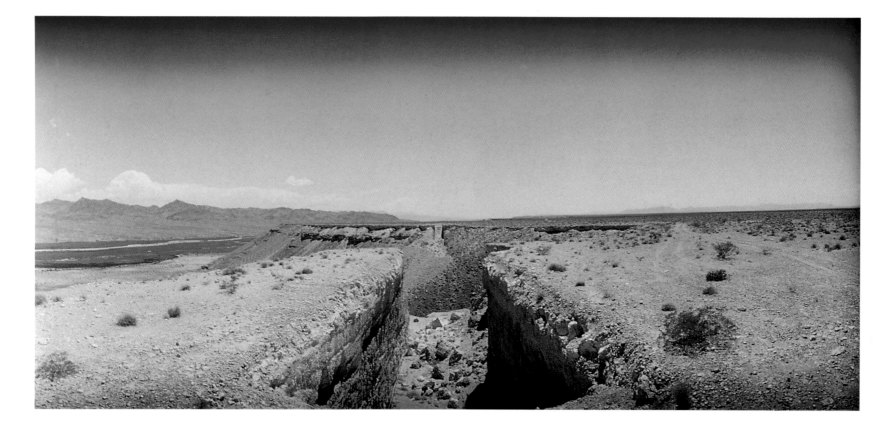

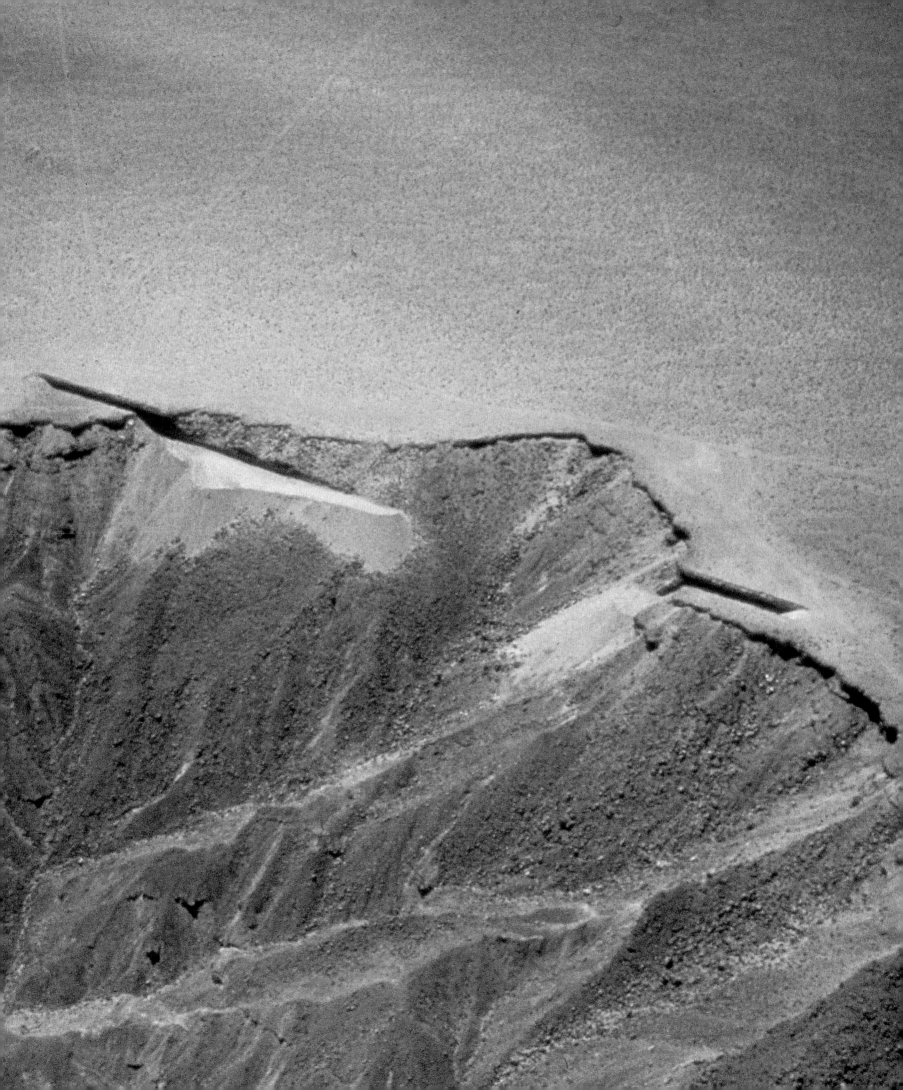

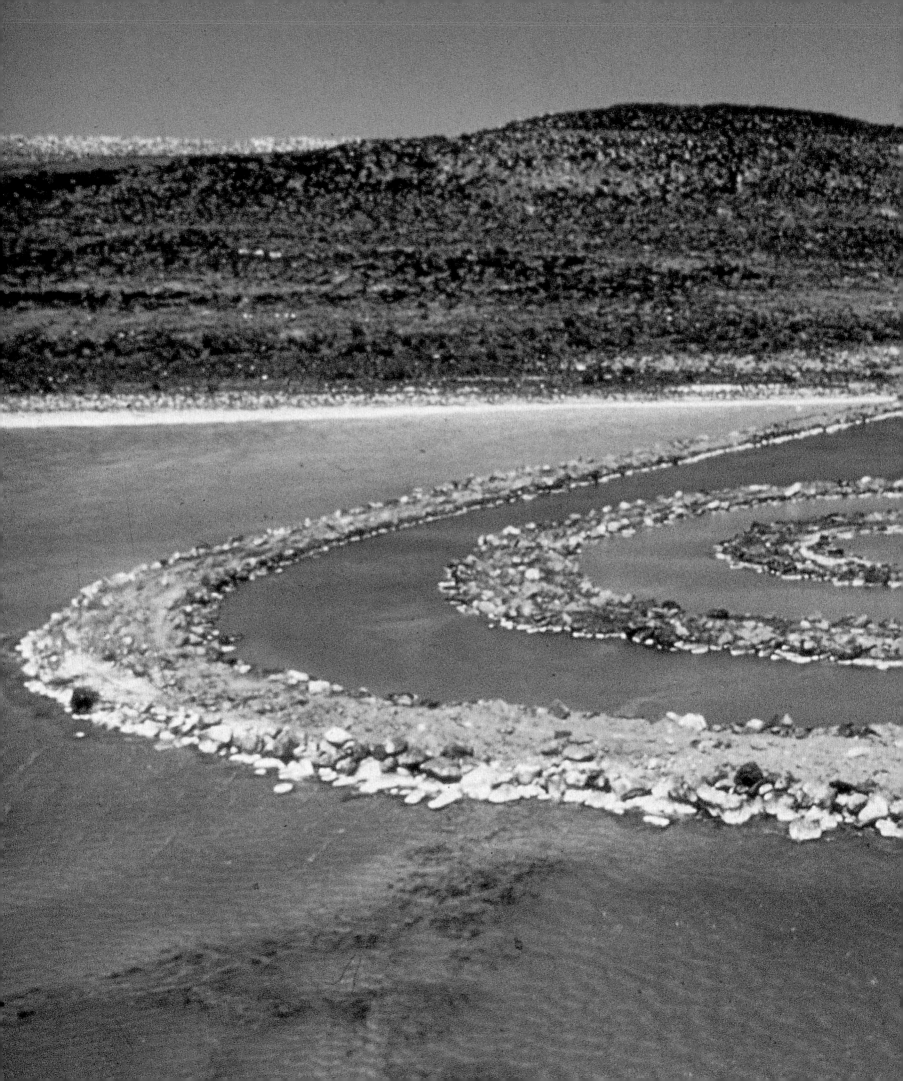

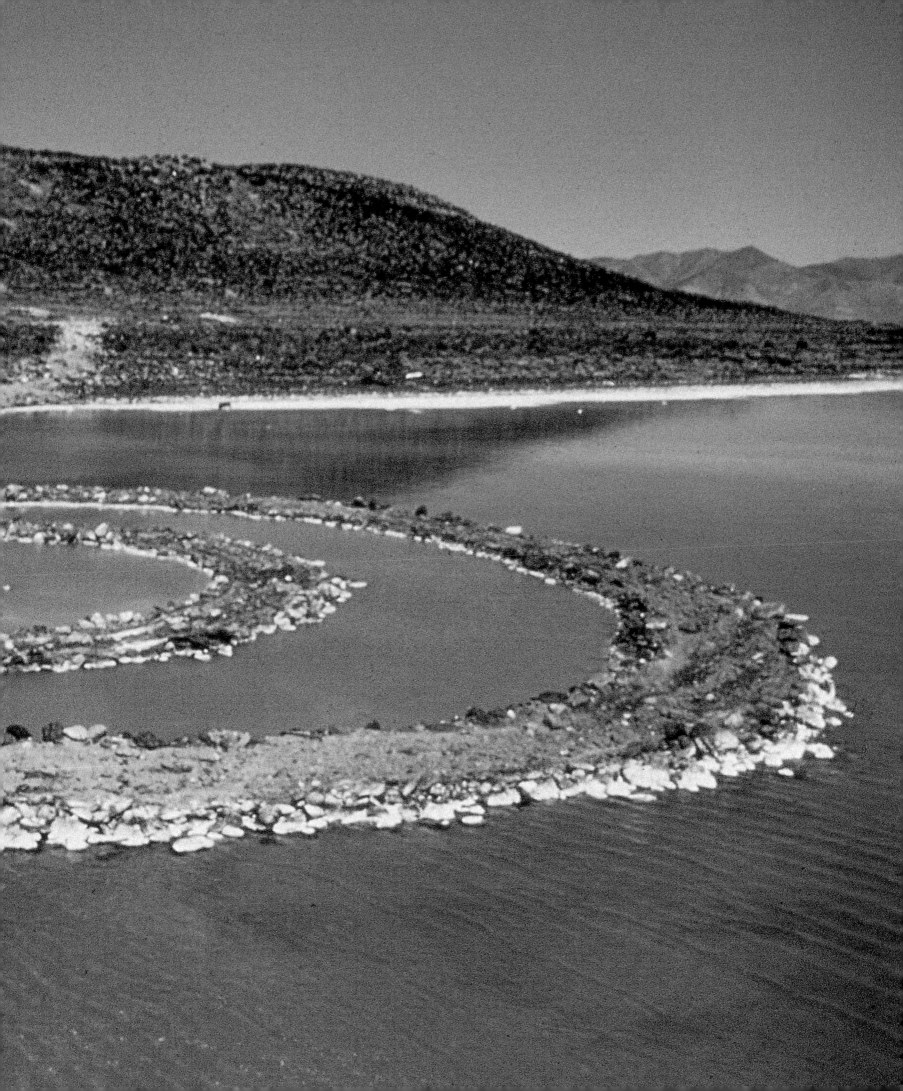

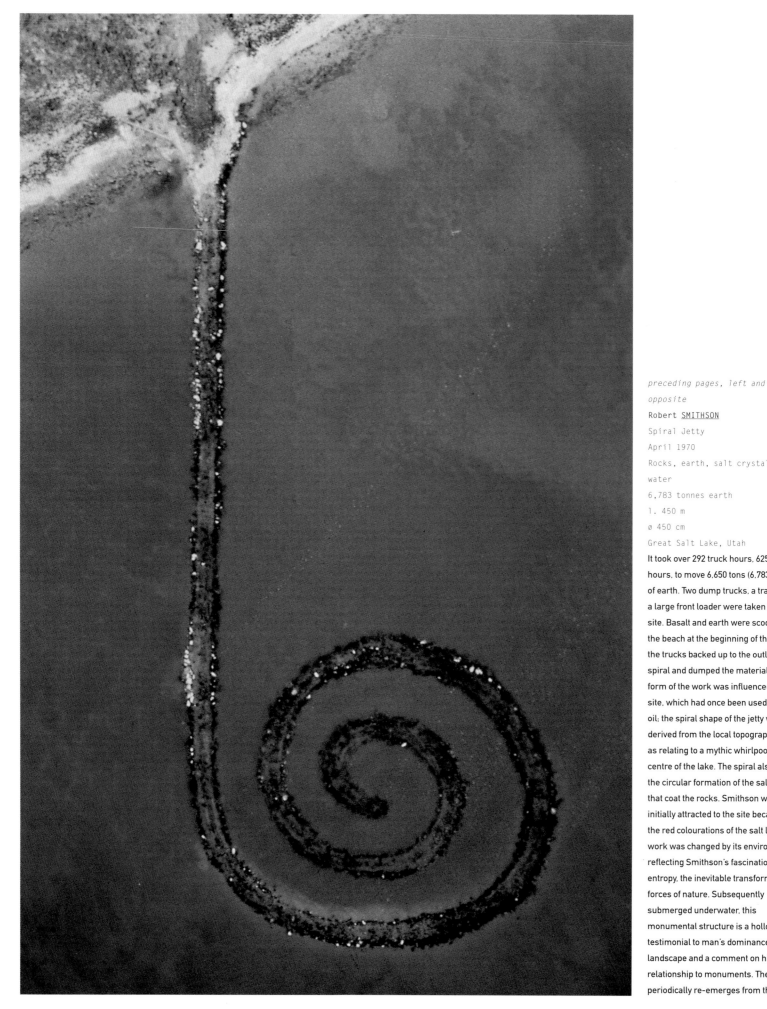

preceding pages, left and opposite
Robert SMITHSON
Spiral Jetty
April 1970
Rocks, earth, salt crystals,
water
6,783 tonnes earth
l. 450 m
ø 450 cm
Great Salt Lake, Utah

It took over 292 truck hours, 625 man hours, to move 6,650 tons (6,783 tonnes) of earth. Two dump trucks, a tractor and a large front loader were taken to the site. Basalt and earth were scooped from the beach at the beginning of the jetty; the trucks backed up to the outline of the spiral and dumped the material. The form of the work was influenced by the site, which had once been used to mine oil; the spiral shape of the jetty was derived from the local topography as well as relating to a mythic whirlpool at the centre of the lake. The spiral also reflects the circular formation of the salt crystals that coat the rocks. Smithson was initially attracted to the site because of the red colourations of the salt lake. The work was changed by its environment, reflecting Smithson's fascination with entropy, the inevitable transformative forces of nature. Subsequently submerged underwater, this monumental structure is a hollow testimonial to man's dominance of the landscape and a comment on his relationship to monuments. The work periodically re-emerges from the lake.

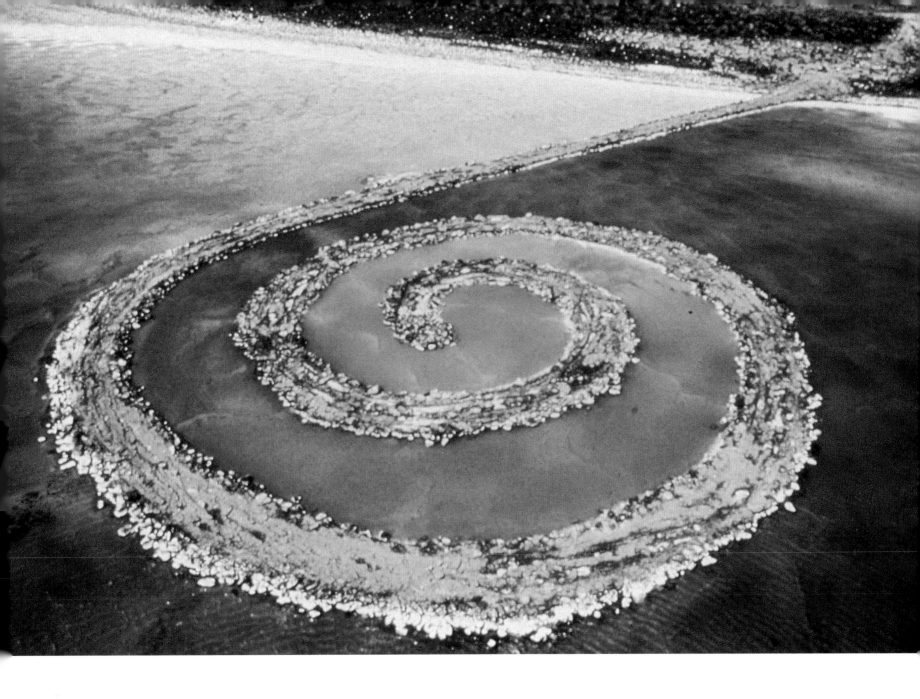

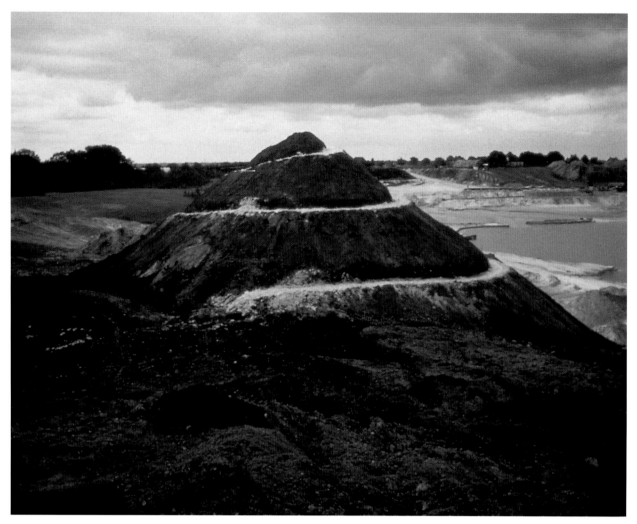

Robert <u>SMITHSON</u>
Spiral Hill
1971
Earth, topsoil, sand
ø 23 m at base
Emmen, Holland

Created in an abandoned sand quarry as one of two works on this site (the other being *Broken Circle*), this was the first work by Smithson to 'reclaim' an industrial site. As the artist explained, 'In a very densely populated area like Holland, I feel it's best not to disturb the cultivation of the land. With my work in the quarry, I somehow re-organized a disrupted situation and brought it back to some kind of shape'.
– Robert Smithson, 'Interview with Gregoire Müller', 1971

Spiral Hill was constructed out of earth over which several inches of black topsoil were laid. White sand was spread along the edges of the spiral path. The anticlockwise direction of the path forms an ancient symbol of destruction. The hill can be seen as an analogy for the Tower of Babel, a reference to man's destruction, here specifically environmental destruction. The work was intended to deteriorate gradually and then disappear, but the local community has voted to maintain the work in its original form.

Robert <u>SMITHSON</u>
Sunken Island
1971
Rocks piled in a lagoon
ø 150 cm
Summerland Key, Florida

Sunken Island was made by consolidating rocks from the bottom of the lagoon in which the work was built. The rocks were encrusted with small slimy plant and animal life and sponges called 'deadman's fingers'. Smithson used the water, vegetable and mineral matter as if they were a whole, interconnected material.

Richard <u>FLEISCHNER</u>
Sod Maze
1974
Sod, earth
h. 46 cm
ø 350 cm
Chateau-sur-Mer, Newport, Rhode
Island

Sod Maze comprises four concentric, gently sloping mounds of earth with a single path to the centre. The path is visible due to the low relief of the construction, and may be followed or abandoned at will. The form relates to prehistoric fortifications and burial grounds.

Robert <u>SMITHSON</u>
Amarillo Ramp
1973
Earth, flint
ø 46 m at top
ø 46 - 49 m at base
Tecovas Lake, Texas

Seen initially from above as it is approached, *Amarillo Ramp* changes significantly upon being entered. By walking upon it, the viewer is aware of his/her constantly changing relationship to the surroundings and heightened sense of the temperature, light and sounds of nature. The sculpture is a partial circle built on a dry lakebed in an area rich in flint. The colour of the earth changes throughout the day.

Smithson died in 1973 whilst exploring the site in an airplane; this piece was completed by Nancy Holt, Richard Serra and Tony Shafrazi.

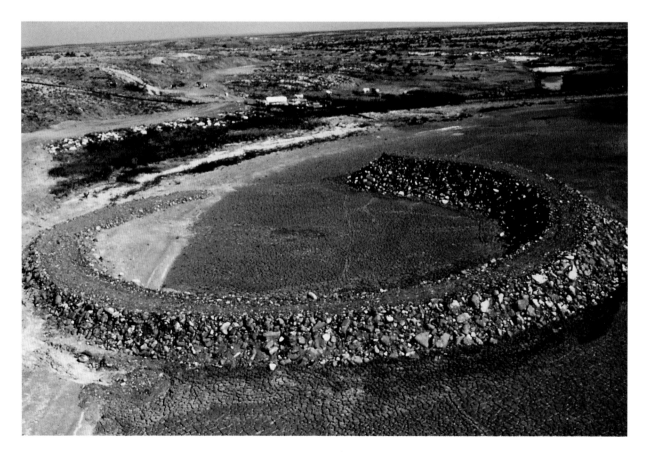

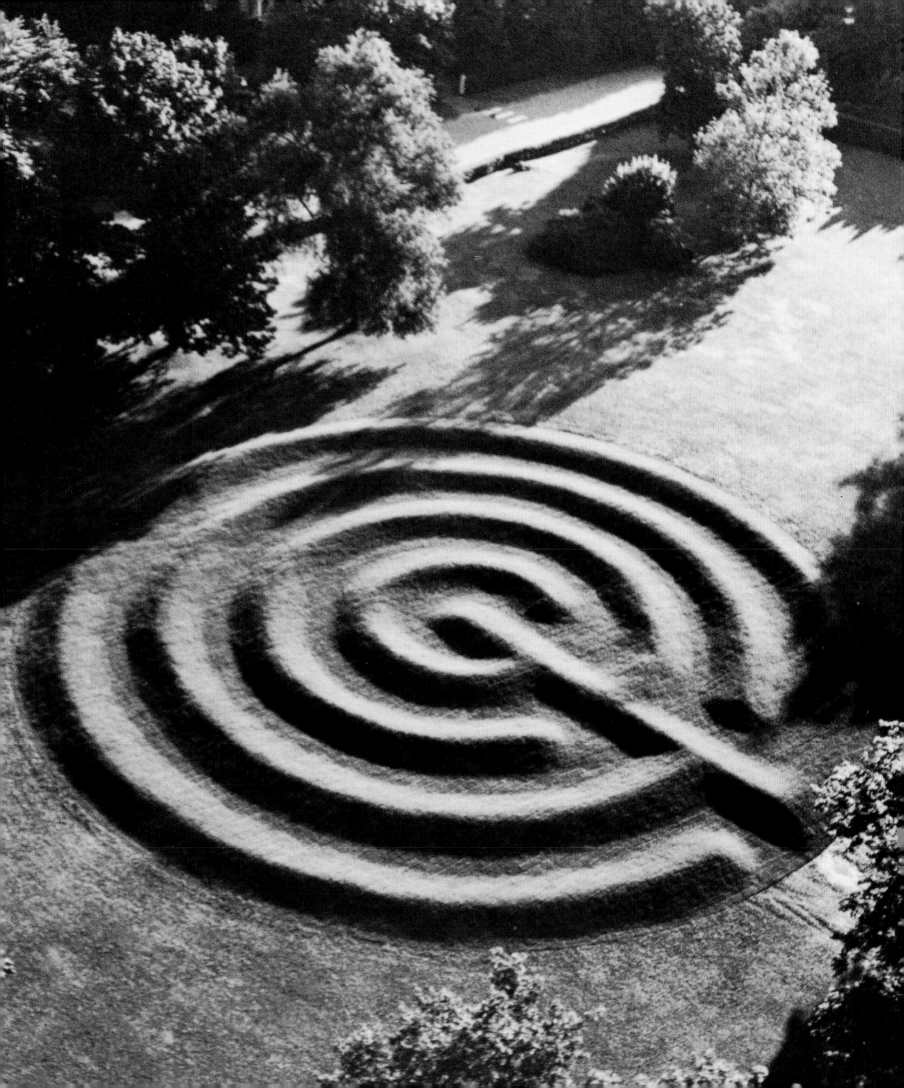

Herbert <u>BAYER</u>
Mill Creek Canyon Earthworks
1979-82
Earth
1 hectare
King County, Washington

Set in a park and designed to take into account both environmental and human needs, this work is composed of five geometric elements: two mounds, one round and one oblong; a cone surmounted by a bridge over a pond; a ring mound and pond; and a ring mound bisected by the creek. The design controls storm-water runoff into Mill Creek Canyon, King County, Washington as the mounds function as drainage basins. They also provide seating for visitors during the dry season.

Roden Crater (looking northeast)
1977-present
Volcanic mountain
Flagstaff, Arizona

The site is a hemispherically-shaped, dish-like space, between 122 and 305 m above a plain. Turrell excavated the crater to form a perfect circle. The site's relationship with space and light is of utmost importance. It is approached from the west by driving across the desert. The road makes a half circle on the north side of the crater and comes up a ravine on its northeast side. At the top of the ravine the visitor reaches a walkway that follows the circular malapai rim of the fumarole on the northeast side of the crater. The walkway is approximately 76 m above the plain. At the top of the fumarole are several new spaces from which a tunnel, 2.6 m in diameter and 2.8 m high, extends 315 m. The crater acts as an observatory, whilst from the edge of the volcano the geologic disruption of the region dating back to prehistoric times can be seen. The work explores light as it is spread across the sky. The site was chosen to take advantage of the Arizona sky, one of the clearest in the world. The artist has stated, 'My wish is to use light as the material, not the subject, to affect the medium of perception […] Our ability to perceive the sky is directly related to the expansion of territories of the self […] The spaces I encountered in flight encouraged me to work with larger amounts of space and with a more curvilinear sense of the space of the sky and its limits'.
– James Turrell, 'Roden Crater', 1993

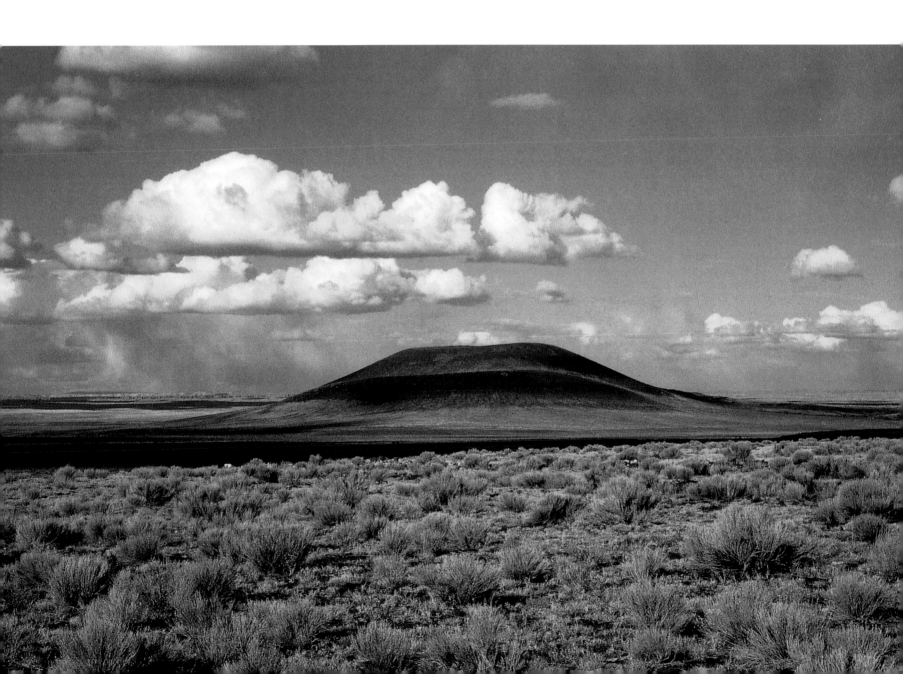

James <u>TURRELL</u>
Roden Crater
(Further into the second stage of
crater bowl reshaping)
1977-present
Volcanic mountain
Flagstaff, Arizona

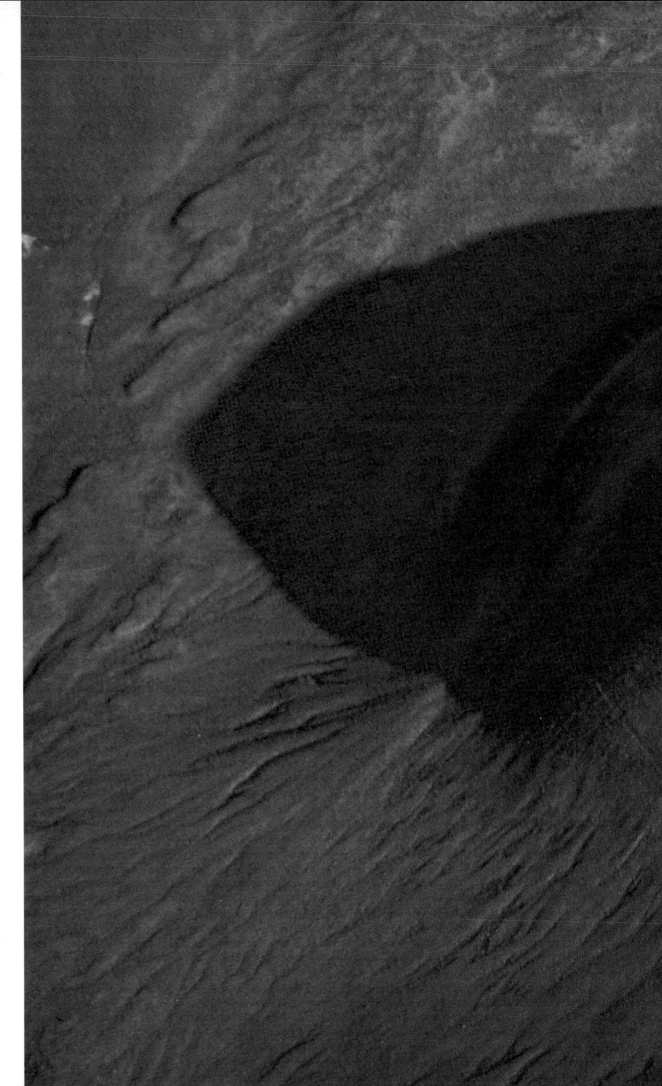

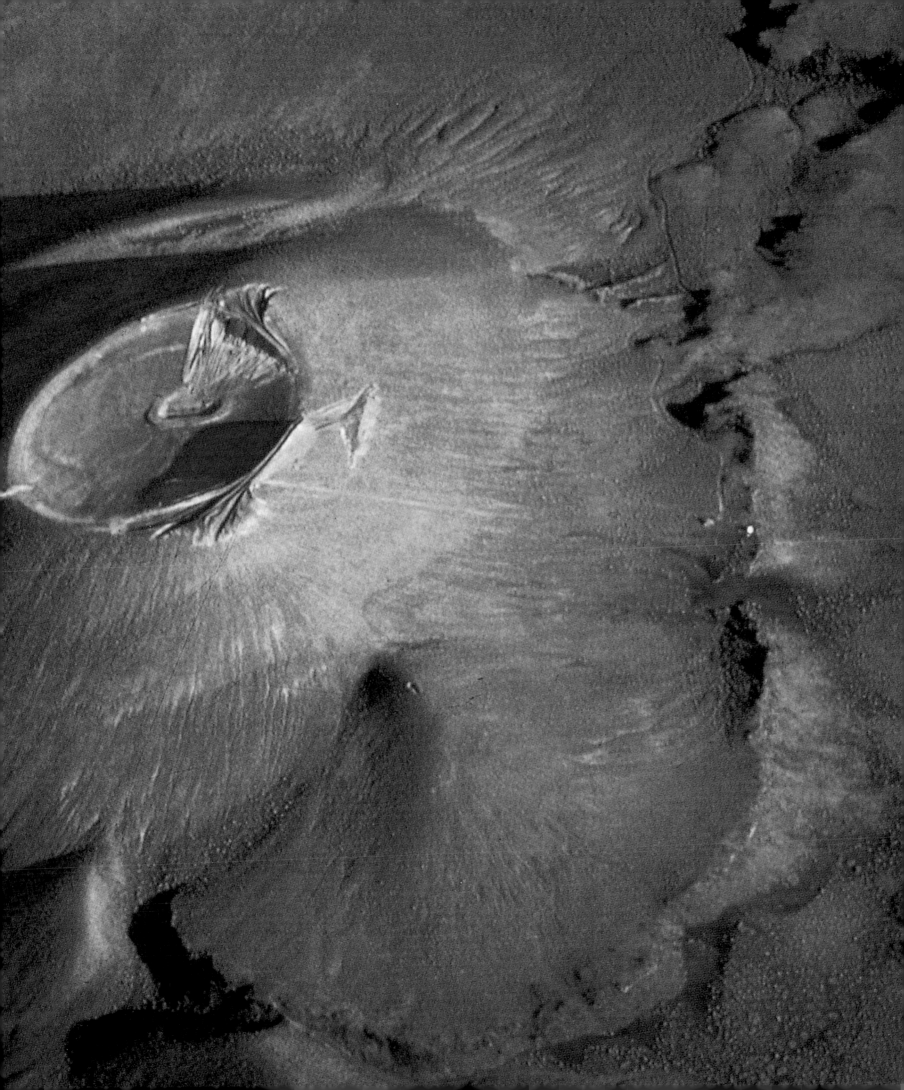

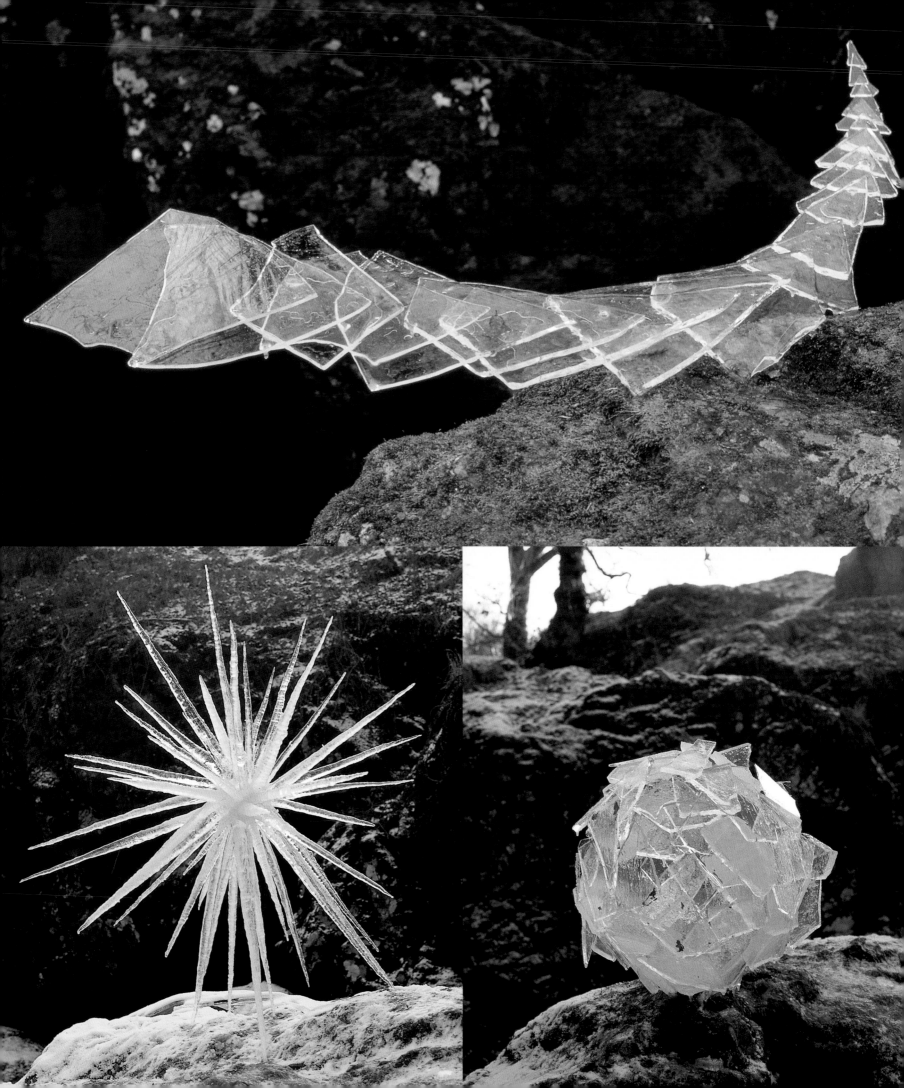

Andy <u>GOLDSWORTHY</u>
Ice Piece
12 January 1987
Cibachrome photograph
76 × 76 cm
Scaur Water, Penpont,
Dumfriesshire, Scotland

'thick ends dipped in snow then water
held until frozen together
occasionally using forked sticks as
support until stuck
a tense moment when taking them
away
breathing on the stick first to release it'

 Goldsworthy creates works in the
landscape using found materials and
natural processes, as well as his own
physical manipulation of the materials
through breathing, handling or holding,
to create new forms. The works are
often very short-lived and are recorded
as photographs. Goldsworthy's
interventions in nature heighten our
awareness of the beauty of nature, as
well as of its enduring and also
ephemeral qualities.

Andy <u>GOLDSWORTHY</u>
Ice Piece
7-8/10-11 January, 1987
Cibachrome photograph
76 × 76 cm
Scaur Water, Penpont,
Dumfriesshire, Scotland

Andy <u>GOLDSWORTHY</u>
Ice Piece
7-8/10-11 January, 1987
Cibachrome photograph
76 × 76 cm
Scaur Water, Penpont,
Dumfriesshire, Scotland

Andy <u>GOLDSWORTHY</u>
Torn Hole
24 July, 1986
Cibachrome photograph
91 × 61 cm
Trinity College Entrance,
Cambridge

'horse chestnut tree
torn hole
stitched around the edge with grass
stalks
moving in the wind'

Andy <u>GOLDSWORTHY</u>
Ice Piece
7-8/10-11 January, 1987
Cibachrome photograph
76 × 76 cm
Scaur Water, Penpont,
Dumfriesshire, Scotland

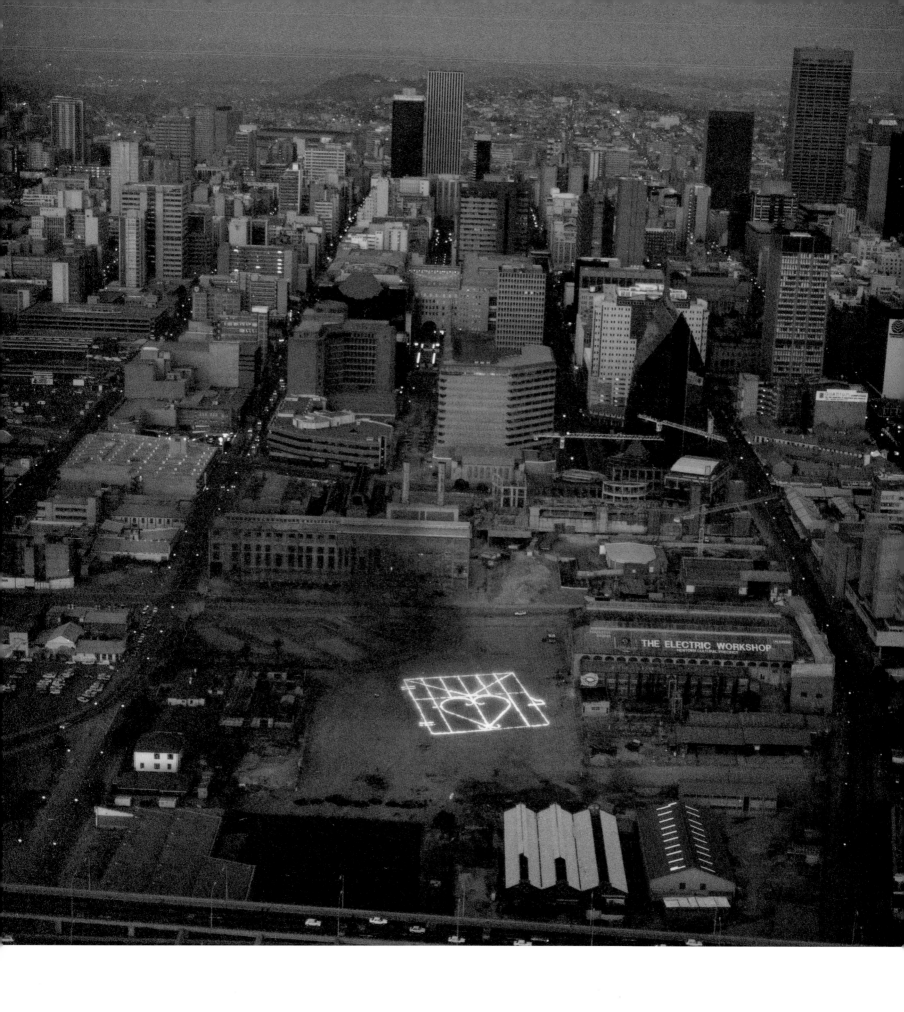

Doris <u>BLOOM</u> and William <u>KENTRIDGE</u>
Gate
1995
Fire drawing
64 × 42 m
Johannesburg, South Africa

Doris <u>BLOOM</u> and William <u>KENTRIDGE</u>
Heart
1995
Whitewash drawing
130 × 70 m
Walkerville, Johannesburg, South
Africa

This is an anatomical image of a heart drawn in chalk on fire-scarred *veld* (open country). The conditions of production are horizontal; those of experience, vertical. This complexity is mirrored by the context of the Johannesburg Biennale for which it was created in 1995. The work is experienced very differently depending on whether it is seen from above or from ground level. Seen from the ground the drawing is a labyrinth of running chalk lines which make a heart, the shape of which can only be discerned indistinctly. The running lines can also be a way of circumscribing a piece of land. The drawing can only be seen in its entirety from the air.

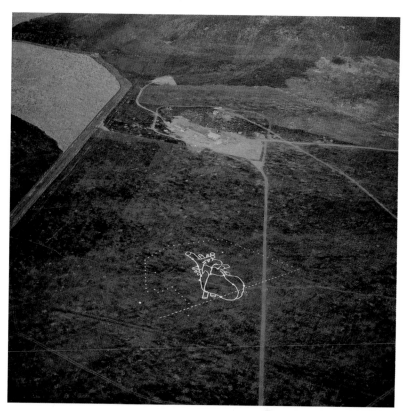

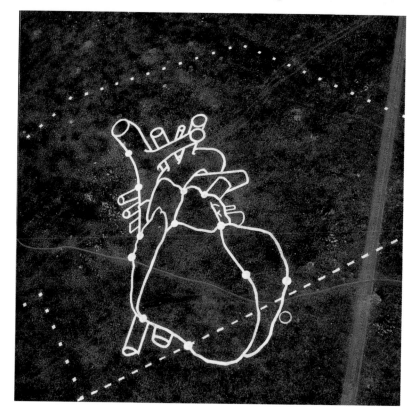

INTERRUPTION

These projects conjoin the environment and human activity by employing non-indigenous, man-made materials ranging from asphalt or glue to a row of Cadillacs; the works expand to match the large scale of the environment itself. They use manufactured substances and structures, or machines and technology, to frame, set in motion or harness natural elements ranging from coastlines to forked lightning. The artists place an increasing emphasis on the transgressive qualities of the activity, questioning the definition of what is 'natural'. They both participate in and critique the kind of terrestrial exploitation frequently carried out in the name of industrial and urban development. They also interrupt the landscape by bringing its dirt and organic randomness into the acculturated white cube of the gallery.

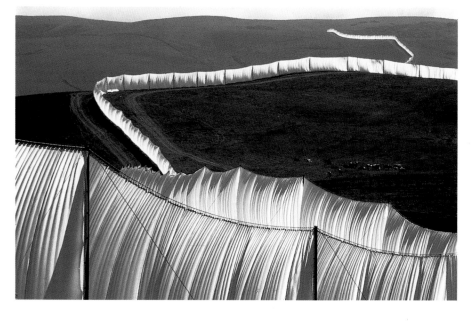

CHRISTO and JEANNE-CLAUDE
Running Fence
1972-76
Steel, nylon
5.5 m × 39 km
Sonoma and Marin Counties, California

Running Fence took the artists four years to complete and the technical and legal problems encountered during its planning and construction are integral to the work. At 5.5 m high and 39 km long, extending east-west near freeway 101, north of San Francisco and dropping down to the Pacific Ocean at Bodega Bay, it was made of 200,000 m² of heavy woven white nylon fabric, hung from a steel cable strung between 2,050 steel poles (each 6.5 m long, 9 cm in diameter) embedded 1 m into the ground and braced laterally with guy wires (145 km of steel cable) and 14,000 earth anchors. The top and bottom edges of the 2,050 fabric panels were secured to the upper and lower cables by 350,000 hooks. Helped by hundreds of workers, engineers, advisors, students and farmers, the work had a strong social element. *Running Fence* was visible for fourteen days. Acting as an artificial barrier, the work connected the land to the sea and sky surrounding it, making explicit the arbitrary nature of political and geographical boundaries.

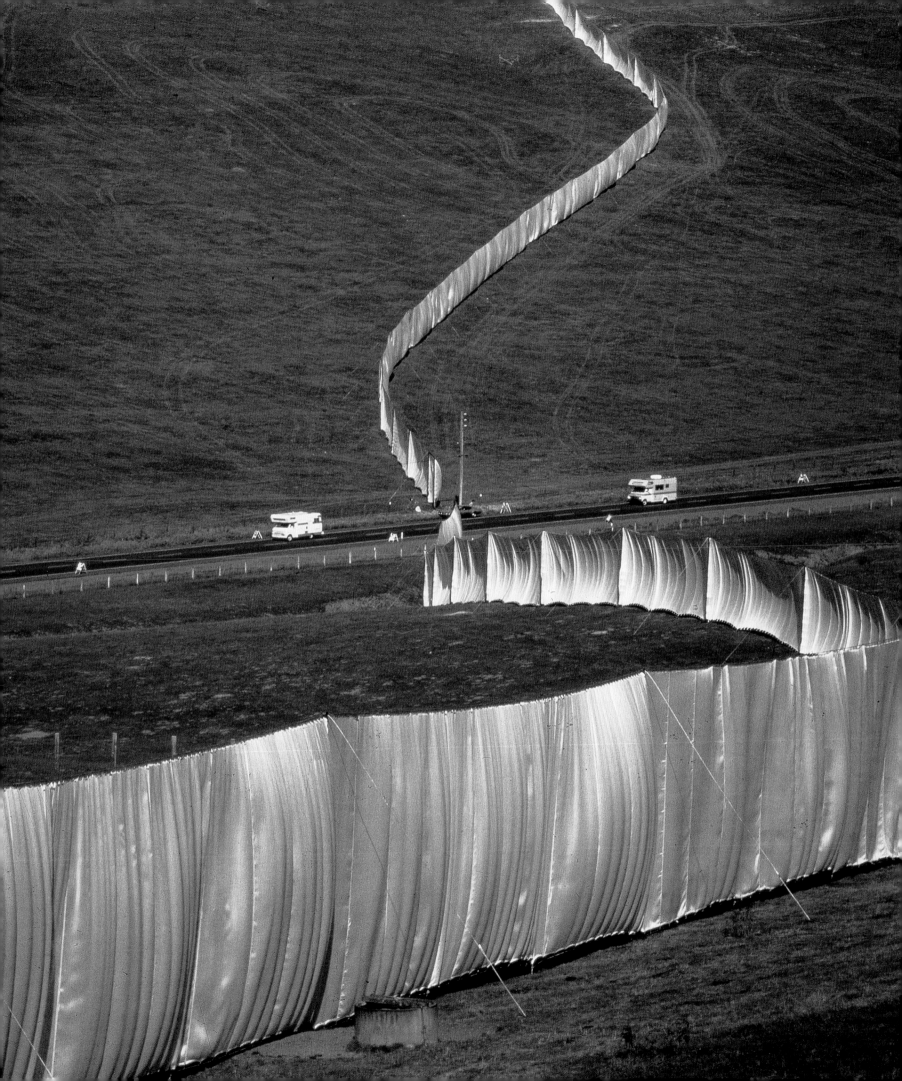

Carl <u>ANDRE</u>
Secant
1977
100 sections of Douglas fir timbers
30 × 30 × 90 cm each
30 × 30 × 9,150 cm overall
Roslyn, New York

Made directly in the landscape, *Secant* was located at the top of a grassy mound; from there it descended into a rolling meadow surrounded by trees. The line of the work articulated the rise and fall of the land and introduced a different scale into the natural setting. A secant is a straight line connecting a curve at two points; Andre's work was both the undulating line of timbers and the straight line connecting the two ends. The artist said, 'The line is the first and also the very last thing, not only in painting, but also, more generally, in every construction. The line is passage, movement, collision, boundary, support, link, division … By elevating the line to the status of prime element, with whose help alone we are able to construct and create, we reject any aesthetics of colour, the treatment of surfaces … and style.'
– Carl Andre, artist's statement

Hans <u>HAACKE</u>
Sky Line
23 June, 1967
Helium-filled balloons, string
Central Park, New York

Helium-filled balloons were released in Central Park, New York, mapping a bright line in the sky.

INTERRUPTION

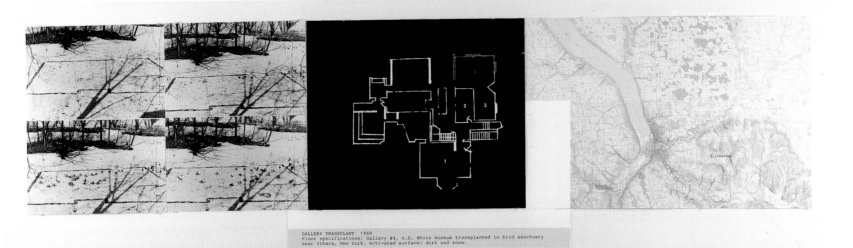

GALLERY TRANSPLANT 1969
Floor specifications: Gallery #4, A.D. White Museum transplanted to bird sanctuary
near Ithaca, New York. Activated surface: dirt and snow.

Carl ANDRE
Log Piece (destroyed)
1968
Wood
Approx. 1. 3,050 cm
Aspen, Colorado

The work consisted of a line of wood timbers placed one behind the other. Wood as a sculptural material has a long and distinguished history, and for Andre it also has poetic resonances. The serial nature of elements was echoed in the repetitive structure of the work. Viewing the work involved pacing out the length of the work, the distance between two points connected by a line. This made clear the spatial situations of length and distance. The elements' repetitive rhythm, which could only be experienced by walking, allowed the viewer to sense the work's temporal qualities. Time reveals itself to be made up of small units of space, and the indivisibility of space and time becomes apparent.

Dennis OPPENHEIM
Gallery Transplant
1969
Colour photograph, black and white photographs, gallery floorplan, hand-stamped topographic map
102 × 457 cm

The floor plan of gallery number 4 of the Andrew Dickson White Museum, Ithaca, New York, was transplanted to Bird Sanctuary, Ithaca, New York, by drawing on the ground using dirt and snow. Oppenheim's concern in his series of Gallery Transplants was to create a dynamic relationship with the site becoming a surface for inscription. The manipulation of the location takes the place of the object. Transplanting the site to a different context produced objects and signs with different functions. Through this activity, the world which Oppenheim has created becomes an ensemble to be deciphered.

This work was first made for the 'Earth Art' exhibition at the Andrew Dickson White Museum, Cornell University, Ithaca, New York, 1969.

Dennis <u>OPPENHEIM</u>
Whirlpool, Eye of the Storm
1973
Airplane, jet of smoke
1,206 × 6,436 m area
Duration 1 hour
El Mirage Dry Lake, California

An airplane pilot, directed by radio from the ground, traced the schemata of a tornado in the sky using the jet of smoke discharged by the aircraft.

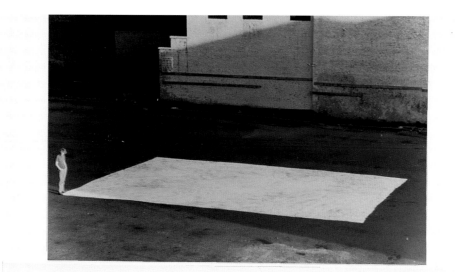

SALT FLAT. 1969. 1000 pounds of baker's salt placed on asphalt surface and spread into a rectangle, 50' X 100'. Sixth Ave., New York, New York. Identical dimensions to be transferred in 1' X 1' X 2' salt-lick blocks to ocean floor off the Bahama Coast. Identical dimensions to be excavated to a depth of 1' in Salt Lake Desert, Utah.

Dennis <u>OPPENHEIM</u>
Salt Flat
1968
Colour photographs and black and white photographs, topographic map
152 × 102 cm
Sixth Avenue, New York

Oppenheim spread 1,000 lbs (454 kg) of salt in a rectangle on an asphalt surface. Identical dimensions were transferred in 30 × 30 × 60 cm salt-lick blocks to the ocean floor off the Bahama Coast. Identical dimensions were excavated to a depth of 30 cm in the Salt Lake Desert, Utah. Documentation of these events in the form of photographs and maps were exhibited in the gallery.

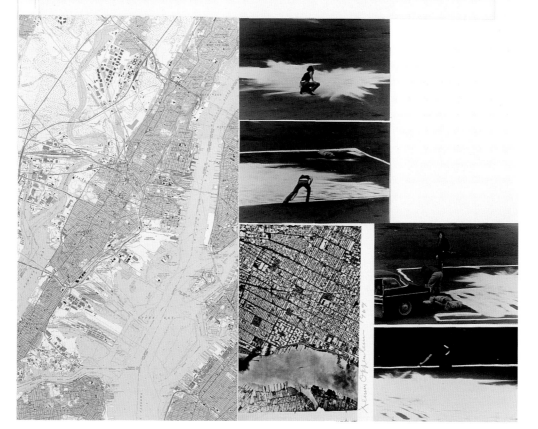

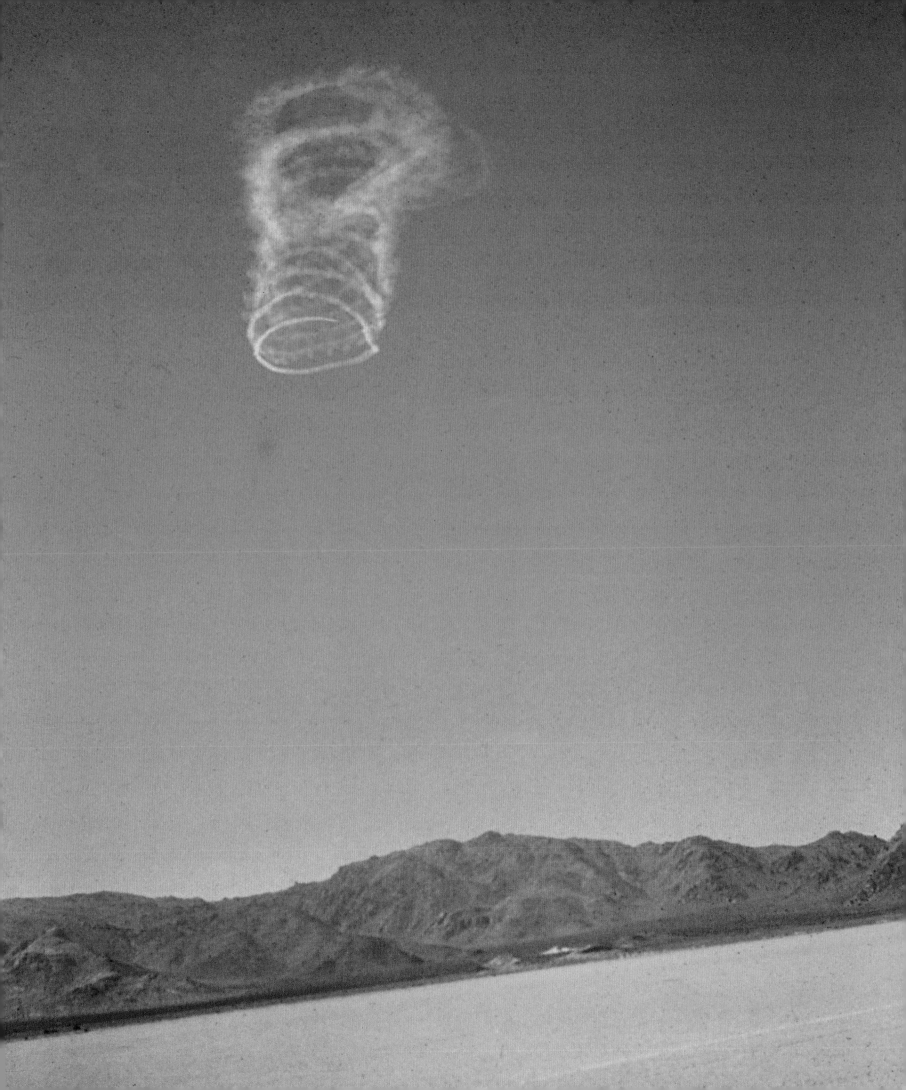

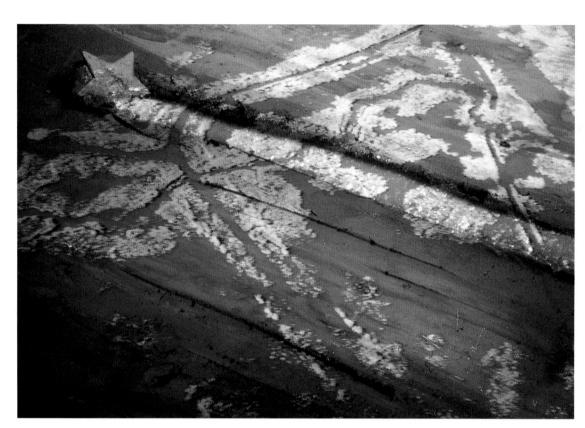

Dennis OPPENHEIM
Star Skid
1977
Cast concrete, broken glass
stars
ø 914 cm each
Trench, 61 m
Project proposal for Western
United States

Oppenheim proposed placing giant stars made of concrete and glass in the landscape. Visible from the air with a trench leading up to each one, the stars would have looked as if they had fallen from the sky and skidded to a halt in the earth.

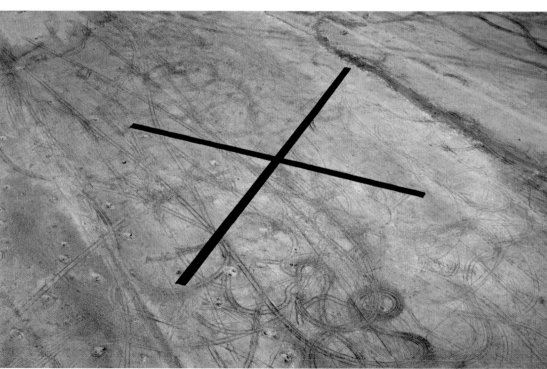

Dennis OPPENHEIM
Relocated Burial Ground
1978
Asphalt primer
610 m² intersection
El Mirage Dry Lake, California

Using an industrial primer, Oppenheim marked the landscape with a square cross echoing the marking of a topographic map to indicate a site. The form of a cross also carries symbolic, religious overtones, as well as being a symbol of negation. The asphalt primer would not have made an indelible mark on the landscape; instead it disappeared in the same way that traces of ancient burial sites may have been erased or buried as the forces of nature erase man-made markings of the land.

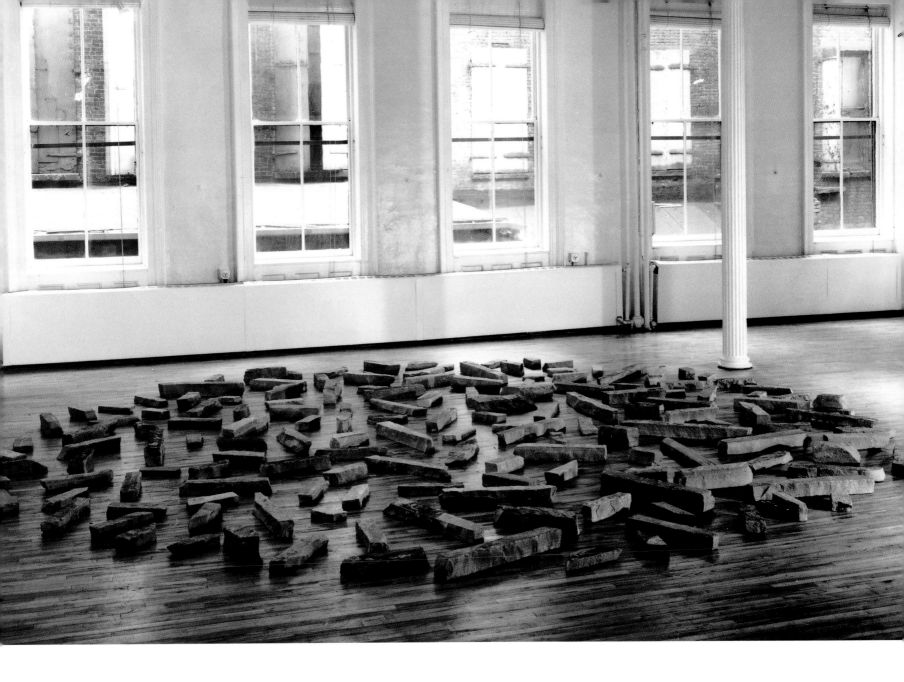

Richard LONG
Stone Circle
1976
Approx. 156 Tennessee stones
ø 671 cm

Long's work has always demonstrated a strong conceptual emphasis, as well as a concern with the materiality of the natural world and modern urban space. The process of making each piece is the central focus of his practice. The works which Long brings into the gallery environment act as signifiers of his resolute involvement with the earth and its materials. In them, he sets up a tension between the natural world and the architectural setting in which they are placed.

CHRISTO and JEANNE-CLAUDE
Wrapped Coast
1969
Erosion-control fabric, rope
93 km²
Little Bay, Australia

The cliff-lined shore area which was wrapped is approximately 2.5 m long, 46 to 244 m wide, 26 m high at the northern cliffs, and was at sea level at the southern sandy beach. An expanse of 93 km² of erosion-control fabric was used for the wrapping and 56 km of polypropylene rope tied the fabric to the rocks. 25,000 fasteners: threaded studs and clips were used to secure the rope to the rocks. The coast remained wrapped for a period of ten weeks. Afterwards all materials were removed and the site was returned to its original condition.

Wrapping the coast veiled the real contours of the territory. The rope used to secure the fabric to the site formed lines which recalled the grid of a map. The landscape was simultaneously covered – blocked out – and discovered in a different form.

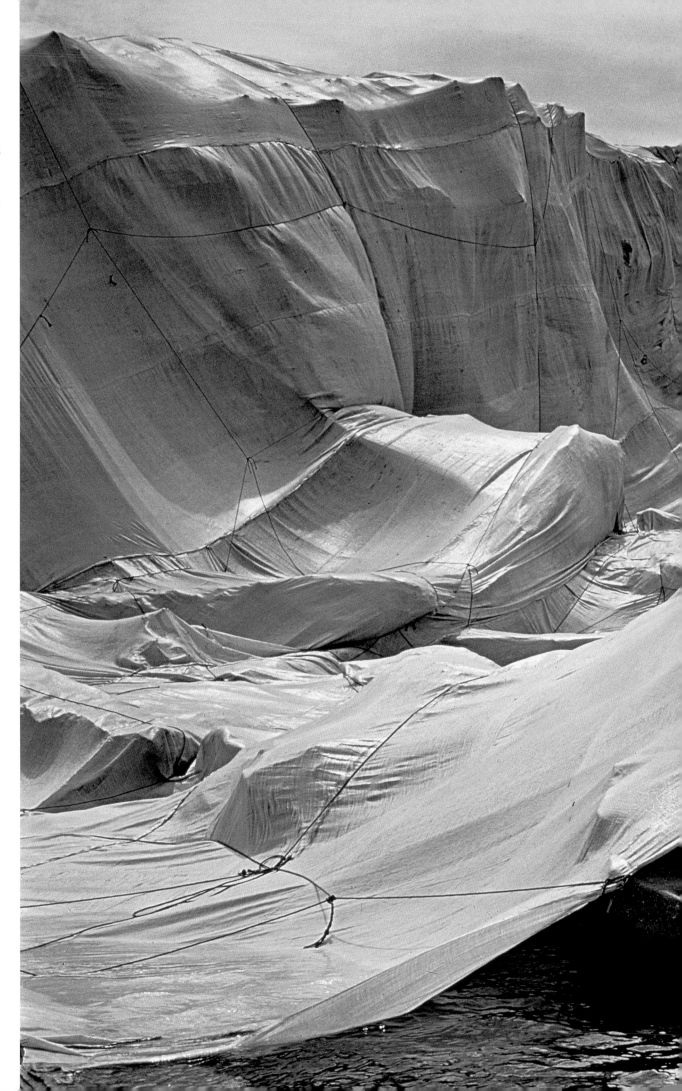

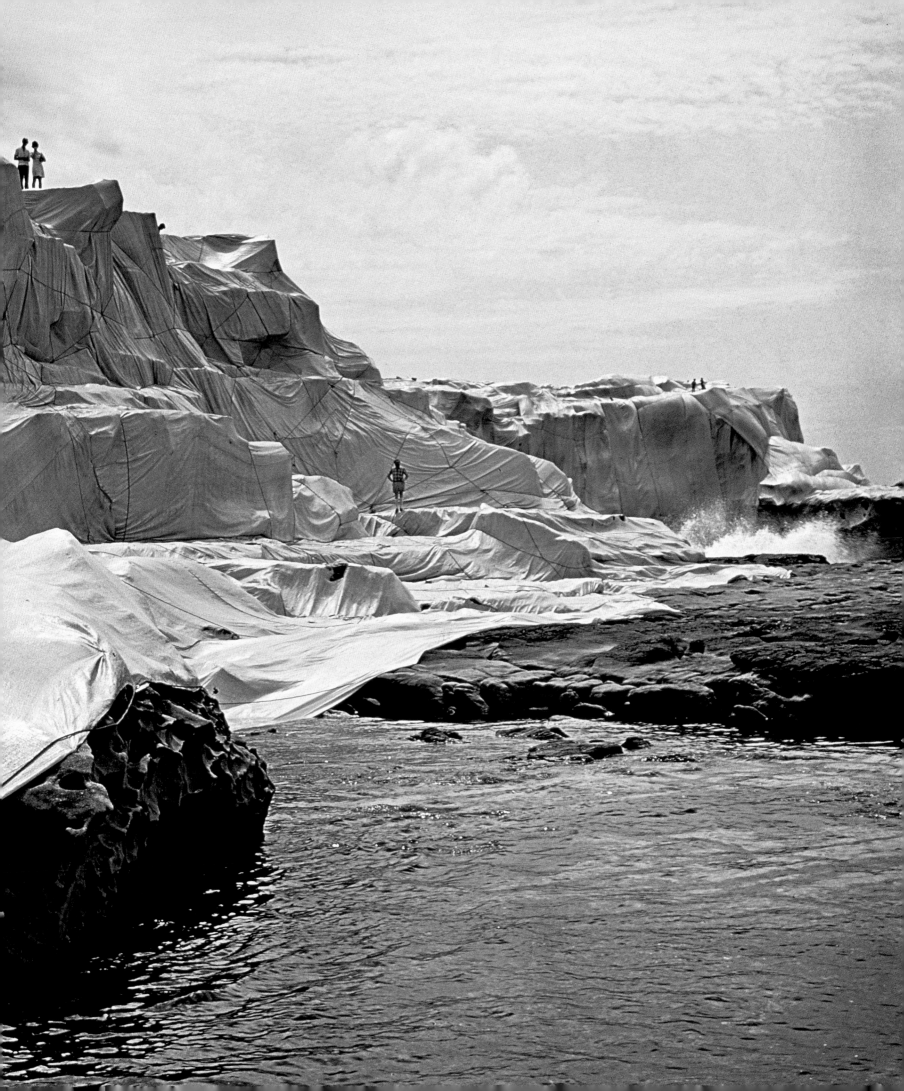

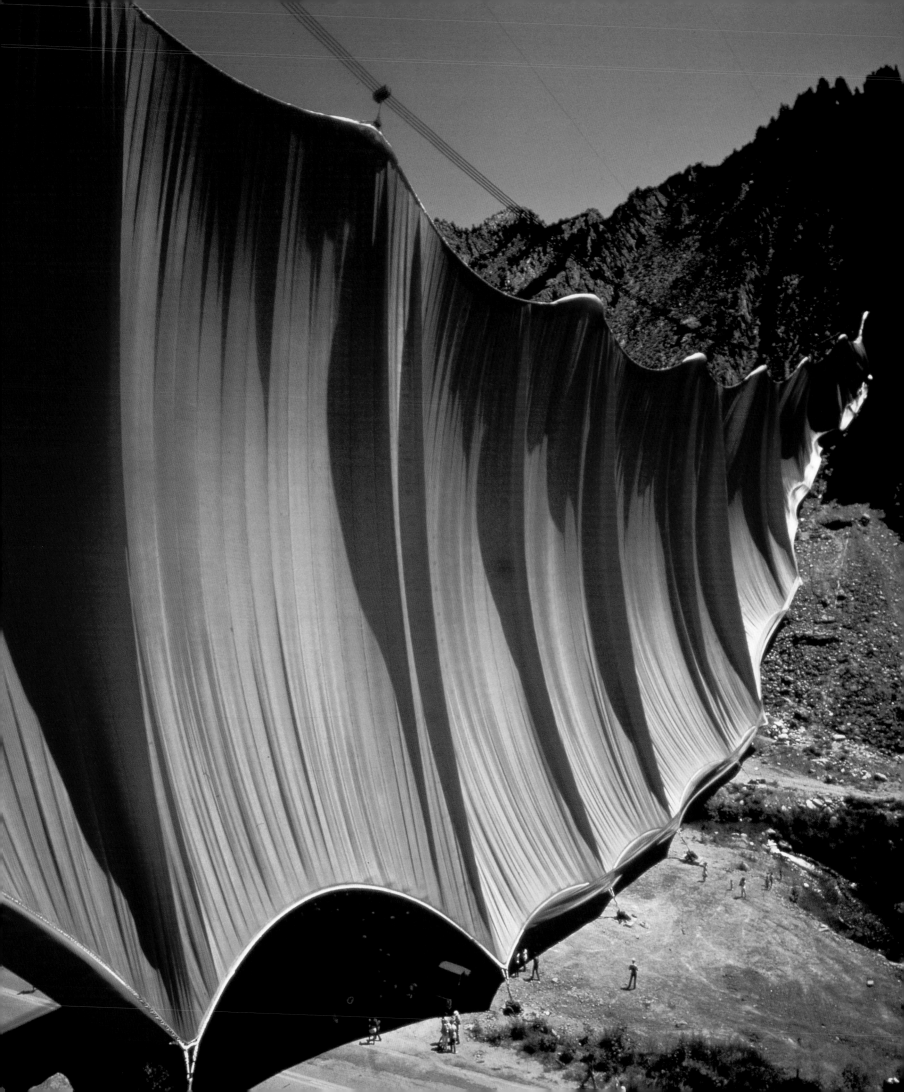

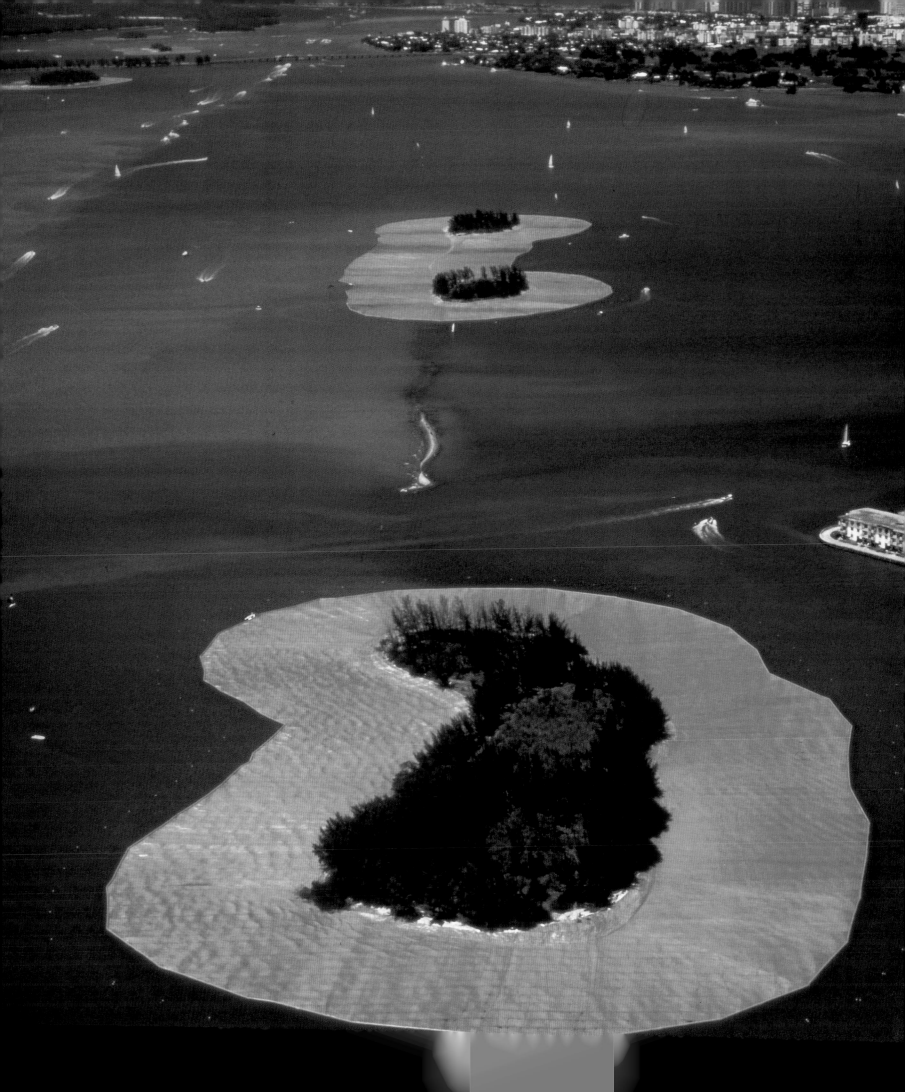

page 82

CHRISTO and JEANNE-CLAUDE
Valley Curtain
1970-72
Steel, nylon
12,780 m²
Rifle, Colorado

Christo and Jeanne-Claude were helped by a wide group of people ranging from construction workers to temporary helpers, art-school and college students. 12,780 m² of orange nylon fabric were secured along the valley of Rifle, Colorado. The *Valley Curtain* was suspended at a width of 381 m and curved from 111 m in height at each end to 55 m at the centre. The *Curtain* remained clear of the valley's slopes and bottom. A 3 m skirt was attached to the lower part of the *Curtain* between the thimbles and the ground.

This was a very short-lived piece: twenty-eight hours after it had been erected, high winds swept through the valley making it necessary to take the curtain down.

overleaf

CHRISTO and JEANNE-CLAUDE
Surrounded Islands
1980-83
Woven polypropylene
585 m² of fabric floating around 11 islands
Biscayne Bay, Florida

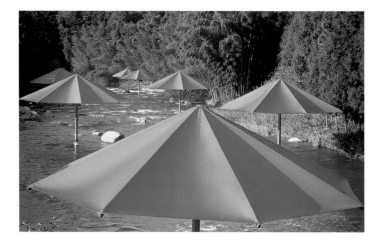

CHRISTO and JEANNE-CLAUDE
The Umbrellas, Japan-USA
1984-91
Fabric, aluminium, steel, wood
3,100 octagonal umbrellas
Umbrellas, h. 6 m each
ø 9 m each
Valleys: Ibaraki, Japan, 19 km (1,340 blue parasols); California, USA 26 km (1,760 yellow parasols)

On 4 October 1991, Christo and Jeanne-Claude's 1,880 workers began simultaneously to open the 3,100 umbrellas in two distant parts of the world, Ibaraki, Japan and California. In Japan the valley is located 120 km north of Tokyo. In the US the valley is located 96 km north of Los Angeles. Manufacturers in Japan, the US, Germany and Canada had prepared the umbrellas: the fabric, aluminium super-structure, steel frame bases, anchors, wooden base supports, bags and moulded base covers. All the umbrellas were assembled in Bakersfield, California, from where 1,340 umbrellas were shipped to Japan. All the umbrellas in Japan were blue, those in California were yellow. The installation lasted nineteen days.

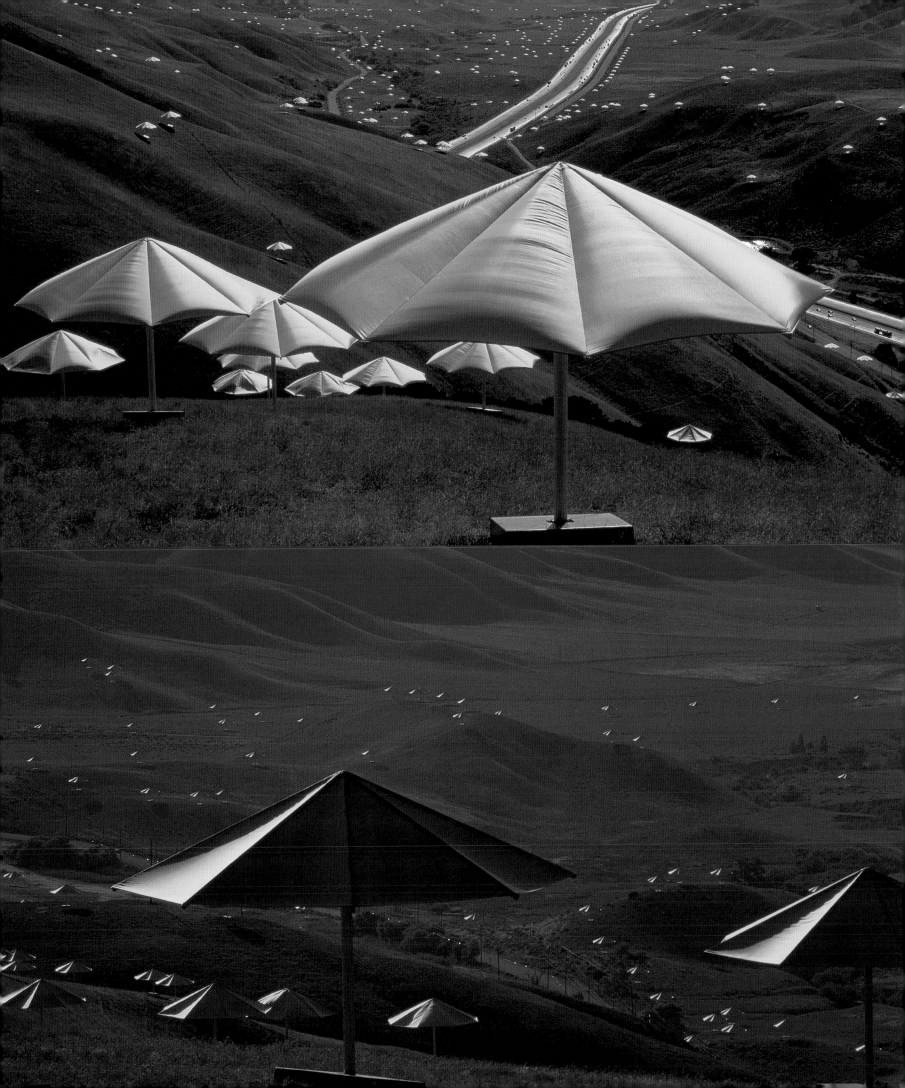

Nancy HOLT

The Last Map Used to Locate Buried Poem Number 4 for Michael Heizer

1969-71

Hand-marked topographic map

These buried poems were private artworks. Holt dedicated the poems to five different people (Michael Heizer, Philip Leider, Carl Andre, John Perrault and Robert Smithson) and chose the remote sites according to certain physical, spatial and atmospheric qualities which would evoke a particular person for her. The poems were buried in vacuum containers, and the recipient recieved a map which contained all the necessary information for the poem to be found and dug up. The map provided Holt with both a physical location and characteristics which she could relate to a specific person, as well as a symbolic space in which to construct the meaning presented in the poems. Along with the instructions on how to find the site she included details of the history, geology, flora and fauna of the site as well as maps, pictures and specimens of rocks and leaves.

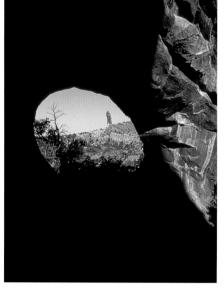

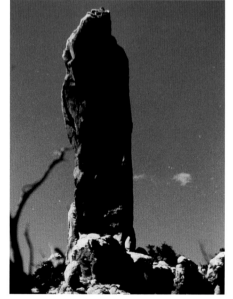

Nancy HOLT

Buried Poem Number 4

for Michael Heizer

The Double 0

1971

Colour photograph

Arches National Park, Utah

Nancy HOLT

Buried Poem Number 4

for Michael Heizer

Dark Angel through Double 0 Arch

1971

Colour photograph

Arches National Park, Utah

Nancy HOLT

Buried Poem Number 4

for Michael Heizer

Dark Angel

1971

Colour photograph

Arches National Park, Utah

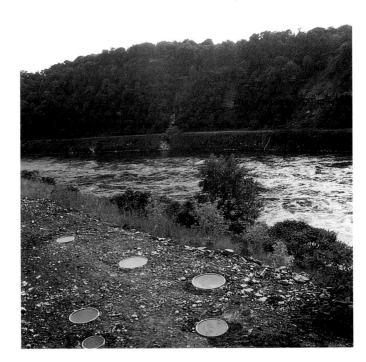

Nancy <u>HOLT</u>
Hydra's Head
1974
Concrete, water, earth
7316 litres water
Area, 854 × 1891 cm
2 pools, ø 122 cm each
3 pools, ø 91 cm each
1 pool, ø 61 cm
depth, 91 cm
Niagara Riverbank, Artpark,
Lewiston, New York

This was an installation made alongside
the Niagara River. Concrete disks holding
pools of water in varying sizes were
sunk into the earth. The configuration of
the pools matches the stellar
constellation Hydra. This work explores
the idea of man's relationship with the
universe rather than just the immediate
environment.

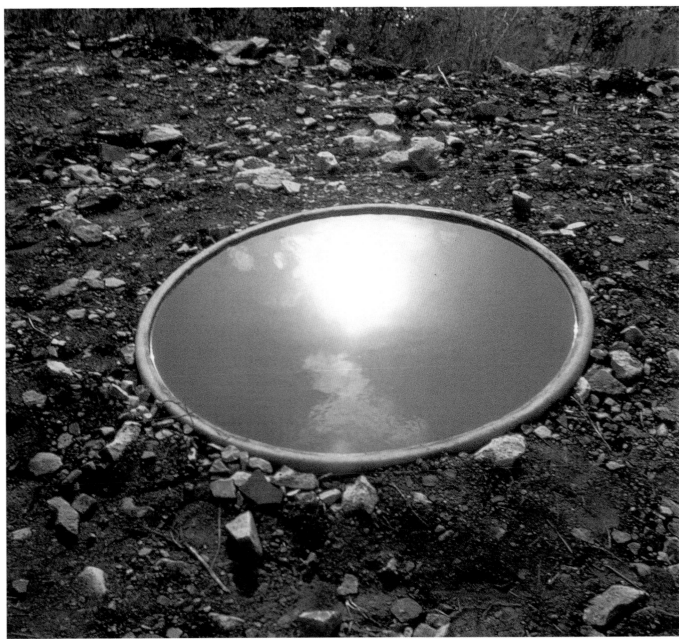

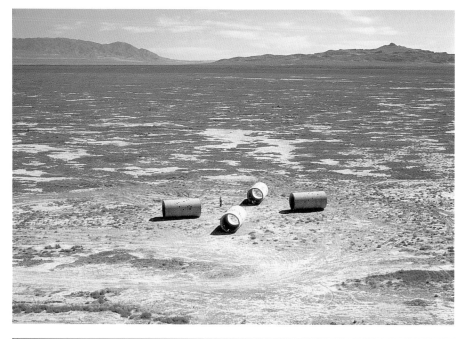

Nancy HOLT
Sun Tunnels
1973-76
Concrete
Tunnels: outside ø 372 cm
inside ø 244 cm
l. 2,600 cm on diagonal
Great Basin Desert, Utah

Four concrete tunnels are laid out on the desert floor in an open X configuration, 26 m long on the diagonal. At the centre is a cement circle flush with the ground. The holes in the upper half of the tunnel walls vary from 18-25 cm in diameter. These are configured to correspond to different stellar constellations. The tunnels are aligned with the angles of the rising and setting of the sun on the days of the solstices. When light from either the sun or moon shines through the holes, a changing pattern of pointed ellipses and circles is cast on the bottom half of each tunnel. The installation is set in an immense landscape which changes according to the cycles of the sun and moon and is intended to introduce the viewer to the cosmic dimension of time.

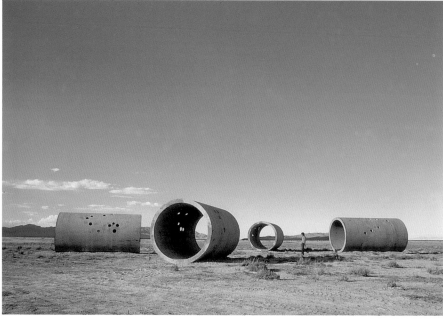

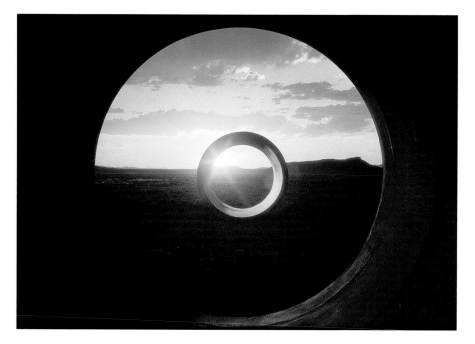

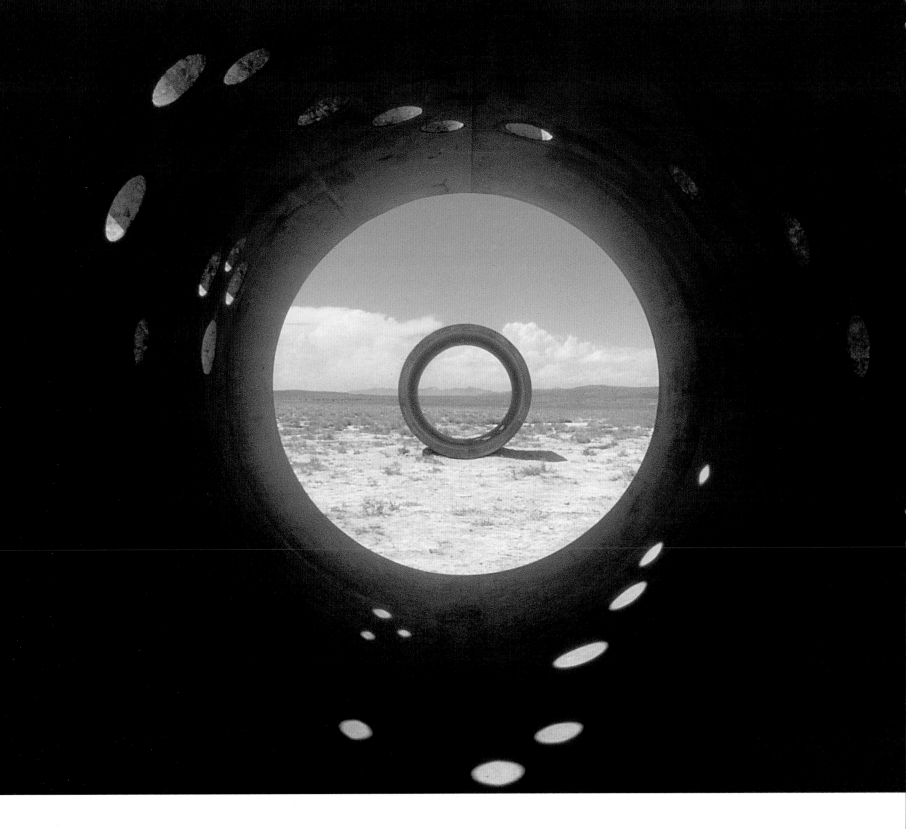

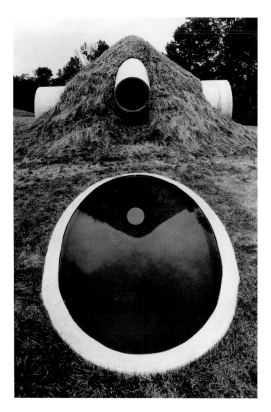

Nancy <u>HOLT</u>
Star-Crossed
1979-81
Earth, concrete, water, grass
mound
h. 427 cm
ø 1,220 cm
Pool, 574 × 221 × 46 cm
Large tunnels, ø 198 cm
l. 762.5 cm
Small tunnels, ø 91.5 cm
l. 569 cm
Miami University Art Museum,
Oxford, Ohio

The oval pool fits exactly into the field of vision framed through the small tunnel and appears circular. Looking up the small tunnel the other way, a circle of sky can be seen. The circle of sky is also reflected in the pool.

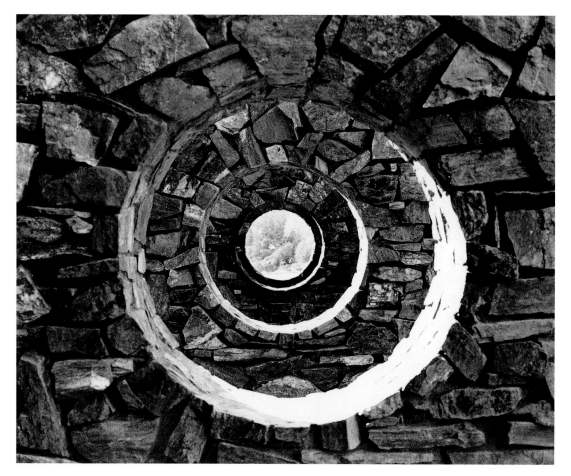

Nancy <u>HOLT</u>
Stone Enclosure: Rock Rings
1977-78
Rocks
Outer ring, 1,220 cm
Inner ring, 610 cm
Ring walls, h. 305 cm
Wall thickness, 61 cm
Holes, ø 102 cm
Arches, h. 244 cm
w. 137.25 cm
Western Washington University
Grounds, Bellingham, Washington

The work is made from 200 to 230-million year old schist, hand-quarried from a mountain 65 miles northeast of the site. The orientation of the piece was calculated from the North Star. The arches run N-S and the holes run NE-SW, E-W and SE-W.

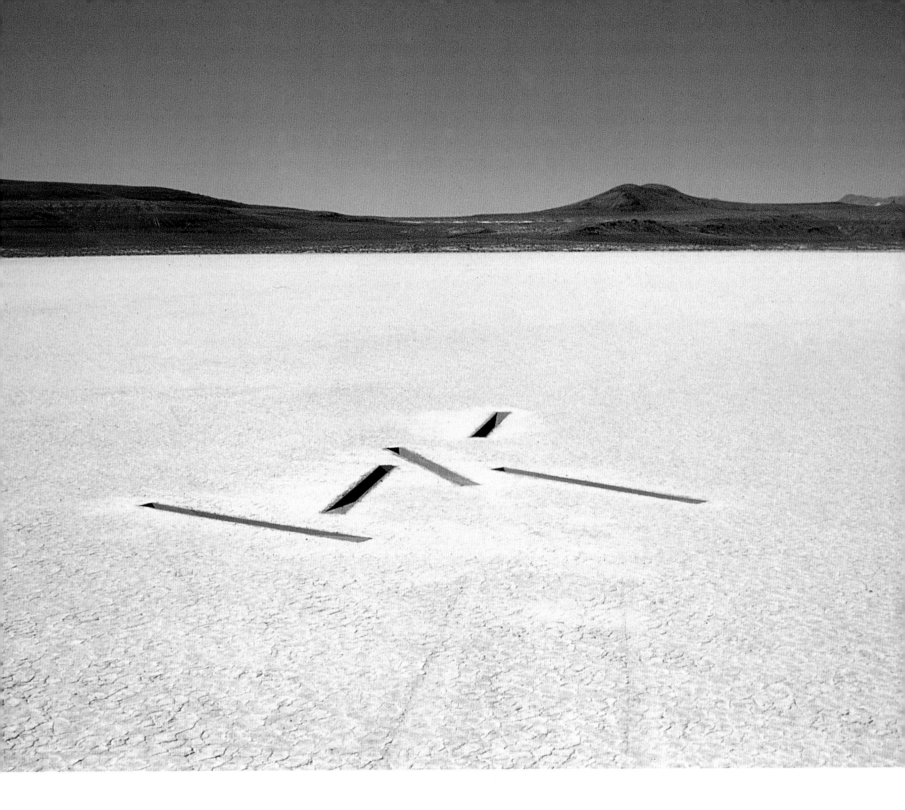

Michael HEIZER
Dissipate (deteriorated)
8 of Nine Nevada Depressions
1968
Wood
1,400 × 1,500 × 30 cm
Black Rock Desert, Nevada

Heizer set pieces of wood into the flat bottom of a dried lake. The artist was aware
how quickly this work would be reclaimed into the landscape. He explained, 'As the
physical deteriorates, the abstract proliferates, exchanging points of view'.
– Michael Heizer, *Artforum*, 1969

　His main interest in making this piece was the gradual transformation and
deterioration of the piece with the passage of time as the natural environment erases
his intervention in the landscape.

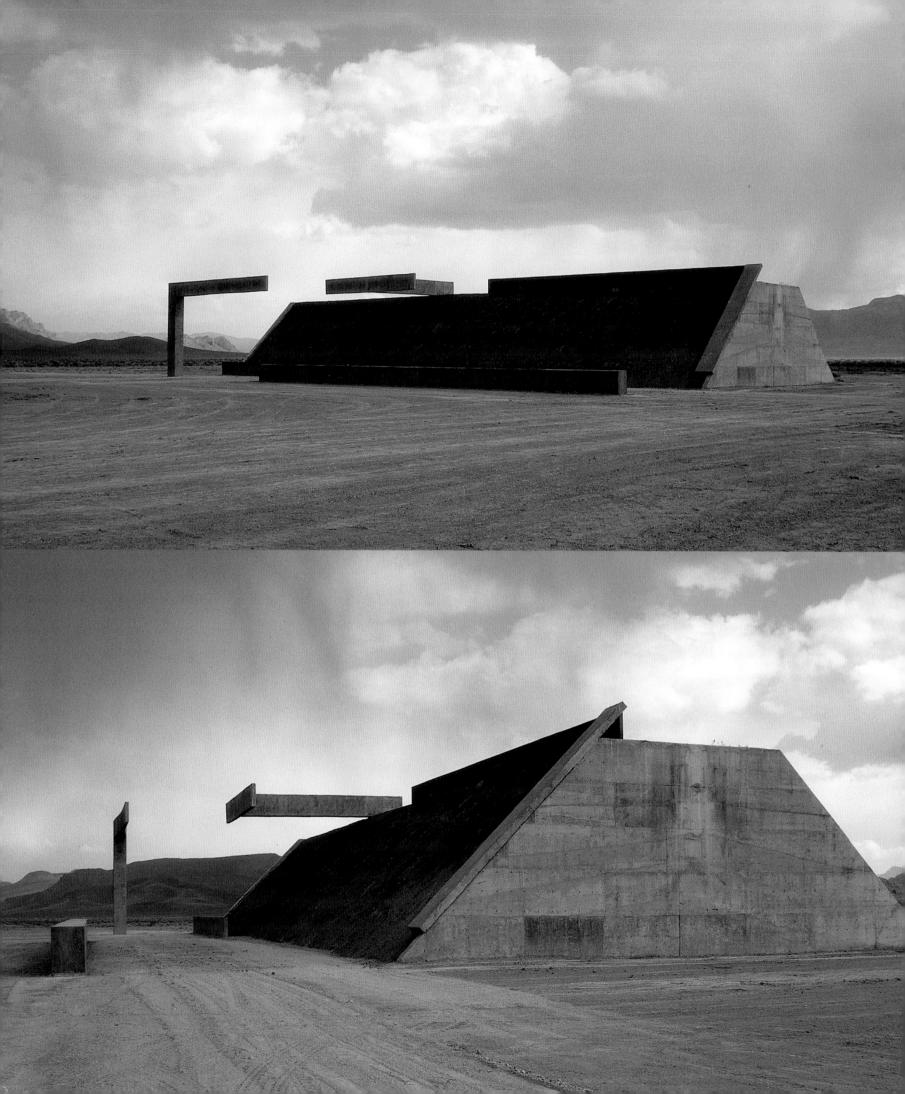

Michael HEIZER
Complex City
1972-76
Concrete, steel, compacted earth
7 × 366 × 159 m overall
Garden Valley, Nevada

Created in the empty Nevada desert, this work plays on the viewer's experience
of scale within the landscape. The sculpture, which is made in three parts, was
constructed with concrete and volcanic rock surfaces. The structure can be entered;
once inside the city, the viewer is confronted by the enormous sculptures and can see
nothing of the surrounding landscape; only the sky remains visible. The presence of
the objects overwhelms with the immensity of its scale. Heizer remarks: 'It is
interesting to build a sculpture that attempts to create an atmosphere of awe […]
Immense, architecturally-sized sculpture creates both the object and the atmosphere
[…] Awe is a state of mind equivalent to religious experience […] To create a
transcendent work of art means to go past everything.'
– Michael Heizer, 'Interview with Julia Brown', 1984

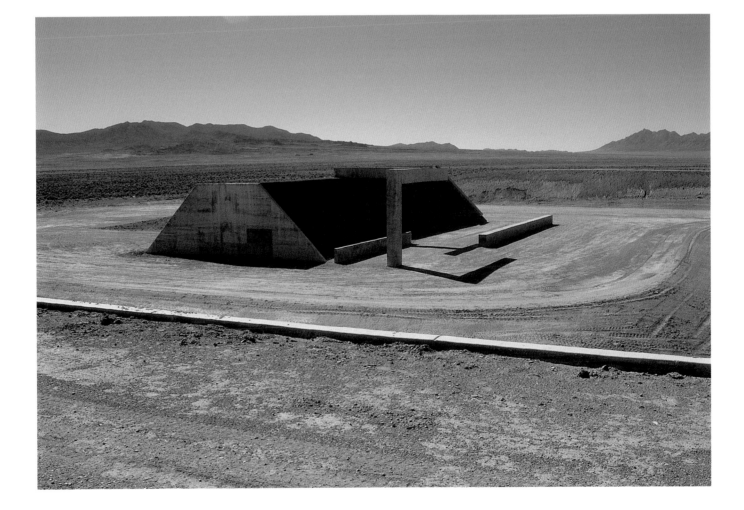

Robert <u>SMITHSON</u>
Incidents of Mirror-Travel in the
Yucatan
1969
Colour photographs
9 parts, 27 × 27 cm each

In this series of photographs in nine
different sites, Smithson maps a physical
journey through the landscape. The
natural environment is transformed
and fractured in the surfaces of twelve
mirrors which Smithson took with him
on the trip and placed in different con-
figurations in the natural environment.
The work also concerns time and
memory; the works existed only for a
very short time, but the images trapped
by the camera are timeless traces of
memory.

The photographic work was originally
made as a magazine spread in *Artforum*,
September 1969.

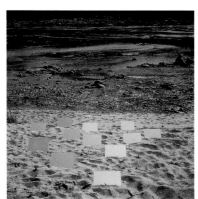

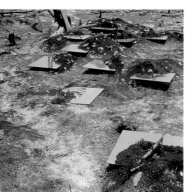

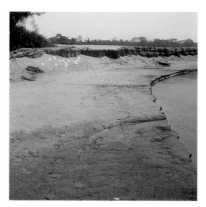

Robert SMITHSON
Gravel Corner Piece
1968
Mirrors, gravel
91 × 91 × 91 cm

This was one of a series of corner pieces installed in the gallery using gravel, sand, rock, salt, slate, red sandstone and chalk. Three mirrors are positioned in a corner and gravel is piled in the resulting angle. The mirrored world extends in three different directions, multiplying by a factor of four the square on the floor as well as the rock, turning it into a symmetrical cone.

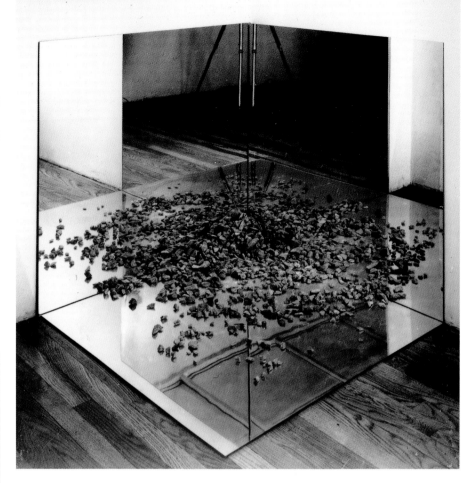

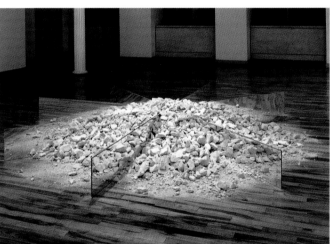

Robert SMITHSON
Chalk and Mirror Displacement
1969
Chalk from quarry in Oxted, England, mirrors
16 mirrors, 25.5 × 150 cm each
h. 25 cm overall
ø 305 cm overall

This piece was duplicated so that it could appear simultaneously at a chalk quarry in Oxted and the Institute of Contemporary Arts, London. Sixteen mirrors were joined back to back to form a circle with eight diameter lines around which chalk was piled in lumps and powdered form. Composed of a circle, a reflective surface and clumps of white material, this piece uses the same basic vocabulary of shapes that Smithson employed in some of his other earthworks, most notably *Spiral Jetty* and *Broken Circle*. Here the mirrors replace the water.

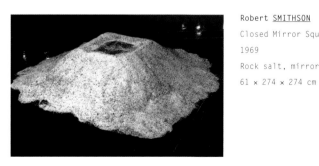

Robert SMITHSON
Closed Mirror Square
1969
Rock salt, mirrors, glass
61 × 274 × 274 cm

Robert <u>SMITHSON</u>
The Map of Broken Glass
(Atlantis)
11-31 July, 1969
Clear broken glass
Approx. 540 × 600 cm
Lovelandies Island, New Jersey

Smithson made this work outdoors from pieces of broken glass. The glass is a map of a non-existent island which catches the sun's rays and radiates brightness without electric technology. The cracked transparency of the piles of glass diffuse the light of their solar source. Like the sun's rays which collide with the gases that enclose the earth, so the glass shatters the light, reflecting it off the brittle mass. The map is a series of upheavals and collapses as the unstable fragments are captured by light and shadow. The work was commissioned for a group exhibition sponsored by the Long Beach Island Foundation of Arts and Sciences.
'Details and Spec: After map of Lewis Spence
See History of Atlantis
Several tons of broken clear (glass) need
Trace limits (approx.) on floor lightly then fill it in
Get few big pieces say 122 cm by 92 cm stick them upright slightly leaning and supported by 30 cm pieces
Balance big pieces against each other use smaller pieces to shore them up'
– Robert Smithson, 1981

Robert <u>SMITHSON</u>
Glue Pour (destroyed)
1970
Glue
Dimensions variable
Vancouver

A bucket of glue was poured down a slope of soil and gravel. As the glue travelled down the slope, seeping into its contours, loose soil was dragged with it. Smithson's interest in the transformative forces of the natural environment was continued with this work.

Robert <u>SMITHSON</u>
Partially Buried Woodshed
1970
Woodshed, 20 truckloads of earth
300 × 3300 × 1400 cm
Kent, Ohio

A dilapidated woodshed, used for storing dirt, gravel and firewood, was found on the Kent State University Campus. Under Smithson's directions, Rich Helmling, a building contractor, piled twenty loads of earth onto the woodshed until the central beam cracked. Crucial to the piece, the cracking of the centre beam directly communicated the role of action and gravity in this sculpture and involved a dialogue between external and internal space. To Smithson this was a symbol of entropy; further change and weathering would occur over time. Entropy was a key issue for the artist, denoting the process of transformation which works undergo when abandoned to the forces of nature.

Robert <u>SMITHSON</u>
Asphalt Rundown
1969
Asphalt
Dimensions variable
Rome

A dumptruck released a load of asphalt down an eroded hillside in an abandoned section of a gravel quarry. As it flowed down the hillside it merged with the earth, filling in washed-out gullies. The asphalt became a casting of erosion; the piece a tribute to entropy. The work also references Jackson Pollock's drip paintings. Smithson 'paints' with asphalt onto the landscape, monumentalizing the drip as a slow ooze.

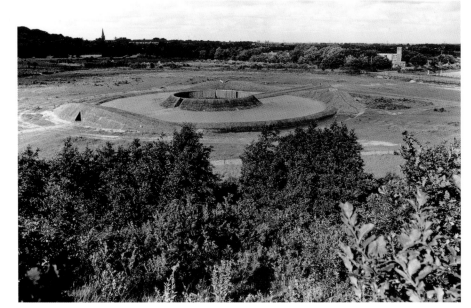

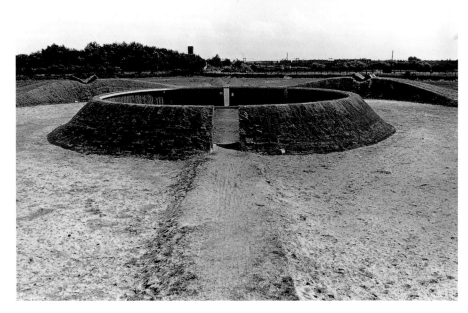

Robert MORRIS
Observatory (first version,
destroyed)
1971
Earth, timber, steel, granite,
water
ø 70 m
Ijmuiden (Holland)

The *Observatory* consisted of two con-
centric rings of earth. The inner ring
was formed of earth piled up against a
circular wooden stockade. The outer
circumference consisted of three
embankments and two canals. Entrance
to the piece was gained via a triangular
passage cut through the embankment
towards the west. Once inside the
stockade there were three outer
openings. The first looked east along
two parallel channels which ended in
two steel plates propped on a diagonal.
The interval between these plates
marked the position of the sun at the
equinoxes. The two other openings
marked the points of the sunrise on
the summer and winter solstices
respectively. The work was designed
to be experienced both aesthetically and
in relation to its physical and temporal
existence, both as a monument and as
a way of positioning man in the cosmos.
The observatory makes reference to
neolithic monuments, such as
Stonehenge, which, according to a
theory popular especially in the early
1970s, are thought to have served as
calendars. It leads to different
awarenesses of time, in terms both of
the time it takes to view the site and the
time of human history.

Robert MORRIS
Grand Rapids Project
1974
Earth, grass, asphalt, slope of a hill, ramps
2 ramps, 146 m each
Belknap Park, Grand Rapids, Michigan

This was the first Land Art work in the landscape to be funded by US government funds. An abandoned hill at the outskirts of Grand Rapids was encircled with a path at the base and another at the summit. These two paths were connected by two X-shaped roads on the side of the hill, with a platform at the intersection. Following this precedent, the National Endowment for the Arts, the General Services Administration and other state, county and municipal organizations showed an increasing receptiveness towards this kind of art. This developed alongside a growing commitment by artists to creating works in sites which have a public function.

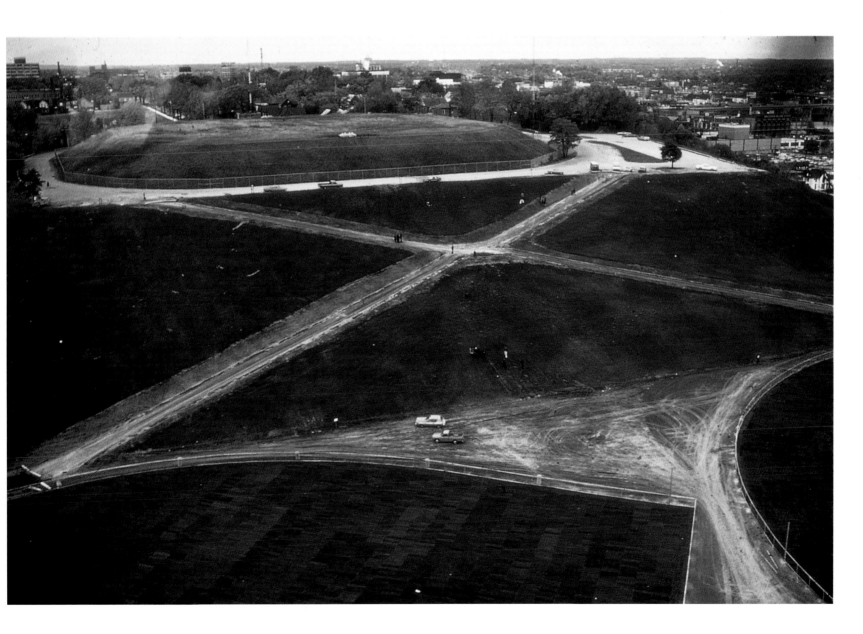

102 Robert <u>MORRIS</u>
Steam (second version)
1974
Vapour vents, rocks, wood
Dimensions variable
Western Washington University,
Bellingham
This piece involved the natural phenomena of condensation and evaporation and was dependent on the natural conditions of temperature, humidity, pressure and wind velocity. The work was concerned with nature and atmosphere. Steam, drawn from the city's underground supply, was driven through pipes and filtered above ground through openings in a large rock bed. The work, whilst sculptural, was made from anti-sculptural media, and had very little 'object' quality, although it did have a sense of physicality, existing as a hot, amorphous cloud seeping from the ground, billowing skyward and dissipating.

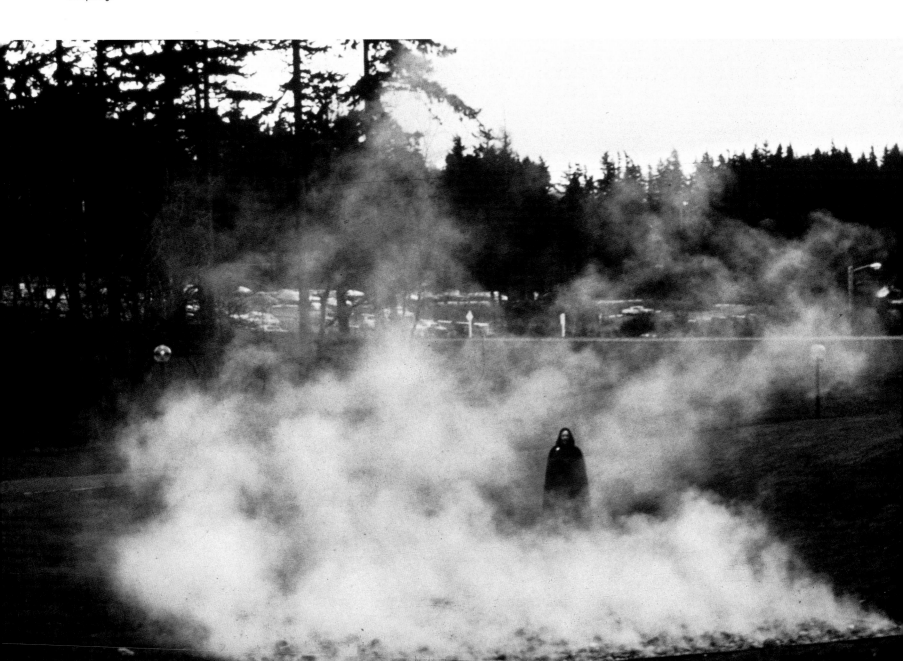

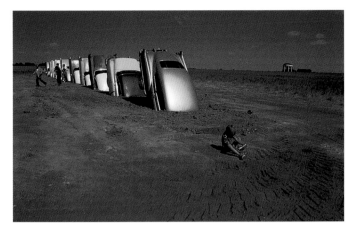 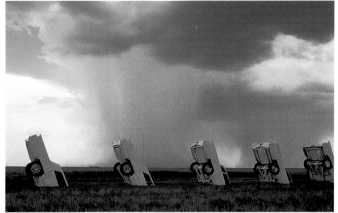

ANT FARM (Chip LORD, Hudson MARQUEZ, Doug MICHELS)
Cadillac Ranch
1974
10 Cadillac automobiles
274 × 4,605 × 213 cm
Amarillo,Texas

Built in June 1974, *Cadillac Ranch* was made up of ten Cadillacs, ranging from a 1949
Club Coupe to a 1963 Sedan, buried fin-up in a wheat field in Texas. The piece was
constructed in four days using a motorized back-hoe and low-tech surveying tools.
On the fifth day the work was unveiled. In the tradition of readymades, the work uses
mass-produced parts which have symbolic overtones. The Cadillac was a status
symbol of 1960s America, indicating that the owner was financially successful and
had therefore 'made it'. By using the Cadillacs as mere component parts of a work,
Ant Farm subverted their symbolic function. The piece functions as a kind of cemetery,
a comment on social values as well as their deathly polluting effect on the
environment.

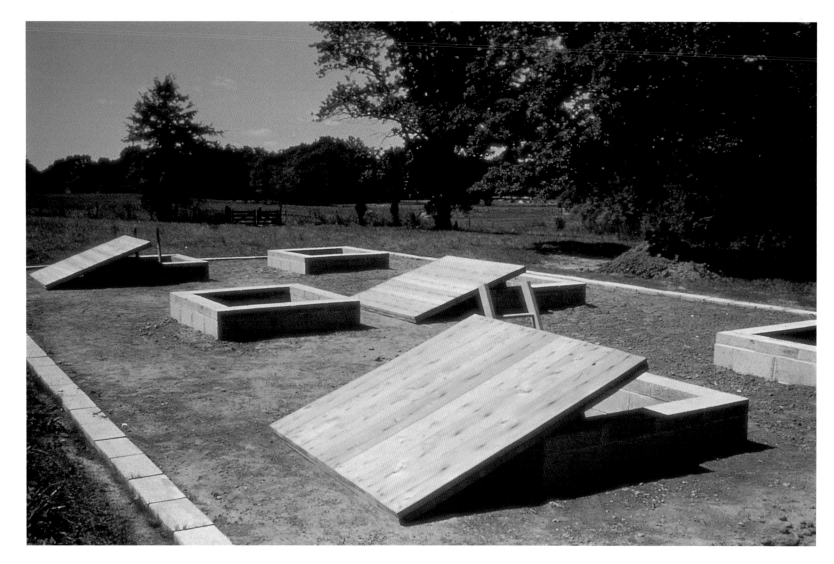

Alice AYCOCK
A Simple Network of Underground Tunnels
1975
Earth, concrete, timber
Wall, 30 × 900 × 1,500 cm
Underground excavation, 600 × 1,200 cm
Merriewold West, Far Hills, New Jersey

An area of approximately 6 × 12 m was excavated and a series of six concrete block
wells, connected by tunnels, were built. Three of the wells were open entry wells 2 m
deep. These were indicated above ground, capped with permanent covers and a layer
of earth. The viewer could crawl from entry well to entry well through narrow tunnels,
81 cm wide and 71 cm high, interrupted by vertical 'relieving' wells which were closed
and completely surrounded by earth. The underground structure was demarcated by
a wall 30 × 900 × 1,500 cm. The dark underground tunnels were designed to produce
an uncomfortable response in the audience. In conceiving this work Aycock drew on
experiences from her past, combining personal memories and dreams with
architectural history.

Mary MISS
Perimeters/Pavilions/Decoys
1977-78
Wood, steel, earth
Tallest tower, 550 cm
Pit opening, 500 cm²
Underground excavation, 12 m²
Nassau County Museum, Roslyn, New
York

Mary MISS
Perimeters/Pavilions/Decoys
1977-78
Wood, steel, earth
Tallest tower, 550 cm
Pit opening, 500 cm²
Underground excavation, 12 m²
Nassau County Museum, Roslyn,
New York

Three tower-like structures, two earth
mounds and an underground courtyard
were built on a four-acre site. To see the
work, the viewer has to walk through the
whole field: there are changes of scale in
the towers and inaccessible spaces in
the underground structure. Boundaries
and perceptions of distance are brought
into question as are the limits of illusion
and reality. The work must be walked
through in order to be experienced in its
entirety. The viewer is therefore aware
of both the passage of time and of the
changing relationships of the body in
space.

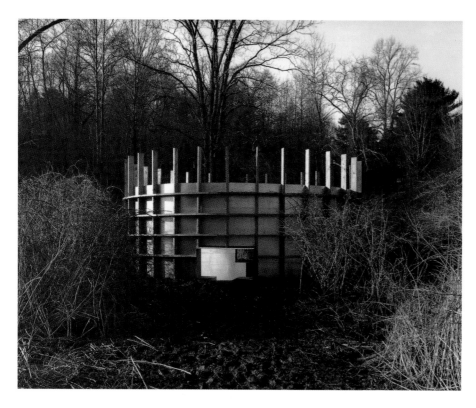

Mary <u>MISS</u>
Sunken Pool
1974
Wood, steel, earth
ø 610 cm
inside h. 396 cm
outside h. 305 cm
Greenwich, Connecticut

Walter DE MARIA
Vertical Earth Kilometer
1977
Metal, sandstone
1. 1 km
ø 5 cm
22 tonnes
Friedrichsplatz, Kassel

A km-long rod of metal was buried vertically in the ground. The boring of the shaft, which goes through six geological layers, took seventy-nine days. The continuous metal rod is made of 167 m-long rods, screwed tightly together. The sandstone square which surrounds the top of the shaft is at the intersection of two paths which traverse the Friedrichsplatz in Kassel, Germany site of the international contemporary art surveys, Documenta. The work is only visible in section; the kilometre of metal plunged into the earth can be seen as a representation of time in a vertical dimension.

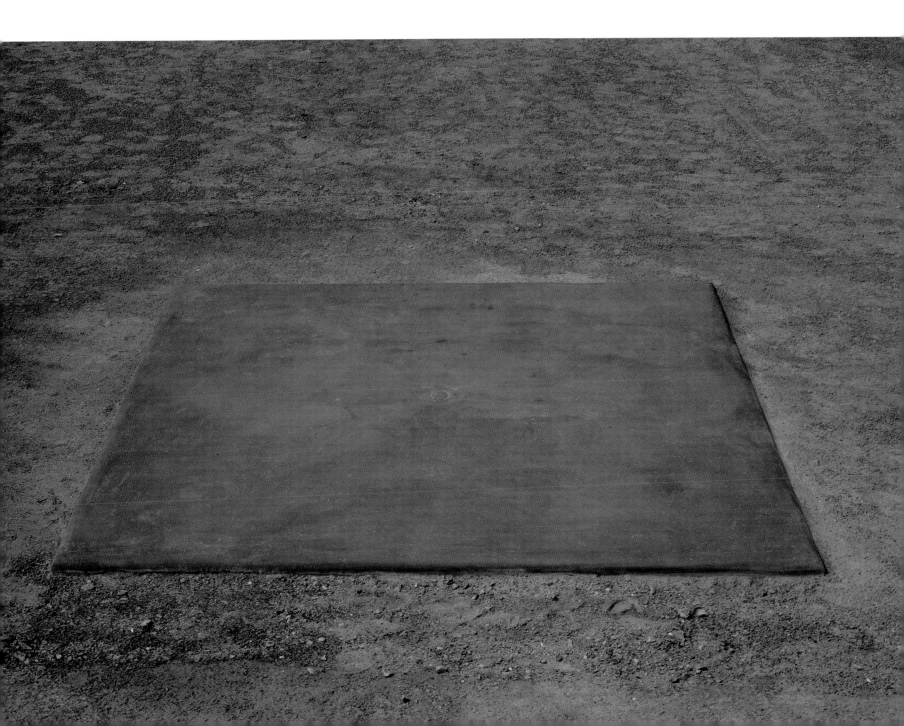

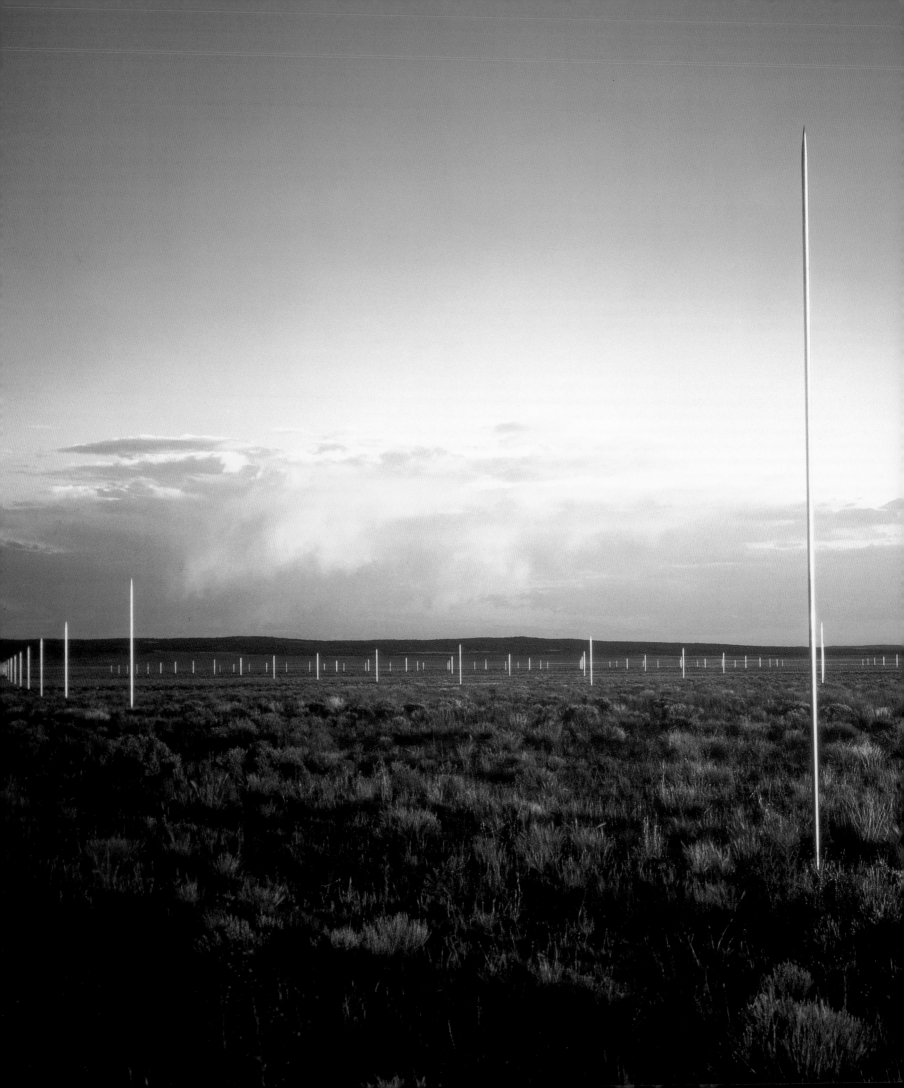

Walter <u>DE MARIA</u>
The Lightning Field
1977
Stainless steel poles
1 × .62 mile (1.6 km × 1 km)
New Mexico

The work is located in west central New Mexico, 2,195 m above sea level, 18.5 km east of the Continental Divide. Four-hundred custom-made, highly polished stainless steel poles with solid, pointed tips are arranged in a rectangular grid array. They are spaced 67 m apart; there are sixteen poles to the width (1 km) running north-south, twenty-five poles to the length (1.6 km), running east-west. Only after a lightning strike has advanced to an area of about 61 m above *The Lightning Field* can it sense the poles. The experience of the work directly in nature, the effects of the changing light, the shifting space, heat and the sense of waiting for a specific event (the lightning) heightens the viewer's sense of scale and time.

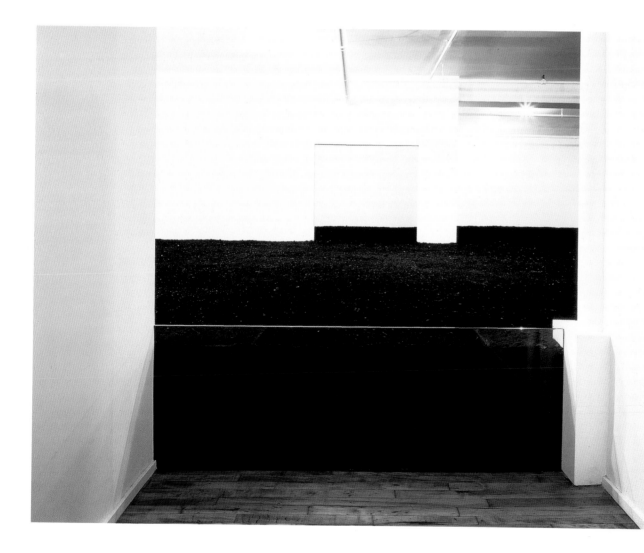

Walter <u>DE MARIA</u>
The New York Earth Room
1977
Earth, peat, bark
h. 56 cm
Surface area, 335 m²
197 m³ earth
300 kg earth
Dia Center for the Arts, New York

By filling a loft space in Manhattan with earth, De Maria makes a theatrical use of space. It is the space itself which is being shown, transformed both by the quantity and nature of the material filling it, as well as the smell. The earth brings the viewer into contact with raw nature in an urban environment. The work can only be contemplated through a doorway. A sense of exclusion is experienced by the viewer, as the space occupied by the work cannot be entered.

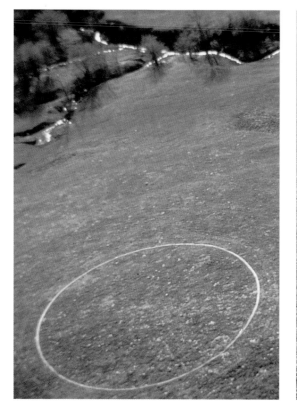 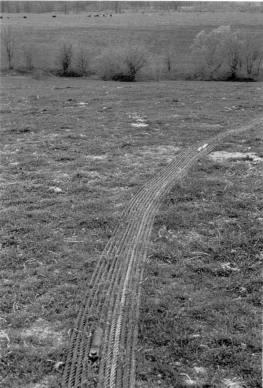

Betty <u>BEAUMONT</u>
Cable Piece
1977
Iron cable
ø 30 m
Macomb, Illinois

This work consists of an iron ring made out of 12 km of 1 cm diameter cable. The ring measures 30 m in diameter. This piece is the fifth in a series of time-based landscape projects . The iron ring is slowly burying itself, sinking into the ground, and the strands of the cable have begun to deteriorate. The iron content of the piece affects the growth of the grass, and its development over the years is being monitored by infra-red photography. Because of the huge scale, it is impossible to see the work in its entirety from the ground.

Meg <u>WEBSTER</u>

Glen

1988

Earth, steel, plants, fieldstone

361 × 1,300 × 1,300 cm

Walker Art Center, Minneapolis

This was a temporary, large-scale, site-specific sculpture. Constructed in response to the surrounding landscape, a depression was carved into the slope that forms the eastern border of the Minneapolis Sculpture Garden. Two triangular steel slabs served as retaining walls and formed the entrance to the interior of the piece. The terraced interior was planted with carefully arranged flowering plants, creating a surface rich with colour, texture and scent; organic materials combined with minimal forms. For Webster the womb-like work had sexual and specifically female overtones as it had to be entered in order to be fully experienced. The flowering plants and insect activity in spring emphasized the idea of procreation, birth and regeneration.

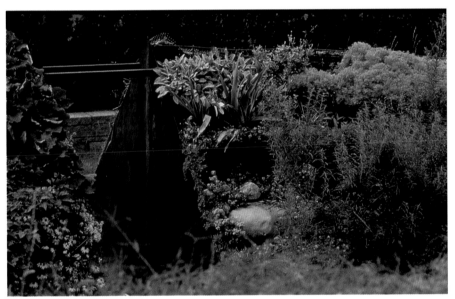

Meg <u>WEBSTER</u>

Double Bed for Dreaming

1988

Peat moss, soil, seeds

198 × 160 × 25 cm

In her moss bed works, Webster emphasizes the process of making – for example pounding soft earth into a mould – and also the cycle of natural history through the growth of moss or other plants during the lifespan of a piece. She works with natural elements of the landscape using loam, moss, natural plants, water and salt as her raw materials. Her work often features simple geometric shapes that derive from Minimalism. The demands that the pieces make on the environments and systems that contain them are an important part of their meaning. Webster brings elements of the landscape into a man-made environment, creating a tension between art and nature.

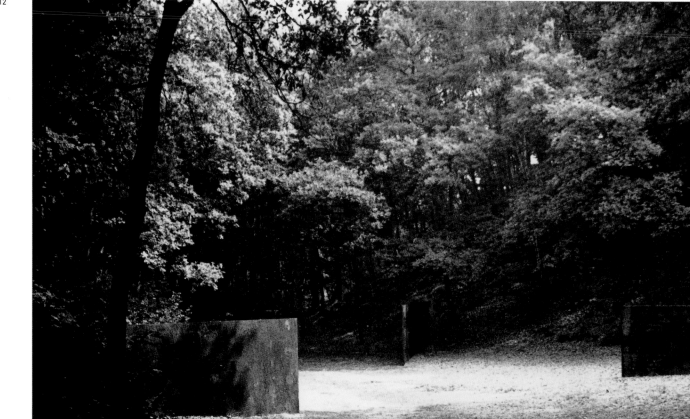

Richard SERRA

Spin Out (for Robert Smithson)

1973

Hot-rolled steel

3 plates, 309 × 1,219 × 4 cm each

Rijksmuseum Kröller-Müller, Otterlo

The work consists of three plates which are laid out in an elliptical valley at 12, 4 and 8 o'clock. The space in-between the three plates is an isosceles triangle 46 × 24 × 24 m. Each plate is approximately 3 m high, 12 m long and 4 cm thick. They are sunk into the incline at equal elevations. Serra's work explores topology and locomotion. When viewing the work at ground level, the plates at first appear parallel; when the viewer walks left, the plates move right. As the viewer walks into them they open up and appear to push outwards into the side of the hill. A ridge 46 m high encircles the space. When the viewer walks on the ridge, thereby viewing the work from above, the space appears elliptically compartmentalized; the viewer cannot see this when walking through the piece. Viewing the piece from overhead or viewing it from within creates a very different experience of place.

Toshikatsu ENDO
Epitaph - Cylindrical II
1990
Event with wood, tar, fire, earth, air, sun, water
h. 240 cm
ø 250 cm

Endo's work is often based on simple forms reminiscent of Minimal Art, but his work does not follow in that tradition. Rather it is concerned with an inner ideology and history, with mythology and human existence. Fire and water are both important elements: fire is a devastating force of nature whilst at the same time a source of energy. Fire possesses alchemical qualities and is also purifying. Water is a 'reserved and neutral' material, but since its form can never be ordered, it also represents chaos. The hidden caches of water inside some of Endo's sculptures are a reminder of the fluidity of all things. The burning of the work is often carried out outdoors; this ceremonial event is not directed at an audience. Endo documents the process with photographs and the resultant form is exhibited. The works are not simply concerned with process or form but allude to inner layers of human consciousness, the universal psyche and mythology.

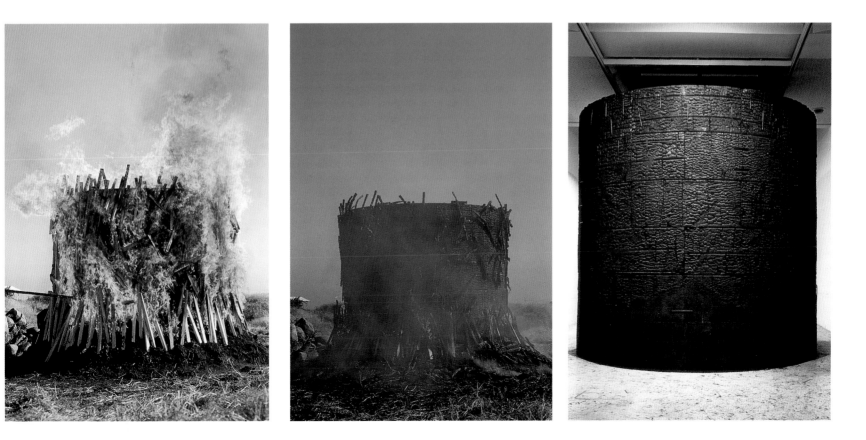

INVOLVEMENT

Works here focus on the artist as an individual acting in a one-to-one relationship with the land. Some artists use their bodies to make a performative relationship with an organic environment; the scale of the works is in relation to the human form. They emphasize a primal and symbolic link with the earth, creating contemporary forms of ritual. Others react against the monumentality of much early American Land Art by making transitory and ephemeral gestures. A sculpture may comprise the artist taking a walk across a field, subtly realigning elements within it to mark their passage. Artists also use their bodies to map the landscape, presenting photographic documentation of their journies. Drawing on Conceptual Art's strategies, some use words to substitute a picture of the land with its evocation as a physical experience. In contrast to the boundlessness suggested by early earthworks, the landscape may be revealed as a zone of invasion or exclusion, divided by invisible yet complex networks of political and ethnic boundaries.

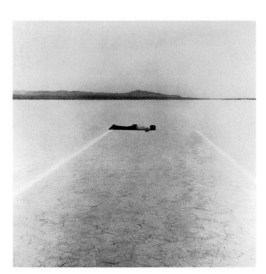

Walter DE MARIA
Mile Long Drawing (destroyed)
1968
White chalk
2 lines, w. 10 cm each,
3.56 cm apart
l. 1 mile (1.6 km) each
Mojave Desert, California
De Maria drew two parallel chalk lines on a dry desert lake bed.

Kazuo SHIRAGA
Challenging Mud
1955
Performance
Ohara-Kaikan, Tokyo
In this performance at the first Gutai exhibition, Shiraga writhed around in a pile of mud. He believed that the mud possessed a spirit of its own with which he battled. Only when exhausted, cut and bruised, did Shiraga stop. This type of performance which tested the artist's endurance was typical of the Gutai group, an experimental art group founded in Osaka in 1954 by Jiro Yoshihara, of which Shiraga was a key member.

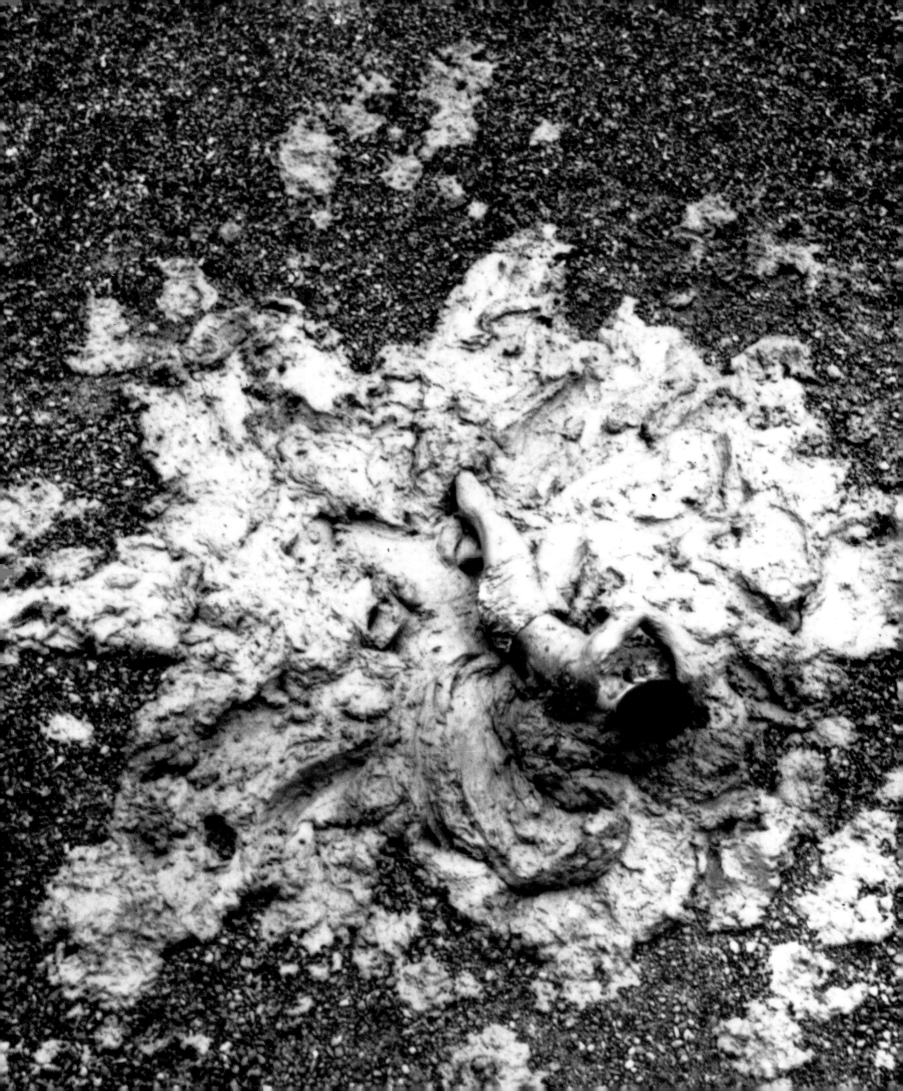

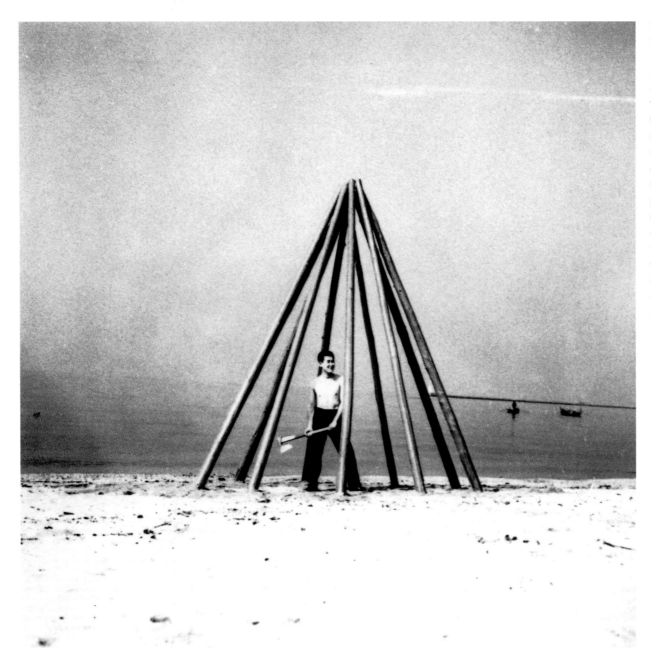

Kazuo <u>SHIRAGA</u>
Please Come In
1955
Performance
Ashiya, Japan

The work was originally created for
the 'Experimental Outdoor Modern Art
Exhibition', Ashiya. This was the first
major activity of the Gutai Art Association
since its founding in December 1954.
Shiraga erected a cone of ten posts
painted red. Standing inside the
structure and wielding an axe, Shiraga
scarred the inside to create a violent
'drawing'. The gestural display of gashes
was said to 'express instinctive
destruction'. This particular version was
made for photographers from *Life
Magazine* in April 1956.

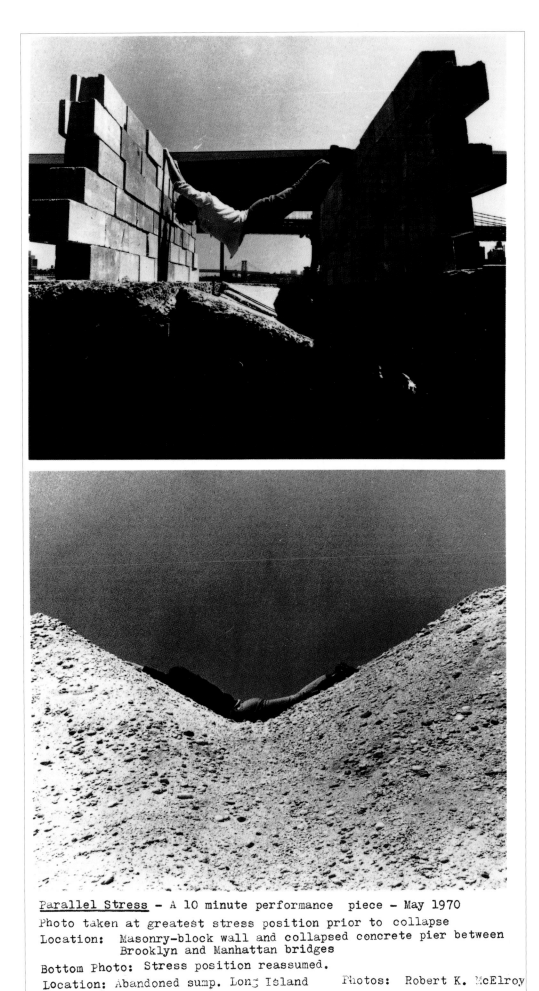

Parallel Stress
May 1970
Performance
Pier between Brooklyn and
Manhattan bridges and an
abandoned sump in Long Island,
New York

This was a ten-minute performance piece between a masonry-block wall and a collapsed concrete pier between Brooklyn and Manhattan bridges. The photograph was taken at the point at which Oppenheim's body was in the position of greatest stress.

The artist tested the capability of his body to suspend itself between two masonry walls. The stress was recorded by the position of his body as it arched. Oppenheim's body formed a human bridge, echoing the Brooklyn and Manhattan bridges on either side of him. Oppenheim held the position until his body collapsed, just as that section of the dock itself had already collapsed. Oppenheim performed this over and over, widening the gap between the walls.

The stress position was repeated for one hour in a cavity in the ground in an abandoned sump on Long Island.

Parallel Stress - A 10 minute performance piece - May 1970
Photo taken at greatest stress position prior to collapse
Location: Masonry-block wall and collapsed concrete pier between
 Brooklyn and Manhattan bridges
Bottom Photo: Stress position reassumed.
Location: Abandoned sump. Long Island Photos: Robert K. McElroy

Peter HUTCHINSON
Underwater Dam (detail)
1969
Underwater photograph
70 × 51 cm
Tobago, West Indies

This was part of a project carried out by Hutchinson in the late summer of 1969. Sacks of sand were dropped from a boat to form a dam in an underwater gorge three metres deep. Hutchinson then photographed the work.

Peter HUTCHINSON
Flower Triangle Undersea (detail)
1969
Underwater photograph
70 × 51 cm
Tobago, West Indies

Hutchinson planted yellow flowers in the sand in shallow water in the form of an isosceles triangle a shape that recurs in the artist's work. This is associated with the form of the tree of life and also has spiritual resonance for the artist, signifying a harmony of spirit, soul and body.

Peter HUTCHINSON
Threaded Calabash (detail)
1969
Underwater photograph
70 × 51 cm
Tobago, West Indies

These works belong to one of Hutchinson's earliest series. The artist strung fruits, oranges, gourds, onions, tomatoes and bread in plastic bags on a fishing line. These were thrown into the sea, weighted down with a stone or tied to corals and left to the current. The liquid environment allowed the suspended objects to appear weightless, while the constant movement changed the regularity of the rows. Through these works Hutchinson created new underwater landscapes with materials alien to that environment – fruit and vegetables which normally grow on firm soil. The works lasted only a few days, during which time a relationship was established between the environments above and below the water. The underwater sculpture was recorded in colour photographs.

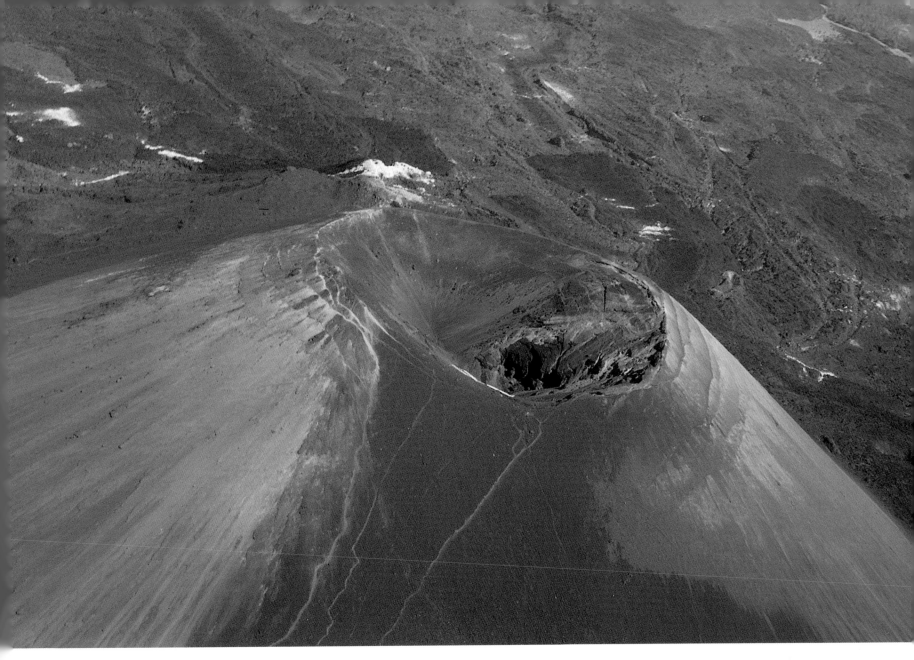

Peter <u>HUTCHINSON</u>
Paricutin Volcano Project (aerial view)
1970
Bread, plastic
1. 76 m
Paricutin, Mexico

Hutchinson arranged a band of white bread wrapped in plastic 76 m long along the rim of the Paricutin volcano. The bread took six days to grow mould; the warmth, moisture and vapour from the volcano accelerated this process. The fast-growing type of mould allowed the artist to record the continuous changes in the mould's decolouration and decay.

Peter <u>HUTCHINSON</u>
Mould from Paricutin Volcano
Project (detail)
1970
Colour photograph
99 × 180 cm

Peter <u>HUTCHINSON</u>
Paricutin Volcano Project
1970
Colour photograph
99 × 180 cm

Charles <u>SIMONDS</u>
Landscape - Body - Dwelling
1971
Artist's body, clay
Life-size

In this work Simonds constructed dwellings for imaginary miniature inhabitants –
the 'Little People' – using his own body as the landscape. The artist used his whole
body as the site on which to enact the birth of these miniature civilizations. In this ver-
sion of the work, Simonds' hip served as a hillside on which to construct dwellings. 'I
lie down nude on the earth, cover myself with clay, remodel and transform my body into a
landscape with clay, and then build a fantasy dwelling-place on my body on the earth.'
– Charles Simonds, 'Microcosm to Macrocosm', 1974

 The work exploits the sexual and sacred associations of the earth. The earth,
architecture and the body are all analogous to different dwellings. Simonds went on to
build cities or dwellings for the Little People on sites in New York, especially derelict
sites and abandoned buildings. He also constructed these works in museums.

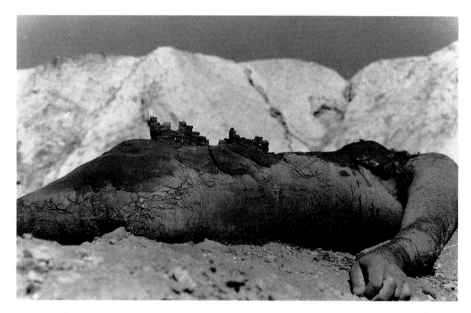

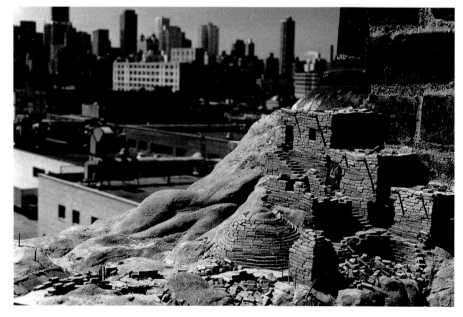

Charles <u>SIMONDS</u>
Dwelling
1974
Clay, sand, wood
1. 1.3 cm each brick
P.S. 1., New York

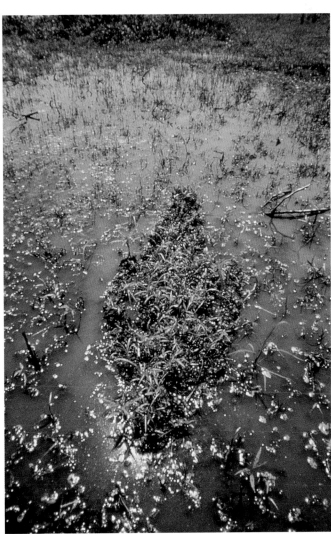

Ana <u>MENDIETA</u>

Untitled (from the 'Silueta'
series)
1979
Artist's body, grass, swamp, snow
Life-size
Amana, Iowa

These works began as a series of self-portraits in which Mendieta literally inscribed her presence onto the landscape. This series encompassed an extensive spectrum of media, materials and method. The inscriptions of female forms in the landscape were built in mud, rocks or earth, assembled with leaves, moss or flowers, stained in blood, etched in fire or ash, and washed away by water or smoke. Often these works were made in conjunction with personal rituals for healing, purification and transcendence. The 'Silueta' works synthesize aspects from the culture of Mendieta's birthplace, Cuba, with aspects from her adopted culture, the United States, and also a powerful sense of sexual identity. These works are documented in photographs and on Super-8 film.

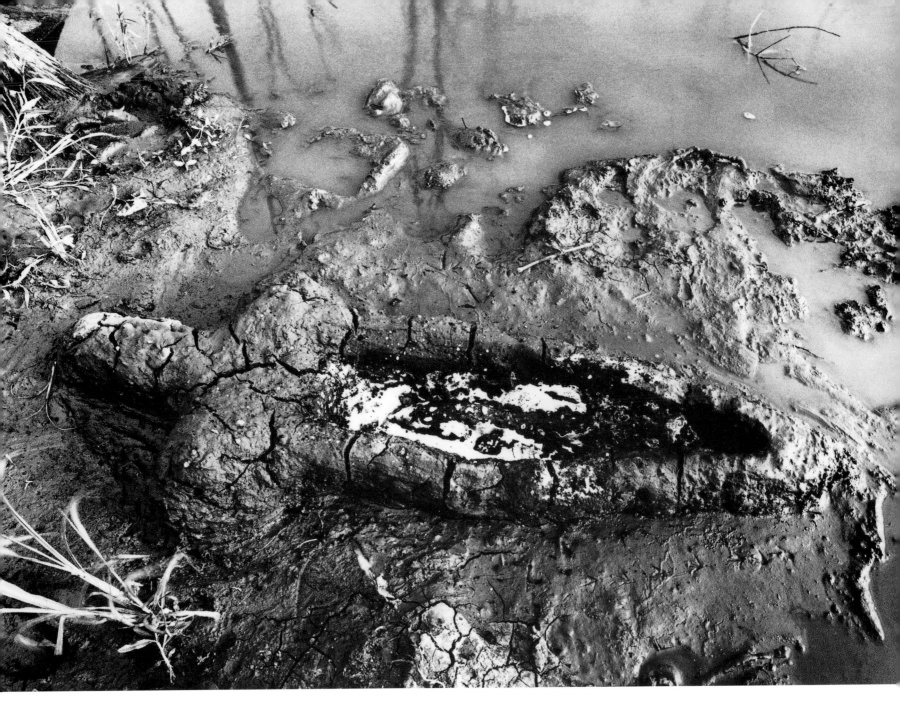

Ana <u>MENDIETA</u>
Birth, from the 'Silueta' series
1982
Earth, artist's body, mud,
gunpowder
Life-size
Old Man's Creek, Iowa

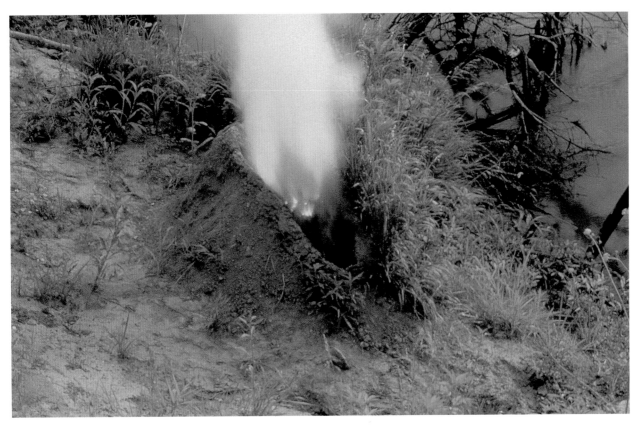

Ana <u>MENDIETA</u>
Untitled from the 'Volcano'
Series
1979
Performance, earth, gunpowder
Life-size
Sharon Arts Center, Iowa

Ana <u>MENDIETA</u>
Untitled, from the 'The Tree of
Life' series
1978
Artist's body, tree trunk, leaves
Life-size
Old Man's Creek, Iowa

Ana <u>MENDIETA</u>
Untitled
1983
Sand, binder, wood
160 × 99 × 5 cm

Ana <u>MENDIETA</u>
Incantation to Olokun-Yemaya
1977
Artist's body, earth, mud
Life-size
Iowa

WORKS

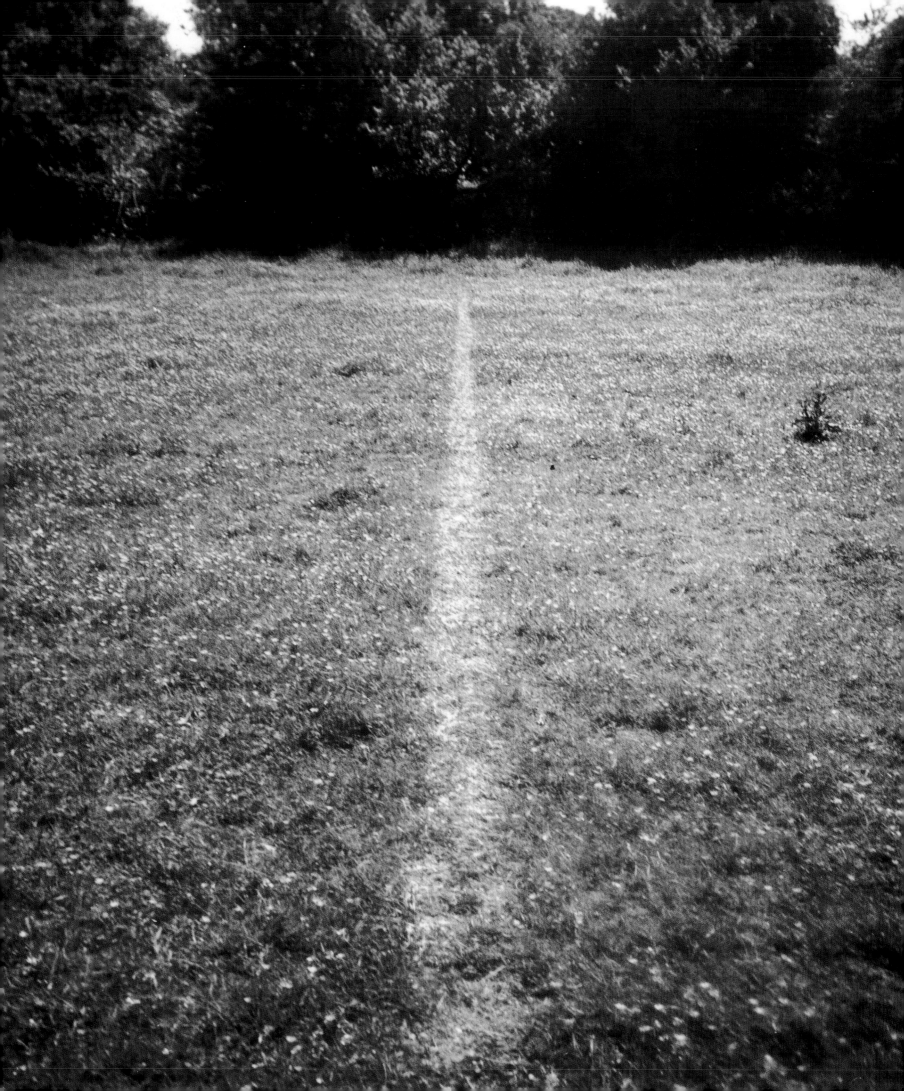

Richard LONG
A Line Made by Walking
1967
Black and white photograph
37.5 × 32 cm
Somerset, England

Long made this work by walking
repeatedly backwards and forwards
along the same line in a field, wearing
away a path by flattening the grass.
Long leaves a trace of his presence in
the environment, but the mark is
ephemeral, lasting only as long as it
takes the grass to spring back. This
marking of the earth is analogous to
drawing with his feet.

Richard LONG
A Line in the Himalayas
1975
Black and white photograph

Walking has always been an activity central to Long's art, most often in inaccessible,
unpopulated, barren regions, where expanses are vast and natural materials
abundant. It is during such walks that Long alters the terrain, shaping stones in
simple geometric configurations. These temporal events are experienced by the artist
and presented to the viewer as a map, word piece or photograph.

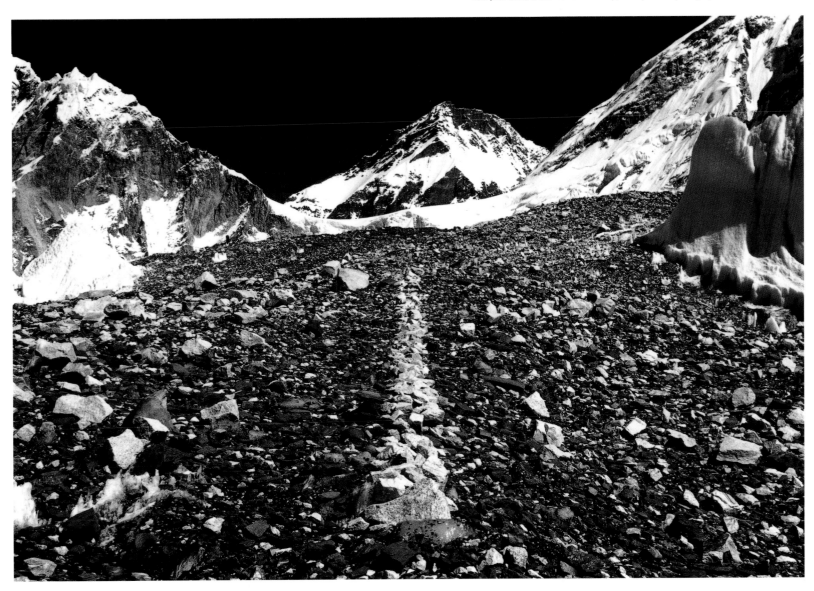

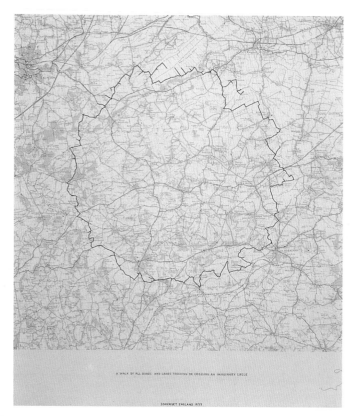

A Walk by All Roads and Lanes
Touching or Crossing an Imaginary
Circle
1977
Map, text
88 × 123 cm
Somerset, England

The act of drawing on the land is exemplified in this map upon which the artist has marked his itinerary along roads and lanes in the English countryside which trace the outline of an approximate circle. Here Long 'draws' his signature simple geometric forms on a vastly enlarged scale, in part underlining the immense difference between the direct experience of the landscape – with the sights and sounds of the outdoors – and its potentially absurd translation into a two-dimensional form. In a sense, the drawing is made by the artist's walk, as if Long were himself a giant pencil or marker tracing a line on the huge canvas of the earth's surface.

Richard LONG

Circle in Africa, Mulanje
Mountain, Malawi
1978
Black and white photograph

WATERLINES

EACH DAY A WATERLINE
POURED FROM MY WATER BOTTLE
ALONG THE WALKING LINE

FROM THE ATLANTIC SHORE TO THE MEDITERRANEAN SHORE
A 560 MILE WALK IN 20^{1}/$_{2}$ DAYS ACROSS PORTUGAL AND SPAIN

1989

Richard LONG

Waterlines
1989
Text on board
79 × 160 cm

Some of Richard Long's works consist of plain text describing, in simple words, the process of making the work or the route of a walk. At times paired with the photographic representation of the corresponding work, the text pieces share more characteristics with Long's photographs than might initially appear: both are black and white, 'objective' presentations of the work in its entirety Just as these text pieces give a thorough 'picture' of the work in a concise, straightforward manner, Long's photographs similarly do not dwell on detail but provide a comprehensive, singular overview of his sculpture whilst suggesting the process by which they were made. Like concrete poetry and some language-based Conceptual Art practices, these works prompt virtual pictures which exist, at times, only in the viewer's mind.

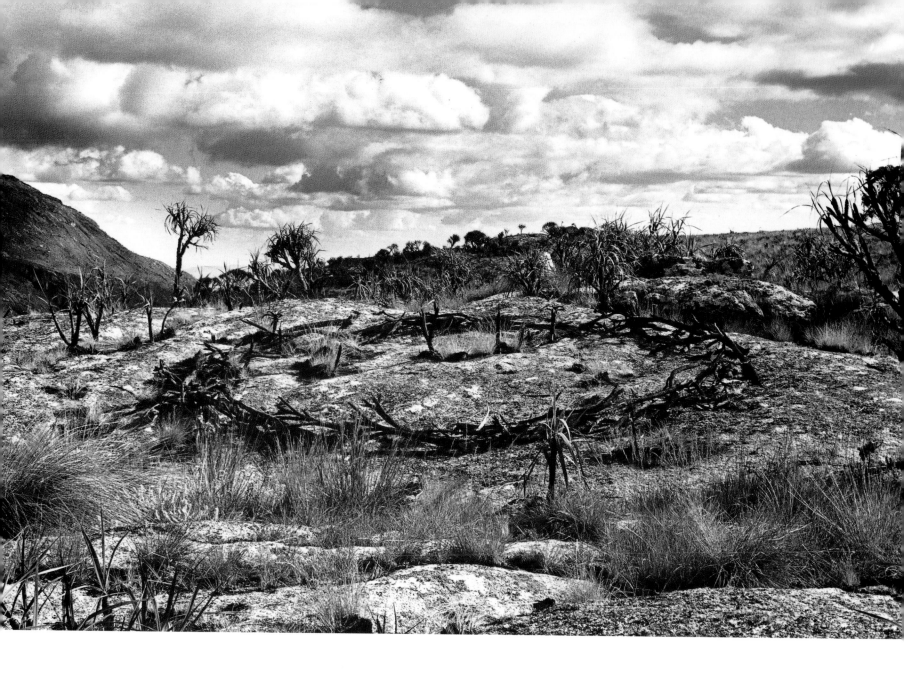

Richard <u>LONG</u>
A Line in Scotland, Cul Mor
1981
Black and white photograph

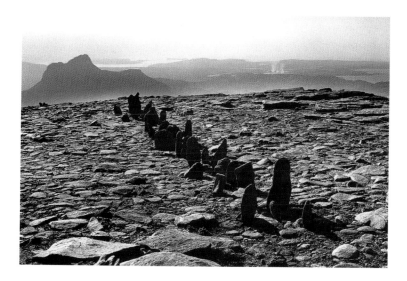

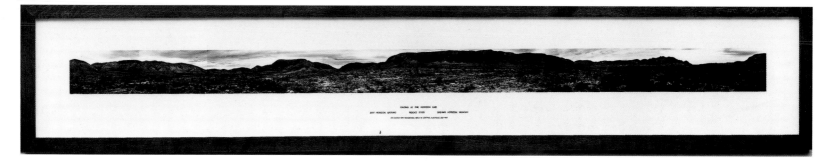

Hamish FULTON

Gazing at the Horizon Line, Sky
Horizon Ground, Australia
July 1982
Framed black and white
photograph, text
245 × 46 cm

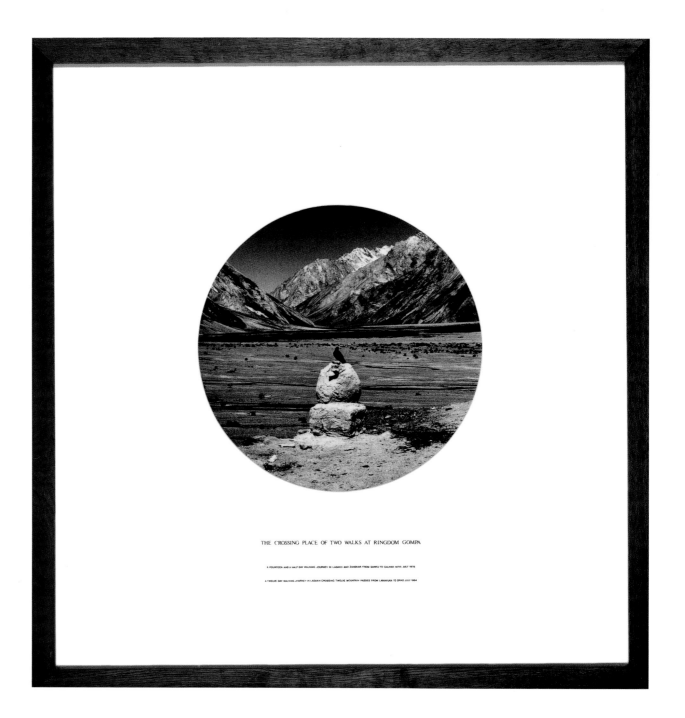

THE CROSSING PLACE OF TWO WALKS AT RINGDOM GOMPA

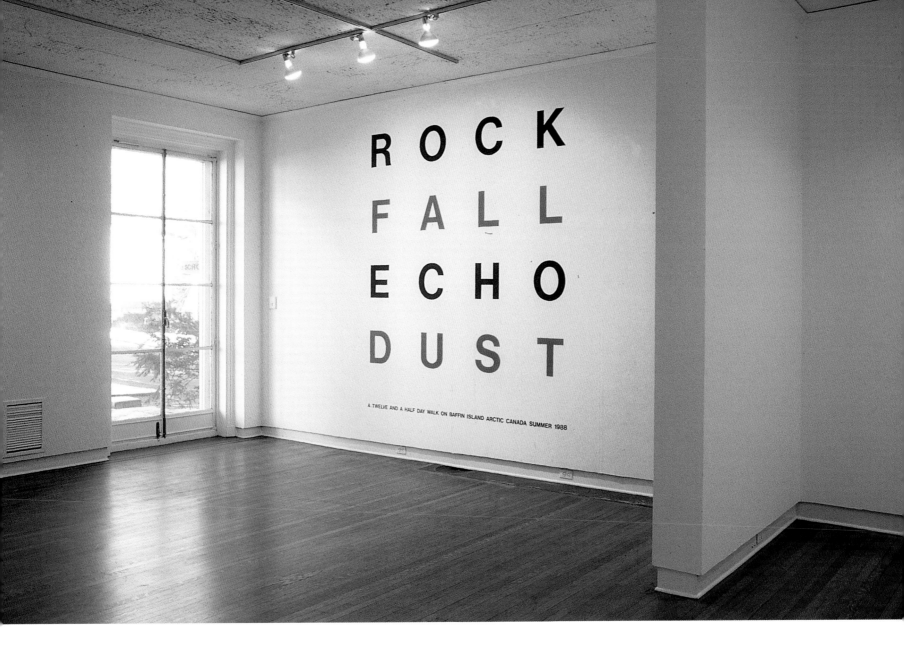

Hamish FULTON
Rock Fall Echo Dust (A Twelve and
a Half Day Walk on Baffin Island
Arctic Canada Summer 1988)
1988
Wall painting installation at
Tyler Gallery, Philadelphia

Hamish FULTON
The Crossing Place of Two Walks at Ringdom Gompa
1984
Framed black and white photograph, text
107 × 114 cm

Since 1969 Fulton's work has resulted from walks in the landscape. The walks are
represented through the combined mediums of words and photographs. The duration
of the walks ranges from one day to several months. Fulton's reaction to the land-
scape depends on the length of the walk and the number of photographs taken. The
actual walk is an essential aspect of the work, which is based on the maxim 'no walk,
no work'. The physicality of walking helps to evoke a state of mind and a relationship
to the landscape. Fulton believes that there is a very strong correlation between his
state of mind and his walking performance. When he walks he always attempts to empty
his mind as much as possible, so enhancing the meditative quality of his walking.

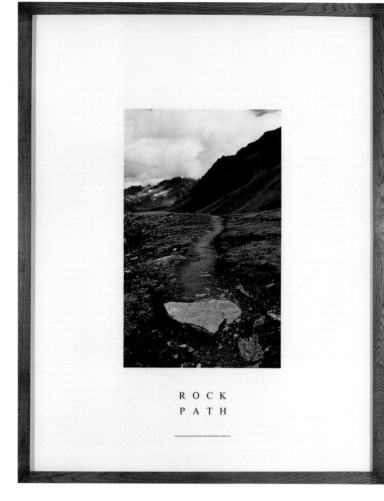

R O C K
P A T H

NIGHT CHANGING SHAPES

A CONTINUOUS 106 MILE WALK WITHOUT SLEEP
COUNTRY ROADS KENT AND SUSSEX
ENGLAND 14 15 NOVEMBER 1991

Hamish <u>FULTON</u>
Rock Path, Switzerland
1986
Framed black and white
photograph, text
142 × 110 cm

Hamish <u>FULTON</u>
Night Changing Shapes
1991
Framed black and white
photograph, text
143 × 117 cm

Hamish FULTON 131
No Talking for Seven Days
(Walking for Seven Days in a Wood
January Full Moon Cairngorms
Scotland 1993)
1993
Painted text on wall

NO TALKING FOR SEVEN DAYS

WALKING FOR SEVEN DAYS IN A WOOD JANUARY FULL MOON CAIRNGORMS SCOTLAND 1993

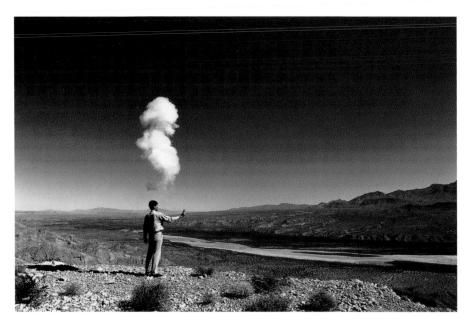

CAI Guo Qiang
The Century with Mushroom Clouds
14 February, 1996
10 grams gunpowder
Event
Nuclear Test Site, Nevada

The work was made when Cai Guo Qiang carried out field research at a former nuclear test site in Nevada (active 1951-93), the focus of which was to inspect a nuclear-ravaged site in the Nevada desert (which contained the devasted reconstruction of a Japanese village) as a possible future 'tourist' spot. Cai Guo Qiang envisaged reclaiming the polluted ruins of a civilization through the imagination of art. His miniature versions of nuclear mushroom clouds were detonated in the desert and in the environs of Manhattan. The irony of nuclear force for the artist is that it has effected some of the worst tragedies of human history whilst at the same time producing monumental and beautiful imagery. Cai Guo Qiang describes his works as a means of 'fighting fire with fire'.

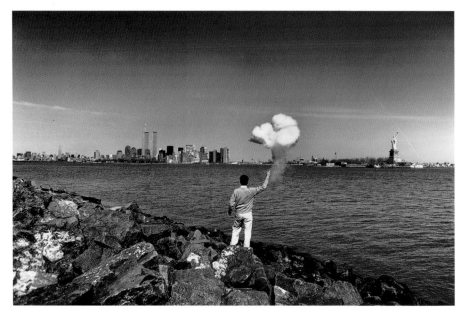

CAI Guo Qiang
The Century with Mushroom Clouds
20 April, 1996
10 grams gunpowder
New York

Illegal Border Crossing between
Austria and the Principality of
Liechtenstein
1993
Performance
Border between Bangs, Austria and
Ruggell, Liechtenstein
One of eight 'Border Crossings'
for the Austrian contribution to
the Venice Biennale 1993

The artist outlines the project as follows:
How to get there: Train Vienna –
Feldkirch, 7 hrs 45 mins
Bus Feldkirch – Bangs 15 mins.
Point of departure: Gasthaus zum Stern,
Bangs
Time required on foot: 45 mins
Danger zones: Unwooded areas of
meadow. Areas free from undergrowth
Camouflage: Light, rainproof hiking
attire; riding kit (with horse)
Level of difficulty: No real danger

'We cross the road, heading in the
direction of the chapel and the alpine
elm – planted in 1813 (to mark the
liberation from the French). Keeping to
the right, we traverse the white
farmstead and stables – the red and
white barrier with border-control hut,
already in site.
Cautiously, we cross the meadow and
seek cover in the embankment of the
Hasenbach. Taking a run-up, we clear
this natural boundary. The meandering
drainage ditch might be confusing. Only
the ground marked by red and blue
wooden stakes is no longer Austrian
territory.
We are careful not to be so rash as to
break cover too soon. Large cultivated
fields offer little protection from view,
making it not so easy to enter the village
of Ruggell unseen.'

Disguised as a hitchhiker, Müller left
Austria and crossed the borders to eight
neighbouring countries. The work took
on more sinister political implications
when he was arrested by border control
guards in Czechia, and forbidden to re-
enter the country for three years.

Cildo MEIRELES
Geographical Mutations: Rio-São
Paulo border
1969
Leather case, soil, plants
Rio de Janeiro - São Paulo border

The project concerns the transformation
of the landscape. The work recorded
here was made on the border between
Rio de Janeiro and São Paulo (Brazil) and
consisted of making a hole on each side
of the border and exchanging soil, plants
and debris from these two holes. Inside
the case the topographical pattern of the
border is reproduced and contains part
of the material from these excavations,
carried out in November 1969.

Cildo MEIRELES
Geographical Mutations: Rio-São
Paulo border
1969
Leather case, soil, plants
Rio de Janeiro - São Paulo border

Cildo MEIRELES
Condensations 2 – Geographical
Mutations: Rio-São Paulo border
1970
Soil, silver, onyx, amethyst
Rio de Janeiro – São Paulo border
This work is one of many miniaturized
versions (mostly rings) Meireles created
of his works the *Geographical Mutations*.
Inside the ring is a sample of soil and a
diagram relating to the process and
construction of the work.

IMPLEMENTATION
Alongside the formal and aesthetic innovation represented by Land Art, it also precipitated an investigation into the environment as ecosystem and depository of socio-political realities. Artists contested the perception of nature as a blank canvas or as an infinitely exploitable resource. Exploring nature as a dynamic and interactive system, they point out parallels with social and political structures and their impact on each other. The scope of radical transformation embarked upon by feminist artists also came to encompass environmental issues. The works brought together here demonstrate how human relations with the natural environment are based not only on perception and pleasure, but also exploitation, waste and destruction. Industrial development, urban expansion, mass market agriculture and scientific intervention within natural processes are perceived as causes of global pollution and social alienation. The practices surveyed here range from sculpture to performance. They present responses that combine incisive critique with practical and redemptive strategies which can be effected by the individual.

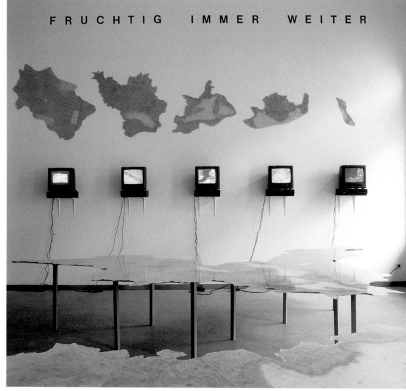

Peter FEND
Ocean Earth: Europa
1991
Maps, board, Plexiglas, television monitors
Dimensions variable
Installation, Kunstraum Daxer, Munich

The many semi-enclosed or fully enclosed salt seas in Europe are suffering from severe environmental degradation. Defining Europe as the land 'from the Atlantic to the Urals', Fend identified thirteen regional sea basins and divided them into two groups. The waters of one group drain into the open Atlantic, the others into interior seas such as the Mediterranean or Caspian. Each basin is represented on a satellite monitor. In these two images, ten of the total thirteen ocean basins for Europe are displayed, with the slogan, 'Europe's ecological regions being made ever more fertile'. The maps on the walls are taken from US Aeronautical charts and show the individual sea basins. The two table-mounted maps in these installation shots all show sea-basins. The first presents all basins as sloped into the North Atlantic (from the Iberian Current to Barents Sea), and the second is of all basins as sloped into Europe's interior seas such as the Mediterranean.

The aim of Fend's methodolgy is to contribute to a financeable and systematic construction of outdoor earthworks as functional architecture. There are three stages of the work: 1) mapping the saltwater catchments; 2) monitoring the changing conditions of each basin; and 3) harvesting the nutrients that accumulate in salt waters, using semi-submersible rigs to support crops of giant brown algae. This algae supports large marine populations; its chief industrial product is methane or hydrogen gas, a renewable, non-polluting fuel.

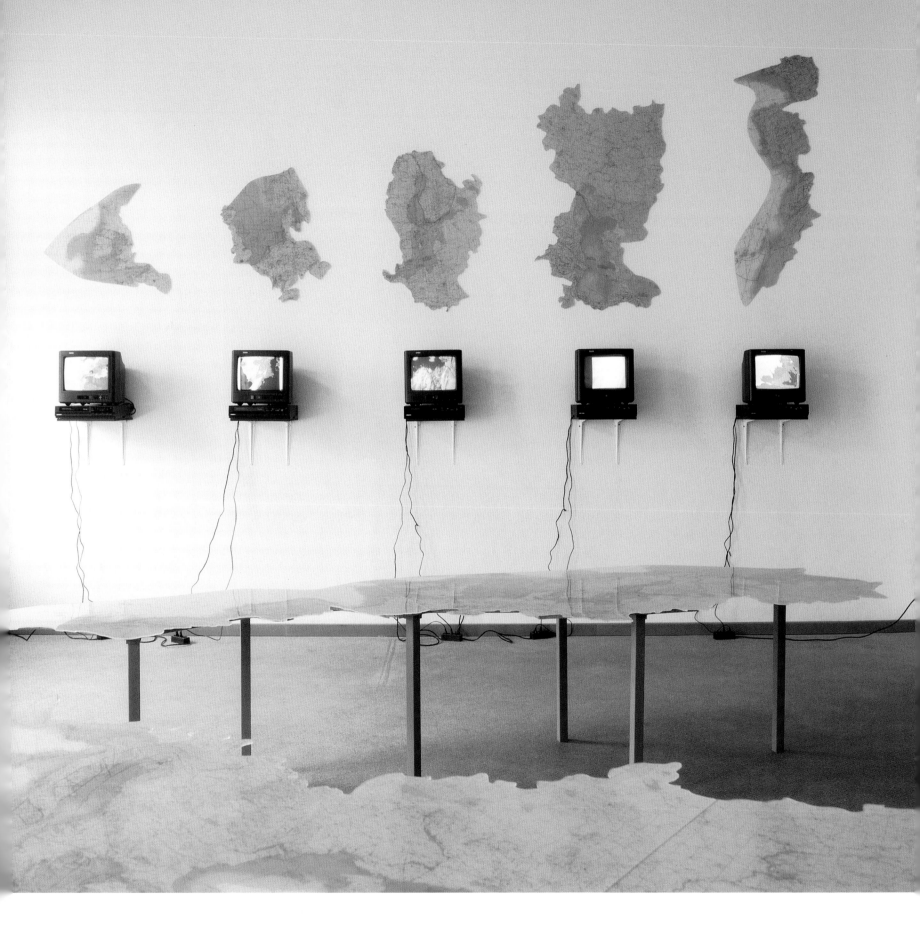

Hans <u>HAACKE</u>
Grass Grows
1969
Earth, winter and annual rye
grass
Dimensions variable
Ithaca, New York

The simple title of this work describes
both the subject and the intent. This work
was a modification of the original piece
shown at the Howard Wise Gallery in
1966, where Haacke grew grass on top of
a 3-foot (91.5 cm) square Plexiglas cube.
The phenomenon of organic growth as
an essential component of an ecosystem
is an early example of issues which
would later be explored further in more
fully developed ecological artworks.

 This version of *Grass Grows* was made
for the 'Earth Art' exhibition at the
Andrew Dickson White Museum, Cornell
University, Ithaca, 1969.

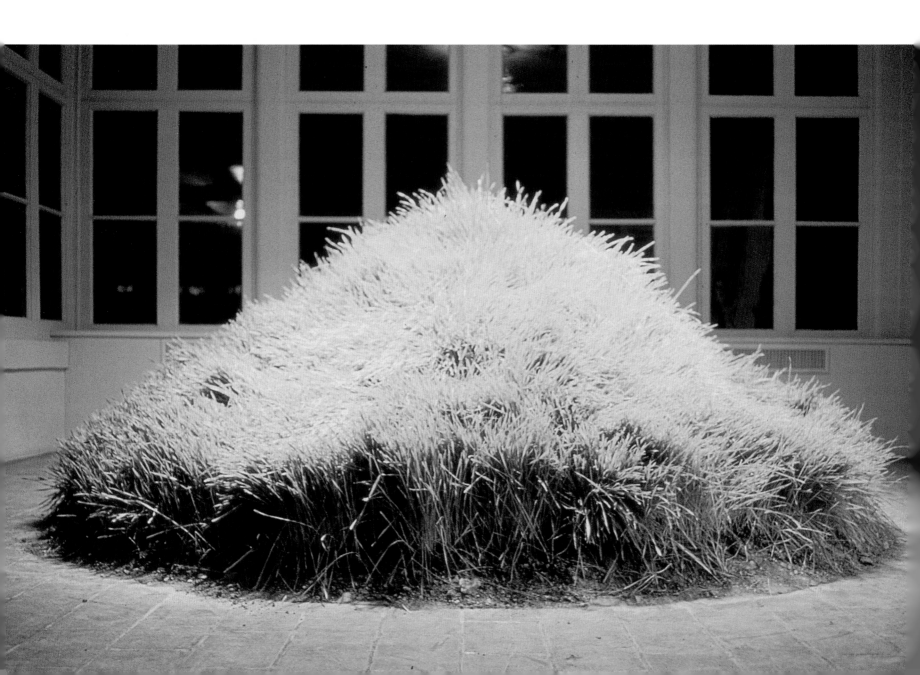

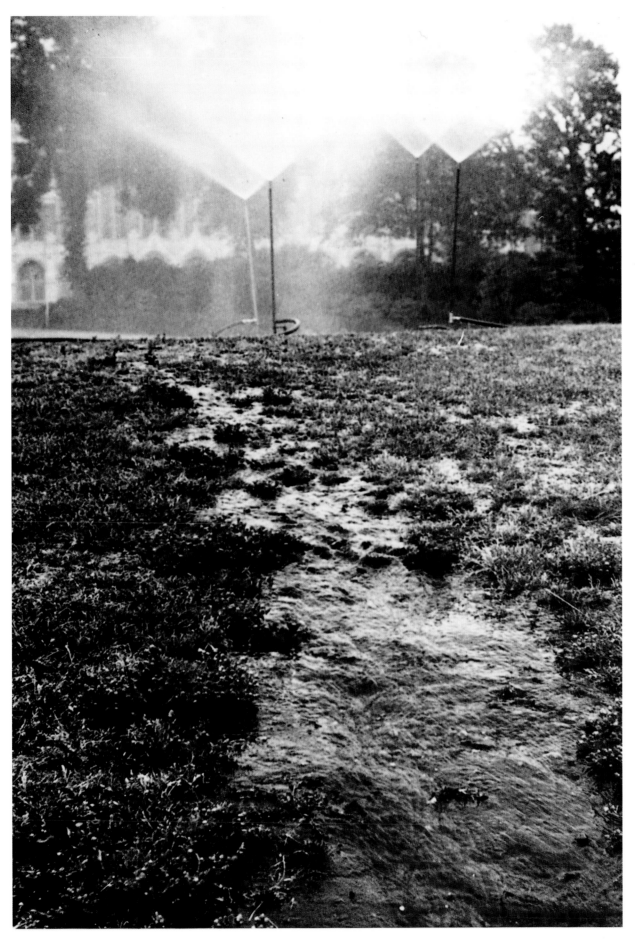

Fog, Flooding, Erosion
1969
Water, wind, irrigation system
Dimensions variable
Seattle, Washington

A set of sprinklers were left on, flooding
the surrounding grass with water. The
excess water became a destructive
rather than nurturing force. The
flooding waters eroded the soil, turning
the lawn into a pool of mud.

Hans <u>HAACKE</u>
Ten Turtles Set Free
20 July 1970
Turtles
St. Paul-de-Vence, France

In a metaphorical gesture Haacke purchased ten turtles (an endangered species)
from a pet shop and later released them into a forest near St. Paul-de-Vence, south of
France. This was a symbolic act which called into question human interference with
the freedom of animals and their imprisoned position as pets. This was one of the first
works to dramatize human disregard to animals and their threatened status.
Haacke's liberation of the turtles was an acknowledgement of a principle of
environmental ethics – that every life has a right to exist for its own sake.

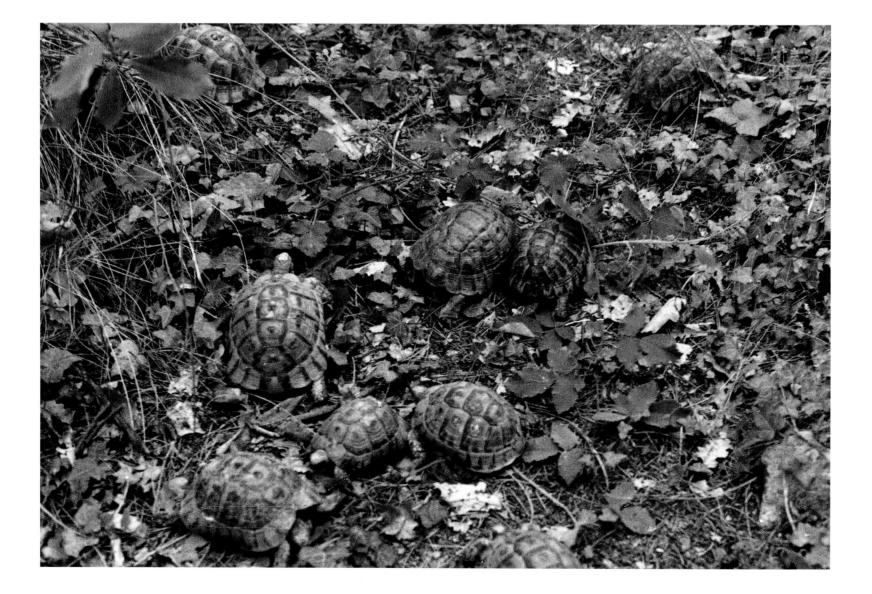

IMPLEMENTATION

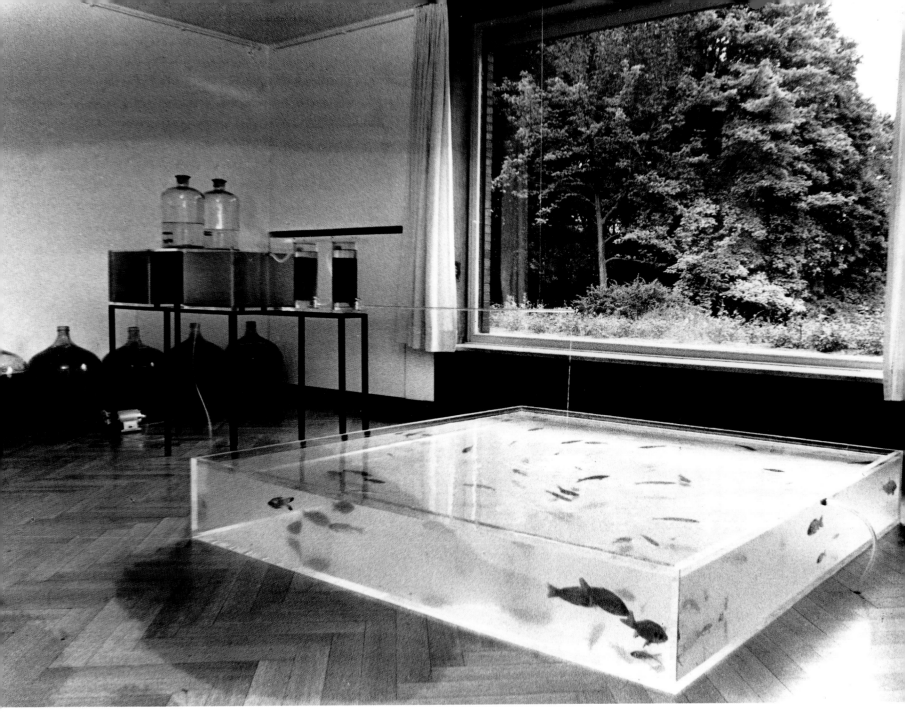

Hans HAACKE

Rhine-Water Purification Plant

1972

Rhine-water, glass bottles, acrylic containers, charcoal and sand filter, hose, goldfish

Dimensions variable

Installation, Museum Haus Lange, Krefeld

Haacke obtained polluted Rhine-water from a Krefeld sewage plant. The water was pumped into an elevated acrylic basin from large glass bottles in the gallery in which the water was stored. Chemicals were injected into the water to cause the pollutants to settle. The sedimentation process continued in a second acrylic container. From there the partially purified water flowed through a charcoal and a sand filter and eventually dropped into a large basin with goldfish. A hose carried the overflow out to the garden, where it seeped into the ground and joined the ground water level. This work, which resembled a laboratory experiment, called into question a specific environmental problem – water pollution in Krefeld, where the Rhine was used as the repository of raw industrial and household sewage. The goldfish tank was set in front of a view of wooded landscape behind the museum, establishing a dialogue between two eco-systems, one life-supporting, one on the verge of collapse.

Helen Mayer <u>HARRISON</u> and Newton
<u>HARRISON</u>
Portable Farm: The Flat Pastures
1971-72
Gro-lux lights, wood, earth,
dwarf citrus trees, avocado tree
4 pastures, 122 × 304 cm each
New Houston Museum of Fine Arts,
Houston, Texas

Helen Mayer <u>HARRISON</u> and Newton <u>HARRISON</u>
Portable Orchard, Survival Piece No. 5
1972
Gro-lux lights, wood, earth, dwarf citrus trees, avocado trees
Dimensions variable
California State University, Fullerton

Portable Orchard was an orchard of eighteen trees planted in hexagonal boxes in 1 yd³ (0.765 m³) of earth, with hexagonal light boxes over them. At the opening, the exhibition was accompanied by a tableau of fruit and a citrus feast. Newton Harrison constructed the environment and Helen Mayer Harrison designed the tableau and constructed the feasts which were designed as social interactions. Many of the orchards in Orange County, California, at the time of the exhibition were dying from smog or being removed by spreading urbanization. Placing an orchard in an art gallery highlighted the problems of the survival both of the orchards and the communities which depended on them.

Helen Mayer HARRISON and Newton HARRISON
If This Then That (The First Four): San Diego as the Center of the
World
1974
Photosensitive paper laid on canvas, oil, ink, graphite
244 × 244 cm

The mural is a projection map of the world with San Diego at the centre. This was their first work on the Greenhouse effect and proposed the need for planning on climate change.

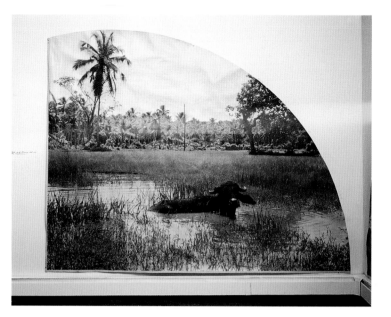

Helen Mayer HARRISON and Newton HARRISON
The Lagoon Cycle
1972-82
Photographs, text, collage, drawings
1. 106 m

This 106 m mural installation is made up of over fifty parts featuring different stages of the cycle. Each lagoon image is composed of several panels. The panels are made up of aerial and site photomurals, collage and drawings; there are occasional portraits and some narrative overlay. The text is an extended, semi-autobiographical dialogue between two characters, a 'Lagoon Maker' and a 'witness', interspersed with stories and anecdotes. The narrative traces the Harrisons' working process, which typically begins with an accidental encounter with a problem and for which a solution is sought through dialogue. The dialogue serves to establish the philosophical basis for the ecological argument often used by the Harrisons in later works; they recount elements of their research, the development of attitudes, potential solutions and contradictions. *The Lagoon Cycle* begins with observations on the life of a small crustacean and ends in the Pacific Ocean with the Greenhouse effect.

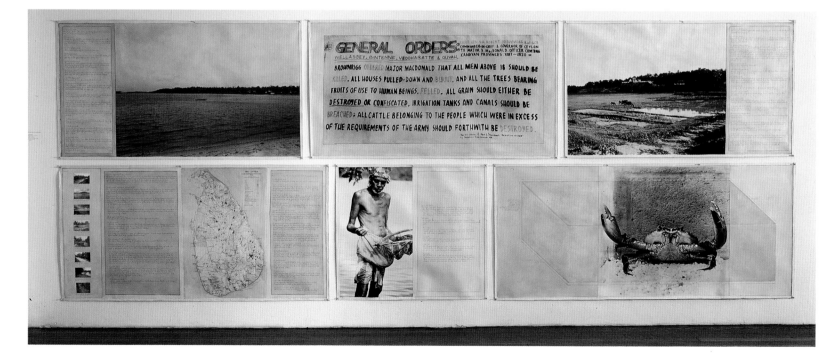

left

Helen Mayer HARRISON and Newton HARRISON

That Idiot Theseus Did in the Minotaur (Sketch for the Seventh Lagoon, Buffalo Wallow)

1982

One of two photographic paintings on wedge-shaped panels

246 × 30 cm

The water buffalo was an integral part of an ecosystem which included the indigenous human population. In this sketch for the Seventh Lagoon, Buffalo Wallow, the Harrisons' narrative shows the water buffalo as a more effective element than the tractor. It reproduced itself for nothing, provided free labour, did not require fuel, did not pollute the environment. In addition it was a source of milk and meat. As water buffalo disappeared the rate of malaria increased.

Helen Mayer HARRISON and Newton HARRISON

The Lagoon Cycle: Fifth Lagoon

1972-82

Photographs, collage, text, drawings

Dimensions variable

Installation, Johnson Museum, Cornell University

The Harrisons believe that in order to effect environmental change, ecological art must look at and respond to the totality of interrelationships that define ecosystems. Since 1977 they have been examining ways of maintaining the ecological balance of watersheds, which are critical for sustaining biodiversity and ensuring the quality of water which is affected by human activity.

 Their work is communicated through maps and collaged photographs accompanied by poetic narration or dialogue and occasionally performances by the artists. It is concerned with encouraging communication between the community, civic organizations and government. Visual documentation is combined with the artists' impressions of the place, as well as descriptions of possible solutions to pollution problems.

Helen Mayer HARRISON and Newton HARRISON

The Lagoon Cycle: Fourth Lagoon

1972-82

Sepia toned photomural paper mounted on canvas, painted with oils, graphite, ink

Dimensions variable

Installation, Johnson Museum, Cornell University

Helen Mayer HARRISON and Newton HARRISON
Breathing Space for the Sava River, Yugoslavia (detail)
1988-90
Photo collage, text, maps
1. 38 m

The Harrisons have been concerned with the pollution of watersheds, that are critical in terms of maintaining biodiversity and ensuring the quality of water since 1977. In this piece the Harrisons used photographs and text to illustrate the collision between man and nature along the Sava River in former Yugoslavia. The artists photographed the course of the Sava River from its twin sources in mountain and swamp until it flows into the Danube River near Belgrade. The river, clean at its source, becomes poisoned by the outflow of wastes from a nuclear power plant and factories along its route. The Harrisons documented the toxins dumped into the river by a paper mill and fertilizer plant just before it enters a nature reserve. In order to preserve the ecological balance as much as possible, the Harrisons proposed making swamps along the drainage ditches which empty into the reserve. Through a careful selection of plants, a natural system of purification could effectively eliminate many pollutants. To reduce fertilizer runoff and stem algae bloom, organic farming along the edges of the preserve was suggested. Finally, water used for cooling at the nuclear plant could be recycled into holding ponds for raising warm-water fish.

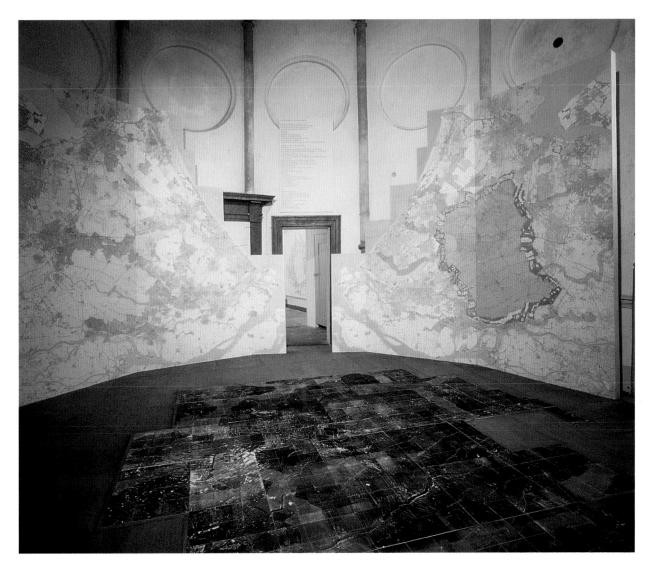

Helen Mayer <u>HARRISON</u> and Newton <u>HARRISON</u>

Vision for the Green Heart of Holland
1995
Maps, drawings, video, text, ceramic tiles
Dimensions variable
Installation, Catheren Chapel, Gouda (Holland)

The Harrison Studio (Helen Mayer Harrison, Newton Harrison, Gabriel Harrison and Vera Westergaard) was commissioned by the Cultural Council of South Holland to find a solution to the present gradual erosion of the 'Green Heart' of Holland. The Harrisons proposed a Ring of Biodiversity, 140 km long and 1 – 2 km wide, which would act as an interface between rural and urban environments. The ring aims to sustain the full range of biodiversity of the natural landscape and also to produce cleaner air and water for present and future generations. The ring would function as an example for the future and also as an indicator of the wellbeing of the Green Heart habitat of Holland.

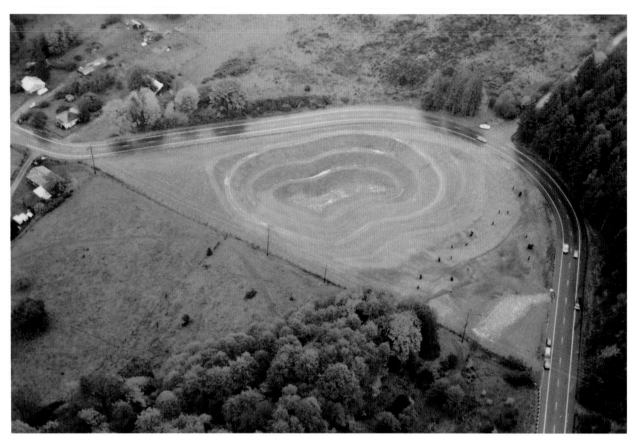

Robert <u>MORRIS</u>
Untitled (reclamation of Johnson
Gravel Pit)
1979
Earth, grass, tree stumps
1.6 hectares
King County, Washington

Built in an abandoned quarry, the piece consists of concentric terraces and slopes forming an amphitheatre in the centre of the site, with a hill rising in the lower section. From within the amphitheatre only the sky is visible; from the hill the viewer surveys the largely rural Kent Valley, in King County, Washington. A few scattered tree stumps remain as emblems of resource utilization. Morris' work demonstrates the aesthetic possiblities of art-as-land reclamation and the economic viability of Land Art.

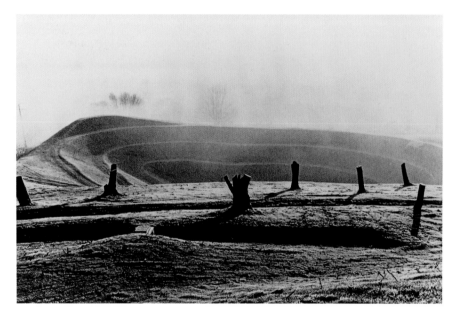

Harriet FEIGENBAUM

Erosion and Sedimentation Plan for Red Ash and
Coal Silt Area - Willow Rings
Planted 1985
Willow trees
6 hectares
Scranton, Pensylvannia

On a 6-hectare site scarred by strip-mining activities the artist planted three circles
of willow trees following the site's bowl-shape topography. The trees were planted
around a pond formed from coal-dust run-off. *Willow Rings* is maintained as a
wetland wildlife preserve. Attempting to maintain a balance between people and
nature by restoring a damaged area of the landscape to a natural habitat, this work
reflects Feigenbaum's commitment to land reclamation.

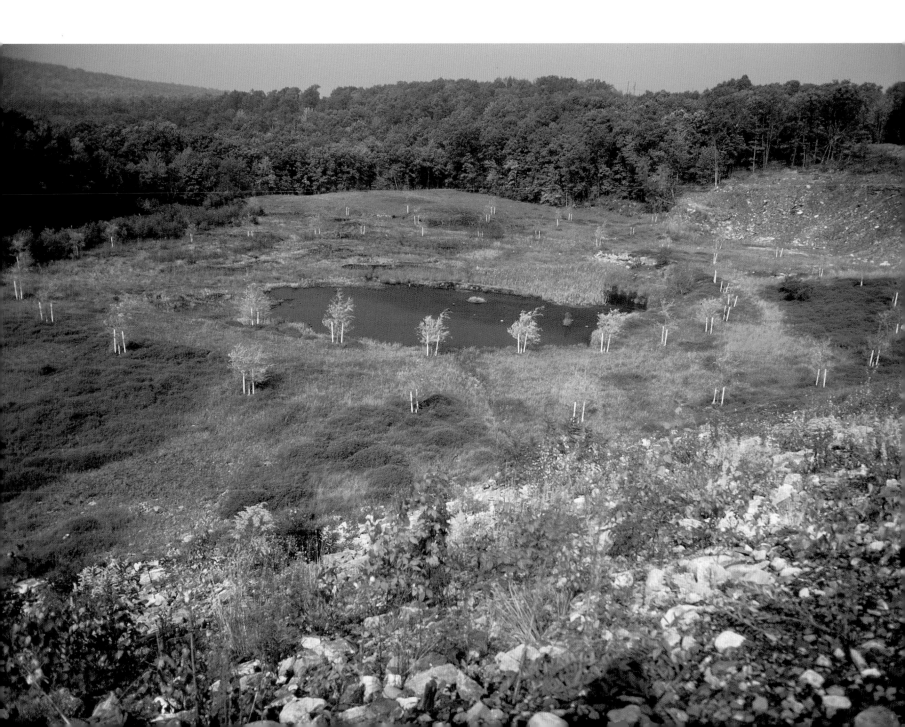

Alan <u>SONFIST</u>

Time Landscape™

1965-78

Vegetation

14 × 61 m

New York

Time Landscape™ is Sonfist's earliest
environmental narrative landscape,
started in 1965 on a plot located on the
corner of Houston and La Guardia Place
in New York City. Once an urban
wasteland, Sonfist planted this
abandoned lot covered with rubble with
forest plants indigenous to Manhattan,
and re-created the soil and rock
formations that had once existed there
before the Western settlers arrived. The
sculpture is designed to evolve
continually as the plants grow. Sonfist
explains that it is important to plant
indigenous forests, otherwise the city
will lose its heritage. This landscape
offers the viewer three natural terrains:
an open field of grasses and flowers, a
pioneer forest of birch, cedars and
flowering bush, and a mature oak forest.
Migrating birds and other small animals
make *Time Landscape*™ their home
within the city, bringing the urban
dweller back into contact with nature.

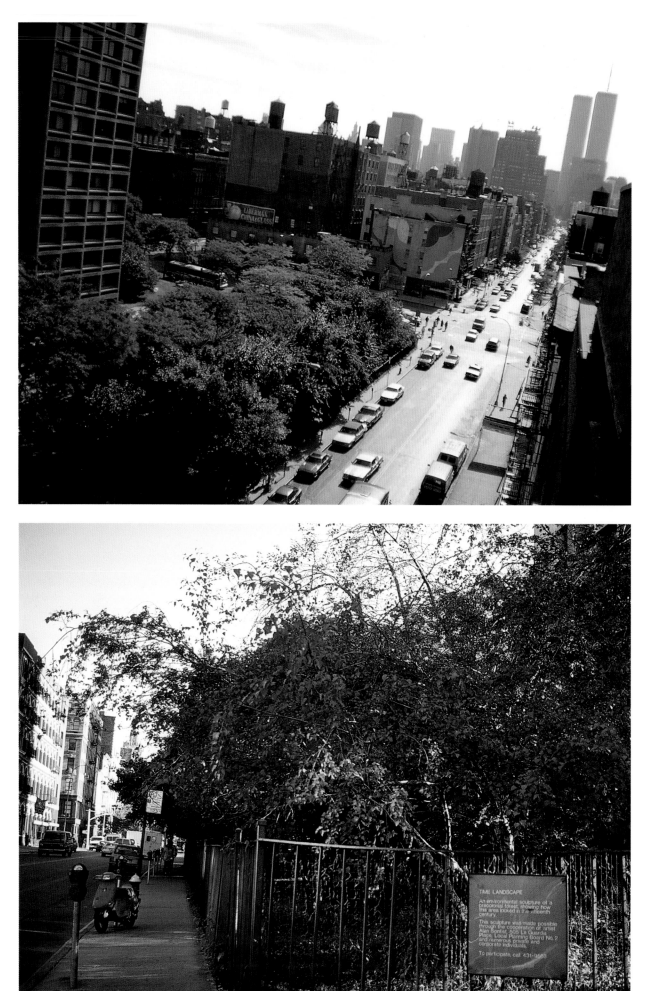

Alan <u>SONFIST</u>

Circles of Time

1986-89

Bronze, rock, plants, trees

Dimensions variable

Villa Celle, Florence

This work incorporates the metaphor of human intervention within the reclamation of the original land. The sculpture traces the use of the land from primaeval forest to the present. The centre ring, built on raised ground, is a primaeval forest. The next ring represents the first settlers who cultivated herbs for cooking and medicinal use. The third ring represents the influence of the Greeks with bronze casts made from endangered trees. The fourth ring is the Greek symbol of victory, a 9-foot (275 cm) tall laurel hedge, pierced with low passageways for entry. Next is a Roman road built of stones in the Roman style. The outermost ring integrates the sculpture with the current agricultural uses of the land. The olive trees which were set in a grid formation have been replanted in a circular formation and are still harvested. The original grasses have been replanted so that the sheep can still graze.

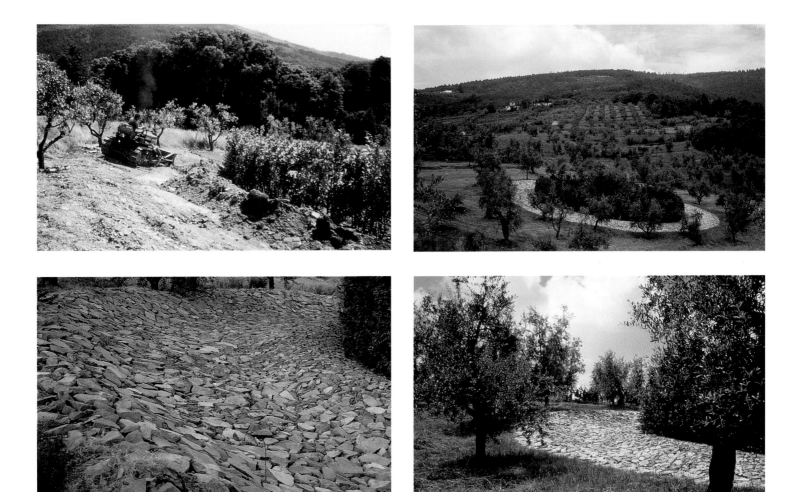

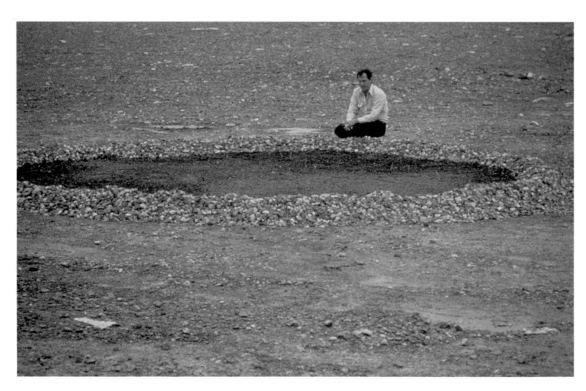

Alan <u>SONFIST</u>
Pool of Virgin Earth
1975
Earth, seeds
ø 1,525 cm
Artpark, Lewiston, New York

On a chemical waste dumping ground, Sonfist created a pool of virgin soil to catch blowing seeds from the air and begin the rebirth of the forest. Sonfist's aim was to recreate the forest that may have grown there before humankind's desecration of his environment, restoring the land to its natural state.

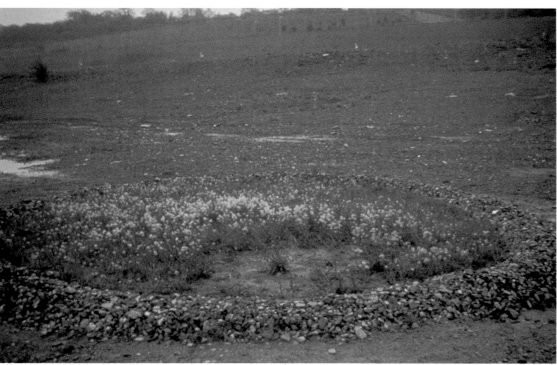

Mierle Laderman UKELES
Hartford Wash: Washing, Tracks,
Maintenance: Outside
From the 'Maintenance Art'
performance series
1973
Hartford, Connecticut

In her manifesto 'Maintenance Art'
Ukeles acknowledged the drudgery of
maintenance activities such as cleaning
and washing whilst also acknowledging
their necessity. In a series of thirteen
performances dating from 1973 to 1976,
she cleaned a SoHo street and museum
floors as well as performing all the
duties of the guards in a museum.
Similarly, Ukeles selected and perfor-
med certain activities of maintenance
which she then labelled as 'art'.

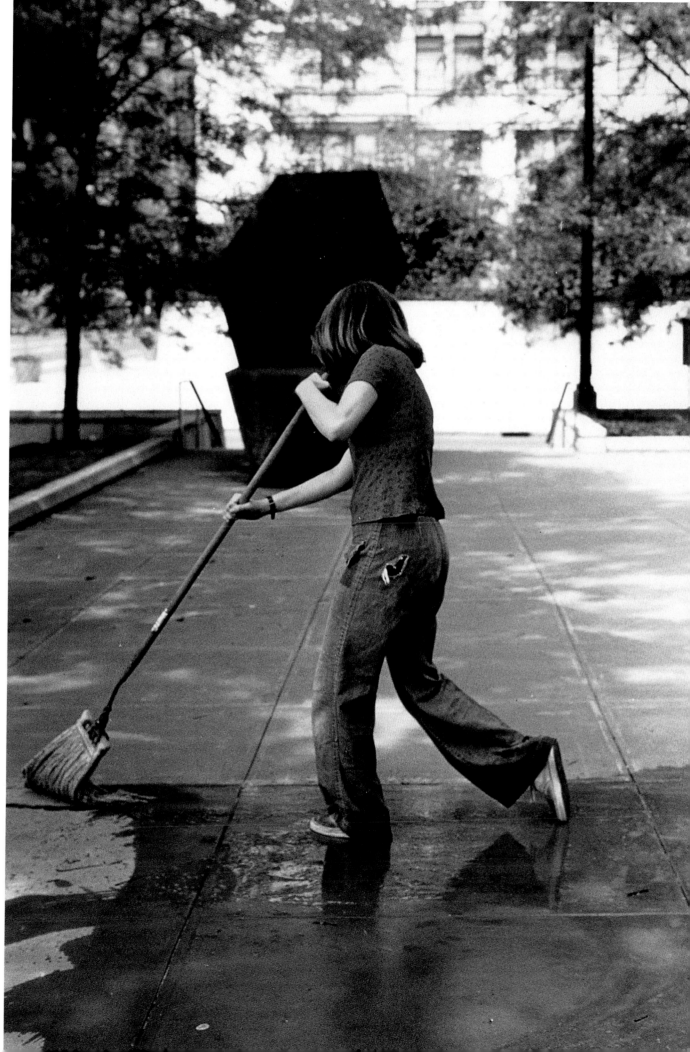

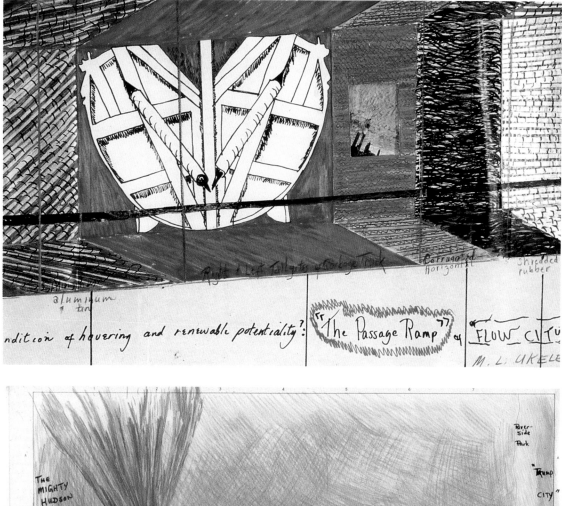

Mierle Laderman <u>UKELES</u>
Flow City
1983-90
Pencil on paper
63 × 94 cm

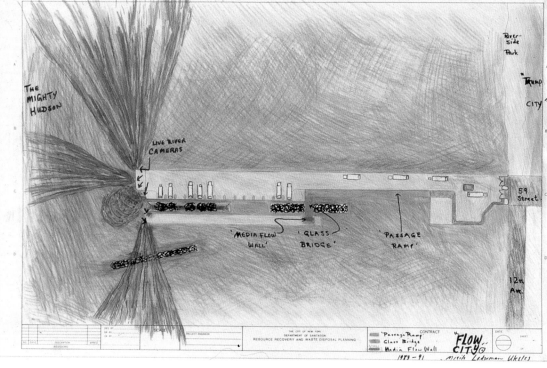

Mierle Laderman <u>UKELES</u>

Flow City

1983-90

59th Street Marine Transfer
Station, New York

Designed with engineers from Greeley
Hanson and made in collaboration with
the New York Department of Sanitation,
Flow City is installed in a garbage
recycling unit on West 59th Street and
the Hudson River in midtown
Manhattan. The work is a demonstration
of Ukeles' concern to educate the public
about its role in controlling the tide of
waste which is poured into the
environment. It involves an on-site look
at the process of disposing of waste. In
the first section, *Passage Ramp*, a 76 m-
long walkway is made of twelve
recyclable materials, including 6 m of
crushed glass and 6 m of shredded
rubber. At the top of the ramp is the
Glass Bridge which is 12 m long and 5.5
m wide. From the bridge the viewer can
watch the garbage trucks beneath them,
which are loaded in fourteen dumping
bays under the *Glass Bridge*. At the end
of the bridge is *Media Flow Wall*, a 3 ×
5.5 m-long wall of crushed glass with
twenty-four monitors set into it. The
video wall is programmed with live
cameras which are located both on and
off site. The monitors transmit three
kinds of flow-imagery: river, landfill and
recycling.

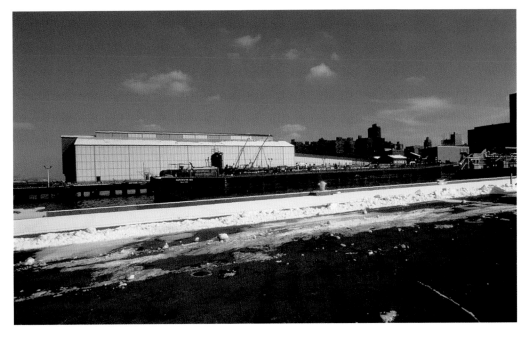

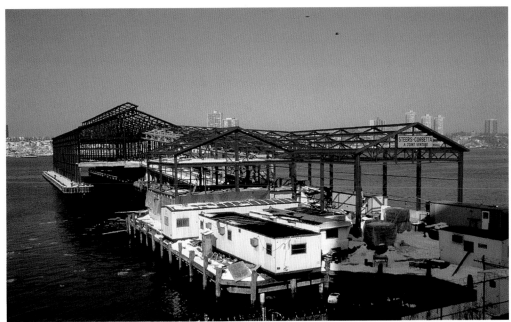

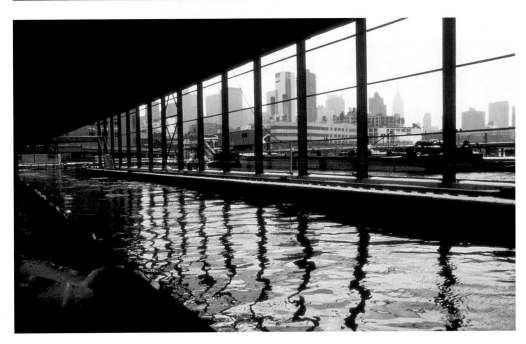

Bonnie SHERK
The Farm
1974
Animals, plants
2.2 hectares
San Francisco

Sherk's farm was one of the first ecological works to integrate both land and animals. This environmental and social artwork brought many people from different disciplines and cultures together along with plants and animals. *The Farm* involved extensive land transformation, including the integration of disparate pieces of land, all adjacent to and incorporating a major motorway interchange, into a new park. *The Farm* restored a sustainable eco-system to a previously destroyed site and provided an educational facility to increase awareness of the value and beauty of nature.

Bonnie SHERK
The Raw Egg Animal Theatre
(TREAT)
1976
Indoor installation,
San Francisco

The Raw Egg Animal Theatre (TREAT) was an area within *The Farm* specifically dedicated to education about animals. Children from over seventy-five public schools, primarily urban, visited as part of their school day and experienced both nature and art.

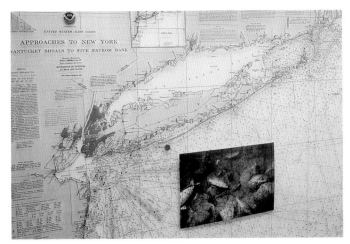

Betty <u>BEAUMONT</u>
Ocean Landmark Project
1978-80
Soundings map, collage,
photograph
Dimensions variable

This is an underwater environmental
work on the floor of the Atlantic, made of
510 tonnes of processed coal-waste, a
potential pollutant which has undergone
a planned transformation, turning it into
a flourishing ecosystem. The coal waste
now provides the site for a lush
underwater garden. 17,000 coal fly-ash
blocks were fabricated, shipped to the
ocean site (64 km from the New York
Harbor and 5 km off Fire Island National
Seashore) and laid on the continental
shelf. The *Ocean Landmark Project*
started to change at the point of
installation in 1980, and has created a
sustainable environment for marine life.
The work has also been documented as
sound, video, image and written
information.

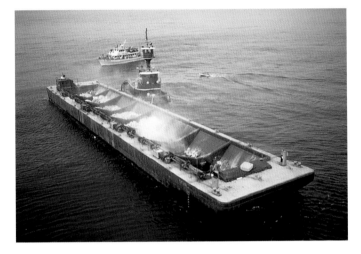

Betty <u>BEAUMONT</u>
Ocean Landmark Project: The
Object
1978-80
Model of coal fly-ash blocks
366 × 152 × 71 cm

Betty <u>BEAUMONT</u>
Ocean Landmark Project
1978-80
Drawings, video, model
Dimensions variable
Installation, The Museum of
Modern Art, New York, 1990

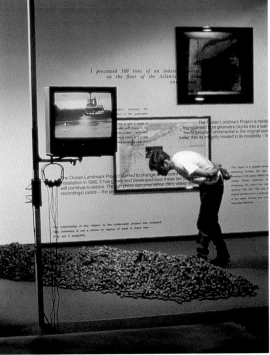

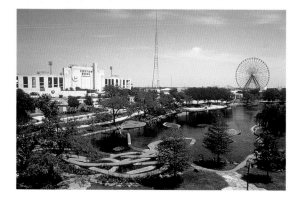

Patricia JOHANSON
Fair Park Lagoon
1981-86
Painted concrete, water, aquatic plants
Dallas, Texas

Commissioned by the Dallas Museum of Art, this project was designed to revitalize the Fair Park Lagoon. Johanson discovered that the area had once been a thriving wetland habitat. After purifying the lagoon, which was suffocated by algae, she reintroduced native plants, fish and reptiles to revitalize and balance the food chain. At either end of the Park complex groupings of painted concrete paths, bridges and benches were installed, based on the forms of the aquatic plants in the water. 'The real reason I only design parks and fountains these days is I'm sick of the whole museum/collector/auction house complex with their self-congratulatory prattle about how much they're doing for culture'. Johanson's work is an effort to reconciliate environmental art and social purpose.

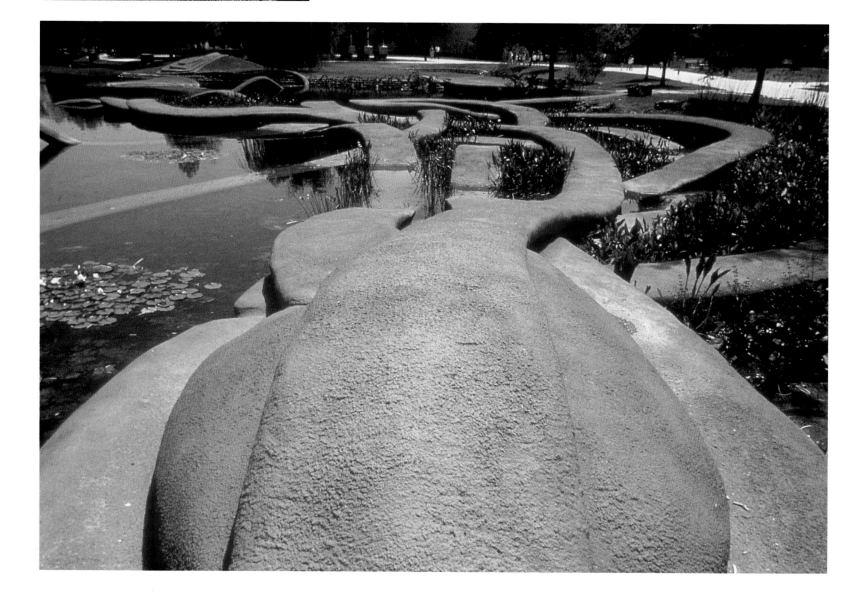

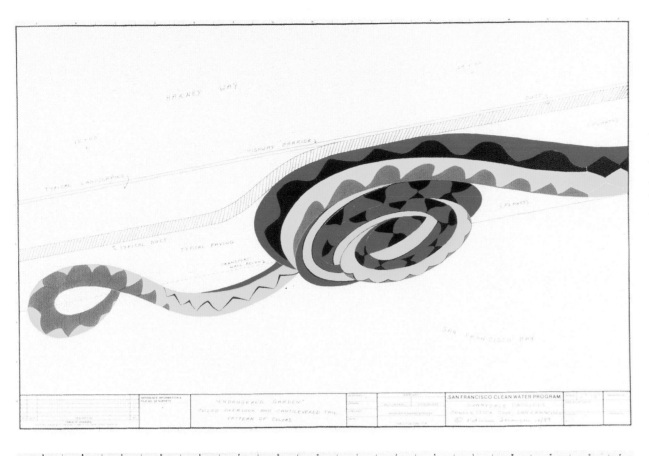

Endangered Garden, Sunnydale
Facilities, Site Plan
1988
Acrylic, ink on paper
56 × 9.5 cm
Candlestick Cove, San Francisco

A new sewer outlet was needed for the Bay Area of San Francisco, and Johanson was approached by the San Francisco Arts Trust to work on it. Johanson's role was not only to make the outlet attractive, but also to transform it into both an aesthetic and environmentally sound project. Johanson discovered that the area hosted a large number of endangered species. Many species struggling for survival could be helped by providing the appropriate habitat. Johanson's design made the site an extension of the adjacent California State Recreation Area. The endangered garter snake was selected to provide the visual form for the project. Its colours and patterns were to be translated into a series of gardens which would provide sustenance for locally threatened species.

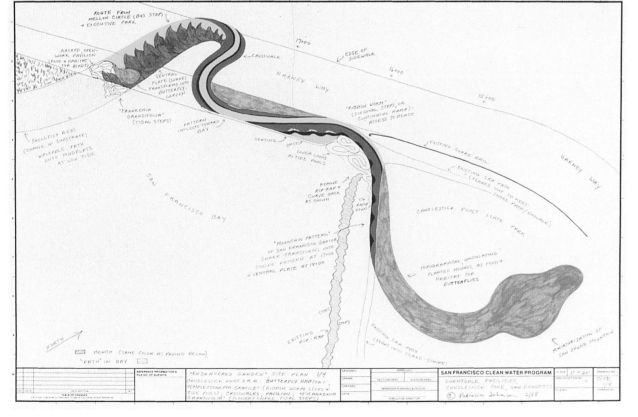

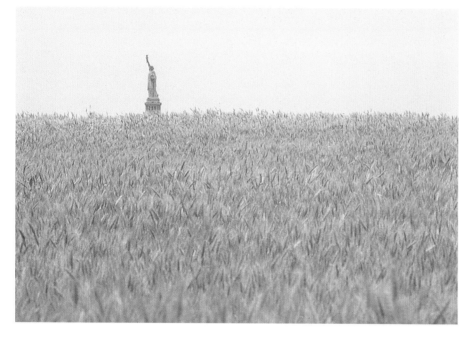

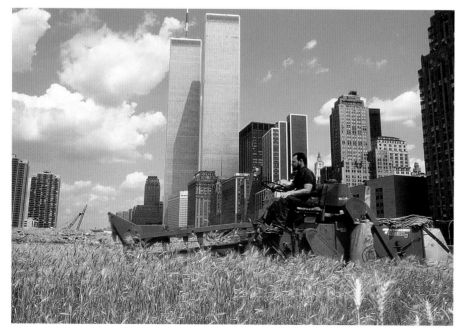

Agnes <u>DENES</u>
Wheatfield - A Confrontation.
Summer 1982
Wheat
2 acres (0.8 hectares)
Battery Park Landfill, Manhattan

After months of preparations, in May 1982 a 2-acre (0.8 hectare) wheatfield was planted on a landfill in lower Manhattan, two blocks from Wall Street and the World Trade Center, facing the Statue of Liberty. Two-hundred truckloads of dirt were brought in and 285 furrows were dug by hand and cleared of rocks and garbage. The seeds were sown by hand and the furrows covered with soil. The field was maintained for four months; an irrigation system was set up and the field was weeded, cleared of wheat smut, fertilized and sprayed against mildew fungus. The crop was harvested on 16 August and yielded almost 1,000 lbs of healthy, golden wheat.

In planting and harvesting a wheat crop in the midst of an urban environment, Denes called attention to human values, misplaced priorities and ecological concerns. The paradox of growing wheat on an area of land worth $4.5 billion, called attention to the hunger and mismanagement of resources which afflicts some parts of the world whilst others thrive. Some of the harvested grain travelled around the world in an exhibition entitled 'The International Art Show for the End of World Hunger', organized by the Minnesota Museum of Art (1987-90).

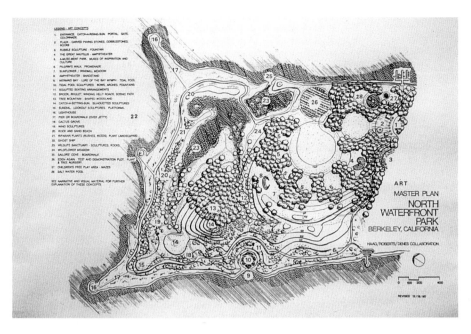

Agnes DENES

North Waterfront Park Masterplan

1988

Ink, charcoal on paper

74 × 56 cm

Wildlife Sanctury, Berkeley, California

This shows an intermediate plan developed in collaboration with two landscape architects, R. Haag and J. Roberts. The masterplan entailed the conversion of a 97-acre (39-hectare) landfill, surrounded by water on three sides in the San Francisco Bay, into an oasis for people and nature. The final plan involves many elements, including a wildflower meadow, a sunflower field, wooded hills, petroglyphs carved into the earth and stone, amphitheatres and stone terraces, a 12-acre (5-hectare) wildlife sanctuary consisting of a freshwater lake and brackish marsh, tidal pools with sculptural forms and water catchments. Two lighthouses were designed, one to burn off methane produced by the landfill, the other to collect sunlight which is emitted at night. Denes' work restores an obsolete site (an island of garbage) into a rich environment, preserving wildlife and creating a place where nature can be experienced and enjoyed.

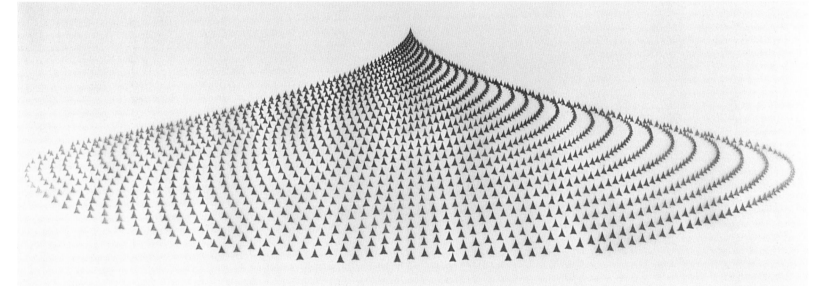

Agnes DENES

Tree Mountain - A Living Time Capsule

10,000 Trees, 10,000 People, 400 Years

1982

Metalic ink on mylak

86 × 244 cm

Ylöjärvi, Finland

A huge man-made mountain measuring 420 m long, 270 m wide, 28 m high and elliptical in shape was planted with 10,000 trees by 10,000 people from all over the world at Pinziö gravel pits near Ylöjärvi, Finland, as part of a massive earthwork and land reclamation project. The project was officially announced by the Finnish government at the Earth Summit in Rio de Janeiro on Earth Environment Day, 5 June 1992, as Finland's contribution to help alleviate the world's ecological stress. Sponsored by the United Nations Environmental Program and the Finnish Ministry of the Environment, *Tree Mountain* is protected land to be maintained for four centuries, eventually creating a real (virgin) forest. The trees are planted in an intricate mathematical pattern derived from a combination of the golden section and pineapple/sunflower patterns. *Tree Mountain* is the largest monument on earth that is international in scope, unparalleled in duration, and not dedicated to the human ego, but to benefit furture generations with a meaningful legacy. *Tree Mountain*, conceived in 1982, affirms humanity's commitment to the future as well as to the ecological, social and cultural life on the planet. It is designed to unite the human intellect with the majesty of nature.

The meadow
1986-present
4,000 m²
Eschenau, Germany

herman de vries' project 'wiese' (meadow) is situated in the countryside near Eschenau at the edge of the Steigerwald. The meadow has been created as an alternative to the heavily industrialized agricultural landscape surrounding it. 'Decultivation for renaturalization' is the concept by which herman de vries has approached nature both as an artist and a scientist. His activities involve collecting and classifying the material he has found and the direct application of conservation techniques. Through the re-introduction of wild plants into the meadow, de vries has created ideal living conditions for a large number of insects, butterflies and beetles that have now returned to the area.

Joseph <u>BEUYS</u>
7,000 Oaks
1982
7,000 granite blocks, 7,000 holm oak trees
Action
Documenta 7, Friedrichsplatz, Kassel

Beuys' planting of 7,000 oak trees throughout the city of Kassel for Documenta 7 embodied a wide concept of ecology which grows with time. 7,000 trees were planted next to a basalt stone marker. Beuys stated that the project is a 'movement of the human capacity towards a new concept of art, in symbolic communication with nature'. The first tree was planted in 1982; the last tree was planted eighteen months after Beuys' death at the opening of Documenta 8 in 1987 by his son Wenzel Beuys.
'I believe that planting these oaks is necessary not only in biospheric terms, that is to say, in the context of matter and ecology, but in that it will raise ecological consciousness – raise it increasingly, in the course of years to come, because we shall never stop planting.'
– Joseph Beuys, quoted by Johannes Stüttgen, 1982

Joseph <u>BEUYS</u>
7,000 Oaks
1982
Basalt stone markers
Friedrichplatz, Kassel

Between the opening of Documenta 7 in 1982 and Documenta 8 in 1987, the pile of basalt markers gradually dwindled until the last tree was planted on 8 June 1987.

Joseph <u>BEUYS</u>
7,000 Oaks
1996
Tree Planting Ceremony
Dia Center for the Arts, New York

Dia Center for the Arts financed the initial *7,000 Oaks* in Kassel. They have continued the project in New York with the planting of several different kind of trees, each paired with a basalt stone. The work embodies Beuys' utopian idea of social sculpture, designed to effect a revolution in human consciousness. The intention of such a tree-planting event is to point up the transformation of all life, of society and of the whole ecological system.

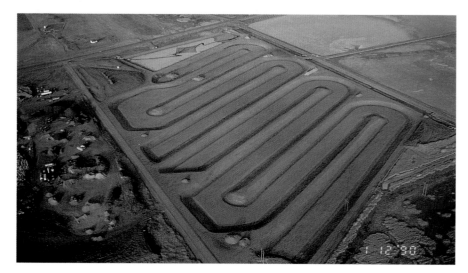

Viet NGO
Devil's Lake Wastewater Treatment
Plant
1990
Water, aquatic plants
20 hectares
Devil's Lake, North Dakota

Ngo describes his work as 'a fusion of engineering, architectural planning and art'. He has created a system for treating waste waters using natural biological means instead of mechanical or chemical processes. This system, which he has called the Lemna System, relies on floating plants which can be used throughout the world – they thrive anywhere, from cold climates to the desert. The plants grow very fast in specially designed ponds to treat waste to a very fine degree.

The 20-hectare waste-water treatment plant at Devil's Lake is situated in a former wetland environment. The Lemna facility consists of nine serpentine channels which remove harmful phosphorus, nitrogen and algae before releasing the treated water into one bay of Devil's Lake. The harvested plants are used as an organic fertilizer. School children are taken on tours to learn about biology, the environment and its preservation.

Buster SIMPSON
The Hudson Headwaters Purge – 'Anti-acid Treatment'
1991
Soft limestone disks
h. 8 cm each
ø 61 cm each
Headwaters of the Hudson River, Lake Placid, New York

The installation *Hudson Headwaters Purge* is part of a continuing series, dating back to 1983, which illustrates Simpson's concern with the damage to water and wildlife resulting from acid rain. Numerous disks of soft chalk limestone measuring 61 cm in diameter by 8 cm thick have been dropped into the Hudson River. The limestone neutralizes or 'sweetens' acidic waters for a limited time. The process of adding limestone to acidic rivers is now a standard practice with environmental agencies. Simpson himself wades into the water to place the disks, a gesture reminiscent of Native American ceremonial practices. Simpson's work attempts to revive ailing waters through chemistry and art.

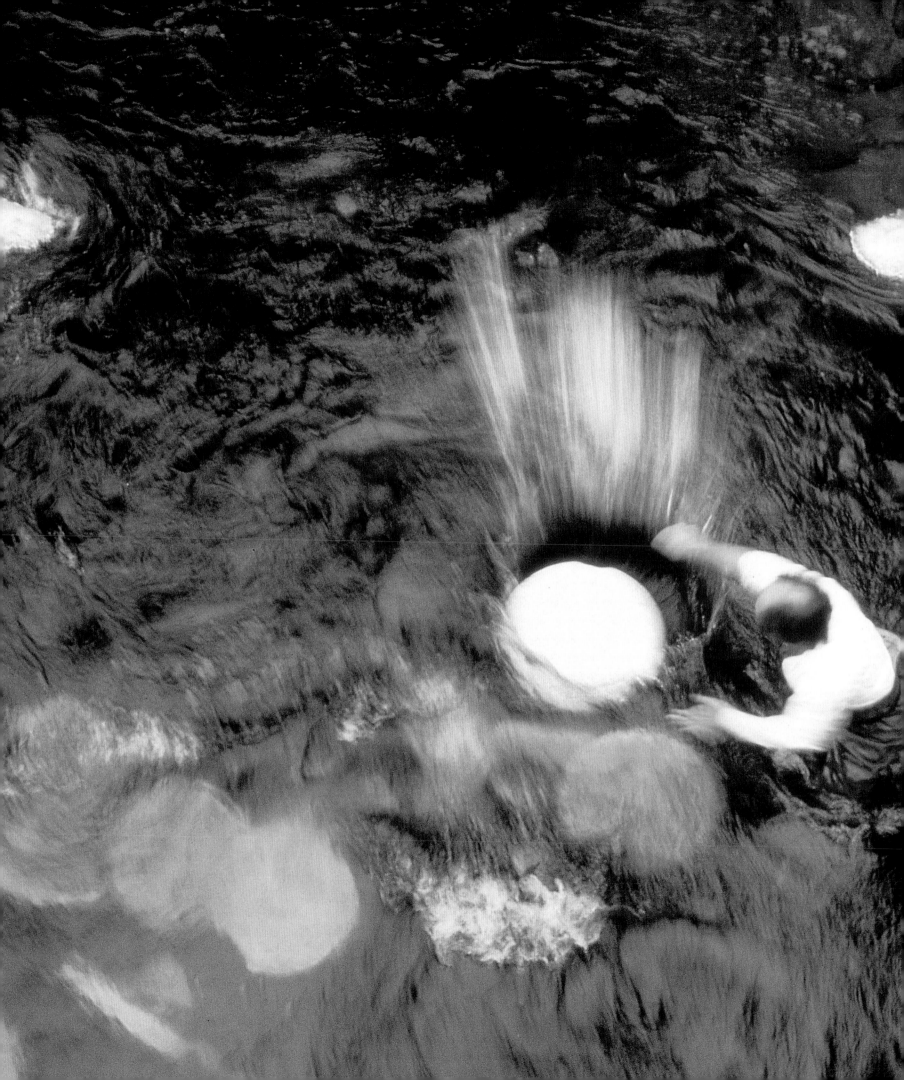

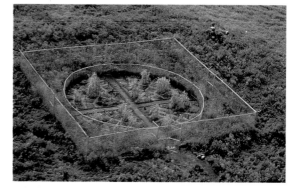

Mel CHIN
Revival Field, Pig's Eye Landfill
1990-93
Plants, industrial fencing,
hazardous waste landfill
Approx. 3 × 18 × 18 m
St. Paul, Minnesota

This work was created as an exploration of the use of plants as remediation tools. An 18 m² section of landfill contaminated by heavy metals such as cadmium was planted in a circular pattern with species specifically chosen for their ability to remediate soil. The circle was subdivided by intersecting paths which separated different plant varieties. Six types of plants, two pH and two fertilizer tests were used in each quadrant. The circular area, planted with detoxifying weeds, served as the control test site. The square, planted with local grasses, served as the control site.

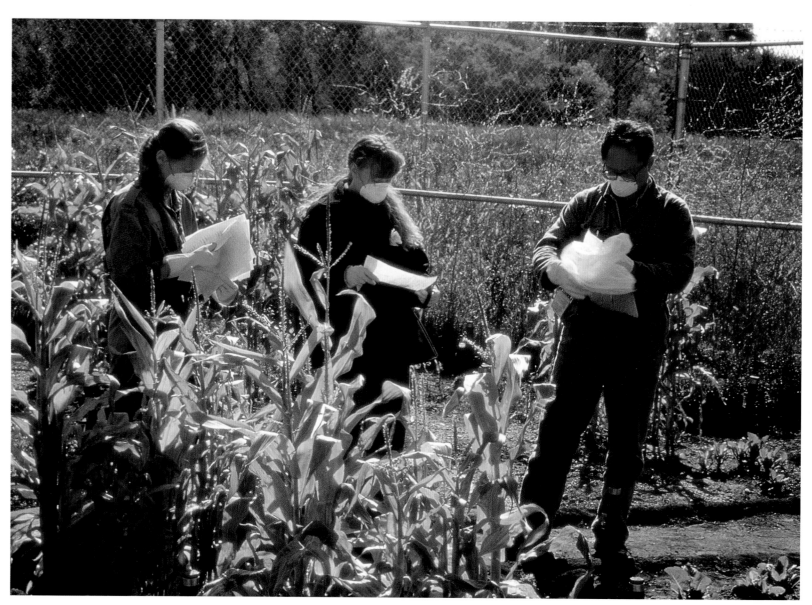

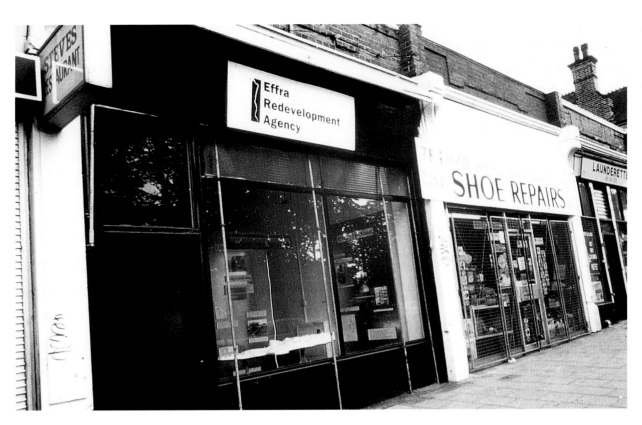

Effra Redevelopment Agency
1992
London

This was one of a series of projects in which London was looked at as a tidal basin. A proposal was made to redevelop the River Effra in Brixton which had been buried since the 1880s. The project was carried out as a marketing campaign: public meetings were held to solicit local opinion, an architect built a model of the proposed redevelopment, press releases were sent out and press coverage was obtained. Once public attention had been attracted to the question of restoring the site, the Effra Redevelopment Agency stopped all work and was dismantled.

PLATFORM
Delta
1993
Bronze bell, stone, micro turbine
London

At Bell Lane Creek, where the River Wandle meets the Thames, a bronze bell has been built onto the sluice gate. This rings with the movement of the tides. The names of animals which once inhabited the Wandle have been carved into the sluice structure. A micro-hydro turbine generates energy from the Wandle, which lights the assembly hall of a nearby school. The area, now an industrial wasteland, was designated a delta by PLATFORM for this project. PLATFORM are concerned with democracy and social power as much as with environmental issues. As a result of PLATFORM's activities, a group called 'The Wonderful Delta Network' has been formed who are active in trying to restore the area.

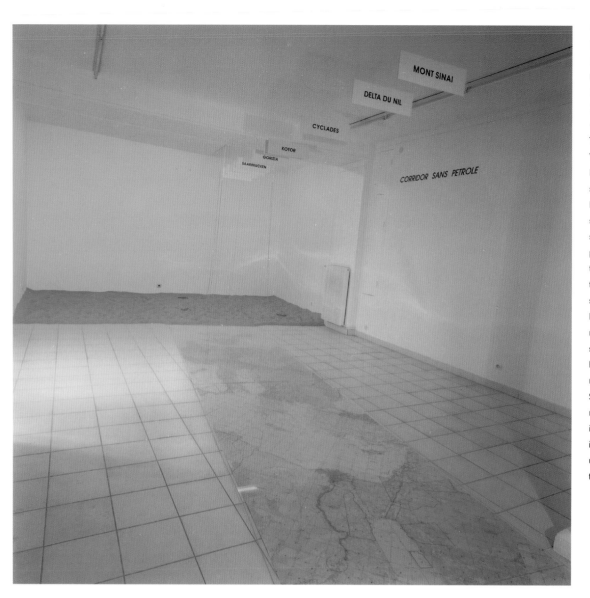

Peter FEND
Ocean Earth: Oil Free Corridor
1993
Mixed media
Dimensions variable
Installation, FRAC Poitou -
Charentes

This work was originally shown at the Venice Biennale, 1993. The Adriatic and Red Seas are suggested as possible sites for the development of Ocean Earth's Giant Algae System. These systems, which can be grown in the seas, provide a renewable and non-polluting energy source as an alternative to petroleum. The first contracted sites in this oil-free corridor ran along an axis stretching from Iceland, through the North Sea, to former Yugoslavia's mountains, including significant sites such as Mount Athos, Mount Sinai and Mecca. The charts on the floor show a marketing territory for the Giant Algae System. This system challenges the mineral fuels industry, as the aim is to introduce a global algae production industry which will make oil and gas unprofitable and – in view of the pollution they cause – unappealing.

Peter FEND
Offshore Soil Rig
1993
Fibreglass, nylon fabric,
cable, aluminium
Installation, FRAC Poitou-
Charentes

Peter FEND
Offshore Soil Rig (detail)
1993
Fibreglass, nylon fabric, cable,
aluminium
Installation, FRAC Poitou-
Charentes

Designed with naval architect Marc Lombard, this is a 1:15 scale model of an offshore giant algae system Clear Air Rig or Offshore Soil Rig designed to produce energy without any polluting greenhouse effect by-products.

Since this model was exhibited in 1993, a much more technically developed model has been conceived. Parts of the structure have been built and are ready for sea trials. A contract has been signed to allow production.

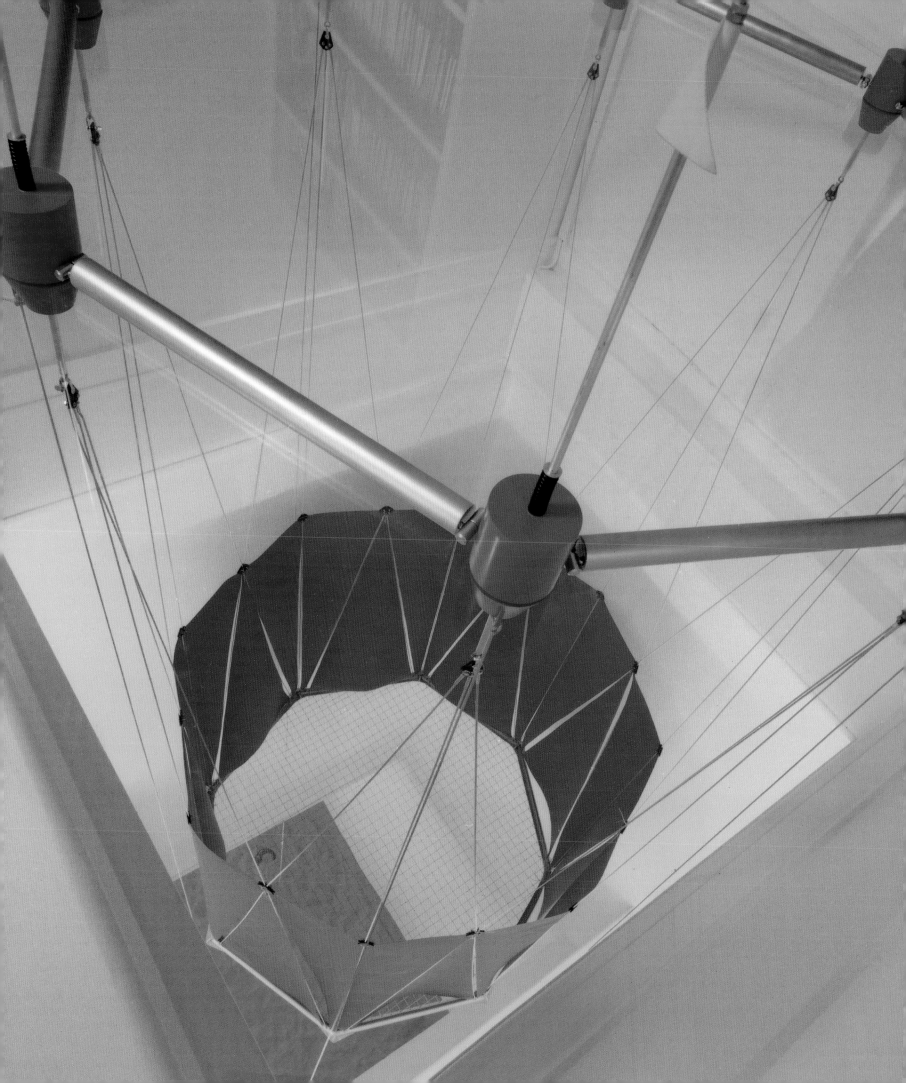

Peter FEND
Ocean Earth: Site Simulator for
Tivat Bay
1991
Installation

Tivat Bay is a semi-enclosed saltwater basin in Montenegro. Ocean Earth was responsible for surveying the basin and determining where and how to increase its monitored bioproductivity and finding optimal sites for biological harvesting. The objective is to allow an urban settlement with virtually no pollution.

Peter FEND
Ocean Earth: Processed Imagery
from AVHRR of the North Sea
15-16 May, 1988

These satellite images, taken over twenty-four hours, show an explosion of algae bloom from the small point where it began in Anholt, to nearly all the waters surrounding Denmark. The existence of the wild blooms of algae are attributed to excessive fertilizer and pollutant runoff. The green colour in the water indicated the increased temperature of the sea-surface which is about 6– 8º warmer than normal.

In spring 1988 the algae bloom wiped out millions of fish and is thought to have contributed to the immune-system breakdowns of sea mammals. The question of 'toxic' algae had confused scientists for some time, since algae alone could not be responsible for the devastating effects on aquatic life.

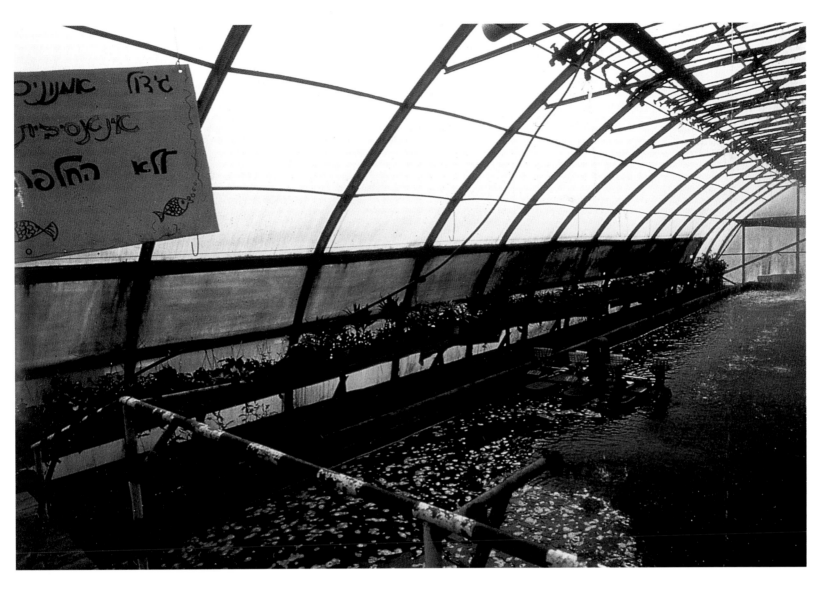

Avital GEVA
Greenhouse
1977-96
Metal, plastic, plants, fish, water, sun, soil
Ein-Shemer, Israel

Geva sees this work primarily as an educational tool and a system of renewal. The *Greenhouse* is an experimental project in a socio-agricultural domain. Geva constructed the *Greenhouse* and set up a teaching and experimental programme himself, modelling the system on cooperation, investigation, examination and observation. The *Greenhouse* is meant to be based on an economic balance and is staffed by workers on the Ein-Shemer kibbutz. Geva claims that art is wilting because it has not connected itself to real life. He is not interested in art in museums. 'I see art as a series of experiments. On the basis of these experiments people learn art … I don't care what they call it, art, or anti-art. The problem is the society we live in.'
– Avital Geval, 'On the Greenhouse', 1993

IMAGINING

The artists in this section make works that take the land not as physical matter, but as metaphor or signifier. They understand it as a concept, as an optical construction or linguistic elaboration that may take the form of a diagram, a sentence or a photograph. Forms of measurement such as maps and place names are deconstructed and played with as theoretical constructs, arbitrary and contingent acts of interpretation. Some works here evoke the landscape architects of the formal gardens of the past in which planting, statuary and architectural follies were all part of a rich iconography symbolizing culture, civilization and mortality. Contemporary artists similarly regard the environment as a historical narrative which provides a repertoire of potent symbols that can also be deployed to describe contemporary society.

Ian Hamilton FINLAY
Signature of the Artist Hodler
1987
Inscribed stone
Furka Pass, Switzerland

Ian Hamilton Finlay carved an enlarged representation of Hodler's signature on a stone on the Furka Pass in Switzerland. Ferdinand Hodler was a Swiss painter famous for his landscape paintings, to which this photograph bears a striking resemblance.

Ian Hamilton FINLAY
View of the lochan at Little Sparta
Lanarkshire, Scotland

SITE SCULPTURE PROJECT 42° PARALLEL PIECE
14 LOCATIONS ('A' THROUGH 'N') ARE TOWNS EXISTING EITHER EXACTLY
OR APPROXIMATELY ON THE 42° PARALLEL IN THE UNITED STATES.
LOCATIONS HAVE BEEN MARKED BY THE EXCHANGE OF CERTIFIED
POSTAL RECEIPTS SENT FROM AND RETURNED TO 'A' –TRURO,
MASSACHUSETTS. AUGUST- SEPTEMBER 1968

Left and opposite
Douglas HUEBLER
42 Degree Parallel Piece
1968
Map documentation
Dimensions variable

On a map of the US, Conceptual Artist Douglas Huebler marked fourteen cities and towns situated approximately along the 42nd parallel. From Truro, Massachusetts, he mailed fourteen letters to each one of these cities on the same day. The letters, having no specific destination, were subsequently mailed back to Huebler. The work consisted both of Huebler's thought and the action of sending the letters, and of the postal receipts which constituted the exhibited work together with a map of the letters' path. The line of the 42nd parallel and the US postal system became temporary vehicles of time and distance, whilst the receipts, removed from their static administrative existence, acquired a dynamic and historic weight. The work acts as a description of movement through space. It also serves to re-inject art ideas into the fabric of ordinary existence by using the postal service as the tool to carry out the work within controlled parameters established by the artist.

Map to not indicate: CANADA, JAMES BAY, ONTARIO, QUEBEC, ST. LAWRENCE RIVER, NEW BRUNSWICK, MANITOBA, AKIMISKI ISLAND, LAKE WINNIPEG, LAKE OF THE WOODS, LAKE NIPIGON, LAKE SUPERIOR, LAKE HURON, LAKE MICHIGAN, LAKE ONTARIO, LAKE ERIE, MAINE, NEW HAMPSHIRE, MASSACHUSETTS, VERMONT, CONNECTICUT, RHODE ISLAND, NEW YORK, NEW JERSEY, PENNSYLVANIA, DELAWARE, MARYLAND, WEST VIRGINIA, VIRGINIA, OHIO, MICHIGAN, WISCONSIN, MINNESOTA, EASTERN BORDERS OF NORTH DAKOTA, SOUTH DAKOTA, NEBRASKA, KANSAS, OKLAHOMA, TEXAS, MISSOURI, ILLINOIS, INDIANA, TENNESSEE, ARKANSAS, LOUISIANA, MISSISSIPPI, ALABAMA, GEORGIA, NORTH CAROLINA, SOUTH CAROLINA, FLORIDA, CUBA, BAHAMAS, ATLANTIC OCEAN, ANDROS ISLANDS, GULF OF MEXICO, STRAITS OF FLORIDA.

ART & LANGUAGE
(Terry ATKINSON, Michael BALDWIN)
Map
1967
Ink on paper
Dimensions variable

This work is concerned with the disjunction between maps as visual information systems and the physical reality of what they are supposed to represent. The *Map* works of Atkinson and Baldwin also explore the correlation – or rather the impossibility of precise correlation – between the representation of a three-dimensional object, the earth, and a two-dimensional surface, the map. As the artists explain, 'Strictly speaking, the map cannot achieve what it says it does because the surface of the Pacific Ocean is not completely flat – the waves "have height" and are constantly in motion.'
– Art & Language, 'Some Notes', 1967

178 John BALDESSARI

The California Map Project,

Part 1: CALIFORNIA

1969

11 type-R prints and text

20 × 25 cm each

Baldessari describes the work as
follows: 'Photographs of letters that spell
CALIFORNIA and of the map used for
locating the site for each letter. The
letters vary in scale from one foot to
approximately one hundred feet, and in
materials used. The letters are located
as near as possible within the area
occupied by the letters on the map. The
idea was to see the landscape as a map
and to actually execute each letter and
symbol of the map employed on the
corresponding part of the earth. It was an
attempt to make the real world match a
map, to impose a language on nature
and vice-versa.'

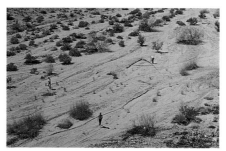

IMAGINING

Gordon MATTA-CLARK
Realty Positions: Fake Estates
1973
Dimensions variable
New York City

In 1973 Matta-Clark purchased thirteen unused areas of land that were left over when certain districts in the borough of Queens were re-mapped and property lines re-drawn. The plots bought by Matta-Clark for between $25 and $75 each are often isolated and irregular sites, sometimes only 2 × 3 feet (61 × 91.5 cm), located where other properties meet in a block. Although the sites could not be occupied, the work confirms the American Dream that everyone can become a landowner.

Jan <u>DIBBETS</u>
Perspective Corrections (Square
with Two Diagonals)
1968
Black and white photograph on
photographic canvas
120 × 120 cm

Jan Dibbets' *Perspective Corrections*
experiment with the optical construction
of space inherited from the Renaissance,
usually using string stretched over the
ground to form squares or rectangles.
The principle of these works is to
invalidate the illusion of perspective
created by photographic construction,
while creating another illusion, which
suggests that the square visible in the
photograph is not in the photograph but
superimposed on it. The correction of
one illusion produces another illusion so
that the viewer is led to deconstruct the
understanding of pictorial perspective.

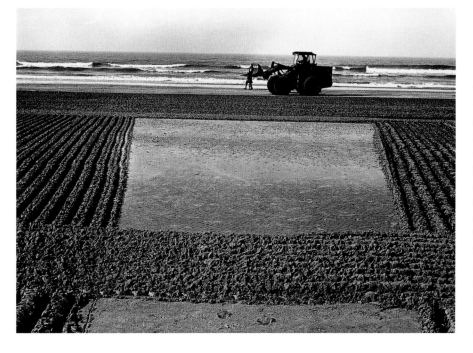

Jan <u>DIBBETS</u>
12 Hours Tide Objects with
Correction of Perspective
1969
Film for television

This work was made for Gerry Schum's
'Land Art' exhibition for television,
broadcast in Germany on 15 April 1969.
Dibbets' described it, 'The project will be
made at the beach when the water is low.
It will be wiped out when the water is
coming up again. It takes about eight
hours (flood-tide). The whole thing is
specifically constructed for TV. So during
the time at which people are looking at
this project on TV, they will have an
original artwork by Dibbets in their
room. When it is finished, the work of art
no longer exists.'
– Jan Dibbets, *Land Art*, exhibition
catalogue, 1969

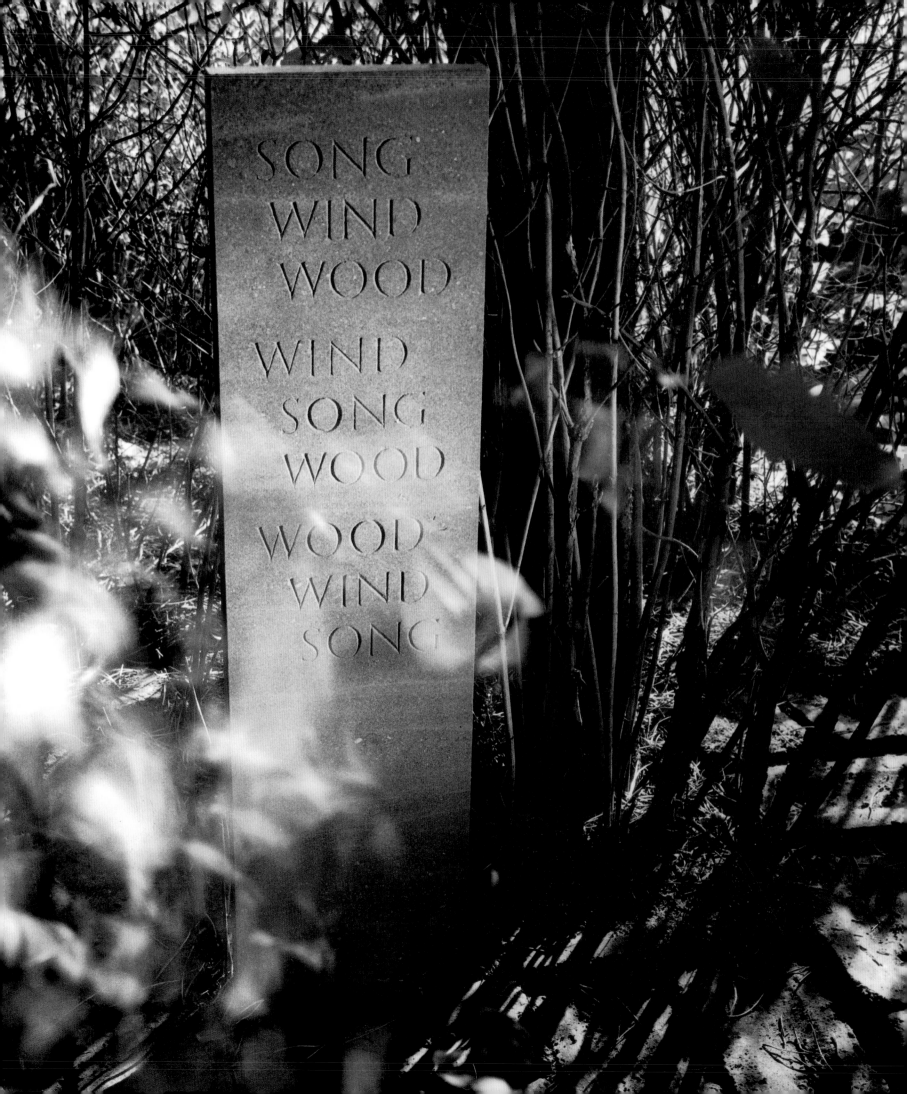

Ian Hamilton <u>FINLAY</u>
Woodwind Song
1968
Slate
Little Sparta, Lanarkshire,
Scotland

This is a slate stele bearing three
different sequences of the three words
'wood wind song'. It stands in a grove
of pines which 'sing' when the wind
blows through them.

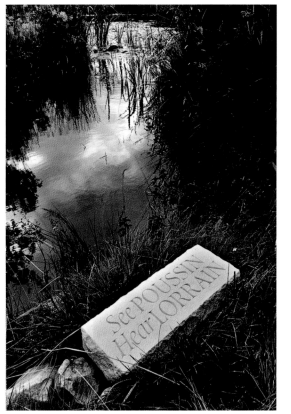

Ian Hamilton <u>FINLAY</u>
See Poussin, Hear Lorrain
1975
Stone
Little Sparta, Lanarkshire,
Scotland

Finlay's garden at Little Sparta makes
clear his veneration of the picturesque.
In this garden Finlay aspires to a nature
improved by the intellect rather than left
untouched. In this he reveals a close link
with the French seventeenth-century
landscape painter Nicolas Poussin, who
organized nature in his paintings with
great precision in order to present it as
perfect. Where Poussin's work reveals a
clarity of visual and intellectual purpose,
French seventeenth-century Landscape
painter Claude Lorrain's approach to
landscape was more resonant and
atmospheric. Finlay's inscription, on a
stone beside a pond, highlights the
counterpoint between Poussin's rigour
and Claude's more romantic approach to
nature. This work was made in
collaboration with John Andrew.

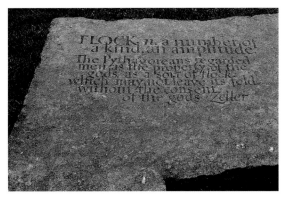

Ian Hamilton <u>FINLAY</u>
Flock
1991
Stone, lawn
Stockwood Park, Luton

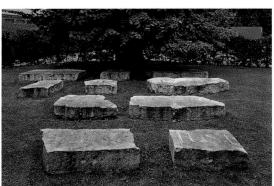

Ian Hamilton <u>FINLAY</u>
The Present Order
1983
Stone
Little Sparta, Lanarkshire,
Scotland

The words carved on these stones are
taken from a statement made by St. Just
during the French Revolution and read
'The Present Order is the Disorder of the
Future'.

Alighiero BOETTI

The Thousand Longest Rivers in the World

1979

Silk embroidery, cloth

280 × 460 cm

Drawing on a diverse range of resources, Boetti looked at the process of classifying rivers and the status of this information. The elusive nature of water, the difficulty of identifying their source and the linguistic problems connected with their identity all raise doubts as to the classifying and naming methods applied. Man's mapping of nature, the attempt to pin it down as something fixed, becomes provisional and illusory.

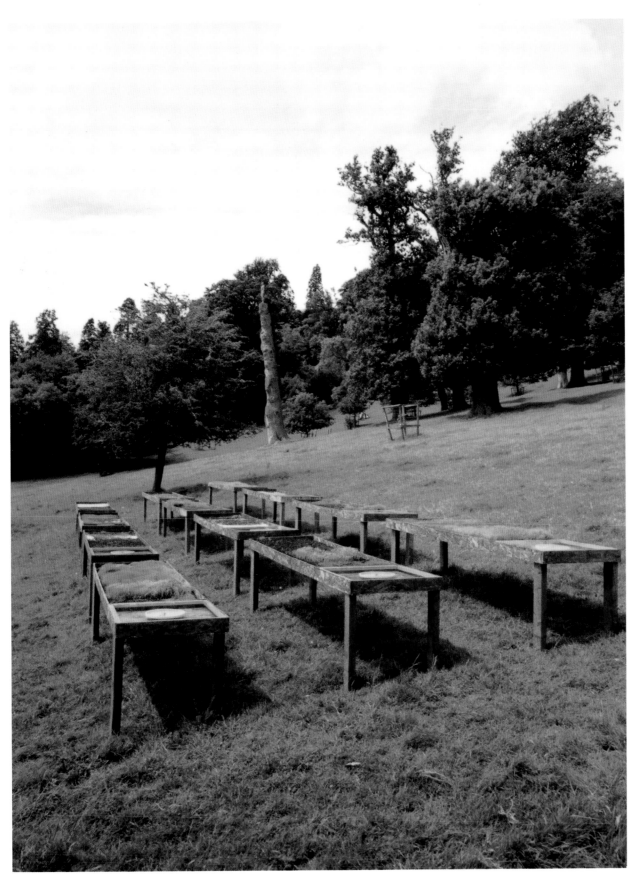

William <u>FURLONG</u>

Time Garden: HA HA
1993
Imported grasses, soil samples
from different countries, clocks,
wooden trays
12 units, 61 × 244 cm each
Killerton Park, Devon

The work is structured according to twelve of the world's time zones. It is made up of twelve trays planted with grass seeds from one of twelve global time zones. The composition of the growing medium in each of the trays also corresponds to that found in one of the zones. At the end of each tray, a clock is set to a one-hour time difference, thus creating a chronological atlas. The trays were installed as low tables on the wind-swept approach to Killerton House, Devon, during the months from June to October. The grasses grew unevenly.

The work explores the idea of mapping the world through vertical divisions, along lines of latitude, rather than according to land mass. The uneven growth of the grasses from different regions of the world, placed within the fertile and productive environments of the park area, are a reminder of locations around the world where human survival and existence depend on fragile and often hostile socio-ecological balances.

Lothar <u>BAUMGARTEN</u>
Theatrum Botanicum
1993–94
Trees, plants, flowers, stone
Fondation Cartier, Paris

The plan of the garden is based on geometric forms: a rectangle, a circle, an oval and a triangle, each figure embedded in the other. A vast isosceles triangle appears to contain all the others, and particularly the rectangle traced by the French architect Jean Nouvel's glass building. Baumgarten has created different types of landscape in different areas of the garden, ranging from a formal seating area to plots of wild plants. Moving through the garden the viewer experiences different environments within an urban setting.

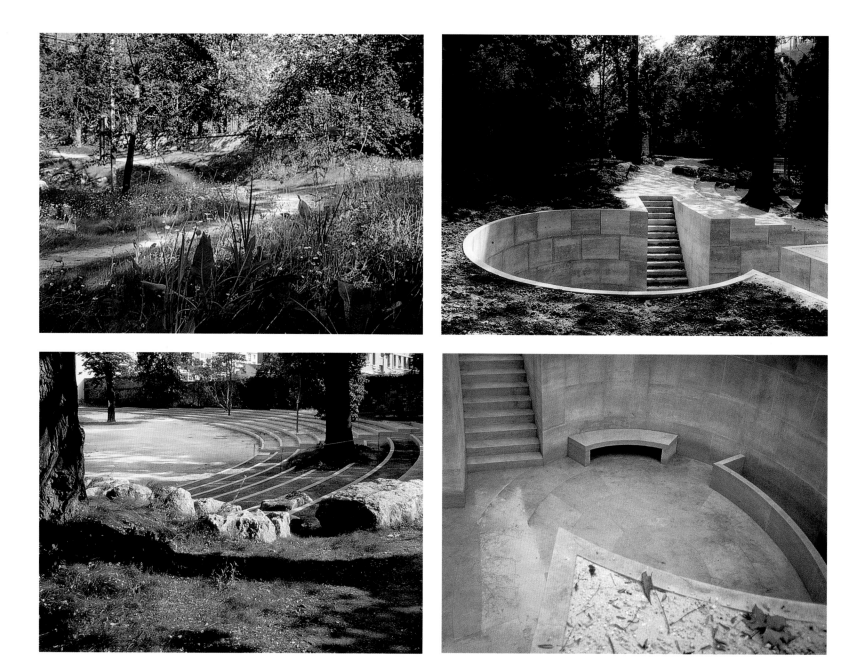

Christian Philipp <u>MÜLLER</u>
A Balancing Act
1997
Wood, brass, video display, documentation
Dimensions variable
Museum Fridericianum, Documenta X, Kassel

Müller's installation is built around an open window of the Museum Fridericianum, which reveals a bird's eye view of the Friedrichsplatz. With the construction of an underground car park, the permanent works by De Maria (*Vertical Earth Kilometre*, Documenta 6, 1977) and Beuys (*7,000 Oaks*, Documenta 7, 1982) have now been displaced from their central position in the square. Müller exhibits documentation relating to the funding of these two earlier sculptures. Alongside this documentation is a 6 m-long balancing rod on a sculptural base, which is constructed half in brass, half in oak (a reference to De Maria's vertical brass rod and Beuys' oak trees). Müller has also embedded a video screen in the wall of the Fridericianum which records a performance before the opening of Documenta X, in which Müller, with the balancing rod in hand, walked repeatedly between Beuys' trees and De Maria's sculpture. His action traces a very specific line between the two sculptures, although they were not made in relation to one another. Müller's emphatic connection of the two works underlines that the new symmetrical design of the square completely ignores the presence of the two sculptures.

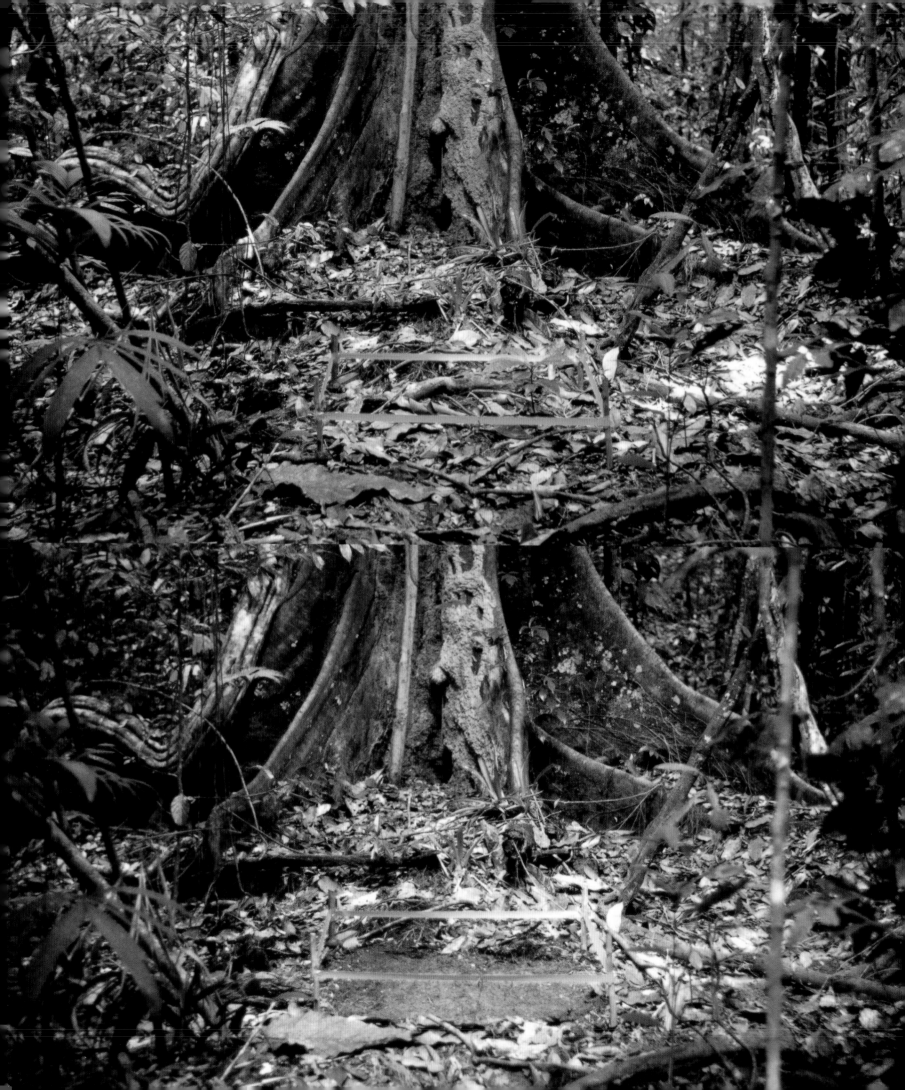

Mark DION
A Meter of Jungle (detail)
1992
Jungle floor, debris
1 × 1 m
Project for 'Arte Amazonas', Rio
de Janeiro

This work was created during the Rio Earth Summit in 1992. Dion transported 1 m² of soil and debris from a rainforest park in Belem, located at the mouth of the Amazon, to the exhibition hall in Rio for display. By bringing the jungle into the exhibition space – displacing the material from its surroundings – and dissecting and classifying it, Dion highlights the role of displacement in the formation of scientific knowledge. Dion pays homage to the Naturalist William Beebe by adopting the methods he employed in carrying out his field work experiments. Materials taken from a particular site are analyzed in isolation in the Non-site of the gallery space, where displaced specimens are used to illustrate man's 'knowledge'. By taking his sample from the jungle floor, Dion focuses attention on the invisible microcosms in the soil. All elements in the environment are just as important in the role of conservation, as the removal of just one element alters the whole ecosystem.

Mark DION
The Tasting Garden (proposal)
1996
Gouache, paper
30.5 × 61 cm
Project proposal for 'Art Transpennine', Yorkshire, England

The work is concerned with the conservation of biological diversity. In a corner of the garden of the Harewood Estate, a proposed network of paths creates a tree-like figure. The main path constitutes the tree trunk and the side paths, its branches. These also deviate into smaller paths which terminate in semi-circular areas. In this area the viewer encounters a rectangle of stone set into the ground and inscribed with the name of a fruit tree variety, followed with an odd and anachronistic description of the qualities of the fruit, particularly the taste. Beyond this inlayed tablet stands a short concrete column bearing a bronze plate, on which sits an oversized bronze fruit. Immediately behind the column and a short distance off the pathway is the tree itself. The trees come in three forms: a newly planted sapling, an adult tree or a withered and bare bronze trunk representing extinct tree species. The main branches of the tree pathway represent the major northern fruit crop trees. The terminal nodes represent distinct varieties.

DOCU-MENTS

LAWRENCE ALLOWAY

CARL ANDRE

TERRY ATKINSON AND

MICHAEL BALDWIN

ALICE AYCOCK

GEORGE BAKER

JOHN BALDESSARI

J.G. BALLARD

STEPHEN BANN

JOHN BARRELL

JEAN BAUDRILLARD

JOHN BEARDSLEY

BETTY BEAUMONT

WALTER BENJAMIN

JOSEPH BEUYS

DORIS BLOOM

GUY BRETT

JULIA BROWN

EDMUND BURKE

JACK BURNHAM

RACHEL CARSON

MEL CHIN

CHRISTO AND JEANNE-CLAUDE

JOHN COPLANS

WALTER DE MARIA

GUY DEBORD

RICHARD DEMARCO

AGNES DENES

JAN DIBBETS

MARK DION

TOSHIKATSU ENDO

MICHAEL FEHR

HARRIET FEIGENBAUM

PETER FEND

IAN HAMILTON FINLAY

MICHEL FOUCAULT

SIGMUND FREUD

MICHAEL FRIED

KENNETH FRIEDMAN

HAMISH FULTON

WILLIAM FURLONG

AVITAL GEVA

SMADAR GOLAN

ANDY GOLDSWORTHY

STEPHEN JAY GOULD

DONNA HARKAVY

HELEN MAYER HARRISON

AND NEWTON HARRISON

ALANNA HEISS

MICHAEL HEIZER

DAVE HICKEY

NANCY HOLT

DOUGLAS HUEBLER

PETER HUTCHINSON

JOHN BRINCKERHOFF

JACKSON

PATRICIA JOHANSON

WILLIAM KENTRIDGE

JACK KEROUAC

ROSALIND KRAUSS

BRUCE KURTZ

KATE LINKER

LUCY R. LIPPARD

RICHARD LONG

CHIP LORD

JOSEPH MASHECK

GORDON MATTA-CLARK

THOMAS MCEVILLEY

ROBERT MORRIS

CHRISTIAN PHILIPP

MÜLLER

FUMIO NANJO

VIET NGO

ISAMU NOGUCHI

CLAES OLDENBURG

DENNIS OPPENHEIM

CRAIG OWENS

PLATFORM

UVEDALE PRICE

HAROLD ROSENBERG

ANNE-MARIE SAUZEAU

BOETTI

SIMON SCHAMA

GERRY SCHUM

RICHARD SERRA

WILLOUGHBY SHARP

BONNIE SHERK

FUJIKO SHIRAGA

CHARLES SIMONDS

BUSTER SIMPSON

ROBERT SMITHSON

ALAN SONFIST

KATE SOPER

NANCY SPERO

HENRY DAVID THOREAU

SIDNEY TILLIM

JANE TOMKINS

GUY TORTOSA

JAMES TURRELL

MIERLE LADERMAN

UKELES

DIANE WALDMAN

OCTAVIO ZAYA

1. [see page 193]

Casper David <u>FRIEDRICH</u>

The Wreck of the Hope

1824

Oil on canvas

96 × 126 cm

2. [see page 194]

The Grounds of Stourhead

Wiltshire, England

3. [see page 194]

Nicolas <u>POUSSIN</u>

Landscape with Traveller

Washing His Feet

1648

Oil on canvas

74 × 100 cm

4. [see page 195]

Claude <u>LORRAIN</u>

Landscape with Sacrifice

to Apollo

1662

Oil on canvas

176 × 223 cm

5. [see page 197]

Dennis <u>HOPPER</u>

Easy Rider

1969

95 mins., colour

Film still

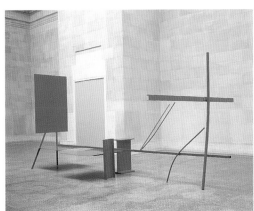

6. [see page 198]

Jasper <u>JOHNS</u>

Map

1963

Encaustic and collage on

canvas

152 × 236 cm

8. [see page 212]

Anthony <u>CARO</u>

Early One Morning

1962

Steel and aluminium

painted red

290 × 620 × 333 cm

7. [see page 199]

Stonehenge

c. 2600 BC

Salisbury Plain

Wiltshire, England

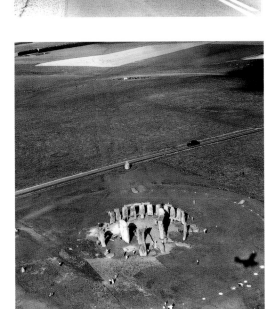

9. [see page 239]
Susan <u>HILLER</u>
Dream Mapping
1974
Black and white
photograph of event
Hampshire, England

10. [see page 245]
Panorama of a Roman Road
Northumberland, England

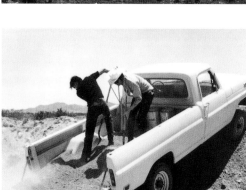

11. [see page 247]
John <u>FORD</u>
The Searchers
1956
119 mins., colour
Film still

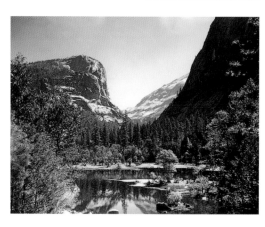

12. [see page 251]
Yosemite National Park
Sierra Nevada Mountains,
California

13. [see page 251]
Albert <u>BIERSTADT</u>
The Rocky Mountains
1863
Oil on canvas
180 × 306 cm

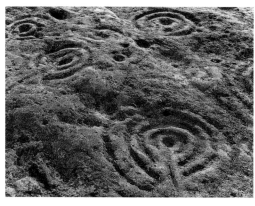

14. [see page 251]
Cup and Ring markings
Stone
Roughting Linn,
Northumberland, England

15. [see page 281]
Michael <u>HEIZER</u> and
Robert <u>SMITHSON</u>
13 July 1968
Las Vegas, Nevada

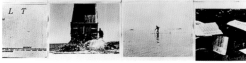

16. [see page 283]
Robert <u>SMITHSON</u>
The Spiral Jetty
1970
35 mins., black and
white
Film stills

INCEPTION

'Why is it, I wonder', writes the critic and theorist John Brinckerhoff Jackson at the beginning of his essay, 'The Word Itself', 'that we have trouble agreeing on the meaning of "landscape"?' The idea of Land Art is, as Jackson says of the landscape, 'something which we think we understand'. Yet concepts of both 'land' and 'art' remain incredibly varied and are historically and ideologically inscribed. Jackson's text and the others collected in this section address broad background ideas related to the production of Land Art: constructs of the 'picturesque' and the 'sublime'; evolving ideas of landscape in relation to spiritual, physical, social and political issues; and examples of contemporary aesthetic theories that both draw from and refine their antecedents. Identifying strategies and tendencies emerging in the late 1960s, these texts lay out the critical foundations of Land and Environmental Art.

1. Casper David Friedrich

Edmund BURKE
A Philosophical Enquiry into the Origin of our Ideas on the Sublime and Beautiful
[1757]

THE SUBLIME

[...] The passion caused by the great and sublime in *nature*, when those causes operate most powerfully, is astonishment: and astonishment is that state of the soul in which all its motions are suspended, with some degree of horror. In this case the mind is so entirely filled with its object, that it cannot entertain any other, nor by consequence reason on that object which employs it. Hence arises the great power of the sublime, that, far from being produced by them it anticipates our reasonings, and hurries us on by an irresistible force. Astonishment, as I have said, is the effect of the sublime in its highest degree; the inferior effects are admiration, reverence and respect.

No passion so effectually robs the mind of all its powers of acting and reasoning as *fear*. For fear being an apprehension of pain or death, it operates in a manner that resembles actual pain. Whatever therefore is terrible, with regard to sight, is sublime too, whether this cause of terror be endued with greatness of dimensions or not; for it is impossible to look on anything as trifling, or contemptible, that may be dangerous. There are many animals, who, though far from being large, are yet capable of raising ideas of the sublime, because they are considered as objects of terror. As serpents and poisonous animals of almost all kinds. And to things of great dimensions, if we annex an adventitious idea of terror, they become without comparison greater. A level plain of vast extent on land, is certainly no mean idea; the prospect of such a plain may be as extensive as a prospect of the ocean; but can it ever fill the mind with anything so great as the ocean itself? This is owing to several causes; but it is owing to none more than this, that the ocean is an object of no small terror. Indeed terror is in all cases whatsoever, either more openly or latently, the ruling principle of the sublime [...]

Edmund Burke, 'A Philosophical Enquiry into the Origin of our Ideas of the Sublime and Beautiful', *The Philosophy of Edmund Burke: A Selection of his Speeches and Writings*, ed. Louis I. Dredvold and Ralph G. Ross, University of Michigan Press, Ann Arbor, 1967, pp. 256-57; 262. Originally published by R. and J. Dodsley, London, 1757

Uvedale PRICE
An Essay on the Picturesque
[1796]

[...] Picturesqueness, therefore, appears to hold a station between beauty and sublimity; and on that account, perhaps, is more frequently and more happily blended with them both than they are with each other. It is, however, perfectly distinct from either; and first, with respect to beauty, it is evident, from all that has been said, that they are founded on very opposite qualities; the one on smoothness, the other on roughness; — the one on gradual, the other on sudden variation; — the one on ideas of youth and freshness, the other on that of age, and even of decay ...

These are the principal circumstances by which the picturesque is separated from the beautiful. It is equally distinct from the sublime; for though there are some qualities common to them both, yet they differ in many essential points, and proceed from very different causes. In the first place, greatness of dimension is a powerful cause of the sublime; the picturesque has no connection with dimension of any kind (in which it differs from the beautiful also) and is as often found in the smallest as in the largest objects. The sublime being founded on principles of awe and terror, never descends to any thing light or playful; the picturesque, whose characteristics are intricacy and variety, is equally adapted to the grandest and to the gayest scenery. Infinity is one of the most efficient causes of the sublime; the boundless ocean, for that reason, inspires awful sensations: to give it picturesqueness you must destroy that cause of its sublimity; for it is on the shape and disposition of its boundaries that the picturesque in great measure must depend.

Uniformity (which is so great an enemy to the picturesque) is not only compatible with the sublime, but often the cause of it. That general equal gloom which is spread over all nature before a storm, with the stillness so nobly described by Shakespeare, is in the highest degree sublime. The picturesque requires greater variety, and does not show itself till the dreadful thunder has rent the region, has tossed the clouds into a thousand towering forms, and opened (as it were) the recesses of the sky. A blaze of light unmixed with shade, on the same principles, tends to the sublime only: Milton has placed light, in its most glorious brightness, as an inaccessible barrier round the throne of the Almighty:

'For God is light,
And never but in unapproached light
Dwelt from eternity.
And such is the power he has given even to its diminished splendour,
That the brightest seraphim
Approach not, but with both wings veil their eyes.'

In one place, indeed, he has introduced very picturesque circumstances in his sublime representation of the deity; but it is of the deity in wrath – it is when from the weakness and narrowness of our conceptions we give the names and the effects of our passions to the all-perfect Creator:

'And clouds began
To darken all the hill, and smoke to roll
In dusky wreaths reluctant flames, the sign
Or wrath awak'd.'

In general, however, where the glory, power or majesty of God are represented, he has avoided that variety of form and of colouring which might take off from simple and uniform grandeur, and has encompassed the divine essence with unapproached light, or with the majesty of darkness.

Again (if we descend to earth), a perpendicular rock of vast bulk and height, though bare and unbroken – a deep chasm under the same circumstances, are objects that produce awful sensations; but without some variety and intricacy, either in themselves or their accompaniments, they will not be picturesque. Lastly, a most essential difference between the two characters is, that the sublime by its solemnity takes off from the loveliness of beauty, whereas the picturesque renders it more captivating.

According to Mr. Burke, the passion caused by the great and sublime in *nature*, when those causes operate most powerfully, is astonishment; and astonishment is that state of the soul in which all its motions are suspended with some degree of horror: the sublime also, being founded on ideas of pain and terror, like them operates by stretching the fibres beyond their natural tone. The passion excited by beauty is love and complacency; it acts by relaxing the fibres somewhat below their natural tone, and this is accompanied by an inward sense of melting and languor.

Whether this account of the effects of sublimity and beauty be strictly philosophical, has, I believe, been questioned, but whether the fibres, in such cases, are really stretched or relaxed, it presents a lively image of the sensations often produced by love and astonishment. To pursue the same train of ideas, I may add, that the effect of the picturesque is curiosity; an effect which, though less

splendid and powerful, has a more general influence; it neither relaxes nor violently stretches the fibres, but by its active agency keeps them to their full tone, and thus, when mixed with either of the other characters, corrects the languor of beauty, or the horror of sublimity. But as the nature of every corrective must be to take off from the peculiar effect of what it is to correct, so does the picturesque when united to either of the others. It is the coquetry of nature; it makes beauty more amusing, more varied, more playful, but also,
'Less winning soft, less amiably mild.'
Again, by its variety, its intricacy, its partial concealments, it excites that active curiosity which gives play to the mind, loosening those iron bonds with which astonishment chains up its faculties.

Where characters, however distinct in their nature, are perpetually mixed together in such various degrees and manners, it is not always easy to draw the exact line of separation: I think, however, we may conclude, that where an object, or a set of objects, is without smoothness or grandeur, but from its intricacy, its sudden and irregular deviations, its variety of forms, tints and lights and shadows, is interesting to a cultivated eye, it is simply picturesque; such, for instance, are the rough banks that often inclose a bye-road or a hollow lane: Imagine the size of these banks and the space between them to be increased till the lane becomes a deep dell, the coves large caverns, the peeping stones hanging rocks, so that the whole may impress an idea of awe and grandeur; the sublime will then be mixed with the picturesque, though the scale only, not the style of the scenery, would be changed. On the other hand, if parts of the banks were smooth and gently sloping, or the middle space a soft close-bitten turf, or if a gentle stream passed between them, whose clear unbroken surface reflected all their varieties – the beautiful and the picturesque, by means of that softness and smoothness, would then be united.

Uvedale Price, 'An Essay on the Picturesque', *The Genius of the Place: The English Landscape Garden, 1620-1820*, ed. John Dixon Hunt and Peter Willis, Harper and Row, New York, 1975, pp. 354-57. Originally published by J. Robson, London, 1796

John Brinckerhoff
JACKSON
The Word Itself [1984]

Why is it, I wonder, that we have trouble agreeing on the meaning of 'landscape'? The word is simple enough, and it refers to something which we think we understand; and yet to each of us it seems to mean something different.

What we need is a new definition. The one we find in most dictionaries is more than three hundred years old and was drawn up for artists. It tells us that a landscape is a 'portion of land which the eye can comprehend at a glance'. Actually when it was first introduced (or reintroduced) into English it did not mean the view itself, it meant a *picture* of it, an artist's interpretation. It was his task to take the forms and colours and spaces in front of

him – mountains, river, forest, fields and so on – and compose them so that they made a work of art.

There is no need to tell in detail how the word gradually changed in meaning. First it meant a picture of a view; then the view itself. We went into the country and discovered beautiful views, always remembering the criteria of landscape beauty as established by critics and artists. Finally, on a modest scale, we undertook to make over a piece of ground so that it resembled a pastoral landscape in the shape of a garden or park. Just as the painter used his judgement as to what to include or omit in his composition, the landscape gardener (as he was known in the eighteenth century) took pains to produce a stylized 'picturesque' landscape, leaving out the muddy roads, the plowed fields, the squalid villages of the real countryside and including certain agreeable natural features: brooks and groves of trees and smooth expanses of grass. The results were often extremely beautiful, but they were still pictures, though in three dimensions.

The reliance on the artist's point of view and his definition of landscape beauty persisted throughout the nineteenth century. Olmsted and his followers designed their parks and gardens in 'painterly' terms. 'Although three-dimensional composition in landscape materials differs from two-dimensional landscape painting, because a garden or park design contains a *series* of pictorial compositions', the *Encyclopaedia Britannica* (thirteenth edition) informs us, ' ... nevertheless in each of these pictures we find the familiar basic principles of unity, of repetition, of sequence and balance, of harmony and contrast'. But within the last half century a revolution has taken place: landscape design and landscape painting have gone their separate ways. Landscape architects no longer turn to Poussin or Salvator Rosa or Gilpin for inspiration; they may not even have heard of their work. Knowledge of ecology and conservation and environmental psychology are now part of the landscape architect's professional background, and protecting and 'managing' the natural environment are seen as more important than the designing of picturesque parks. Environmental designers, I have noticed, avoid the word *landscape* and prefer *land* or *terrain* or *environment* or even *space* when they have a specific site in mind. *Landscape* is used for suggesting the aesthetic quality of the wider countryside.

As for painters, they have long since lost interest in producing conventional landscapes. Kenneth Clark, in his book *Landscape into Painting*, comments on this fact. 'The microscope and telescope have so greatly enlarged the range of our vision', he writes, 'that the snug, sensible nature which we can see with our own eyes has ceased to satisfy our imaginations. We know that by our new standards of measurement the most extensive landscape is practically the same as the hole through which the burrowing ant escapes from our sight'.

This does not strike me as a very satisfactory explanation of the demise of traditional landscape painting. More than a change in scale was responsible. Painters have learned to see the environment in a new and more subjective manner: as a different kind of experience. But that is not the point. The point is, the two disciplines

which once had a monopoly on the word – landscape architecture and landscape painting – have ceased to use it the way they did a few decades ago, and it has now reverted as it were to the public domain.

What has happened to the word in the meantime? For one thing we are using it with much more freedom. We no longer bother with its literal meaning – which I will come to later – and we have coined a number of words similar to it: roadscape, townscape, cityscape, as if the syllable *scape* meant a space, which it does not; and we speak of the wilderness landscape, the lunar landscape, even of the landscape at the bottom of the ocean. Furthermore the word is frequently used in critical writing as a kind of metaphor. Thus we find mention of the 'landscape of a poet's images', 'the landscape of dreams', or 'landscape as antagonist', or 'the landscape of thought', or, on quite a different level, the 'political landscape of the NATO conference', the 'patronage landscape'. Our first reaction to these usages is that they are far-fetched and pretentious. Yet they remind us of an important truth: that we always need a word or phrase to indicate a kind of environment or setting which can give vividness to a thought or event or relationship; a background placing it in the world. In this sense *landscape* serves the same useful purpose as do the words *climate* or *atmosphere*, used metaphorically. In fact *landscape* when used as a painter's term often meant 'all that part of a picture which is not of the body or argument' – like the stormy array of clouds in a battle scene or the glimpse of the Capitol in a presidential portrait. In the eighteenth century, *landscape* indicated scenery in the theatre and had the function of discreetly suggesting the location of the action or perhaps the time of day. As I have suggested elsewhere, there is no better indication of how our relation to the environment can change over the centuries than in the role of stage scenery. Three hundred years ago Corneille could write a five-act tragedy with a single indication of the setting: 'The action takes place in the palace of the king'. If we glance at the work of a modern playwright we will probably find one detailed description of a scene after another, and the ultimate in this kind of landscape, I suppose, is the contemporary movie. Here the set does much more than merely identify the time and place and establish the mood. By means of shifts in lighting and sound and perspective the set actually creates the players, identifies them and tells them what to do: a good example of environmental determinism.

But these scenic devices and theatre landscapes are mere imitations of real ones: easily understood by almost everyone, and shared. What I object to is the fallacy in the metaphorical use of the word. No one denies that as our thoughts become complex and abstract we need metaphors to give them a degree of reality. No one denies that as we become uncertain of our status we need more and more re-enforcement from our environment. But we should not use the word *landscape* to describe our private world, our private microcosm, and for a simple reason: a landscape is a concrete, three-dimensional shared reality [...]

John Brinckerhoff Jackson, 'The Word Itself', *Discovering the Vernacular Landscape*, Yale University Press, New Haven and London, 1984, pp. 3-5

John BARRELL
The Idea of Landscape in the Eighteenth Century [1972]

[...] If the landscape and the features within it are to be successfully subjected to the poet, and to be organized by him, until they become as far as possible the landmarks on his eye's journey, elements in a general composition which does its best to prevent the particular things within it from asserting themselves at all, the poet must have the space between the landscape and himself which a high viewpoint affords. Only as it looks from rising ground can the eye separate the immediate, disorganized foreground from the malleable area beyond it. The importance of this separation of the poet from the landscape he describes is reflected in the poetic vocabulary of the eighteenth century, and particularly in those words which were more or less interchangeable with the word 'landscape' itself – 'view', 'prospect', 'scene' – all of which make the land something out there, something to be looked at from a distance, and in one direction only. 'Prospect' carries this sense from its Latin root, *pro-spicere*, to look forward, or out into the distance: before anything else a prospect is what is in front of you – the phrase *en face* perhaps expresses it best – and some distance away. And though in the eighteenth century this sense of direction became gradually more submerged, it did keep a limiting influence over the sense that could be made of the word. Thus, when Thomson writes in this passage that the 'prospect' spreads immense 'around', there is certainly a tension between the sense of 'prospect', something in a fixed and opposite position to the observer, and 'around', which suggests a wide arc of landscape stretching out beyond the arc of the poet's vision. This tension relates very closely to the process of organization both Claude and Thomson were engaged in: that of organizing what was in fact an arc – the 'circling landscape' as it was often called by eighteenth-century poets – on to a flat surface, that of the canvas or an imaginary one. It was partly to make this feat or organization easier for the connoisseur of landscape that the Claude-glass was invented: a plano-convex mirror which 'gathers every scene reflected in it into a tiny picture'.

The word 'scene', applied to a landscape, assumed also that what was being described lay opposite the observer, *en face*: and this sense came with it from its theatrical origin – the flat and square-shaped *skēnē* behind the orchestra in a Greek theatre, and the square frame of the proscenium arch which the English theatre had adopted since the Restoration. A 'scene', then, in the description of landscape, is something opposite you and enclosed by the limits of your vision in very much the same way as a painting is enclosed within its frame [...]

What is uncultivated is uncivilized – that is its attraction – and thus also mysterious; but just as a progressive farmer can enclose a tract of heath or moorland, and cultivate it, so the picturesque traveller can appropriate and thus destroy in the places he visits

precisely what attracts him to them, the sense that they are mysterious and unknowable: and he does this not only by putting the places he visits on the map, whether literally or in some other sense, but also because the only way he can know a landscape as picturesque is by applying to it a set of 'picturesque rules', as it were categories of perception without which any knowledge of the landscape would be impossible for him [...]

John Barrell, 'The Idea of Landscape in the Eighteenth Century', *The Idea of Landscape and the Sense of Place*, 1730-1840, Cambridge University Press, Cambridge, 1972, pp. 22-23; 62

Kenneth FRIEDMAN
Words on the Environment [1983]

[...] In *Frame Analysis: An Essay on the Organization of Experience* (1974), social anthropologist Erving Goffman made a charming leap of imagination that is instructive for the study and criticism of Environmental Art. He perceived that words shape the organization of experience, that our organization and framing of experience shape our perception, and that all the many factors involved in the development of 'words' of 'organization' or of 'framing' are theoretically of equal importance, differing in reality only according to time and circumstance. As a result, he took a truism on which most social scientists agree, using it to create the framework for a remarkable volume by drawing on sources as common as newspaper articles. Rather than using constructed experiments or observed interactions as he had with great success in past studies, Goffmann's leap consisted in the sensible choice of using some of the very materials that create and frame experience in the most common and pervasive manner.

In considering Environmental Art, most critics and artists have failed to appreciate the meaning, context and nature of the environment. That is to say that a notion of *Environmental Art* has been elaborated from theories of art and from notions of an art that is related to nature, nature being 'the environment' in which 'Environmental Art' takes place. Nothing could be more evidently sensible in today's art world – and nothing could be more wrong.

To understand Environmental Art, one must begin with a simple yet significant question: What is the environment? or perhaps, What does the word *environment* mean?

Webster's Collegiate Dictionary (1943), an excellent version of *Webster's New International* (second edition), defines the word *environment* in this manner: '1: act of environing; state of being environed 2: that which environs; surroundings; specifically the aggregate of all the external conditions and influences affecting the life and development of an organism, etc., human behaviour, society, etc'.

The degree to which the word *environment* is related to the sense of surrounding or of overall placement and situation can be seen through the development and descent of the word from its origin in Latin. Bloch and von

4. Claude Lorrain

Wartburg in their *Dictionnaire Étymologique de la langue française* (second edition, 1950) locate its origin in the Latin word *vibrare*, which Partridge reports as meaning 'to shake or brandish' in *Origins: A Short Etymological Dictionary of Modern English*. From that word grew *virare* of Vulgar Latin and *gyrare* of Late Latin, *gyrare* meaning 'to turn (something), (anything) about' and *virare* meaning 'to cause something to go about', particularly – in its original meaning – a vessel or ship. Through Old French and French, the word became *virer*, and into English as *veer*, as well as the nautical term *wear* meaning to cause a vessel to go about by turning the bow away from the wind.

The word *virer* in Old French and French had a derivative word, *viron*, meaning 'a circle, a round, the country around (or surrounding something)', which appeared in Old French and in Early Modern French. From that word Old French and French gave birth to the word *environ* meaning 'in/around' and functioning as a preposition and later as an adverb. In Middle French and Early Modern French *à l'environ* came to mean 'in the vicinity', and from it the plural noun *environs* was adopted by the English language. The Old French preposition *environ* also gave rise to the verb *environner*, whence emerged the verb 'to environ'. While other Old French and Middle French words are related – as are certain archaic meanings from Early English, including the rare word *environment* – the current meaning and use of the word *environment* apparently derives from the verb 'to environ'.

Current acceptable meaning in common English is evident in *Webster's Seventh New Collegiate Dictionary* (1969), based on *Webster's Third New International Dictionary*: '1: something that environs: surroundings 2a: the complex of climatic, edaphic and biotic factors that act upon an organism or an ecological community and ultimately determine its form and survival b: the aggregate of social and cultural conditions that influence the life of an individual or community'.

With the growth of concern for the biosphere as a political issue of the movements identified with 'ecology' and 'environmental activism', the term began to be inappropriately and almost exclusively applied to 'nature'. The misunderstanding bound up in this media-influenced slippage of meaning should be evident in the fact that it is the total environment (social, political, economic, cultural and natural) that affects our relationship to 'nature and ecology' as it has come to be understood. Given that human beings and their culture are in the largest scale of description simply a form of life moving about and acting on the surface of the planet, the drilling of an oil company is as much a part of the 'environment' as a tree. That the oil company acts differently towards its host organism, the planet, than does a tree is significant, but both exist and remain. In some senses one can view human culture in its use of planetary resources much as one can view a colony of animals in its use of a forest or a group of insects meeting in the core of a planet. It is the decisions that human societies make that control their uses of nature and of the planet. Thus it is that, at least in human terms, the widest use of the word *environment* is in a direct sense the most appropriate.

Thomas Ford Hoult's *Dictionary of Modern Sociology*

(1977) defines the word *environment* appropriately for our purposes: 'In the most general sense, all the external conditions, physical and sociocultural, which can influence an individual or a group; sometimes used to denote physical surroundings as distinguished from the sociocultural; when employed in the general sense, often used synonymously with *milieu*'.

Hoult goes on to cite Kingsley Davis, who in *Human Society* (1949) wrote that 'there is no such thing as "the" environment. There are many different environments, and what is environment in one sense may not be so in another'.

The term *Environmental Art* has come to have a meaning that summons up images of earth art or art forms involved with 'ecological investigations'. A closer look at Environmental Art and at artists who engage environmental concerns in their art will reveal dimensions that are as much cultural as natural. Human beings create art as a cultural act, commenting through culture on culture itself and on all those aspects of existence and experience that affect them – including nature.

Only false romanticism or thin analysis can imagine Environmental Art to be related exclusively to 'the natural'. A phenomenon is lodged within the contexts of both culture and nature, as are all forms of art to a greater or lesser degree. As an art form concerned with the relation of our species and our societies to the planet on which we live or as an art form using our placement on and perception of the planet, what is called Environmental Art is as clearly focused on culture as it is on anything else. The focus may be diffuse, it may change and vary in proportion and perspective in the work of one artist or another, it may even seem to have more to do with 'nature' than with 'culture' as subject matter, but Environmental Art remains an art form that must – in order to be successful – deal with 'all the external conditions, physical and socio-cultural, which can influence an individual or a group'.

Kenneth S. Friedman, 'Words on the Environment', *Art in the Land*, ed. Alan Sonfist, E. P. Dutton & Co., New York, 1983, pp. 253–56

Dave HICKEY
Earthscapes, landworks and Oz [1971]

'The country is really too big for human beings to live in without making a conscious adjustment, and there are only two you can make: You can either increase, through mind or machine, your own reach in space and time, or you can break that space into man-sized chunks. The artist working in this environment, almost by necessity, renders his strategy public ... '

A strict decorum governs conversation between man and man in hard climates and desolate country. Direct assertions are taboo, as are conversations face to face, since you can read private things in a man's face. And since they demand response, direct questions are always redesigned. So conversation, in such country, takes place

with men standing side by side addressing themselves to some external object or phenomenon with an attention which amazes outlanders. They do not understand that those two men standing on the concrete apron of the Mobil station, staring down the highway towards a fragile wisp of cloud, may, while discussing that cloud, reveal their souls, and only discover as much of one another as they want.

My father-in-law is a man of such elegance. When we talk we mostly look at clouds, cottonland, horses, heavy equipment or just distance, but we get it said. We might say it more eloquently before Michael Heizer's *Double Negative*. Since my father-in-law makes roads, moves earth and loves the big machinery such work requires, it would be the kind of work he might enjoy; and since it is huge and vulnerable, it would lend itself to his most Roman topic (the favourite of all adult males west of Fort Worth): the ravages of nature upon the works of man. He would like driving out to the site in his white jeep, wearing his narrow-brimmed Stetson, his khaki slacks and jacket and his Gokey boots. The more difficult the trip, the more completely it would reinforce his serene pessimism. *That* would be his idea of going to see some art; mine, too, in proper company.

In big country you do not see in the ordinary way. There is no 'middle distance', only 'near' and 'far', the dust at your feet and the haze on the horizon. Between, just a rushing away. There is literally nothing to see, so that is what you look at: the nothingness – the nothing-ness. Vacant space is the physical fact you perceive most insistently, pressing down on the earth as the prehistoric oceans used to. Objects intrude upon the vacancy to little effect; they only clutter your sight. Since you do not see things, but simply *see*, it is always easier to experience what has been taken away than what has been added. So you can 'add' by taking away. By making his two cuts across the concavity of the mesa, Heizer has 'created' a 'double negative' space between them. Once negative by the mesa's *cul de sac*, and twice by the horizontal column implied by the cuts.

I wonder if this particular negative space would be as palpable in a more cluttered, 'positive' environment? I *do* know that privative pieces – those which involve cutting away, digging out or marking – have much more authority and intimacy with the country itself than the additive pieces like Smithson's *Spiral Jetty* or Heizer's *Black Dye and Powder Dispersal*, which are dwarfed in a way that even smaller privative pieces are not. Smithson's *Jetty*, particularly, has a beaux-arts look about it, more related to other sculpture than to the lake. Like Wallace Stevens' jar, it makes the 'slovenly wilderness' surrounding it, 'no longer wild', and like the jar, 'it takes dominion everywhere'. Which is all right if you like imperialistic art, which I do. Somehow, though, I would rather it took dominion over the MoMA than over the Great Salt Lake.

Rereading the above – strange, that the things we say in the presence of art are always indirect. Our critical remarks veil personal confessions, and our private revelations are nothing but aesthetics in disguise. But just as well – I mean, art can be so much *less* than an occasion for discourse, and art's attempts to subvert discussion

only assure us that the talk, when it arises, will have a certain density and subtlety. It is misleading, though, to speak of quality in art when what we are really appraising is the quality of our own response. For me, there is a distinction between art which is *attractive* and art which I think is *good*. When a work is either or neither, there is no question of taste; but when I suspect that it may be both, there are difficulties – as with so much of the work done in the landscape. It is so *attractive* at a primitive personal and cultural level (that level I share with my father-in-law who, for all his virtues, cares not a rip for art) that it is always difficult to decide whether a work is true to itself or only true to some old echoes within myself, some resonant private mythology.

'Well. Yes! Dorothy, and the Scarecrow, and the Tin Woodman, and the Cowardly Lion, and Toto have been to Oz. It was far out and groovy (Oz was), but insincere. And, like wow, the Wizard for all his power was kinda fakey and sexually ambiguous. I mean, it was the Emerald City, and the road was yellow brick, and it did go to Oz and not to Kansas City, and it was in technicolour which Kansas isn't to this day, but it wasn't real, y'know? Now, tomorrow Dorothy is going to borrow Auntie Em's trencher and cut a Möbius strip in the No. 7 Pasture. She says it is going to be a half-mile long and a quarter-mile wide and Art. Can you dig it?'

Radical gestures have an elegance and inevitability about them, but they lack much sense of becoming. Now it follows: that an art concerned with the gap between the world and our idea of it would eventually address itself to the world itself and the systems we use to parcel it up; that an art concerned with the semantics of specific objects would soon become involved with subtler forms of nominalization (with mass, locative, gerundive and collective concepts and their physical equivalents); that painting obsessed with the idea of 'ground' and sculpture with the logistics of 'grounding' would eventually discard the metaphor and address the archetypal plane/plain. The question is, what follows that?

It doesn't follow that American artists are once more fleeing back to the landscape with the equipment and ideology of some secular and cosmopolitan art, that they are once again making art out of the ironic relationship between dirt, earth, country, property, landscape, territory and nature. That seems to be one of the dumbest *American Dreams*: to capture the landscape while capturing our imaginations. The military metaphor is unnerving (people are always *capturing* the American imagination); but from Emerson's *Nature* to Fitzgerald's Dutch sailors (the eyes of the Hudson River School), to those ever-so Easy Riders aboad their chrome ponies, souls stuffed with tapioca and reruns of the Cisco kid, it is manifest.

Once more 'The Nature thing!' I don't want to sound like a sissy, but I can't see why people find nature more 'natural' than anything else, or better for being so. The natural part of nature makes you sweat, sting and shiver. Forget it.

Do I imply that Dorothy, fresh back from Oz, cannot find happiness as an artist in the fields of Kansas? – that true happiness might elude her as she solves mapping

problems in the wheat up top Auntie Em's thresher? I certainly hope not. I couldn't think of a more excellent enterprise. Making art in the landscape allows the elevation of many splendid activities from the bondage of utility into the realms of imitation – activities like sipping iced tea from a big glass while sitting on a tractor seat, loading a rock crusher, mapping out the land beneath your feet or clearing your sinuses with the fragrance of asphalt. As George Puttenham was wont to say, the artist is 'both a maker and a counterfeiter'. These are all things worth doing in and of themselves, however rich in reference.

I emphasize this because, according to the art press, I am probably one of that effete corps of dealers, critics, curators and collectors who are supposedly incensed, bewildered and frightened by the people who make Earth Art. This isn't the case. I am incensed, bewildered and frightened by the people who make laws, but towards Earth Artists I am sympathetic, even enthusiastic. I know that the movement (pun?) could use some detractors (pun?!), but this isn't the good old days, when we had an avant-garde, when you were judged by the quality of your enemies, when you had it made if Harold Rosenberg used the *New Yorker* space usually allotted to the J. Press ad to announce that Kurt Schwitters did what you are doing x number of years ago. Ubi sunt? *Now* you have it made if you can survive the banal praise and keep the guts or stomach to make art.

I don't, however, look forward to the much-heralded abolition of the object from art. For all the rage at our acquisitive society, I must agree with Mary McCarthy that Americans, beset by traditions of rationalism, puritanism and transcendentalism, have never had a truly easy intimacy with objects. It is certainly an acquired taste with me, and after years of cultivating it I'm not about to quit. Earth Art, at least, isn't predicated upon the abolition of the object. It is concerned with marking out, activating and controlling spaces; and an object in an unbounded environment *occupies* space, it doesn't control it – unless it is truly monumental. (Dennis Oppenheim's plan to move a 14,000-foot mountain to Kansas should delight Dorothy.) Otherwise, an object only controls enclosed spaces by interaction with the enclosure. So Heizer's granite masses in cement depressions are bivalent. Each entire piece is an exterior work, while the granite masses create interior works *vis-à-vis* the enclosures.

Which doesn't mean that the status of the object is not in jeopardy from the museums, who have nullified the liveliest object-art by hoarding it in a place where there is nothing but art and therefore no need for it. The *virtue* of object art (where surface and symbol are co-extensive, portable and visible) is that it can be moved into the funkiest, most secular places and not lose its recognition. So there is always the possibility of confronting it unawares and responding to it while you are munching a peanut butter sandwich or looking for the *TV Guide*, without getting into your art-watching suit. Sometimes, when this happens, you can have a kind of low-grade epiphany, the kind which would help Lew Archer solve a case, but which only helps us non-fiction characters forget the war.

For example, the other morning I was reading an article

about earthworks titled 'Dirty Pictures' (heh, heh) when I noticed from the corner of my eye that the linear configurations Peter Plagens had left on his large paper painting, when he painted it brown, were the same as those Heizer was marking onto the desert with his bike, and the same brown colour. Peter had painted out 120 square feet of taped-together roadmap to make that painting. In effect he had painted the earth back over the ideational system of the map, leaving a negative configuration scarily similar to the one Heizer was mapping on the surface. That doesn't *mean* anything, of course, but it does illustrate how object art will get you through breakfast. It has some implications as well.

To understand how appropriate it is that America was named for the man who mapped her rather than the man who discovered her, you should make the run I make from time to time: from Kansas City through Oklahoma City and Dallas down to Austin, where I live. You drop like a tear down the face of the map, running before the wind which hasn't hit so much as a billboard since it left Canada, through country of such spectacular monotony that, like a blind man, you become acutely sensitized to the conceptual spaces through which you are plummeting – time zones, states, counties, water districts, flyways, national parks, weather systems (the skies are not cloudy all day). In mid-morning you lose the CBS station in Kansas City and pick up the NBC station in Pittsburg, Kansas, off to the east. You have studied the comparative news styles of the networks, so now you can concentrate on the stylistic variations among the individual broadcasters (Dallas Townsend has one great voice). Hourly you note the incremental change in the news text, suggesting how time passes at the highest priority.

At sundown you pick up WBAP out of Fort Worth, and after midnight, the all-night truck driver's show: country-western music – cold soul, sugar – little black pills and neon lights. The station broadcasts at fifty thousand watts, and after dark you can pick it up coast to coast. From the dedications, I guess most truckers do: 'Could you please play something by Little Jimmy Dickens for Leroy who's driving for Snowcrop out of Butte, from Laura and Sue in Bozier City … and here's one from the girls at the Cline's Corners truck stop for Jim Bob Brown who's driving tonight for Double-M way up in Maine. I hope you're listening Jim Bob, 'cause here comes Roger Miller and *Bobbie McGee*'.

The lights of Oklahoma City are sucked behind you, and soon you are running south again down your own short tunnel of light. In your mind the entire spread of the American night is plotted out, its pastures dark, its cities beds of coals, and its highways being traced by the puddles of light that run before the big trucks, whose drivers, up on the high lonesome, must feel the earth is rolling and the truck standing still. Somewhere west, near Salinas, Roger has let her slip away.

The country is really too big for human beings to live in without making a conscious adjustment, and there are only two you can make: You can either increase, through mind or machine, your own reach in space and time, or you can break that space into man-sized chunks. The artist working in this environment, almost by necessity, renders

5. Dennis Hopper

his strategy public. The trail-hands who used to drive cattle up and down the trail to Montana tried both ways. They had songs like *The Texas Rangers* which through incremental variations could extend to literally hundreds of verses, so that a cowboy walking his horse broke his day into discrete distances of time, but none so small as the 'narrow grave, just six by three'. This, by the way, is essentially the strategy of Ed Ruscha's books which contain sequences of photographs of gas stations, parking lots, apartment houses, swimming pools, etc., each photograph depicting one stopping place, or increment, on a human journey through space and time. A good rhetorician could also make a case for *Nine Swimming Pools* as an earthwork (heh, heh).

At night the cowboys would make up and recite brags by which they imaginatively expanded themselves into the landscape so as not to be swallowed up, 'I'm big and I'm bold, boys, and I was big and bold when I was but nine days old. I've rode everything with hair on it and a few things that was too tough to grow any hair. I've rode bull moose on the prod, she-grizzlies and long bolts of lightning. I got nine rows of jaw teeth and holes bored for more. When I'm hungry I eat stick dynamite cut with alkali, when I'm thirsty I can drink a rising creek plumb dry, and when I'm tired, I pillow my head on the Big Horn Mountains, and stretch out from the Upper Grey Bull River clean over to the Crazy Woman Fork. I set my boots in Montana and my hat in Colorado. My bed tarp covers half of Texas and all of Old Mexico. The Grand Canyon, son, ain't nothing but my bean hole ...'

Maybe this is what MacLeish meant when he said that 'the West is a country in the mind and so eternal'. The trucker listening to WBAP, the cowboy reciting his brag, the earth artist executing a gigantic work at a distance of a few feet, all carry in their head the topographical image, which, at any given point on the surface, has more interest than the terrain they can actually see. I would imagine that for most Westerners this translation from man-high ground view into an aerial mapping is a cultural reflex. Before one of Oppenheim's double or triple-scale mapping problems, or Heizer's or De Maria's desert drawings, this translation from ground level to topography is rendered conscious and the viewer participates in the same kind of psychological apotheosis as the cowboy in his brag. It is a pity aerial photos exist to preconfirm your vision.

It should be obvious that the status of objects in the West is tenuous enough without any assistance from Canal Street. Even should an innocent object escape time, wind, weather and the Baptist Church, there is still the *social* thing, 'Nice people buy land, only trashy folks buy things'. So you can always tell the artists who make things out here by the silly little smile that flickers around their lips. Like kamikaze pilots building their own planes, they are constantly amazed by the lunacy of their own activity.

The question is: Why have the national art magazines both overrepresented and misrepresented the earthworks movement and its related disciplines, choosing to portray them as a kind of agrarian Children's Crusade against the art market and the museum system, when this is obviously not the case? First: the work *is* marketable – *anything* is marketable, as St. Paul so aptly demonstrated. Second: the

museums have proved a good source of commissions for these artists. And third: even if the work weren't marketable and the museums were rejecting it, an aesthetic trench in Utah is going to have about as much effect on the object market and museum endowments as admission figures at the Grand Canyon.

The answer might be: It is not the Earth Artists who are challenging the market and the museums, but the magazines themselves. Earth Art and its unpackageable peers cannot hurt the market, but extensive magazine coverage can, since not as much object art will get exposure. The magazines have found in this unpackageable art a vehicle through which they can declare their independence from the art dealers who invented the critical press, nurtured it, and have tended to treat it like a wholly owned subsidiary. Now there is an art form ideally suited to presentation via magazine. Work consisting of photographs and documentation is not presented by journalism, but as journalism – a higher form, needless to say.

The people on the magazines must believe (and I think rightly) that these indefinite art forms might do for the magazines what Pop Art did for the dealers – lend a certain institutional lustre, and with it a modicum of arbitrary power.

Should these art forms flourish and develop we shall soon need a kind of *National Geographic for Aesthetes*. Already Philip Leider and Diane Waldman have been out to see *Double Negative*, and have returned with (literally and figuratively) breathless accounts. New styles of criticism are evolving: it's goodbye Clement Greenberg and Michael Fried, hello Ernie Pyle and Richard Harding Davis. As the artist's style of life becomes less analogous to that of the craftsman and more analogous to that of the professional soldier, concerned with specific campaigns in specific sites, with logistics, ordnance and the burdens of command, so art history and memoirs will change their tone, and we will find chapters like 'The Mojave Desert Affair: Tactical Successes, Strategic Failures', replete with snide attacks on the bureaucrats who never came out in the sun, brief praise for one bureaucrat who, although a peasant who didn't understand a thing, did nevertheless sign the check. (No more, no more Kirk Douglas, earless in Amsterdam, lusting for life. Now it's David Lean directing Lee Van Cleef in *Jones of the Mojave*.) What can happen, simply, is what happened to poetry and poets. The rituals that used to constitute marketing promotion – lectures, magazine articles, visiting-artist grants, museum commissions – can become money-making activities in themselves. This is not so far-fetched as it sounds. An artist who makes documents needs an editor, not a dealer.

Now Pop Art was really *dealer's* art. It *belonged* in a commercial gallery, and it lent the men who dealt in it a certain mystery and charisma. Consider: here is this commercial image done up as a painting, somehow transubstantiated from dross into 'art', an object of a higher order, but still for sale. And here is this guy in his handmade shoes and his serene smile selling this 'higher-order-soup-can' for thousands of bucks. Right? While this poor schmoe down the street is hustling *real* soup cans for two-bits and his have *soup*. Obviously it takes a higher-

order tradesman to hustle this higher order of merchandise. A Wizard? Right, Dot!

There was a lot of *that* about the Pop exhibitions in the 1960s. It was a cosmopolitan moment, with a kind of self-conscious, genuine-rhinestone, shallow-sophistication, tinsel-glamour joy. And then, as now, the pure in heart were appalled; and then, as now, it was hard to tell the true Marxist revulsion with capitalism from the old-line, shabby-genteel revulsion with people 'in trade', as they say in Jane Austen. And the times were changing until the first Castelli Warehouse show showed how they could stay the same. In a twinkling we went from Ultra Violet to the Red Guard, from Ben Day to May Day, from androgynous popsters to post-cultural-revolution macho heavies. But the relationship of the work to the warehouse, and of its aesthetic to 'mainstream sculpture', is structurally analogous with the relationship of Pop to the gallery and the aesthetics of Pop to mainstream painting.

There is a curious kind of Shem-Shaun relationship, too, between Pop Art and Earth Art. They are both arts of location and dislocation, deriving energy from sophisticated forms of trespassing. The Pop Artist imposes his vulgar image on the sanctioned 'art' environment, while the Earth Artist imposes his artificial image upon a secular 'non-art' location. Between the two there is a great deal of work with processes and indefinite objects which, while violating the gallery space the way Pop did, concerns itself with place in a general way. It is hard to say, for instance, whether De Maria's *Pure Dirt* is a simple indefinite object piece, an audacious Pop gesture, or an earthwork under house arrest, and it doesn't really matter. What is interesting is that Dennis Oppenheim has executed the antithesis to De Maria's thesis: his *Gallery Transplant* replicates the floor plan of a Stedelijk Museum gallery on a lot in Jersey City. Here Oppenheim demonstrates the inverse attitude about mediation which again pairs earthworks with Pop. The artist will begin with a mediated image (Johns with a map of the United States) which he remediates by, in essence, painting a picture of a picture. The Earth Artist will often begin with a mediated image as well (Oppenheim with a map of the United States), but Oppenheim will de-mediate. With alterations he will force the map back upon the earth which it represents. This, again, is not unlike Lichtenstein applying the Ben Day illusionistic shadows and highlights to an actual round coffee-cup. Another kind of thesis and antithesis. Probably the most illuminating 'cut' which could be made would be to distinguish the arts of location and dislocation according to their specificity. That is, to distinguish those arts concerned with the semantic idea of 'place', those concerned with the cultural idea of 'art' and 'non-art' space, and those concerned with actual cartographic 'location'. This would make a cut which would group Huebler's conceptual pieces and Oldenburg's monument proposals and Ruscha's books with the other work I have been discussing.

It is in Terry Allen's studio in Lubbock, a storefront out on the Amarillo highway. Terry is banging his piano, and beer cans are dancing atop it; the wind is banging signs and doors, and the November sky is full of local topsoil. Everyone in the room is laughing to hold back tears of

6. Jasper Johns

sublime self-pity as Terry plays *A Truckload of Art*. It is more than the paranoia and bathos of the song; there is an authentic ambivalence between a commitment to technicolour Oz and the sepia-tone city outside:
'A truckload of art from New York City,
Came rolling down the road;
Yeah ... the driver was singing and the sunset was pretty,
But the truck turned over and she rolled off the road.

Yeah ... a Truckload of Art is burning near the highway,
Precious objects are scattered all over the ground,
A terrible sight, if a person were to see it,
But there weren't nobody around.

Yes ... the driver went sailing high in the sky,
Landing in the gold lap of the Lord,
Who smiled and then said, 'Son you're better off dead,
Than hauling a truckload full of hot avant-garde'.

Oh ... a Truckload of Art is burning near the highway,
An' it's raging *far out* of control,
An' what the critics have cheered is now shattered and queered,
And their noble reviews have been stewed on the road.'
— Lyrics by Terry Allen, courtesy Clean Music Inc.

Dave Hickey, 'Earthscapes, landworks and Oz', *Art in America*, New York, September-October 1971, pp. 40-49

Willoughby SHARP
Notes Toward an
Understanding of Earth Art
[1970]

Since the fall of 1966, a new kind of sculpture has become increasingly recognized. The exhibition of these works and the critical interest they have stimulated indicates that this seemingly accidental, unordered, and unpretentious art is the outcome of a sculptural sensibility which is quite independent of the last dominant mode, Minimal Sculpture. Variously characterized as anti-form, anti-illusion, elemental sculpture, impossible art, microemotive art, the new naturalism and poor art, the new work was examined in at least four other important exhibitions in 1969: '9 at Leo Castelli', New York City; 'When Attitudes Become Form', Kunsthalle Bern; 'Square Tags in Round Holes', Stedelijk Museum, Amsterdam; and 'Anti-Illusion: Procedures/ Materials', Whitney Museum of American Art, New York City.

One of the most striking aspects of this work is the wide range and unusual character of the materials employed, materials seldom previously associated with the making of sculpture. These have certain features in common: they tend to be easily manipulated, commonplace, flexible and often heavily textured. How far contemporary sculptors have ventured in their search for new materials for sculptural expression is clearly shown by the following list, by no means exhaustive: air, alcohol, asbestos, ashes,

bamboo, benzene, candles, chalk, charcoal, down, dust, earth, excelsior, felt, fire, flares, flock, foam, graphite, grease, hay, ice, lead, mercury, mineral oil, moss, rocks, rope, rubber, sand, sawdust, seeds, slate, snow, steel wool, string, tar, twigs, twine, water and wax.

The treatment of material by different sculptors is hardly less diverse than the range of things used and is to a large extent dictated by the properties peculiar to each. They are bent, broken, curled, crumpled, heaped, or hung; piled, propped, rolled, scattered, sprayed, spread and sprinkled. Such procedures appear casual, off-hand; they blatantly defy the definition of sculpture as something modeled or carved. Nothing is *made* in the traditional sense; materials are allowed to subside into, or assume, their final shape naturally without being coerced into a preconceived form. The tools employed are very basic or else considered redundant. With a tremendous vocabulary of means at its disposal, the new sculpture manifests itself in an infinite variety of configurations. A common denominator of these works is their focus on physical properties — density, opacity, rigidity — rather than on geometric properties.

A natural consequence of the features singled out above is the intimate relation which the work bears to its site. Many pieces are improvised *in situ*. Distribution of the constituent matter is intuitive and informal, and little attempt is made to arrange the material. The massiveness of the works is often dictated by economic factors rather than by aesthetic considerations. A sense of anonymity and impermanence emanates from them. Of especial importance in the context of site is the work's relation to the floor or the ground. The new sculpture does not stand remote and aloof on a pedestal. It is laid down on the ground or cut beneath its surface. The floor or ground often forms an integral part of the piece, as may the wall plane. Spectators can sometimes pass through the work as well as past it or around it.

Apart from the new attitude to making and the close work-to-place relationship, other aspects of the new sculptural sensibility are an emphasis on time and process, and anti-object orientation, and a desire to subvert style. The new works seem to proclaim the artists' rejection of painting and previous sculptural concerns; the production of artifacts; the commercial art world and its consumer ethos; the urban environment; and the long-standing aesthetic preoccupations with colour, composition, illusion and the internal relation of parts. Many works express a strong desire to draw attention by artistic means to real phenomena. Materials usually thought of as mundane and inartistic have now been designated as aesthetically interesting. With the new sculpture, the pure presentation of materials in carefully selected situations has become a significant aesthetic statement. The non-utilitarian use of certain ordinarily useful materials is not without a sense of paradox: many of the works display a certain stubbornness and recalcitrance, as though they refuse to be absorbed into the existing culture. One major consequence of this is that the traditional line between art and life has become blurred. We are encouraged to draw the distinction between the two afresh.

SOURCES AND INSPIRATIONS OF EARTHWORKS
Early indications of a painterly interest in earth materials may be seen in Duchamp's *Dust* (1920), the pebbles in Pollock's *Number 29* (1950) and Robert Rauschenberg's *Nature Paintings* (1952–53). A more environmental attitude is present in Herbert Bayer's outdoor playground, *Earth Mound* (1955) in Aspen, Colorado; in Walter De Maria's proposal for an 'art yard' (1960) using earthmovers in an empty city lot; and in Heinz Mack's *Sahara Project* (1961), an 'art reservation' which aimed to activate sculpturally a large-scale land mass. A number of kinetic sculptors became interested in earthmoving works in the mid sixties. In 1964 David Medalla made both his first *Sand Machine* and the first of his series of *Mud Machines*. In 1966 Günther Uecker did two works with sand, *Small and Large Desert* and *Sand Mill*. After that, the interest in outdoor earthworks accelerated with Robert Morris' *Model and Cross-Section for a Project in Earth and Sod* (1966) and *Earth Project* (1967); Robert Smithson's *Tar Pool and Gravel Pit* (1966); Hans Haacke's *Grass Cube* (1966) and *Grass Mound* (1967); Mike Heizer's *Depressions* (1968); Barry Flanagan's *One Space Sand Sculpture* (1967); Richard Long's *Dirt* (1967); Claes Oldenburg's *Pit* (1967); Dennis Oppenheim's *Cut in an Oakland Mountain* (1967); Walter De Maria's *Pure Dirt* (1968), and Jan Dibbets' *Grass Roll* (1967). While local factors have played some role in shaping the works of these artists, cross-currents in the art world and the almost immediate information flow have brought about the existence of a truly international sensibility with national variants. Given the number of significant works with earth, critics have hailed an Earth Art movement. But most of the artists mentioned have sculptural concerns which transcend the use of any single material or group of materials. There is no Earth Art, there are just a number of earthworks, an important body of work categorized under a catchy heading.

The sources of the earth sensibility are extremely diverse: Pollock's drip paintings inspired by the Indian sand painters, Rauschenberg's realization that everything can be used as artistic material, Kaprow's emphasis on the process of materials used in large-scale situations, and Morris' writings focusing on the way in which sculpture is experienced. These all have made a strong impact on most of the Earth Artists, especially the Americans. Older works have also had an influence. Carl Andre has said that archaic earthworks have had a tremendous influence on his thinking. Stonehenge and the English countryside which he visited in 1954 also made a great impact on his sculpture. Andre's interest in the six-inch-high Indian mounds which stretch for miles through Minnesota is also relevant, since he showed a small mound of white sand in the 'Monument and Tombs' exhibition at the Museum of Contemporary Crafts in New York City in 1967. But Andre is primarily concerned with place and elemental units rather than the use of earth materials *per se*.

Robert Smithson, who spent his childhood in Passaic, New Jersey, on the cliffs of the Palisades, is interested in geological phenomena and has created sculptural projects with glaciers and volcanoes. Another influence on Smithson has been his work since July 1966 as 'artist-

7. Stonehenge

consultant' for the architects-engineers, Tippetts-Abett-McCarthy-Stratton, in the development of an air terminal site near Fort Worth and Dallas. This experience introduced the artist to a systems approach for the study of information: maps, surveys, reports, specifications and construction models.

The influence of formal garden arrangements shows up in Dennis Oppenheim's 1968 scale models which use grass, trenches, furrows, flowers and hedges. His recent work, *Wheat*, in Holland calling for the seeding of a field in accordance with its topographical configuration and the subsequent harvesting of it relates directly to ordinary farming.

Born of German farming parents, Günther Uecker says that his strongest childhood memories are of drawing in the sand on the shores of the Baltic and ploughing the Mecklenbergian fields, an activity which was to be simulated in one of his proposals for the 'Earth Art' exhibition. Another formative influence of Uecker's work has been his interest in Oriental culture, particularly the Zen rock gardens. Richard Long's works which almost disappear into the land, appear to have grown directly out of his physical environment, the gently rolling moorlands of south-west England surrounding his home in Bristol. His soft-edged indentations certainly reflect the subtleties of the English landscape.

It also may be significant that two of the earth workers, David Medalla and Mike Heizer, have fathers who are anthropologists. Heizer's *Depressions*, diggings done with simple tools like a pick and shovel in the Nevada mudflats, resemble the abandoned excavation sites that he frequented during his youth.

COMMON ASPECTS OF EARTHWORKS

Despite the extremely disparate origins of Earth Art, several sculptural concerns are widely shared by Earth Artists, including a total absence of anthropomorphism and a pervasive conception of the natural order of reality. The conceptual bases of the works vary greatly, but visually they all tend to be unpretentious and relatively unobtrusive. This apparent lack of sophistication, however, is deceptive. The works are without physical support, without base, grounded in their environment either indoors or out. The result is an unframed experience with no one correct perspective or focus.

Outdoor works such as Oppenheim's ice cut in Beebe Lake present the dynamics of elements in the environment. The whole work cannot be taken in at a single glance. The spectator has to experience the different stages of the system if he wants to experience the whole work, which has its own life span. Neither can such works be fully understood through single photographs in the manner of traditional painting or sculpture.

Apart from the time dimension, which forms an integral part of much of the work with earth materials, the most common perceptible aspects of earthworks is their formal simplicity. The materials are treated in a direct, straightforward manner, allowing physical comportment of substance to take precedence over any plastic ambition. In many cases the medium is presented intact with minimum formal modification. Although Smithson has

said that he is not interested in presenting the medium for its own sake, several artists (De Maria, Long, Morris) are. But the intellectual and artistic aspirations evident in their work, as in all the earthworks in the exhibition, go further than mere media presentation. Each artist has carefully worked out a theoretical framework for his sculptural projects, and in a sense this may be said to be a substitute for the traditional sculptural 'base'. Haacke entertains a programmatic approach to his work and advocates sculpture which 'experiences, reacts to its environment, changes, is non-stable ... which lives in time and makes the "spectator" experience time ...' He stresses process, the growth cycle of living systems, allowing them to develop from birth to death. Uecker, a German kineticist and member of the Zero Group, has written very little about the aesthetics of his work; he wants the beauty of the material and its motion to become self-evident. So he endeavours to purify, to reduce to the elemental zero point everything but the essential aesthetic experience of the work. He wants to 'beautify the world with movement'. Neil Jenney's work aspires to transcend its visual image through an environmental theatricality, a tableau consisting of objects which shock the spectator when he realizes that they are not a part of the natural environment but of the piece. According to Jenney, 'The activity among the physical presences of the items and events they realize, providing they exist together, is theatrical'. Related to this attitude is De Maria's and Heizer's concern for the religious aspect of their work, which is not without a moral element. De Maria has written, 'God has created the earth – and we have ignored it'. And Heizer states that art is tending more towards religion. Similar sentiments are present in the persistent pantheism of many of the outdoor earthworks. Perhaps this connects to Heizer's anti-urbanism, a quality of much of the work in earth. It is a reaction to the city where art is necessarily first seen in a gallery or museum. Jenney takes a different attitude, 'Take any portion of the world out there; put it out of context in a gallery, and it's beautiful'. Jenney's dependence on the gallery site singles him out from the other artists in the Cornell exhibition, all of whom have executed or made plans for outdoor works. If his work were placed in an outdoor situation it would probably go unnoticed, because it could not work against the natural environment. Being professionals, all the artists take their exhibition opportunities where they come and are reluctant to express general preferences. Heizer, for example, says that he works outside because he likes the space and it is the only place where he can display mass. But he claims that there are just as many aesthetic restrictions working in the Mojave Desert as there are in the Dwan Gallery. Such viewpoints indicate the strong environmental sensibility and the concern for a man-nature interaction that these artists share.

Another force operative in bringing the new sculpture back to earth is the artists' sharp awareness of the artistic 'mistakes' of the immediate past. The drunken redundancy of the abstract expressionist gesture, the commercialism and camp of Pop Art, and the pristine absolutism of minimal sculpture all were only incidental factors in these individual modes until they were exploited

by the gallery and museum system, by an overanxious press geared to superficial exposition, and by an insensitive art public [...]

IDEOLOGICAL BASES OF THE NEW SCULPTURE

Earthworks show a clear emancipation from ideologies and doctrinaire aesthetic codes. Only a few of the new sculptors have themselves been associated with recent attempts made in New York City to plan reforms of the existing art world structure.' These call for radical postures including the payment of rental fees by museums for works shown in exhibitions, the boycott of commercial galleries by artists, more legal protection against the exploitation of art works, and increased control by the artist over his work. Such potential reforms obviously require long and careful exploration. But experimental exhibitions like this one help to modify the prevalent anachronistic situation of contemporary art in America. A marked feature of this radical work is that it casts doubt on a whole range of previous assumptions about the nature of sculpture, the nature of art itself. It is understandable that Earth Art should throw open to question the exhibition system generally adopted throughout the world. The artist is traditionally expected to make a work in his studio; when the work is selected for an exhibit he rarely has further contact with it. Now it is possible for the artist to leave his studio and produce whatever he wants in the exhibition area itself, and this offers him a way of having greater control over his artistic output.

THE AESTHETIC SIGNIFICANCE OF THE NEW SCULPTURE

In art's escape from object orientation, the new sculpture is trying to confront new issues, ones of vast scale, of open, unstructured space and non-materialistic attitudes. The cloud-seeding project that Oppenheim proposed for the opening of the exhibition, his large-scale crop arrangements in Holland, and his recent underwater projects in the Bahamas indicate the wide-ranging nature of current sculptural concerns. Earth Art calls for the radical reorganization of our natural environment; it offers the possibility of mitigating man's alienation from nature. While the new sculptor is still thinking aesthetically, his concerns and techniques are increasingly becoming those of the environmental manager, the urban planner, the architect, the civil engineer, and the cultural anthropologist. Art can no longer be viewed primarily as a self-sufficient entity. The iconic content of the work has been eliminated, and art is gradually entering into a more significant relationship with the viewer and the component parts of his environment.

1 See the publications of the Artworkers Coalition,
 Box 553, Old Chelsea Station, New York, New York 10011.
Willoughby Sharp, 'Notes Toward an Understanding of Earth
Art', *Earth*, Andrew Dickson White Museum, Cornell
University, Ithaca, New York, 1970, n.p.

SPACE
IS FUNDAMENTAL
IN ANY FORM OF
COMMUNAL LIFE;
SPACE
IS FUNDAMENTAL
IN ANY EXERCISE
OF POWER

Michel FOUCAULT Space, Knowledge and Power, 1984

Michel FOUCAULT
Space, Knowledge and Power [1984]

Space is fundamental in any form of communal life; space is fundamental in any exercise of power.

Michel Foucault, 'Space, Knowledge and Power', an interview with Paul Rabinow, trans. Christian Hubert, *The Foucault Reader*, ed. Paul Rabinow, Pantheon, New York, 1984

Claes OLDENBURG
I Am for an Art … [1961]

I am for an art that is political-erotical-mystical, that does something other than sit on its ass in a museum.
I am for an art that grows up not knowing it is art at all, an art given the chance of having a starting point of zero.
I am for an art that embroils itself with the everyday crap & still comes out on top.
I am for an art that imitates the human, that is comic, if necessary, or violent, or whatever is necessary.
I am for an art that takes its form from the lines of life itself, that twists and extends and accumulates and spits and drips, and is heavy and coarse and blunt and sweet and stupid as life itself […]
I am for the art that grows in a pot, that comes down out of the skies at night, like lightning, that hides in the clouds and growls. I am for art that is flipped on and off like a switch […]
I am for the art of scratchings in the asphalt, daubing at the walls. I am for the art of bending down and kicking metal and breaking glass, and pulling at things to make them fall down […]

Claes Oldenburg, 'I Am for an Art…', The Store, New York, December, 1961; reprinted in *Oldenburg*, Arts Council of Great Britain, London, 1970; *Art in Theory 1900-1990: An Anthology of Changing Ideas*, ed. Charles Harrison and Paul Wood, Blackwell Publishers, Oxford and Cambridge, Massachusetts, 1992, pp. 727-29

Harold ROSENBERG
De-aestheticization [1972]

The sculptor Robert Morris once executed before a notary public the following document:
'Statement of Aesthetic Withdrawal
The undersigned, Robert Morris, being the maker of the metal construction entitled Litanies, described in the annexed Exhibit A, hereby withdraws from said construction all aesthetic quality and content and declares that from the date hereof said construction has no such quality and content.
Dated: November 15, 1963
Robert Morris'

Not having seen *Litanies* or read the description of it in Exhibit A, I cannot say how it was affected by Morris' withdrawal or what its aesthetic condition was after the artist signed his statement. Perhaps the construction turned into what one permissive critic has called a 'super-object of literalist art' or an 'anti-object of Conceptual Art'. Or perhaps it became an 'anxious object', the kind of modern creation that is destined to endure uncertainty as to whether it is a work of art or not. In any case, the obvious intent of Morris' deposition was to convert *Litanies* into an object of the same order as the reductionist-inspired boxes, modules and shaped canvases that flooded the art world in the sixties. Morris' de-aestheticized construction anticipated, for example, the demand of Minimalist Donald Judd for an art with 'the specificity and power of actual materials, actual colours, actual space'.

Both Morris' aesthetic withdrawal and Judd's call for materials that are more real, or actual, than others — for example, brown dirt rather than brown paint — imply a decision to purge art of the seeds of artifice. Towards that end, Morris' verbal exorcism would probably be less effective than Judd's pre-selected substances. For works to be empty of aesthetic content, it seems logical that they be produced out of raw rocks and lumber, out of stuff intended for purposes other than art, such as strips of rubber or electric bulbs, or even out of living people or animals. Better still, non-aesthetic art can be worked into nature itself, in which case it becomes, as one writer recently put it, 'a fragment of the real within the real'. Digging holes or trenches in the ground, cutting tracks through a cornfield, laying a square sheet of lead in the snow (the so-called earthworks art) do not in their de-aestheticizing essence differ in any way from exhibiting a pile of mail sacks, tacking a row of newspapers on a wall or keeping the shutter of a camera open while speeding through the night (the so-called anti-form art). Aesthetic withdrawal also paves the way for 'process' art — in which chemical, biological, physical or seasonal forces affect the original materials and either change their form or destroy them, as in works incorporating growing grass and bacteria or inviting rust — and random art, whose form and content are decided by chance. Ultimately, the repudiation of the aesthetic suggests the total elimination of the art object and its replacement by an idea for a work or by the rumour that one has been consummated — as in Conceptual Art. Despite the stress on the actuality of the materials used, the principle common to all classes of de-aestheticized art is that the finished product, if any, is of less significance than the procedures that brought the work into being and of which it is the trace.

The movement towards de-aestheticization is both a reaction against and a continuation of the trend towards formalistic over-refinement in the art of the sixties, and particularly in the rhetoric that accompanied it. Asserting the nostalgia of artists for invention, craftsmanship and expressive behaviour, earthworks protest against the constricting museum-gallery system organized around a handful of aesthetic platitudes. Works that are constructed in the desert or on a distant seashore, that are not for sale and cannot be collected, that are formless piles of rubbish or that are not even works but information about plans for works or events that have taken place are, one earthworks artist is quoted as saying, a 'practical alternative to the absolute city system of art'. Here the sociology of art overtly enters into the theory and practice of creation. The current defiance of the aesthetic is the latest incident in the perennial reversion to primitivism in the art of the past hundred years and the exaltation of ruggedness, simplicity and doing what one chooses without regard to the public and its representatives […]

Harold Rosenberg, 'De-aestheticization', *De-definition of Art: Action Art to Pop to Earthworks*, Horizon Press, New York, 1972, pp. 28-29; 32

Michael HEIZER,
Dennis OPPENHEIM,
Robert SMITHSON
Interview with *Avalanche* [1970]

Avalanche Dennis, how did you first come to use earth as sculptural material?
Dennis Oppenheim Well, it didn't occur to me at first that this was what I was doing. Then gradually I found myself trying to get below ground level.
Avalanche Why?
Oppenheim Because I wasn't very excited about objects which protrude from the ground. I felt this implied an embellishment of external space. To me a piece of sculpture inside a room is a disruption of interior space. It's a protrusion, an unnecessary addition to what could be a sufficient space in itself. My transition to earth materials took place in Oakland a few summers ago, when I cut a wedge from the side of a mountain. I was more concerned with the negative process of excavating that shape from the mountainside than with making an earthwork as such. It was just a coincidence that I did this with earth.
Avalanche You didn't think of this as an earthwork?
Oppenheim No, not then. But at that point I began to think very seriously about place, the physical terrain. And this led me to question the confines of the gallery space and to start working things like bleacher systems, mostly in an outdoor context but still referring back to the gallery site and taking some stimulus from that outside again. Some of what I learn outside I bring back to use in a gallery context.
Avalanche Would you agree with Smithson that you, Dennis and Mike, are involved in a dialectic between the outdoors and the gallery?
Oppenheim I think that the outdoor/indoor relationship in my work is more subtle. I don't really carry a gallery disturbance concept around with me; I leave that behind in the gallery. Occasionally I consider the gallery site as though it were some kind of hunting ground.
Avalanche Then for you the two activities are quite separate?
Oppenheim Yes, on the whole. There are areas where they

begin to fuse, but generally when I'm outside I'm completely outside.

Robert Smithson I've thought in this way too, Dennis. I've designed works for the outdoors only. But what I want to emphasize is that if you want to concentrate exclusively on the exterior, that's fine, but you're probably always going to come back to the interior in some manner.

Avalanche So what may really be the difference between you is the attitude you have to the site. Dennis, how would you describe your attitude to a specific site that you've worked with?

Oppenheim A good deal of my preliminary thinking is done by viewing topographical maps and aerial maps and then collecting various data on weather information. Then I carry this with me to the terrestrial studio. For instance, my frozen lake project in Maine involves plotting an enlarged version of the International Date Line into a frozen lake and truncating an island in the middle. I call this island a time-pocket because I'm stopping the IDL there. So this is an application of a theoretical framework to a physical situation – I'm actually cutting this strip out with chain saws. Some interesting things happen during this process: you tend to get grandiose ideas when you look at large areas on maps, then you find they're difficult to reach so you develop a strenuous relationship with the land. If I were asked by a gallery to show my Maine piece, obviously I wouldn't be able to. So I would make a model of it.

Avalanche What about a photograph?

Oppenheim OK, or a photograph. I'm not really that attuned to photos to the extent to which Mike is. I don't really show photos as such. At the moment I'm quite lackadaisical about the presentation of my work; it's almost like a scientific convention. Now Bob's doing something very different. His non-site is an intrinsic part of his activity on the site, whereas my model is just an abstract of what happens outside and I just can't get that excited about it.

Avalanche Could you say something, Bob, about the way in which you choose your sites?

Smithson I very often travel to a particular area; that's the primary phase. I begin in a very primitive way by going from one point to another. I started taking trips to specific sites in 1965: certain sites would appeal to me more – sites that had been in some way disrupted or pulverized. I was really looking for a denaturalization rather than built-up scenic beauty. And when you take a trip you need a lot of precise data, so often I would use quadrangle maps; the mapping followed the travelling. The first non-site that I did was at the Pine Barrens in southern New Jersey. This place was in a state of equilibrium, it had a kind of tranquillity and it was discontinuous from the surrounding area because of its stunted pine trees. There was a hexagon airfield there which lent itself very well to the application of certain crystalline structures which had preoccupied me in my earlier work. A crystal can be mapped out, and in fact I think it was crystallography which led me to map-making. Initially I went to the Pine Barrens to set up a system of outdoor pavements but in the process I became interested in the abstract aspects of mapping. At the same time I was working with maps and aerial photography for an architectural company. I had

great access to them. So I decided to use the Pine Barrens site as a piece of paper and draw a crystalline structure over the landmass rather than on a 20 × 30 sheet of paper. In this way I was applying my conceptual thinking directly to the disruption of the site over an area of several miles. So you might say my Non-site was a three-dimensional map of the site.

Oppenheim At one point in the process you've just described, Bob, you take a quadrangle map of an airport. In my recent piece at the Dwan Gallery, I took the contour lines from a contour map of Ecuador, transferred this two-dimensional data onto a real location. I think there's a genuine similarity here. In this particular case I blew up the information to full size and transferred it to Smith County, Kansas, which is the exact centre of the United States.

Smithson I think that what Dennis is doing is taking a site from one part of the world and transferring the data about it to another site, which I would call a dis-location. This is a very specific activity concerned with the transference of information, not at all a glib expressive gesture. He's in a sense transforming a terrestrial site into a map. Where I differ from Dennis is that I'm dealing with an exterior and an interior as opposed to two exterior situations.

Avalanche Why do you still find it necessary to exhibit in a gallery?

Smithson I like the artificial limits that the gallery presents. I would say my art exists in two realms – in my outdoor sites which can be visited only and which have no objects imposed on them, and indoors, where objects do exist ...

Avalanche Isn't that a rather artificial dichotomy?

Smithson Yes, because I think art is concerned with limits and I'm interested in making art. You can call this traditional if you like. But I have also thought about purely outdoor pieces. My first earth proposals were for sinks of pulverized materials. But then I got interested in the indoor-outdoor dialectic. I don't think you're freer artistically in the desert than you are inside a room.

Avalanche Do you agree with that, Mike?

Michael Heizer I think you have just as many limitations, if not more, in a fresh air situation.

Avalanche But I don't see how you can equate the four walls of a gallery, say, with the Nevada mudflats. Aren't there more spatial restrictions in a gallery?

Heizer I don't particularly want to pursue the analogy between the gallery and the mudflats. I think the only important limitations on art are the ones imposed or accepted by the artist himself.

Avalanche Then why do you choose to work outdoors?

Heizer I work outside because it's the only place where I can displace mass. I like the scale – that's certainly one difference between working in a gallery and working outdoors. I'm not trying to compete in size with any natural phenomena, because it's technically impossible.

Avalanche When Yves Klein signed the world, would you say that was a way of overcoming limits?

Smithson No, because then he still has the limits of the world ...

Avalanche Dennis, recently you have been doing really large-scale outdoor pieces. What propels you to work

outdoors rather than in an already structured situation?

Oppenheim I'm following a fairly free path at present so I'm not exclusively outdoors in that sense. In fact I'm tending to refer back to the gallery.

Avalanche Why do you find that necessary?

Oppenheim It's a kind of nostalgia, I think. It seems to me that a lot of problems are concerned mainly with presentation. For some people the gallery issue is very important now but I think that in time it will mellow. Recently I have been taking galleries apart, slowly. I have a proposal that involves removing the floorboards and eventually taking the entire floor out. I feel this is a creeping back to the home site.

Avalanche Bob, how would you describe the relation between the gallery exhibit and nature?

Smithson I think we all see the landscape as co-extensive with the gallery. I don't think we're dealing with matter in terms of a back-to-nature movement. For me the work is a museum. Photography makes nature obsolete. My thinking in terms of the site and the non-site makes me feel there's no need to refer to nature anymore. I'm totally concerned with making art and this is mainly an act of viewing, a mental activity that zeroes in on discrete sites. I'm not interested in presenting the medium for its own sake. I think that's a weakness of a lot of contemporary work.

Avalanche Dennis, how do you see the work of other New York sculptors, specifically Morris, Judd, LeWitt and Andre?

Oppenheim Andre at one point began to question very seriously the validity of the object. He began to talk about sculpture as place. And Sol LeWitt's concern with systems, as opposed to the manual making and placement of object art can also be seen as a move against the object. These two artists have made an impact on me. They built such damn good stuff that I realized an impasse had been reached. Morris also got to the point where if he'd made his pieces a little better, he wouldn't have had to make them at all. I felt that very strongly and I knew there must be another direction in which to work.

Avalanche Are you referring to Morris' minimal work?

Oppenheim Yes, his polyhedrons. The earth movement has derived some stimulus from Minimal Art, but I think that now it's moved away from their main preoccupations.

Heizer I don't think that you're going to be able to say what the source of this kind of art is. But one aspect of earth orientation is that the works circumvent the galleries and the artist has no sense of the commercial or the utilitarian. But it's easy to be hyperaesthetic, and not so easy to maintain it.

Smithson If you're interested in making art then you can't take a kind of facile cop-out. Art isn't made that way. It's a lot more rigorous.

Heizer Eventually you develop some sense of responsibility about transmitting your art by whatever means are available.

Avalanche What do you have to say about that, Dennis?

Oppenheim I think we should discuss what's going to happen to Earth Art, because the cultural reverberations stimulated by some of our outdoor pieces are going to be very different from those produced by a piece of rigid

indoor sculpture.

Avalanche For one thing, I think a lot of artists will begin to see the enormous possibilities inherent in working outdoors. 'Everything is beautiful but not everything is art'.

Heizer Do you mean something ought to be said about the *importance* of what's being done with earth?

Avalanche Yes.

Heizer Well, look at it this way. Art usually becomes another commodity. One of the implications of Earth Art might be to remove completely the commodity-status of a work of art and to allow a return to the idea of art as ...

Avalanche Art as activity?

Heizer No, if you consider art as activity then it becomes like recreation. I guess I'd like to see art become more of a religion.

Avalanche In what sense?

Heizer In the sense that it wouldn't have a utilitarian function any more. It's OK for the artist to say he doesn't have any mercenary intentions, knowing full well that his art is used avariciously.

Avalanche So the artist's responsibility extends beyond the creative act?

Heizer The artist is responsible for everything, for the work and for how it's used. Enough attacks have been made on my work for me to have considered protecting it, like a dog burying a bone in the ground.

Oppenheim Don't you see art as involved with weather or perhaps redirecting traffic?

Heizer I like your idea, Dennis, but it sounds as though you want to make a rain machine, which I don't think is what you mean at all.

Avalanche Aren't you indicating possibilities here that other artists haven't really explored? It seems to me that one of the principal functions of artistic involvement is to stretch the limits of what can be done and to show others that art isn't just making objects to put in galleries, but that there can be an artistic relationship with things outside the gallery that is valuable to explore. Mike, what are you trying to achieve by working in nature?

Heizer Well, the reason I go there is because it satisfies my feeling for space. I like that space. That's why I choose to do my art there.

Avalanche Has your knowledge of archaeological excavations had any bearing on your work?

Heizer It might have affected my imagination because I've spent some time recording technical excavations. My work is closely tied up with my own experiences; for instance, my personal associations with dirt are very real. I really like it, I really like to lie in the dirt. I don't feel close to it in the farmer's sense ... And I've transcended the mechanical, which was difficult. It wasn't a legitimate art transition but it was psychologically important because the work I'm doing now with earth satisfies some very basic desires.

Avalanche So you're really happy doing it.

Heizer Right. I'm not a purist in any sense and if I'm at all interested in Bob's or Dennis' work, it's because I sense in it the same kind of divergence from a single ideal as in my own. That's why I said earlier that Earth Art is a very private thing. And of course I'm not at all concerned about style.

Smithson I think most of us are very aware of time on a geological scale, of the great extent of time which has gone into the sculpting of matter. Take an Anthony Caro: that expresses a certain nostalgia for a Garden of Eden view of the world, whereas I think in terms of millions of years, including times when humans weren't around. Anthony Caro never thought about the ground his work stands on. In fact, I see his work as anthropocentric Cubism. He has yet to discover the dreadful object. And then to leave it. He has a long way to go.

Avalanche It seems to me that this consciousness of geological process, of very gradual physical change, is a positive feature, even an aesthetic characteristic of some of the more significant earth works.

Smithson It's an art of uncertainty because instability in general has become very important. So the return to Mother Earth is a revival of a very archaic sentiment. Any kind of comprehension beyond this is essentially artificial.

Avalanche Geological thinking seems to play an important role in your aesthetic.

Smithson I don't think we're making an appeal to science at all. There's no reason why science should have any priority.

Heizer Scientific theories could just as well be magic as far as I'm concerned. I don't agree with any of them.

Avalanche Do you see them as fiction?

Smithson Yes.

Heizer Yes. I think that if we have any objective in mind it's to supplant science.

Smithson I wrote an article recently entitled 'Strata' covering the Precambrian to the Cretaceous periods. I dealt with that as a fiction. Science works, yes, but to what purpose? Disturbing the grit on the moon with the help of billions of dollars. I'm more interested in all aspects of time. And also in the experiences you get at the site, when you're confronted by the physicality of actual duration. Take the Palisades Non-site: you find trolley tracks embedded in the ground, vestiges of something else. All technology is matter built up into ideal structures. Science is a shack in the lava flow of ideas. It must all return to dust. Moondust, perhaps.

Avalanche Why don't we talk about one of your pieces, Bob, the one on the Mono Lake, for example.

Smithson The Mono Lake Non-site, yes. Maps are very elusive things. This map of Mono Lake is a map that tells you how to get nowhere. Mono Lake is in northern California and I chose this site because it had a great abundance of cinders and pumice, a fine granular material. The lake itself is a salt lake. If you look at the map, you'll see it is in the shape of a margin – it has no centre. It's a frame, actually. The non-site itself is a square channel that contains the pumice and the cinders that collected around the shores of the lake at a place called Black Point. This type of pumice is indigenous to the whole area.

Avalanche What exactly is your concept of a Non-site?

Smithson There's a central focus point which is the non-site; the site is the unfocused fringe where your mind loses its boundaries and a sense of the oceanic pervades, as it were. I like the idea of quiet catastrophes taking place ... The interesting thing about the site is that, unlike the non-site, it throws you out to the fringes. In other words, there's nothing to grasp onto except the cinders and there's no way of focusing on a particular place. One might even say that the place has absconded or been lost. This is a map that will take you somewhere, but when you get there you won't really know where you are. In a sense the Non-site is the centre of the system, and the site itself is the fringe or the edge. As I look around the margin of this map, I see a ranch, a place called the sulphur pond; falls, and a water tank; the word 'pumice'. But it's all very elusive. The shorelines tell you nothing about the cinders on the shore. You're always caught between two worlds, one that is and one that isn't. I could give you a few facts about Mono Lake. Actually, I made a movie about it with Mike Heizer. It's in a state of chaos, it's one of those things that I wouldn't want to show to more than a few people. But Mono Lake itself is fascinating. Geologists have found evidence of five periods of glaciation in the Sierra. The first began about half a million years ago, the last ended less than fifteen thousand years ago. The glaciers left prominent marks upon the landscape, they gouged out canyons, broadening and deepening them into U-shaped valleys with steep headwalls and then advanced onto the plain. They built up high parallel ridges of stony debris called moraines. There are all sorts of things like that. The Mono craters are a chain of volcanic cones. Most of them were formed after Lake Russell evaporated. That's why I like it, because in a sense the whole site tends to evaporate. The closer you think you're getting to it and the more you circumscribe it, the more it evaporates. It becomes like a mirage and it just disappears. The site is a place where a piece should be but isn't. The piece that should be there is now somewhere else, usually in a room. Actually everything that's of any importance takes place outside the room. But the room reminds us of the limitations of our condition.

Avalanche Why do you bother with Non-site at all?

Smithson Why do I?

Avalanche Why don't you just designate a site?

Smithson Because I like the ponderousness of the material. I like the idea of shipping back the rocks across the country. It gives me more of a weighty sensation. If I just thought about it and held it in my mind it would be a manifestation of idealistic reduction and I'm not really interested in that. You spoke about evil: actually for a long time people thought mountains were evil because they were so proud compared to the humble valleys. It's true! Something called the mountain controversy. It started in the eighteenth century.

Avalanche How would you characterize your attitude to nature?

Smithson Well, I developed a dialectic between the mind-matter aspects of nature. My view became dualistic, moving back and forth between the two areas. It's not involved with nature, in the classical sense. There's no anthropomorphic reference to environment. But I do have a stronger tendency towards the inorganic than to the organic. The organic is closer to the idea of nature: I'm more interested in denaturalization or in artifice than I am in any kind of naturalism.

Avalanche Are there any elements of destruction in your work?

Smithson It's already destroyed. It's a slow process of

destruction. The world is slowly destroying itself. The catastrophe comes suddenly, but slowly.

Avalanche Big bang.

Smithson Well, that's for some. That's exciting. I prefer the lava, the cinders that are completely cold and entropically cooled off. They've been resting in a state of delayed motion. It takes something like a millennium to move them. That's enough action for me. Actually that's enough to knock me out.

Avalanche A millennium of gradual flow ...

Smithson You know, one pebble moving one foot in two million years is enough action to keep me really excited. But some of us have to simulate upheaval, step up the action. Sometimes we have to call on Bacchus. Excess. Madness. The end of the World. Mass Carnage. Falling Empires.

Avalanche Mmmm ... What would you say about the relationship between your work and photographs of it?

Smithson Photographs steal away the spirit of the work ...

Oppenheim One day the photograph is going to become even more important that it is now – there'll be a heightened respect for photographers. Let's assume that art has moved away from its manual phase and that now it's more concerned with the location of material and with speculation. So the work of art now has to be visited or abstracted from a photograph, rather than made. I don't think the photograph could have had the same richness of meaning in the past as it has now. But I'm not particularly an advocate of the photograph.

Avalanche It's sometimes claimed that the photo is a distortion of sensory perception.

Heizer Well, the experience of looking is constantly altered by physical factors. I think certain photographs offer a precise way of seeing works. You can take a photograph into a clean white room, with no sound, no noise. You can wait until you feel so inclined before you look at it and possibly experience to a greater depth whatever view you have been presented with.

Avalanche What are your primary concerns, Mike, in carrying out one of your *Depressions*?

Heizer I'm mainly concerned with physical properties, with density, volume, mass and space. For instance, I find an 18-foot2 (1.7 m^3) granite boulder. That's mass. It's already a piece of sculpture. But as an artist it's not enough for me to say that, so I mess with it. I defile ... if you're a naturalist you'd say I defiled it, otherwise you'd say I responded in my own manner. And that was by putting some space under the boulder. My work is in opposition to the kind of sculpture which involves rigidly forming, welding, sealing, perfecting the surface of a piece of material. I also want my work to complete its life-span during my lifetime. Say the work lasts for ten minutes or even six months, which isn't really very long, it still satisfies the basic requirements of fact ... Everything is beautiful, but not everything is art.

Avalanche What makes it art?

Heizer I guess when you insist on it long enough, when you can convince someone else that it is. I think that the look of art is broadening. The idea of sculpture has been destroyed, subverted, put down. And the idea of painting has also been subverted. This has happened in a very

strange way, through a process of logical questioning by artists. It hasn't been like these various looks which appear every twenty years or so; they're just minor phenomena within the larger one that will be remembered.

Avalanche Do you approve of this undermining of existing art forms?

Heizer Of course I do, because then the artist will realize that only a real primitive would make something as icon-like, as obviously pagan as a painting. I worked all those years painting and now I'm critical of the fact that I won't allow myself to do those mindless things any more. It looks as though the whole spirit of painting and sculpture could be shrugged off, in two years' time perhaps. It's almost totally inconsequential. Of course it'll never happen, but it's conceivable, it could happen.

Michael Heizer, Dennis Oppenheim, Robert Smithson, 'Interview with *Avalanche*', *Avalanche*, New York, Autumn 1970, pp. 48-71; reprinted in *The Writings of Robert Smithson*, ed. Nancy Holt, New York University Press, New York, 1979

INTEGRATION

The synchronicity between social and cultural conditions that characterized the 1960s was clearly evident in the decade's artmaking and theory. Complex and complimentary impulses grew from a frustration with the formal and economic frameworks of Modernism and a growing counter-cultural ethos, driving early Land Artists like De Maria, Heizer, Smithson and Oppenheim away from the city and into the desert, 'Processes of heavy construction have a devastating kind of primordial grandeur […] The actual *disruption* of the earth's crust is at times very compelling … The tools of art have too long been confined to the "studio". The city gives the illusion that the earth does not exist', notes Smithson in his essay, 'A Sedimentation of the Mind: Earth Projects'. The essays collected in Integration begin to sketch out the contemporary socio-cultural context of Land and Environmental Art: the rise of anti-establishment critique; the celebration of the industrial, man made environment; and the heroic posture of the 'artist-as-pioneer' in the open space of a landscape subjected to repeated and variable forms of myth-making, symbolic analysis and practical exploitation.

Isamu NOGUCHI
Artist's statement [1926]

It is my desire to view nature through nature's eyes, and to ignore man as an object for special veneration. There must be unthought of heights of beauty to which sculpture may be raised by this reversal of attitude.

An unlimited field for abstract sculptural expression would then be realized in which flowers and trees, rivers and mountains, as well as birds, beasts and man, would be given their due place. Indeed, a fine balance of spirit with matter can only concur when the artist has so thoroughly submerged himself in the study of the unity of nature as to truly become once more a part of nature – a part of the very earth, thus to view the inner surfaces and the life elements. The material he works with would mean to him more than mere plastic matter, but would act as a co-ordinant and asset to his theme. In such a way may be gained a true symphony in sculpture.

It is difficult to visualize sculpture in words, especially that kind for which there are but few similes. Some sculptors today appreciate the importance of matter, but are too much engrossed with symbolism. Others who are undoubtedly artists are interested only in the interpretation of strictly human forms. May I therefore, beg to recognize no antecedents with this declaration of intentions?

Isamu Noguchi, 'Artist's statement', Guggenheim Fellowship application, 1926; reprinted in *Isamu Noguchi, A Sculptor's World*, Harper and Row, New York, 1968, p. 16

Isamu NOGUCHI
Artist's statement [1946]

The essence of sculpture is for me the perception of space, the continuum of our existence. All dimensions are but measures of it, as in the relative perspective of our vision lie volume, line, point, giving shape, distance, proportion. Movement, light, and time itself are also qualities of space. Space is otherwise inconceivable. These are the essences of sculpture and as our concepts of them change so must our sculpture change.

Since our experiences of space are, however, limited to momentary segments of time, growth must be the core of existence. We are reborn, and so in art as in nature there is growth, by which I mean change attuned to the living. Thus growth can only be new, for awareness is the everchanging adjustment of the human psyche to chaos. If I say that growth is the constant transfusion of human meaning into the encroaching void, then how great is our need today when our knowledge of the universe has filled space with energy, driving us toward a greater chaos and new equilibriums.

I say it is the sculptor who orders and animates space, gives it meaning.

Isamu Noguchi, 'Artist's statement', *Fourteen Americans*, ed. Dorothy C. Miller, The Museum of Modern Art, New York,

1946, p. 39; Bruce Altshuler, *Noguchi*, Abbeville, New York, 1994, pp. 105-6

Jack KEROUAC
On the Road [1959]

What is that feeling when you're driving away from people and they recede on the plain till you see their specks dispersing? – it's the too-huge world vaulting us, and it's good-bye. But we lean forward to the next crazy venture beneath the skies [...]

I wondered what the Spirit of the Mountain was thinking, and looked up and saw jackpines in the moon, and saw ghosts of old miners, and wondered about it. In the whole eastern dark wall of the Divide this night there was silence and the whisper of the wind, except in the ravine where we roared; and on the other side of the Divide was the great Western Slope, and the big plateau that went to Steamboat Springs, and dropped, and led you to the western Colorado desert and the Utah desert; all in darkness now as we fumed and screamed in our mountain nook, mad drunken Americans in the mighty land. We were on the roof of America and all we could do was yell, I guess – across the night, eastward over the Plains, where somewhere an old man with white hair was probably walking towards us with the Word, and would arrive any minute and make us silent [...]

Jack Kerouac, *On the Road*, Viking, New York, 1959, p. 55; 156

Rosalind KRAUSS
Passages in Modern Sculpture [1977]

[...] The *Double Negative*, an earthwork sculpture by Michael Heizer, was made in 1969 in the Nevada desert. It consists of two slots, each 40 feet deep and 100 feet long, dug into the tops of two mesas, sited opposite one another and separated by a deep ravine. Because of its enormous size, and its location, the only means of experiencing this work is to be in it – to inhabit it the way we think of ourselves as inhabiting the space of our bodies. Yet the image we have of our own relation to our bodies is that we are *centred* inside them; we have knowledge of ourselves that places us, so to speak, at our own absolute core; we are wholly transparent to our own consciousness in a manner that seems to permit us to say, 'I know what *I* think and feel but *he* does not'. In this sense the *Double Negative* does not resemble the picture that we have of the way we inhabit ourselves. For, although it is symmetrical and has a centre (the mid-point of the ravine separating the two slots), the centre is one we cannot occupy. We can only stand in one slotted space and look across to the other. Indeed, it is only by looking at the other that we can form a picture of the space in which we stand.

By forcing on us this eccentric position relative to the centre of the work, the *Double Negative* suggests an alternative to the picture we have of how we know ourselves. It causes us to meditate on a knowledge of ourselves that is formed by looking outward toward the responses of others as they look back at us. It is a metaphor for the self as it is known through its appearance to the other.

The effect of the *Double Negative* is to declare the eccentricity of the position we occupy relative to our physical and psychological centres. But it goes even further than that. Because we must look across the ravine to see the mirror image of the space we occupy, the expanse of the ravine itself must be incorporated into the enclosure formed by the sculpture. Heizer's image therefore depicts the intervention of the outer world into the body's internal being, taking up residence there and forming its motivations and its meanings.

Both the notion of eccentricity and the idea of the invasion of a world into the closed space of form reappears in another earthwork, conceived contemporaneously with the *Double Negative* but executed the following year in the Great Salt Lake in Utah. Robert Smithson's *Spiral Jetty* (1970) is a heaped runway of basalt rock and dirt, fifteen feet wide, which corkscrews fifteen hundred feet out into the red water of the lake off Rozelle Point. Like the *Double Negative*, the *Spiral Jetty* is physically meant to be entered. One can only see the work by moving along it in narrowing arcs toward its terminus.

As a spiral this configuration does have a centre which we as spectators can actually occupy. Yet the experience of the work is one of continually being de-centred within the great expanse of lake and sky. Smithson himself, in writing about his first contact with the site of this work, evokes the vertiginous response to perceiving himself as de-centred: 'As I looked at the site, it reverberated out to the horizons only to suggest an immobile cyclone while flickering light made the entire landscape appear to quake. A dormant earthquake spread into an immense roundness. From that gyrating space emerged the possibility of the *Spiral Jetty*. No idea, no concepts, no systems, no structures, no abstractions could hold themselves together in the actuality of that phenomenological evidence'.

The 'phenomenological evidence' out of which Smithson's idea for the *Jetty* came, derived not only from the visual appearance of the lake, but also from what we might call its mythological setting, which Smithson refers to in his terms 'immobile cyclone' and 'gyrating space'. The occurrence of a huge interior salt lake had for centuries seemed to be a freak of nature, and the early inhabitants of the region sought its explanation in myth. One such myth was that the lake had originally been connected to the Pacific Ocean through a huge underground waterway, the presence of which caused treacherous whirlpools to form at the lake's centre. In using the form of the spiral to imitate the settlers' mythic whirlpool, Smithson incorporates the existence of the myth into the space of the work. In doing so he expands on the nature of that external space located at our bodies' centres which had been part of the *Double Negative*'s image. Smithson creates an image of our psychological response to time and of the way we are determined to control it by the creation of historical fantasies. But the

Spiral Jetty attempts to supplant historical formulas with the experience of a moment-to-moment passage through space and time [...]

Rosalind Krauss, *Passages in Modern Sculpture*, MIT Press, London and Cambridge, Massachusetts, 1996, pp. 280-82. Originally published by Viking Press, New York, 1977

Thomas MCEVILLEY
The Rightness of Wrongness: Modernism and its Alter Ego ... [1992]

[...] In 1968 Earth Art was born in the works of Oppenheim and a group of other young artists, such as Michael Heizer, Walter De Maria, Robert Smithson and others. Most of these artists were recently out of art school and inspired by the sense of multiplying options in the air. Earth Art was a multifaceted strategy to redirect the art energy. On the one hand, it located the artwork in the real world of the landscape – indeed, often it made the landscape the work, but not in the sense of the Romantic reverence for scenery: it could be a scene of urban decay and desolation, or a strip-mined area that was brought into the expanded realm of art. In this sense Earth Art, like other tendencies of the time, was about demystifying art by taking it out of its sheltered milieu into the world. On the other hand, for some of its practitioners Earth Art had certain ancient resonances, harking back to the era of megaliths, pyramids, and other monumentally scaled sacred objects sited in the landscape. In this somewhat contrary sense it sought to regain a pre-modern feeling of the extra-aesthetic sacredness of art through a change of scale and location. Oppenheim's work was more of the first type than the second, but it had a theoretical focus that was different from either: it involved dispassionately working out certain principles that related primarily to a quasi-scientific methodology for art making, rather than to aesthetics, ideas of sanctity, or the project of demystification.

Oppenheim's *Landslide* (1968), executed off exit 52 of the Long Island Expressway, was one of the first earthworks that was actually realized rather than merely contemplated or sketched out; it was used by both *Time* and *Life* magazines in that year to indicate the beginning of the trend. Almost didactic in its dispassionate approach, *Landslide* involved angled boards arranged around a slope. It extended the idea of minimal sculpture into nature with suggestions of longitude and latitude lines, while simultaneously evoking the idea of a bleacher or a communal viewing platform. Oppenheim thought of it as 'activating' a pre-existing area of the world. In so far as an area of the world would be changed into an art area by this activation, the beginnings of 'systems art', named by Jack Burnham in the 1968 *Artforum* article 'Real Systems Art', can be seen. (Systems art operated by transferring an object or site from one semantic system to another.)

In the spring of 1968 Oppenheim worked furiously at

these theoretical proposals, defining the parameters of the emerging genre of Earth Art as he went along. *Directed Seeding* (1969) was a wheat field harvested along lines pre-set by the artist in an oversize parody of action painting and painterly composition in general. In *Annual Rings*, the pattern of growth rings from a tree trunk was transferred to a huge scale and etched into the snow-covered ice of a waterway occupying the United States-Canada border and crossing a time zone line. Oppenheim's tactic of reconceiving something by radically altering its scale (usually by enlarging it) was emerging in these pieces, as well as his tendency to emphasize borders – temporal, spatial, behavioural – the breaching of them, the exchange of systems and contexts, and so on. In *Contour Lines Scribed in Swamp Grass* (1968) a pattern of elevation lines from a topographical map was transferred to a swampy field that lacked the indicated elevation and would be submerged under water at certain times, the cartographer's sign was shifted both in scale and in meaning.

The rules that emerged for these works involved a found or real world element, such as the map lines, as an ethical surrogate for the site. Oppenheim, like other classical conceptualists, felt constrained to work by preconceived extra-aesthetic rules that go back in form to Duchamp's quasi-scientific instructions for *3 Standard Stoppages* in 1913–14. Among other things, this served to deny the traditional aesthetic view of art as an absolutely free play of intuitions – a view that seemed somewhat irresponsible in its disregard for external realities. The romantic-modernist belief that art was opposed to science was annulled by the introduction of scientific elements into the vocabulary. At the same time art was to be relocated culturally in an area of practical rather than dreamy endeavour. What was emerging as a guiding principle in Oppenheim's work was a requirement that any element be justified by some external or found index; the lines, for example, of *Annual Rings* or *Contour Lines* could not be drawn freehand by the artist out of an expressive impulse; tree rings, map signs, or whatever, they had to have some real-world, semantic context from which they were being appropriated into the 'creative', or recontextualizing, act.

Sometimes the real world index appears flexible and somewhat subjective. In *Salt Flat* (1968) Oppenheim spread rock salt over a rectangular area of earth on Sixth Avenue in Manhattan; the size of the area was dictated by the amount of the material he could afford to buy. The arbitrary, real-world index that served as limit for the piece was the money in his pocket. For the most part, however, the method remained linked to a kind of objectivity outside of the artist while carrying forward the issues of the moment, such as the critique of the relation between the gallery and the outside world. In the *Gallery Transplant*, for example, Oppenheim took the dimensions of a gallery, then marked off a similarly bounded space outdoors. A cognitive reversal is involved; the real-world index ironically was derived from the gallery, and then transposed to the outside world as a rejection of the reality of the gallery. Structurally, Smithson's Non-sites are similar in mediating the ideological opposition between

the autonomous artwork isolated in the gallery and the engaged artwork sited in the outside world. The Non-sites are simpler, however, than the *Gallery Transplants* in that they do not involve the ironic reversal.

Another transplant piece, done for the first Earth Art show, which was organized by Willoughby Sharp for the Cornell University gallery in 1969, further complicated the method. Oppenheim redrew the boundary lines of the gallery in the snow of a bird sanctuary nearby. The gallery space transplanted into nature was then randomly activated by flocks of birds alighting on it in different compositions that were unaffected by the artist's intentions. The piece involved another important anti-modernist rule or tendency that was being articulated in the works as they emerged. The modernist aesthetic view of art promulgated a myth of the complete control exercised by the artist – in whose work, for example, it was supposedly impossible to change anything without losing aesthetic integrity. Duchamp had articulated the counterprinciple, that of allowing chance to decide parts of the work (again in *3 Standard Stoppages*), and that part of his artistic legacy was also bearing fruit now. In Oppenheim's Cornell gallery transplant, for example, the intervention of flights of birds was an element outside the artist's control. Increasingly Oppenheim would come to feel that the artist should create the circumstances for an artwork to occur in – or set going the chain of causes which would produce it – but not the work itself, which remains hidden or unknown till it appears out of the manipulated causal web. The concept resembles the modernist idea of the artwork as something self-created or miraculous, but reverses the power hierarchy. In the modernist discourse the artwork, though in a sense self-created, still sprang somehow from the artist as medium; in this approach the artwork springs from the world as medium, the artist being more distanced.

Various works of the period investigated siting the art event within the agricultural and climatic time cycles of nature. The *Gallery Transplant* in the bird sanctuary, for example, was done in the winter and disappeared when the snow melted. It was like a part of nature in other words, and passed with the changing of the seasons. In *One Hour Run* (1968) Oppenheim parodied action painting by cutting snowmobile tracks intuitively or expressively in the snow for one hour. Such pieces flaunted both their ephemerality and their conditionality, operating against the modernist crypto-religious belief in the artwork as eternal and autonomous like a Platonic Idea. The work is subject to the conditions of nature like everything else, in opposition to modernist work, which was conceived as outside of nature and not susceptible to its rhythms of change and decay.

Oppenheim's work is characterized not only by the kind of clear analytical seeing of theoretical issues that is found, for example, in Smithson's work of the period too, but also by a tendency to complexify methods of presentation through structural reversals. In *Cancelled Crop* (1969) a crop was harvested in the shape of an X and the harvested wheat was kept from processing and never consumed. A cultural sign, the X of cancellation, has been applied to a field of wheat as it might be applied to another

sign on a sheet of paper. Culture has co-opted nature. The retention of the wheat from processing and consumption is again symbolically a subversion of aestheticism – a denial that the raw material of life needs reshaping as art and presenting to an audience. So nature re-engulfs culture again, but on culture's terms. There is little hint of the flower child mood of affirmation of nature as a solution to the problems of culture.

For Oppenheim, the commitment to the earth as a site was part of a more general commitment to the site. Other sited pieces located the artwork in urban rather than rural matrices. In *Sound Enclosed Land Area* (1969) four tape recorders were buried in cages at four points in Paris, delineating a rectangle of 500 × 800 m. Each tape loop projected a voice repeating its respective cardinal point: North, South, East or West. Here the solipsistic emphasis of much early Conceptual Art was stressed. Joseph Kosuth's work showing a chair and a photograph of the chair, or William Anastasi's picture of a wall hung on the same wall, and other works of the era, are related. In something of the spirit of Frank Stella's famous remark about minimal paintings, 'What you see is what you get', works like these tend to emphasize the self-identicalness of the real-world elements of the piece, in opposition to the modernist idea of the alchemical transformation of real-world elements by the art-making process [...]

Thomas McEvilley, 'The Rightness of Wrongness: Modernism and its Alter Ego …', *Dennis Oppenheim: Selected Works 1967-90*, P.S. 1 Museum, The Institute for Contemporary Art/Harry N. Abrams, New York, 1992, pp. 16-21

Jan DIBBETS

Artist's statement [1972]

I think it's quite a good thing to do, but it's stupid for other people to do it, or to buy it from me. What matters is the feeling. I discovered it's a great feeling to pick out a point on the map and to search for the place for three days, and then to find there are only two trees standing there, and a dog pissing against the tree. But someone who tried to buy that from you would be really stupid, because the work of art is the feeling, and he couldn't buy that from me ...

I must say I don't see how to sell these kinds of ideas. If someone can use them he can take them. Selling is not a part of art.

I really believe in having projects which in fact can't be carried out, or which are so simple that anyone could work them out. I once made four spots on the map of Holland, without knowing where they were. Then I found out how to get there and went to the place and took a snapshot. Quite stupid. Anybody can do that.

Jan Dibbets, 'Artist's statement', *Conceptual Art*, Ursula Meyer, E.P. Dutton & Co., New York, 1972, p. 121

I really believe in having projects which in fact can't be carried out, or which are so simple that anyone could work them out. I once made four spots on the map of Holland, without knowing where they were. Then I found out how to get there and went to the place and took a snapshot. Quite stupid. Anybody can do that.

Jan DIBBETS Artist's statement, 1972

Diane WALDMAN
Holes without History [1971]

The vast expanse of the desert was matched by its stillness, the arid heat and the wind. There were no signs of life except for the occasional cloud of dust raised by an automobile off in the distance. It took two days to reach Michael Heizer's *Double Negative*. Our first attempt failed when the only road became impassable, the cars bogged down, tyres spinning, and the spectre of getting stuck or miscalculating a turn and going off the road over the edge of the precipice was all too real. We tried again the next day, this time by avoiding the road and cutting across the mesa looking for any signs of tyre tracks to follow that might have been left by the pick-up trucks of the cattle ranchers in the area. After two hours of gauging direction largely by intuition, we succeeded in threading our way to the edge of the mesa. In contrast to the monotony of the parched, cracked earth of the mesa – a flat landscape of rocks, tumbleweed and scrub brush – the drop off the escarpment unfolded a vista of harsh beauty, with the work itself cut below the shelf of the mesa, overlooking the snaking ribbon of the Virgin River far below. In its present state, *Double Negative* is imposing: measuring 1,600 × 50 × 30 feet (5,246 × 15 × 9 m), with a displacement of 240,000 tons (244,800 tonnes), it is considerably larger than its first state; the original version (1969), displaced 40,000 tons (40,800 tonnes) and measured 1,100 × 42 × 30 feet (335 × 13 × 9 m). The work consists of two facing cuts; from the air it is possible to see the entire configuration but you cannot apprehend the work itself. From the shelter of the walls, one can begin to sense the enormity of the structure, but because of the chasm that separates the east and west faces, it is impossible to view the work in its entirety from any one direction. At the edge of the mesa, one can get another, but still fragmented, view of the work. It is the land, of course, that unifies *Double Negative*. A hard landscape, the site neither enhances nor detracts from the work itself. As a result, *Double Negative* is not only free of gratuitous decoration, a characteristic that unfortunately obtains in much other recent environmental work, but the grandeur and simplicity of its form convey a sense of its inevitability – of its being part of the land.

It had been difficult for me as a native New Yorker to imagine the change of context that the work occasions, for not only does it place an entirely new set of demands upon the object-oriented, studio/museum-going viewer, but it also presents a landscape and a frame of reference alien to conventional expectations of art and the art experience. This is true in particular of Heizer's work, but also of other recent art, evolving as it has from conditions which many younger artists working in New York found it necessary to reject. Critics writing about so-called earthworks, which first came to their attention as a 'movement' in a Dwan Gallery show in October 1968, saw it as a concerted effort to reject the more pervasive conventions of recent art – not only the discrete, finite object, but the gallery-museum complex that harbours it. This uncompromising reaction was inevitable; to propose a new type of art it was necessary to re-examine the framework that surrounded the art of the 1960s. While rejection of the object, per se, is a *fait accompli*, many of the artists working with earth have been influenced by the minimalists, whose position they rejected but who in fact were initially responsible for the displacement of the object. In de-emphasizing the importance of the end-state, the minimalists predicted several subsequent developments: with Robert Morris, the focus of process/materials was carried on by a group of younger artists, who have chosen to retain, however surreptitiously, the object or some semblance of it; with Sol LeWitt, whose early ideation has been extended by a younger group of Conceptual Artists; and with Carl Andre, whose declaration of sculpture as 'place' has provided some of the impetus to earthworks. Andre's evident concern for situation, for allowing a specific location to determine in part the final dimensions of a work, is one that he shares with Flavin; Andre himself has referred to it as 'post studio art'. For those artists engaged in earthworks, the minimalist emphasis on environment prompted an all but total removal to the outdoors. If the simple basic shapes, cuts or markings in or upon nature characteristic of many earthworks appear to devolve from the modular units of the minimalists, this resemblance is at best superficial. The significant difference in attitude can perhaps best be described by the term 'de-differentiation', the 'reversion of specialized structures (as cells) to a more generalized or primitive condition often as a preliminary to major change'.

What, then, are earthworks? Remote, largely inaccessible, they are sites known to a larger public solely by means of photographs or occasionally film. Documentation is fragmentary, incomplete and an inadequate surrogate for the reality of the work, leaving the viewer totally unequipped to do more than barely comprehend the experience. It is a common assumption, but a misleading one, that earthworks only exist for the photographs; but to experience these sites at all, the viewer is usually thrust back upon either the photographs or residual experiences with nature, which, for the urban art audience, is unrewarding. Although the art is often vast in scale, it cannot be considered public; earthworks have, in fact, disrupted the traditional relationship between scale and public monuments. Perversely illogical in their physical removal from their audience, such works are, none the less, entirely aesthetic in their appropriation of nature for the very reason that they impose the system of the individual artist upon the much larger and entirely separate system of the earth. But if the gratification for the spectator denied access to the work is all but impossible, the gratification for the artist must be enormous. As Heizer has said, 'In the desert, I can find that kind of unraped, peaceful, religious space artists have always tried to put into their work. I don't want any indication I've been here at all. My holes should have no history, they should be indeterminate in time and inaccessible in locale'.

In giving up the finite object, the artists making earthworks have returned to a more direct contact with their materials, moving away from the urban mechanized environment and the rigid standardized industrial units of the minimalists to the very opposite extreme. In this shift away from precise geometric forms, both the earthworkers and the process artists are giving currency to a type of expressionism that in some ways resembles 1950s attitudes. This is best explained by Robert Morris, who wrote, 'Random piling, loose stacking, hanging, giving passing form to the material. Chance is accepted and indeterminacy is implied since replacing will result in another configuration. Disengagement with preconceived enduring forms and orders for things is a positive assertion. It is part of the work's refusal to continue aestheticizing form by dealing with it as a prescribed end'.

Of those artists currently using nature as form/medium/content/place, Michael Heizer is the most intransigent. Born in Berkeley, California, in 1944, he attended the San Francisco Art Institute in 1963–64. After a period as a painter, he begun to work with earth in 1967. Heizer's early projects indicate a concern for random order; in *Dissipate*, Number 8 of *Nine Nevada Depressions* (1968), five shallow cuts, each 12 feet (366 cm) long and spanning 50 × 50 feet (15 × 15 m), in the Black Rock Desert, Nevada, were simply, in the artist's own words, 'toothpicks thrown on a tabletop'. The ironic, casual, throwaway quality of this work was entirely at odds with the monumental severity and starkness of the desert. This was all the more evident in that our frame of reference (i.e. the canvas rectangle, the loft or gallery) no longer exists. The gesture was almost self-effacing in its acknowledgement of man's fundamentally inconsequential efforts to compete with the overwhelming scale and austere beauty of nature, arrogant in the decision to tackle nature and urgent in its expression of the need for catharsis to create anew. Admitting as much, Heizer has said, 'Man will never create anything really large in relation to the world – only in relation to himself and his size. The most formidable objects that man has touched are the earth and the moon. The greatest scale he understands is the distance between them, and this is nothing compared to what he suspects to exist'.

From shallow cuts, frankly linear in disposition, in such early works as *Dissipate, Circular Surface Drawing* and *Loop Drawing*, Heizer moved through a succession of displacements and depressions, *Munich Depression* (1969) and the more recent *Double Negative*. Although Heizer's work requires much of the same type of physical effort and activity as Richard Serra's lead prop-pieces, the traces of such activity are unrecorded. The documentation of the artist's process holds little interest for Heizer, and is of little consequence to the viewer; one's apprehension of and relationship to the work, even vicariously, does not depend upon either the angst of the creative act or its traces. But just as Heizer imposes his own aesthetic vision on nature, he allows nature to act on a work. Time, therefore, becomes an important condition of his work: erosion, changes of season, etc., become integral to his concept. In so far as *Double Negative* approximates a configuration that achieves a precarious accommodation with both the forces of nature and art, it is Heizer's most brilliant work to date.

In any comparison of Heizer's work with that of his contemporaries, some striking differences emerge. This is partially due to the circumstances of his early development: as a teenager he accompanied his father, the anthropologist Robert Heizer, on numerous archaeological expeditions. Coming to New York in 1966, Heizer had missed the evolution of minimal sculpture, and expressed a decided preference for painting; he produced a large number of canvases most of which he subsequently destroyed. His first earthworks, which seem quasi-geometric in structure, have an element of the irrational to them, readily distinguishable from the pristine formality of the minimalists; this strain of the arbitrary or the capricious appears from time to time both in his large works and in such minuscule pieces as *Windows/ Matchdrop* (1969). Even more pronounced is his predilection for an open-ended form, or a variety of forms, a contrast to the basic unit-structure of the minimalists. In the area of scale – such minimalists as Andre, Judd, Morris or LeWitt were decidedly anti-monumental – and most particularly in the shift from studio to site, Heizer's work takes a fundamentally different direction from that of the sculpture of the early 1960s. In establishing his concept of 'place', Andre was actually defining an environmental situation. Once a work of his was realized, however, it could be moved to another context and another situation. In fact the minimalists demonstrated that while a work could articulate a given situation, it also retained its autonomy as an object, and despite any change in context/location, the work itself remained consistent. For Heizer, however, 'place' presumes the virtual authority of a given site, to which the work must adapt. It is the conclusive factor in determining the final outcome of a work. To the extent that many of the other artists working with earth were closely aligned with Minimalism, their work can be seen as a continuation of those ideas, as primarily a shift in medium, rather than the radical shift in direction of Heizer's work.

If the 1960s were witness to an art of pragmatism (there is no fundamental difference in this respect between Pop Art, colour abstraction and Minimalism), which has resulted in a cul-de-sac, then it is not difficult to understand why Heizer did in fact react so violently. In doing so, he found in so-called 'primitive' cultures not only a basic harmony between their art and the land (e.g. Central and South American Indian cultures) but an identification with certain basic modes of visualization. This fact in itself is not unusual. One is reminded of the Abstract-Expressionists' interest in the Jungian 'collective unconscious' and of the statement written to *The New York Times* in 1943 by Gottlieb and Rothko (with the editorial aid of Barnett Newman):

'1. To us art is an adventure into an unknown world, which can be explored only by those willing to take the risks.
2. This world of the imagination is fancy-free and violently opposed to common sense.
3. It is our function as artists to make the spectator see our way, not his way.
4. We favour the simple expression of the complex thought. We are for the large shape because it has the impact of the unequivocal. We wish to re-assert the picture place. We are for flat forms because they destroy illusion and reveal truth.
5. It is a widely accepted notion among painters that it does not matter what one paints as long as it is well painted. This is the essence of academism. There is no such thing as good painting about nothing. We assert that the subject is crucial and only that subject-matter is valid which is tragic and timeless. This is why we profess spiritual kinship with primitive and archaic art'.[4]

Myth offered the Abstract-Expressionist a way of forcibly breaking with tradition; *Double Negative*, and the desert work in general, is also a rejection – largely of the current situation of the arts. The troubled heritage of this country – the splendid beauty of the land, the struggle between two alien cultures that is still very much a part of our consciousness – is exemplified in many ways in *Double Negative. Double Negative* is the result of the artist's awareness of the history of taste, of the positive contributions of European art, and of a basic understanding of its failure for this time. As Barnett Newman wrote:

'The artist in America is, by comparison to European artists, like a barbarian. He does not have the super-fine sensibility towards the object that dominates European feeling. He does not even have the objects.

This is, then, our opportunity, free of the ancient paraphernalia, to come closer to the sources of the tragic emotion. Shall we not, as artists, search out the new objects for its image?'[5]

The fact is, however, that there is little in *Double Negative* specifically referential: the work is not 'archaizing' – anything but. There is instead a sense of the unfamiliar, the unknown, a subliminal association perhaps with other forms, in a work that is thoroughly contemporary. Conventional forms, like monuments, can be appropriated without a need to consider hierarchical values, consequently the artist can retain the presence of great scale without recourse to legend or myth. If any myth exists it is the myth of a new America, for which Las Vegas is the symbol. By day the mountains surrounding Las Vegas turn the town into one long stretch of dismal houses, parking lots, cheap stores. The ranchers in the area carry rifles in the back of their pick-up trucks: eyes like slits, from squinting in the sun, gaze suspiciously at strangers from leathery faces. At night, when the neons come on, the mountains disappear, the desert is forgotten, the sound of slot machines, dice, flashy cars replace the silence of the day.

' ... coyotes, Silver Slipper, pumas, mesquite, scorpions, AEC research and test centre, baccarat, natural pyramid, kangaroo rats, mescal, squirrels, cultural phototroposis, quail, Ruth pit, carp, Tropicana, faro wheel, 87% land government ownership, hot springs, mule deer, sidewinders, Great Basin, open speed limits, gila monsters, eagles, manganese, Wagon Wheel, creosote, horned toads, rhyolite, wild horses, Yucca Flat, slot machines, centipedes, herons, joshua, antimony, Hacienda, suicide table, Mint, hawks, greatest US state transient population, Harold's Club, uranium, black widows, copper, diatomite, owls, petroglyphs, Caesar's Palace, 3885 registered brands, keno, sulphur, mountain lions, Showboat, tungsten, Frontier, cindercones, gold, tarantulas, diamondbacks, chapparal, silver ... pine, Stardust, octillo, barite, Indian reservations, buckhorn, neon wedding chapels, F-111's, prairie dogs, roulette, Flamingo, vultures, Boulder Dam, roadrunners, International, geysers, pelicans, Landmark, timber rattlers, sand, titanium, craps, javelinas, cholla, bingo, county-optioned prostitution, yucca, turtles, Circus-Circus, tufa, blackjack, seagulls, basalt, nuclear munitions stockpile, Four Queens, six-week divorces, molybdenum, Golden Nugget, drift shafts, Las Vegas, jackrabbits, Sands, bobcats, Harrahs, 1 member US House of Representatives, Sierra Nevada (solid granite), sink-holes, bats, sage, mudflats, Barney's, Mormon tea, Harvey's, silica, Folies Bergères, Aladdin, frogs, potential SST landingstrip, seven mile tunnel, the Strip, mackinaw, juniper, kildeer, rodeo horses, cottonwoods, lizards, cattle, legalized gambling, only architecturally uniform US city, feldspar, bombing ranges, Sahara, wolves, Thunderbird, granodiorite, Mapes, borate, Lady Luck, thorium, antelope ... '[6]

1 Howard Junker, 'The New Sculpture: Getting Down to the Nitty Gritty', *The Saturday Evening Post*, 241/22, November 2, 1968, p. 42
2 Robert Morris, 'Anti Form', *Artforum*, no 8, New York, April 1968, p. 35
3 'The Art of Michael Heizer', *Artforum*, no 4, New York, December 1969, p. 36
4 *The New York Times*, 6 June, 1943
5 *Tiger's Eye*, no 3, March 1948, p. 111
6 Statement by the artist published in *Michael Heizer/ Actual Size*, Detroit Institute of Arts, Detroit, 1971

Diane Waldman, 'Holes without History', *ARTnews*, no 70, New York, May 1971, pp. 44-48; 66-67

Robert SMITHSON
A Sedimentation of the Mind: Earth Projects [1968]

The earth's surface and the figments of the mind have a way of disintegrating into discrete regions of art. Various agents, both fictional and real, somehow trade places with each other – one cannot avoid muddy thinking when it comes to earth projects, or what I will call 'abstract geology'. One's mind and the earth are in a constant state of erosion, mental rivers wear away abstract banks, brain waves undermine cliffs of thought, ideas decompose into stones of unknowing and conceptual crystallizations break apart into deposits of gritty reason. Vast moving faculties occur in this geological miasma, and they move in the most physical way. This movement seems motionless, yet it crushes the landscape of logic under glacial reveries. This slow flowage makes one conscious of the turbidity of thinking. Slump, debris slides, avalanches all take place within the cracking limits of the brain. The entire body is pulled into the cerebral sediment, where particles and fragments make themselves known as solid consciousness. A bleached and fractured world surrounds the artist.

To organize this mess of corrosion into patterns, grids and subdivisions is an aesthetic process that has scarcely been touched.

The manifestations of technology are at times less 'extensions' of man (Marshall McLuhan's anthropomorphism) than they are aggregates of elements. Even the most advanced tools and machines are made of the raw matter of the earth. Today's highly refined technological tools are not much different in this respect from those of the caveman. Most of the better artists prefer processes that have not been idealized, or differentiated into 'objective' meanings. Common shovels, awkward-looking excavating devices, what Michael Heizer calls 'dumb tools', picks, pitchforks, the machine used by suburban contractors, grim tractors that have the clumsiness of armoured dinosaurs and ploughs that simply push dirt around. Machines like Benjamin Holt's steam tractor (invented in 1885) – 'It crawls over mud like a caterpillar'. Digging engines and other crawlers that can travel over rough terrain and steep grades. Drills and explosives that can produce shafts and earthquakes. Geometrical trenches could be dug with the help of the 'ripper' – steel-toothed rakes mounted on tractors. With such equipment construction takes on the look of destruction; perhaps that's why certain architects hate bulldozers and steam shovels. They seem to turn the terrain into unfinished cities of organized wreckage. A sense of chaotic planning engulfs site after site.

Subdivisions are made – but to what purpose? Building takes on a singular wildness as loaders scoop and drag soil all over the place. Excavations form shapeless mounds of debris, miniature landslides of dust, mud, sand and gravel. Dump trucks spill soil into an infinity of heaps. The dipper of the giant mining power shovel is 25 feet high and digs 140 yds³ (250 tons) in one bite. These processes of heavy construction have a devastating kind of primordial grandeur and are in many ways more astonishing than the finished project – be it a road or a building. The actual *disruption* of the earth's crust is at times very compelling, and seems to confirm Heraclitus' *Fragment 124*, 'The most beautiful world is like a heap of rubble tossed down in confusion'. The tools of art have too long been confined to 'the studio'. The city gives the illusion that earth does not exist. Heizer calls his earth projects, 'The alternative to the absolute city system'.

Recently, in Vancouver, Iain Baxter put on an exhibition of *Piles* that were located at different points in the city; he also helped in the presentation of a *Portfolio of Piles*. Dumping and pouring become interesting techniques. Carl Andre's *Grave Site* – a tiny pile of sand, was displayed under a stairway at the Museum of Contemporary Crafts last year. Andre, unlike Baxter, is more concerned with the *elemental* in things. Andre's pile has no anthropomorphic overtones; he gives it a clarity that avoids the idea of temporal space. A serenification takes place. Dennis Oppenheim has also considered the 'pile' – 'the basic components of concrete and gypsum ... devoid of manual organization'. Some of Oppenheim's proposals suggest desert physiography – mesas, buttes, mushroom mounds, and other 'deflations' (the removal of material

from beach and other land surfaces by wind action). My own *Tar Pool and Gravel Pit* (1966) proposal makes one conscious of the primal ooze. A molten substance is poured into a square sink that is surrounded by another square sink of coarse gravel. The tar cools and flattens into a sticky level deposit. This carbonaceous sediment brings to mind a tertiary world of petroleum, asphalts, ozokerite, and bituminous agglomerations.

PRIMARY ENVELOPMENT

At the low levels of consciousness the artist experiences undifferentiated or unbounded methods of procedure that break with the focused limits of rational technique. Here tools are undifferentiated from the material they operate on, or they seem to sink back into their primordial condition. Robert Morris sees the paint brush vanish into Pollock's 'stick', and the stick dissolve into 'poured paint' from a container used by Morris Louis.' What then is one to do with the *container*? This entropy of technique leaves one with an empty limit, or no limit at all. All differentiated technology becomes meaningless to the artist who knows this state. 'What the Nominalists call the grit in the machine', says T.E. Hulme in *Cinders*, 'I call the fundamental element of the machine'. The rational critic of art cannot risk this abandonment into 'oceanic' undifferentiation, he can only deal with the limits that come after this plunge into such a world of non-containment.

At this point I must return to what I think is an important issue, namely Tony Smith's 'car ride' on the 'unfinished turnpike'. 'This drive was a revealing experience. The road and much of the landscape was artificial, and yet it couldn't be called a work of art'.² He is talking about a sensation, not the finished work of art; this doesn't imply that he is anti-art. Smith is describing the state of his mind in the 'primary process' of making contact with matter. This process is called by Anton Ehrenzweig 'dedifferentiation', and it involves a suspended question regarding 'limitlessness' (Freud's notion of the 'oceanic') that goes back to *Civilization and Its Discontents*. Michael Fried's shock at Smith's experiences shows that the critic's sense of limit cannot risk the rhythm of dedifferentiation that swings between 'oceanic' fragmentation and strong determinants. Ehrenzweig says that in Modern Art this rhythm is 'somewhat onesided' – toward the oceanic. Allan Kaprow's thinking is a good example – 'Most humans, it seems, still put up fences around their acts and thoughts'.³ Fried thinks he knows who has the 'finest' fences around their art. Fried claims he rejects the 'infinite', but this is Fried writing in *Artforum*, February 1967, on Morris Louis: '*The dazzling blankness of the untouched canvas at once repulses and engulfs the eye, like an infinite abyss, the abyss that opens up behind the least mark that we make on a flat surface, or* would *open up if innumerable conventions both of art and practical life did not restrict the consequences of our act within narrow bounds*'. The 'innumerable conventions' do not exist for certain artists who *do* exist within a physical 'abyss'. Most critics cannot endure the suspension of *boundaries* between what Ehrenzweig calls the 'self and the non-self'. They are

apt to dismiss Malevich's *Non-Objective World* as poetic debris, or only refer to the 'abyss' as a rational metaphor 'within narrow bounds'. The artist who is physically engulfed tries to give evidence of this experience through a limited (mapped) revision of the original unbounded state. I agree with Fried that limits are not part of the primary process that Tony Smith was talking about. There is different experience before the physical abyss than before the mapped revision. Nevertheless, the quality of Fried's *fear* (dread) is high, but his experience of the abyss is low – a weak metaphor – 'like an infinite abyss'.

The bins or containers of my Non-sites gather *in* the fragments that are experienced in the physical abyss of raw matter. The tools of technology become a part of the Earth's geology as they sink back into their original state. Machines like dinosaurs must return to dust or rust. One might say a 'de-architecturing' takes place before the artist sets his limits outside the studio or the room.

BETTER HOMES AND INDUSTRIES

'Great sprays of greenery make the Lambert live-in room an oasis atop a cliff dwelling. In a corner, lighted by skylights and spotlights, "Hard Red", an oil by Jack Bush. All planting by Lambert Landscape Company.'
– Photograph caption, *House and Garden*, July 1968

In *Art in America*, September–October 1966, there is a portrait of Anthony Caro, with photographs of his sculpture in settings and landscapes that suggest English gardening. One work, *Prima Luce 1966*, painted yellow, matches the yellow daffodils peeking out behind it, and it sits on a well cut lawn. I know, the sculptor prefers to see his art indoors, but the fact that this work ended up where it did is no excuse for thoughtlessness about installation. The more compelling artists today are concerned with 'place' or 'site' – Smith, De Maria, Andre, Heizer, Oppenheim, Huebler – to name a few. Somehow, Caro's work picks up its surroundings, and gives one a sense of a contrived, but tamed, 'wildness' that echoes to the tradition of English gardening.

Around 1720 the English invented the antiformal garden as protest against the French formal garden. The French use of geometric forms was rejected as something 'unnatural'. This seems to relate to today's debate between so-called 'formalism' and 'anti-formalism'. The traces of weak naturalism cling to the background of Caro's *Prima Luce*. A leftover Arcadia with flowery overtones gives the sculpture the look of some industrial ruin. The brightly painted surfaces cheerfully seem to avoid any suggestion of the 'romantic ruin', but they are on closer investigation related to just that. Caro's industrial ruins, or concatenations of steel and aluminium may be viewed as Kantian 'things-in-themselves', or be placed into some syntax based on So and So's theories, but at this point I will leave those notions to the keepers of 'modernity'. The English consciousness of art has always been best displayed in its 'landscape gardens'. 'Sculpture' was used more to *generate a set of conditions*.

Clement Greenberg's notion of 'the landscape' reveals itself with shades of T.S. Eliot in an article, 'Poetry of

8. Anthony Caro

Vision'.[4] Here 'Anglicizing tastes' are evoked in his descriptions of the Irish landscape. 'The ruined castles and abbeys', says Greenberg, 'that strew the beautiful countryside are gray and dim', shows he takes 'pleasure in ruins'. At any rate, the 'pastoral', it seems, is outmoded. The gardens of history are being replaced by sites of time.

Memory traces of tranquil gardens as 'ideal nature' – jejune Edens that suggest an idea of banal 'quality' – persist in popular magazines like *House Beautiful* and *Better Homes and Gardens*. A kind of watered down Victorianism, an elegant notion of industrialism in the woods; all this brings to mind some kind of wasted charm. The decadence of 'interior decoration' is full of appeals to 'country manners' and liberal-democratic notions of gentry. Many art magazines have gorgeous photographs of artificial industrial ruins (sculpture) on their pages. The 'gloomy' ruins of aristocracy are transformed into the 'happy' ruins of the humanist. Could one say that art degenerates as it approaches gardening?[5] These 'garden-traces' seem part of time and not history, they seem to be involved in the dissolution of 'progress'. It was John Ruskin who spoke of the 'dreadful Hammers' of the geologists, as they destroyed the classical order. The landscape reels back into the millions and millions of years of 'geologic time'.

FROM STEEL TO RUST

As 'technology' and 'industry' began to become an ideology in the New York Art World in the late 1950s and early 1960s, the private studio notions of 'craft' collapsed. The products of industry and technology began to have an appeal to the artist who wanted to work like a 'steel welder' or a 'laboratory technician'. This valuation of the material products of heavy industry, first developed by David Smith and later by Anthony Caro, led to a fetish for steel and aluminium as a medium (painted or unpainted). Moulded steel and cast aluminium are machine manufactured, and as a result they bear the stamp of technological ideology. Steel is a hard, tough metal, suggesting the permanence of technological values. It is composed of iron alloyed with various small percentages of carbon; steel may be alloyed with other metals, nickel, chromium, etc., to produce specific properties such as hardness and resistance to rusting. Yet, the more I think about steel itself, devoid of the technological refinements, the more rust becomes the fundamental property of steel. Rust itself is a reddish brown or reddish yellow coating that often appears on 'steel sculpture', and is caused by oxidation (an interesting non-technological condition), as during exposure to air or moisture; it consists almost entirely of ferric oxide, Fe_2O_3 and ferric hydroxide, $Fe(OH)_3$. In the technological mind rust evokes a fear of disuse, inactivity, entropy, and ruin. Why steel is valued over rust is a technological value, not an artistic one.

By excluding technological processes from the making of art, we began to discover other processes of a more fundamental order. The breakup or fragmentation of matter makes one aware of the sub-strata of the earth before it is overly refined by industry into sheet metal, extruded I-beams, aluminium channels, tubes, wire, pipe, cold-rolled steel, iron bars, etc. I have often thought about non-resistant processes that would involve the actual sedimentation of matter or what I called 'Pulverizations' back in 1966. Oxidation, hydration, carbonization, and solution (the major processes of rock and mineral disintegration) are four methods that could be turned towards the making of art. The smelting process that goes into the making of steel and other alloys separates 'impurities' from an original ore, and extracts metal in order to make a more 'ideal' product. Burnt-out ore or slag-like rust is as basic and primary as the material smelted from it. Technological ideology has no sense of time other than its immediate 'supply and demand', and its laboratories function as blinders to the rest of the world. Like the refined 'paints' of the studio, the refined 'metals' of the laboratory exist within an 'ideal system'. Such enclosed 'pure' systems make it impossible to perceive any other kinds of processes than the ones of differentiated technology.

Refinement of matter from one state to another does not mean that so-called 'impurities' of sediment are 'bad' – the earth is built on sedimentation and disruption. A refinement based on all the matter that has been discarded by the technological ideal seems to be taking place. The coarse swathes of tar on Tony Smith's plywood mock-ups are no more or less refined than the burnished or painted steel of David Smith. Tony Smith's surfaces display more of a sense of the 'prehistoric world' that is not reduced to ideals and pure Gestalts. The fact remains that the mind and things of certain artists are not 'unities', but *things* in a state of arrested disruption. One might object to 'hollow' volumes in favour of 'solid materials', but no materials are solid, they all contain caverns and fissures. Solids are particles built up around flux, they are objective illusions supporting grit, a collection of surfaces ready to be cracked. All chaos is put into the dark inside of the art. By refusing 'technological miracles' the artist begins to know the corroded moments, the carboniferous states of thought, the shrinkage of mental mud, in the geologic chaos – in the strata of aesthetic consciousness. The refuse between mind and matter is a mine of information.

THE DISLOCATION OF CRAFT – AND FALL OF THE STUDIO

Plato's *Timaeus* shows the demiurge or the artist creating a model order, with his eyes fixed on a non-visual order of Ideas, and seeking to give the purest representation of them. The 'classical' notion of the artist copying a perfect mental model has been shown to be an error. The modern artist in his 'studio', working out an abstract grammar within the limits of his 'craft', is trapped in but another snare. When the fissures between mind and matter multiply into an infinity of gaps, the studio begins to crumble and fall like The House of Usher, so that mind and matter get endlessly confounded. Deliverance from the confines of the studio frees the artist to a degree from the snares of craft and the bondage of creativity. Such a condition exists without any appeal to 'nature'. Sadism is the end product of nature, when it is based on the biomorphic order of rational creation. The artist is fettered by this order, if he believes himself to be creative, and this allows for his servitude which is designed by the vile laws of Culture. Our culture has lost its sense of death, so it can kill both mentally and physically, thinking all the time that it is establishing the most creative order possible.

THE DYING LANGUAGE

The names of minerals and the minerals themselves do not differ from each other, because at the bottom of both the material and the print is the beginning of an abysmal number of fissures. Words and rocks contain a language that follows a syntax of splits and ruptures. Look at any *word* long enough and you will see it open up into a series of faults, into a terrain of particles each containing its own void. This discomforting language of fragmentation offers no easy Gestalt solution; the certainties of didactic discourse are hurled into the erosion of the poetic principle. Poetry being forever lost must submit to its own vacuity; it is somehow a product of exhaustion rather than creation. Poetry is always a dying language but never a dead language.

Journalism in the guise of art criticism fears the disruption of language, so it resorts to being 'educational' and 'historical'. Art critics are generally poets who have betrayed their art, and instead have tried to turn art into a matter of reasoned discourse, and, occasionally, when their 'truth' breaks down, they resort to a poetic quote. Wittgenstein has shown us what can happen when language is 'idealized', and that it is hopeless to try to fit language into some absolute logic, whereby everything objective can be tested. We have to fabricate our rules as we go along the avalanches of language and over the terraces of criticism.

Poe's *Narrative of A. Gordon Pym* seems to me excellent art criticism and prototype for rigorous 'non-site' investigations. 'Nothing worth mentioning occurred during the next twenty-four hours except that, in examining the ground to the eastward third chasm, we found two triangular holes of great depth, and also with black granite sides.' His descriptions of chasms and holes seem to verge on proposals for 'earthwords'. The shapes of the chasms themselves become 'verbal roots' that spell out the difference between darkness and light. Poe ends his mental maze with the sentence – 'I have graven it within the hills and my vengeance upon the dust within the rock'.

THE CLIMATE OF SIGHT

The climate of sight changes from wet to dry and from dry to wet according to one's mental weather. The prevailing conditions of one's psyche affect how he views art. We have already heard much about 'cool' or 'hot' art, but not much about 'wet' and 'dry' art. The *viewer*, be he an artist or a critic, is subject to a climatology of the brain and eye. The wet mind enjoys 'pools and stains' of paint. 'Paint' itself appears to be a kind of liquefaction. Such wet eyes love to look on melting, dissolving, soaking surfaces that give the illusion at times of tending toward a gaseousness, atomization or fogginess. This watery syntax as at times related to the 'canvas support'.

'The world disintegrates around me.'
– Yvonne Rainer

'By Palm Desert springs often run dry.'
– Van Dyke Parks, *Song Cycle*

The following is a proposal for those who have leaky minds. It could be thought of as The Mind of Mud, or in later stages, The Mind of Clay.

THE MUD POOL PROJECT
1. Dig up 100 ft² area of earth with a pitchfork.
2. Get local fire department to fill the area with water. A fire hose may be used for this purpose.
3. The area will be finished when it turns to mud.
4. Let it dry under the sun until it turns to clay.
5. Repeat process at will.

'When dried under the sun's rays for a sufficiently long time, mud and clay shrink and crack in a network of fissures which enclose polygonal areas.'
– Fredric H. Lahee, *Field Geology*

The artist or critic with a dank brain is bound to end up appreciating anything that suggests saturation, a kind of watery effect, an overall seepage, discharges that submerge perceptions in an onrush of dripping observation. They are grateful for an art that evokes general liquid states, and disdain the desiccation of fluidity. They prize anything that looks drenched, be it canvas or steel. Depreciation of aridity means that one would prefer to see art in a dewy green setting, say the hills of Vermont, rather than the Painted Desert.

Aristotle believed that heat combined with dryness resulted in fire: where else could this feeling take place than in a *desert* or in Malevich's head? 'No more "likenesses of reality", no idealistic images, nothing but a desert!' says Malevich in *The Non-Objective World*. Walter De Maria and Michael Heizer have actually worked in the Southwestern deserts. Says Heizer, in some scattered notes, 'Earth liners installed in Sierras, and down on desert floor in Carson-Reno area'. The desert is less 'nature' than a concept, a place that swallows up boundaries. When the artist goes to the desert he enriches his absence and burns off the water (paint) on his brain. The slush of the city evaporates from the artist's mind as he installs his art. Heizer's 'dry lakes' become mental maps that contain the vacancy of Thanatos. A consciousness of the desert operates between craving and satiety.

Jackson Pollock's art tends towards a torrential sense of *material* that makes his paintings look like splashes of marine sediments. Deposits of paint cause layers and crusts that suggest nothing 'formal' but rather a physical metaphor without realism or naturalism. *Full Fathom Five* becomes a Sargasso Sea, a dense lagoon of pigment, a logical state of an oceanic mind. Pollock's introduction of pebbles into his private topographies suggests an interest in geological artifices. The rational idea of 'painting' begins to disintegrate and decompose into so many sedimentary concepts. Both Yves Klein and Jean Dubuffet hinted at global or topographic sedimentary notions in their works – both worked with ashes and cinders. Says Dubuffet, regarding the North and South Poles, 'The revolution of a being on its axis, reminiscent of a dervish,

suggests fatiguing, wasted effort; it is not a pleasant idea to consider and seems instead the provisional solution, until a better one comes along, of despair'. A sense of the earth as a map undergoing disruption leads the artist to the realization that nothing is certain or formal. Language itself becomes mountains of symbolic debris. Klein's IKB globes betray a sense of futility – a collapsed logic. G.E.M. Anscombe writing on 'Negation' in *An Introduction to Wittgenstein's Tractatus* says, 'but it is clear then an all-white or all-black globe is not a map'. It is also clear that Klein's all blue globe is not a map; rather it is an anti-map; a negation of 'creation' and the 'creator' that is supposed to be in the artist's 'self'.

THE WRECK OF FORMER BOUNDARIES
The strata of the earth is a jumbled museum. Embedded in the sediment is a text that contains limits and boundaries which evade the rational order, and social structures which confine art. In order to read the rocks we must become conscious of geologic time, and of the layers of pre-historic material that is entombed in the earth's crust. When one scans the ruined sites of prehistory one sees a heap of wrecked maps that upsets our present art historical limits. A rubble of logic confronts the viewer as he looks into the levels of the sedimentations. The abstract grids containing the raw matter are observed as something incomplete, broken and shattered.

In June 1968, my wife Nancy, Virginia Dwan, Dan Graham and I visited the slate quarries in Bangor-Pen Angyl, Pennsylvania. Banks of suspended slate hung over a greenish-blue pond at the bottom of a deep quarry. All boundaries and distinctions lost their meaning in this ocean of slate and collapsed all notions of Gestalt unity. The present fell forward and backward into a tumult of 'de-differentiation', to use Anton Ehrenzweig's word for entropy. It was as though one was at the bottom of a petrified sea and gazing on countless stratographic horizons that had fallen into endless directions of steepness. Syncline (downward) and anticline (upward) outcroppings and the asymmetrical cave-ins caused minor swoons and vertigos. The brittleness of the site seemed to swarm around one, causing a sense of displacement. I collected a canvas bag full of slate chips for a small Non-site.

Yet, if art is art it must have limits. How can one contain this 'oceanic' site? I have developed the Non-site, which in a physical way contains the disruption of the site. The container is in a sense a fragment itself, something that could be called a three-dimensional map. Without appeal to 'Gestalts' or 'anti-form', it actually exists as a fragment of a greater fragmentation. It is a three-dimensional *perspective* that has broken away from the whole, while containing the lack of its own containment. There are no mysteries in these vestiges, no traces of an end or a beginning.

CRACKING PERSPECTIVES AND GRIT IN THE VANISHING POINT
Parallactic perspectives have introduced themselves into the new earth projects in a way that is physical and three-dimensional. This kind of convergence subverts Gestalt

surfaces and turns sites into vast illusions. The ground becomes a map.

The map of my *Non-site #1 (an indoor earthwork)* has six vanishing points that lose themselves in a pre-existent earth mound that is at the centre of a hexagonal airfield in the Pine Barren Plains in South New Jersey. Six runways radiate around a central axis. These runways anchor my thirty-one subdivisions. The actual Non-Site is made up of thirty-one metal containers of painted blue aluminium, each containing sand from the actual site.

De Maria's parallel chalk lines are 12 feet apart and run half a mile along the Dry Lake of El Mirage in the Mojave Desert. The dry mud under these lines is cracking into an infinite variety of polygons, mainly six-sided. Under the beating sun shrinkage is constantly going on, causing irregular outlines. Rapid drying causes widely spaced cracks, while slow drying causes closely spaced cracks.[6] De Maria's lines make one conscious of a weakening cohesion that spreads out in all directions. Nevada is a good place for the person who wants to study cracks.

Heizer's *Compression Line* is made by the earth pressing against the sides of two parallel lengths of plywood, so that they converge into two facing sunken perspectives. The earth surrounding this double perspective is composed of 'hardpan' (a hard impervious sediment that does not become plastic, but can be shattered by explosives). A drainage layer exists under the entire work.

THE VALUE OF TIME
For too long the artist has been estranged from his own 'time'. Critics, by focusing on the 'art object', deprive the artist of any existence in the world of both mind and matter. The mental process of the artist which takes place in time is disowned, so that a commodity value can be maintained by a system independent of the artist. Art, in this sense, is considered 'timeless' or a product of 'no time at all'; this becomes a convenient way to exploit the artist out of his rightful claim to his temporal processes. The arguments for the contention that time is unreal is a fiction of language, and not of the material of time or art. Criticism, dependent on rational illusions, appeals to a society that values only commodity-type art separated from the artist's mind. By separating art from the 'primary process', the artist is cheated in more ways than one. Separate 'things', 'forms', 'objects', 'shapes', etc., with beginnings and endings, are mere convenient fictions: there is only an uncertain disintegrating order that transcends the limits of rational separations. The fictions erected in the eroding time stream are apt to be swamped at any moment. The brain itself resembles an eroded rock from which ideas and ideals leak.

When a *thing* is seen through the consciousness of temporality, it is changed into something that is nothing. This all-engulfing sense provides the mental ground for the object, so that it ceases being a mere object and becomes art. The object gets to be less and less but exists as something clearer. Every object, if it is art, is charged with the rush of time even though it is static, but all this depends on the viewer. Not everybody sees the art in the same way, only an artist viewing art knows the ecstasy or

dread, and this viewing takes place in time. A great artist can make art by simply casting a glance. A set of glances could be as solid as any thing or place, but the society continues to cheat the artist out of his 'art of looking', by only valuing 'art objects'. The existence of the artist in time is worth as much as the finished product. Any critic who devalues the *time* of the artist is the enemy of art and the artist. The stronger and clearer the artist's *view* of time the more he will resent any slander on this domain. By desecrating this domain, certain critics defraud the work and mind of the artist. Artists with a weak view of time are easily deceived by this victimizing kind of criticism, and are seduced into some trivial history. An artist is enslaved by time only if the time is controlled by someone or something other than himself. The deeper an artist sinks into the time stream the more it becomes *oblivion*; because of this, he must remain close to the temporal surfaces. Many would like to forget time altogether, because it conceals the 'death principle' (every authentic artist knows this). Floating in this temporal river are the remnants of art history, yet the 'present' cannot support the cultures of Europe, or even the archaic or primitive civilizations; it must instead explore the pre- and post-historic mind; it must go into the places where remote futures meet remote pasts.

1 Robert Morris in *Artforum*, New York, April 1968

2 Samuel J. Wagstaff, Jr., 'Talking with Tony Smith', *Artforum*, New York, December 1966

3 Allan Kaprow in *Artforum*, New York, June 1968

4 Clement Greenberg, 'Poetry of Vision', *Artforum*, New York, April 1968

5 The sinister in a primitive sense seems to have its origin in what could be called 'quality gardens' (Paradise). Dreadful things seem to have happened in those half-forgotten Edens. Why does the Garden of Delights suggest something perverse? Torture gardens. Deer Park. The Grottos of Tiberius. Gardens of Virtue are somehow always 'lost'. A degraded paradise is perhaps worse than a degraded hell. America abounds in banal heavens, in vapid 'happy-hunting grounds', and in 'natural' hells like Death Valley National Monument or The Devil's Playground. The public 'sculpture garden' for the most part is an outdoor 'room', that in time becomes a limbo of modern isms. Too much thinking about 'gardens' leads to perplexity and agitation. Gardens like the levels of criticism bring one to the brink of chaos. This footnote is turning into a dizzying maze, full of tenuous paths and innumerable riddles. The abysmal problem of gardens somehow involves a fall from somewhere or something. The certainty of the absolute garden will never be regained.

6 See E.M. Kindle, 'Some Factors Affecting the Development of Mud Cracks', *Journal of Geology*, vol 25, 1917, p. 136

Robert Smithson, 'A Sedimentation of the Mind: Earth Projects', *Artforum*, New York, September 1968, pp. 44-49; reprinted in *The Writings of Robert Smithson*, ed. Nancy Holt, New York University Press, New York, 1979, pp. 82-91; *Robert Smithson: The Collected Writings*, ed. Jack Flam, University of California Press, Berkeley, 1996, pp. 100-13

Robert SMITHSON
The Spiral Jetty [1972]

'Red is the most joyful and dreadful thing in the physical universe; it is the fiercest note, it is the highest light, it is the place where the walls of this world of ours wear the thinnest and something beyond burns through.'
– G.K. Chesterton

My concern with salt lakes began with my work in 1968 on the Mono Lake Site-Nonsite in California.[1] Later I read a book called *Varnishing Trails of Atacama* by William Rudolph which described salt lakes (salars) in Bolivia in all stages of desiccation, and filled with micro bacteria that give the water surface a red colour. The pink flamingoes that live around the salars match the colour of the water. In *The Useless Land*, John Aarons and Claudio Vita-Finzi describe Laguna Colorada, 'The basalt (at the shores) is black, the volcanoes purple, and their exposed interiors yellow and red. The beach is grey and the lake pink, topped with the icing of iceberg-like masses of salts'.[2] Because of the remoteness of Bolivia and because Mono Lake lacked a reddish colour, I decided to investigate the Great Salt Lake in Utah.

From New York City I called the Utah Park Development and spoke to Ted Tuttle, who told me that water in the Great Salt Lake north of the Lucin Cutoff, which cuts the lake in two, was the colour of tomato soup. That was enough of a reason to go out there and have a look. Tuttle told my wife, Nancy Holt, and myself of some people who knew the lake. First we visited Bill Holt who lived in Syracuse. He was instrumental in building a causeway that connected Syracuse with Antelope Island in the southern part of the Great Salt Lake. Although that site was interesting, the water lacked the red colouration I was looking for, so we continued our search. Next we went to see John Silver on Silver Sands Beach near Magna. His sons showed us the only boat that sailed the lake. Due to the high salt content of the water it was impractical for ordinary boats to use the lake, and no large boats at all could go beyond the Lucin Cutoff on which the transcontinental railroad crossed the lake. At that point I was still not sure what shape my work of art would take. I thought of making an island with the help of boats and barges, but in the end I would let the site determine what I would build. We visited Charles Stoddard, who supposedly had the only barge on the north side of the cutoff. Stoddard, a well-driller, was one of the last homesteaders in Utah. His attempt to develop Carrington Island in 1932 ended in failure because he couldn't find fresh water. 'I've had the lake', he said. Yet, while he was living on the island with his family he made many valuable observations of the lake. He was kind enough to take us to Little Valley on the East side of the Lucin Cutoff to look for his barge – it had sunk. The abandoned man-made harbours of Little Valley gave me my first view of the wine-red water, but there were too many 'Keep Out' signs around to make that a practical site for anything, and we were told to 'stay away' by two angry ranchers. After fixing a gashed gas tank, we returned to Charles Stoddard's house north of Syracuse on the edge of some salt marshes. He showed us photographs he had taken of 'icebergs',[3] and Kit Carson's cross carved on a rock on Fremont Island. We then decided to leave and go to Rozel Point.

Driving west on Highway 83 late in the afternoon, we passed through Corinne, then went on to Promontory. Just beyond the Golden Spike Monument, which commemorates the meeting of the rails of the first transcontinental railroad, we went down a dirt road in a wide valley. As we travelled, the valley spread into an uncanny immensity unlike the other landscapes we had seen. The roads on the map became a net of dashes, while in the far distance the Salt Lake existed as an interrupted silver band. Hills took on the appearance of melting solids, and glowed under amber light. We followed roads that glided away into dead ends. Sandy slopes turned into viscous masses of perception. Slowly, we drew near to the lake, which resembled an impassive faint violet sheet held captive in a stoney matrix, upon which the sun poured down its crushing light. An expanse of salt flats bordered the lake, and caught in its sediments were countless bits of wreckage. Old piers were left high and dry. The mere sight of the trapped fragments of junk and waste transported one into a world of modern prehistory. The products of a Devonian industry, the remains of a Silurian technology, all the machines of the Upper Carboniferous Period were lost in those expansive deposits of sand and mud.

Two dilapidated shacks looked over a tired group of oil rigs. A series of seeps of heavy black oil more like asphalt occur just south of Rozel Point. For forty or more years people have tried to get oil out of this natural tar pool. Pumps coated with black stickiness rusted in the corrosive salt air. A hut mounted on pilings could have been the habitation of 'the missing link'. A great pleasure arose from seeing all those incoherent structures. This site gave evidence of a succession of man-made systems mired in abandoned hopes.

About one mile north of the oil seeps I selected my site. Irregular beds of limestone dip gently eastward, massive deposits of black basalt are broken over the peninsula, giving the region a shattered appearance. It is one of few places on the lake where the water comes right up to the mainland. Under shallow pinkish water is a network of mud cracks supporting the jigsaw puzzle that composes the salt flats. As I looked at the site, it reverberated out to the horizons only to suggest an immobile cyclone while flickering light made the entire landscape appear to quake. A dormant earthquake spread into the fluttering stillness, into a spinning sensation without movement. This site was a rotary that enclosed itself in an immense roundness. From that gyrating space emerged the possibility of the *Spiral Jetty*. No ideas, no concepts, no systems, no structures, no abstractions could hold themselves together in the actuality of that evidence. My dialectics of site and nonsite whirled into an indeterminate state, where solid and liquid lost themselves in each other. It was as if the mainland oscillated with waves and pulsations, and the lake remained rock still. The shore of the lake became the edge of the sun, a boiling curve, an explosion rising into a fiery prominence. Matter collapsing

into the lake mirrored in the shape of a spiral. No sense wondering about classifications and categories, there were none.

After securing a twenty-year lease on the meandering zone,[4] and finding a contractor in Ogden, I began building the jetty in April 1970. Bob Phillips, the foreman, sent two dump trucks, a tractor and a large front loader out to the site. The tail of the spiral began as a diagonal line of stakes that extended into the meandering zone. A string was then extended from a central stake in order to get the coils of the spiral. From the end of the diagonal to the centre of the spiral, three curves coiled to the left. Basalt and earth was scooped up from the beach at the beginning of the jetty by the front loader, then deposited in the trucks, whereupon the trucks backed up to the outline of stakes and dumped the material. On the edge of the water, at the beginning of the tail, the wheels of the trucks sank into a quagmire of sticky gumbo mud. A whole afternoon was spent filling in this spot. Once the trucks passed that problem, there was always the chance that the salt crust resting on the mud flats would break through. The Spiral Jetty was staked out in such a way as to avoid the soft muds that broke up through the salt crust, nevertheless there were some mud fissures that could not be avoided. One could only hope that tension would hold the entire jetty together, and it did. A cameraman was sent by the Ace Gallery in Los Angeles to film the process.

The scale of the Spiral Jetty tends to fluctuate depending on where the viewer happens to be. Size determines an object, but scale determines art. A crack in the wall if viewed in terms of scale, not size, could be called the Grand Canyon. A room could be made to take on the immensity of the solar system. Scale depends on one's capacity to be conscious of the actualities of perception. When one refuses to release scale from size, one is left with an object or language that appears to be certain. For me scale operates by uncertainty. To be in the scale of the Spiral Jetty is to be out of it. On eye level, the tail leads one into an undifferentiated state of matter. One's downward gaze pitches from side to side, picking out random depositions of salt crystals on the inner and outer edges, while the entire mass echoes the irregular horizons. And each cubic salt crystal echoes the Spiral Jetty in terms of the crystal's molecular lattice. Growth in a crystal advances around a dislocation point, in the manner of a screw. The Spiral Jetty could be considered one layer within the spiralling crystal lattice, magnified trillions of times.

This description echoes and reflects Brancusi's sketch of James Joyce as a 'spiral ear' because it suggests both a visual and an aural scale, in other words it indicates a sense of scale that resonates in the eye and the ear at the same time. Here is a reinforcement and prolongation of spirals that reverberates up and down space and time. So it is that one ceases to consider art in terms of an 'object'. The fluctuating resonances reject 'objective criticism', because that would stifle the generative power of both visual and auditory scale. Not to say that one resorts to 'subjective concepts', but rather that one apprehends what is around one's eyes and ears, no matter how unstable or fugitive. One seizes the spiral, and the spiral becomes a seizure.

After a point, measurable steps ('Scale skal n. It. or L; It. Scala; L scala usually scalae pl., 1. a. originally a ladder; a flight of stairs; hence, b. a means of ascent'[5]) descend from logic to the 'surd state'. The rationality of a grid on a map sinks into what it is supposed to define. Logical purity suddenly finds itself in a bog, and welcomes the unexpected event. The 'curved' reality of sense perception operates in and out of the 'straight' abstractions of the mind. The flowing mass of rock and earth of the Spiral Jetty could be trapped by a grid of segments, but the segments would exist only in the mind or on paper. Of course, it is also possible to translate the mental spiral into a three-dimensional succession of measured lengths that would involve areas, volumes, masses, moments, pressures, forces, stresses and stains; but in the Spiral Jetty the surd takes over and leads one into a world that cannot be expressed by number or rationality. Ambiguities are admitted rather than rejected, contradictions are increased rather than decreased – the alogos undermines the logos. Purity is put in jeopardy. I took my chances on a perilous path, along which my steps zigzagged, resembling a spiral lightning bolt. 'We have found a strange footprint on the shores of the unknown. We have devised profound theories, one after another, to account for its origin. At last, we have succeeded in constructing the creature that made the footprint. And lo! it is our own.'[6] For my film (a film is a spiral made up of frames) I would have myself filmed from a helicopter (from the Greek helix, helikos meaning spiral) directly overhead in order to get the scale in terms of erratic steps.

Chemically speaking, our blood is analogous in composition to the primordial seas. Following the spiral steps we return to our origins, back to some pulpy protoplasm, a floating eye adrift in an antediluvian ocean. On the slopes of Rozel Point I closed my eyes, and the sun burned crimson through the lids. I opened them and the Great Salt Lake was bleeding scarlet streaks. My sight was saturated by the colour of red algae circulating in the heart of the lake, pumping into ruby currents, no they were veins and arteries sucking up the obscure sediments. My eyes became combustion chambers churning orbs of blood blazing by the light of the sun. All was enveloped in a flaming chromosphere; I thought of Jackson Pollock's Eyes in the Heat (1964; Peggy Guggenheim Collection). Swirling within the incandescence of solar energy were sprays of blood. My movie would end in sunstroke. Perception was heaving, the stomach turning, I was on a geologic fault that groaned within me. Between heat lightning and heat exhaustion the spiral curled into vapor- ization. I had the red heaves, while the sun vomited its corpuscular radiations. Rays of glare hit my eyes with the frequency of a Geiger counter. Surely the storm clouds massing would turn into a rain of blood. Once, when I was flying over the lake, its surface seemed to hold all the properties of an unbroken field of raw meat with gristle (foam); no doubt it was due to some freak wind action. Eyesight is often slaughtered by the other senses, and when that happens it becomes necessary to seek out dispassionate abstractions. The dizzying spiral yearns for the assurance of geometry. One wants to retreat into the cool rooms of reason. But no, there was Van Gogh with his easel on some sun-baked lagoon painting ferns of the Carboniferous Period. Then the mirage faded into the burning atmosphere.

FROM THE CENTRE OF THE SPIRAL JETTY

North—Mud, salt crystals, rocks, water
North by East—Mud, salt crystals, rocks, water
Northeast by North—Mud, salt crystals, rocks, water
Northeast by East—Mud, salt crystals, rocks, water
East by North—Mud, salt crystals, rocks, water
East—Mud, salt crystals, rocks, water
East by South—Mud, salt crystals, rocks, water
Southeast by East—Mud, salt crystals, rocks, water
Southeast by South—Mud, salt crystals, rocks, water
South by East—Mud, salt crystals, rocks, water
South—Mud, salt crystals, rocks, water
South by West—Mud, salt crystals, rocks, water
Southwest by South—Mud, salt crystals, rocks, water
Southwest by West—Mud, salt crystals, rocks, water
West by South—Mud, salt crystals, rocks, water
West—Mud, salt crystals, rocks, water
West by North—Mud, salt crystals, rocks, water
Northwest by West—Mud, salt crystals, rocks, water
Northwest by North—Mud, salt crystals, rocks, water
North by West—Mud, salt crystals, rocks, water

The helicopter manoeuvred the sun's reflection through the Spiral Jetty until it reached the centre. The water functioned as a vast thermal mirror. From that position the flaming reflection suggested the ion source of a cyclotron that extended into a spiral of collapsed matter. All sense of energy acceleration expired into a rippling stillness of reflected heat. A withering light swallowed the rocky particles of the spiral, as the helicopter gained altitude. All existence seemed tentative and stagnant. The sound of the helicopter motor became a primal groan echoing into tenuous aerial views. Was I but a shadow in a plastic bubble hovering in a place outside mind and body? Et in Utah ego. I was slipping out of myself again, dissolving into a unicellular beginning, trying to locate the nucleus at the end of the spiral. All that blood stirring makes one aware of protoplasmic solutions, the essential matter between the formed and the unformed, masses of cells consisting largely of water, proteins, lipoids, carbohydrates and inorganic salts. Each drop that splashed onto the Spiral Jetty coagulated into a crystal. Undulating waters spread millions upon millions of crystals over the basalt.

The preceding paragraphs refer to a 'scale of centres' that could be disentangled as follows:
(a) ion source in cyclotron
(b) a nucleus
(c) dislocation point
(d) a wooden stake in the mud
(e) axis of helicopter propeller
(f) James Joyce's ear channel
(g) the Sun
(h) a hole in the film reel.
Spinning off of this uncertain scale of centres would be

an equally uncertain 'scale of edges':

(a) particles
(b) protoplasmic solutions
(c) dizziness
(d) ripples
(e) flashes of light
(f) sections
(g) footsteps
(h) pink water.

The equation of my language remains unstable, a shifting set of co-ordinates, an arrangement of variables spilling into surds. My equation is as clear as mud – a muddy spiral.

Back in New York, the urban desert, I contacted Bob Fiore and Barbara Jarvis and asked them to help me put my movie together. The movie began as a set of disconnections, a bramble of stabilized fragments taken from things obscure and fluid, ingredients trapped in a succession of frames, a stream of viscosities both still and moving. And the movie editor, bending over such a chaos of 'takes' resembles a paleontologist sorting out glimpses of a world not yet together, a land that has yet to come to completion, a span of time unfinished, a spaceless limbo on some spiral reels. Film strips hung from the cutter's rack, bits and pieces of Utah, out-takes overexposed and underexposed, masses of impenetrable material. The sun, the spiral, the salt buried in lengths of footage. Everything about movies and moviemaking is archaic and crude. One is transported by this Archeozoic medium into the earliest known geological eras. The movieola becomes a 'time machine' that transforms trucks into dinosaurs. Fiore pulled lengths of film out of the movieola with the grace of a Neanderthal pulling intestines from a slaughtered mammoth. Outside his 13th Street loft window one expected to see Pleistocene faunas, glacial uplifts, living fossils and other prehistoric wonders. Like two cavemen we plotted how to get to the *Spiral Jetty* from New York City. A geopolitics of primordial return ensued. How to get across the geography of Gondwanaland, the Austral Sea and Atlantis became a problem. Consciousness of the distant past absorbed the time that went into the making of the movie. I needed a map that would show the prehistoric world as co-extensive with the world I existed in.

I found an oval map of such a double world. The continents of the Jurassic Period merged with continents of today. A microlens fitted to the end of a camera mounted on a heavy tripod would trace the course of 'absent images' in the blank spaces of the map. The camera panned from right to left. One is liable to see things in maps that are not there. One must be careful of the hypothetical monsters that lurk between the map's latitudes; they are designated on the map as black circles (marine reptiles) and squares (land reptiles). In the pan shot one doesn't see the flesh-eaters walking through what today is called Indochina. There is no indication of Pterodactyls flying over Bombay. And where are the corals and sponges covering southern Germany? In the emptiness one sees no Stegosaurus. In the middle of the pan we see Europe completely under water, but not a trace of the Brontosaurus. What line or colour hides the Globigerina Ooze? I don't know. As the pan ends near

Utah, on the edge of Atlantis, a cut takes place, and we find ourselves looking at a rectangular grid known as Location NK 12–7 on the border of a map drawn up the US Geological Survey showing the northern part of the Great Salt Lake without any reference to the Jurassic Period.

'... the earth's history seems at times like a story recorded in a book each page of which is torn into small pieces. Many of the pages and some of the pieces of each page are missing ...'[7]
– Thomas H. Clark and Colin W. Stern, *Geological Evolution of North America*, n.d.

I wanted Nancy to shoot 'the earth's history' in one minute for the third section of the movie. I wanted to treat the above quote as a 'fact'. We drove out to the Great Notch Quarry in New Jersey, where I found a quarry facing about twenty feet high. I climbed to the top and threw handfuls of ripped-up pages from books and magazines over the edge, while Nancy filmed it. Some ripped pages from an Old Atlas blew across a dried out, cracked mud puddle.

'According to all we know from fossil anatomy that beast was comparatively harmless. Its only weapons were its teeth and claws. I don't know what those obscene-looking pouches mean – they don't show in any fossil remains yet found. Nor do I know whether red is their natural colour, or whether it is due to faster decay owing to all the oil having dripped down off them. So much for its supposed identity.'[8]
– John Taine, *The Greatest Adventure*, 1963

The movie recapitulates the scale of the *Spiral Jetty*. Disparate elements assume a coherence. Unlikely places and things were stuck between sections of film that show a stretch of dirt road rushing to and from the actual site in Utah. A road that goes forward and backward between things and places that are elsewhere. You might even say that the road is nowhere in particular. The disjunction operating between reality and film drives one into a sense of cosmic rupture. Nevertheless, all the improbabilities would accommodate themselves to my cinematic universe. Adrift amid scraps of film, one is unable to infuse into them any meaning, they seem worn-out, ossified views, degraded and pointless, yet they are powerful enough to hurl one into a lucid vertigo. The road takes one from a telescopic shot of the sun to a quarry in Great Notch New Jersey, to a map showing the 'deformed shorelines of ancient Lake Bonneville', to *The Lost World*, and to the Hall of Late Dinosaurs in American Museum of Natural History.

The hall was filmed through a red filter. The camera focuses on a Ornithominus Altus embedded in plaster behind a glass case. A pan across the room picked up a crimson chiaroscuro tone. There are times when the great outdoors shrinks phenomenologically to the scale of a prison, and times when the indoors expands to the scale of the universe. So it is with the sequence from the Hall of Late Dinosaurs. An interior immensity spreads throughout the hall, transforming the lightbulbs into dying suns. The red filter dissolves the floor, ceiling and walls

into halations of infinite redness. Boundless desolation emerged from the cinematic emulsions, red clouds, burned from the intangible light beyond the windows, visibility deepened into ruby dispersions. The bones, the glass cases, the armatures brought forth a blood-drenched atmosphere. Blindly the camera stalked through the sullen light. Glassy reflections flashed into dissolutions like powdered blood. Under a burning window the skull of a Tyrannosaurus was mounted in a glass case with a mirror under the skull. In this limitless scale one's mind imagines things that are not there. The blood-soaked dropping of a sick Duck-Billed Dinosaur, for instance. Rotting monster flesh covered with millions of red spiders. Delusion follows delusion. The ghostly cameraman slides over the glassed-in compounds. These fragments of a timeless geology laugh without mirth at the time-filled hopes of ecology. From the soundtrack the echoing metronome vanishes into the wilderness of bones and glass. Tracking around a glass containing a 'dinosaur mummy', the words of *The Unnameable* are heard. The camera shifts to a specimen squeezed flat by the weight of sediments, then the film cuts to the road in Utah.

1 Dialectic of Site and Non-site

 Site Non-site
 1. Open Limits Closed Limits
 2. A Series of Points An Array of Matter
 3. Outer Co-ordinates Inner Co-ordinates
 4. Subtraction Addition
 5. Indeterminate Certainty Determinate Uncertainty
 6. Scattered Information Contained Information
 7. Reflection Mirror
 8. Edge Centre
 9. Some Place (physical) No Place (abstract)
 10. Many One

RANGE OF CONVERGENCE

The range of convergence between Site and Non-site consists of a course of hazards, a double path made up of signs, photographs and maps that belong to both sides of the dialectic at once. Both sides are present and absent at the same time. The land or ground from the Site is placed *in* the art (Non-site) rather than the art placed *on* the ground. The Non-site is a container within another container – the room. The plot or yard outside is yet another container. Two-dimensional and three-dimensional things trade places with each other in the range of convergence. Large scale becomes a small. Small scale becomes large. A point on a map expands to the size of the land mass. A land mass contracts into a point. Is the Site a reflection of the Non-site (mirror), or is it the other way around? The rules of this network of signs are discovered as you go along uncertain trails both mental and physical.

'No fish or reptile lives in it (Mono Lake), yet it swarms with millions of worms which develop into flies. These rest on the surface and cover everything on the immediate shore. The number and quantity of those worms and flies is absolutely incredible. They drift up in heaps along the shore.'
– W. H. Brewer, *The Whitney Survey*, 1863

2 London, 1960, p. 129

3 'In spite of the concentrated saline quality of the
 water, ice is often formed on parts of the Lake. Of
 course, the lake brine does not freeze; it is far too
 salty for that. What actually happens is that during
 relatively calm weather, fresh water from the various
 streams flowing into the lake "floats" on top of the salt
 water, the two failing to mix. Near mouths of rivers and
 creeks this "floating" condition exists at all times
 during calm weather. During the winter this fresh water
 often freezes before it mixes with the brine. Hence, an
 ice sheet several inches thick has been known to extend
 from Weber River to Fremont Island, making it possible
 for coyotes to cross to the island and molest sheep
 pastured there. At times this ice breaks loose and floats
 about the lake in the form of "icebergs".'
 - David E. Miller, *Great Salt Lake Past and Present*,
 Pamphlet of the Utah History Atlas, Salt Lake City, 1949

4 *Township 8 North of Range 7 West of the Salt Lake Base and
 Meridian*: Unsurveyed land on the bed of the Great Salt
 Lake, if surveyed, would be described as follows:
 Beginning at a point South 3000 feet and West 800 from
 the Northeast Corner of Section 8, Township 8 North,
 Range 7 West; thence South 45° West 651 feet thence North
 60° West 651 feet; thence North 45° E 651 feet; thence
 Southeasterly along the meander line 675 feet to the
 point of beginning.Containing 10.00 acres, more or less.
 - *Special use Lease Agreement No. 222*; witness: Mr. Mark
 Crystall.

5 *Webster's New World Dictionary of the American Language*
 (College Edition), World Publishing Co., 1959

6 A.S. Eddington, quoted on p. 232 in *Number, the Language
 of Science*, Tobias Dantzig, Doubleday Anchor Books, 1954

7 Thomas H. Clark, Colin W. Stern, *Geological Evolution of
 North America*, n.d., New York, Ronald Press Co., p. 5

8 John Taine, *The Greatest Adventure, Three Science Fiction
 Novels*, Dover Publications Inc., New York, 1963, p. 239
 Robert Smithson, 'The *Spiral Jetty*', *The Writings of Robert
 Smithson*, ed. Nancy Holt, New York University Press, New
 York, 1979, pp. 143-55; *Robert Smithson: The Collected
 Writings*, ed. Jack Flam, University of California,
 Berkeley, pp. 143-54

John COPLANS
The Amarillo Ramp [1974]

[...] Smithson's overriding concern, especially in the last two years of his life, was to propagate his art as 'a resource that mediates between ecology and industry'. He visited several strip mines, and negotiated for earthworks which he argued would be ways of reclaiming the land in terms of art. He wrote to numerous mining companies, especially those engaged in strip mining, reminding them that 'the miner who cuts into the land can either cultivate or devastate it'. Through a Wall Street friend, he finally contacted a receptive mining company. They were enthusiastic about his proposal for a 'tailings' earthwork at a mine in Creede, Colorado. At this mine, vast quantities of rock are broken up, subjected to a chemical process to extract the ore, and the residue washed into tailings ponds – a hydraulic system for flushing waste. Since the company required a new pond anyway, and since Smithson's earthwork could cost very little more, his ideas aroused their interest. In his proposal for *Tailings Pond*, Smithson envisaged a work that would continuously progress over twenty-five years or so. Some 9,000,000 tons (9,180,000 tonnes) of tailings would complete the earthwork, to have been approximately 2,000 feet (610 m) in diameter. Smithson allowed for an overflow if the projected quantity of tailings exceeded expectations by extending the design to accommodate the excess tailings into another half-section [...]

After two years of site selections, fund raising, and inevitable cancellations, his proposal for the construction of *Tailings Pond* realized at last Smithson's vision of an art that mediated between the industrial technological processes at work within the landscape. It confirmed his idea that the artist could become a functional worker within society; and making an art that restored to the common man his sense of place in the world.

The *Amarillo Ramp*, however, came into existence by chance. Smithson and his wife, Nancy Holt, visited Creede to work out the final design for *Tailings Pond*, but actual work on the project was delayed for a few more months. All the abortive attempts over the preceding two years to make a piece had left Smithson with a sense of repressed and contained energy that needed unleashing. While passing time in New Mexico they met a friend, Tony Shafrazi, who told of a ranch with desert lakes he was about to visit in the Texas Panhandle. The thought of desert lakes teased Smithson's imagination to such an extent that he and Holt decided to go along.

The Marsh Ranch is about 15 miles (24 km) northwest of Amarillo township, situated near the rim of the Bush Dome, a giant underground cavern deep in the earth, used to supply the Western world's readily available supply of helium gas. The rich helium source, found in the Texas gas fields near Amarillo after World War I, was the first tapped locally; then as other fields were opened in the Texas Panhandle, Oklahoma, and Kansas, helium gas was piped to the Bush Dome, processed and stored there. Helium is a 'noble' gas, one that will not react chemically with other gases or burn, and one crucial to the space programme since it is used to maintain pressure in rocket fuel tanks.

Other than a small, heavily fenced, and quite anonymous industrial processing unit nearby, there is little evidence of its presence near the ranch. It is typical of the area that until one has probed around, it is hard to grasp the extraordinary evolutionary process the surrounding land has undergone, especially in recent time – a quality that fascinated Smithson.

This part of Texas, east of a line drawn from Amarillo to New Mexico, appears on early maps as the Great American Desert, and the Panhandle (which, in fact, is the northern part of Texas) is still called West Texas, a re-minder that geographically it was considered within the arid Western frontier. The Indians have inhabited the area for thousands of years, beginning with the archaic Plains Indians. Until the last quarter of the nineteenth century, when they were cleared out by the US Cavalry in one of the last actions against Indians, the nomadic Comanches lived there. The area is rich in flint, much prized by the Indians, who sought, worked and traded it widely. The remains of a pre-Columbian trading kiva exist 12 miles (19 km) south of the *Amarillo Ramp* on the bank of the Canadian River [...] The area was considered unsuitable for white settlement until the 1880s, when the railway line was built. The opening of the area for ranching immediately attracted speculative international capital, principally English and Scottish, and settlement of the area by whites began in earnest.

I'm told that when the first ranchers came, the buffalo grass supported a greater number of cattle. It is a natural species of the dry plains east of the Rocky Mountains, a tender protein-rich grass, the food of the great herds of buffalo wandering the prairies, and requires no artificial fertilization. Unlike other ranching operations which must grow feed, the Amarillo ranchers were blessed with a natural food source for their cattle. Continual overgrazing systematically depleted the grass. Now the grass is cropped short and laced with mesquite, yucca and other noxious weeds that got a toehold from seeds in the droppings of the first cattle driven into the area.

Although at first it seems impossibly desolate, the Amarillo area is a dynamic center of agribusiness, a central geographic location where cattle, grain and rail transportation come together. Now, only ninety years after the opening of the Fort Worth and Denver City Railway, what was formerly considered unusable desert has become one of the beef lockers of the world.

The Marsh Ranch straddles a primeval watershed (probably a lake or sea bottom at one time) covered by a red rock of compressed clay. Nowadays, water flows down through this watershed into Tecovas Creek, which feeds into the Canadian River about 12 miles (19 km) north of the ranch, and then into the Mississippi. At the flood point of the Tecovas Creek, just beyond Tecovas Lake, which is a man-made dam, the action of the water has gouged a deep, twisted rocky canyon.

The dam that forms Tecovas Lake was built in the early sixties. Since then it has been silted some thirty to forty per cent with fine red clay. Before the dam was emptied for the building of *Amarillo Ramp*, the water level was roughly 8 feet (244 cm). The dam is part of a unique irrigation system called the Keyline, the first of its kind built in the Western hemisphere. Pioneered by a visionary Australian, P.A. Yeomans, the system is based on the local control and development of land and water resources. Large dams can cost enormous sums of money, and the feeder canals and pumping systems necessary to distribute the water can be equally expensive. By contrast, the Keyline system utilizes every drop of water where it falls. Rainwater usually runs off the land faster than the soil can absorb it, and is consequently wasted. Yeomans' plan doctors the land in such a way that water is conserved as close to the water-shed as possible. At the Marsh Ranch the water running down the watershed is dammed, pumped to a ridge 80 feet (24 m) above, fed through 5 miles (8 km) of ditch to a lake, then conducted by gravity downhill, point by point over the surface of the land. The land is plowed to get an even coverage from the water. The sparse rainfall of 20 inches (51 cm) a year is utilized to the maximum. I think what

interested Smithson was the wonderful simplicity of the system, the manner in which it so economically employs smaller and smaller systems to overcome the aridity of the area.

After Smithson saw Tecovas Lake, he was able to convince Stanley Marsh to let him build an earthwork. Marsh hired a plane so Smithson could take aerial photographs to chart the lake's position and size.

Smithson went up in the plane, photographed the lake and made some drawings. Later, he and Holt waded into the lake and staked out a piece, but Smithson rejected this plan and began again. A second proposal, for a work about 250 feet (76 m) in diameter, was dismissed because he felt it displaced too much of the area of the lake. He reduced it to 150 feet (46 m). After this third proposal was staked out, Marsh hired the same aircraft to view the staked-out piece from the air. On 20 July 1973, the plane was flying low over the site when it stalled and dived into the ground, killing everyone on board.

Soon after Smithson's death Holt thought that the piece should be built. Shortly after her return to New York, she saw Richard Serra, who had witnessed part of the construction of *Spiral Jetty*. He brought up the subject of finishing *Amarillo Ramp* and volunteered his help. After the funeral, he reminded Holt of his offer, and she made the decision to return immediately and finish the earthwork with Serra and Tony Shafrazi.

It took about three weeks for the *Amarillo Ramp* to be built. I know objections will be voiced as to whether it really is a piece by Smithson, and whether during the process of building, Smithson would not have altered his plan. But Holt attended all the initial planning. She worked with him on many of his projects, and Smithson discussed with her the final shape of the *Amarillo Ramp* in great detail, including the use and piling of the rock from the nearby quarry, from which he had decided to draw material. Smithson left specific drawings giving the size, gradation of the slope, and the staked-out shape of the piece in the water. It must be remembered, too, that Smithson never visualized the final design of any work as completely predetermined. The workers who built the *Spiral Jetty* were not just hired hands; they offered their own suggestions as to how the machines and materials could be employed to realize Smithson's temperament.

When Holt, Serra and Shafrazi arrived in Texas, they found that the water level of the Tecovas Lake had risen, and the stakes were almost covered. Their first problem was how to begin to work. They could not find the drain to the dam which they knew existed, even though they searched for hours in the muddy water. To pump the lake dry would have taken three weeks, so they cut the dike and emptied the lake, according to Serra's report, completely changing the place. The mud lay several feet deep, like a quagmire. The lake bed quickly became covered with crabs, crayfish, and sand-dabs dying in the sun.

You come across the *Amarillo Ramp* suddenly. You drive across the ranch following a track that meanders according to slight changes in the topography for the landscape, which is rolling, yucca-studded prairie. You don't realize that you are on a plateau, about 90 or so vertical feet (27 m) above the lowest level of the land, until you hit the edge of the bluff that slopes first sharply, and then gently down to Tecovas Lake. There below, beached like something that has drifted in, is the earthwork. The curve of the shape repeats the rhythm of the edges of the lake and the surrounding low valley. As you walk down the slope toward it, there is a point – about three-quarters of the way down – when the higher part of the ramp slices across the horizon, after which the sides loom up vertically to block the horizon. From the top of the bluff (an upper sighting platform) the earthwork is planar; it gradually becomes elevational on approach, but you don't really sense or grasp the verticality of the piece until you are close, at the very bottom of the incline and about to climb the ramp.

Seen from above, it is a circle; as you climb, it becomes an inclined roadway. Walking up the slope of the ramp, you look up-valley, far off toward low, flat hills; as you negotiate the curve and reach the topmost part, you look down-valley, across the dike, to the land below that gathers into the canyon beyond. The top is also a sighting platform from which to view the whole landscape 360 degrees. Returning down the earthwork, you retrace your footsteps, going past your own past, and at the same time you see the makings of the earthwork, the construction of the construction: the quarry in the nearby hillside from which the rocks were excavated; the roadway to the earthwork along which they were transported; the tracks of the earth-moving equipment; the tops of wooden stakes with orange-painted tips that delineated the shape still sticking out here and there; and the slope of the ramp shaped by the piled red shale and white caliche rock. An acute sense of temporality, a chronometric experience of movement and time, pervades one's experience of the interior of the earthwork. And something else, too, in walking back and looking down toward the inside, you are intensely aware of the concentric shape that holds its form by compression, heavy rock densely piled and impacted. Stepping off the earthwork, one has a sense of relief from pressure, stepping back into the normal world's time and space, and even a sense of loss. The piece then, is not just about centring the viewer in a specific place, but also about elevating and sharpening perception through locomotion. The *Amarillo Ramp* is mute until entered. And it is only later, when you return to the top of the bluff, and look back, that you realize how carefully it has been sited, how on first seeing the earthwork from above, in plan, everything is revealed by predestination. Once on the bluff again, you are reminded that even if you think you know the patter of the world, you still have to move through it to experience life. Thus to think of the *Amarillo Ramp* in traditional terms, as an object or sculpture dislocated from its surroundings, is to view it abstractly, to strip it of the existential qualities with which it is endowed [...]

John Coplans, 'The Amarillo Ramp', *Artforum*, New York, April 1974; reprinted in *Provocations: Writings by John Coplans*, ed. Stuart Morgan, London Projects, London, 1996, pp. 143-55

James TURRELL
Roden Crater [1993]

[...] If you stand on an open plain you will notice that the sky is not limitless and it has a definable shape and a sense of enclosure, which is referred to as celestial vaulting. If you lie down the shape changes. Clearly, these limits are malleable. I looked for a hemispherically-shaped, dished space, between 400 and 1,000 feet above a plain, in order to work with the limits of the space of the sky. The plain would provide the opportunity for celestial vaulting. The dish shape would effect changes in the perception of the size and shape of the sky. The height above the plain was important so that the slight quality of concave curvature to the earth experienced by pilots at low altitudes would increase the sense of celestial vaulting after you emerged from the crater space. I also wanted a high-altitude site so that the sky would be a deeper blue, which would increase a sense of close-in celestial vaulting from the bottom of the crater.

I flew all the Western states looking for a site [...] I did not want the work to be a mark upon nature, but I wanted the work to be enfolded in nature in such a way that light from the sun, moon and stars empowered the spaces. Usually art is taken from nature by painting or photography and then brought back to culture through the museum. I wanted to bring culture to the natural surround as if one was designing a garden or tending a landscape. I wanted an area where you had a sense of standing *on* the planet. I wanted an area of exposed geology like the Grand Canyon or the Painted Desert, where you could feel geologic time. Then in this stage set of geologic time, I wanted to make spaces that engaged celestial events in light so that the spaces performed a 'music of the spheres' in light. The sequence of spaces, leading up to the final large space at the top of the crater, magnifies events. The work I do intensifies the experience of light by isolating it and occluding light from events not looked at. I have selected different portions of sky and a limited number of events for each of the spaces. This is the reason for the large number of spaces. Each space essentially looks to a different portion of sky and accepts a limited number of events [...]

James Turrell, 'Roden Crater', *James Turrell, Air Mass*, The South Bank Centre, London, 1993

James TURRELL
Mapping Spaces [1987]

Light is a powerful substance. We have a primal connection to it. But, for something so powerful, situations for its felt presence are fragile. I form it as much as the material allows. I like to work with it so that you feel it physically, so you feel the presence of light inhabiting a space. I like the quality of feeling that is felt not only with the eyes. It's always a little bit suspect to look at something really beautiful like an experience in nature and want to

make it art. My desire is to set up a situation to which I take you and let you see. It becomes your experience. I am doing that at Roden Crater. It's not taking from nature as much as placing you in contact with it.

James Turrell, 'Roden Crater', James Turrell, Air Mass, The South Bank Centre, London, 1993

Andy GOLDSWORTHY
Stone [1994]

Fixed ideas prevent me from seeing clearly. My art makes me see again what is there, and in this respect I am also rediscovering the child within me. In the past I have felt uncomfortable when my work has been associated with children because of the implication that what I do is merely play. Since having children of my own, however, and seeing the intensity with which they discover through play, I have to acknowledge this in my work as well.

I had to forget my idea of nature and learn again that stone is hard and in so doing found that it is also soft. I tore leaves, broke stones, cut feathers … in order to go beyond appearances and touch on something of the essence. I would often start by clearing a space in which to work and put things – place was as closely cropped as the material.

I cannot disconnect materials as I used to. My strongest work now is so rooted in place that it cannot be separated from where it is made – the work is the place. Atmosphere and feeling now direct me more than the picking up of a leaf, stick, stone …

Inevitably materials and places gather associations and meanings as my work develops, but in ways that draw me deeper into nature rather than distracting me from it. What I could previously see only by working close up is now also visible to me from a distance. I now want to understand the untorn leaf, the unbroken stone, the uncut feather, the uncleared space … and to perceive all materials as the same energy revealed differently.

I am no longer content simply to make objects; instead of placing works upon a stone, I am drawn to the stone itself. I want to explore the space within and around the stone through a touch that is a brief moment in its life. A long resting stone is not an object in the landscape but a deeply ingrained witness to time and a focus of energy for its surroundings.

My work does not lay claim to the stone and is soon shed like a fall of snow, becoming another layer in the many layers of rain, snow, leaves and animals that have made a stone rich in the place where it sits.

Although I occasionally work in wildernesses, it is the areas where people live and work that draw me most. I do not need to be the first or only person in a place. That no-one has gone before me would be a reason for me not to go there and I usually feel such places are best left.

I am drawn to wildness but do not have to be in a wilderness to find it. If much of my work appears to be made in such places it is because I find wildness in what is often considered commonplace. Going to other countries is interesting but not essential to my art. Most (if not all) that I need can be found within walking distance of my home. When travelling I regret the loss of a sense of change. I see differences not changes. Change is best experienced by staying in one place. I travel because I am invited and accept this just as I do ice when it's freezing and leaves in autumn. The choice of where to work is never entirely within my control.

I am not a great traveller and when abroad I will settle into a daily routine of going back and forth to work in the same place. Even in the vast Australian outback I worked mainly in one area of a small hill. I returned there on my second visit and would be happy to go there for a third.

I revisit some stones, as I do places, many times over. Each work teaches me a new aspect of the stone's character. A stone is one and many stones at the same time – it changes from day to day, season to season.

I do not simply cover rocks. I need to understand the nature that is in all things. Stone is wood, water, earth, grass … I am interested in the binding of time in materials and places that reveals the stone in a flower and the flower in a stone.

It is difficult for a sculptor to work with petals, flowers and leaves because of their decorative associations. I cannot understand nature without knowing both the stone and the flower. I work with each as they are – powerful in their own ways – the flesh and bones of nature.

I feel the same about colour. Colour for me is not pretty or decorative – it is raw with energy. Nor does it rest on the surface. I explore the colour within and around a rock – colour is form and space. It does not lie passively or flat. At best it reaches deep into nature – drawing on the unseen – touching the living rock – revealing the energy inside.

Andy Goldsworthy, 'Stone', Stone, Harry N. Abrams, New York; Viking Books, London, 1994, p. 6

Doris BLOOM and William KENTRIDGE
Heart and Gate [1995]

The manifestation of the project sets off a dialogue which is the very content of the work. It is a dialogue which is not about anything specific, not about any special common past although there are of course myriads of references everywhere to the artists' origins and life trajectories. To their childhood and growing up, from smells to values, from habits to momentous experiences. It is a dialogue alone as a marker of a kind of life principal, an apolitical life principle with political consequences. Especially if tread

upon. Dialogue is thus not an ideological concept. It is a concept which belongs to the flowing and uncompleted life and as such is on the side of openness and freedom.

People are moved by dimension, they are brought together by something which seems larger than themselves, even incomprehensible. It is precisely this kind of movement which precisely Land Art has the capacity to create as genre, if one can use the word. Land Art lifts the work out of the realm of the personal and out of the magic circle of the individual artist-destiny and turns it into a space, a context, a world which one cannot say is the private individual's inner sphere. Land Art is to a radical degree an art of exteriority. It marks the world as an extended field expending its energies in the marking of the world rather than in the communication of a personal or private truth. In the simple sense of the word, Land Art brings our attention back to the world.

The two Land Art projects, Heart and Gate, can be seen in photographic representation. They are a kind of documentation of ceremonial beginning and serve to dramatise the meeting of two artists.

Doris Bloom and William Kentridge, 'Heart and Gate', unpublished artists' statement, 1995

Sidney TILLIM
Earthworks and the New Picturesque [1968]

In 1964 Donald Judd wrote that conventional media and the canvas rectangle were no longer adequate for a contemporary expression and called for an art with 'the specificity and power of actual materials, actual colour, actual space'. The recently concluded exhibition of earthworks at the Dwan Gallery in New York brings to a climax the subsequent involvement with 'actual' media in recent art. The earthworks were just that – works made either with actual soil or by marking lines, digging holes and cutting rings on and into selected portions of the earth's surface (illustrated in the exhibition by photographs of the various sites). Never has it been clearer that anything can be an artistic medium, as long as it is used literally rather than symbolically. At the same time, in the light of all this, rarely has the future of Modernism seemed more problematical.

Earthworks represent a special and conceptual involvement with literal nature and it is not an accident that almost every artist in the show exhibited 'minimal' art in seasons past. Either passages of landscape are turned into art, or object-art is turned into a kind of landscape, or object and landscape are combined in a way that is both aesthetic and atavistic. Dennis Oppenheim proposes to mow rings up to ten miles wide in the wheat fields surrounding an active volcano in Ecuador next July, whereas Robert Morris assembles, in a gallery, and for one time, a compost of dark soil, a profusion of pipes, lengths of felt and a gelatinous mass of thick industrial grease. Other varieties of the literalist landscape experience, either illustrated or actually shown in the exhibition,

EARTHWORKS, THEN, ARRIVE AT A MOMENT WHEN MODERNISM IS AT THE LOWEST EBB IN ITS HISTORY, AND IS THEREFORE IMPLICATED IN, INDEED SIGNALS, THE WEAKNESS OF MODERNISM AS A WHOLE.

Sidney TILLIM Earthworks and the New Picturesque, 1968

include the vast parallel lines drawn across a Western wasteland by Walter De Maria, and a gallery in Munich with wall-to-wall dirt, also by De Maria. Rough-hewn blocks of wood by Carl Andre were illustrated snaking through forest underbrush; Michael Heizer dug slit trenches in forests and sun-baked mud flats. Claes Oldenburg showed some dirt in a plastic container; the dirt was said to be seeded with worms. The hole he had dug and filled up again behind the Metropolitan Museum of Art was presented on film.

What I think is involved in Earth Art in particular and actual media art in general is a twentieth-century version of the *picturesque*. The picturesque was a theory of landscape that emerged in the late eighteenth and early nineteenth centuries, especially in England. As the word itself implies, the picturesque referred to landscape seen in an essentially pictorial way. Landscapes were judged for their pictorial beauties and the same effects in painting were highly praised. In other words it was a way of seeing nature and the setting was very important. An extensive body of literature describing and illustrating picturesque tours came into being.

Minimalist art is likewise dependent on setting. Whether of the technological and hard-edged sort, or the geological and much softer kind, minimalist art is a form of man-made nature or nature made over by man. It does not present objects with art on them but useless artifacts that create a setting rather than a space. The relationship, then, between an observer of minimalist art, or a minimalist object-scape, call it, is analogous to the relationship between the cultivated man of taste and his picturesque view. It was this quality which provoked Michael Fried to describe minimalist or, as he called it, literalist, sculpture, pejoratively as 'theatrical'. For in the theatrical work the observer is no longer outside of the work of art but is instead a part of its setting. The work thus 'performs' for the observer. Some minimalist sites can only be appreciated from the air. On the other hand, Robert Smithson virtually parodied the modern picturesque when he visited the 'monuments' of Passaic, carrying his Instamatic camera like the older connoisseur carried a sketchbook, perhaps. And like him, Smithson wrote up his tour and illustrated it with photographs – of a factory building, sand pits, drainage pipes and the effluvia of industrialism generally.

As in the earlier and original picturesque, the values of judging and choosing 'sites', or 'Non-sites' (as Smithson calls his gallery objects), or the style in which a landscape is made over, derive entirely from art. A thorough knowledge of modernist art' is therefore a prerequisite for the refinement actually involved in the literalist picturesque. For instance, qualities of shape and composition or non-composition derive from specifically abstract precedents. Thus some are purely planar and/or linear (Heizer's earth rings, De Maria's lines), some are Pop (Smithson's bins of rocks and photographs, his trip to Passaic, Oldenburg's hole in Central Park), others are virtually abstract expressionist in a conceptualized way (Morris' dirt pile). Earthworks were limited to works involving the earth, but the media aesthetic is not limited to a geological palette and other artists are working in

other media which interpolate a corresponding landscape of tactility. And much of it combines both soft and hard components to recapitulate the basic formal dichotomy (edge versus mass) at the root of all art since the very moment, in fact, when the cult of the picturesque began to flourish. Consequently, it is further confirmation of my analogy that Minimalism has resulted in a body of theoretical writing comparable to that produced by the proselytizers and theorists of the original picturesque.

But the picturesque was more than just a theory of landscape in nature and art. It was a crucial episode in the history of taste. Less than sublime, yet seeking a surrogate for the ideal, it signalled, by virtue of its resultant sentimentality, the end of the ideals of high art. It substituted the sentimental for nobility of feeling and developed the cult of nature as an antidote to the excessive sophistication of cultivated society. At the same time it was an affectation of cultivated taste at its most refined. Its incipient morbidity matured finally with the complete failure of scale in the early nineteenth century (not even Romanticism could save monumentality; realism was inimical to it and to the rise of Victorianism).

As the twentieth-century form of the picturesque, earthworks signify an analogous degree of over-cultivation of the modernist idiom. And it implements the condition of over-refinement in the course of seeking to renew Modernism by a direct involvement with 'actual' media, an involvement that has run the gamut from wood, metal, plastics, the entire industrial process and now common dirt. It thus links up with Pop Art as a kind of precious primitivism seeking revitalization through willful banality. And like Pop Art, it is effective only in so far as it confirms the stylistic attrition it seeks to reverse.

We can understand now why formalists restrict the possibility of quality to an increasingly narrow sector of art. As more and more art defects from what formalists consider rigorous historical self-criticism, as more and more artists substitute their own historical-theoretical definitions of modernist art history, the fewer the options for a preponderantly formalist solution to problems of contemporary style. Thus the intensity of the formalist position increases to the degree that its conception of quality is isolated in an art culture that has turned to other means, including the extravagant ones in earthworks, for solutions to problems of contemporary style. Clement Greenberg, the principal formalist critic of modern times, was aware of the significance of growing unrest in Modernism when he concluded something of a defense of abstract art in 1964 in an article, 'The "Crisis" of Abstract Art', in curiously cautious, even anticipatory terms. Rejecting notions of a 'crisis', he claimed colour painting as the successor to painterly abstraction. Then he terminated his article as follows:
'An unexplored realm of picture-making is being opened up – in a quarter where young apes cannot follow – that promises to be large enough to accommodate at least one more generation of major painters.'
'At least one more generation': a modest, almost chastened claim, as if Greenberg here senses that the fabric of Modernism is wearing thin. And now, even the

best modernist abstraction is not immune from the delicacy that is robbing Modernism of its power. Earthworks, then, arrive at a moment when Modernism is at the lowest ebb in its history, and is therefore implicated in, indeed signals, the weakness of Modernism as a whole.

An extreme is too much, and that by definition. It is possible only through an oversimplification of alternatives and an utter dependence on the one that is chosen. This is necessary in revolution, but when evolution has assimilated revolution, extremism becomes a form of sentimentality. In minimalist sculpture, this has led to an exaggeration of belief in one aspect of art – the medium – and it furthermore holds that every medium has inherent properties which determine the shape of the entire work. Yet it is impossible not to impose on a medium. If we do not attempt to control it through, say, shape, we still say where the shape will happen. Thus Minimalism affects an absence of contrivance when in practice it is all contrivance, brutal and exquisite at the same time.

On the other hand, the sentimental is a solution and has its pleasures. It is the only way to solve a certain kind of problem. Minimalists seek a complex lack of complexity, a monumentality without parts and a 'natural' selection of forms. Thus, from the didactic side of Minimalism we can learn a great deal about the problem of shape, colour and scale in post-colour art. From its unconscious or conscious affinity with architecture – and the landscapists among the minimalists are neo-Gothic type visionaries – we learn of an exceptional desire for a consanguinity of art and architecture, of architecture and nature, a desire that is not only social, but ultimately moral. In any event, it is significantly mysterious, involved somehow in a yearning for a ritual impulse which whole societies once experienced in common. But recovery is impossible unless one has models to remind one of what has been lost. Because Minimalism rejects the past, it can only illustrate the impulse through a medium which becomes a surrogate for representation.

1 I don't use this word with Clement Greenberg's
 precision; I mean by it, here at least, roughly
 everything that comes out of the 'avant-garde'.
Sidney Tillim, 'Earthworks and the New Picturesque',
Artforum, no 7, New York, December 1968, pp. 43-45

INTERRUPTION

The texts included here expand on early investigations of the landscape, often dovetailing larger philosophical questions with specific analyses of artistic practice. 'Certain art is now using as its beginning and as its means, stuff, substances in many states - from chunks, to particles, to slime, to whatever - and pre-thought images are neither necessary nor possible', writes Robert Morris in his 'Notes on Sculpture'. 'Alongside this approach is change, contingency, indeterminacy', he continues, 'in short, the entire area of process. Ends and means are brought together in a way that never existed before in art'. Whether orchestrating existing elements in a landscape, introducing new non-indigenous products into it, or taking elements from the land into the gallery, the kinds of art-making described and implied by the texts in this grouping are involved in exploring attitudes to form, material and process. They represent a radical opening out of the object of art and its relation to both viewer and space.

Michael FRIED
Art and Objecthood [1967]

[…] I am suggesting, then, that a kind of latent or hidden naturalism, indeed anthropomorphism, lies at the core of literalist theory and practice. The concept of presence all but says as much, though rarely so nakedly as in Tony Smith's statement, 'I didn't think of them [i.e., the sculptures he "always" made] as sculptures but as presences of a sort'. The latency or hiddenness of the anthropomorphism has been such that the literalists themselves have, as we have seen, felt free to characterize the modernist art they *oppose*, e.g., the sculpture of David Smith and Anthony Caro, as anthropomorphic – a characterization whose teeth, imaginary to begin with, have just been pulled. By the same token, however, what is wrong with literalist work is not that it is anthropomorphic but that the meaning and, equally, the hiddenness of its anthropomorphism are incurably theatrical. (Not all literalist art hides or masks its anthropomorphism; the work of lesser figures like Steiner wears it on its sleeve.) *The crucial distinction that I am proposing so far is between work that is fundamentally theatrical and work that is not.* It is theatricality which, whatever the

differences between them, links artists like Bladen and Grosvenor, both of whom have allowed 'gigantic scale [to become] the loaded term' (Morris), with other, more restrained figures like Judd, Morris, Andre, McCracken, LeWitt and – despite the size of some of his pieces – Tony Smith.' And it is in the interest, though not explicitly in the *name*, of theatre that literalist ideology rejects both modernist painting and, at least in the hands of its most distinguished recent practitioners, modernist sculpture.

In this connection Tony Smith's description of a car ride taken at night on the New Jersey Turnpike before it was finished makes compelling reading:

'When I was teaching at Cooper Union in the first year or two of the 1950s, someone told me how I could get on to the unfinished New Jersey Turnpike. I took three students and drove from somewhere in the Meadows to New Brunswick. It was a dark night and there were no lights or shoulder markers, lines, railings or anything at all except the dark pavement moving through the landscape of the flats, rimmed by hills in the distance, but punctuated by stacks, towers, fumes and coloured lights. This drive was a revealing experience. The road and much of the landscape was artificial, and yet it couldn't be called a work of art. On the other hand, it did something for me that art had never done. At first I didn't know what it was, but its effect was to liberate me from many of the views I had had about art. It

seemed that there had been a reality there which had not had any expression in art.

'The experience on the road was something mapped out but not socially recognized. I thought to myself, it ought to be clear that's the end of art. Most painting looks pretty pictorial after that. There is no way you can frame it, you just have to experience it. Later, I discovered some abandoned airstrips in Europe – abandoned works, surrealist landscapes, something that had nothing to do with any function, created worlds without tradition. Artificial landscape without cultural precedent began to dawn on me. There is a drill ground in Nuremberg large enough to accommodate two million men. The entire field is enclosed with high embankments and towers. The concrete approach is three 16-inch (41 cm) steps, one above the other, stretching for a mile or so'.

What seems to have been revealed to Smith that night was the pictorial nature of painting – even, one might say, the conventional nature of art. And *this* Smith seems to have understood, not as laying bare the essence of art, but as announcing its end. In comparison with the unmarked, unlit, all but unstructured turnpike – more precisely, with the turnpike as experienced from within the car, travelling on it – art appears to have struck Smith as almost absurdly small ('All art today is an art of postage stamps', he has said), circumscribed, conventional … There was, he seems

NEVER

to have felt, no way to 'frame' his experience on the road, that is, no way to make sense of it in terms of art, to make *art* of it, at least as art then was. Rather, 'you just have to experience it' – as it *happens*, as it merely *is*. (The experience *alone* is what matters.) There is no suggestion that this is problematic in any way. The experience is clearly regarded by Smith as wholly accessible to everyone, not just in principle but in fact, and the question of whether or not one has really *had* it does not arise. That this appeals to Smith can be seen from his praise of Corbusier as 'more available' than Michaelangelo, 'The direct and primitive experience of the High Court Building at Chandigahr is like the Pueblos of the Southwest under a fantastic overhanging cliff. It's something everyone can understand'. It is, I think, hardly necessary to add that the availability of modernist art is not of this kind, and that the rightness or relevance of one's conviction about specific modernist works, a conviction that begins and ends in one's experience of the work itself, is always open to question.

But what was Smith's experience on the turnpike? Or to put the same question another way, if the turnpike, airstrips and drill ground are not works of art, what *are* they? What, indeed, if not empty, or 'abandoned', *situations*? And what was Smith's experience if not the experience of what I have been calling *theatre*? It is as though the turnpike, airstrips and drill ground reveal the theatrical character or literalist art, only without the object, that is, *without the art itself* – as though the object is needed only within a *room*[2] (or, perhaps, in any circumstances less extreme than these). In each of the above cases the object is, so to speak, *replaced* by something: for example, on the turnpike by the constant onrush of the road, the simultaneous recession of new reaches of dark pavement illumined by the onrushing headlights, the sense of the turnpike itself as something enormous, abandoned, derelict, existing for Smith alone and for those in the car with him ... This last point is important. On the one hand, the turnpike, airstrips and drill ground belong to no one; on the other, the situation established by Smith's presence is in each case felt by him to be *his*. Moreover, in each case being able to go on and on indefinitely is of the essence. What replaces the object – what does the same job of distancing or isolating the beholder, of making him a subject, that the object did in the closed room – is above all the endlessness, or objectlessness, of the approach or onrush or perspective. It is the explicitness, that is to say, the sheer persistence, with which the experience presents itself as directed at him from outside (on the turnpike from outside the car) that simultaneously makes him a subject – makes him subject – and establishes the experience itself as something like that of an object, or rather, of objecthood. No wonder Morris' speculations about how to put literalist work outdoors remain strangely inconclusive: 'Why not put the work outdoors and further change the terms? A real need exists to allow this next step to become practical. Architecturally designed sculpture courts are not the answer nor is the placement of work outside cubic architectural forms. Ideally, it is a space without architecture as background and reference, that would give

different terms to work with.'

Unless the pieces are set down in a wholly natural context, and Morris does not seem to be advocating this, some sort of artificial but not quite architectural setting must be constructed. What Smith's remarks seem to suggest is that the more effective – meaning effective as *theatre* – the setting is made, the more superfluous the works themselves become [...]

1 It is theatricality, too, that links all these artists
 to other figures as disparate as Kaprow, Cornell,
 Rauschenberg, Oldenburg, Kienholz, Segal, Samaras,
 Christo, Kusama ... the list could go on indefinitely.
2 The concept of a room is, mostly clandestinely,
 important to literalist art and theory. In fact, it can
 often be substituted for the word 'space' in the latter:
 something is in my space if it is in the same *room* with me
 (and if it is placed so that I can hardly fail to notice
 it).
Michael Fried, 'Art and Objecthood', *Artforum*, New York,
June 1967, pp. 19-20

Carl ANDRE
Artist's statement [1970]

My idea of a piece of sculpture is a road. That is, a road doesn't reveal itself at any particular point or from any particular point. Roads appear and disappear. We either have to travel on them or beside them. But we don't have a single point of view for a road at all, except a moving one, moving along it. Most of my works – certainly the successful ones – have been ones that are in a way causeways – they cause you to make your way along them or around them or move to the spectator over them. They're like roads, but certainly not fixed point vistas. I think sculpture should have an infinite point of view. There should be no one place, nor even a group of places where you should be.

Carl Andre, 'Artist's Statement', *Extraneous Roots*,
Frankfurt Museums für Moderne Kunst, 1991, p. 52. Originally
published in *Artforum*, New York, June 1970, pp. 55-61.

Dennis OPPENHEIM
Another Point of Entry:
Interview with Alanna Heiss
[1992]

[...] *Alanna Heiss* Let's talk about your early pieces, where ideas were more important than seduction, more vital than visuals. *Annual Rings* (1968) and *Landslide* (1968) have a quasi-scientific quality to them, which seems to be at odds with what feels like the old-fashioned notion of the artist immersing himself in nature. In a 1968 article on earthworks, Sidney Tillim speculated about Earth Art as a 'picturesque quest', as a substitution of sentimentality for nobility of feeling, the cult of nature as an anecdote for

excessive cultural sophistication.

Dennis Oppenheim Well, this notion of the artist immersing himself in nature – the theory of the picturesque – was not part of the recipe of entry that concerned all Earth Artists. Only a few of them have had a dialogue with this idea, perhaps Richard Long and some other English artists. My use of quasi-scientific nuance or notation was meant to oppose abstract gestures on the land, lines that only meant themselves and didn't refer to anything else. I believed applying abstract gesture onto the land was carrying a studio ideology that referred to painting, out of doors. It was retrograde. If you were going to use land, you should make it part of a holistic, ecological, geological, anthropological continuum.

So when I did lines on the snow, lines which came from a map, I referred to them as information lines. They may have looked like abstract gestures, even abstract expressionist gestures, but the intent was to suture the work with lines or notations that had larger fields of association. Lines could mean rainfall or temperature. I was not paying attention to the picturesque as a possibility. I used terms like 'studio organism', quasi-ecological terms that were meant to contrast studio habits with exterior habits or habitats. I took my clues from ecology, pushing towards what the critic Jack Burnham called 'real time systems'. A sculptor in real time systems wouldn't want studio references to bleed into the land. He would want to have a new dialogue with the external site.

Heiss So, if you weren't searching out locations because they were beautiful or interesting to you, how would you determine where you would do an Earth Art piece, for example? Why choose exit 52 on the Long Island Expressway for *Landslide*?

Oppenheim I was drawn to ravaged sites. When I wanted to undertake a piece, I would go to New Jersey and stomp around chemical dumps. This was one of the reasons why it was difficult to do earthworks under the jurisdiction of a planned exhibition. Sites were places that had not been incorporated into a system – dumps, borders of countries, deserts and waste lands – peripheries. If the land wasn't degenerate enough for me, I'd write words like 'diphtheria' on the hillside. The idea was a severe disjuncture from the pastoral [...]

Heiss But Tillim also implied that you guys were all kidding. Instead of staring at the sunset and sighing, you were taking a chainsaw and cutting a hole in the ground and looking at the sunset and sighing. So you were doing basically the same thing.

Oppenheim Well, one has to come to grips with what amount of the gesture went towards the site and what amount didn't have anything to do with it. A good part of the thinking could have been supplanted to objects or non-objects or dematerialized states, not locations. There are Earth Artists who have only focused on a very specific formal treatment for twenty-five years. Clearly, a large percentage of their momentum was already monomaniacal at the time.

For me, Earth Art was already decompartmentalized and splitting apart as I was doing it. It quickly whiplashed into what was diametrically opposed to it – Body Art. I knew that I could have gotten another ten years out of

MY IDEA OF A PIECE OF SCULPTURE IS A ROAD. THAT IS, A ROAD DOESN'T REVEAL ITSELF AT ANY PARTICULAR POINT OR FROM ANY PARTICULAR POINT. ROADS APPEAR AND DISAPPEAR. WE EITHER HAVE TO TRAVEL ON THEM OR BESIDE THEM. BUT WE DON'T HAVE A SINGLE POINT OF VIEW FOR A ROAD AT ALL, EXCEPT A MOVING ONE, MOVING ALONG IT.

Carl ANDRE Artist's statement, 1970

226

making inscriptions in the ground before they would start to wear thin. I also knew I would have trouble justifying such a mono-directional pursuit. I wasn't looking for the Earth Art to give way, and Body Art to take over; I was looking for a kind of hybrid unbeknownst to me. It was like mixing your own chemistry as you're thinking. Mixing liquids in your own system, not knowing the exact outcome.

Heiss Was your Earth and Body Art an extension, or a denunciation, of the influence of Minimalism on art in the late 1960s and 1970s?

Oppenheim Conceptual Art, by and large, was in a dialogue with Minimalism, and was literally descended from Minimalism through its practitioners. They retain a dialogue to this day. In fact, the earthworks you see now that are done by the classic practitioners are either a continuation of this original position or a degeneration rising out of sheer fatigue from the distance they've gone. That's one of the problems with formalism; a fatigue factor registers in the work.

Heiss Was your work an extension or a denunciation?

Oppenheim The urge was to go beyond Minimalism. It was clear, even to the minimalists, that their idea was reaching ground zero. That's why phenomenology became a way of expanding the domain – and a valid way at that. We know that Minimalism quickly lifted off into phenomenology via the work of Bruce Nauman and Turrell and the writings of Robert Morris.

Heiss Dennis, how does it feel to look back on Earth and Body Art pieces that you made twenty years ago, that do not exist, except in documentation that seems so limited and in some cases inferior?

Oppenheim In 1968 and 1969 I lived in an apartment. I didn't need a studio. Everything that I had done as an artist was contained in one small case of slides. And it accounted for two of the most strenuous years of work in my whole life. I distinctly remember realizing this while sitting and looking at virtually everything I had done [...]

Heiss Over the years pictures documenting your early work have become iconic, but what do they really communicate about those works or about the experience of making those works to us twenty years later?

Oppenheim As pictures age, they remove themselves from the instant; certain things happen to the information in them. I've always admitted that it was necessary to make photographic documentation. It was a naivete that co-existed with the outdoor work.

Heiss In a 1968 article in *Newsweek*, there is a picture of *Landslide*, taken from the top of the hill, and you're standing at the bottom. I looked at it and said, 'Wait a minute. This makes the piece completely different from the way I know it from other pictures'. What really was the piece? [...]

Oppenheim The photographer who took the picture for *Newsweek* assumed a strange position on the bank. After looking through the lens he said, 'I could destroy you with this shot'. I realized then that we had problems. On one hand, I knew virtually nobody was going to see *Landslide*, except the photographer. But once he clicked the shutter, millions of people were going to see the piece. So I realized the photograph was important. As much as I may have

recognized the importance of documentation, and even if I focused on it to the point where it fed my ideas through paranoia, I couldn't make the obsession stick. The next day I was off doing another piece, caring even less about the way it would be seen. This is the truth [...]

You can't understand how strange it was to be a sculptor who exhibited photographs. You operated on truly a large scale, but when photographs represented the work everything closed down into a pictorial configuration. You were always making excuses for poor documentation, saying what you were doing was an advanced art, and there were only a few ways to communicate it. But in reality the work was gone, and there was nothing to see. That was the way I wanted it [...]

Heiss But, what *was* the piece? In your mind, did those early pieces exist beyond your original realization through documentation, however modest? For example, in my mind, Smithson's *Spiral Jetty* is just two photographs.

Oppenheim That's certainly what Baudrillard would say.

Heiss It's a memory to me, aided by two photographs. Not many people saw it. By the way, I have no problem with ephemeral art. Most art exists in memory aided by photographs. After all, how many times do you check in at the Prado? How many times do you actually see Bosch's paintings?

Oppenheim There's another point here, Alanna, another consideration about *Spiral Jetty* and the early Earth Art pieces. In terms of percentages, they didn't have a high visual quality. *Spiral Jetty* is 75 per cent mental. It doesn't need pictorial differentiations. It's basically the *idea* of earthworks, the idea of the salt flats. There are millions of spiral configurations. In other words, it's about the salt, submersions, the jetty, what is around the salt flats. In the end, it's about mental configurations.

Some of my pieces, like the snow pieces, were about temperature, the fact that it was freezing. When you do a drawing of the piece, and it's freezing with a chill factor as you move a pencil across the paper, that's the idea. The visual quotient is not as strenuous as you think. What am I supposed to do? Carry around ice cubes, asking people to put their hand inside the bag?

Heiss Relative to painting and sculpture, it took a lot of money to make Earth Art, to get everything right [...] The artist was given a chance to do something on a scale that was not only beyond a gallery or a museum, but beyond nationality [...]

Oppenheim It *was* radical, if you consider late 1967 or 1968 as the time when most of these huge pieces were done. I defend the approach of radicality, the fact that outdoor works invited a dialogue with real time in ways that art had not done before. They were a strenuous departure from the traditional art settings and contexts. Unfortunately, the work quickly became postured, a recycling of abstract sculptural idiom. In other words, it just didn't go the full nine yards. I chose a course, a diabolical act, to circumvent it. I found this other agitation, the body, and I felt that unless I have myself the chance to pursue it, I was going to be forever disappointed. I couldn't help but stretch myself into it.

Heiss You undertook the body art as a parallel activity?

Oppenheim I started a dialogue between 'land wounds'

and scars on my body in works like *Land Incision* (1968) and *Art & Wire* (1969). Then in 1969, I got video equipment, and I began to record activities. Earth Art quickly evolved into Body and Performance Art for me [...]

Alanna Heiss, 'Another Point of Entry: An Interview with Dennis Oppenheim', *Dennis Oppenheim: Selected Works 1967-90*, P.S. 1 Museum - The Institute for Contemporary Art/Harry N. Abrams, New York, 1992, pp. 138-50

CHRISTO and JEANNE-CLAUDE
Project Notes [1969–91]

WRAPPED COAST, LITTLE BAY, ONE MILLION SQUARE FEET, SYDNEY, AUSTRALIA, 1969
Little Bay, property of Prince Henry Hospital, is located 9 miles (14.5 km) south-east of the centre of Sydney. The cliff-lined shore area that was wrapped is approximately 1.5 miles (2 km) long, 150—800 feet (46—244 m) wide, 85 feet (26 m) high at the northern cliffs, and was at sea level at the southern sandy beach.

One million square feet (93,000 m²) of erosion control fabric (synthetic woven fibre usually manufactured for agricultural purposes), were used for the wrapping. 35 miles (56 km) of polypropylene rope, 1.5 (4 cm), tied the fabric to the rocks.

Ramset guns fired 25,000 charges of fasteners, threaded studs and clips to secure the rope to the rocks.

Mr. Ninian Melville, a retired major in the Army Corps of Engineers, was in charge of the workers at the site.

17,000 manpower hours, over a period of four weeks, were expended by fifteen professional mountain climbers, 110 labourers, architecture and art students from the University of Sydney and East Sydney Technical College, as well as a number of Australian artists and teachers.

The project was financed by Christo and Jeanne-Claude through the sale of original preparatory drawings and collages.

The coast remained wrapped for a period of ten weeks from 28 October, 1969. Then all materials were removed and the site returned to its original condition.

CHRISTO AND JEANNE-CLAUDE, VALLEY CURTAIN, RIFLE, COLORADO, 1970–72
On August 10, 1972, in Rifle, Colorado, between Grand Junction and Glenwood Spring in the Grand Hogback Mountain Range, at 11 am, a group of thirty-five construction workers and sixty-four temporary helpers, art schools, college students and itinerant art workers tied down the last of twenty-seven ropes that secured the 142,000 square feet (12,780 m²) of woven nylon fabric orange Curtain to its moorings at Rifle Gap, seven miles (11 km) north of Rifle, on Highway 325.

Valley Curtain was designed by Dimiter Zagoroff and John Thomson of Unipolycon of Lynn, Massachusetts, and Dr. Ernest C. Harris of Ken R. White Company, Denver, Colorado. It was built by A and H Builders Inc. of Boulder,

Colorado. It was built by A and H Builders Inc. of Boulder, Colorado, President, Theodore Dougherty, under the site supervision of Henry B. Leininger.

By suspending the Curtain at a width of 1,250 feet (381 m) and a height curving from 365 feet (111 m) at each end to 182 feet (55.5 m) at the centre, the Curtain remained clear of the slopes and the Valley bottom. A 100-foot (3 m) skirt attached to the lower part of the Curtain visually completed the area between the thimbles and the ground.

An outer cocoon enclosed the fully fitted Curtain for protection during transit and at the time of its raising into position and securing to the eleven cable clamp connections at the four main upper cables. The cables spanned 1,368 feet (417 m), weighed 110,000 lbs (49,895 kg) and were anchored to 792 tons (720 tonnes) of concrete foundations.

An inner cocoon, integral to the Curtain, provided added insurance. The bottom of the Curtain was laced to a 3-inch (7.5 cm) diameter Dacron rope from which the control and tie-down lines ran to the twenty-seven anchors.

The *Valley Curtain* project took twenty-eight months to complete.

Christo and Jeanne-Claude's temporary work of art was financed by the *Valley Curtain* Corporation (Jeanne-Claude Christo-Javacheff, president) through the sale of the studies, preparatory drawings and collages, scale models, early works and original lithographs

On August 11, 1972, twenty-eight hours after completion of the Valley Curtain, a gale estimated in excess of 60 mph (100 kmph) made it necessary to start the removal.

CHRISTO AND JEANNE-CLAUDE, RUNNING FENCE, SONOMA AND MARIN COUNTIES, CALIFORNIA, 1972–76
Running Fence, 18 feet (5.5 m) high, 24.5 miles (39 km) long, extending east-west near Freeway 101, north of San Francisco, on the private properties of fifty-nine ranchers, following the rolling hills and dropping down to the Pacific Ocean at Bodega Bay, was completed on September 10, 1976.

The art project consisted of: forty-two months of collaborative efforts, the ranchers' participation, eighteen Public Hearings, three sessions at the Superior Courts of California, the drafting of a 450-page Environmental Impact Report and the temporary use of the hills, the sky and the Ocean.

All expenses for the temporary work of art were paid by Christo and Jeanne-Claude through the sale of studies, preparatory drawings and collages, scale models and original lithographs.

Running Fence was made of 240,000 square yards (200,000 m²) of heavy woven white nylon fabric, hung from a steel cable strung between 2,050 steel poles (each: 21 feet [6 m] long, 3.5 inches [9 cm] in diameter) embedded 3 feet (1 m) into the ground, using no concrete and braced laterally with guy wires (90 miles [145 km] of steel cable) and 14,000 earth anchors. The top and bottom edges of the 2,050 fabric panels were secured to the upper and lower cables by 350,000 hooks. All parts of *Running Fence's* structure were designed for complete removal and

no visible evidence of *Running Fence* remains on the hills of Sonoma and Marin Counties. As it had been agreed with the ranchers and with County, State and Federal Agencies, the removal of *Running Fence* started fourteen days after its completion and all materials were given to the ranchers. *Running Fence* crossed fourteen roads and the town of Valley Ford, leaving passage for cars, cattle and wildlife, and was designed to be viewed by following 40 miles (65 km) of public roads, in Sonoma and Marin Counties.

CHRISTO AND JEANNE-CLAUDE, THE UMBRELLAS, JAPAN-USA, 1984–91
At sunrise, on October 9, 1991, Christo and Jeanne-Claude's 1,880 workers began to open the 3,100 umbrellas in Ibaraki and California, in the presence of the artists.

This Japan-US temporary work of art reflected the similarities and differences in the ways of life and the use of the land in two inland valleys, one 12 miles (19 km) long in Japan, and the other 18 miles (29 km) long in the US.

In Japan, the valley is located north of Hitachiota and south of Satomi, 75 miles (120 km) north of Tokyo, around Route 349 and the Sato River, in the Prefecture of Ibaraki, on the properties of 459 private landowners and governmental agencies.

In the US, the valley is located 60 miles (96.5 km) north of Los Angeles, along Interstate 5 and the Tejon Pass, between south of Gorman and Grapevine, on the properties of Tejon Ranch, twenty-five private landowners as well as governmental agencies.

Eleven manufacturers in Japan, US, Germany and Canada prepared the various elements of *The Umbrellas*: fabric, aluminium super-structure, steel frame bases, anchors, wooden base supports, bags and moulded base covers. All 3,100 umbrellas were assembled in Bakersfield, California, from where the 1,340 blue umbrellas were shipped to Japan.

Starting in December 1990, with a total work force of 500, Muto Construction Co. Ltd. in Ibaraki, and A. L. Huber & Son in California installed the earth anchors and steel bases. The sitting platform/base covers were placed during August and September 1991.

From September 19 to October 7, 1991, an additional construction work force began transporting the umbrellas to their assigned bases, bolted them to the receiving sleeves, and elevated the umbrellas to an upright closed position. On October 4, students, agricultural workers and friends, 960 in US and 920 in Japan, joined the work force to complete the installation of *The Umbrellas*.

The Christos' twenty-six million dollar temporary work of art was entirely financed by the artists through The Umbrellas, Joint Project for Japan and USA Corporation (Jeanne-Claude Christo-Javacheff, president). Previous projects by the artists have all been financed in a similar manner through the sale of the studies, preparatory drawings, collages, scale models, early works and original lithographs. The artists do not accept any sponsorship.

The removal started on October 27 and the land restored to its original condition. *The Umbrellas* were taken apart and all elements were recycled.

The umbrellas, free-standing dynamic modules,

reflected the availability of the land in each valley, creating an invitational inner space, as houses without walls, or temporary settlements and related to the ephemeral character of the work of art. In the precious and limited space of Japan, *The Umbrellas* were positioned intimately, close together and sometimes following the geometry of the rice fields. In the luxuriant vegetation enriched by water year round, the umbrellas were blue. In the California vastness of uncultivated grazing land, the configuration of the umbrellas was whimsical and spreading in every direction. The brown hills are covered by blond grass, and in that dry landscape, *The Umbrellas* were yellow.

From October 9, 1991 for a period of eighteen days, the umbrellas were seen, approached and enjoyed by the public, either by car from a distance and closer as they bordered the roads, or by walking under *The Umbrellas* in their luminous shadows.

Christo and Jeanne-Claude, Press releases for 'Wrapped Coast, Little Bay, Sydney, Australia', 1969; 'Valley Curtain, Rifle, Colorado', 1970-72; 'Running Fence, Sonama and Marin Counties, California', 1972-76, 'The Umbrellas, Japan and USA, 1984-91

Nancy HOLT
Sun Tunnels [1977] [revised 1995]

Sun Tunnels is in north-western Utah on land I bought specifically as a site for the work. The forty acres are in a large, flat valley with saline soil and very little vegetation. It's land worn down by Lake Bonneville, an ancient lake that gradually receded over thousands of years – the Great Salt Lake is what remains of the original lake today. From my site you can see mountains with horizontal lines where the old lake bit into the rock as it was going down. The mirages are extraordinary; you can see whole mountains hovering over the Earth, reflected upside down in the heat. The feeling of timelessness is overwhelming.

Time is not just a mental concept or a mathematical abstraction in Utah's Great Basin Desert. Time takes on a physical presence. The rocks in the distance are ageless; they have been deposited in layers over hundreds of thousands of years. Only ten miles south of the *Sun Tunnels* site are the Bonneville Salt Flats, one of the few areas in the world where you can actually see the curvature of the Earth. Being part of that kind of landscape and walking on earth that has never been walked on before evokes a sense of being on this planet, rotating in space, in universal time.

By marking the yearly extreme positions of the sun on the horizon, *Sun Tunnels* indicates the cyclical time of the solar year. The tunnels are aligned with each other and with the angles of the rising and setting of the sun on the days of the solstices, around June 21 and December 21. On these days the sun is seen on the horizon centred through tunnels. Actually, around the Summer Solstice the sun can be seen through the tunnels for many days, the sunlight glowing bright gold on the tunnel walls.

The four concrete tunnels are laid out on the desert in an open X configuration, 86-feet (26 m) long on the

diagonal. Each tunnel is 18-feet (5.5 m) long and has an outside diameter of 9 feet, 2.5 inches (3 m), and an inside diameter of 8 feet (2 m).

The configuration of holes in the upper half of each tunnel corresponds with a constellation, either Capricorn, Columbia, Draco or Perseus. The four diameters of the holes vary from 7 to 10 inches (18–25 cm), relative to the magnitude of the stars to which they correspond. During the day, the sun, a star among stars, shines through the holes, casting a changing pattern of pointed ellipses and circles of light on the bottom half of each tunnel. The shapes and positions of the areas of light differ from hour to hour, day to day, and season to season, relative to the positions of the sun. The spots of warm light in the cool, shady tunnels are like stars cast down to Earth, inverting the sky, turning day into night. And on many desert nights, moonlight shines through the holes, casting its own paler pattern.

Since the two grants I received from the National Endowment for the Arts and the New York State Council for the Arts covered only one-third of the total cost for making *Sun Tunnels*, I had to finance the rest with my own money. This meant making business deals to keep the cost down, which did not come easily to me and was often exasperating. I don't have any romantic notions about testing the edges of the world that way. It's just a necessity. It doesn't lead to anything except the work.

I wanted to bring the vast space of the desert back down to human scale. I had no desire to make a megalithic monument. The panoramic view of the landscape is too overwhelming to take in without visual reference points. The view blurs out rather than sharpens. When you stand at the centre of the work, the tunnels draw your vision into the landscape, opening up the perceived space. But once you're inside one of the tunnels, the work encloses and surrounds you, and the landscape is framed through the ends of the tunnels and through the star holes.

The material and colour of the tunnels is the same as the soil in the landscape they are a part of. The inner substance of the concrete – the solidified sand and stone – can be seen on the insides of the holes where the core drill cut through and exposed it.

The local people and I differ on one point: if the land isn't suitable for grazing, or if it doesn't have water, or minerals, or shade, or interesting vegetation, then they think it's not much good. They find it strange when I camp out at my site, although they say they're glad I found a use for the land. Many of the area residents who came to my Summer Solstice camp-out had never been in that valley before. So by putting *Sun Tunnels* in the middle of the desert, I have not put it in the middle of the residents' regular surroundings. The work paradoxically makes available, or focuses on, a part of the environment that most of the people who live nearby wouldn't normally have paid much attention to.'

1 With a few additions and changes the text for *Sun Tunnels*
 has been excerpted from my article, 'Sun Tunnels', in
 Artforum, New York, April 1977, pp. 32-37
Nancy Holt, 'Sun Tunnels', *Artforum*, New York, April 1977,
pp. 32-37

Michael HEIZER
Interview with Julia Brown
[1984]

Julia Brown Could you elaborate on your ideas about materials?

Michael Heizer My obligation as a sculptor is to work with anything that is tangible and physical. I realize there is expressive potential in materials, but I'm more interested in the structural characteristics of materials than their beauty. I think earth is the material with the most potential because it is the original source material.

Brown What is involved in your choice of materials?

Heizer The first object sculpture I built was *Displaced/Replaced Mass*, which used granite blocks set inside three depressions in the ground which were lined with concrete. These materials were close to the existing materials of the region. The rock was grey, the concrete was grey, the entire work was colourless. The materials were chosen for their nature and application. What it would look like was not the issue. I hope to find this as a surprise at the end of the work rather than use known factors in a calculated manner to achieve predictable results.

Brown Do you differentiate between man-made materials and natural materials?

Heizer Yes, synthetics are intensifications of the organic sources.

Brown In what way do you mean intensification? What is more intense than something in its natural state as it is?

Heizer I think you mean 'being' as opposed to matter. I only mean the material. Steel is an intensification of iron ore through a process of additives and temperature. Aluminium is bauxite, combining additives and a refining process. Bronze is an alloy of copper and tin. These are chemical manipulations of basic minerals that cast off impurities and introduce strengthening minerals that intensify the original material.

Brown Could you discuss your work process? Regardless of the scale of the project you seem very much involved with making your work yourself with direct physical labour.

Heizer There are several reasons I work this way: cost, my ability to produce without fabricators, and the way the value of work is affected if it is, or is not, made by the artist.

Brown What is the differentiation between your control in your work process and the influence of the forces such as gravity and weight?

Heizer When I began to build sculpture I always made it outdoors. I immediately encountered large amounts of material and eventually tried to incorporate gravity as a free and natural source of energy.

Brown Is the juxtaposition of the geometric and organic an issue for you as in *Adjacent, Against, Upon* in Seattle?

Heizer Geometry is organic. The study of crystallography demonstrates that there is more geometry in nature than man could ever develop. It's all organic in the first place so there is no reason why a crystal form which exists can't expand and then ultimately be a part of an amalgam that is larger and less crystalline in form. There is no sense of order that doesn't exist in nature. You won't find the exact shape of an airplane in nature, but I don't mean that, I mean basic forms, as opposed to designed forms.

Brown Is composition important to you?

Heizer Very; whatever can be found and used to stimulate cognitive response is important.

Brown There seems to be a difference in those works that are cut into the earth like *Double Negative* and those works that take materials out of the earth such as *Adjacent, Against, Upon*, and place them in a different context. This difference seems as much in content and process as in resultant form.

Heizer It might appear to be regressive to restate physical volume after the negative works. From my point of view, the totally negative works are phenomenological. There is no indication of why they are there, or what happened to the voided material. The *Double Negative*, due to gravity, was made using its own substance, leaving a full visual statement and an explanation of how it was made. In *Double Negative* there is the implication of an object or form that is actually not there. In order to create this sculpture material was removed rather than accumulated. The sculpture is not a traditional object sculpture. The two cuts are so large that there is an implication that they are joined as one single form. The title *Double Negative* is a literal description of two cuts but has metaphysical implications because a double negative is impossible. There is nothing there, yet it is still a sculpture.

This work was followed by *Complex One*, an attempt to build an object sculpture based on architectural size and concepts and using natural materials from that place. The idea was to restate the sand and gravels that existed under the silt overburden. I piled the alluvial to form the mastaba, washed the sand and gravel, mixed it with cement and reinforcing bar, put it in wooden forms. I ended with a surprisingly primitive and independent work that was actually technologically, socially dependent. It interested me to think about building *Complex One* on the edge of a nuclear test site in Nevada, and having the front wall be a blast shield. We had specifications for seismic conditions for the strength of concrete that were the highest specifications that could be achieved. We measured all our water, we washed all our sand, we mixed carefully and had laboratory shear tests that surpassed what the engineer said we were required to have.

Brown Your land in Nevada is next to a nuclear testing site?

Heizer Yes, it's a highly charged area, but I'm reluctant to discuss it that much.

Brown But it's part of your planning?

Heizer Part of my art is based on an awareness that we live in a nuclear era. We're probably living at the end of civilization.

Brown What are you planning after *Complex One*? Are you building *Complex Two*?

Heizer I'm building *Complex Two*, *Three* and *Four* right now. They will all be separate works. *Complex Two* is basically completed, *Three* and *Four* are under way. *Complex Two* is already as big as the *Double Negative*; it's over a quarter of a mile (26 m) long.

Brown Is it a form above the ground?

Heizer It's half above the ground and half below the ground. I didn't want to repeat the idea of putting an object on the surface of the ground; *Complex Two* is halfway above and halfway under the ground. What I've done is taken the area in front of *Complex One* and lowered it 20 feet (76 m). I removed it, so now when you approach *Complex One* you're 20 feet (76 m) underground and you look up at it. The ground level has been dropped, it's like a plaza. The sculpture will be enclosed on all four sides. The plaza floor drops again making it multi-level. The plaza will be the only place to see these works because all four face onto it; they are all frontal.

Brown What is the function of the plaza?

Heizer It is a reversal of issues; since the earth itself is thought to be stable and obvious as 'ground', I have attempted to subvert or at least question this. To remove and lower the grade around an object made of earth and placed on the earth, would possibly make the remaining surrounding earth a pedestal, visually, at least from certain viewpoints. You can walk around the back of each individual work but you won't see much other than the back of a pile of dirt. You have to go inside to see it. It's a complex that faces itself, there's only one way to see it and that's from inside.

Brown Is *Complex One* related to your paintings?

Heizer My idea with *Complex One* was to create an object that was essentially frontal. I thought about paintings and sculpture simultaneously. Due to the size of the facades I also thought about billboards and the big casino signs in Vegas. My feelings was that if you create a sculpture weighing in excess of 9,000 tons (9,180 tonnes), it would indisputably be a sculpture even though the frontal area was the only 'treated' area. I based components of *Complex One* on paintings; three or four paintings include most of the elements in that sculpture. *Complex Two* has a relationship to my paintings from the mid 1970s.

I decided to make the City visible only from the inside. Ten years ago the valley was remote, the work was isolated and could be in the open. Since then, there has been the threat of the MX missile being built there and now powerlines are coming in through the valley. I want to cut off the view of those things. I also want to enforce the idea that it's not landscape art.

Brown How are you doing that?

Heizer If you walk down into the plaza you either see the sky or the sculpture but you don't see any mountains or land.

Brown So the approach to the sculpture is less important to you than what happens when you are actually in it.

Heizer It's like making a room; the sculpture makes its own area, it's completely isolated. The only thing you can see is the sky. It stops the idea that this is a form of landscape art, to be seen in some beautiful part of the the world. It becomes more effective visually because you don't see a tree, you don't see a hill, you don't see a cow walking around. You see nothing except the art. It's a way to enhance and concentrate vision. In some ways it is similar to the intent of a museum or gallery [...]

Michael Heizer, 'Interview with Julia Brown', *Sculpture in Reverse*, ed. Julia Brown, The Museum of Contemporary Art, Los Angeles, 1984

Robert SMITHSON

The Monuments of Passaic: Has Passaic replaced Rome as the eternal city? [1967]

'He laughed softly. "I know. There's no way out. Not through the Barrier. Maybe that isn't what I want, after all. But this – this – " He stared at the Monument. "It seems all wrong sometimes. I just can't explain it. It's the whole city. It makes me feel haywire. Then I get these flashes – "'
— Henry Kuttner, *Jesting Pilot*

' ... today our unsophisticated cameras record in their own way our hastily assembled and painted world.'
— Vladimir Nabokov, *Invitation to a Beheading*

On Saturday, September 30, 1967, I went to the Port Authority Building on 41st Street and 8th Avenue. I bought a copy of the *New York Times* and a Signet paperback called *Earthworks* by Brian W. Aldiss. Next I went to ticket booth 21 and purchased a one-way ticket to Passaic. After that I went up to the upper bus level (platform 173) and boarded the number 30 bus of the Inter-City Transportation Co.

I sat down and opened the *Times*. I glanced over the art section: a 'Collectors', Critics', Curators' Choice' at A.M. Sachs Gallery (a letter I got in the mail that morning invited me 'to play the game before the show closes October 4'), Walter Schatzki was selling 'Prints, Drawings, Watercolours' at '33 1/3% off', Elinor Jenkins, the 'Romantic Realist', was showing at Barzansky Galleries, XVIII-XIX Century English Furniture on sale at Parke-Bernet, 'New Directions in German Graphics' at Goethe House, and on page 29 was John Canaday's column. He was writing on 'Themes and the Usual Variations'. I looked at a blurry reproduction of Samuel F. B. Morse's *Allegorical Landscape* at the top of Canaday's column; the sky was a subtle newsprint grey, and the clouds resembled sensitive stains of sweat reminiscent of a famous Yugoslav watercolourist whose name I have forgotten. A little statue with right arm held high faced a pond (or was it the sea?). 'Gothic' buildings in the allegory had a faded look, while an unnecessary tree (or was it a cloud of smoke?) seemed to puff up on the left side of the landscape. Canaday referred to the picture as 'standing confidently along with other allegorical representatives of the arts, sciences and high ideals that universities foster'. My eyes stumbled over the newsprint, over such headlines as 'Seasonal Upswing', 'A Shuffle Service', and 'Moving a 1,000 Pound Sculpture Can Be a Fine Work of Art, Too'. Other gems of Canaday's dazzled my mind as I passed through Secaucus. 'Realistic waxworks of raw meat beset by vermin' (Paul Thek), 'Mr Bush and his colleagues are wasting their time' (Jack Bush), 'a book, an apple on a saucer, a rumpled cloth' (Thyra Davidson). Outside the bus window a Howard Johnson's Motor Lodge flew by – a symphony in orange and blue. On page 31 in Big Letters: THE EMERGING

POLICE STATE IN AMERICA SPY GOVERNMENT. 'In this book you will learn ... what an Infinity Transmitter is.'

The bus turned off Highway 3, down Orient Way in Rutherford.

I read the blurbs and skimmed through *Earthworks*. The first sentence read, 'The dead man drifted along in the breeze'. It seemed the book was about a soil shortage, and the *Earthworks* referred to the manufacture of artificial soil. The sky over Rutherford was a clear cobalt blue, a perfect Indian summer day, but the sky in *Earthworks* was a 'great black and brown shield on which moisture gleamed'.

The bus passed over the first monument. I pulled the buzzer-cord and got off at the corner of Union Avenue and River Drive. The monument was a bridge over the Passaic River that connected Bergen County with Passaic County. Noonday sunshine cinema-ized the site, turning the bridge and the river into an over-exposed *picture*. Photographing it with my Instamatic 400 was like photographing a photograph. The sun became a monstrous light bulb that projected a detached series of 'stills' through my Instamatic into my eye. When I walked on the bridge, it was as though I was walking on an enormous photograph that was made of wood and steel, and underneath the river existed as an enormous movie film that showed nothing but a continuous blank.

The steel road that passed over the water was in part an open grating flanked by wooden sidewalks, held up by a heavy set of beams, while above, a ramshackle network hung in the air. A rusty sign glared in the sharp atmosphere, making it hard to read. A date flashed in the sunshine ... 1899 ... No ... 1896 ... maybe (at the bottom of the rust and glare was the name Dean & Westbrook Contractors, N.Y.). I was completely controlled by the Instamatic (or what the rationalists call a camera). The glassy air of New Jersey defined the structural parts of the monument as I took snapshot after snapshot after snapshot. A barge seemed fixed to the surface of the water as it came toward the bridge, and caused the bridgekeeper to close the gates. From the banks of Passaic I watched the bridge rotate on a central axis in order to allow an inert rectangular shape to pass with its unknown cargo. The Passaic (west) end of the bridge rotated south, while the Rutherford (east) end of the bridge rotated north; such rotations suggested the limited movements of an outmoded world. 'North' and 'south' hung over the static river in a bi-polar manner. One could refer to this bridge as the 'Monument of Dislocated Directions'.

Along the Passaic River banks were many minor monuments such as concrete abutments that supported the shoulders of a new highway in the process of being built. River Drive was in part bulldozed and in part intact. It was hard to tell the new highway from the old road; they were both confounded into a unitary chaos. Since it was Saturday, many machines were not working, and this caused them to resemble prehistoric creatures trapped in the mud, or, better, extinct machines – mechanical dinosaurs stripped of their skin. On the edge of this prehistoric Machine Age were pre- and post-World War II suburban houses. The houses mirrored themselves into colourlessness. A group of children were throwing rocks at

each other near a ditch. 'From now on you're not going to come to our hide-out. And I mean it!', said a little blonde girl who had been hit with a rock.

As I walked north along what was left of River Drive, I saw a monument in the middle of the river – it was a pumping derrick with a long pipe attached to it. The pipe was supported in part by a set of pontoons, while the rest of it extended about three blocks along the river bank till it disappeared into the earth. One could hear debris rattling in the water that passed through the great pipe.

Nearby, on the river bank, was an artificial crater that contained a pale limpid pond of water, and from the side of the crater protruded six large pipes that gushed the water of the pond into the river. This constituted a monumental fountain that suggested six horizontal smokestacks that seemed to be flooding the river with liquid smoke. The great pipe was in some enigmatic way connected with the infernal fountain. It was as though the pipe was secretly sodomizing some hidden technological orifice, and causing a monstrous sexual organ (the fountain) to have an orgasm. A psychoanalyst might say that the landscape displayed 'homosexual tendencies', but I will not draw such a crass anthropomorphic conclusion. I will merely say, 'It was there'.

Across the river in Rutherford one could hear the faint voice of a P.A. system and the weak cheers of a crowd at a football game. Actually, the landscape was no landscape, but 'a particular kind of heliotypy' (Nabokov), a kind of self-destroying postcard world of failed immortality and oppressive grandeur. I had been wandering in a moving picture that I couldn't quite picture, but just as I became perplexed, I saw a green sign that explained everything:

YOUR HIGHWAY TAXES 21

AT WORK

Federal Highway	US Dept. of Commerce
Trust Funds	Bureau of Public Roads
2867000	State Highway Funds
2867000	

New Jersey State Highway Dept.

That zero panorama seemed to contain *ruins in reverse*, that is – all the new construction that would eventually be built. This is the opposite of the 'romantic ruin' because the buildings don't *fall* into ruin *after* they are built but rather *rise* into ruin *before* they are built. This anti-romantic *mise-en-scène* suggests the discredited idea of *time* and many other 'out-of-date' things. But the suburbs exist without a rational past and without the 'big events' of history. Oh, maybe there are a few statues, a legend and a couple of curios, but no past – just what passes for a future. A Utopia minus a bottom, a place where the machines are idle, and the sun has turned to glass, and a place where the Passaic Concrete Plant (253 River Drive) does a good business in STONE, BITUMINOUS, SAND and CEMENT. Passaic seems full of 'holes' compared to New York City, which seems tightly packed and solid, and those holes in a sense are the monumental vacancies that define, without trying, the memory-traces of an abandoned set of futures. Such futures are found in grade-B Utopian films, and then imitated by the suburbanite. The windows of City Motors auto sales proclaim the existence of Utopia through 1968 WIDE TRACK PONTIACS –

Executive, Bonneville, Tempest, Grand Prix, Firebirds, GTO, Catalina and LeMans – that visual incantation marked the end of the highway construction.

Next I descended into a set of used car lots. I must say the situation seemed like a change. Was I in a new territory? (An English artist, Michael Baldwin, says, 'It could be asked if the country does in fact change – it does not in the sense a traffic light does'.) Perhaps I had slipped into a lower stage of futurity – did I leave the real future behind in order to advance into a false future? Yes, I did. Reality was behind me at that point in my suburban Odyssey.

Passaic centre loomed like a dull adjective. Each 'store' in it was an adjective unto the next, a chain of adjectives disguised as stores. I began to run out of film, and I was getting hungry. Actually, Passaic centre was no centre – it was instead a typical abyss or an ordinary void. What a great place for a gallery! Or maybe an 'outdoor sculpture show' would pep that place up.

At the Golden Coach Diner (11 Central Avenue) I had my lunch, and loaded my Instamatic. I looked at the orange-yellow box of Kodak Verichrome Pan, and read a notice that said:

READ THIS NOTICE:

This film will be replaced if defective in manufacture, labelling or packaging, even though caused by our negligence or other fault. Except for such replacement, the sale or any subsequent handling of this film is without other warranty or liability.

EASTMAN KODAK COMPANY DO NOT OPEN THIS CARTRIDGE OR YOUR PICTURES MAY BE SPOILED – 12 EXPOSURES – SAFETY FILM – ASA 125 22 DIN.

After that I returned to Passaic, or was it the *hereafter* – for all I know that unimaginative suburb could have been a clumsy eternity, a cheap copy of The City of the Immortals. But who am I to entertain such a thought? I walked down a parking lot that covered the old railroad tracks which at one time ran through the middle of Passaic. That monumental parking lot divided the city in half, turning it into a mirror and a reflection – but the mirror kept changing places with the reflection. One never knew what side of the mirror one was on. There was nothing *interesting* or even strange about that flat monument, yet it echoed a kind of cliché idea of infinity: perhaps the 'secrets of the universe' are just as pedestrian – not to say dreary. Everything about the site remained wrapped in blandness and littered with shiny cars – one after another they extended into a sunny nebulosity. The indifferent backs of the cars flashed and reflected the stale afternoon sun. I took a few listless, entropic snapshots of that lustrous monument. If the future is 'out-of-date' and 'old-fashioned', then I had been in the future. I had been on a planet that had a map of Passaic drawn over it, and a rather imperfect map at that. A sidereal map marked up with 'lines' the size of streets, and 'squares' and 'blocks' the size of buildings. At any moment my feet were apt to fall through the cardboard ground. I am convinced that the future is lost somewhere in the dumps of the non-historical past, it is in yesterday's newspapers, in the *jejune* advertisements of science fiction movies, in the false mirror of our rejected dreams. Time turns metaphors

into *things*, and stacks them up in cold rooms, or places them in the celestial playgrounds of the suburbs.

Has Passaic replaced Rome as The Eternal City? If certain cities of the world were placed end to end in a straight line according to size, starting with Rome, where would Passaic be in that impossible progression? Each city would be a three-dimensional mirror that would reflect the next city into existence. The limits of eternity seem to contain such nefarious ideas.

The last monument was a sandbox or a model desert. Under the dead light of the Passaic afternoon the desert became a map of infinite disintegration and forgetfulness. This monument of minute particles blazed under a bleakly glowing sun, and suggested the sullen dissolution of entire continents, the drying up of oceans – no longer were there green forests and high mountains – all that existed were millions of grains of sand, a vast deposit of bones and stones pulverized into dust. Every grain of sand was a dead metaphor that equalled timelessness, and to decipher such metaphors would take one through the false mirror of eternity. This sandbox somehow doubled as an open grave – a grave that children cheerfully play in.

'… all sense of reality was gone. In its place had come deep-seated illusions, absence of pupillary reaction to light, absence of knee reaction – symptoms of all progressive cerebral meningitis: the blanketing of the brain …'
– Louis Sullivan, 'one of the greatest of all architects', quoted in Michel Butor's *Mobile*

I should now like to prove the irreversibility of eternity by using a *jejune* experiment for proving entropy. Picture in your mind's eye the sandbox divided in half with black sand on one side and white sand on the other. We take a child and have him run hundreds of times clockwise in the box until the sand gets mixed and begins to turn grey; after that we have him run anti-clockwise, but the result will not be restoration of the original division but a greater degree or greyness and an increase of entropy.

Of course, if we filmed such an experiment we could prove the reversibility of eternity by showing the film backwards, but then sooner or later the film itself would crumble or get lost and enter the state of irreversibility. Somehow this suggests that the cinema offers an illusive or temporary escape from physical dissolution. The false immortality of the film gives the viewer an illusion of control over eternity – but 'the superstars' are fading.

Robert Smithson, 'The Monuments of Passaic: Has Passaic replaced Rome as the eternal city?', *Robert Smithson: Sculpture*, ed. Robert Hobbs, Cornell University Press, Ithaca, New York, 1981, pp. 90-94. Originally published in *Artforum*, New York, December 1967

Robert **MORRIS**

Notes on Sculpture Part 4: Beyond Objects [1969]

[…] 'Then, the field of vision assumes a peculiar structure.

In the centre there is the favoured object, fixed by our gaze; its form seems clear, perfectly defined in all its details. Around the object, as far as the limits of the field of vision, there is a zone we do not look at, but which, nevertheless, we see with an indirect, vague, inattentive vision ... If it is not something to which we are accustomed, we cannot say what it is, exactly, that we see in this indirect vision.'
— Ortega y Gasset

'Our attempt at focusing must give way to the vacant all-embracing stare ...'
— Anton Ehrenzweig

If one notices one's immediate visual field, what is seen? Neither order nor disorder. Where does the field terminate? In an indeterminate peripheral zone, none the less actual or unexperienced for its indeterminacy, that shifts with each movement of the eyes. What are the contents of any given sector of one's visual field? A heterogeneous collection of substances and shapes, neither incomplete nor especially complete (except for the singular totality of figures or moving things). Some new art now seems to take the conditions of the visual field itself (figures excluded) and uses these as a structural basis for the art. Recent past art took the conditions within individual things — specific extension and shape and wholeness of one material — for the project of reconstituting objects as art. The difference amounts to a shift from a figure-ground perceptual set to that of the visual field. Physically, it amounts to a shift from discrete, homogeneous objects to accumulations of things or stuff, sometimes very heterogeneous. It is a shift that is on the one hand closer to the phenomenal fact of seeing the visual field and on the other is allied to the heterogeneous spread of substances that make up that field. In another era, one might have said that the difference was between a figurative and landscape mode. Fields of stuff which have no central contained focus and extend into or beyond the peripheral vision offer a kind of 'landscape' mode as opposed to a self-contained type of organization offered by the specific object.

Most of the new work under discussion is still a spread of substances or things that is clearly marked off from the rest of the environment and there is not any confusion about where the work stops. In this sense, it is discrete but not object-like. It is still separate from the environment so in the broadest sense is figure upon a ground. Except for some outside work which removes even the frame of the room itself, here the 'figure' is literally the 'ground'. But work that extends to the peripheral vision cannot be taken in as a distinct whole and in this way has a different kind of discreteness from objects. The lateral spread of some of the work subverts either a profile or plan view reading. (In the past I have spread objects or structures into a 25 to 30 foot [762–915 cm] square area and the work was low enough to have little or no profile and no plan view was possible even when one was in the midst of the work. But in these instances, the regularity of the shape and homogeneity of the material held the work together as a single chunk.) Recent work with a marked lateral spread and no regularized units or symmetrical intervals tends to fracture into a continuity of details. Any overall wholeness

is a secondary feature often established only by the limits of the room. It is only with this type of recent work that heterogeneity of material has become a possibility again; now any substances or mixtures of substances and the forms or states these might take — rods, particles, dust, pulpy, wet, dry, etc. — are potentially usable. Previously, it was one or two materials and a single or relative form to contain them. Any more and the work began to engage in part-to-part and part-to-whole relationships. Even so, Minimal Art, with two or three substances, gets caught in plays of relationships between transparencies and solids, voids and shadows, and the parts separate and the work ends in a kind of demure and unadmitted composition.

Besides lateral spread, mixing of materials and irregularity of substances, a reading other than a critical part-to-part or part-to-whole is emphasized by the indeterminate aspect of work which has physically separate parts or is loose or flexible. Implications of constant change are in such work. Previously, indeterminacy was a characteristic of perception in the presence of regularized objects — i.e., each point of view gave a different reading due to perspective. In the work in question indeterminacy of arrangement of parts is a literal aspect of the physical existence of the thing.

The art under discussion relates to a mode of vision which Ehrenzweig terms variously as scanning, syncretistic or dedifferentiated — a purposeful detachment from holistic readings in terms of Gestalt-bound forms. This perceptual mode seeks significant clues out of which wholeness is sensed rather than perceived as an image and neither randomness, heterogeneity of content, nor indeterminacy are sources of confusion for this mode. It might be said that the work in question does not so much acknowledge this mode as a way of seeing as it hypostatizes it into a structural feature of the work itself. By doing this, it has used a perceptual accommodation to replace specific form or image control and projection. This is behind the sudden release of materials that are soft or indeterminate or in pieces which heretofore would not have met the Gestalt-orientated demand for an imagistic whole. It is an example of art's restructuring of perceptual relevance which subsequently results in an almost effortless release of a flood of energetic work [...]

Robert Morris, 'Notes on Sculpture 4: Beyond Objects', *Artforum*, New York, April 1969, pp. 51-53

Chip LORD
Automerica [1976]

A Cadillac magazine ad from 1949 proclaimed 'Regardless of the price class from which you expect to select your next car, you are cordially invited to inspect the new Cadillac in your Dealer's showroom', and at the bottom of the page: '*Cadillac: The Standard of the World*'. During the 1950's Cadillac really was the 'Standard of the World', in engineering, 'ride', safety and dependability. It was also a status symbol, something to aspire to own, a symbol that a person had arrived at a comfortable level or accomplishment of life. But as the decade of the 1950s

proceeded, something strange and wonderful happened to this 'Standard' — it sprouted tail fins, and they grew each year, until by 1959 they stood 42 inches (107 cm) off the ground.

As kids growing up in America during this decade, we were acutely aware of the class symbolism and styling trends that the Cadillac represented. General Motors used Cadillac to introduce the tail fin because they believed the prestige of Cadillac would make the radical styling idea, the tail fin, acceptable to all consumers. This consciousness was something shared by the members of Ant Farm, so when Stanley Marsh invited us to make a proposal for a site specific art work in 1973, we proposed the *Cadillac Ranch*.

The piece was built in June 1974, after several months of preliminary work acquiring Cadillacs. It was constructed over four days using a motorized back-hoe and primitive surveying tools. On the fifth day, Marsh hosted a party to celebrate the unveiling. It stands 300 yards (274 m) from Interstate 40, the highway that replaced Route 66 in 1965. Like the best ready-mades, it accumulates power from the fact of its mass-produced component parts and the cultural history they bring with them to the work. Also, it was built just after the 'Arab Oil Embargo', an international action by the oil cartel that demonstrated to America its dependence on fossil fuel and the absurdity of the cars its auto industry was producing. Almost immediately, it began garnering media attention.

Chip Lord, Automerica, E.P. Dutton & Co., New York, 1976

Alice AYCOCK
Project for a Simple Network of Underground Wells and Tunnels [1975]

Excavate an area approximately 20 × 40 feet (6 × 12 m). Build a series of six concrete block wells, 4 feet, 4 inches square (39.5 m²), connected by tunnels. Three of the wells are open entry wells, 7 feet (2 m) deep. Three of the wells, 7 feet, 8 inches (2 m) deep, are indicated above ground but capped with permanent covers and a layer of earth. One can crawl from entry well to entry well through narrow tunnels, 32 inches (81 cm) wide and 28 inches (71 cm) high, interrupted by vertical 'relieving' wells which are closed and completely surrounded by earth. The underground structure is demarcated by a 12-inch (30.5 cm) wall, 28 × 50 feet (8.5 × 15 m).

A subterranean network of passages set up for the purpose of operating below the surface of the earth; Gaston Bachelard's reference to 'underground manoeuvres' and childhood fears of the cellar and attic. (See Bachelard, Gaston, *The Poetics of Space*, 'The house, from cellar to attic, the significance of the hut')

The circular pits of the Matmatis people who live beneath the Tunisian desert; square courtyards extending 30 feet (9 m) below the earth which are light wells for

underground dwellings in the loess belt of China; burial holes now inhabited by the living in Siwa, Egypt; tunnels to underground bunkers (Mallory, Keith, and Arvid Otrar, *The Architecture of War*, p. 118); The Federal Reserve Bank of New York – subterranean vaults five storeys deep; dug-outs, cellars, sarcophagi.

The 12 inch (30.5 cm) high outside wall designates that a specific area of earth can be penetrated – that a solid mass is pocketed with empty spaces, like the caves of Kor which were a 'honeycomb of sepulchres'. The covered wells indicated on the surface are visual clues. Something is under there. Once underground a person crawls in the dark from light source to light source. The structure is understood by physically exploring it while remembering the surface configuration.
The lumpenproletarians jumping out of their barrels.
– a still from Eisenstein's film, *Strike*

Second Hag:
 Come hither.
She (to the young woman):
 O my darling don't stand by, and
 see this creature drag me [down]!
Second Hag:
 'Tis the law drags you.
She:
 'Tis a hellish vampire, clothed all
 about with blood, and boils and
 blisters.
– adapted from Aristophanes, *Ecclesiazusae*

The Hopi/Anasazi Indian *kiva* – a ceremonial chamber sunk in the earth, roofed with timber and earth. It developed from pithouses, corn storage cisterns and burial pits. Climbing down inside a building is a significantly different experience than entering from the side. It involves a greater expenditure of energy. It's harder to get out.
 Troglodyte – literally, one who creeps into holes; from trogle – a gnawed hole.
 Montague Summers' reference to instances in which exhumed corpses were found to have swallowed their shrouds and eaten their own flesh
—See Summers, Montague, *The Vampire in Europe*

'A hundred or so irregular niches, analogous to mine, furrowed the mountain and the valley. In the sand there were shallow pits; from these miserable holes (and from the niches) naked, grey-skinned, scraggly-bearded men emerged. I thought I recognized them; they belonged to the bestial breed of the troglodytes, who infest the shores of the Arabian Gulf and the caverns of Ethiopia; I was not amazed that they could not speak and that they devoured serpents ... To leave the barbarous village, I chose the most public hours, the coming of evening, when almost all the men emerge from their crevices and pits and look at the setting sun, without seeing it.'
—Jorge Luis Borges, *The Immortal*

The entry wells are deep enough so that once inside a person is completely surrounded by concrete and cannot see out. [...] Some tunnel entrances are at the bottom of the wells – one crawls under the structure; through the centre of the mass.

The concrete walls of the tunnels and wells are basically retaining walls. They hold back earth, like cellar walls. The project as an idea evokes anxiety in people – anticipatory categorizing. Bachelard links the space of the cellar with feelings of 'exaggerated fear' and 'buried madness'.

Vincent Scully's reference to Greek mystery cults whose architectural sites generally 'invoke interior, cave experience' e.g., the underground chambers dedicated to the goddess Rhea where castration rites were celebrated; Rider Haggard's character, She, who lived for 2,000 years attended by deaf mutes with her dead lover in the caves of Kor, a charnel house containing the embalmed bodies of a mysterious civilization.

At the intersection of the tunnels and the closed vertical wells there is a drop-off where one reaches out into dark empty space:
' ... my chin rested upon the floor of the prison, but my lips, and the upper portion of my head, although seemingly at a less elevation than the chin, touched nothing ... I put forward my arm, and shuddered ...'
– Edgar Allen Poe, *The Pit and the Pendulum*.

Alice Aycock, 'Project for a Simple Network of Underground Wells and Tunnels', *Projects in Nature, Eleven Environmental Works Executed at Merriewold West, Far Hills, New Jersey*, Merriewold West, Inc, New Jersey, 1975, n.p.

Kate LINKER

Mary Miss [1983]

Mary Miss' enterprise is directed towards a viable public art – towards an art in which the viewer is more than the neutral percipient of its processes. In a period marked by overwhelming dissension and by the increasing reduction of experience, her work represents an attempt to compose a common language – to use vernacular elements and images existing within the everyday environment, to draw on archetypal sensations of space and to create, against a background of shimmering signs, dense perceptual experience.

Miss has composed one of the most complex meditations on space in the art of the last two decades, both through her exploration of its multiple dimensions, by which space moves us perceptually and allusively in time, and through her attention to the transition from private to public site. During the late 1960s, prior to widespread minimalist discontent, Miss was already involved in her own, content-oriented production, foreshadowing a broad redirection of concerns. Yet Miss' work also puts into relief certain questions common to 'architectural sculpture'. She has repeatedly disclaimed interest in specific reference to architecture and in the precise nature of the constructed form, 'The experience you can have with a construction in a landscape in a particular situation interests me more than just what the structure is'. Built forms, among others, are employed for their physical appeal, for their ability to define space, and for the emotional force of their configurations. References are progressively milled, distilled and transformed within her work to yield the inherent power of their forms. In her work the relations of means and ends, reference and form and, indeed, sculpture and architecture are interwoven to produce a concise reflection on space.

Kate Linker, 'Mary Miss', *Art & Architecture*, Institute of Contemporary Arts, London, 1983, p. 128

Walter DE MARIA

The Lightning Field [1970]

SOME FACTS, NOTES, DATA, INFORMATION, STATISTICS AND STATEMENTS
The Lightning Field is a permanent work.
The land is not the setting for the work but a part of the work.

The work is located in West Central New Mexico.
The states of California, Nevada, Utah, Arizona and Texas were searched by truck over a five-year period before the location in New Mexico was selected.
Desirable qualities of the location included flatness, high lightning activity and isolation. The region is located 7,200 feet (2,196 m) above sea level. The *Lightning Field* is 11.5 miles (12 km) east of the Continental Divide.
The earliest manifestation of Land Art was represented in the drawings and plans for the *Mile-Long Parallel Walls in the Desert*, 1961–63.
The Lightning Field began in the form of a note, following the completion of *The Bed of Spikes* in 1969.
The sculpture was completed in its physical form on November 1, 1977.
The work was commissioned and is maintained by the Dia Center for the Arts, New York.

In July 1974, a small *Lightning Field* was constructed. This served as the prototype for the 1977 *Lightning Field*. It had thirty-five stainless steel poles with pointed tips, each 18 feet (5.5 m) tall and 200 feet (61 m) apart, arranged in a five-row by seven-row grid. It was located in Northern Arizona. The land was loaned by Mr. and Mrs. Burton Tremaine. The work now is in the collection of Virginia Dwan. It remained in place from 1974 through 1976 and is presently dismantled, prior to an installation in a new location.
The sum of the facts does not constitute the work or determine its aesthetics.

The Lightning Field measures 1 mile × 1 km and 6 m (5,280 feet × 3,300 feet).
There are 400 highly polished stainless steel poles with solid, pointed tips.
The poles are arranged in a rectangular grid array (16 to the width, 25 to the length) and are spaced 220 feet (67 m) apart. A simple walk around the perimeter of the poles takes approximately two hours.
The primary experience takes place within *The Lightning Field*.

Each mile-long row contains twenty-five poles and runs east-west.

Each kilometre-long row contains sixteen poles and runs north-south.

Because the sky-ground relationship is central to the work, viewing *The Lightning Field* from the air is of no value.

Part of the essential content of the work is the ratio of people to the space: a small number of people to a large amount of space.

Installation was carried out from June through October, 1977.

The principal associates in construction, Robert Fosdick and Helen Winkler, have worked with the sculpture continuously for the last three years.

An aerial survey, combined with computer analysis, determined the positioning of the rectangular grid and the elevation of the terrain.

A land survey determined four elevation points surrounding each pole position to insure the perfect placement and exact height of each element.

It took five months to complete both the aerial and the land surveys.

Each measurement relevant to foundation position, installation procedure and pole alignment was triple-checked for accuracy.

The poles's concrete foundations, set one foot below the surface of the land, are 3 feet (91.5 cm) deep and 1 foot (30.5 cm) in diameter.

Engineering studies indicated that these foundations will hold poles to a vertical position in winds of up to 110 miles (176 km) per hour.

Heavy carbon steel pipes extend from the foundation cement and rise through the lightning poles to give extra strength.

The poles were constructed of type 304 stainless steel tubing with an outside diameter of 2 inches (5 cm).

Each pole was cut, within an accuracy of 0.002 of a centimetres (.001 of an inch), to its own individual length.

The average pole height is 20 feet 7.5 inches (627 cm).

The shortest pole height is 15 feet (458 cm).

The tallest pole height is 26 feet 9 inches (815 cm).

The solid, stainless steel tips were turned to match an arc having a radius of 6 feet (183 cm).

The tips were welded to the poles, then ground and polished, creating a continuous unit.

The total weight of the steel used is approximately 38,000 lbs (17,252 kg).

All poles are parallel and the spaces between them are accurate to within .25 of an inch (0.5 cm).

Diagonal distance between any two contiguous poles is 311 feet (95 m).

If laid end to end the poles would stretch over 8,240 feet (25 km) (1.5 miles).

The plane of the tips would evenly support an imaginary sheet of glass.

During the mid-portion of the day seventy to ninety per cent of the poles become virtually invisible due to the high angle of the sun.

It is intended that the work be viewed alone, or in the company of a very small number of people, over at least a twenty-four-hour period.

The original log cabin located 200 yards (183 m) beyond the mid-point of the northern most row has been restored to accommodate visitors' needs.

A permanent caretaker and administrator will reside near the location for continuous maintenance, protection and assistance.

A visit may be reserved only through written correspondence.

The cabin serves as a shelter during extreme weather conditions or storms.

The climate is semi-arid; 11 inches (28 cm) of rain is the yearly average.

Sometimes in winter, the *Lightning Field* is seen in light snow.

Occasionally in spring, 30- to 50-mile-an-hour (48- to 80-km-an-hour) winds blow steadily for days.

The light is as important as the lightning.

The period of primary lightning activity is from late May through early September.

There are approximately sixty days per year when thunder and lightning activity can be witnessed from *The Lightning Field*.

THE INVISIBLE IS REAL

The observed ratio of lightning storms which pass over the sculpture has been approximately three per thirty days during the lightning season.

Only after a lightning strike has advanced to an area of about 200-feet (61 cm) above the *Lightning Field* can it sense the poles.

Several distinct thunderstorms can be observed at one time from *The Lightning Field*.

Traditional grounding cable and grounding rod protect the foundations by diverting lightning current into the earth.

Lightning strikes have not been observed to jump or arc from pole to pole.

Lightning strikes have done no perceptible damage to the poles.

On very rare occasions when there is a strong electrical current in the air, a glow known as 'St. Elmo's Fire' may be emitted from the tips of the poles.

Photography of lightning in the daytime was made possible by the use of camera triggering devices newly developed by Dr. Richard Orville, Dr. Bernard Vonnegut and Robert Zeh, of the State University of New York at Albany.

Photography of *The Lightning Field* required the use of medium- and large-format cameras.

No photograph, group of photographs or other recorded images can completely represent *The Lightning Field*. *Isolation is the essence of Land Art.*

Walter De Maria, 'The Lightning Field', Artforum, New York, April 1970, p. 57

Rosalind KRAUSS
Sculpture in the Expanded Field [1979]

[...] Even though *sculpture* may be reduced to what is in the Klein group the neuter term of the *not-landscape* plus the *not-architecture*, there is no reason not to imagine an opposite term – one that would be both *landscape* and *architecture* – which within this schema is called the *complex*. But to think the complex is to admit into the realm of art two terms that had formerly been prohibited from it: *landscape* and *architecture* – terms that could function to define the sculptural (as they had begun to do in Modernism) only in their negative or neuter condition. Because it was ideologically prohibited, the complex had remained excluded from what might be called the closure of post-Renaissance art. Our culture had not before been able to think the complex, although other cultures have thought this term with great ease. Labyrinths and mazes are *both* landscape and architecture; Japanese gardens are *both* land-landscape and architecture; the ritual playing fields and processionals of ancient civilizations were all in this sense the unquestioned occupants of the complex. Which is *not* to say that they were an early, or a degenerate, or a variant form of sculpture. They were part of a universe or cultural space in which sculpture was simply another part – not somehow, as our historicist minds would have it, the same. Their purpose and pleasure is exactly that they are opposite and different.

The expanded field is thus generated by problematizing the set of oppositions between which the modernist category *sculpture* is suspended. And once this has happened, once one is able to think one's way into this expansion, there are – logically – three other categories that one can envision, all of them a condition of the field itself, and none of them assimilable to *sculpture*. Because as we can see, *sculpture* is no longer the privileged middle term between two things that it isn't. *Sculpture* is rather only one term on the periphery of a field in which there are other, differently structured possibilities. And one has thereby gained the 'permission' to think these other forms [...]

It seems fairly clear that this permission (or pressure) to think the expanded field was felt by a number of artists at about the same time, roughly between the years 1968 and 1970. For, one after another, Robert Morris, Robert Smithson, Michael Heizer, Richard Serra, Walter De Maria, Robert Irwin, Sol LeWitt, Bruce Nauman ... had entered a situation the logical conditions of which can no longer be described as modernist. In order to name this historical rupture and the structural transformation of the cultural field that characterizes it, one must have recourse to another term. The one already in use in other areas of criticism is Postmodernism. There seems no reason not to use it.

But whatever term one uses, the evidence is already in. By 1970, with the *Partially Buried Woodshed* at Kent State University, in Ohio, Robert Smithson had begun to occupy the complex axis, which for ease of reference I am calling *site construction*. In 1971 with the observatory he built in wood and sod in Holland, Robert Morris had joined him. Since that time, many other artists – Robert Irwin, Alice Aycock, John Mason, Michael Heizer, Mary Miss, Charles Simonds – have operated within this new set of possibilities.

Similarly, the possible combination of *landscape* and *not-landscape* began to be explored in the late 1960s. The term *marked sites* is used to identify work like Smithson's

Spiral Jetty (1970) and Heizer's *Double Negative* (1969), as it also describes some of the work in the 1970s by Serra, Morris, Carl Andre, Dennis Oppenheim, Nancy Holt, George Trakis, and many others. But in addition to actual physical manipulations of sites, this term also refers to other forms of marking. These might operate through the application of impermanent marks – Heizer's *Depressions*, Oppenheim's *Time Lines*, or De Maria's *Mile Long Drawing*, for example – or through the use of photography. Smithson's *Mirror Displacements in the Yucatan* were probably the first widely known instances of this, but since then the work of Richard Long and Hamish Fulton has focused on the photographic experience of marking. Christo's *Running Fence* might be said to be an impermanent, photographic and political instance of marking a site […]

Rosalind Krauss, 'Sculpture in the Expanded Field', *October*, no 8, Cambridge, Massachusetts, Spring 1979, pp. 38-41

Donna HARKAVY
Meg Webster [1988]

Evident as her debt to minimalist sculpture is, the sources of her imagery are equally in the Earth Art movement of the 1970s. The relationship of Webster's work to the Earth projects of Robert Smithson, Nancy Holt, Robert Morris and Michael Heizer, whom Webster worked for in 1983, is most evident in her outdoor sculpture. Her first major outdoor commission was *Hollow*, a packed earth structure which she completed in 1985 on a site at the Nassau County Museum of Fine Art in Roslyn Harbor, New York. From the outside, *Hollow* resembled a large cylinder, gently tapering at the top and partially submerged in the ground. Architectural in scale – its interior walls measured 10 feet (305 cm) high – it vaguely suggested the dwelling of some primitive society. From the exterior, its severe geometry and relatively uninflected surface gave no hint of what lay inside. The visitor approached the piece by walking down a 90 foot (27.5 m) long, gently sloping dirt path. Given the length of the walkway and its gradual descent below ground, approaching and penetrating the work assumed ritual significance. Entering the sculpture through its slot-like portal, one encountered a lush interior – a great mass of brightly coloured flowering plants.

Two rock seats were provided from which visitors could contemplate this rich profusion of plants. In the Nassau piece, as in her other outdoor works, Webster wants to intensify the viewer's perception of nature. 'I'm not making nature, surely', she has said, 'but I'm pulling [the viewer] to it'.¹ A viewer able to return several times over a period of months to this meditative environment could not help but focus on nature's processes. As the seasons changed, so did Webster's sculpture.

Glen (1988), another large-scale enclosed sculpture, commissioned for the Minneapolis Sculpture Garden, is Webster's most site-specific outdoor work to date. It consists of a circular depression carved into the slope that forms the eastern border of the Garden, and it was constructed in response to the surrounding landscape. Two triangular steel walls that serve as retaining walls from a strongly sculptural entryway to the interior of the piece and establish a ceremonial nexus between its interior and exterior. The terraced interior of *Glen* is planted with carefully arranged flowering plants. The overall effect is like a pointillist canvas: the varicoloured flowers are like dots of paint that merge to create an all-over surface. Webster's 'canvas', however, is rich with texture and scent.

Webster's environmental structures are distinguished by their strong spatial quality and the way in which they enhance a sense of place by surrounding the viewer. For such earth structures, she prefers a circular form because it is primary and enclosing, like embracing arms. Webster has also characterized her planted works as womanly and sexual, not only because of their womb-like quality and the nurturing attention required to maintain them, but also because the works must be penetrated in order to be fully experienced. In spring, especially, the pieces are alive with possibility; procreation occurs over and over by insects pollinating the flowers, investing her work with the spirit of birth and regeneration.

Although Webster, by her own account, never actively participated in the rhetoric of Minimalism, she nevertheless believes her work 'continues the dialogue' with its aesthetic principles. In expressing her relationship to Minimalism, she says, 'I'm coming at it because of the geometry … and the need to present an idea or concept'. By her use of organic materials such as earth, hay and plants in combination with the cool vocabulary of minimalist sculpture, Webster creates sensuous animate forms.

1 Unless otherwise noted, all quotations are from a conversation with the artist, 1 July 1987
Donna Harkavy, 'Meg Webster', *Sculpture Inside Outside*, Walker Art Center, Minneapolis, 1988, p. 264

Richard SERRA
Spin-Out '72-'73 for Bob Smithson [1973]

What I've decided is that what I'm doing in my work right now has nothing to do with the specific intentions […]

If I define a work and sum it up within the boundary of a definition, given my intentions, that seems to be a limitation on me and an imposition on other people of how to think about the work. Finally, it has absolutely nothing to do with my activity or art. I think the significance of the work is in its effort not in its intentions. And that effort is a state of mind, an activity, an interaction with the world […]

You can talk about them. You can talk about defining the topology of the place, and the assessment of the characteristics of the place, through locomotion. You can talk about the path through the place which defines the two boundaries as you walk through the piece. There is a certain kind of parallax […]

First you see the plates as parallel; when you walk left, they move right. As you walk into them, they open up, and there's a certain kind of centrifugal push into the side of the hill. In fact the people at the Kröller-Müller wanted to call the piece 'Centrifugaal' in Dutch. They talked a lot about vorticism. And then when you walk above it, there's another path which connects the two sides of the valley.

There's a ridge which encircles the whole space at about 150 feet. When you walk on the ridge, there's a contraction and the space becomes elliptically compartmentalized, which you can't see as you walk through it, and it's a different way of understanding your relation to the place: you're overhead looking down. The plates were laid out at twelve, four and eight o'clock in an elliptical valley, and the space in between them forms an isosceles triangle, 152 feet (46 m) on the long side, 78 and 78 feet (24 m) on the legs. Each plate is 10 feet (3 m) high by 40 feet (12 m) long by 1.5 inches (4 cm) thick hot rolled steel sunk into the incline at an equal elevation. Now all of those things could be talked about, and those in part were the intentions […]

When you imply that there's some sort of specific intentions, that someone's going to learn something from a work, or that it's goal-oriented in that way, or that it's going to teach something … I don't even know if that's true or valid any more. I think that art's about a certain kind of activity that burns itself out and then there's something else, and it burns itself out as you finish each piece.

The focus of the art for me is the experience of living through the pieces, and that experience may have very little to do with physical facts of the work of art, very little to do with that. But when you're talking about intentions, all you're telling people about is the relation of physical facts. And I think an artwork is not merely correctly predicting all the relations you can measure […]

Some people think it is, so they set up a construct and tell people their intentions, and then the construct verifies the intentions. Everybody has their own language structure that they put in it – they run it on a tape loop in their head – and what that does, those kinds of intentions, is to preclude people from experiencing the work. And right now my pieces are mostly involved with walking and looking. But I can't tell someone how to walk and look. The piece in Holland takes up … I mean, there isn't any definition of boundary … it takes up the whole valley. You can walk through it in as many ways as you can conceivably think of walking through it […]

Richard Serra, 'Spin Out '72-'73 for Bob Smithson 1973', *Avalanche*, New York, Summer/Fall 1973; reprinted in *Richard Serra, Interviews, etc., 1970-1980*, The Hudson River Museum, New York, 1980, pp. 36-37

INVOLVEMENT
Along with the development of aggressively interventionist strategies in the land came competing theoretical approaches and a growing emphasis on the individual as subject in the landscape. 'There was a feeling that art need not be a production line of more objects to fill the world', Richard Long writes; 'My interest was in a more thoughtful view of art and nature. I was for an art made on common lands, by simple means, on a human scale. It was the antithesis of so-called American Land Art, where the artist needed money to be an artist, to buy real estate, to claim possession of the land and wield machinery'. Long's stated desire to be 'a custodian of nature, not an explorer of it', characterizes both the practical and philosophical drift of this section. Increasingly reflective of the broader social and political specifics of the times – the rise of 'Body Art', the impact of feminism, situationism and interest in different belief systems – these texts also reference elements of a cultural past. The works to which they correspond bring these arguments into a context of more subjective meanings and activities, sometimes combining the personal with the political.

Henry David THOREAU
Walking [1861]

I wish to speak a word for Nature, for absolute freedom and wildness, as contrasted with a freedom and culture merely civil – to regard man as an inhabitant, or a part and parcel of Nature, rather than a member of society. I wish to make an extreme statement, if so I may make an emphatic one, for there are enough champions of civilization: the minister and the school committee and every one of you will take care of that.

I have met with but one or two persons in the course of my life who understood the art of Walking, that is, of taking walks – who had a genius, so to speak, for *sauntering*, which word is beautifully derived 'from idle people who roved about the country, in the Middle Ages, and asked charity, under pretence of going *à la Saint Terre*', to the Holy Land, till the children exclaimed, 'There goes a *Sainte-Terrer*', a Saunterer, a Holy-Lander. They who never go to the Holy Land in their walks, as they pretend, are indeed mere idlers and vagabonds; but they who do go there are saunterers in the good sense, such as I mean. Some, however, would derive the word from *sans terre*, without land or a home, which, therefore, in the good sense, will mean, having no particular home, but equally at home everywhere. For this is the secret of successful sauntering. He who sits still in a house all the time may be the greatest vagrant of all; but the saunterer, in the good sense, is no more vagrant than the meandering river, which is all the while sedulously seeking the shortest course to the sea. But I prefer the first, which, indeed, is the most probable derivation. For every walk is a sort of crusade, preached by some Peter the Hermit in us, to go forth and reconquer this Holy Land from the hands of the Infidels.

It is true, we are but faint-hearted crusaders, even the walkers, nowadays, who undertake no persevering, never-ending enterprises. Our expeditions are but tours, and come round again at evening to the old hearthside from which we set out. Half the walk is but retracing our steps. We should go forth on the shortest walk, perchance, in the spirit of undying adventure, never to return, prepared to send back our embalmed hearts only as relics to our desolate kingdoms. If you are ready to leave father and mother, and brother and sister, and wife and child and friends, and never see them again – if you have paid your debts, and made your will, and settled all your affairs, and are a free man – then you are ready for a walk [...]

Henry David Thoreau, 'Walking', *The Portable Thoreau*, ed. Carl Bode, Viking, New York, 1980, pp. 592-93. Originally published in *The Atlantic Monthly*, Boston, 1861

Sigmund FREUD
Moses and Monotheism
[1938]

Man found that he was faced with the acceptance of 'spiritual' forces, that is to say such forces as cannot be apprehended by the senses, particularly not by sight, and yet having undoubted, even extremely strong, effects. If we may trust to language, it was the movement of the air

If you are ready to leave father and mother, and brother and sister, and wife and child and friends, and never see them again – if you have paid your debts, and made your will, and settled all your affairs, and are a free man – then you are ready for a walk.

Henry David THOREAU Walking, 1861

that provided the image of spirituality, since the spirit borrows its name from the breath of wind (*animus*, *spiritus*, Hebrew: *ruach* = smoke). The idea of the soul was thus born as the spiritual principle in the individual ... Now the realm of spirits had opened for man, and he was ready to endow everything in nature with the soul he had discovered in himself.

Sigmund Freud, 'Moses and Monotheism', *Bartlett's Quotations*, Little Brown and Company, Boston, 1980, p. 679. Originally published Alfred A. Knopf, New York, 1939

Guy DEBORD
Theory of the Dérive [1956]

Among the various Situationist methods is the *dérive* [literally: 'drifting'], a technique of transient passage through varied ambiances. The dérive entails playful-constructive behaviour and awareness of psycho-geographical effects; which completely distinguishes it from the classical notions of the journey and the stroll.

In a dérive one or more persons during a certain period drop their usual motives for movement and action, their relations, their work and leisure activities, and let themselves be drawn by the attractions of the terrain and the encounters they find there. The element of chance is less determinant than one might think: from the dérive point of view cities have a psychogeographical relief, with constant currents, fixed points and vortexes which strongly discourage entry into or exit from certain zones.

But the dérive includes both this letting go and its necessary contradiction: the domination of psychogeographical variations by the knowledge and calculation of their possibilities. In this latter regard, ecological science – despite the apparently narrow social space to which it limits itself – provides psychogeography with abundant data [...]

Chance plays an important role in dérives precisely because the methodology of psychogeographical observation is still in its infancy. But the action of chance is naturally conservative and in a new setting tends to reduce everything to an alternation between a limited number of variants, and to habit. Progress is nothing other than breaking through a field where chance holds sway by creating new conditions more favourable to our purposes. We can say, then, that the randomness of the dérive is fundamentally different from that of the stroll, but also that the first psychogeographical attractions discovered run the risk of fixating the dériving individual or group around new habitual axes, to which they will constantly be drawn back [...]

Guy DeBord, 'Theory of the Dérive', *Internationale Situationiste*, no 2, Paris, 1956; reprinted in *Art in Theory 1900-1990: An Anthology of Changing Ideas*, ed. Charles Harrison and Paul Wood, Blackwell Publishers, Oxford and Cambridge, Massachussetts, 1992, p. 696

Fujiko SHIRAGA
About Myself and the Outdoor Exhibition [1955]

Around the time of the outdoor exhibition, I was searching intensely for an existence beyond my own. I was determined to express, as a human being, an immense force – a force so great that it would defy any human control.

I want to create an enormous gash in an empty sky.

No material or skill will be visible, but it will arouse awe in the viewer's mind and unhinge his mind. It has nothing to do with a natural phenomenon: it is a product of my own mind. I do not want to turn my impression of natural phenomena into any kinds of forms – even abstract ones.

Fujiko Shiraga, 'About Myself and the Outdoor Exhibition', *Gutai*, no 3, Osaka, October 20, 1955, p.23; reprinted in *Japanese Art After 1945: Scream Against the Sky*, ed. Alexandra Munroe, Guggenheim Museum, New York, 1994, n.p.

Peter HUTCHINSON
Paricutin Volcano Project [1970]

Jay and I left New York City by jet and arrived in Mexico City the afternoon of Tuesday, January 6, 1970. We stayed at the Hotel Genève. The next morning we contacted Bernard at his office and explained the project [...]

I wanted a dormant but live volcano, with bare rock, ground heat and steam. The only way to find out was to go. I knew that the volcano had burst out of a field in 1943. In nine years it had grown to 1,400 feet (about 9,000 feet above sea level), making it the most recent growth of an entire volcano (I believe the only growth of an entire large volcano in living memory).

From Uruapan we took a taxi to an Indian village, ten miles away. The roads were very bad. The trip took well over an hour. The countryside was dotted with old volcanoes, typically flat on top, mostly overgrown by trees. It was easy to see the different ages of these old volcanoes, in fact, by judging how erosion had altered their shape and by the thickness of the vegetation on the slopes [...]

The path was steep and first led downhill through pine forest and across sharp sloped but dry arroyos [...] After a mile or two we entered a grassy field and saw the volcano several miles away. It was a rounded cone, half lightish ash, half black cinder. The second peak (at the other crater rim) was not at first visible from this, the north-west side.

Then we saw the jet black edge of the lava flow. It had destroyed two villages. The second village – Paricutin – was completely covered by many feet of lava but the church tower survived and still stands. The lava shield surrounded the volcano on almost all sides, except for a narrow approach from the south. There had been three

major lava flows. After it cooled, the lava lay from 10 to 50 feet thick, completely impassable. The surface was very rough, composed of large often loose cinder blocks which were sharp and treacherous, often weak enough to break under a person's weight. We rounded promontory after promontory of the lava, indented with deep bays of blackened flat ground [...]

I looked into the crater. It was about 300 feet deep, a double inverted cone, with one point about twenty feet below the other. The sides were steep and much eroded. The grit and ash was slowly filling in the bottom which contained these materials. Across from us were cliffs of red lava rock. About fifty feet below the edge on the side where we stood was a magnificent deposit of sulphur – yellow, red, green, black and gold (perhaps sulphur-oxides, carbon and ores of various kinds that were deposited by the steam or gas). Gases still came from this area in some quantity [...]

The volcano looked perfect for my project. I could use the edge (as I had projected in a model in my March 1969 show), or possibly the inside of the crater, though this seemed somewhat impractical because of the steep eroding ash sides and the presence of probably poisonous gases [...]

At the top I told everyone that I didn't want to be rushed. We went about feeling the rocks for temperature differences and looking for steam patches. There was enough steam coming from the cinders on the flattish ledge by the crater. In one cleft, though, there was gas which had built up thin orange deposits of crystals. We became used to spotting the dangerous emissions and holding our breath near them. Steam was whitish while the gases were bluish or brownish.

I laid out a line of bread as marker, using the natural fault lines for my shapes. The bread was mostly wet from the steam from its overnight storage. The Indians and Bernard started tearing open the bread packages and filling in the shapes I had marked [...]

My project was to lay the bread, wet it once and let the steam and the heat of the rocks and sun do the rest. I expected mould to grow in large quantities and I hoped in patches large enough to show in the photographs I would take. I would cover the bread with plastic in the interim which would condense the water on its surface and make a super-saturated environment, in which mould likes to grow. This, in effect, would make a greenhouse environment in surroundings which hitherto had been practically sterile and certainly unable to support moulds or even lichens [...] I wanted an amorphous effect that would change colour as mould grew. The only shapes involved were dictated by the nature of the faults that were splitting up the edge into segments that would eventually crumble and fall into the crater. The result was a kind of tripartite line with uneven edges and thickness, becoming in part both line and shape.

Now I photographed the piece from various places around the crater edge. In 1958 (according to the National Geographic Society) the width of the crater was 875 feet (26,687 cm). I estimated the width as much greater – due I suppose to erosion of the edges and thus a constant widening effect. My piece was roughly 250 feet (7,625 cm)

in length and using this as a yardstick I estimated (from aerial photographs taken later) that the crater was very roughly 1,400 feet (42,700 cm) in diameter. However, accurate measurements were not taken since this was not my purpose for being there. The crater appears almost circular […]

The spores of these yeasts and moulds that I expected to grow were to come from the air – I didn't seed them. They might be rarer at altitude but there are few places on this planet where they are not found – perhaps in the deepest seas or at the poles. These spores are incredibly hardy in their non-active spore stage and can exist for long periods without damage. Some can withstand boiling temperatures and 0°F or below. But most need the range from 33°F to around 95°F before they can grow, sporulate and reproduce. I was aiming for the fastest growth condition and planned to allow only five or six days for this project. Some spores can reach sporulation in thirty-six hours or less if conditions are right […]

I found myself growing stronger but getting more cut up every day from falling in the hard cinders and basalt. This new landscape is not yet eroded into the soft shapes we all expect. Jay and I counted the ravens. I see six, he sees ten, I twelve, he fourteen. They float like vultures. Would they eat the bread? I saw an ant, a seedling, a spider web, a dead bee near a 200°F+ smoke hole. I never saw red grass before. It was incredibly quiet there. No insect hum, even the few birds were silent. I saw a cricket or grasshopper on the highest peak. The sky was very clear and blue – beautiful conditions for photography […]

Six days later I went back to the Indian village […]

The bread had grown mould as I hoped. The steam had heated and wetted it and near ideal growing conditions must have been attained night and day because the mould was growing in large patches. Only in the one section where we had wet the bread once but where there was not steam, was there no mould. Here the bread had dried and bleached even whiter from the sun. In the mould-growing areas there were large patches (about two to three inches in diameter) of black bread mould (white in this stage), red bread mould (pinkish orange) and a dark red species that I do not know. I brought some of the moulds back with me in a film can. I took them to Columbia University for analysis. Unfortunately, in my sample the red bread mould had killed off the other molds. There were also live bacteria and dead round worms present […]

It is not extraordinary to grow mould on bread. I was not doing so in any scientific sense. I was attempting several other things – to juxtapose a micro-organism against a macrocosmic landscape, yet in such amount that the results would be plainly visible through colour changes. I also chose an environment that, although having the necessary elements for growth, needed a subtle alteration on utilization to make growth possible. Volcanic ground in a sense is new material, sterilized and reorganized then thrown out from the deeper crust of the earth. It is similar to the earliest earth landscapes and related to the early geological periods such as the pre-Cambrian when moulds and algae played the dominant role on dry land that today belongs to the higher mammals and insects. Today, when volcanoes appear from the sea,

they are first colonized by bacteria, moulds and algae. The conditions of early history are continually duplicated.

Peter Hutchinson, 'Paricutin Volcano Project', 1969. Originally published in *Dissolving Clouds*, Provincetown Arts, 1994, pp. 48-51

Lucy R. LIPPARD
Overlay: Contemporary Art and the Art of Prehistory
[1983]

RITUAL

Discussing or even exploring the prehistoric sites today is like visiting a museum, or peering around a church as a tourist. For all the formal beauties that are accessible, the essence of life is elusive. Contemporary artists are looking to ancient forms both to restore that breath and also to take it for themselves. The animating element is often ritual – private or public, newly created or recreated through research and imagination (in itself a breath of life). Artmaking is a ritual, perhaps the most valid – if elitist – one left to this society. It is, however, in danger of becoming as disengaged as institutionalized religion. Émile Durkheim's conclusion that 'religion is something eminently social' should also apply to art. 'Collective representation accumulated over vast spans of space and time are results of a special intellectual activity … which is infinitely richer and more complex than that of the individual.'[1]

The dominant alienation of maker from what is made, and the alienation of art and work from life, has led some contemporary artists to a conscious restoration of severed connections. Over the last fifteen to twenty years there has been a move to reconnect 'medium and message', 'subject and object', in the course of which some artists have become quite literally *closer* to their art. They have become more necessary to its perception – not only as the actors in body art or performance art, but also as the major protagonists of their individual aesthetic ideas in lectures and writing. The result has been an increased dialogue between them and their specialized art audiences. Too often, however, a broader audience remains out of reach, even to those artists most resistant to the erosion of art's communicative functions, because available forms are not easily understood.

Immateriality and impermanence, for instance, though sometimes valid strategies against commodification, have often backfired, leading to the same kind of isolation and inaccessibility the artists hoped to overcome. Although the form has changed – for example, from expensive steel to inexpensive xerox, or from object to action – the content is still meaningless to many people. In an ambivalent antidote to this situation, many artists have found themselves drawn more directly into all aspects of making, explaining and distributing, even promoting and selling their art. In the process, they become public figures and their art, almost accidentally, has to become more public

too. For some this syndrome is irrelevant, part of one 'movement' or another, or 'making it'; for others it has been an eye-opener, a consciousness-raiser, a way for the audience and its life concerns to enter and directly affect the art being made.

Of those who have tried to replace society's passive expectations of art with a more active model, many have chosen to call their activities 'rituals'. The word is used very broadly, but its use indicates a concern with that balance between individual and collective, theory and practice, object and action that is at the core of any belief system. Durkheim's division of religious phenomena into beliefs and rites is applicable to aesthetics. 'The first', he says, 'are states or opinions and consist in representations; the second are determined modes of action'.[2]

Any discussion of ritual in recent art raises the important question of the relationship of belief to the forms that convey it, or at least suggest its structure in a general way. Images and activities borrowed from ancient or foreign cultures are useful as talismans for self-development, as containers. But they become ritual in the true sense only when filled by a communal impulse that connects the past (the last time we performed this act) and the present (the ritual we are performing now) and the future (will we ever perform it again?).

When a ritual doesn't work, it becomes an empty, self-conscious act, an exclusive object involving only the performer, and it is often embarrassing for anyone else to witness. When a ritual does work, it is inclusive, and leaves the viewer with a need to participate again. At this point, ritual becomes propaganda in the religious sense in which the word originated – the sense that evolved from the rituals of the Catholic Church, the sense of 'spreading the word' (or the seed, as in propagation). Today, as Dennis Oppenheim has put it, 'ritual is an injected ingredient … It's an objectively placed idiom necessary to move the work away from certain kinds of sterility'.[3] But the concept of knowing through doing and communicating through participating continues, whether it is applied to daily routines or mystical states of enlightenment.

The active, or formal, element of repetition which characterizes so much and such diverse American art from the last three decades can be seen as an acknowledgement of the need for ritual. Art that is called ritual but is never repeated is finally an isolated gesture rather than a communal process. Repetition is necessary to ritual, and repetition was a major component of the work of those artists in the late 1960s who were adapting a deadpan minimal style to an often sensually obsessive content. (Freud compared culture to neurosis, equating philosophy with paranoia, religion or ritual with compulsion, and art with hysteria.) It seems probable that in the New Stone Age, ritualization of tasks and 'learning by heart' were the prime manner of perpetuating belief and history. Eventually oral history was handed down only by travelling bards and minstrels, who were 'homeless', as artists are in this society. Eva Hesse said she used repetition in her sculpture because it recalled 'the absurdity of life', 'If something is absurd, it's much more exaggerated, more absurd if it's repeated … Repetition does enlarge or increase or exaggerate an idea or purpose in a statement'.[4]

Yvonne Rainer has said of her choreography, 'If something is complex, repetition gives people more time to take it in'.[5]

The feminist development of ritual in art came in response to a genuine need on both the personal level (for identity) and the communal level (for a revised history and a broader framework in which to make art). Mary Beth Edelson, who sees herself as creating a 'liturgy' for the feminist movement, introduced the function of ritual to her children in the early 1970s:

'I was setting aside a particular time, saying to them, "This activity that we do now is special. This time and these gestures I hope will make a lasting impression on you. So we are going to act it out. We are going to ritualise our behaviour and document ourselves with photographs. The photographs will stand as a record of the unity and wonder that we experienced".'[6]

At the same time, women noticed correspondences with traditional female work and arts. Artists began to see utilitarian activities with aesthetic eyes, sometimes as the counterparts of mantras – social formulas for coping with oppression, for surviving. 'The cumulative power of infinite repetition' was manifested, for instance, in the masonry techniques of the women who built the immense Pueblo Bonito in Chaco Canyon, a complex layering of small stone fragments. Vincent Scully has remarked how the ritual dances there were performed 'tight up against the buildings … and the beat of those dances is built into the architecture, which thus dances too'.[7] Artist Judith Todd has observed how the pueblo was laid out in clusters resembling matrilocal living patterns, and how the concentric arrangement and obsessive layering of the *kivas*, or domed underground chambers, also symbolized protection, the way the earth enfolds the soul, in a labyrinthine pattern.[8]

The rituals of modern artists evoke primitive rituals, especially those of the agrarian cycle of the birth, growth, sacrifice and rebirth of the year god; the circle dance encouraging sun and moon to turn; the Troy dances of life and death. Michelle Stuart has written about her earth-on-paper scrolls, 'Move the body repeatedly and you will start knowing yourself because you no longer know anything at all. When I pound rocks or rub over layers and layers of dirt and move my body in dance, I don't want to stop … Destroying to create a new state of being. It's like a murder – the destructiveness of creating'.[9] Yet the forms do not survive without the beliefs, as Jamake Highwater, a Blackfoot/Cherokee who is both a participant in and articulate critic of avant-garde culture, says in his book *Dance: Rituals of Experience*. Describing the labyrinthine patterns of the farandole in southern France – a snakelike winding dance which is still executed but has lost its significance – he observes that when expressive form is abandoned, 'what remains is neither art nor ritual but something else … decorative entertainment'.[10]

In the 1960s, experimental dance broke away from the theatre world and became more closely associated with the visual arts, influencing them, in turn, to incorporate body and movement. Repetition suggests not only eroticism, but action and 'revolution'. Process and performance and ritual art are all to a degree restless

oppositions to the status quo. Visual artists' interest in dance coincided with the political need to 'dematerialize' art objects. Dance is also experience ritualized, and Mircea Eliade has observed that 'reality is acquired solely through repetition or participation'.[11] 'No form of dance is permanent', wrote critic John Martin. 'Only the basic principle of dance is enduring, and out of it, like the cycle of nature itself, rises an endless succession of new springs out of old winters'.[12]

Dance is considered the oldest art, and certainly the most socialized. With singing and music, it is the art most rooted in a continuing present, 'Myths are things which never happen but always are'.[13] Ritual takes place in the temporal framework of myth, in that Celtic 'time between times' of twilights, mists and hybrids which John Sharkey has compared to the 'entrelacs' of Celtic visual arts, the intertwining knots and puns and curves – repetitive images arising from tasks set the contemplative mind.[14]

Also Jesus was worshipped as 'the dancers' master' (and the mosaic labyrinths set in the floors of medieval churches were surely vestiges of dances as well as pilgrimage metaphors), 'Christianity has lost its dances'[15] and consequently its spiral, growing motion, the natural circling around the spindle/axis. All that remains is the linear procession. A sixth-century Gnostic hymn warned, 'Who danceth not, knoweth not what cometh to pass'. A more recent version is Emma Goldman's 'If there's no dancing at the revolution, I'm not coming'. (A revolution is, by definition, a circle dance.) In contemporary art, ritual is not just a passive repetition but the acting out of collective needs […]

1 Émile Durkheim, *The Elementary Forms of the Religious Life*, The Free Press, New York, 1965, p. 29

2 Ibid., p. 51

3 Dennis Oppenheim, 'Dennis Oppenheim: An Interview by Allan Schwartzman', in *Early Work by Contemporary Artists*, New Museum, New York, 1977

4 Eva Hesse, quoted in Lucy R. Lippard, *Eva Hesse*, New York University Press, New York, 1976, p. 5

5 Yvonne Rainer, quoted in Lucy R. Lippard, *From the Center*, E.P. Dutton, New York, 1976, p. 270

6 Mary Beth Edelson, in 'Goddess Imagery in Ritual', interview by Gayle Kimball, *Women's Culture*, Scarecrow Press, Metuchen, New Jersey, 1981, p. 91; 96

7 Vincent Scully, *Pueblo: Mountain, Village, Dance*, Viking, New York, 1975, p. 61

8 Judith Todd, 'Opposing the Rape of Mother Earth', *Heresies*, issue 5, 1978, p. 90

9 Michelle Stuart, *Return to the Silent Garden* (unpublished journal). See also her artist's book *The Fall*, Printed Matter, New York, 1977

10 Jamake Highwater, *Dance: Rituals of Experience*, A & W Publishers, New York, 1978, p. 32

11 Mircea Eliade, *The Myth of the Eternal Return*, Pantheon, New York, 1954, p. 34

12 John Martin, quoted in Highwater, op. cit., p.37

13 Salustius, quoted on title page of Highwater, op. cit.

14 John Sharkey, *Celtic Mysteries*, London, Thames & Hudson, 1975, p. 92

15 Francis Huxley, *The Way of the Sacred*, Doubleday, Garden City, New York, 1974, p. 156

Lucy R. Lippard, *Overlay: Contemporary Art and the Art of Prehistory*, Pantheon Books, New York, 1983, pp. 159-63

Charles SIMONDS
Microcosm to Macrocosm, Fantasy World to Real World: Interview with Lucy R. Lippard [1974]

Lucy R. Lippard What do you do?

Charles Simonds 1) *Birth*: In 1970 I buried myself in the earth and was reborn from it. This exists as a 16mm film and a double series of twenty-four time-lapse colour photographs.
2) *Landscape-Body-Dwelling*: (First done 1971). I lie down nude on the earth, cover myself with clay, remodel and transform my body into a landscape with clay, and then build a fantasy dwelling-place on my body on the earth. There are two films of this (1971, 1973).
3) *Dwellings*: Since 1970, most of my time has been spent going around the streets of New York building clay dwelling-places for an imaginary civilization of Little People who are migrating through the city.
4) *Project Uphill*: For the last year I have been working with the Lower East Side Coalition for Human Housing and the community on East 2nd Street, designing a park-playlot – a hilly landscape between Houston and 2nd Streets, Avenues B and C; construction begins in the spring.

Lippard How do all these things relate to each other?

Simonds I'm interested in the earth and myself, or my body and the earth, what happens when they become entangled with each other and all the things they include emblematically or metaphorically; like my body being everyone's body and the earth being where everybody lives. The complexities work out from this juncture. One of the original connections between the earth and my body is sexual. This infuses everything I do, both the forms and the activities. In my own personal mythology I was born from the earth, and many of the things I do are aimed at refreshing and articulating that awareness for myself and others. *Landscape-Body-Dwelling* is a process of transformation of land into body, body into land. I can feel myself located between the earth beneath me (which bears the imprint of my body contour) and the clay landscape on top of me (the underside of which bears the other contour of my body). Both *Birth* and *Landscape-Body-Dwelling* are rituals the Little People would engage in. Their dwellings in the streets are part of that sequence. It's the origin myth – the origin of the world and of man and of the people. This progression establishes beliefs and relationships at the very centre, at the very beginning, in a physical way. Then I am free to go and spread these beliefs into the world as a fantasy through the Little People, and into the world as a reality through the park.

Lippard Doesn't it bother you that there isn't anything people can look back to from a greater distance?

Simonds Well, some of the effect of the things I do is

strengthened by the fact that they're ephemeral. If you leave thoughts behind you that other people can develop, you've had an effect on how the world looks or how it's thought about. I don't see any reason to leave behind 'things' which lose their meaning in time, or even exist as a symbol of meaning at a given time past. The few objects I do make each year, also landscapes with life architectures on them, are much more conceptualized – one thought brought to one place in one form […]

For myself, I think of them in terms of making. Their high point for me is the moment when I finish them, when the clay is still wet and I'm in control of all the textures of the sand and the colours, when earth is sprinkled on the clay and it's soft and velvety, very rich. As they dry, they fade, and cease to be as vivid for me. Actually, I'm constructing a little world of my own, allowing part of me to make a place to be. It's a very calm feeling. Even when I'm surrounded by lots of activity, my focus is on this very small world. The Little People, as they inhabit that space, take on their own energy and draw me along […]

The dwellings have a past as ruins and they are the past of the human race, a migration. They throw into relief the scale and history of the city. You have that feeling of falling into a small and distant place which, when entered, becomes big and real – a dislocation which gives it a dreamlike quality.

To look at one dwelling on a formal, art-informational level is a mistake. It's more fruitful to relate them to the American Indian image they recall because, like the Indians, the Little People's lives centre around belief, attitudes towards nature, towards the land; because of their vulnerability but persistence taken against a capitalist New York City […]

The city has to do with a concept of nature that exploits, pictorializes, steps outside of nature and tries to superimpose on it both an abstract ideal of 'good design' and/or a short-sighted capitalism. By working on land that's already ruined, you're hopefully preventing what could happen in the future by working with what did happen in the past. Right now, given the state of the city, the park's undulating hills are a superimposition, the same way the little landscapes are drawn onto the architecture. The park can be seen as a montage of horizontal landscape on the vertical axis of the city, but this site is most important to me because pedestrians can also walk through it. It's a passageway of real earth forms, a respite from the city, not like those vest-pocket parks which are like stage backdrops, or dead ends. To bring the relationship of city to land form more into balance, many vacant lots and odd pieces could be landscaped to create a meandering web of hills flowing throughout the city, a continuous reminder of the earth's contours beneath the asphalt.

Robert Smithson's idea of dealing with mining companies, with the real world that is visually and conceptually and economically concerned with the earth, focuses on the relationship between an aesthetic consciousness and reality. Strip mining is based on what is the quickest and least expensive way of ripping up the earth and taking out of it what is wanted. Smithson was trying to find ways that his work could profit from the amount of energy and earth-moving actually employed, and at the same time, ways he could restructure the strip miners' thoughts to include other values not strictly capitalistic. […] Vacant space on the Lower East Side represents a kind of devastation of the earth similar to a strip mine. Poor planning has made that land unproductive, i.e., unprofitable. A raped piece of land has no life left in it, attracts no life to it. Last week a dead dog was found in the lot where the park will be.

Lippard Does is have to be art that restores that devastation?

Simonds That's just it. Seeing it as *art* is totally irrelevant in terms of what we know art's relationship to the real world to be right now. You want to affect the consciousness that's actually chewing up the earth. What those people end up doing to the earth is what we will ultimately experience the earth to be. That great gash in the middle of the country is what comes back to us as a visual image, a gesture, a concept […]

Charles Simonds, 'Microcosm to Macrocosm, Fantasy World to Real World', Interview with Lucy R. Lippard, *Artforum*, New York, February 1974, pp. 36-39

Nancy SPERO
Tracing Ana Mendieta [1992]

Ana Mendieta carved and incised in the earth and stone, and, in July 1981, on the almost inaccessible walls of caves in Jasuco Park in Cuba: always the symbol of the female body, the breathing woman's body melding with the earth or stone or trees or grass, in a transformative representation of the living body mutating into another substance. This repetitive ritual, never the same, always the same, was in sum a constellation of tiny planets – the female mark, the vulva, featureless, sexual, dug into the ground.

Alone with her special tools and gear, she would hike to a chosen site, lie down and mark her body on the ground, dig trenches, filling them with gunpowder and setting them alight to blaze madly. Celebrating the small earthen shape of an abstracted female form. A violent ritual, yet contained. The land eventually covered up the traces of the performance as her art eroded and the earth returned to its previous state. The only records are photographs and videos made by the artist.

Ana did not rampage the earth to control or dominate or to create grandiose monuments of power and authority. She sought intimate, recessed spaces, protective habitats, signalling a temporary respite of comfort and meditation. The imprint of a woman's passage eroding and disappearing, the regrowth of grass or the shifting of sands or a carved fragmentary relief, a timeless cycle momentarily interrupted, receiving the shape of a woman – a trace, such as the smudged body-print a victim of fire might leave, or a shadow, the recessive mark left by a victim of the bomb in Hiroshima or Nagasaki …

Ana's anger fed her desire to create works of endurance, works made to exorcise – with blood, with fire, with rock, with earth, with stress – her profound sense of displacement. Her art is an elemental force, divorced from accidents of individuality, speaking of life and death, growth and decay, of fragility yet indomitable will. It is an intense, unified oeuvre, encompassing the violent fire pieces and the quietly lyrical works in which she lay on the ground covered with leaves or flowers, observing the transmutation of matter and spirit that marks the rites of nature and of nature's reclamation. If one of her sculptures were sent to a distant planet or were kept sealed for thousands of years on earth, it would still convey the imagery, strength, mystery and sexuality of the female human form – woman's body and spirit inscribed.

Walking around Washington Square Park, I sometimes think I see Ana running, circling the park as she used to. We would wave to one another and continue on our individual routines.

Nancy Spero, 'Tracing Ana Mendieta', *Artforum*, New York, April 1992, pp. 75-77; republished in *Nancy Spero*, Phaidon Press, London, 1996, p. 139

Alan SONFIST
Autobiography [1975]

1946 May 26 at 10:10 p.m.: my first experience was air.

1948 First major project was to build a tower in a hole – which I covered.

1949 Collected coconuts – and made pyramids.

1950 Planted my first seeds in a pickle jar and observed the growth.

1951 Sat on an anthill and was covered with ants; sticks trailed me.

1952 Planted seeds from the fruit I ate in the Bronx Park; my orange seeds did sprout.

1953 Upon tightroping on a waterfall, I woke up in a hospital with my face bandaged.

1954–59 Visited all the museums in New York City; I went to Museum of Natural History at least once a month to observe the stuffed animals; at this period I was going to Bronx Zoo and looking at caged animals.

1954 Set my right arm on fire; discovered a dead dog that had fallen from the falls – went back several times.

1955 Grew crystals; walked off a cliff – froze my left hand.

1956 Upon the death of my great-grandmother, I was told that I am a great artist; created animals and talked; woke up under my bed.

1957 Summer rock turning; rolled down a hill – lost consciousness.

1958 Swam a mile within a triangle.

1959 Sat with an antelope in its cage.

1960 Started a freshwater aquarium with two guppies and five snails.

1961 My brother shot a bird and I cried; brother and I built a box we lived in for the summer.

1962–65 Joined my subconscious under self-induced hypnosis; played with animals of the past.

1963 Constructed a fuel cell; sun paintings.

1964 Collected dead animals; collected nestings of animals; made sounds of animals.

1965 Land exchange – Macomb, Illinois, to Levittown,

Long Island; 'Observations' – Verbal to visual translation; produced a spiritual production called 'Lifening' that showed the essence of life; ran until I was out of breath, then ran twice as far.

1967 Ended painting by stretching rubber that decayed into powder in 1970; glass block flowing to a plate.

1968 Started growing micro-organism as an entity; water falls in midair; weather change in my body.

1969 Illusion of dominance – snails dominated a freshwater aquarium; skydiving began and ended; walking through the dark, I became one with an animal; white powders – minerals – vegetables – animals; took samples of New York City air – posted the analysis with the samples on locations samples were taken from; placed a mound of seeds in the centre of Central Park, New York City, allowing displacement by wind; 'Observations' – Made graphic patterns of 100 people through the Whitney Museum, New York City; ecological environment – time landscape; land exchange – Bronx, New York, to Fallsburg, New York; seed distribution.

1970 Planted plastic and real flowers in Central Park, New York City; floated in the ocean facing down for six hours; 'Observations' – Physical media reaction; 'Observations' – Avoid – Enter; placed a thorn in my heel to become aware of my foot; 'Observations' – Spatial energy, Milan, Italy; loop – listen; nonmoving movie and nonmoving movie – moving; presentation of natural phenomena designated as 'scenic' by Kodak; beans – sprouts – flowers – beans; natural variations; movie: accumulation movie collects dust; motion into line; 'Observations' – Visitors' physical characteristics; posted sign 'Look at the sky – we are at the end of the spiral of the Milky Way'; seed distribution – international project; printed labels 'Please recycle this can' to be put on metal containers and returned to the president of Continental Can Corporation; posted sign 'Send to your Congressman a pollutant or a piece of pollution and send the documentation to the gallery'; 'Observations' – Star plotting: people were asked to 'go right ten stars from the North Star'; water, earth, air, outer space sounds; animal markings; closed an eye for a day; dark and light collections; memory maps; 'Observations' – Natural – Artistic; living myth.

1971 Animal hole diggings – piles of mud; collected breaths of air; visitors' reaction box; lived on island surrounded by floating isles of oil; tracked a deer by the signs of the forest; land exchange – Montclair, New Jersey, to Panama to Carl Shultz Park; nature theatre – twenty-four [hour] life cycle; fish in suspension – released; snail excrement patterns; nest building – selection of artificial and natural material; bird exchange; occupation – position; 'Observations' – Visitor reaction enclosure; 'Observations' – After seeing this exhibition, what type of project would you create; victim-victor room; rock into sand – water into air; movies: energy build-up, perceptual micro-changes, moving rock, consummation, nature's time; through the dark I killed an animal; experienced the sea in five different languages; movements of time; filled a room with nitrous oxide gas to slow down perception; danced in the cut of the earth.

1972 Area earth mound; bird migration patterns; rubber maze forming a channel; experienced and lived the

Altamira Cave; North Star plotting – international project; talking bird – talking people; taped earth sounds from 20 feet (610 cm) to 200 feet (6,100 cm) over New York and Milan; earth core 0 to 30 feet (915 cm) in New York City and Akron, Ohio; droppings – Akron, Ohio; founded corporation Conditions, Inc.: identified trees by touch and smell; lived in darkness for a day; tracking a cat, at the same time being tracked by the cat; turned over areas with the Andover Forest; dreams with Asher B. Durand; theatre of characteristics; patterns and structures; line of fire; landscapes (elements selection) from Tarrytown, New York, re-created from Macomb, Illinois, 1965; earth liftings on four sides; created the animals of my past; 'Observations' – People with different characteristics were asked in the local newspaper to go to museum (Akron) each day; recording of high and low days; sculpture dusted for fingerprints; erosion casting; three weeks tracking army ants in Central American jungle; walked into my shadow.

1973 Landscapes (elements selection) from Orange, Newark, and Montclair, New Jersey; trees of Andover; cyclical timing of existence; marsh reconstitution – Cambridge, Massachusetts; land exchange – Central Park, New York City, to Mount Berry, Georgia; after death body becomes work of art in Museum of Modern Art, New York City; lived in darkness for a week; smell of death coming forth from enclosures; impressive – artistic; 'Observations' – Cherry blossoms – Natural-artistic at the Corcoran Museum Art School, Washington DC; spatial energy – Cincinnati, Ohio; tracked a deer over its path that existed two days earlier in Mount Berry, Georgia; revisited the animals of Bronx Zoo; sun burnt a hole through a cloud – I sat within; watched the earth move – looking at a square inch; became one with my shadow; ball into plate; battling trees.

1974 Listened to a square inch of ground; two birds called, I joined; sun rose five times during a day; dropped 100 feet in about thirty seconds; looked at the star – felt a web surround me; revisited Charles – looking at a tree; came to a beginning or a rainbow; left side of my body became numb; as the sun opened and closed, I followed; lay in the nesting of the deer.

Alan Sonfist, 'Autobiography', *Alan Sonfist*, Herbert F. Johnson Museum of Art, Cornell University, 1975, exhibition leaflet, n.p.

Richard **LONG**
Five, six, pick up sticks
Seven, eight, lay them
straight [1980]

I like simple, practical, emotional, quiet, vigorous art.

I like the simplicity of walking, the simplicity of stones.

I like common materials, whatever is to hand, but especially stones. I like the idea that stones are what the world is made of.

I like common means given the simple twist of art.

I like sensibility without technique.

I like the way the degree of visibility and accessibility of my art is controlled by circumstance, and also the degree to which it can be either public or private, possessed or not possessed.

I like to use the symmetry of patterns between time, places and time, between distance and time, between stones and distance, between time and stones.

I choose lines and circles because they do the job.

My art is about working in the wide world, wherever, on the surface of the earth.

My art has the themes of materials, ideas, movement, time. The beauty of objects, thoughts, places and actions.

My work is about my senses, my instinct, my own scale and my own physical commitment.

My work is real, not illusory or conceptual. It is about real stones, real time, real actions.

My work is not urban, nor is it romantic. It is the laying down of modern ideas in the only practical places to take them. The natural world sustains the industrial world. I use the world as I find it.

My art can be remote or very public, all the work and all the places being equal.

My work is visible or invisible. It can be an object (to possess) or an idea carried out and equally shared by anyone who knows about it.

My photographs are facts which bring the right accessibility to remote, lonely or otherwise unrecognisable works. Some sculptures are seen by few people, but can be known about by many.

My outdoor sculptures and walking locations are not subject to possession and ownership. I like the fact that roads and mountains are common, public land.

My outdoor sculptures are places. The material and the idea are of the place; sculpture and place are one and the same. The place is as far as the eye can see from the

sculpture. The place for a sculpture is found by walking. Some works are a succession of particular places along a walk, e.g. *Milestones*. In this work the walking, the places and the stones all have equal importance.

My talent as an artist is to walk across a moor, or place a stone on the ground.

My stones are like grains of sand in the space of the landscape.

A true understanding of the land requires more than the building of objects.

The sticks and stones I find on the land, I am the first to touch them.

A walk expresses space and freedom and the knowledge of it can live in the imagination of anyone, and that is another space too.

A walk is just one more layer, a mark, laid upon the thousands of other layers of human and geographic history on the surface of the land. Maps help to show this.

A walk traces the surface of the land, it follows an idea, it follows the day and the night.

A road is the site of many journeys. The place of a walk is there before the walk and after it.

A pile of stones or a walk, both have equal physical reality, though the walk is invisible. Some of my stone works can be seen, but not recognised as art.

The creation in my art is not in the common forms — circles, lines — I use, but the places I choose to put them in.

Mountains and galleries are both in their own ways extreme, neutral, uncluttered; good places to work.

A good work is the right thing in the right place at the right time. A crossing place.

Fording a river. Have a good look, sit down, take off boots and socks, tie socks on to rucksack, put on boots, wade across, sit down, empty boots, put on socks and boots. It's a new walk again.

I have in general been interested in using the landscape in different ways from traditional representation and the fixed view. Walking, ideas, statements and maps are some means to this end.

I have tried to add something of my own view as an artist to the wonderful and undisputed traditions of walking, journeying and climbing. Thus, some of my walks have been formal (straight, circular) almost ritualised. The patterns of my walks are unique and original; they are not like following well-trodden routes taking travellers from one place to another. I have sometimes climbed around mountains instead of to the top. I have used riverbeds as footpaths. I have made walks about slowness, walks about stones and water. I have made walks within a place as opposed to a linear journey; walking without travelling.

Words after the fact.

Richard Long, 'Five, six, pick up sticks Seven, eight, lay them straight', Anthony d'Offay Gallery, London, September 1980

Hamish FULTON
Into a Walk into Nature [1995]

The physical involvement of walking creates a receptiveness to the landscape. I walk on the land to be woven into nature. Vertical trees and horizontal hills. The character of a walk cannot be predicted. A walk is practical not theoretical. A crosscountry walk including camping allows a continuity of time influenced by the weather. A road walk can *transform* the everyday world and give a heightened sense of human history, but in the end all avenues point to the 'wilderness'. I drive a car but do not use it to go to or from a walk. I make art in the capitalist system which in itself is a political statement (selling art for the next walk). I do not live in the Highlands of Scotland but in the heavily trafficked rural suburbia of south-east England. I am not a studio artist. There is no one system by which I choose to make all my walks. I have no plans for making walks indoors but I imagine it could be possible. (Absent — the landscape is not in the gallery.) A physically demanding walk is more rewarding than a walk not about exertion and both are of equal importance. All my walks are related, from the first to the last. When I am not walking I eat and drink too much. When I walk and camp I carry all my food therefore I eat less, which is the preferred state. Weaker but lighter, but the rucksack 'heavier'. On a road walk the availability of drink and food keeps the energy levels high. Petrol — food as fuel, not a stimulant. Occasionally I make route-finding mistakes. I have lost two tents on separate occasions both in gusting winds; both were mistakes, not accidents. I once made the error of falling into a small crevasse, in retrospect, not an experience to have missed. Walking the dog. Most, though

not all, of my walks have been made alone. When walking alone, nothing is deflected. A walk has a life of its own, and does not need to be made into a work of art. Few of my photographs show people, but my art should not be thought of as anti-people. On my walks I have met many inspiring human beings and on one walk I encountered a family of three grizzly bears. My art has been influenced by a variety of friends. To name but a few: Marina Abramović, Roger Ackling, Richard Long and Nancy Wilson — by the walking peoples of the world from all periods of history, native American culture, Tibetan religious art, mountaineers and Japanese Haiku poets. My art acknowledges the element of time, the time of my life. (One distance in the mountains, another distance down the road.) The artwork cannot re-present the experience of a walk. The flow of influences *should* be from nature to me, not from me to nature. I do not directly rearrange, remove, sell and not return, dig into, wrap or cut up with loud machinery any elements of the natural environment. All my artworks are made from commercially available materials (wooden frames and photographic chemicals). I do not use found-natural-objects like animal bones and river stones. However, the difference between these two ways is symbolic, not ecological. Some technology has greatly enhanced human life but often it forms a barrier between us and nature. Divisions. Some human abilities based on a close relationship with nature have been lost, broken lineage. Most of my text works are in the English language. I respect the existence of all languages. Both sides of the river. As an 'arm-chair mountaineer', my art has been influenced by the British Himalayan climber, Doug Scott, not by the Romantics Turner and Wordsworth. I grew up in the ship-building city of Newcastle-upon-Tyne. Through art-making I feel a continuity with my childhood and always carry a mental image of the Northumbrian landscape. (In cold weather, packing the rucksack for a hot weather walk. In warm weather, packing the rucksack for a cold weather walk.) I am not a world traveller and have only visited a few countries. In itself, transport (sitting) is of little interest to me. I would prefer to walk for a week rather than ride around in a vehicle for six months. The world gets bigger the more I travel. For me, staying in one place and 'travelling' are of equal importance. Far away and long ago. (No meaning in distant places, conversations of the here and now.) In the valley, dreaming of the hill. On the hill, wishing for the valley. Lying, sitting, standing, walking. (Walking, standing, sitting, lying.) *Movement* is an important *dimension* in my art. Movement exists in relation to its apparent opposite, stillness. The designed city exists in relation to its opposite, the landscape. Natural, but less wild. Interrelated borderline. Yin and Yang. Mountain high, river deep. Nothing stays the same. Everything is changing. One things leads to another. Here we go again. All my walk texts are true. If they were not, the only person I could cheat would be myself. I have chosen to record the walks out of respect for their existence. The texts are facts for the walker and fiction for everyone else. Walking into the distance beyond imagination. For years I only made framed photo-text works, now in addition I can see the purpose of investigating a variety of ideas. Plans stored on

paper, a wall painting could be repainted one hundred years later. (Weight form colour. Framed art works are objects, not sculptures.) Walking is the constant, the art medium is the variable. Numbers are both of significance and no significance. The total number of leaves on one tree exists whether counted or not. (Counted, not estimated.) I am curious about the number seven. Erosion. Mountain skylines are the meeting place of heaven and earth. The outline of a small, roadside stone can be drawn around immediately. An unrecognizable shape of an indescribable colour is something not easily categorized. I see the landscape not in terms of just materials but of environments with a diversity of life forms, snakes, spiders, worms and lice. Trekking through jungles and across ice caps would be genuine adventures, but they also imply money, jet travel, too much travel. It is good to walk from my doorstep starting at sunset and ending at sunrise. Walking without a map in an unspectacular landscape. In 1973 after completing a 1,022-mile (1,644 km) walk, I made the commitment to only make art resulting from the experience of individual walks. If I do not walk, I cannot make a work of art. To date, I have 'spent' more time involved in making artworks and exhibitions than walking. (Exhibition administration takes away too much energy from walking.) A work of art may be purchased but a walk cannot be sold. Over the years I have consistently made walks though I would describe them as short: this is a question of scale and standards. Observations are not objects, walking is active. My orientation to words and drawings results from the ease of carrying pen and paper, not chisel (hammer) and stone. Imposed order on paper, not the land. It should be possible for me to make art with no words. Talking and no talking are of equal importance. 'Too much talking' with mind and voice can deflect nature so that I no longer see the drifting clouds or hear the birds sing. As an artist, I cannot imagine making only walks and no works of art. I am an artist who walks, not a walker who makes art. Irony results from being wet and cold and seeing it's going to happen all over again very soon. Humour is an important part of life.

Hamish Fulton, 'Into a Walk into Nature', *Thirty One Horizons*, Lenbachhaus, Munich, 1995, pp. 8-10

Stephen BANN
The Map as Index of the Real: Land Art and the Authentication of Travel [1994]

Maps can mean many things, and often their meanings change over the centuries of their existence. Maps which at first had a way-finding purpose read very differently when their directions can no longer be relied on. They become icons from the distant past. An equally pronounced variation of meaning occurs when the map enters the regime of representation: that is to say, when it is annexed to, or included in, a work of art.

This article is about the special circumstances in which the map is used to reproduce, and at the same time to authenticate, the artist's journey, as in the distinctive contemporary form of expression which goes by the name of Land Art. However, I shall be arguing that this contemporary art movement is not unprecedented in the way it utilizes the map. Indeed the map's role of authenticating travel can be seen as a perennial possibility, depending on the precise conditions which the cartographic sign is designed to fulfil. My introduction to Land Art will thus include a specific reference to the representation of a seventeenth-century map which works in this way.

I shall, however, begin with a more famous seventeenth-century example which could well be used to demonstrate the many-layered possibilities of the map within representation. Jan Vermeer's *Art of Painting* incorporates a splendid map of the United Provinces, displayed on the back wall of an artist's studio.[1] The map is rendered with astonishing precision, so much so that it has become 'a source for our knowledge of cartographic history'.[2] But it is more than that. Lit dramatically from the side, with its intricately painted folds and crinkles denoting its status as an object, the map becomes an index of Vermeer's exceptional skill in describing the infinite particularities of the visible world. Both an object of knowledge, marking real relationships and distances, and a represented object caught in the glancing light, it functions as an eloquent internal metaphor of Vermeer's art […]

Let me juxtapose with Vermeer's work a painting of the same period but with virtually nothing else in common: the miniature of John Bargrave and his two travelling companions painted by Matteo Bolognini at Siena in 1647. In Vermeer's painting, the map serves as the ultimate index of *history* rather than *discourse*: it is what pre-exists the work of representation and what can act as a paradigm for the 'Art of Describing', though only in so far as it manifests a system of relations which diagrammatically reproduces those in the real world. In Bolognini's painting, the map serves instead to say, this is where we are, and this is where we are going. The index finger of John Bargrave, the leader of the little expedition, designates their place of temporary residence and the direction which they will take on proceeding to the goal of their journey, the city of Rome […]

This representation of a map is there to perform, through enunciation, an indexical function. The bottom edge of the map exactly corresponds to the bottom edge of the image; the written information corresponds to the main towns featured in the trio's expedition; moreover, they are featured in such a way that we, the observers, can read their names. When Bargrave established his Cabinet of Curiosities in his canon's lodgings at Canterbury in the 1660s, and when he arranged to hang his little painting on a ribbon from one of the wooden knobs, he was simply fulfilling the project which had been inherent in the commission from the start. 'Here we are, and this is where we are going' was converted into 'This is where we were, and this is where we went next'.

It may well seem that I have made a kind of elision in passing from Vermeer to the Bargrave miniature in this way. For in Vermeer's work, play is being made with the notion of enunciation as an authorial function, a function which the map does not share. In the Bargrave miniature, Bolognini the artist, responding to a specific commission, has abdicated his authorial role in favour of the enunciative presence assumed by the three travellers. My subject is the recent phenomenon of Land Art, and I cannot remain for much longer in the seventeenth century without seeming irrelevant. But I will emphasize, before vaulting over the centuries and landing in the present, that there seems to me to be as good a reason for scrutinizing the art of the seventeenth century for signs of the duplication of the authorial and the enunciative role as there is for drawing attention to its presence in contemporary art. In other words, in its use of maps, Land Art does not disavow the inheritance of landscape art which most art historians agree commenced its development in the early seventeenth century. Precisely the reverse, it is the very disposition of land artists to seek a fuller register of semiotic possibilities, including that of the map, which denotes their kinship with the seventeenth century as opposed to the later centuries of landscape painting with whose precedent the land artists often appear to be making a decisive break […]

The recent display at the Tate Gallery, London, featuring Richard Long among other Land Artists, reflects the roles of those different elements in the very heterogeneity of its installation. Photographs show us Richard Long's *A Square of Ground* (1966) and, on the wall in the background, the same artist's *Cerne Abbas Walk* (1975). Let us treat the map, for the moment, rather like the map in Vermeer's *Art of Painting*, as something waiting in the background to be incorporated into the total field of Long's art, while we look more carefully at the object in the foreground, which may be as deceptive as the easel painting in the foreground of the Vermeer. This foreground object is a cube in section, visibly made of plaster and painted on the upper surface. But it is also quite clearly a derivative of a certain kind of landscape.

Svetlana Alpers writes well about a type of Dutch seventeenth-century landscape painting, of which Philips Koninck was a well-known exponent, where the frame delimits what would otherwise be a seemingly endless stretch of flat Dutch countryside seen from a high viewpoint under a sullen sky.[3] Long's work is reminiscent of this, but it has proceeded through an intermediate stage, incorporating the technical innovations of our own period, just as Koninck used the inventions of his own. I would suggest that Long's landscape can be read through the medium of aerial photography, since it is not a square of ground in the literal sense, but a section of an aerial prospect of ground, delimited by an implicit grid in the way a map grid delimits. Positioned at a low height in relation to our viewpoint, it produces the structural features of the aerial view, with the effect that its smooth green surfaces become fields, its rough green forests and its crannies rushing streams. This very early work by Long thus positions the spectator, and through invoking the technical feature of a specific mode of viewing, opens up the object to a landscape reading. In a sense, he has not ceased to do this, although since then he has kept his feet on the ground as well as venturing a view from the upper air.

Cerne Abbas Walk is a good example of the complex

and heterogenous elements that combine to form Long's discourse. There are two framed prospects, one a landscape photograph which does not bear a caption, and the other a montage, whose ground is the Ordnance Survey map of a part of central Dorset. The photograph needs no caption. It is a view of the Dorset countryside, lit obliquely perhaps by a setting sun; as a photograph, it is before all else indexical, denoting that the artist has stopped for a while in that precise location. The framed map, however, needs to be captioned; a pasted piece of paper bears the legend 'A six day walk over all roads lanes and double tracks inside a six mile wide circle centred on the Giant of Cerne Abbas'. This explains the formal features of the drawn lines which occupy the centre of the map; an implied circle with its centre at Cerne Abbas has been outlined, and the different tracks which lie within the circle have been emphasized because they – unlike the conceptual circle – have been tramped over exhaustively in the course of the six days.

I am reminded here of the work of Patrick Wright, who has been investigating a curious phenomenon resembling the boy-scout movement which developed in a Dorset estate during the 1930s.[4] In retrospect, this para-political group has come to seem both fascinating and slightly sinister, by virtue of the similarity of its guiding ideas with some of the headier ideologies of the period. In the same way, I can imagine that a few decades from now, the very idea of an artist walking systematically through the countryside will have come to have an archaic, perhaps even quaint significance. Just as a person on foot in a rich American suburb is a focus of immediate suspicion, it is conceivable that a person who walks over all roads, lanes and double tracks may soon appear eccentric, if the public pressure protecting rights of way is not maintained.

This is just speculation, but it links up with the point that I have tried to make about the landscape vision of Wals, or the expedition of John Bargrave, which resulted in the publication of the first English guide to Italy (1648).[5] At the beginning of a practice which will be later sanctioned by culture, its elements are no doubt in suspension (like atoms in a molecule) and particularly accessible to knowledge. Thus retrospectively, the Bargrave trio seem to have been embarked on a Grand Tour, but it was a Grand Tour in the days before such a practice had acquired its later, conventional characteristics and when the etymology of a term deriving from 'Tour' or 'Circle' was still so fresh that the traveller might well imagine himself indeed to be inscribing a circle on the map. Much more work remains to be done, in my view, on what might be called the 'self-image' of the traveller: indeed, at a time when travel has been largely reduced to a uniform, accelerated process to which even the sea cannot be allowed to interpose a barrier, the genealogy of the practice, in a Nietzschean sense, still remains to be written.

We can see Richard Long and a handful of other, mainly British artists, as contributing to this process of historical reconstruction. I have been struck for some time by the coincidence that Kenneth Clark's influential book, *Landscape into Art*,[6] with its bleak forecasts for the future of landscape painting, went into a second edition at the very moment in the mid 1970s when Richard Long and his

colleagues were effectively renewing the art of landscape after their training in the Sculpture School of St. Martin's College of Art. But what they were renewing was the use of iconic, symbolic and indexical elements in combination, rather than the mimetic tradition acclaimed by Ruskin and by Clark. In artistic terms, Long's model is not the seamless web of the mimetic prospect, carried to its ultimate degree of finesse by Turner, but the collage practice of the cubists, juxtaposing and superimposing separate registers of meaning within the visual field. So an official, numbered image of the phallic giant is pasted over the map, not indeed where it belongs in topographical terms, but just below the prehistoric encampment of Maiden Castle. The infinite particularity of the map's detail, its palimpsest of names, places and physical features, is obliterated by the image's presence, and by the authorial sign which marks the date of Long's intervention: Dorset 1975.

I should stress at this point that Long does not always use maps in his work; indeed the constant factor is not any one mode of transcribing the landscape but his insistence on more than one mode operating simultaneously. This is what I have called the semiotic dimension, meaning that the representation draws attention to its signifying level at the same time as it offers an icon or prospect of the real world. One of Long's most celebrated pieces, dating from 1967 (the year after his *Square of Ground*) is *A Line Made by Walking*. Here the 'line' both makes the picture, in a compositional sense, and serves as an index of the artist's movement through the landscape. Hubert Damisch has drawn attention to the Roman institution of *repetitio rerum*, when the Roman army would pause at the frontier of a territory to be invaded, and rehearse its capture in a symbolic sense before proceeding to march in.[7] Long's work also is a *repetitio rerum*, but in reverse, in that he flattens the meadow grasses with his boots before recording the prospect with his camera. The two operations coincide in the spectator's reaction: I, too, can imagine myself walking that line.

It is worth making a rapid comparison with the American pioneers of Land Art, also featured in the Tate display, since their works make use of the same composite elements even if their overall effect tends to be rather different. Dennis Oppenheim's *Salt Flat* (1968) documents a massive transfer of salt from one place to another – a contemporary version of the proverb about sending coals to Newcastle. A thousand pounds of baker's salt are laid out on an asphalt surface 50 × 100 feet (15 × 30 m) and, as the inscription puts it, 'identical dimensions are to be transferred in 1 × 1 × 2 foot (30 × 30 × 60 cm) salt lines' to Salt Lake Desert, Utah, where they will presumably revert to invisibility. In this case, as in so many others, the sheer scale of the American landscape determines that the American Land Artist should be engaged in large-scale feats of installation or transposition. As with Walter De Maria's *The Lightning Field*, a desert has to be sought out and the work abandoned in solitary splendour, seemingly infinitely remote and sublime, like the summit of Everest or the surface of the Moon.[8] In comparison, Oppenheim is conducting a fairly modest operation, but the map of

Manhattan and New Jersey which he includes to mark the urban site of the salt installation has no function other than to act as a pointer. Indeed the square within a circle which indicates the gallery site on the Avenue of the Americas looks suspiciously like a gun-sight, as if some airborne weapon were targeting the work for destruction.

Richard Long's map pieces from the 1970s manage to preserve the features which had been established by the pioneering work of the 1960s, even though no photographic image supports the landscape vision. It is interesting to follow the mental operations which we perform when looking at works from this period, like *Eight Walks* or *A Hundred Mile Walk along a Line in County Mayo, Ireland*. Essential to our interpretation is an awareness that Long's engagement with landscape has a history and has taken many different forms: this helps to create the contract, without which we should not even be willing to accept the claims that are being implicitly made.

In *Eight Walks*, Long superimposes the squared grid of the Ordnance Survey on a detailed map of the Dartmoor area but it is up to us to interpret his 'walks' – the eight, thickly-drawn, straight lines of equal length – as real tracks in time and space, in the same way as the map offers us potential tracks in time and space which we could take if we had the leisure. Long's tracks are not the conventional paths that we would take if we were walking on Dartmoor. They represent an order that is only comprehensible if we imagine the map as a physical projection seen from a great height. The contour lines and the numerous map-signs which characterize the terrain convey to us, as map-readers, what we often call 'the lie of the land'. Long's straight lines, as walks, have to espouse the irregularities of the land, and consequently their measured symmetry is offset by the varied times that each single track has taken to complete, ranging between sixty and seventy minutes.

The *Hundred Mile Walk* in Ireland is more mysterious. Indeed I am not entirely sure how the distance given on the map (a distance presumably great enough to traverse the whole country from east to west) has here been compressed into a single county. Perhaps the terrain requires additional miles up and down, perhaps the various rivers had to be side-tracked and forded, perhaps the mileage indicates both an outward and a return journey. The interest of the work depends on the expectation that there will be a reasonable answer to these issues, and that we can reach it simply by the inspection of the work – that is, the map with superimposed line and caption. In this case, the credit given to the Irish Ordnance Survey puts us in no doubt that this is an official, copyrighted map such as we might ourselves use if we were in the area. But, as the title Ordnance Survey recalls, the origins of mapping lie in practical, often military, purposes, where the challenge is precisely to dominate the vagaries of landscape through the planning of roads, canals and lines of communication. Long aestheticizes the map but his walking project, done to time and most often in a straight line, repeats the regulatory strategy of the engineer – except that on this occasion what is being organized is not the free flow of commerce or military supplies but the structure of a personal performance. This performance is indeed gratuitous except in so far as it mobilizes our own perceptions of landscape.

I have assumed up to this point that the different semiotic registers which converge in one of Long's landscape works are identifiable and distinct. In the *Cerne Abbas* piece, for example, there is a clear discrimination between the icon as image – the giant – and the icon as diagram – the map. The indexical element is present because photographs are used and, principally, because the tracks within the circle are the record of the artist's walk. An artistic practice which works through these particular means does so to a large extent by multiplying the possibilities of additional readings and by the ambiguities inherent in the process. For instance, the placing of a photograph of the Dorset countryside in close conjunction with a map and a title referring to a walk invites us to make an indexical reading of the icon offered by the photograph: where on his travels did the artist obtain this particular view? Equally, the imaginary circle which occurs on the map, the result of numerous walks terminated at a pre-arranged point, becomes a symbolic construct giving unity and completion to the whole enterprise.

Both Long and his close colleague the Land artist Hamish Fulton in fact achieve some of their most memorable effects through simplifying their graphic means and concentrating their expression in a single trace which condenses a whole signifying process. Long's *The Crossing Place of Road and River* (1977) involves two adjacent panels. On the left is a photograph indicating the well-worn track which crosses the infant river. On the right, however, is – at first sight – a purely graphic configuration of lines. The legend required to interpret it reads: 'A Walk of the same length as the River Avon: A 26 Mile Northward Walk along the Foss Way Roman Road'. Consciously or not, Long has used the same device as the Swiss concrete artist Max Bill, who called a work from the immediate post-war period *Six Lines of Equal Length*,[9] the point being that the common property of the coiled and uncoiled lines is far from being perceptually obvious and has to be conceived by the mind, almost in the teeth of the visual evidence. Likewise, Long challenges us mentally to stretch out all the crinkles of the River Avon and line it up beside the Foss Way which, being a Roman road, is a byword for straightness.[10]

I want here to reiterate the general proposition about Land Art which has been implicit in my argument. This is that the break which has evidently occurred with the great mimetic tradition of landscape painting acclaimed by Ruskin and Clark, can be seen as a return to the genealogy of landscape representation; more specifically, it can be interpreted as a reversion to the more open semiotic register of the seventeenth century, when issues of description and transcription, enunciation and effacement of the authorial presence, were being worked out across a range of differing practices, one of which was landscape painting and another the compilation of travel guides. Since practices like these had not become conventionalized, they were, to some extent, experiments in signification; and this is how we can most fruitfully regard them, rather than as the precursory stages of a cultural phenomenon whose later development we know only too well.

But Land Art is not simply or primarily a reversion. It is a confrontation with the contemporary world, and a way

of retrieving a type of sensibility most appropriate to it at a time when landscape has become the stake of so many competing agencies and interests. In this respect, the use of the map seems to me to have an exemplary purpose. For the map to be appropriated as a vehicle of personal expression and as a mode of enunciation, assumptions have to be made. One assumption is that this diagrammatic, essentially non-sensuous type of artefact can condense within itself cultural ideas of a rich not to say over-prodigal interest. I have quoted in an earlier paper on aspects of mapping the extraordinary passage where the American poet H.D. considers the map of Greece:

'Look at the map of Greece. Then go away and come back and look and look and look at it. The jagged contours stir and inflame the imagination ... Look at the map of Greece. It is a hieroglyph ... That leaf hanging a pendant to the whole of Europe seems to indicate the living strength and sap of the thing it derives from'.[11]

Here the poet swerves iconically in the course of her reflections and invites us to see this hieroglyph as a leaf form, because she is in the business of using words. The challenge is still one of discovering an existential content in the seemingly arbitrary form of the map.

Hamish Fulton's *Coast to Coast Walks* (1987) is spare and at first sight uninspiring by comparison.[12] But in the dimensionality of the listed years – each of which marks a track made according to a preconceived plan – we are offered a kind of symbolic time, or history. This history is in turn linked to a more profound, more extensive history. We are all familiar with those historical atlases that show battlefields, often indicated with crossed swords, and their dates. These are both like and unlike Fulton's tracks, in that Fulton's marks are not punctual and conflictual but labile and harmonious. He not only signals, in the course of a walk, the abraded stone on the Dover Road which evokes a vanished age of pedestrian travel but also, in the *Coast to Coast Walks*, communicates an almost filial attention to the land and its outline. It is as if, while railways and motorways scar and sear the surface, the tread of the artist's foot, in his preordained labour of many years, could bind it up again.

1 Vermeer's *Art of Painting* is reproduced in Svetlana Alpers, *The Art of Describing - Dutch Art in the Seventeenth Century*, John Murray, London, 1983, plate 2 and, for details of the map, p. 120; 123

2 Ibid., p. 120

3 Ibid., pp. 142-45

4 Patrick Wright's work has not yet been published.

5 John Raymond, *An Itinerary contayning a Voyage made through Italy in the Yeare 1646 and 1647*, Humphrey Mosely, London, 1648

6 Published by John Murray, 1949, 1976, 1979; another edition 1956, Penguin Books, Harmondsworth

7 Hubert Damisch, *Théorie du Nuage. Pour une Historie de la Peinture*, Le Seuil, Paris, 1972, p. 158

8 For a description of De Maria's *Lightning Field* (rarely photographed since it involves many square miles of desert), see Frank Popper, *Art of the Electronic Age*, Thames and Hudson, London, 1993.

9 For a reproduction of Max Bill's *Six Lines of Equal Length*, see the exhibition catalogue *Max Bill*, Buffalo, New York, 1994; p. 84.

10 In as much as the common river name 'Avon' was derived by the Romans in Britain from the generic Celtic word for 'river'; a congenial aspect of Long's work is the way it is saturated with meanings from the world outside the frame.

11 H.D., *Ion - A Play after Euripides*, Black Swan Books, Redding Ridge, Connecticut: New Edition, 1986, pp. 132-33. See also 'The Truth in Mapping', in Stephen Bann, *The Inventions of History*, Manchester University Press, Manchester, 1990, pp. 200-20

12 For a reproduction of Fulton's *Coast to Coast Walks* see Bann, Ibid., p. 218.

Stephen Bann, 'The Map as Index of the Real: Land Art and the Authentication of Travel', *Imago Mundi*, no 46, British Library, London, 1994, pp. 9-18. This article is an abbreviated version of a lecture delivered at the Warburg Institute, London, October 1993.

Christian Philipp MÜLLER
Green Border [1993]

[...] 'In view of the tensions and misunderstandings that had arisen with regard to the integration of Austrian artists in international exhibition halls, the Austrian government decided in the autumn of 1912 to build a separate Austrian pavilion on the premises of the Biennale in Venice.'[1]

Because of the outbreak of the First World War it proved impossible to realize the plans designed by Josef Hoffmann in October 1913. It was only on January 5, 1934, that Vienna decided to build an Austrian pavilion in Venice. After lengthy political controversies about who was to be the architect, Josef Hoffmann emerged as the winner. Only one month later he presented his first drawings. The implementation of the project was, however, left to the pro-government architect Kramreiter, whose own project had been rejected [...]

The slightly modified plans of 1938 did not include the park designed by the Venetian architect Artuso. His intention had been to plant rapidly growing poplar trees in order to create a green belt between the boundary of the Biennale premises and the pavilion. Hoffmann enclosed the courtyard and its sculptures with a high wall and by means of this horizontal structure, which also characterizes the rest of the pavilion, he delineated Austrian territory. By the time of the 21st Biennale, however, Austria had disappeared from the map of Europe. The documents that were supposed to be used to invite Austrian artists to the 1938 Biennale, duly signed by the President and the Secretary General of the Biennale, are still kept in the Biennale archives at Canale Grande. 'As you rightly assume, Berlin has informed us that the artists from the Ostmark will be presented in the German pavilion.'[2] The 'Austrian' landscape was, however, present at the 21st Biennale in the main Italian pavilion in the form of paintings by the artists of the eighteenth and nineteenth

10. Panorama of a Roman Road

centuries. Hofmann's pavilion remained empty until 1948. It was only then and until his death in 1956 that Josef Hoffmann, in his capacity as Commissioner, was entrusted with the selection of Austrian artists [...]

When I visited the site for the first time in August 1992, I was struck by the overgrown inner courtyard and an emergency exit in the left corner of the courtyard. Through the double door you enter a sort of no-man's land. A few metres behind you can see the wall topped with barbed wire, which surrounds the Biennale premises. I immediately decided to integrate this piece of land, which had been forgotten and preserved for almost forty years, into the exhibition area. First of all I wanted to clear the sickle-shaped green space towards the Austrian pavilion. In Venice, where every single tree is subject to nature protection, this was not an easy task. We finally succeeded in removing the undergrowth but for the plants foreseen in the plans of 1954. We had to fulfil certain requirements but still got the permission from the authorities responsible for the protection of monuments in Venice to remove a section of the rounded part of the courtyard wall. From the spacious inner courtyard we can now look onto a landscape. The visitor stands on Austrian Biennale territory and has a free view towards an open border. (Until 1866 Venice belonged to the Austro-Hungarian Monarchy.) In my contribution to the Biennale this 'open border' stands for the present geographical borders of Austria.

Neutral countries such as Austria or Switzerland are now trying to redefine their position in Europe. The European Communities have done away with many barriers; membership is, however, still controversial. Austria's neighbours in the East, on the other hand, are redefining their borders and find themselves confronted with a process of growing disintegration. Austria has become a sort of tunnel between the former Eastern bloc and Western Europe, through which professional organizations smuggle political and economic refugees across the border against payment of vast amounts of money. I wanted to find out myself how easy it is to cross the Austrian borders now. Disguised as a hiker I left Austria unnoticed and went to eight neighbouring countries: Italy, Switzerland, the Principality of Liechtenstein, Germany, Czechia, Slovakia, Hungary and Slovenia. I used maps produced in Austria (scale: 1:50 000) and tried to find wooded areas near the borders. In Czechia my Polish assistant and I experienced the difference between the border as an artistic concept and political reality. For more than two hours nobody prevented us from taking photographs and walking around freely. Suddenly, however, we were seized by frontier patrolmen and got a stamp in our passports that forbids us to re-enter the country within the next three years [...]

For each of these eight border regions I have chosen one page from this publication, which is now kept in the archives of the Austrian National Library in Vienna. They will be exhibited in the right wing of the pavilion, which Josef Hoffmann had intended for the presentation of graphic arts. We can see landscape paintings showing regions no longer belonging to Austria, such as Merano and Brno. In the archives of the Vienna Albertina and the Kupferstichkabinett of the Academy of Fine Arts we can

find thousands of drawings and watercolours depicting landscapes. These works of art, reminiscent of former Austrian possessions, are however subject to such strict rules and regulations that prevented me from getting the permission to exhibit them in Hoffmann's open pavilion.[3]

Together with the drawings we will exhibit eight trees that will represent the different landscapes of the border regions.[4] Planted into old terracotta pots from the almost forgotten Orangerie belonging to the Administration of Municipal Parks in Venice, these trees create the impression of an Orangerie of the North. I do not want to evoke the dream of classical Italy in Venice, but rather show non-exotic trees from an Austrian tree nursery. In order to conserve the exhibits over the four months' exhibition period, we try to limit the temperature to 20°C and reduce air humidity. The inner courtyard of the Hofmann pavilion situated between the two wings with their glass windows reminds me of the parks of the classical suburban mansions. '*Gli horti, e i giardini – altre al comodo – rendono una certa magnificienza, e grandezza alla casa.*[5] The classical Renaissance villa of the Veneto dominates the landscape. There is a garden in front of the buildings and behind them there is an open space without any walls. Owners do not need fences. Josef Hoffmann wanted to design the space in front of his pavilion along these lines, but was denied to do so by the Biennale management. The courtyard I opened in 1993 permits a view of the garden [...]

I used more than 300 plants grown by professional Venetian tree nurseries to redesign the rear part of the courtyard. A slightly sweeping line of bricks separates the earthy ground from the square-shaped tiles. Garden mould from Austria and Veneto ensures the opulent growth of the plants arranged in a way that is reminiscent of English horticultural landscaping.

I transferred the total width of the central entrance to the diameter of a garden table. This round garden table is placed in the left corner of the inner courtyard and turns around a new centre, a tree. The table top is made of the most popular Austrian timber varieties.[6] There you can buy this publication [...]

1 Hansjörg Plattner, in: Josef Hoffmann, 50 Jahre österreichischer Pavillon Biennale Venedig, Vienna 1984, p. 24

2 From the letter of the Secretary General to the former Commissioner Professor Christian L. Martin in Vienna, dated May 2, 1938/XVI Biennale, Venice archives

3 Constant temperature of 18-20°C, relative humidity of 50-55% and light intensity reduced to 50 lux, loan limited to a maximum of 10 weeks, transport and high insurance premiums

4 With kind permission of Professor Dr. Georg Grabherr, who also kindly agreed to provide the botanical explanations

5 Vincenzo Scamozzi, 'Dell'idea dell'Architettura universale', in *Venetia presso l'autore* MDCXVI III, 22, p. 32 f

6 Source: *Prozentuelle Verteilung der Baumarten in Österreich*, 1986/1990, Austrian Federal Ministry for Agriculture and Forestry, Vienna

Christian Philipp Müller, 'Green Border', *Austrian*

Contribution to the 45th Venice Biennale, Bundesministerium für Unterricht und Kunst, Vienna, 1993, n.p.

Guy BRETT
Cildo Meireles: Through [1989]

The work of Cildo Meireles gives one the feeling that it is located simultaneously in two worlds: in a quiet classroom where questions of perception and the philosophy of meaning are teased out — and in the street, or in the forest [...]

At the end of the 1960s and in the early 1970s, Cildo's meditations on space and on dimension were poetically and paradoxically encapsulated in boxes and similar devices. After conduction a *reductio ad absurdum* of classical Euclidian and perspectival space by constructing a sort of portable indoor corner, a blind trap of the bourgeois' 'own four walls', which was shown in various places, including the beach on one occasion, Cildo moved to investigate space in its multiple connotations: as 'physical geometric, historical, psychological, topological and anthropological'. One box in his *Arte Fisica* series (1969) contained a map and a bundle of 30 kilometres of string which had been stretched along a section of the coast in the state of Rio de Janeiro. Another box, this time a leather case in his series *Geographical Mutations* (1969), recorded an action he undertook at the frontier between the states of Rio de Janeiro and São Paulo. The nature of frontiers as mental constructs was indicated by digging a hole on either side and transferring earth, plants, etc. from one hole to the other. The leather case was made as a portable version of the event. In a beautiful extension of this play on dimensions, Cildo made two exquisite fingerrings in 1970. One, pyramidical in form and made of gold, had a single grain of sand inside visible through a tiny sapphire 'window' (*Desert*); the other was a version of the *Geographic Mutations*: *Rio – São Paulo Frontier* in silver, sapphire, onyx and amethyst. These perceptions of space clearly inform Cildo's more overtly political work which he began around 1970. Here must be recognized not only the artist's personal courage in producing this work at the height of Brazil's military dictatorship (1970 was perhaps the most terrible year of the regime), but also his artistic audacity [...]

The fact that the passage of time, political changes and fashion, have tried to institutionalize such work, or made fun of its hopes of intervention in the real world (as had intended to happen with all twentieth century movements which have broken the barrier between art and life), does not make the issues it raised, of contextualization and efficacy, any less pressing. One of its legacies must precisely be imagination and flexibility in the use of different 'place/times'.

Guy Brett, *Cildo Meireles: Through*, Kanaal Art Foundation, Kotrijk, Belgium, 1989

Octavio ZAYA
Cai Guo Qiang [1996]

[...] Since the mid 1980s, Cai Guo Qiang has been creating complex events and art projects throughout the world, projects which emphasize the cosmic laws of opposition between creation and destruction, *yin* and *yang*. By selecting specific sites for his intervention and action, in much the same way as an acupuncture doctor selects specific spots on the body, Cai has been using the techniques of Chinese geomancy (*feng-shui*). In making a comprehensive study of the conditions of the site, including geography, history and industry, he diagnoses and heals the land. Gunpowder is the main ingredient or material in these actions that culminate in a momentary phenomenon, 'a momentary eternity' in which, as Cai says, 'all forms of existence, heaven, earth and human beings, lose awareness. Time and space are suspended, or rather, they return to their starting point. They are in harmony with the *ch'i* (the vital force, the energy,) of the universe.'

In 1993, the fire which Cai carefully arranged to extend along the Great Wall of China ran ten kilometres in the Gobi Desert and then disappeared. In *Dragon Meridian*, the exhibition which mapped this action in Japan, Cai made medicine from plants grown in the Gobi Desert, and fed it to people who were going to China, in connection with his project in that location. This was a preventive measure to help people get used to an unknown land by becoming as one with it beforehand. In the project he presented in 1995 at the first Johannesburg Biennale, *Restrained Violence. Rainbow*, an abandoned construction (facing the Power Plant building which housed the installations of many participant countries), suddenly exploded before our eyes (momentarily). Inside the Power Plant building, Cai showed an installation that emphasized the healing power of fire.

In the exhibition of *The Century with Mushroom Clouds* project that Cai opened in May at P.S. 1, the photographs of the small mushroom clouds that he created with gunpowder at the Nevada Test Site are not the only mushrooms on display. Cai is also presenting drawings of mushrooms, produced by controlled explosions on paper, and the real Chinese healing mushrooms which contribute to the regulation of the body from within. Again, this project emerges from the three basic Taoist concepts which organize each of his 'rituals': grasping the whole, going beyond the surface to find the essence of things and maintaining balance.

Octavio Zaya, 'Cai Guo Qiang', *Flash Art*, Milan, October 1996, p. 103

Jane TOMKINS
Language and Landscape:
An Ontology for the Western
[1990]

[...] The opening shots of Western movies signal the importance of the landscape, of matter over words. The fact of the land put out front, before the story proper begins, has a message of its own to send. This scene, composed of solids rising from a level plain bathed in a pristine light, declares the irrefragability of the physical world and celebrates its hardness. But the opening landscape shot, clearly intended to frame the action, is itself silent. Its power lies in its taciturnity. Nature's silence guarantees its value and makes an existential claim. This alone is real, it says, this abides.

The first sight we see is usually a desert or prairie, punctuated by buttes and sagebrush, or sometimes by cattle, small hills or a wagon train. Not infrequently, a rider appears in the opening shot, but more often, the human figures enter the picture later. The desert offers itself as the white sheet on which to trace a figure, make an impression. It is a tabula rasa on which man can write, as if for the first time, the story he wants to live. That is why the first moment of western movies, in which the landscape is empty, is so full of promise. It is the New World, represented here, not for the first time, as a void.

The scene's austerity, the sense of its dryness and exposure, translate into a code of asceticism that founds our experience of western stories from the start. It is an environment inimical to human beings, a landscape defined by absence: absence of trees, of greenery, of houses, of the signs of civilization, above all absence of water and shade. Here a person is exposed, the sun beats down, there is no place to hide. The landscape of the western challenges the body to endure hardship – that is its fundamental message at the physical level. It says: this is a hard place to be, you will have to do without here. Its spiritual message is the same, and equally irresistible: come and suffer. The negations of the physical setting – no shelter, no water, no rest, no comfort – are its siren song. Be brave, be strong enough to endure this and you will become like this – hard, austere, sublime.

The American West as imagined in these narratives incarnates the European sublime. Men may dominate or simply ignore women in Westerns, they may break horses and drive cattle, kill game and kick dogs and beat one another to a pulp, but they never lord it over nature. Nature is the one transcendent thing, the one thing larger than men in this world. Nature is the ideal towards which human nature strives. Not *imitatio Christi* for the Western hero, then, but *imitatio naturae*. What is imitated is a physical thing, not a spiritual idea; a solid state of being, not a process of becoming; a material entity, not a person; a condition of objecthood, not a form of consciousness. The landscape's final invitation – death as merger – promises absolute materialization. Meanwhile, the qualities that nature implicitly possesses – power, endurance, rugged majesty – are the only ones that men can aspire to while they live.

The validity and primacy of nature are echoed in the hero's looks. He must be an emanation of the land; as far as possible, indistinguishable from it. Here is the title character of *Hondo*, in L'Amour's opening description: 'He rolled the cigarette in his lips, liking the taste of the tobacco, squinting his eyes against the sun glare. His buckskin shirt, seasoned by sun, rain and sweat, smelled stale and old. His jeans had long since faded to a neutral colour that lost itself against the desert.'

The first thing L'Amour mentions is a man-made thing, the cigarette, but it is quickly resolved into a sensory effect, the taste, and its organic substance, the tobacco, and both give way, via the hero's eyes, to 'the sun glare'. The entire passage melds its heterogenous elements – man-made objects (cigarette, shirt), natural substances (tobacco, buckskin), parts of the body (lips, eyes), bodily effluvia (sweat, smell), natural phenomena (sun, wind, rain, desert) – into a single continuum. Everything blends imperceptibly into the desert.

'He wore nothing that gleamed. The lineback's dun colour shaded into the desert as did his own clothing.'

'[His face] had all the characteristics of the range rider's – the leanness, the red burn of the sun, and the set changelessness that came from years of silence and solitude.'

'He was a big man, wide-shouldered, with the lean, hard-boned face of the desert rider. There was no softness in him. His toughness was ingrained and deep.'

'He had plainly come many miles from somewhere across the vast horizon, as the dust upon him showed. His boots were white with it. His overalls were grey with it. The weather-beaten bloom of his face shone through it duskily.'

These quotations, from three different novels (*Hondo, Riders of the Purple Sage*, and *The Virginian*), are all describing the same man, a man, as L'Amour writes in the foreword to *Hondo*, 'bleak as the land over which he rode', and described on the cover of *Heller with a Gun* as 'merciless as the frontier that bred him'. Perhaps Zane Grey sums it up best in his description of the quintessential cowboy, Nels, in *The Light of Western Stars* (1913): 'He's just come to be part of the desert, you might say he's stone an' fire an' silence an' cactus an' force'.

The qualities needed to survive on the land are the qualities the land itself possesses. And these qualities are not regarded as merely necessary to survival, they are the acme of human moral perfection. The ethical system the Western proposes, and the social and political hierarchy it creates, never appear to reflect the interests or beliefs of any particular group, or of human beings at all. They seem to have been dictated, primordially, by nature itself. The sage-dotted plains, the buttes, the infinite sky tell more plainly than any words what is necessary in a man. Thus the landscape sets up, by implied contrast, an image of the effete life that the genre never tires of criticizing, the 'fancy words and pretty actions' L'Amour dismissed in *Radigan*. We know that the people who get off the stage wearing suits and top hats and carrying valises are doomed, not because of anything anyone says about them but because of the mountains in the background and the desert underfoot that is continuous with the main street of town.

It is, of course, an *interpretation* of nature that does the

11. John Ford

work I am referring to. The various kinds of hardness western nature seems to inculcate are projected onto the landscape by men and read back off it by them. The emptiness we see there, the sense of a hostile environment, is an effect of a certain way of life and of mental habitude.

For the desert is no more blank or empty than the northeastern forests were when the Puritans arrived there. It is full of growing things and inhabited by animals and people, just as Massachusetts was before the English came – though they called it a *vacuum domicilium*. An empty space. When European man walks or rides into a forest, however, he is lost among the trees, he can't see ahead, he doesn't know what might be lurking there. Strategically, he is at a disadvantage. And visually, the forest doesn't provide a flattering contrast to the human figure. It surrounds it, tends even to obscure it, literally with shadows and structurally by its similarity of composition (vertical trees and the vertical human form) and by its competitive detail. But when a lone horseman appears on the desert plain, he dominates it instantly, his view extends as far as the eye can see, enemies are exposed to his gaze. Strategically, he has an even chance. Visually, he conquers; he is the most salient point in the picture, dark against light, vertical against horizontal, solid against plane, detail against blankness.

Thus the blankness of the plain serves a political function that remains below the level of consciousness. It implies – without ever stating – that this is a field where a certain kind of mastery is possible, where a person can remain completely autonomous, alone and in control of himself, while controlling the external world through brute strength and sheer force of will. The Western situates itself characteristically in the desert, because the desert seems by its very existence to affirm that life must be seen from the point of view of death, that physical stamina and strength are the sine qua non of personal distinction, that matter and physical force are the substance of ultimate reality, and that sensory experience, the history of the body's contact with the world, is the repository of all significant knowledge.

It is the power of the Western that when we are reading the novel or watching the movie these truths seem to be self-evident. But of course they do not simply emanate from nature itself, as the desert landscape would have us believe; they are dictated by the very things the Western is pitting itself so strenuously against: language, book-learning, laws, abstract systems of exchange, big corporations, social hierarchies, fancy clothes, plush interiors, temperance, the way ladies are taught to behave in society. The opposition the Western sets up between landscape and language, nature and culture, matter and representation, itself belongs to a particular mode of representing the world. Therefore, the story the Western tells, which *seems* to be about the struggle between a pristine nature and a decadent culture, is really about who will have the right to dictate the terms according to which the culture operates, to say what the true oppositions are, or, to put it somewhat differently, it is about who will have the right to name God.

That right, in the course of the nineteenth century, had been passing from the clergy into the hands of popular women authors, whose power the Western genre is contesting. And so when the hero rides out of the desert at the beginning of the story, and back into the desert at the end, his existence and journey are an assertion that ontological purity resides in the masculine body, in masculine action, in a masculine vision of the world [...]

Jane Tomkins, 'Language and Landscape: An Ontology for the Western', *Artforum*, New York, February 1990, pp. 96–99

Toshikatsu ENDO
On Fire [1991]

The imagination of fire should not be limited to the consciousness of fire as an independent phenomenon. From a structural viewpoint one of the primary elements that compose the universe, fire exists on a continuum with those other material phenomena: earth, water, air and sun. Most important is the following: it is within the cosmological relation – where human life becomes linked with fire, earth, water, air, sun and other physical elements of the universe – that the material imagination can become manifest and bring meaning.

In my early work, I began to use water with increasing frequency. At that time, through sheer mental exhaustion I was attracted to the most moderate, flexible and neutral of materials. But perhaps most importantly, I felt that materials such as water could be considered within a somewhat expanded concept of Minimal Art, where words are reduced to a minimum.

I soon realized that I had been mistaken. Before long, water began to tell its many stories and from behind its transparent surface emerged strange and uncertain signals. They were the words, the meanings given to water throughout the history of humanity. Water was no longer simply a liquid contained, but an endless spring of meaning welling up from the depths of the earth.

Then arose the idea of returning water to the earth: using a shovel to dig a hole in the ground and filling its centre with water. I understood the duality – that by my action water was simultaneously removed from the earth. This gesture, a secret rite for the release of repressed desires – was also a requiem for the water.

Water passed through my body, circulating within and finally breaking out through some inner fracture. Suddenly, the water, that which had been returned to the earth and that which had been taken from the earth, metamorphosed into fire and burst into flames.

These acts seemed to touch some place where seductive memories tinged with madness have been concealed within us, memories of destruction, burial and prayer [...]

Toshikatsu Endo, 'On Fire', *Toshikatsu Endo*, Tokyo Museum of Contemporary Art, 1991, n.p.

Fumio NANJO
Toshikatsu Endo [1989]

The bulk of Toshikatsu Endo's works consist of circles, squares, cubes and rectangles. These simple forms are reminiscent of minimalist art. However, this likeness does not extend to his materials. Nor does formal analysis provide us with an understanding of his works. They are based on an inner ideology bound up with history, mythology and human existence.

Many of Endo's works are burnt and scorched black. Burning makes wood more resilient, hinting that the work will actually last longer than ordinary wood sculptures. On the symbolic level, it seems that they last for half of eternity. In this way, one can think of their existing beyond time. At the same time, black, which as a colour is the ultimate and absolute, imposes on the works a serious spiritual tension devoid of embellishment.

The burning of the works is usually done out in nature. Sometimes on a lake, in a forest, or on top of a mound of earth. This ceremonial event is never public; it is not directed at an audience. Endo performs this alone. But it is possible for us to follow the working process in our imagination as photographs are taken on site. Apart from the wooden works, fire is also often used and contrasted with water in earth works which consist of hollows in soil. It looks as if flames are rising from the bowels of the earth, as in a volcano. The swaying, image-evoking flames are not controlled by man but by part of the immensity of nature.

On the other hand, water is much more crucial to Endo's works than fire. For instance, the work shown at the Indian Triennale in 1986 and at the Venice Biennale in 1988 consists of twenty-two black cylinders the tops of which are filled with water. This is also a feature of a work consisting of a round block of wood which has its hollow parts filled with water. The work *Allegory II. Coffin of Seele* (1985), which is made of a rectangular, coffin-like box, has water in it, even though it is not visible for the viewer. In his Land Art works, too, water is used in circular shapes.

Besides wood, Endo uses stone, iron and bronze. In his stone works some of the stones in circles have been burnt. And some of the stones are actually made of bronze cast into stone forms. In one of his bronze works Endo has very carefully etched the surface. [...]

What then is important to Endo? It is important to search for the archetypes within man. Water, for instance, has, from the beginning, had a special attraction for him due to its close links with human existence, history and life. It is impossible to bind the use of water to just one incident, or to just one meaning. Water relates to a variety of stories and symbols connected with human life. It is difficult to limit its significance.

We can, however, experience many aspects of water just by letting it keep its manifold features. We can experience the precise, refined aspect of water when we see it on top of the cylinders, as they are filled to the brim, the surface tension raising the water above the edge without running over. We meet another similar aspect when the water in a circular earthen pit reflects the sky. Here we get a feeling of experiencing a peaceful effect which is only one of its innumerable modes of existence. Thus, water in Endo's work relates to fundamental states of mind without the need for specific interpretation.

The same can be said of fire. Like water, throughout history fire has been both man's servant and enemy. The control of fire has been not only a technical problem but also a feature of civilization. Today we have forgotten how natural and wild fire actually is. Originally, fire was one of the most devastating forces in nature, at the same time as being a visible form of energy. When we see the fire in these works we feel struck to the heart and experience a mysterious sense of excitement […]

When contemporary Japanese art is shown in the West, it has a fundamental disadvantage compared with western art. If it relies on expressive means similar to those of western art, it is looked upon as a kind of imitation. On the other hand, if it possesses profoundly Japanese qualities, the only response it arouses is an interest in the exotic. Japanese artists of today seem to need to find a new kind of orientation that is neither Japanese nor western. In this sense, we can say that Endo's works are neither western nor are they superficially Japanese, based on worn-out concepts. He has a world of his own which integrates both the Japanese and the western […]

Fumio Nanjo, 'Toshikatsu Endo', *Toshikatsu Endo*, Nordic Arts Centre, Helsinki, 1989, pp. 12-13.

IMPLEMENTATION

Political topicality and the idea of environmental stewardship as a lyric device in the production of aesthetic experience are matched here by a rise in pragmatism. The grass roots social movements of the times demonstrated the potential for transforming personal philosophical concerns into practical action. The evolution of theoretical critique gave rise to functional activity; poetic interventions found parallels in science and politics. The diversification and democratization of the social world was reflected in the artworld. As Helen Mayer Harrison and Newton Harrison note, 'Our work causes the conversation to drift in another direction. We take up the cultural and political, the aesthetic and the ecological, all at once'. Cleaning, planting, remedial work, conservation: all of these conventional pursuits, traditionally outside the purview of artmaking, are brought together in the appraisals of and statements by the artists included in Implementation. As Mierle Laderman Ukeles said in a 1991 interview, 'It's not just artists decorating landfills. I'm talking about artists sitting at the decision-making table – [creating projects] that will save our earth, our air, our water. If we survive people will look back and say, "That's the great design of our age".'

Rachel CARSON
A Fable for Tomorrow [1962]

There was once a town in the heart of America where all life seemed to live in harmony with its surroundings. The town lay in the midst of a checkerboard of prosperous farms, with fields of grain and hillsides of orchards where, in spring, white clouds of bloom drifted above the green fields. In autumn, oak and maple and birch set up a blaze of colour that flamed and flickered across a backdrop of pines [...]

Along the roads, laurel, viburnum and alder, great ferns and wildflowers delighted the traveller's eye through much of the year. Even in winter the roadsides were places of beauty, where countless birds came to feed on the berries and on the seed heads of the dried weeds rising above the snow. The countryside was, in fact, famous for the abundance and variety of its bird life, and when the flood of migrants was pouring through in spring and autumn people travelled from great distances to observe them. Others came to fish the streams, which flowed clear and cold out of the hills and contained shady pools where trout lay [...]

Then a strange blight crept over the area and everything began to change. Some evil spell had settled on the community: mysterious maladies swept the flocks of chickens; the cattle and sheep sickened and died. Everywhere was a shadow of death. The farmers spoke of much illness among their families. In the town the doctors had become more and more puzzled by new kinds of sickness appearing among their patients. There had been several sudden and unexplained deaths, not only among adults but even among children, who would be stricken suddenly while at play and die within a few hours.

There was a strange stillness [...] only silence lay over the fields and woods and marsh.

On the farms the hens brooded, but no chicks hatched. The farmers complained that they were unable to raise any pigs [...] The apple trees were coming into bloom but no bees droned among the blossoms, so there was no pollination and there would be no fruit.

The roadsides, once so attractive, were now lined with browned and withered vegetation as though swept by fire. These, too, were silent, deserted by all living things. Even the streams were now lifeless [...]

In the gutters under the eaves and between the shingles of the roofs, a white granular powder still showed a few patches; some weeks before it had fallen like snow upon the roofs and the lawns, the fields and streams.

No witchcraft, no enemy action had silenced the rebirth of new life in this stricken world. The people had done it themselves [...]

Rachel Carson, 'A Fable for Tomorrow', *Silent Spring*, Houghton Mifflin, Boston, 1962, pp. 21-22

Simon SCHAMA
Landscape and Memory
[1995]

[...] If a child's vision of nature can already be loaded with complicating memories, myths and meanings, how much more elaborately wrought is the frame through which our adult eyes survey the landscape. For although we are accustomed to separate nature and human perception into two realms, they are, in fact, indivisible. Before it can ever be a repose for the senses, landscape is the work of the mind. Its scenery is built up as much from strata of memory as from layers of rock.

Objectively, of course, the various ecosystems that sustain life on the planet proceed independently of human agency, just as they operated before the hectic ascendancy of *Homo sapiens*. But it is also true that it is difficult to think of a single such natural system that has not, for better or worse, been substantially modified by human culture. Nor is this simply the work of the industrial centuries. It has been happening since the days of ancient Mesopotamia. It is coeval with writing, with the entirety of our social existence. And it is this irreversibly modified world, from the polar caps to the equatorial forests, that is all the nature we have.

The founding fathers of modern environmentalism, Henry David Thoreau and John Muir, promised that 'in wildness is the preservation of the world'. The presumption was that the wilderness was out there, somewhere, in the western heart of America, awaiting discovery, and that it would be the antidote for the poisons of industrial society. But of course the healing wilderness was as much the product of culture's craving and culture's framing as any other imagined garden. Take the first and most famous American Eden: Yosemite. Though the parking is almost as big as the park and there are bears rooting among the McDonald's cartons, we still imagine Yosemite the way Albert Bierstadt painted it or Carleton Watkins and Ansel Adams photographed it: with no trace of human presence. But of course the very act of identifying (not to mention photographing) the place presupposes our presence, and along with us all the heavy cultural backpacks that we lug with us on the trail.

The wilderness, after all, does not locate itself, does not name itself. It was an act of Congress in 1864 that established Yosemite Valley as a place of sacred significance for the nation, during the war which marked the moment of Fall in the American Garden.¹ Nor could the wilderness venerate itself. It needed hallowing visitations from New England preachers like Thomas Starr King, photographers like Leander Weed, Eadwaerd Muybridge, and Carleton Watkins, painters in oil like Bierstadt and Thomas Moran, and painters in prose like John Muir to represent it as the holy part of the West; the site of a new birth; a redemption for the national agony; an American re-creation. The strangely unearthly topography of the place, with brilliant meadows carpeting the valley flush to the sheer cliff walls of Cathedral Rock, the Merced River

winding through the tall grass, lent itself perfectly to this vision of a democratic terrestrial paradise. And the fact that visitors had to *descend* to the valley floor only emphasized the religious sensation of entering a walled sanctuary.

Like all gardens, Yosemite presupposed barriers against the beastly. But its protectors reversed conventions by keeping the animals in and the humans out. So both the mining companies who had first penetrated this area of the Sierra Nevada and the expelled Ahwahneechee Indians were carefully and forcibly edited out of the idyll. It was John Muir, the prophet of wilderness, who actually characterized Yosemite as a 'park valley' and celebrated its resemblance to an 'artificial landscape-garden ... with charming groves and meadows and thickets of blooming bushes'. The mountains that rose above the 'park' had 'feet set in pine-groves and gay emerald meadows, their brows in the sky; bathed in light, bathed in floods of singing water, while snow-clouds avalanche and the winds shine and surge and wreathe about them as the years go by, as if into these mountain mansions Nature had taken pains to gather her choicest treasures to draw her lovers into close and confiding communion with her'.²

But of course nature does no such thing. We do. Ansel Adams, who admired and quoted Muir, and did his best to translate his reverence into spectacular nature-icons, explained to the director of the National Park Service, in 1952, that he photographed Yosemite in the way he did to sanctify 'a religious idea' and to 'inquire of my own soul just what the primeval scene really signifies'. 'In the last analysis', he wrote, 'Half Dome is just a piece of rock ... There is some deep personal distillation of spirit and concept which moulds these earthly facts into some transcendental emotional and spiritual experience'. To protect Yosemite's 'spiritual potential', he believed, meant keeping the wilderness pure; 'unfortunately, in order to keep it pure we have to occupy it'.³

There is nothing inherently shameful about that occupation. Even the landscapes that we suppose to be most free of our culture may turn out, on closer inspection, to be its product. And it is the argument of *Landscape and Memory* that this is a cause not for guilt and sorrow but celebration. Would we rather that Yosemite, for all its over-population and over-representation, had *never* been identified, mapped, emparked? The brilliant meadow-floor which suggested to its first eulogists a pristine Eden was in fact the result of regular fire-clearances by its Ahwahneechee Indian occupants. So while we acknowledge (as we must) that the impact of humanity of the earth's ecology has not been an unmixed blessing, neither has the long relationship between nature and culture been an unrelieved and predetermined calamity. At the very least, it seems right to acknowledge that it is our shaping perception that makes the difference between raw matter and landscape [...]

1 For the Edenic associations of Yosemite, see John F. Sears, *Sacred Places: American Tourist Attractions in the Nineteenth Century*, Oxford University Press, Oxford, 1989, p. 133

2 John Muir, *The Mountains of California*, New York, 1894, p. 3

3 Ansel Adams, *On Our National Parks*, Boston, Toronto and London, 1992, pp. 113-17

Simon Schama, *Landscape and Memory*, Alfred A. Knopf, New York, 1995, pp. 7-10

Robert SMITHSON
Untitled (Across the Country ...) [1979]

ACROSS THE COUNTRY THERE ARE MANY MINING AREAS, DISUSED QUARRIES, AND POLLUTED LAKES AND RIVERS. ONE PRACTICAL SOLUTION FOR THE UTILIZATION OF SUCH DEVASTATED PLACES WOULD BE LAND AND WATER RE-CYCLING IN TERMS OF 'Earth Art'. RECENTLY, WHEN I WAS IN HOLLAND, I WORKED IN A SAND QUARRY THAT WAS SLATED FOR REDEVELOPMENT. THE DUTCH ARE ESPECIALLY AWARE OF THE PHYSICAL LANDSCAPE. A DIALECTIC BETWEEN LAND RECLAMATION AND MINING USAGE MUST BE ESTABLISHED. THE ARTIST AND THE MINER MUST BECOME CONSCIOUS OF THEMSELVES AS NATURAL AGENTS. IN EFFECT, THIS EXTENDS TO ALL KINDS OF MINING AND BUILDING. WHEN THE MINER OR BUILDER LOSES SIGHT OF WHAT HE IS DOING THROUGH THE ABSTRACTIONS OF TECH-NOLOGY HE CANNOT PRACTICALLY COPE WITH NECESSITY. THE WORLD NEEDS COAL AND HIGH-WAYS, BUT WE DO NOT NEED THE RESULTS OF STRIP-MINING OR HIGHWAY TRUSTS. ECONOMICS, WHEN ABSTRACTED FROM THE WORLD, IS BLIND TO NATURAL PROCESSES. ART CAN BECOME A RESOURCE THAT MEDIATES BETWEEN THE ECOLOGIST AND THE INDUSTRIALIST. ECOLOGY AND INDUSTRY ARE NOT ONE-WAY STREETS, RATHER THEY SHOULD BE CROSS-ROADS. ART CAN HELP TO PROVIDE THE NEEDED DIALECTIC BETWEEN THEM. A LESSON CAN BE LEARNED FROM THE INDIAN CLIFF DWELLINGS AND EARTHWORKS MOUNDS. HERE WE SEE NATURE AND NECESSITY IN CONSORT.

Robert Smithson, 'Untitled (Across the Country ...)', *The Writings of Robert Smithson*, ed. Nancy Holt, New York University Press, New York, 1979, p. 220

Jack BURNHAM
Hans Haacke – Wind and Water Sculpture [1967]

HAACKE'S USE OF NATURAL MEDIUMS
Haacke's water boxes have a kind of maddening ambiguity. On the one hand he fusses with their shapes, demanding both very precise Archimedean proportions and technical perfection, while on the other he encourages the semi-random activity that pervades the boxes' inside activity. How can an artist demand so much and at the same time be content with the inevitable? It is typical that

12. Yosemite National Park

13. Albert Bierstadt

14. Cup and Ring markings

he refuses to use screws, stainless steel braces or gaskets to put his plastic boxes together, but at the same time he constantly searches for new degrees of freedom.

I can remember when Haacke took me to see an example of his first water boxes (spring 1962), then in the rental collection of The Museum of Modern Art in New York. A secretary commented that museum personnel had been playing with it for days – it seemed to have caused more joyful curiosity than any number of 'sculptures' – and for that reason the museum never thought seriously of buying it as a 'work of art'. For those who watched the water box, the aggregate emotion was that of delight and perplexity.

Most saw the water box as essentially frivolous, lacking the mystery, restraint, impact, technical bravura, cruelty, wit and optical salience that went into the games of other currently successful artists. Here was an art of essential phenomenalism where the obligation to *see* was passed on to the spectator. The artist had structured the events – take it or leave it – the rest was up to the dimmed memory of the viewer: to remember what he had forgotten since childhood about the intimate effects of wind and water.

In this respect, Haacke has spoken several times of the Japanese mode of making precise but informal art and gave me some examples from the seventeen-syllable haiku poems: short, terse fragments that are really tiny universes of sensibility. The water boxes in their own way are encapsulated forms of the poetic condition.
'Spring rain
Conveyed under the trees
In drops.'
Just as within the Plexiglas container, this poem makes the discovery that the same source of water, when altered by an obstacle, can change in consistency and texture. Large irregular drops from the branches of a tree fall on the haiku poet as he stands underneath peering at the fine fabric of spring rain. This is precisely the condition of the gravity-controlled water boxes, where water becomes one thing, then another – always varied to the senses and changing form as it meets new forms of material opposition. Haacke cited another example:
'The dew of the rouge-flower
When spilled
Is simply water.'
We see only what we want to see and the hardest thing to see is what is non-literary in origin, in fact, what is with us from the moment we first open our eyes. Thousands of times I have discharged the contents of a washbasin or have swallowed liquid with the purpose of removing the contents from the cavity of the glass into the cavity created by my digestive system. Few times have I exerted what Husserl calls 'reduction' in isolating either the motions of my body in receiving the water or the actions of the water leaving the glass. This last is what Haacke is about, and its full import only came to me after my visit to his studio in Cologne.

All the containers strewn about his studio may have looked similar, but were in essential ways different from each other. In a typical one water flowed from an uppermost level through a partition with tiny holes to the bottom, creating as it fell a tapestry of small whirlpools and drops. Another container divided water into converging zigzag streams running along transparent sides of the box.

In some cases, not just form and partitioning, but physical principles determine the dynamics of the water boxes. As one cylindrical vessel is inverted, coloured solutions merge, flatten and distend against each other, as Haacke's wife, Linda, remarked, like a Sam Francis painting in slow motion. Later, this idea was incorporated into a series of flat, panel-like constructions having partial plastic walls. Coloured liquids would partition into bubble structures on their journey to the top of the piece, slowly forming and re-forming as they rose upward.

More and more I began to sense that the quality that unified these constructions was their ability to transcend merely mechanical operation and to assume some of the pattern inherent in life processes. In the translational motion of regular water currents, say through a pipe, the water remains unchanged at each segment of the pipe. In contrast, liquids moving through an organic system or digestive tract constantly change in chemical structure as they move in space. Ideally, Haacke would like something like that if it were feasible. The partitions and other deterrents in his constructions are the closest that he can come in this direction.

Through the anonymity of Plexiglas with liquid passing from level to level, he is trying perhaps to get at the clockwork of the human body's own chemistry. There is a sense of immanent completion with the further knowledge that the cycle will begin all over again. One apparatus could be said to simulate cell duplication; with the aid of a small hand pump a chemical engenders overflowing mounds of foam. Soap particles dissolve as they spread out. Not all the action is so apparent. At one window of the studio a large transparent box stood in the sunlight regenerating cycle after cycle of condensation. With slow, endless variation the transparent sides of the box were patterned with beads of moisture only to turn into rivulets of water as they became too heavy to remain drops. In the sun a fine haze of vapour appears near the top of the construction, then drops in tiny trickles along the sides, with pools of water along the bottom.

Haacke had some interesting comments about this last piece. This is one work that did not need to be turned over by the viewer, yet in exhibitions its subtle action is not enough for some people and they *want* to set it on its top. Of course, this just erases the pattern established on the plastic, and the slow process of building up condensation must begin again. Haacke claims that only the most perceptive and sensitive viewers ever like his condensation box. For most observers its rate of change is too slow to sustain any attention. All of which suggests to Haacke that the quieter and simpler phenomena of nature are no match today for what people expect out of life. For the sensitive kinetic artist time scales are an important element – and particularly as they are juxtaposed in mechanical and organic systems.

In relation to this he gave me his own short manifesto.
'... make something which experiences, reacts to its environment, changes, is nonstable ...
... make something indeterminate, that always looks different, the shape of which cannot be predicted precisely ... make something that cannot 'perform' without the assistance of its environment ...
... make something sensitive to light and temperature changes, that is subject to air currents and depends, in its functioning, on the forces of gravity ...
... make something the spectator handles, an object to be played with and thus animated ...
... make something that lives in time and makes the "spectator" experience time ...
... articulate something natural ...'
–Hans Haacke, Cologne, January 1965

Haacke's statement brought to mind the closing efforts of Leonardo da Vinci and his thousands of notations on the nature and substance of air and water; of his lust to comprehend the currents, whorls and eddies; of his plans in old age for miniature experimental water works; of his notebook sketches, which sought to link up relationships between the circulation of water in the earth, in the cells of plants, and the blood pumping through the arteries of the human body, of an instinct that anticipated the statistical mechanics of modern physics by four centuries, and not least of all, the great *Deluge* drawings that tried to capture the violent patterns of wind and water as they destroyed all man-made activity [...]

It is this sensibility, still scientifically accurate in its broader respects, that speaks to an artist such as Haacke and permits him to say, 'I am doing what artists have always done – that is, extending the boundaries of visual awareness'.

Gradually Haacke has moved from the water pieces to a more encompassing determination of the full scope of his work. All usable, flexible forces have become the means for remaking tiny bits of the world into boundless, playful systems. These feats with air drafts and blower systems could be termed *weather events*. In this respect some of Haacke's recent *Sail* (1965) constructions were accompanied by a statement that echoed familiarly of Leonardo.

'If wind blows into a light piece of material, it flutters like a flag or it swells like a sail, depending on the way in which it is suspended. The direction of the stream of air as well as its intensity also determine the movements. None of these movements is without an influence from all the others. A common pulse goes through the membrane. The swelling on one side makes the other side recede; tensions arise and decrease. The sensitive fabric reacts to the slightest changes of air conditions. A gentle draft makes it swing lightly, a strong air current makes it swell almost to the bursting point or pulls so that it furiously twists itself about. Since many factors are involved, no movement can be precisely predicted. The wind-driven fabric behaves like a living organism, all parts of which are constantly influencing one another. The unfolding of the organism in a harmonious manner depends on the intuitiveness and skill of the "wind player". His means to reach the essential character of the material are manipulations of the wind sources and the shape and method of suspending the fabric. His materials are wind and flexible fabric, his tools are the laws of nature. The sensitivity of the wind player

determines whether the fabric is given life and breathes.'

Today in the engineering of complex systems the problem is to make the man-machine relationship as smoothly functional as possible. The more variables present and the faster the machine components must make decisions and transmit actions the less opportunity remains for the human operator to assert his own degree of autonomous control. For this reason – and for more practical ones – Haacke's devices are purposely kept simple and technically unelaborate. He is not after the usual passive knob-pressing kinetic art, neither is the viewer in complete control of the situation; instead, at best, a mutual interaction between viewer and sail system is encouraged. This is a level of authentic sensual involvement that Haacke senses the world has less time for today. Art is natural medicine.

This was apparent the summer before last (1963) when Gerd Winkler of the Hessische Rundfunk, a television station in Frankfurt, made a film in Haacke's studio. One sequence was devoted to the uninhibited play of several children around a group of balloons suspended on a column of air – the children understood the point perfectly of knocking the balloons off the column of air, whereas grown-ups photographed doing the same thing usually felt a bit self-conscious. Certainly Haacke's experimentation begins with the same playful intensity as the early Dadaists, although in spirit it is less attuned to alienation and therapeutic destruction.

One senses an innate distrust by Haacke of complicated machines and electronic equipment, basically on the grounds that they are non-visual and tend to break down. 'The simpler the better' is his sentiment, 'like the standing egg of Columbus. It is best to get along with unmechanical sources of energy.' On a monumental scale he would invent new forms of windmills and sail constructions – 'driven and blown by naturally existing winds'.

In his January 1966 show two 'air events' were set up: a 7×7-foot (2×2 m) chiffon sail suspended loosely parallel to the floor and kept swinging above an oscillating fan, and the other a large, white rubber balloon balanced on an air jet. A number of times I've questioned Haacke on the saleability of such works; after all they are fragile *systems* not stable *objects*. His reply is that he is fortunate to have a gallery that can understand the importance of non-saleable works, and that they have to be made in spite of what happens to them later.

More basic than the category of kineticism or mechanics is the fact that the artist is trying to manipulate purely invisible forces, a strictly non-palpable art, in which effects and interaction count for more than physical durability. This outlook is somehow reminiscent of that of Roger Ascham, tutor to Elizabeth I of England, who wrote in his *Toxophilus: The Schole of Shooting*, 'To see the wind with a man his eyes it is impossible, the nature of it is so fine and subtile'. After this Ascham proceeds to deduce the consistency of the wind from the effects that it has on certain light and flexible objects – grass, snow, dust and other carriers of the invisible forces of hot and cold in reaction to each other.

'Hath the rain a father? Or who hath the drops of dew?' reads the Bible. Still, similar questions can be formed about the origins of the wind. The Earth itself can be looked on as a great wind-making device, forming patterns of evaporation, rain and humidity over its surface as a kind of enormous condensation container. Haacke's interest in the invisible mechanics of nature is like all meaningful art; it is a re-evocation of what was always known about existence, but forgotten at one time or another.

The water constructions are less easy to describe in words because they embody a 'programme' directed by gravity and composed of a number of parts. It was originally the discovery that water is the most living of inorganic substances that brought Haacke to his personal work. I talked to him about this problem of trying to describe what is in fact only moving reflection. Literary illusion and hyperbole seemed to fade in the face of something so completely phenomenal. His retort was that even photographs give a very incomplete impression and that, at the risk of boredom, accurate, extensive descriptions have to be made 'like a police report'.

So then, *process* is the word that describes the procession of hydrodynamical events that permit water to move in one of these boxes from a higher to a lower level. In the simpler containers this is a matter of about five minutes. Each sequence of events is, in effect, a unified visual statement.

At the inception of these hydrodynamic activities the water dimples as the first set of drops begins to pass through the tiny drilled openings of the interior partition. From that point onward animation increases with the more rapid passage of water. Soon the surface of the upper body of water tightens into a relatively stable pattern of vortices. Light reflected from the ridges of the wavelets on the surface becomes the visual means by which liquid flow and drop agitation are observed. This results in a kind of loose network of reflections, seemingly random but statistically determinate. A secondary webbing of light lines is brought to focus on the pedestal surface beneath the water box itself. This is the result of convergent light rays through the lens-simulating contours of the waves above. With exquisite precision the water-drop and its sheath, repeated countless times over the entire surface of the partitions, become a field of repeating miniature fountains in conjunction with the body of water below.

Seen from outside the box, these layers of activity superimpose and assume an interwoven complexity. To the casual observer this description may belabour the actual occurrence – with so much happening so quickly. But Haacke's intention is not to catch each action discretely and precisely as I have described it, it is geared instead towards a mode of relaxed observation. This is a kind of *letting-go* process in which phenomena become secondary to an intuition about the nature of sequential events.

Actually, after watching one of the water boxes, or 'drippers' as Haacke calls them, on a mat, stark white plastic tabletop, I thought I had the answer to what he was aiming at: an extremely old and visceral form of beauty, something, perhaps, fading from contemporary consciousness.

I could picture Thoreau lying on his stomach on the western slopes above Walden Pond watching the surface disturbances on the water: birds, fish, grass, breezes, water bugs – almost like a fireworks display. Here, I remember, was a man who harboured no wishful illusions about the deadening effects of technology, who knew what he was after. At that, a passage from Thoreau's *Journal* came to mind, 'A long soaking rain, the drops trickling down the stubble ... To watch this crystal globe just sent from heaven to associate with me [a raindrop], while these clouds and this sombre drizzling weather shut all in, we two draw nearer and know one another.'

There is a kind of pantheistic union between living and non-living matter in which both assume an organic rapport. I asked Haacke about this in a letter and his answer was something of a shock.

'Good old Thoreau', was his reply, 'romanticism is not really my cup of tea, although I don't deny that there's some of it in me. However, I hate the nineteenth-century idyllic nature-loving act. I'm for what the large cities have to offer, the possibilities of technology and the urban mentality. Plexiglas, on the other hand, is artificial and strongly resists either tactile sensuality or the "personal touch". Plexiglas, mass-production – Thoreau – they don't really fit together.'

For some, including myself, there seems to be a tug-of-war, a tremendous ambiguity in Haacke's efforts. It is as if he is willing to accept the phenomenal forces of nature, but only as long as they are hermetically sealed in a kind of artificial laboratory – not lake water, but the chemist's distilled H_2O [...]

During the spring of 1966 Haacke felt that a prime opportunity for a monumental undertaking was at hand. A 'Zero on the Sea' festival, all expenses paid, was to be sponsored at Scheveningen, Holland, by the local tourist agency. In a letter from just before the trip Haacke wrote in great excitement of some of his proposed undertakings out on the Scheveningen pier:

'I plan to have 60-foot nylon strips, white, being blown out over the sea from flagpoles on the pier – which are closely grouped together so that a constant flicker can be created. And a 150-foot plastic hose, tightly inflated with helium, will fly high above the beach or sea ... And also, I would like to lure 1,000 seagulls to a certain spot (in the air) by some delicious food so as to construct an air sculpture from their combined mass.'

Haacke felt that the entire undertaking was too good to be true, and rightly enough, two weeks before it was to commence, the sponsors called it off for lack of funds.

Nevertheless, he feels that with the elements of his work – wind and water – large scale is an inevitability, although a self-perpetuating source of frustration. Survival in art, as in all other realms of life, is contingent on material adjustment. One begins to embrace, if not see as a positive advantage, those limitations that currently define saleable gallery art. In a letter Haacke wrote, '... in spite of all my environmental and monumental thinking I am still fascinated by the nearly magic, self-contained quality of objects. My water levels, waves and condensation boxes are unthinkable without this physical separation from their surroundings.'

Mechanization is another problem for an artist in Haacke's position. With all of his espousal of the city and the values of mechanization, there is a deep underlying suspicion of the active effect of machines on his art. This is not a rejection of machines *per se*, but of their tendency to dominate in any relationship with man or the elements. If he has an aversion to the use of motors to pump liquids or to keep one of his systems in motion, it has much to do with the proportional size of the motor to the construction and of the quality of the motion generated. In a small construction most motors would be disproportionately large, and electric wiring would deprive the piece of its autonomy and power as a self-sufficient object. There is also the visual irrationality of power apparatus and the lifeless motion that it usually generates. 'Forced' motion has none of the give-and-take and inevitability that characterizes Haacke's method. No such inhibitions exist for a work installed in a large architectural setting. Here the scale 'naturalizes' motor-driven motion. Being incorporated into the architecture, there is no need for isolation as in a small, freestanding work. Of course, with the smaller constructions, the observer is the prime source of power – pushing, shaking and turning the box over. Haacke considers this role of the observer as a motive force to be of prime importance, no casual push-button affair. He has also commented that because this relationship is a physically sensitive one, there are 'good' and 'bad' generators among spectators.

Slowly the line between stable objects that sit passively waiting to be wrapped up and shipped off to some customer's home and the new projects demanding participation and unlimited space seems to be forming. The sense of ownership seems to vaporize from such conceptions as Haacke presents, instead they present the urge to move out into space like so much smoke. What Haacke is doing implies both great economic and material disruptions in the handling of art. But as Takis, the Greek kineticist, has said about the economic fallibilities of artists, 'So, unconsciously perhaps, they establish one of their discoveries, and then become known. Now that they are known, they are afraid to continue their search into the unknown for fear of dis-establishing their known work – all this perhaps unconsciously.'

So far, Haacke has avoided this pitfall and his creations have been event-oriented, not object-directed. Whatever direction he now chooses to travel, his momentum has not abated. He seems to be entering more dangerous altitudes as he flies straight for the clouds, but perhaps, more lucky than Icarus, he will avoid the sun.

Jack Burnham, 'Hans Haacke – Wind and Water Sculpture', *Art in the Land*, ed. Alan Sonfist, E.P. Dutton & Co, New York, 1983, pp. 106-24. Originally published in *Tri-Quarterly*, Supplement no 1, Spring 1967, pp. 1-24

Helen Mayer HARRISON and Newton HARRISON
If This Then That (The First Four): San Diego as the Centre of the World [1974]

I. IF

we are in an interglacial epoch and we are going into a period of heavy glaciation then within the next 10,000 years the mean annual temperatures will drop, the polar caps will enlarge, new glacial masses will form on mountain ranges that do not presently have snow cover and the level of permanent snow cover will expand downward, the oceans will recede to the continental shelf and the habitable zones will be reduced to the land between the tropics of Cancer and Capricorn.

Then the land mass available will be X, the populations it can support will be X, the salinity of the oceans will be X, the mean temperature of the oceans will be X, the mean temperature of the air will be X, the resulting ecological transformations will be X, the resulting human social and political system will be X.

II. IF

according to Bryce, the increase in the atmosphere of particulate matter from volcanic activity and smog screens out more of the heat from the sun,

Then within the next several hundred years the mean annual temperatures will drop, the polar caps will enlarge, new glaciation will begin on mountain ranges that do not presently have snow cover, the level of permanent snow cover will expand downward. The oceans will begin to recede, the continental shelf will begin to be exposed and the habitable zones will decrease.

Then the land mass available will be X, the populations it can support will be X, the salinity of the oceans will be X, the mean temperature of the oceans will be X, the mean temperature of the air will be X, etc.

If only proposition I is true, begin long-range planning.

If only proposition II is true, begin short-range planning.

III. IF

we are in an interglacial epoch and we are emerging from a period of heavy glaciation then within the next 10,000 years the mean annual temperatures will increase, the ocean ice will melt, the polar caps will melt, all glaciation will disappear, the ocean level will rise up to 300 feet, all the low-lying coastal cities and some of the inland ones will be submerged, vast parts of continental US, South America, India, Asia, Australia and China will again be the site of shallow inland seas.

Then the land mass available will be X, etc.

IV. IF

according to Plass, the burning of the currently known supplies of coal and oil over the next hundred years multiplies the CO_2 tonnage of the air 18 times increasing the speed of the greenhouse effect,

Then by the time the ocean-atmosphere CO_2 cycle returns to equilibrium, the CO_2 content of the air will be 10 times greater than it is today. The mean temperature of the earth will be 22° higher, ice pack and glacial melt will raise the ocean levels twenty to thirty feet, many coastal areas and the tropics will be uninhabitable.

Then the land mass available will be X, the populations it can support, etc.

If only proposition III is true, begin long-range planning.

If only proposition IV is true, begin short-range planning.

If it cannot be determined which of these propositions is true or it cannot be determined which combination of these propositions is true or it cannot be determined which of these propositions is false either singly or in combination then begin short- and long-range planning.

Helen Mayer Harrison and Newton Harrison, 'If This Then That (The First Four): San Diego As the Centre of the World', 1974, unpublished paper

Robert MORRIS
Notes on Art as/and Land Reclamation [1980]

[…] 'It was revealed to me that those things are good which yet are corrupted which neither if they were supremely good nor unless they were good could be corrupted.'
— James Joyce, Ulysses

The production of art works in this late industrial age has for the most part been circumscribed and structured by the commodity market. Beyond this, most artistic careers follow the contours of a consumer-oriented market: a style is established within which yearly variations occur. These variations do not threaten the style's identity but change subsequent production enough to make it identifiably new. Such a pattern then comes to be seen as natural and value-free rather than a condition of art distribution and sales. Strictures for change under different social conditions might emphasize disjunctive change, or no change at all. The modes for all change, or non-change, in production, including art, may be limited to three: static, incremental and disjunctive. But that one or more do in fact exist in every culture seems apparent. A given rate change for art production provides a context and coherence beyond a strictly economic referent: it provides the infrastructure for the culture's art history. Beyond this, the mode of art paralleling commodity production with its basic style/yearly variation yields good as well as bad art. While this has proven obviously more economically sound for artists than either the static or disjunctive modes, it is probably safe to say that the disjunctive, when effective, for whatever reasons, has been granted greater cultural value, either in terms of individuals or movements. (It has

been suggested that there may be something genetic in both risk-taking and its approval.') The disjunctive condition itself often ushers in the mode of commodity production in which incremental variations are practiced by 'second-generation' artists. Today the description of this phenomenon often polarizes 'innovators' into one camp and those who produce 'quality' items into the other.

It is interesting to examine site-specific works in the light of these modes. As they have been produced for the last ten to fifteen years, whatever disjunctive threshold they might once have had has long since been passed. On the other hand, site-specific works can hardly be described as commodity production items. They seem to assume the role of a service function rather than that of object production. Yet the majority of those artists showing a sustained interest in site-specific work – in either realized or proposed projects – conform to the 'established style/variation' mode characteristic of commodity object production. This is not surprising: the constraining parameter for change mediates cultural production in general.

While site-specific works have been produced now for over a decade, their sponsorship has been erratic and the budgets generally below what is required for truly ambitious works. There has certainly been no one source of sponsorship: various museums, private individuals, international exhibitions, local communities – these and others have from time to time made site works possible, but often just barely. The works sponsored have more often than not been temporary. But now on the horizon there is potential for widespread sponsorship of outdoor earth and site-specific works. Local, state, federal and industrial funding is on tap. The key that fits the lock to the bank is 'land reclamation'. Art functioning as land reclamation has a potential sponsorship in millions of dollars and a possible location over hundreds of thousands of acres throughout the country.

A number of issues, or perhaps pseudo- or non-issues, are raised by this possible *ménage à trois* between art, government and industry. One of these is not an issue, and that is the objection to art's 'serving' as land reclamation, that it would somehow lose its 'freedom' in so doing. Art has always served. Sometimes the service has been more visible – service to a patron, or to a governmental propaganda campaign. Sometimes the service is less visible, as when art meshes with and reinforces commodity consumption or remains 'abstract' while fulfilling a government commission. Context can also be read as service; it binds the political load of any work of art. In a deeper way, however, context is content. The issue of art as land reclamation is of course blurred by appeals by industry to the 'public need' for more natural resources, and thus more mines and environmental entropy which need cleaning up. While minerals have been mined and used since the end of the Stone Age, the present-day escalation of mineral requirements and the energy needed for accelerating production is not so much an index of public need as of corporate administration. In a complex society, where everything is interconnected, it is not possible to decide which commodity, therefore which technology, therefore which resource, therefore which

mine is essential and therefore worthy of reclamation. It might then seem that to practice art as land reclamation is to promote the continuing acceleration of the resource-energy-commodity-consumption cycle, since reclamation – defined aesthetically, economically, geophysically – functions to make acceptable original acts of resource extraction.

In so far as site works participate in art as land reclamation, they would seem to have no choice but to serve a public relations function for mining interests in particular and the accelerating technological-consumerist programme in general. Participation, however, would seem to be no different from exhibition in any art gallery, which *ipso facto* participates in the commodity structure. None of the historical monumental works known today would have been made if the artists had refused to work (many, of course, had no option to refuse) because of either questionable sponsorship or disagreement with the ends to which the art was used. It is an illusion that artists have ever had anything to say about the functions of their works.

While my project at Johnson Pit no. 30 in King County, Washington is to my knowledge the first instance of the hiring of an artist to produce art billed as land reclamation, the idea is far from new. [2] The coal industry has in fact given the aesthetics of reclamation some attention, 'While aesthetics is a frequent subject of discussion among reclamation officials, regulatory agencies and environmentalists, aesthetic quality and the criteria and standards by which it is evaluated seem to be one of the least understood facets of surface mining.'[3] The *Coal Age Operating Handbook of Surface Mining* notes a research effort (source of funding not given) centred at the University of Massachusetts involving the engineering firm of Skelly and Loy and two faculty members, Robert Mallary, a designer and sculptor, and Ervin Zube, who deals with the 'psychology of landscape assessment'.[4] While the overwhelming local feeling regarding reclamation, according to this research effort, is to 'return it to the previous contour', in Appalachia one of the prevailing surface mining techniques involves the removal of the tops of mountains. The major thrust of the group's 'systems approach' is aimed at dealing with reclamation which retains the flattened mountains of such sites. The research group notes with no trace of irony that 'operators at mountain top removal mine sites are tending to favour this flat-top approach'.[5] (Why wouldn't they, since it would be virtually impossible to rebuild the tops of mountains?) The group has proposed such striking aesthetic formulations as [...]: 'Leav[ing] a few strategically located portions of the site untouched and unmined'.[6] Such approaches are obviously nothing but coal-mining public relations.

What would *not* function as public relations, since any aesthetic effort made during or after mining operations functions to make the operations more acceptable to the public? Such aesthetic efforts are incapable of signalling any protest against the escalating use of non-renewable minerals and energy sources. What, one wonders, could be done for the Kennecott Bingham site, the ultimate site-specific work of such raging, ambiguous energy, so

redolent with formal power and social threat, that no existing earthwork should even be compared to it? It should stand unregenerate as a powerful monument to a one-day nonexistent resource. Other sites come to mind as well: those in Butte, Montana; the abandoned quarry at Marble, Colorado; some of the Vermont granite quarries; and a few of the deep-shaft coal and diamond mines qualify as significant monuments of the twentieth century. Are their implications any less sinister than those of the Great Pyramids? All great monuments celebrate the leading faith of the age – or, in retrospect, the prevailing idiocy. In one form or another technology has produced the monuments of the twentieth century: the mines, the rocket assembly buildings so vast that weather forms inside, the Four Corners Power Complex, the dams of the 1930s, the linear and circular accelerators of the 1950s and 1960s, the radiotelescope arrays of the 1960s and 1970s, and soon, the tunnel complex for the new MX missile. All these structures are testimony to faith in science and technology, the practice of which has brought the world to a point of crisis which nobody knows how to resolve. Art's greatest efforts are by comparison very definitely epiphenomena. Until now there could be no comparison. But the terms change when the US Bureau of Mines contributes to an artist's reclaiming the land. [7] Art must then stand accused of contributing its energy to forces which are patently, cumulatively destructive.

Or is art beyond good and evil? It can and does flourish in the worst moral climates. Perhaps because it is amoral it can deal with all manner of social extremes. It is an enterprise whose nature invites the investigation of extremes. Art erodes whatever seeks to contain and use it and inevitably seeps into the most contrary recesses, touches the most repressed nerve, finds and sustains the contradictory without effort. Art has always been a very destructive force, the best example being its capacity constantly to self-destruct, as in the sinking of Modernism once it became a set of established rules that rationalized a procedure, a life-style. Art has always been dependent upon and served one set of forces or another with little regard for the morality of those forces (pharaoh, pope, nobility, capitalism). It makes little difference what forces make use of art. Art is always propaganda – for someone. History, which is always *someone's* history, invariably attempts to neutralize art (according to someone's history, Speer was a better artist than Géricault). Artists who deeply believe in social causes most often make the worst art.

If the only rule is that art must use what uses it, then one should not be put off by the generally high level of idiocy, politics and propaganda attached to public monuments – especially if one is in the business of erecting them. Should the government/industry sponsorship of art as land reclamation be enthusiastically welcomed by artists? Every large strip mine could support an artist in residence. [8] Flattened mountain tops await the aesthetic touch. Dank and noxious acres of spoil piles cry out for some redeeming sculptural shape. Bottomless industrial pits yawn for creative filling – or deepening. There must be crews out there, straining and tense in the seats of their D-8 caterpillars, waiting for that confident

artist to stride over the ravaged ground and give the command, 'Gentlemen, start your engines, and let us definitively conclude the twentieth century'.

1 David Barash, *The Whisperings Within*, Harper and Row,
 New York, 1979, p. 59

2 I have had discussions with West Virginia mining
 interests about art projects on mined land. See also *The
 Writings of Robert Smithson*, ed. Nancy Holt, New York
 University Press, New York, 1979, pp. 220-1

3 Nicholas P. Chironis, *Coal Age Operating Handbook of
 Surface Mining*, Coal Age Mining Information Services,
 New York, 1978, p. 278

4 Ibid.

5 Ibid., p. 279

6 Ibid., p. 281

7 The US Bureau of Mines contributed $39,000 for my
 project in King County, Washington.

8 Smithson envisioned the possibility of the artist acting
 as a 'mediator' between ecological and industrial
 interests. While it is still conceivable that art works
 as land reclamation might achieve ecological approval
 and the support of a harassed coal industry (and even
 eager governmental money), the notion of 'mediation'
 loses all meaning in this situation. Given the known
 consequences of present industrial energy resources
 policies, it would seem that art's co-operation could
 only function to disguise and abet misguided and
 disastrous policies.

Robert Morris, 'Notes on Art as/and Land Reclamation',
October, no 12, Cambridge, Massachusetts, Spring 1980, pp.
97-102

Jack BURNHAM
Contemporary Ritual:
A Search for Meaning in
Post-Historical Terms [1973]

[...] We tend to think of serious ritual as being terribly primitive and embarrassingly sensual. Quite possibly it is, at least in its purer forms. On its most integral level ritual is the interface between Nature and Culture. To pursue this comparison further, one could say that if ecology is the syntax of Nature, then ritual is its daily, procedural counterpart in Culture. While ecology is simply the way of Nature, ritual has to be learned and adhered to. Given the non-connectedness of the institutions of Western Culture, and with anti-ritual as a way of life, it is probably difficult to envision any fundamental connection between ritual and Nature. In ways rarely understood by social scientists 'magical' and organic are synonymous.[1] Yet as we withdraw from the acausal essence of the organic, we progressively diminish the syntax of living interactions and replace it with property and abstract values. In the anthropologist Mary Douglas' words this constitutes 'a denunciation not only of irrelevant rituals, but of ritualism as such; exaltation of the inner experience and denigration of its standardized expressions; preference for intuitive

and instant forms of knowledge; rejection of mediating institutions, rejection of any tendency to allow habit to provide the basis for a new symbolic system. In its extreme forms anti-ritualism is an attempt to abolish communication by means of complex symbolic systems.'[2] One of the truisms of ecology is that the only test of Nature is the ability to remain. Two hundred years of technological domination has given us an illusionary sense of our own permanence. One of the basic principles of Nature is concerned with asymmetries that develop between bordering ecological subsystems. Given two bordering subsystems (either natural or cultural or a mixture of both), the less-organized sub-system releases energy to the more-organized, and in the process the less-organized sub-system loses information while the more-organized gains some.[3] Over a period of time this produces imbalances between neighbouring ecosystems precipitating crises within the more-organized system. As a culture builds up its urban areas, mechanizes and simplifies its food chains, cuts down its diversity of relations with Nature, it assumes the form of a more organized ecosystem drawing on the surpluses of energy from the simpler ecosystems around it [...]

It is not surprising that a very few artists are beginning to become involved with growth and harvest cycles of nature. Newton Harrison is one of the most intuitive and perceptive artists to move beyond the concerns of recent ecological art. His career in this respect is revealing. In the 1950s Harrison began as a sculptor, turned to painting in the 1960s and by the late 1960s moved into technological art with a series of glow discharge tubes. These provoked several proposals directed towards creating atmospheric effects at high altitudes. Two years ago Harrison produced a compost-earth pasture for the Boston Museum's 'Elements of Art' exhibition and a *Brine Shrimp Farm* for the Los Angeles County Museum's 'Art and Technology' project.

The notion of ecological art was well established before these projects. What distinguishes Harrison's attempts is a desire to question and record his own interactions and to construct systems involving complex hierarchies of organisms. While Harrison, acting out of the long tradition of gallery art, has made strenuous efforts to place his 'Survival Ecosystems' in gallery and museum contexts, he has been forced to rethink the direction and meaning of such large-scale programmes. It seems clear that the relationship between a painter or sculptor and his work is fundamentally different from that of an artist making sophisticated ecosystems. The psychological growth of a studio artist rarely depends upon the success or failure of his art. Though according to Harrison, one cannot work successfully with natural systems without undergoing fundamental personality changes – as slow as these may be. The more a synthesized ecological system depends upon the interaction of its human provider, the more that person must attune himself to its rhythms. Being drawn into an integral, on-going, natural system gradually alters the artist's attitude towards self and the world.

In the fall of 1971, Harrison set up a fish-farm at an American exhibition under the sponsorship of the British Arts Council in London. Fish were grown in tanks for

several weeks in preparation for a series of ritual meals. The fish were harvested and prepared for frying and stews. The fact that this was done at a public opening of an art exhibition caused enormous controversy. Harrison was attacked as a publicity-seeking sadist and the Arts Council was accused of wasting public funds. Though obviously, as a few critics insisted, not only does the killing of animal life go on as a daily aspect of modern survival, but Harrison took pains to kill his fish as humanely as possible. The real focus should have been on the fact that humans feeding on lesser-developed life forms remains a fundamental aspect of ritual art. Rather than suppressing the fact in the unconscious mind – as modern mechanized existence allows us to do – the artist wanted to reveal the most critical aspects of the life-chain.

Harrison believes that effective ritual stems from homage to our life-support systems, which in turn give sustenance and coherence to each social group that participates. Ritual behaviour attaches itself to specific and visible outputs of the system. This homage becomes ritual as people involve themselves with compulsive regularity, and their behaviour assumes the complementary qualities of a natural event. In the artist's eyes, it is this movement towards ornamentation and formalization that makes the whole activity creative and lends the group a sense of oneness, identifying it with a unity greater than itself.

This is true of the simplest task. For instance, there is an enormous difference between 'making earth' and simply composting manure to enrich the soil. Harrison associates all of his mixing with an earlier – yet still important – mixing of paint, clay and plaster, which he now sees as a surrogate for mixing earth and water. Harrison goes on to state that:
'Our most important pre-ritual activities so far are making earth and water, where, in an alchemical fashion we mix sterile and separately hostile elements, where the mixture combines with time and our touch, becoming literally a living element, a medium for growth. Some of this is private and does not bear publicity as yet. For instance, every morning I turn earth for one-half hour. I spend ten minutes of my time with a shovel, ten with a hoe, ten with my hands – and one minute with a hose. Two weeks ago this mixture smelled vile since 30 per cent of it was sewage waste. This morning it smelled neutral – by next week it will smell fresh and go into one of the indoor pastures and I will start the process over again. In the abstract I understand that I make the condition for life and that my activity is homage to that life and feeds back into my body both the food that will come from it and the physical strength that comes from slow rhythmic work. I notice that I breathe in when I pick up a shovel full of earth and breathe out when emptying it. I notice that I make three hoe strokes on inward breathing and three strokes on outward breathing. In the beginning when the mixture smells vile I take very deep breaths, drawing in air slowly, but letting it out quickly. At that point my behaviour is almost gluttonous. I become very possessive, running my hands through the earth to break up small lumps. This behaviour seems compulsive to me. Yet it is very necessary that I touch the soil all over, as a form of ornamentation.'[4]

Harrison's wife Helen has been an instrumental force in many of these projects. She takes over the planting and nurturing of the pastures. Harrison speaks of watching her wash and inspect every leaf of some plants attacked by cabbage worms. The female-male division of tasks between Helen and Newton seems to be a natural detail of their work together. Each has his strengths. Helen comments, 'I talk to plants, tell them what I expect of them and what I will give them – warmth, attention, food, water and companionship. They respond well. It's not that I'm urging or pushing, it's that this behaviour is in some deep sense right and usually works. I treat the flowers and plants as I would animals or children, the words are there but often the relationship occurs without them.'[5]

Lagoon is one of Harrison's more recent projects. This is an indoor micro-system, a tank 8 × 10 × 3 feet (244 × 305 × 91.5 cm) deep containing 1,500 gallons (6,825 ltr) of water. *Lagoon* is a body of water organized to simulate an estuarial pool on or near the equator. High-intensity lamps run in twelve hour cycles like the sun. The entire bottom forms a gravel filter, and the water temperature varies three degrees day and night. While Pacific Ocean water is used, weekly evaporation and the necessary addition of fresh water sets up a condition in part similar to rain, in part like estuarial flow. Within the animal hierarchy, crabs are the end product of this lagoon. Harrison concedes that if he were creating *Lagoon* in the southern California desert, as he eventually hopes to do, he would introduce a natural food-chain to support the crabs. Thus organic life could and would take care of itself. As it is, human energy and processed food complete the ecosystem. Harrison and his wife feed the crabs because their natural foods are not available. Thus the human transaction substitutes and becomes a metaphor for nature.

The feeding procedures simulate conditions, in part, both like estuarial and tidal input. As the crabs are introduced to the tank, their faeces activate the bottom filter. They kill, attack and eat each other until the population is reduced to a reasonable number for the space – about eight square feet per crab; in such a way territories are established for each animal. After territories are recognized, cannibalism ceases, pecking orders are arranged, and mating and moulting proceed. Harrison and his wife have been particularly successful in getting their crabs to mate and produce larvae. Crabs almost never produce offspring under artificial conditions.

Part of Harrison's time is spent in minutely observing the crabs and mimicking their behaviour. This may not be proper zoological procedure, but this little piece of ritual is one of the best ways to learn the crab's habits. At times crabs swim over one another with no signal of recognition, sometimes they approach each other with claws out-stretched and open, circling like wary boxers waiting for an opening. Harrison feels that when he is taking care of the crabs on their terms, he is substituting for nature. Eventually Harrison and his wife want to reintroduce the utilitarian into art at an extremely refined level. And in the process they hope to provide an antidote for the prevailing cynicism of the art world by making art the non-verbal teaching system it once was.

As social life functions are quantified and mechanized, art is progressively trivialized into the shape of consumer goods. Tentative as it is, Harrison's art poses a most complex but fundamental question: namely, can we really sever ourselves from our food and material resources so that there is no longer a magical interface (ritual-art) between the two? In Harrison's mind, such institutions as the supermarket represent mass cultural defocusing mechanisms, the means of disintegrating the bonds between natural micro-systems and human micro-systems (read home or family unit). And in closing Harrison writes, 'It is not the supermarket as a centre of trade, which is its legitimate cultural function, that disrupts man's intuitive contact with his biological sources, but the supermarket as a utopian simplifier and developer of artificial needs that eventually erodes our inner sense of discrimination and our ability to relate magically to the environment.'[6] During the later phases of historical art, the role of the artist, historian and critic was to indoctrinate the public into the aesthetic mystique, thus facilitating 'art appreciation'. Presently, in this post-historical period, we can begin by rediscovering art's quintessential roots. By understanding our lives we can begin to restore art to its rightful function.

1 See 'Objects and Ritual' in Burnham, *Great Western Salt Works: Essays on the Meaning of Post-Formalist Art*, George Braziller, New York, 1974

2 Mary Douglas, *Natural Symbols*, Pantheon Books, New York, 1970, p. 19

3 Ramon Margalef, *Perspective in Ecological Theory*, University of Chicago Press, Chicago and London, 1968, p. 16

4 From a letter by the artist date October 10, 1972

5 Ibid.

6 From a letter by the artist dated November 28, 1972

Jack Burnham, 'Contemporary Ritual: A Search for Meaning in Post-Historical Terms', *Arts Magazine*, New York, 1973; reprinted in *Great Western Salt Works: Essays on the Meaning of Post-Formalist Art*, George Braziller, New York, 1974, pp. 161-62; 162-67

Alan SONFIST
Natural Phenomena as Public Monuments [1968]

Public monuments traditionally have celebrated events in human history – acts of heroism important to the human community. Increasingly, as we come to understand our dependence on nature, the concept of community expands to include non-human elements. Civic monuments, then, should honour and celebrate the life and acts of the total community, the human ecosystem, including natural phenomena. Especially within the city, public monuments should recapture and revitalize the history of the natural environment at that location. As in war monuments that record the life and death of soldiers, the life and death of natural phenomena such as rivers, springs and natural outcroppings need to be remembered.

Historical documents preserve observations of New York City's natural past. When the first European settlers arrived they saw the natural paradise of the Native Americans:

'[…] The region in which they lived, which has now become the area of the greater City, was a paradise of nature, teeming with its products, and rich in natural beauty of woods and waters. Its varied climate, as one old-time writer described it, was "of a Sweet and Wholesome Breath", its "uplands covered with berries, roots, chestnuts and walnuts, beach and oak masts". Birds sang in the branches, the deer and elk roamed the grassy meadows, the waters swarmed with fish, the woods were redolent with the scent of the wild grape and of many flowers. Oak trees grew 70 feet (2,135 cm) high.'
— Reginald Bolton, *Indians of Long Ago*

In a city, public art can be a reminder that the city was once a forest or a marsh. Just as some streets are named after trees, street names could be extended to other plants, animals and birds. Areas of the city could be renamed after the predominant natural phenomena that existed there. For example, Manhattan's Lower East Side could be renamed by its previous marsh characteristics to create another symbolic identity and unification within the urban area. An educational force within the community, it would enable the community to get an overall view of the ecology that once existed.

I propose to create a 'Time Landscape'™, a restoration of the natural environment before Colonial settlement, for the Metropolitan Museum in the north-east corner of the grounds. I have a broad plan that could affect the whole city, for which the sculpture at the Metropolitan would be a model: the museum would be a nexus for the art of historical ecology. Throughout the complex urban city I propose to create a series of historical 'Time Landscapes'™. I plan to reintroduce a beech grove, oak and maple trees that no longer exist in the city. Each landscape will roll back the clock and show the layers of time before the concrete of the city. On Canal Street I propose to create a marshland and a stream; on Spring Street I propose to restore the natural spring; in front of City Hall I propose to restore the historical lake. There are a series of fifty proposals I have made for the City of New York.

The public art in urban centres throughout the world could include the history of their natural environment. 'Time Landscapes'™ renew the city's natural environment just as architects renew its architecture. This is a pilot project for reconstruction and documentation that can coincide with new building in the city. Instead of planting trees in concrete boxes for public plazas, public landscaping can be given meaning by being planted with 'Time Landscape'™ nature indigenous to that site. Obvious examples are marsh pools, grassland flowers, rock ledge moss and ferns. Thus as the city renews itself architecturally, it will re-identify its own unique characteristic natural origins and its own natural traditions.

Since the city is becoming more and more polluted, we could build monuments to the historic air. Museums could

be built that would re-capture the smells of earth, trees and vegetation in different seasons and at different historical times, so that people would be able to experience what has been lost. A museum of air sponsored by the UN can show different air of different countries.

Other projects can reveal the historical geology or terrain. Submerged outcroppings that still exist in the city can be exposed. Glacial rocks can be saved as monuments to a dramatic natural past. If an area has been filled in or a hill levelled out to build buildings, an indicator can be placed to create an awareness of the original terrain. Earth cores that indicate the deep geology of the land can be displayed on the site or within the building.

Because of human development, the island of Manhattan has totally lost its natural contour. By creating markings throughout the streets, the natural outline could be observed again. Indian trails could also be followed with an explanation of why the trail went over certain terrain that no longer exists. The natural past can be monumentalized also by sounds. Continuous loops of natural sounds at the natural level of volume can be placed on historic sites. Streets named after birds can have sounds of those birds or animals played on occasions such as when animals come out of hibernation or at mating time. The sounds, controlled by the local community, change according to the natural pattern of the animals and the rhythmic sounds return to the city. Natural scents can evoke the past as well. At the awakening of a plant at its first blooming, the natural essence can be emitted into the street.

The sun is such a remote but essential part of our life. Its continual presence can be emphasized by building monuments. Sides of buildings in prime locations can be marked with various sun shadow marks at different hours. As the angle of the sun changes during the year, buildings marked in various parts of the city can indicate the time of year. Another example of public monuments to the sun allows people to see the reaction of natural substances to the sun.

Public monuments embody shared values. These values can emerge actively in our public life; there can be public celebrations of natural events. Our definition of what is news is due for a re-evaluation also to include notice of, and explanation of, the natural events that our lives depend on. The migrations of birds and animals should be reported as public events: this information should be broadcast internationally. Re-occuring natural events can be marked by public observational celebrations the longest day, the longest night, the day of equal night and day, the day of lowest tide and so on, not in primitive mythical worship but with the use of technology to predict exact time. Technology can visualize aspects of nature outside the range of the human eye, such as public outdoor projections of telescopic observations – public monuments of the sky. Many aspects of technology that now allow individuals to gain understanding of nature can be adjusted to a public scale. Public monuments can be monuments of observation – sites from which to best observe natural phenomena. The ocean floor at low tide affords re-occuring means of observation. Such monuments are created for certain times of the day of the year.

The concept of what is public monument, then, is subject to re-evaluation and redefinition in the light of our greatly expanded perception of what constitutes the community. Natural phenomena, natural events and the living creatures on the planet should be honoured and celebrated along with human beings and events.

Alan Sonfist, 'Natural Phenomena as Public Monuments', statement delivered at the Metropolitan Museum of Art, New York, 1968. Printed in *Alan Sonfist*, Neuberger Museum, Purchase, New York, 1978

Lucy R. LIPPARD
Overlay: Contemporary Art and the Art of Prehistory
[1983]

[...] Robert Smithson focused on the 'duplicity' of gardens. 'The sinister in a primitive sense seems to have its origin in what could be called "quality gardens" (Paradise)', he mused. 'Dreadful things seem to have happened in those half-forgotten Edens. Why does the Garden of Delight suggest something perverse? ... Too much thinking about "gardens" leads to perplexity and agitation. Gardens ... bring me to the brink of chaos. This footnote is turning into a dizzying maze, full of tenuous paths and innumerable riddles. The abysmal problems of gardens somehow involved a fall from somewhere or something. The certainty of the absolute garden will never be regained.' He sardonically called the idealized 'vista' and 'beautiful scenery', 'Nature with class."

The garden was, indeed, the first bit of nature to be 'owned'. Like woman, it became property. Many socialist writers have equated the evolution of the domination of nature with that of oppression of the underclasses. William Leiss points out that as increased mastery of nature provides increased productivity, there is a qualitative leap in social conflict. 'Mastery of nature without apparent limit becomes the servant of insatiable demands made upon the resources of the natural environment'.[2]

In the eighteenth century, the 'English Garden' 'leapt the fence', as Horace Walpole put it, and all of nature was perceived as a garden. The task of domination had been accomplished and, like the African antelopes running 'free' in the Bronx Zoo, nature could now have her 'freedom'. (Not fortuitously, that eighteenth-century 'leap' or 'escape' coincided with the beginning of the struggle for women's rights and with the Chartist movement in England.) Shepard sees the English Garden as a rebellion against the upper-class taste for opulent formalism that was the antithesis of democratic ideals.[3] It didn't last long. With the Industrial Revolution, all land became potentially exploitable, and the alienation from nature began in earnest. Economically necessitated moves away from the countryside also cut ties between family, place and individual. Today few of us even have a 'home town'. Annette Kolodny has traced through literature a parallel development in colonial America, where land was seen

first as a virgin, then as a mother, and then as a mistress, who was finally just plain raped for profit.[4]

Shepard shows how the notion of land as mother was eventually replaced by the cow, also paralleling woman's loss of status when industrialization replaced her functions as grower and maker of all domestic necessities. The Native Americans' protestations that the land/mother could not be owned, bought or sold, led to their culture's downfall, as well as to the loss of their land. Similarly, they perceive all objects as art because of their organic and useful relationship to the rest of life. The sacred societies 'view the unnecessary proliferation of artefacts, utensils and goods as a form of blasphemy, provoking a loss of meaning'[5] – an all too perfect description of our consumer society.

Francis Huxley shows how the use of standing stones as property markers indicated the process by which 'ritual thought gave birth to the principle of land tenure'.[6] With increased urbanization, even the garden became a luxury accessible only to the upper classes. A late nineteenth-century English gardening book declaimed haughtily that only among 'the classes for whom this work is intended' was there an appreciation for 'what is tasteful and elegant in gardening'.[7]

In recognition of this phenomenon, the 'park' was offered as a democratic use of nature, as a public amenity – often rather patronizingly. Nevertheless, the park in the city *is* a potent metaphor for a public art, an overlay of cyclical stability on growth and variety, with memory (nostalgia, some would say) as compost. Like the garden, it has a double meaning (especially in present-day New York City) in its aura of safety and danger, privacy and controlled freedom. Just as a city is overlaid on nature as an escape from its whims, a park or garden in the city reasserts the earth beneath the concrete and serves to remind city dwellers that all the world's not a city. The park is probably the most effective public art form there is, as an interface between nature and society. Thus Charles Eliot Norton could say of Frederick Law Olmsted, designer of Central Park and Prospect Park, that he stood 'first in the production of great works which answer the needs and give expression to the life of our immense and miscellaneous democracy'.[8]

In 1928 Walter Benjamin recommended the 'mastery not of nature itself but of the relationship between nature and humanity'.[9] Ian McHarg has imagined an ideal society called 'The Naturalists', who make no division between the natural and the social sciences.[10] Rather than dominating nature, they are dominated by a quest to *understand* nature – by definition including humankind. In a sense this returns to the notion of natural order as a social model proposed by early socialists, from Saint-Simon to Feuerbach. Even Marx and Engels briefly flirted with theories based on Francis Morgan's data on the matriarchal structures of the Iroquois.

The way in which the modern world perceives nature as a neutral material, whose use is 'value-free', parallels the rejection of content in the modernist notion of 'art for art's sake', where only the material nature of the medium is significant. McHarg's Naturalists, on the other hand, understand meaningful form, but they prefer the term

'fitness' to 'art' because it embraces natural as well as artificial creativity.

Art is, or should be, like seeding, and this is the central theme of several artists working as contemporary gardeners. Dames says the Neolithic peoples made 'farm art'. In 1970 Carl Andre wrote an ironic statement opposing the Vietnam war called 'Art is a Branch of Agriculture', in which, among other things, he noted that artists must be 'fighting farmers and farming fighters'.[11] At the same time, Alan Sonfist had been literally developing the notion of art as a means of propagation with his international *Seed Distribution* project and a subsequent work at Artpark in which, sensing the location of a past forest, he made a circular pool of virgin soil to catch blowing seeds and begin the forest's rebirth. Poppy Johnson's *Earth Day* piece, planted in a vacant lot near her New York loft in 1969 and celebrated in 1970, resulted in an art harvest of 24 marigolds, 8 sunflowers, 2 rows of dill, 3 ears of corn, 18 cosmos, 3 Iceland poppies, 22 zinnias, 12 cornflowers and 19 summer squash. Also in 1969, Hans Haacke, whose work was concerned with natural and social systems, made an indoor museum piece by seeding a cone-shaped mound of soil with quick-growing winter rye, which was sprouting by the time the show opened. He wasn't interested in the history or the sculptural shape but in 'growth as a phenomenon, with the interaction of forces and energies and information'. His catalogue statement was initially going to be 'Grass Grows'.[12]

Smithson quipped that art degenerates as it approaches gardening. When Haacke was asked how his mound differed from gardening he replied, by *intent*. I, for one, quite enjoy the notion that it did *not* differ from gardening. In a system like ours, where art is separated from life, and art is simply supposed to be about art, only the separation validates the making of art. If there is no separation, what have we lost? Or gained? Lawrence Alloway has pointed out that, 'the notion of interdependence between spectator and work of art is of course profoundly anti-formalist, as it weakens the absoluteness of the subject-object relationship'.[13] Smithson also recognized the importance of providing a 'needed dialectic' between ecology and industry,

'Nature for the dialectician is *indifferent* to any formal ideal ... A lesson can be learned from the Indian cliff dwellings and earthworks mounds. Here we see nature and necessity in consort ... It is possible to have a direct organic manipulation of the land devoid of violence and "macho" aggression ... The farmer's, miner's or artist's treatment of the land depends on how aware he is of himself as nature. After all, sex isn't all a series of rapes. If strip miners were less alienated from the nature in themselves and free of sexual aggression cultivation could take place.'[14]

Ecological art — with its emphasis on social concern, low profile and more sensitive attitudes towards the ecosystem — differs from the earthworks of the mid 1960s. Iain Baxter in Vancouver, through his N.E. Thing Co. (then consisting of himself, his wife Ingrid and their two children), pioneered this direction, though his interest in archaeological and anthropological sources was minimal.

Robert Morris has noted the contradictions involved in the large-scale earth-moving to which he and others are committed,

'The act of digging and piling carried out in an organized way and at an intensified scale has produced sunken gardens and ziggurats on one hand and gigantic geographical scars and ore tailings on the other. The forms are basically the same. The purposes and details vary, labelling one construction sublime, another abysmal ... What marks [art] off from all other organized human activity, is that it does not seek control through explanation, that it offers the freedom to experience and question'.[15]

Herbert Marcuse said that 'man's struggle with nature is increasingly a struggle with society'.[16] Nowhere is this so overt as in the area of 'reclamation art', in which artists attempt to intervene in social interaction with nature. Manipulation of consciousness is the major weapon of both the powerful and the powerless. Art is supposed to affect consciousness of life, but today's reclamation artist is fighting (or being bought out by) multinational giants which have the mass media and whole governments at their disposal. An art resisting commodity status also resists the abuse of natural resources to provide these commodities [...]

1 Robert Smithson, *The Writings of Robert Smithson*, ed. Nancy Holt, New York University Press, New York, 1979, p. 111; see also Robert Hobbs on *Spiral Jetty* in *Robert Smithson: Sculpture*, ed. Robert Hobbs, Cornell University Press, Ithaca, 1981, p. 91

2 William Leiss, *The Domination of Nature*, Beacon, New York, 1974, pp. 156-58

3 Paul Shepard, *Man in the Landscape*, Anchor Natural History Books, Doubleday, New York, 1972, pp. 80-81

4 Annette Kolodny, *The Lay of the Land*, University of North Carolina Press, Chapel Hill, 1975

5 Jack Burnham, *Great Western Salt Works*, George Braziller, New York, 1974, p. 156

6 Francis Huxley, *The Way of the Sacred*, Doubleday, New York, 1974, p. 167

7 This book by Kemp was published in the last half of the nineteenth century. The same tone predominates in Anthony Huxley's *An Illustrated History of Gardening*, Paddington Press, New York, 1978.

8 Charles Eliot Norton, quoted in Smithson, op. cit., p. 126. Smithson's essay, 'Frederick Law Olmsted and the Dialectical Landscape', offers an imaginative modernist view of parks.

9 Walter Benjamin, quoted in Leiss, *The Domination of Nature*, op. cit., p. 198

10 Ian L. McHarg, *Design with Nature*, Doubleday/Natural History Press, New York, 1971, pp. 117-25

11 Carl Andre in *Artforum*, New York, September 1970, p. 35

12 Hans Haacke, in *Earth*, Andrew Dickson White Museum, Cornell University, Ithaca, 1969

13 Lawrence Alloway, 'Time and Nature in Sonfist's Art', in *Alan Sonfist*, Museum of Fine Arts, Boston, 1977, p. 3

14 Smithson, op. cit., p. 123

15 Robert Morris, quoted in *Arts*, New York, July 1979, p. 4

16 Herbert Marcuse, quoted in Leiss, op. cit., p. 22

Lucy R. Lippard, *Overlay: Contemporary Art and the Art of Prehistory*, Pantheon Books, New York, 1983, pp. 227-29; 229-30

259

Lucy R. LIPPARD
The Garbage Girls [1991]

'If it had been the purpose of human activity on earth to bring the planet to the edge of ruin, no more efficient mechanism could have been invented than the market economy.'
— Jeremy Seabrook

In the late 1960s, Conceptual Artists raised the problem of the surfeit of objects in the world, including 'precious' or art objects. Various 'dematerialized' forms were developed that aimed to make art part of the solution rather than part of the problem. Because of the overwhelming power of the market-oriented art world, and the failure to create a new context and new audience for a third-stream art, that particular impetus faded; the dematerialization concept was eventually re-embodied into commodities.

With the growth of a more sophisticated art/political awareness during the 1970s and 1980s, however, this urge towards the conversion of objects into energy has persisted, especially in the environmental domain. In the 1990s, the essence of an ecological art is not the preservation of natural beauty, nor the building of evocative site art, but the disposal of unnatural waste. Garbage is now of greater concern to many progressive artists than glorious vistas, although it does not make the transition from studio to streets very easily. New Yorkers, for instance, are so inured to garbage on the streets that it only shocks them to see it in museums.

A disproportionate number of the artists dealing with waste are women, for obvious reasons pointed out long ago by the pre-eminent 'garbage girl' — Mierle Laderman Ukeles. In the early 1970s, having defined women's social role as 'unification ... the perpetuation and maintenance of the species, survival systems, equilibrium', Ukeles asked the question that continues to resonate today, 'After the revolution, who's going to take out the garbage on Monday morning?' If by 1991 many seem to have given up on that particular revolution and replaced it with 'paradigm shifts', the trash remains.

Ukeles began her 'maintenance art' when her children started to arrive and she found her art time slinking out the kitchen door. To get it back, she simply turned around and renamed her domestic duties 'art', initiating an ongoing series of explorations that have ranged from donning and doffing snowsuits, changing diapers and picking up toys, to scrubbing a museum floor, to following (and praising) the workers who maintain a large city building and finally to becoming the 'official artist-in-residence of the New York City Department of Sanitation', where she found her niche. Since the late 1970s Ukeles has used the department as a base for her now international investigations of social maintenance and waste management. Her work consists of real-life performances of workers' days, research about environmental effectiveness and instal-

260

lations constructed from the products and tools of their labour. One of her many functions is to humanize and beautify (even beatify) those who, like women, do the dirty work, to endow them with grace and nobility. (Once she choreographed a 'street ballet' of garbage trucks.)

Landfills have long been among her prime concerns. In the summer of 1990, Ukeles curated an exhibition for New York's Municipal Art Society called 'Garbage Out Front: A New Era of Public Design'. It focused on imaginative documentation and a simulated cross-section of the Fresh Kills landfill in Staten Island, where she is currently working. 'Is garbage chaos, dissolution, decay?' she asked. 'Can the same inventiveness that we use for production and accumulation of goods be applied to its disposal?' Suggesting that the problem of citizens' unwillingness to take responsibility for the garbage we produce reflects our inability to visualize our relationship to society as a whole, she aims to make every part of the process of waste and waste management visible to everyone participating in it (that is, everyone) so that the redesign of the degraded becomes a symbol of transformation.

Christy Rupp credits Ukeles as the 'mother of it all' in the garbage field, but she has been one of its most popular exponents since the late 1970s, when she began placing images of rats around garbage-strewn New York neighbourhoods as part of her 'City Wildlife Project'. She went on to call attention to the existence of other urban animals, consumerist waste and city neglect with installations under the Williamsburg Bridge, in Palisades Park, at a 42nd Street storefront, and in the lobby of the Commodities Exchange. In San Francisco she constructed *Poly-Tox Park*, a simulated toxic-waste site offered as 'a monument to our legislators and the people who get to determine the safe levels of toxins in our environment'. Her *Social Progress*, a giant ear of corn pulled by a snail and attacked by ants, was installed in front of the Flatiron Building for several months and appeared on the front page of *The New York Times*.

Rupp's gallery art consists of a marvellous menagerie of cardboard and metal that comments on the destruction of family farms, the fate of rust-belt workers during the Reagan era, imports and exports, pesticides and politics in Central America, among other issues. Most recently she has made a series of lethally graceful animal forms outlined in metal and filled with the instruments of their own destruction: a leaping dolphin form stuffed with cat-food cans, a snail shell filled with 'designer water' bottles, a tree stump stuffed with newspapers, sea turtles stuffed with Tide bottles. (She cites the increasing number of harmful products named after natural forces, as in Surf, New Dawn, Bright Water and so on.)

Since the mid 1980s, Rupp has been particularly concerned with fish, water pollution and wetlands. At the moment she is working on the Coney Island Water Pollution Control Plant (sewage, that is) in Sheepshead Bay, Brooklyn, where she has inspired the Department of Environmental Protection to try to re-create wetlands in a degraded creek near the neighbourhood-access promenade she is building. Pursuing other public commissions dealing with water pollution around the country ('They're hiring artists to convince the public the water is potable; you'd drink this purified sewage if the art was good?'), she has discovered that with the increased awareness of water scarcity, fountains are out, so she is making images of the absence of water, such as a parched-earth pavement. For the University of Washington, Rupp is making a 'rollback dam' bench ('You park your butt and feel guilty'), which comments not only on water management but points out that the endangered species act, which was made law at the same time as *Roe v. Wade*, is also endangered by rollback on its near-twentieth birthday.

Many concerned artists make paintings (such as Janet Culbertson's horrifying billboards of a blooming past set in lunar landscapes of destruction) or prefer the indirect referentialism of pretty, natural materials, such as branches, stones, shells and woven grasses, to the ugly and virtually untransformable junk we cast off with such abandon. But the garbage girls (and occasional boys) tend to target the grander environmental horrors. Particularly valuable, therefore, if less visible, are those rare works that name names, calling specific attention to the corporations and the capitalist system on which so much planetary disaster can be blamed. The Alaskan oil spill inspired a great aesthetic spill of art decrying the desecration of nature and animal life, and the blame was so obvious that, for once, Exxon got named again and again. But too often environmental artists fudge and generalize, perhaps with an eye to making it easier to get grants and exhibit in museums often controlled by the very people who are destroying the environment.

One exception is the ecological feminist Betty Beaumont, who has made installation art on toxic wastes using government surplus materials since the 1970s. Her 1978–80 *Ocean Landmark Project* forty miles off New York Harbor was a collaboration with a team of marine scientists, material scientists and industry to study the stabilization of waste materials in land and water environments. It transformed 500 tons (510 tonnes) of an industrial waste product into an underwater sculpture, which has since become a thriving reef environment and fishing grounds. Beaumont's *Windows on Multinationals and Banned Pesticides* of 1984 pointed an aesthetic finger at the First World's toxic dumping and export of banned chemicals in the Third World, citing the pesticide giants Monsanto, Ciba Geigy, Union Carbide and FMC in a scripted audiotape. She is now working on *Fish Tales*, a flash-card set showing some twenty species of unknown fish that have evolved since atomic waste was dumped off the continental shelf.

One of the first garbage pieces that made an impression on me was a mid 1970s work called *Luxo/Lixo* (Luxury/Garbage) by the Brazilian artist Regina Vater, in which she photographically documented the trash discarded in neighbourhoods occupied by different social classes. It would be interesting to see someone pursue these lines in the United States, perhaps in collaboration with the homeless people who are probably our greatest experts in the field of garbage analysis and the unacknowledged leaders of the recycling movement. In the 1980s, a number of other women around the United States have independently chosen garbage and waste as their medium. A sampling:

Jo Hanson's *Public Disclosure: Secrets from the Street* (1980) evolved from collecting the sweepings from her San Francisco doorstep into a citywide piece about litter as cultural artefacts and the quality of the visual environment.

Cecilia Vicuña, a Chilean living in New York, poetically comments on the scale of the solid waste problem by setting adrift in the city's gutters and rivers the tiniest, subtlest rearrangements of found rubbish. A bit of paper and a dead leaf may become a tiny raft, noticed by only an incredulous few among the used condoms and oil slicks of the Hudson River near her house. Vicuña also adds magical reminders of the power of the microcosm to wilderness landscapes and makes little sculptures and indoor installations out of social discards.

In Santa Barbara, in 1987, Ciel Bergman and Nancy Merrill made *Sea Full of Clouds, What Can I Do?*, a room-sized installation of non-biodegradable trash they collected along the beaches. Centred on an altar, accompanied by messages from viewers about their hopes for the health of the world, the piece's 'beauty' belied its humble and dangerous sources.

Also in 1987, in Santa Fe, the French-born artist Dominique Mazeaud began *The Great Cleansing of the Rio Grande River*, organizing spiritually attuned trash brigades in an ongoing and randomly undertaken task that is primarily symbolic. Mazeaud keeps a river journal (her 'riveries') and performs renewal rituals along the Sante Fe River and the Rio Grande. The one I participated in consisted of sowing corn seeds from different locales along the river banks.

In Los Angeles, the 'LA River Project' by Wilson High School teacher Susan Boyle and video artist Cheri Gaulke culminated in a 1990 student installation centred on a 'river' of video monitors offering an array of images of trash-filled water, surrounded by photographs, a chemically analyzed water sample, river artefacts, evidence of wildlife – human and otherwise – and interviews with residents, politicians and poets. The project has now been adopted by the Smithsonian. Manuel Ortega, a student who worked on it, says, 'I don't think I'll ever *not* be involved in the river. It's part of my life now'.

In Boulder, Colorado, sculptor Kristine Smock organized 'The Forest for the Trees' in 1991. A citywide project with some two hundred schoolchildren and poets, it began with collecting trash and ended with a striking, community exhibition of giant sculptures made from the findings – many delightful trees, but also a wacky male figure whose shoes are made entirely of cigarette butts (eat your heart out, Red Grooms) and a huge fish stuffed with that farm-ubiquitous blue plastic. Embraced by satellite events, the project was an important community consciousness raiser, but the sculptures – made primarily by children – were among the most robustly imaginative 'assemblages' (as we say in the business) I've seen in or out of the high-art context.

Since the late 1960s, a few earthworks artists,

IMPLEMENTATION

beginning with Robert Smithson, have also tackled rehabilitation of land devastated by mining, erosion and industrial waste; among these works are Helen Mayer Harrison and Newton Harrison's vast re-conceptualizations of land use, Harriet Feigenbaum's re-forestation project and Alan Sonfist's patch of pre-colonial 'forest' in downtown New York City. As the site of some eleven thousand inactive mines, Colorado has paid special attention to the possibilities of reclamation art. In 1985 Denver sculptor Paul Kleit (now producer of the eerily innovative independent radio programme *Terra Infirma*) wrote an important report for the state Council on the Arts and Humanities and the Colorado Mined Land Reclamation Division, in which four ripe-for-reclamation sites were detailed and solutions recommended. Typically, few if any actual projects seem to have come of this. Some artists who have managed to fight the power and hang in through years of bureaucratic idiocies are:

Nancy Holt, whose most recent work is *Sky Mound*, which will transform an entire 57-acre landfill in the so-called meadowlands of New Jersey into an astronomical observatory. The site is 100 feet (30.5 m) high and contains some ten million tons of garbage. As well as adding earth mounds, methane flares, spinning windforms and steel posts that are aligned to specific lunar, solar and stellar events, Holt is incorporating the technological specifications of landfill closure, including methane recovery wells and a water drainage system, into her sculptural landscape. Circles and rays of light will be captured by a steel ring, arches and poles, with the most spectacular manifestation taking place at noon on the summer solstice. A flat-topped pyramid covered with grassy hills and gravel paths, *Sky Mound* will provide a wildflower and wildlife habitat (for marsh hawks, racoons and rabbits). It will bring another, cosmic, level to the cycles of decay within the landfill. 'I'm not trying to pretend this isn't a dump', Holt has said. 'I'm working with the vernacular of landfill.'

Agnes Denes, who once planted and harvested a wheatfield on an urban landfill, is now working with two landscape architects on the 97-acre North Waterfront park in Berkeley. The accepted master plan has seventeen elements that incorporate soil engineering, methane harvesting, leachate, created wetlands and beaches, wildlife habitats and bird rests, as well as a ghost ship (to recall that the planet is a ship), sunflower/windmills to bring water up to a field of natural sunflowers, invented 'rock art', and a sculpture that changes form and sound as the tide ebbs and flows.

Patricia Johanson has designed sculpture into nature since the 1960s, and is best known for her *Fair Park Lagoon* in Dallas, where the sculpted jetties echo the plants and organisms that inhabit the marshes. Her most recent large-scale environmental work – now under construction – is *Endangered Garden* in Candlestick Cove in San Francisco Bay. By sinking an eyesore (a sewage holding tank for storm overload that is a third of a mile (53 m) long and 40 feet (12 m) wide, she has created a bay walk, a series of transitions, links and accesses, that is also a last stronghold for the butterflies, snakes and birds that

have been pushed out of the city. 'They say this park won't smell,' she says wryly, 'but when they say that at public meetings, people who are veterans of environmental protests laugh'.

In 1990, a bi-cultural, bilingual group of seventeen Vermont and Quebec artists collaborated on '*Deadlines/Ça presse*', a two-part show on acid rain that travelled to schools and other sites in both countries. The project was partially inspired by the Canadian interdisciplinary artists' group Boréal Multi Media, from rural La Macaza in the Laurentians. There are 30,000 dead lakes in eastern Canada, thanks in part to the aerial garbage from midwestern US smokestacks. Boréal organizer Wanda Campbell says she thinks artists can make a difference by creating 'cultural myths', or what might be called 'Wakeup Art'. However, another Vermont show makes me wonder what the audiences wake up to. A Women's Caucus exhibition about environmental distress and exploitative development called 'Mowing the Mountain' at the Burlington Airport was certainly controversial. *The New York Times* quoted one of many baffled and annoyed airport employees as saying, 'I guess we've learned a lot about art from this experience'. Presumably, the artists would have preferred that he learn a lot about the environment.

And, finally, a project by a token garbage boy: Yugoslavian emigré Milenko Matanovic is encouraging the rest of us to share the public burdens with a media-aimed project called 'Trash-Hold' – an 'eco-robic exercise to "trim our waste"'. It opened successfully last March in Chattanooga, Tennessee, but is designed to travel and adapt to any community. The average American, Matanovic points out, discards 5 lbs (2 kg) of garbage a day. In an attempt 'to change bad habits before a crisis point is reached' (I'd argue that that point has already been reached), participants, the higher their profile the better, drag specially designed bags of their garbage around with them all week, as it accumulates, to publicize the extent of the problem. In a closing ceremony, they gather to recycle. In Chattanooga, out of 260 lbs (118 kg) of collected trash, only 20 lbs (9 kg) were not recyclable.

Powerlessness, cynicism and greed all lead to passivity rather than change. Perhaps the greatest question for ecological artists is, how do we generate hope? Recent exhibitions of art about nature in the art world have been decidedly pessimistic. Entitled 'Against Nature', 'The Demoralized Landscape', 'The Unmaking of Nature' and 'Unnatural Causes,' for example, they acknowledge impending catastrophes but provide few visions for a happier future. I know real visions are hard to come by, and we've had a plethora of fake ones. But art should not just be the dark mirror of society any more than it should just be the saccharine in the cup of hemlock.

We're in trouble if all artists can do is activate our fears. As Christy Rupp said with her clipboard *Datafish* in Central Park, the emphasis on information is positive until we get fat on information for information's sake and fail to act on what we know about who's doing it to us. Individually, we can recycle until we're green in the face, but until the corporations, the government, and the ruling class get the

message, not much is going to change. For all the talk about the healing power of the arts, of feminism, of the 1990s – powers I too would love to believe in wholeheartedly – I see no evidence that these crucial changes are immanent. Art can never be more than a Band-Aid or a shot in the arm until it is part of the broader grass-roots movements that goes beyond private responses (individuals account for only about one-third of the world's pollutants) to fundamental social reconstruction.

Lucy R. Lippard, 'The Garbage Girls', *Z Magazine*, New York, December 1991; reprinted in *The Pink Glass Swan: Selected Essays on Feminist Art*, The New Press, New York, 1995

Agnes DENES
Wheatfield – A Confrontation
[1982]

THE PHILOSOPHY
My decision to plant a wheatfield in Manhattan instead of designing just another public sculpture grew out of a long-standing concern and need to call attention to our misplaced priorities and deteriorating human values.

Manhattan is the richest, most professional, most congested and without a doubt most fascinating island in the world. To attempt to plant, sustain and harvest two acres of wheat here, wasting valuable real estate, obstructing the machinery by going against the system, was an effrontery that made it the powerful paradox I had sought for the calling to account [...]

Wheatfield was a symbol, a universal concept. It represented food, energy, commerce, world trade, economics. It referred to mismanagement, waste, world hunger and ecological concerns. It was an intrusion into the Citadel, a confrontation of High Civilization. Then again, it was also Shangri-La, a small paradise, one's childhood, a hot summer afternoon in the country, peace, forgotten values, simple pleasures.

The idea of a wheatfield is quite simple. One penetrates the soil, places one's seed of concept and allows it to grow, expand and bear fruit. That is what creation and life is all about. It's all so simple, yet we tend to forget basic processes. What was different about this wheatfield was that the soil was not rich loam but dirty landfill filled with rusty metals, boulders, old tyres, and overcoats. It was not farmland but an extension of the congested downtown of a metropolis where dangerous crosswinds blew, traffic snarled and every inch was precious realty. The absurdity of it all, the risks we took and the hardships we endured were all part of the basic concept. Digging deep is what art is all about [...]

Wheatfield affected many lives, and the ripples are extending. Some suggested that I put my wheat up on the wheat exchange and sell it to the highest bidder, others that I apply to the government for farmers' subsidy. Reactions ranged from disbelief to astonishment to being moved to tears. A lot of people wrote to thank me for creating *Wheatfield* and asked that I keep it going.

After my harvest, the four-acre area facing New York harbour was returned to construction to make room for a billion-dollar luxury complex. Manhattan closed itself once again to become a fortress, corrupt yet vulnerable. But I think this magnificent metropolis will remember a majestic, amber field. Vulnerability and staying power, the power of the paradox.

THE ACT

Early in the morning on the first of May 1982 we began to plant a two-acre wheatfield in lower Manhattan, two blocks from Wall Street and the World Trade Center, facing the Statue of Liberty.

The planting consisted of digging 285 furrows by hand, clearing off rocks and garbage, then placing the seed by hand and covering the furrows with soil. Each furrow took two to three hours.

Since March over two hundred truckloads of dirty landfill had been dumped on the site, consisting of rubble, dirt, rusty pipes, automobile tyres, old clothing and other garbage. Tractors flattened the area and eighty more truckloads of dirt were dumped and spread to constitute one inch of topsoil needed for planting.

We maintained the field for four months, set up an irrigation system, weeded, cleared out wheat smut (a disease that had affected the entire field and wheat everywhere in the country). We put down fertilizers, cleared off rocks, boulders and wires by hand, and sprayed against mildew fungus [...]

We harvested the crop on August 16 on a hot, muggy Sunday. The air was stifling and the city stood still. All those Manhattanites who had been watching the field grow from green to golden amber, and gotten attached to it, the stockbrokers and the economists, office workers, tourists and others attracted by the media coverage stood around in sad silence. Some cried. TV crews were everywhere, but they too spoke little and then in a hushed voice.

We harvested almost 1,000 pounds of healthy, golden wheat.

Agnes Denes, 'Wheatfield - A Confrontation, Battery Park Landfill, Downtown Manhattan, Two Acres of Wheat Planted and Harvested', unpublished artist's statement, Summer 1982

Agnes DENES
Tree Mountain – A Living
Time Capsule – 10,000 Trees,
10,000 People, 400 Years
[1982–95]

Tree Mountain, conceived in 1982, is a collaborative, environmental artwork that touches on global, ecological, social and cultural issues. It is a massive earthwork and land reclamation project that tests our finitude and transcendence, individuality versus teamwork, and measures the value and evolution of a work of art after it has entered the environment. *Tree Mountain* is designed to unite the human intellect with the majesty of nature.

Ten thousand trees are planted by the same number of people according to an intricate mathematical formula, a combination of the golden section and sunflower/ pineapple patterns that meet not only aesthetic criteria, but remain intact after the forest is thinned a few decades from now. The mathematical expansion changes with one's view and movement around and above the mountain, revealing hidden curves and spirals in its symmetrical design. If *Tree Mountain* is seen from space, the human intellect at work over natural formation becomes evident, yet they blend harmoniously.

Tree Mountain is site-specific. Both shape and size can be adapted to areas of land reclamation and the preservation of forests. In Finland, *Tree Mountain* is 420 m long, 270 m wide, 26 m high and elliptical in shape. Height depends on the restrictions of the site and the availability of materials. The site is a gravel pit being reclaimed. The process of bioremediation restores the land from resource extraction use to one in harmony with nature, in this case, the re-creation of a virgin forest. The planting of trees holds the land from erosion, enhances oxygen production and provides home for wildlife. This takes time and it is one of the reasons why *Tree Mountain* will remain undisturbed for centuries.

For the original model I selected silver fir, because these trees are dying out, and it is important that we preserve them. For the Finnish *Tree Mountain*, pine trees were chosen because they are more typical for this environment. Otherwise, any tree can make up the forest as long as it can live three to four hundred years. The trees must outlive the present era and, by surviving, carry our concepts into an unknown time in the future. If our civilization as we know it ends, or as changes occur, there will be a reminder in the form of a unique and majestic forest for our descendants to ponder. They may reflect on an undertaking that did not serve personal needs but the common good, and the highest ideals of humanity and its environment, while benefiting future generations.

Tree Mountain is a collaborative work in all its aspects, from its intricate landscaping and forestry to the funding and contractual agreements for its strange, unheard-of land-use of three to four centuries. The collaboration expands as ten thousand people come together to plant the trees that will bear their names and remain their property through succeeding generations. The trees can change ownership – people can leave their tree to their heirs, or transfer it by other means, even be buried under it – but *Tree Mountain* itself can never be owned or sold, nor can the trees be moved from the forest. Ownership signifies custodianship. *Tree Mountain* represents the concept, the soul of the art, while the trees are a manifestation of it. Though they may be collectible works of art, inheritable commodities – gaining stature, fame and value as they grow and age as trees – ultimately neither can be truly owned. One can only become a custodian and assume the moral obligations it implies. But meanwhile they remain part of a larger whole, the forest. The trees are individual segments of a single, limited edition – unique patterns in the design of their universe.

And the trees live on through the centuries – stable and majestic, outliving their owners or custodians who created the patterns and the philosophy, but not the tree. There is a strange paradox in this.

Tree Mountain begins its existence when it is completed as a work of art. As the trees grow and wildlife takes over, as decades and centuries pass, *Tree Mountain* becomes a most interesting example of how the passing of time affects a work of art. It can become the instrument that measures the evolution of art. Through changing fashions and beliefs, *Tree Mountain* can pass from being a curiosity to being a shrine, from being the possible remnants of a decadent era to being one of the monuments of a great civilization – a monument not built to the human ego but to benefit future generations with a meaningful legacy. *Tree Mountain* is a living time capsule.

Agnes Denes, 'Tree Mountain - A Living Time Capsule - 10,000 Trees, 10,000 People, 400 Years', unpublished artist's statement, 1982-95

Michael FEHR
herman's Meadow.
A Museum [1992]

herman's meadow is discernible even from a distance – not as a meadow, but as a peculiar, different moment, as a wild, unrestrained piece of land in the midst of a cleared landscape accessible to machines – by the hedges surrounding it. It drives like a wedge out of the forest into the open field of industrialised agriculture, radiating more than formal unrest. For it is bursting with life.

herman de vries began his project 'wiese' (meadow) together with his wife Susanne as a consequence of his work as an artist. They bought a piece of land, approximately 400 m², more than six years ago. As a border, they planted a hedge composed of a variety of shrubs: hazel, hawthorn, blackthorn, dogrose, euonymus, viburnum, rowanberry and privet; as well as a row of cultivated and semi-cultivated trees: hazelnut, rowan, cornelian cherry, medlar, older varieties of apple, pear and plum – and let it take its natural course. Late in the year, after seeding, half of the area was cut and the cuttings removed, so that the fodder meadow – overfertilised up till then with artificial fertilisers and liquid manure three times yearly – would lose some of its richness. In the following year, herman and Susanne collected seeds along embankments, paths and the edge of the forest from plants that had been resistant to the farmers' machines and liquid manure sprays and planted them in their meadow: in molehills and earth which had been dug up by wild boars. Consequently, columbine, naked lady, alchemilla, scabious, pincushion flower, agrimony, angelica, avens, meadow salvia, primrose, valerian, mugwort, leonorus, yellow iris, comfrey, carnations, hops, byrony, rhinanthus and belladonna had a chance to spread. These were joined spontaneously by spiraea, saxifrage, red clover, wood anemone and blue cranesbill; and runners from the aspen at the end of the forest developed shoots in the upper part of the meadow.

After only two years, the meadow had clearly altered its appearance: because the grass was not fertilised, it remained shorter and grew in bushy tufts; instead, herbs and clover shot up high. A large number of moles burrowed in the earth and there were more and more insects: beetles, butterflies, grasshoppers and different kinds of arachnids made the meadow their habitat. They were followed by birds and small animals for which herman and Susanne had created the ideal living conditions in the hedges. Then, after fixing up a watering place which was dry in summer, dragonflies, salamanders and frogs, and ultimately, last year, large numbers of wild boar, which had discovered the abundant supply of larvae in the earth, moved in.

Now, after six years of intensive work, the meadow differs quite visibly from the agricultural acreage around it: a wood of small aspens creates a natural barrier to the forest road, and the hedges, now man-high, shield the meadow from the surrounding manure and pesticide culture. One enters the meadow through an opening in the hedge at one of the upper corners and finds oneself in an almost paradisiacal field in which it hums and buzzes, in which birds twitter, grasshoppers chirp and countless other animals creep through the vegetation. Guided by herman who – strictly watching that only certain paths are taken, explaining the grounds, sharpening the visitors attention by making reference to certain plants and animals, a smell here, a taste there, recommending a view or that one stay a while in one place – hands over the book of Nature in a very gentle, but resolute manner to an ignorant, naive city person like me, who can hardly recognise in this wilderness the caring hand that has given it order. It is a confusing experience trying to see this Central European and highly varied biotope of not even half a hectare as a landscape which has been cultivated by man. Neatly weeded beds, regulated streams and tracts of land that have been freed from trees and shrubs have influenced our notion of Nature to such a degree that here, in this meadow, the more obvious arrangements become the mainstay of perception. The circle of roses which herman and Susanne planted with different Central European varieties at one edge of the meadow constitutes a biotope which may not be entered, and the small ring of hornbeams which was laid out three years ago on another site is designed to protect the couple and their guests from unexpected changes in weather.

herman's meadow is a museum in the best sense of the word, a place which, due to intensive and competent collecting, is the actual reconstruction, the living image of a former, generally prevailing manner of treating Nature, a striking, not-to-be-overlooked place of reflection where the history and future of the region, culture and Nature emerge.

Michael Fehr, 'herman's Meadow: A Museum', *Daidalos*, Berlin, 1992, pp. 34-9

The above extract has been reproduced retaining the author's use of capitalization as in the original text.

Mierle Laderman UKELES
Flow City [1995]

When the department of sanitation began redesigning the waste disposal system for the city of New York in the early 1980s, they invited me to sit in on the meetings. During my *Touch Sanitation* work, I had fallen in love with one of the locations they now wanted to redevelop. It was a location at the base of 59th Street, on the Hudson River. In 1983, I proposed to the department a permanent public environment that would become an organic part of an operating garbage facility. I designed *Flow City* with the design engineers from Greeley Hanson.

The site is one of the most beautiful sites on the Hudson River, midway between the George Washington Bridge and the Statue of Liberty. It is a marine transfer station that handles a waste flow equivalent to that of a city the size of San Francisco. Garbage trucks transfer their payloads into barges that wait in the finger of the Hudson River that flows through the station. The barges are then switched out in a beautiful nautical manoeuvre, and taken by tug to the Fresh Kills Landfill on Staten Island.

Flow City is a radical penetration of art into the workplace. The penetration begins with a *Passage Ramp* that leads to a *Glass Bridge*. From the bridge, visitors will observe the operation of the station. The end of the bridge is called *Media Flow Wall*.

It took about two years in the construction of the facility to build in public access for everybody. When we first proposed *Flow City*, the Department of Ports and Terminals said, 'You can't do that because it's never been done before.' The sanitation department replied, 'Yes we can. It is time to lift the veil on the subject, and this is the way to do it.'

Passage Ramp will be a 248-foot-long (7,564 cm) procession made of ten to twelve recyclable materials, including 20 feet (610 cm) of crushed glass and 20 feet (610 cm) of shredded rubber. I want visitors to feel the extreme diversity in different materials, because if you can appreciate this, then you can't watch them all getting dumped together in the barge without thinking, 'How stupid'. I want visitors to see the materials in a kind of hovering state of flux: thrown out, not yet back. I want the visitors to pass through a state of potentiality.

I have designed the recycling panels in the shape of a running spiral. A running spiral can be found in every culture, and is universally seen as a symbol of regeneration and continuity – the essence of recycling. This work is about a paradigm shift in how we relate to materials in the world. We need to grow beyond the self-destructive cycle of acquiring materials, owning them, using them and then leaving them as if they don't exist anymore.

At the top of the ramp visitors will enter a *Glass Bridge* that is 40 feet (1,220 cm) long and 18 feet (549 cm) wide. On one side of the bridge is the formal city with the icons of New York: the Empire State Building and the World Trade Center. On the other side is the city in flux. The trucks, in fourteen dumping bays, lift their hoppers, and dump their payloads into waiting barges. As the barges are

loaded, the visitors will see them passing beneath their very feet, under the *Glass Bridge*. They will be able to watch all of the things they worked so hard to buy go to waste. I call it the 'Violent Theatre of Dumping'.

At the end of the bridge is the *Media Flow Wall*, a 10 x 18 foot (305 x 549 cm) crushed glass wall with twenty-four monitors set into it. The video wall will be programmed with live cameras, located on and off site, and prepared disc and tape sources. It is an electronic permeable membrane that will enable visitors to pass 'through' this physical point in order to get a broader understanding how this kind of place links up with the systems of the planet. The wall will transmit three kinds of flow-imagery: river, landfill and recycling.

Six live cameras, 350 feet (10,675 cm) away from the facility, will focus continually on the mighty Hudson River. The fact that the garbage is collected and transferred in this particular place prompts a great loss, because the facility bars access to our primal source: the river. This river makes the city live. It will flow back in real time across the *Media Flow Wall*, as cameras focus downriver, upriver, midway, close-up on the face of the water and even beneath the surface, where thirty species of fish presently live in midtown Manhattan.

The wall will also document the accumulation of our garbage at the Fresh Kills Landfill, that will eventually be the highest point on the eastern seacoast, rising almost 500 feet (15,250 cm).

Mierle Laderman Ukeles, 'Flow City', *Sculpting with the Environment*, ed. Baile Oakes, Van Nostrand Reinhold, New York, 1995, pp. 184-87

Peter FEND
A Post-Facto Statement
[1994]

BRIEF HISTORY OF OCEAN EARTH FOUNDED 1980
The Ocean Earth Construction and Development Corporation arose from efforts of artists to develop projects larger than possible for any one artist and of public rather than art-world service.

The company arose from the ferment of the 1960s and 1970s, during which artists moved into video and film as display media, and into earthworks and ecosystems as sculptural and architectural material. Numerous concepts emerged then: that television had become like the cathedrals of prior centuries, and that artists should produce television news as they had produced sculpture and friezes for the cathedrals before; that Earth Art implied an entirely new way of dealing with terrain and regional planning; that artists should function chiefly to investigate and report visually-apprehensible facts of public import, and not to produce decorative objects for adornment; that mass media and not art galleries or museums are the primary field of action.

The company was founded through the efforts of an attorney, Richard Cole, now a partner at Le Boeuf, Lamb, Leiby & MacRae. Much of the intellectual foundation for

the company, and its dedication to large-scale earth monitoring and engineering, comes from lectures by Vincent Scully, architecture historian at Yale. Scully argues that recent Earth Art and Conceptual Art contain the germs of a radically new approach to gardens (or land), fortresses (or military defense systems) and, extendibly, regional planning. Herefrom, the company proceeds into the public arena.

Peter Fend, 'A Post-Facto Statement', *Ocean Earth*, Neue galerie am landesmuseum Joanneum, Graz, 1994, p. 111

Viet NGO
Lemna Systems [1995]

My work is a fusion of engineering, architectural planning and art. I design and build wastewater treatment plants for cities and industries. Having a strong interest in horizontal architecture, I like things that stay on the ground. People have asked me if my work is public art. That is my intention, but I do not like to use these words because they segregate me from the working people. I recognized early on that to be successful in infrastructure work, one needs to be in touch with and to have the support of the general public. The work I do is utilitarian in the most basic manner – it is treating waste, and it is user-friendly and fairly simple to understand, but it is no ordinary task.

As a trained professional engineer, I sought to develop a new technology to treat waste waters using natural biological means instead of mechanical and chemical processes.

The technology that I helped develop is called the *Lemna System*. It relies to a large extent on the use of small floating aquatic plants grown in specially designed ponds to treat waste to a very fine degree. These Lemna facilities are designed as green corridors or punctuation marks in the general urban landscape. They are nice green parks in an odour-free atmosphere, and sometimes they carry interesting design features to tell people about our environment, our soils and our waters.

In general, the isolation that is associated with art concerns me since I like to be accepted by the communities I work in. In a way, one can look at a community as an organic body with many interrelated parts. These parts fulfil certain functions that can be broken down and examined from various angles. Wastewater treatment is certainly a big part and a big function of any community (except in poorer countries that cannot afford treatment). Yet modern designing tends to place wastewater treatment in the background and forget about it. This is evident by the odour problems common to many existing treatment facilities and the fact that international competition for treatment plant designs is rather rare.

I think it is all right to keep treatment plants in the background, but we must not forget about them. They should be designed and maintained with care, in the same manner as other parts of our infrastructure. (Incidentally, only Hollywood movie sets for Western flicks have all infrastructures in the foreground.)

LEMNA SYSTEMS

In tune with the twentieth-century capitalist free market system, Lemna™ is a trademark name, and the concept is patented. Lemna plants are very small floating plants ubiquitous throughout the world. They thrive anywhere from cold climates to the tropics, even in the deserts. In Sardinia, which is rather dry and rocky, it took us less than an hour to find two beautiful species of *Lemnaceae*, the Latin name for these plants. I follow a philosophy of minimum to no interference. I serve only as a cheerleader. I take what already exists in a bioregion and encourage the plants to grow. (In contrast, only immigrants like me are supposed to emigrate to America, but no fruit and vegetables, please.)

Back to the Lemna plants: they grow very fast, and will cover the surface of a pond if undisturbed by winds and waves. They act as a filter to absorb and neutralize pollutants in the water. In addition, they help stabilize the biological reactions in the pond, optimizing natural treatment processes by bacteria, micro- and macro-organisms and by other physical processes.

Lemna plants absorb and control odours by using sulfides, methanes and other gases as food sources; they also shield the pond to prevent odours from escaping to the air.

Lemna plants have very high protein concentrations, making them a potential alternative food source for many parts of the world. (When I started working with Lemna, I dreamt of feeding the world.)

To harvest these plants, we use mechanized pontoon boats equipped with simple hydraulic gears to manage huge quantities of biomass. The harvested plants, which represent the excess growth, are either composed to form a rich fertilizer for organic farming, or with proper testing and analyses, used as a high-protein animal feed.

The clear water produced by this process can be used for irrigation or for other beneficial purposes. In Mexico we use it at one site to irrigate city parks and golf courses. In Egypt we plan to recharge the ground water table and irrigate crops with the effluent.

The design of *Lemna Systems* is thus based on a resource recovery concept: waste water being treated in a natural way will produce clean water which can be re-used for irrigation and for ground water/stream/lake recharge. At the same time, valuable biomass can be harvested for organic fertilizer or a feed source. The sun is the main source of energy, and the earth is reclaimed as fertile ground.

LEMNA DESIGN

To control the growth of the floating plants, a network of floating barriers that form a grid-like pattern is placed on the Lemna pond surface. These barriers can be compared to the facade of a building – they are necessary to support the system, and they carry aesthetic considerations that go beyond the practical. The ponds can also be designed into meandering channels that control the hydraulic flow of incoming water. Together they form a specific landscape that vitalizes an urban design. The facilities may occupy a vast acreage of land and yet appear unobtrusive from the ground. Only from the air can one decipher the true size

and meaning of the works. The design stresses respect for nature and natural things.

Of course, the vision incorporates a very practical side, for the treatment results must be impeccable. The facilities accomplish the routine yet awesome task of cleaning our wastes. They must be attractive for the visitors, comfortable for the workers and satisfactory to the government regulators.

DEVIL'S LAKE, NORTH DAKOTA, OR SNAKE ON THE PLAINS

The citizens of Devils Lake care deeply about their water resources. The City Elders, especially the visionary team of one commissioner and the city engineer, wanted a natural system. So, after 100 public meetings and 1001 late nights of design, we came up with a fifty-acre stylized snake that would meander across a former wetland. This Lemna facility consists of nine serpentine channels to remove the harmful phosphorus, nitrogen and algae before releasing the treated water into one bay of Devils Lake.

Funded by the US Environmental Protection Agency and the city of Devils Lake, the five million dollar project was completed in 1990. The harvested biomass has been used as an organic fertilizer, and schoolchildren are frequently invited on guided tours to learn about biology, the environment and what people can do to aid preservation.

Viet Ngo, 'Lemna Systems', *Sculpting with the Environment*, ed. Baile Oakes, Van Nostrand Reinhold, New York, 1995, pp. 178-81

Mel CHIN
Revival Field [1995]

I had an exhibition at the Hirshhorn in 1989 that represented the culmination of a long period of intense and strenuous labour. I showed large-scale political pieces and a complex installation called *The Operation of the Sun through the Cult of the Hand*. Following that show, I began to pursue a process set off by the completion of these sculptures. This process was an attempt to create situations of provocation and mutation that would challenge my personal artistic stage of development. First I asked myself what my particular passion was at the time. I realized it was a love for making things by hand, and I felt I could continue to make competent work by maintaining this direction for quite a while. After coming to this understanding, I decided to force a mutation in myself by removing the method I had come to rely on from my next work. I decided to propel an evolutionary situation – a condition of extinction and of not-knowing.

I was immersed in a period of re-education which allowed a free association/free-ranging type of research to begin. After reading an article suggesting the use of plants as remediation tools, I immediately saw the possibility for a new project. The irony was that it would require some of the most hand-intensive work I had ever done (sod busting, tilling, seeding, weeding, fence mending, ground hog chasing and so on).

Revival Field was to be a sculpture in the most traditional sense. My primary concern was with the poetic potential of the work, besides the obvious ecological and political aspects. My desire to realize the aesthetic product of *Revival Field* – decontaminated earth – led me to a responsible search for the necessary scientific understanding and method.

I spent several months on a datura dragnet, trying to ascertain all the properties of jimson weed (*Datura stramonium*), beyond its well-known psychedelic and mystical properties. I was unable to verify claims that the plant could be used to remediate soil in the way I envisioned. I continued my research in many directions until I finally found Dr. Rufus Chaney, a senior research scientist at the US Department of Agriculture. He specialized in soil and microbial systems, sludge composting and the transfer of heavy metals from plants to animals to humans. Chaney's proposal in 1983 to use plants as remediation agents for polluted soil had been shelved by the conservative politics of the times. He was one of the few people in the world who had knowledge of and belief in this untested process. My desire to create a sculptural work rekindled Dr. Chaney's hope of bringing this biotechnology into fruition, and we initiated an earnest co-operation that eventually led to the first *Revival Field*.

Together we envisioned *Revival Field* as an experimental project using plants to cleanse industrial contamination from soil. These plants, which have evolved the capacity to selectively absorb and contain large amounts of metal or mineral, are called hyperaccumulators. Historically used as a method of prospecting, the plants were tested and proven to be viable toxic sponges by Dr. Chaney and Dr. R. R. Brooks. We felt that this approach to leaching heavy metals out of tainted soil by safely trapping the toxins in the vascular structure of plants and mining the ash (after proper incineration) could be not only beneficial but practical and economical as well.

We conceived of the project as an ongoing operation until tests could verify significant improvement of a site's quality. The formal configuration of the work consists of two fenced areas – a circle within a square. The fences are standard chain links. The circular area, planted with the detoxifying weeds, serves as the test site, whereas the square, unplanted and of equal area, serves as the control. Paths that intersect in the centre provide access to the site and form a crosshair target when viewed from above. In this case the plants, guided by a natural process, aim at a malignant presence in the ground.

Conceptually, the work is sculpture that involves a reduction process, a traditional method used when carving wood or stone; here, the material is unseen, and the tools consist of biochemistry and agriculture. The work, in its complete incarnation, after the fences are removed and the toxin-laden weeds harvested, will offer minimal visual and formal effects. For a time, an intended invisible aesthetic will be measured scientifically by the quality of a revitalized earth. Eventually the aesthetic will be revealed in the return of growth to the soil.

Unfortunately, my efforts to realize the project were just beginning when controversy over funding led me into an entirely different series of negotiations. I had applied to the National Endowment for the Arts for a grant for *Revival Field* from the Inter-Arts New Forms Category. I soon learned this was the first time that a grant had been vetoed by the chairman of the NEA after being approved by both the panel and the council. I felt a responsibility to question the nature of the rejection and to expose the flaws of a system that allow autocratic control over the use of public funds. With these goals in mind, and with much support from the arts community, I arranged a formal meeting with NEA Chairman John Frohnmayer in Washington. Our constructive discussion set a precedent: an artist may now directly address an NEA chairman regarding such exercises of authority.

The meeting also resulted in re-appropriating funds for the project, and I was able to begin the equally difficult and perhaps even more frustrating task of securing a site. After six months of negotiations for sites all over the country, we were finally able to begin planting the first *Revival Field* in June 1991 on a portion of Pig's Eye Landfill, a state Superfund site in St. Paul, Minnesota. The area contained elevated levels of cadmium, a heavy metal that can be harmful to human health.

The Minnesota *Revival Field* was designed as a replicated field test of green remediation – the first such on-site experiment in the United States, and one of only two in the world. Three zinc and cadmium hyperaccumulators were chosen by Dr. Chaney to match the local ecotype: *Silene cucubalus*, a hybrid zea mays, and *Thlaspi caerulescens*. Merlin red fescue and romaine lettuce were also included to test for metal tolerance and food chain influence. The circular test area was divided into ninety-six separate plots to assess different soil and pH treatments as well as management techniques.

We harvested the Pig's Eye field for the final time in October 1993, ending the first three-year test. Its formal configuration has already been erased with the removal of the fencing. *Thlaspi* samples taken from this site showed significant uptake in the leaves and stems of cadmium and zinc, verifying the potential of green remediation. A second field is already in place at a national priority Superfund site in Palmerton, Pennsylvania. We are planning an international *Revival Field* effort, sponsored by the Ministry of Culture of the Netherlands, at severely contaminated sites in that country and neighbouring Belgium. These additional field tests will offer more valuable data regarding soil treatments and plant hardiness, and will extend biomarker research.

With positive results from Minnesota and additional sites secured, the *Revival Field* project is at a critical stage in its development. At this point, its focus must shift from implementing more field tests to conducting further scientific research. Thus, my most recent work on *Revival Field* has taken place in an editing studio. This indoor labour has produced a short video tape that describes the progress of *Revival Field* to date.

When I originally conceived of *Revival Field*, I was aware that it might not be fully realized in my lifetime. The project is in its infancy, and continues to progress. Whether it is viewed as an alchemic, metallurgic, social, scientific or aesthetic experiment, its goal is to realize the full remediation of a contaminated area. The *Revival Field* project is driven by a desire to find solutions for problems, rather than express problems metaphorically. It will reach its final form, completing an evolutionary aesthetic, when the burden of heavy metal contamination is shed, when *Revival Field* is forgotten and the mechanics of nature can resume their course.

Mel Chin, 'Revival Field', *Sculpting with the Environment*, ed. Baile Oakes, Van Norstrand Reinhold, New York, 1995, pp. 174-77

PLATFORM
Seeing is Believing [1992]

Would you like to open your door each morning to be greeted by the sight of gently flowing waters? Imagine windsurfing down Brixton Road, fishing by the Oval or paddling through West Norwood.

Could you see your neighbourhood with the River Effra running through it?

The Effra once ran through South London, its springs on the hills of Norwood, and its mouth at Vauxhall on the Thames. Queen Elizabeth the First sailed up it to Brixton in the sixteenth century. John Ruskin wrote odes to its beauty in the nineteenth century. Now it lies buried under the streets you walk through every day, an untapped source of great natural beauty and future prosperity.

ERA have a vision of new South London with its river restored: a healthier London – with plants and animals returned to their original habitats; a proper place for your children to play; a wealthier London – with property values increasing, business prospects booming and tourism growing. ERA sees a London where the city and nature live in harmony: a water city – a city of the twenty-first century. The unearthing of the Effra will be Europe's most important and exciting urban renewal programme, *and it is happening on your doorstep.*

Platform, 'Seeing is Believing', *Effra Redevelopment Agency*, London 1992, leaflet, n.p.

Patricia JOHANSON
Fair Park Lagoon [1981–86], and Endangered Garden [1987–97]

A major theme in my work from the beginning has been to reconnect city dwellers with Nature and ensure the survival of plant and animal populations. I envision a new kind of public landscape that balances the needs of human beings with those of the living world. My designs often combine restored ecologies with public access, and transform our traditional image of parks into 'ecology gardens'.

In 1960 I began writing about designing the world as a

work of art. My drawings transformed both functional infrastructure and living nature into art. I devised specific proposals that would restore fertile land, natural waterways, swamps and wildlife corridors to major urban centres. Other drawings combined aesthetic images with parks and habitat, or used art to address environmental concerns such as erosion, sedimentation, flooding, water conservation, sewage treatment and garbage mounds. Design strategies such as *Line Gardens* envisioned the continuity necessary for the survival of large populations, while *Vanishing-Point Gardens* proposed networks of related forms essential to migrating animals. My art projects became incorporated into daily life, and were interwoven with natural ecosystems. The hallmark of my work became to incorporate everything and to harm nothing.

FAIR PARK LAGOON

[...] On my first visit to Fair Park it was apparent that the lagoon was environmentally degraded. The shoreline was eroded and the water was murky. Fertilizer from the lawn washed into the lagoon every time it rained, causing algal bloom. There were few birds, no waterfowl and hardly any plants, animals or fish.

I began by developing my own list of concerns which included creating a functioning ecosystem, providing living exhibits for the Dallas Museum of Natural History, controlling bank erosion and creating paths over water so people could become immersed in the life of the lagoon. I also began to research what different animals eat, because food plants and nesting materials attract wildlife.

Eventually two Texas plants were chosen as models for the sculptures because their forms coincided with the strategy of the design. The delta duck-potato, *Saggitaria platyphylla*, had a mass of twisted roots that I arranged to prevent water from eroding the shoreline. The spaces between the roots became microhabitats for plants, fish, turtles and birds. The roots were built as five-foot wide paths for visitors, while thinner stems rose above the water to serve as perches for birds. Leaf forms further out in the lagoon became islands for animals, while other leaves along the shore formed step seating and overlooks. All the sculptural elements were deployed as lines of defence to break up wave action and prevent further erosion of the shoreline, which was being eaten away at the rate of eight inches a year.

A second sculpture was based on a Texas fern, *Pteris multifida*. The spine and leaflets of the plant were twisted to create bridges, causeways and islands, while cut-out shapes between the walkways became small-scale water landscapes – flower basins and fish ponds. Pond cypress trees will provide a shady canopy over the entire sculpture when they reach maturity.

Biological restoration was a key element in the design of Fair Park Lagoon. Snails, clams, freshwater sponges and shrimp, fish, reptiles and waterfowl are both visually attractive and serve as members of the food-chain. Landscaping was chosen not only as a design element, but also for its food and habitat value. A littoral zone of plants that root in shallow water was created around the edge of the lagoon to stabilize the banks, reduce turbidity, and provide nesting sites for insects, birds and small

mammals. The amount of nutrients available to algae was reduced; water quality was improved; and various species of fish were introduced into the food-chain.

Flocks of wild birds started to arrive, and today the lagoon teems with life. Few would suspect that the landscape is a functional flood basin and recreated swamp with an educational agenda. The sculpture provides access to a functioning ecosystem [...]

ENDANGERED GARDEN

In 1987 I received a call from Jill Manton of the San Francisco Arts Commission. Jill had seen an exhibition of my drawings for *Tidal Landscapes* in 1984, and thought the concept of a sculpture that transformed with rising and falling water would be perfect for a project along the San Francisco Bay. Specifically, the project involved a new thirty-million-dollar sewer that was mandated by the Environmental Protection Agency because the city was dumping raw sewage into the bay. The Department of Public Works had suggested a standard sewage facility for the site, and was immediately attacked by local citizen groups protesting the visual degradation of this sensitive bay front property [...]

After months of research on the site, I discovered that the environs hosted a large number of endangered species, and that formerly it had been an environment rich in native plants, butterflies, birds, waterfowl, intertidal life, fish and shellfish. By providing appropriate food and habitat it might be possible to aid species that were struggling for survival, and involve people in the issue of extinction. Since the site was adjacent to a new California State Recreation Area, it seemed logical to make the sewer structure an extension of the park [...]

The image selected for the project was the endangered San Francisco garter snake, with its colours and patterns translated into a series of gardens which would provide sustenance for locally threatened species. The head of the serpent, an undulating sculptural earth mound, rises up to 20 feet (610 cm) high out of a meadow of native food plants. The mound is covered with flowers that provide nectar for adult butterflies and host plants for their larvae, and is sculpted into microhabitats: windbreaks, sunning platforms and shelter from predators.

As the snake curves around a small beach, *Ribbon Worm Tidal Steps* provide access to the bay. The *Worm* also serves as a ramp for the handicapped, and at high tide its lower loops fill with water, creating habitat for vertically-zoned intertidal communities. The sculpture will become encrusted with barnacles and marine growth, and populated by shrimp, worms, crabs, hydrozoa, sponges and algae. Thus the *Ribbon Worm* becomes a living sculpture – simultaneously aesthetic, functional and nurturing [...]

The project lost much of its habitat value because once the construction permits for the sewer were issued I was not in a strong position to defend all of the original features. Public artists are always vulnerable, and many projects don't even get built. *Endangered Garden* is a beginning, but we still have a long way to go towards realizing that public works can make a major contribution to both ecology and public recreational space.

Patricia Johanson, 'Fair Park Lagoon' and 'Endangered

Garden', *Sculpting with the Environment*, ed. Baile Oakes, Van Nostrand Reinhold, New York, 1995, pp. 56–58

Harriet FEIGENBAUM
Reclamation Art [1986]

[...] In the fall of 1984 I began the quest for another project site, this time armed with a grant from the NEA. Among the new possibilities was a silt pond shown to me by the Lackawanna County district forester. Formerly part of the Greenwood Colliery, the pond is the property of the Greater Scranton Chamber of Commerce. It is dramatically situated below a main access road and is framed on one side by a semicircular 95 foot (30 m) high wall. I decided to make a proposal to the Chamber of Commerce for reclamation of the silt pond. It turned out that this site adjoined that of the Chamber's new office park just getting under way. The pond was to become a wetlands area and they were very much interested in a proposal for it. My project *Erosion Control Plan for Red Ash and Coal Silt Area – Willow Rings*, called for a double ring of willows for the pond area and an accent arc of willows above the semicircular wall (scar). This time I would start with ten 12 foot (366 cm) trees. The Chamber enthusiastically supported the idea and later asked if I would design the grading of the scar. The trees in the basin will be planted in the fall of 1985 and the entire project is to be maintained as a permanent wetlands for wildlife.

As a result of the *Willow* project, the Chamber of Commerce has asked me for proposals for other sites, including several for the office park itself. The Storrs Pit projects have also inspired new opportunities for sites on scarred public land.

Harriet Feigenbaum, 'Reclamation Art', *Issue: A Journal for Artists*, New York, Winter 1986, p. 40

Joseph BEUYS
Interview with Richard Demarco [1982]

Richard Demarco Your exhibition at the Anthony d'Offay Gallery strikes a sombre note underlined by the title, *Dernière Espace avec Introspecteur*. It was conceived in 1964 around the time of your first exhibition at the age of 43 with which it shares, and I'm quoting here, 'a predilection for certain angles and images'. This London exhibition was first presented in Paris in 1982 in January. The title could be misunderstood, but in Caroline Tisdall's catalogue she makes the point that 'it has not to be interpreted as a personal statement about the artist's demise, it has rather more to do with reflecting a feeling about the world'. I know that from the conversation we had here tonight in London that your feelings about the world have led you to consider making a sculpture on a gigantic scale, and could be involving you in personal expression of positive and optimistic energy at Documenta this summer, and will be

entitled appropriately for this, the seventh Documenta, *7000 Oaks*. It will be a celebration of many things, including the life of Jean Giono, the French writer who told the story of Elzeard Bouffier, the French shepherd who, like you, believed in the importance of planting oak trees [...]

Joseph Beuys It is right, and you see already, in this title, the words 'last space' appears, in relation to time. This is not as a demise for my doings. It puts a kind of line under my so-called spatial doings in so-called environments. I want it principally to mark the finish of this kind of work. I wish to go more and more outside, to be among the problems of nature and problems of human beings in their working places. This will be a regenerative activity; it will be a therapy for all of the problems we are standing before ... That is my general aim. I proposed this to Rudi Fuchs when he invited me to participate in the Documenta. I said that I would not like to go again inside the buildings to participate in the setting up of so-called artworks. I wished to go completely outside and to make a symbolic start for my enterprise of regenerating the life of humankind within the body of society and to prepare a positive future in this context.

I think the tree is an element of regeneration which in itself is a concept of time. The oak is especially so because it is a slowly growing tree with a kind of really solid heartwood. It has always been a form of sculpture, a symbol for this planet ever since the druids, who are called after the oak. Druid means oak. They used their oaks to define their holy places. I can see such a use for the future as representing the really progressive character of the idea of understanding art when it is related to the life of humankind within the social body in the future. The tree planting enterprise provides a very simple but radical possibility for this when we start with the seven thousand oaks.

Demarco Why seven thousand, Joseph?

Beuys I think that is a kind of proportion and dimension, firstly because seven represents a very old rule for planting trees. You know that from already existing places and towns. In America there is a very big town called Seven Oaks, also in England at Sevenoaks. You see that seven as a number is organically, in a way, related to such an enterprise and it matches also the seventh Documenta. I said that seven trees is a very small ornament. Seventy is not bringing us to the idea of what I call in German *Verwaldung*. It suggests making the world a big forest, making towns and environments forest-like. Seventy would not signify the idea. Seven hundred again was still not enough. So I felt seven thousand was something I could do in the present time for which I could take the responsibility to fulfil as a first step. So seven thousand oaks will be a very strong visible result in three hundred years. So you can see the dimension of time.

Demarco It is beyond your lifetime and beyond the dimension of the twentieth century ...

Beuys Surely ...

Demarco ... or even the contemporary art world and you will see this as a first step ...

Beuys I see it as a first step because this enterprise will stay forever and I think I see coming the need for such enterprises: tree planting enterprises and tree planting

organizations, and for this the Free International University is a very good body.

Demarco You can see young people all over the world becoming an army of helpers.

Beuys Right.

Demarco All over the world?

Beuys Surely.

Demarco You can see oak planting on the hills of Scotland or Wales ...

Beuys ... and Sicily and Corsica and Sardinia.

Demarco You can see the hillsides around Belfast beginning to be covered.

Beuys Everywhere, everywhere in the world ... also in Russia ... there are too few trees ... Let us not speak about the United States which is a completely destroyed country.

Demarco It is a sadness isn't it in our time that it is the United States which is growing rockets, and nuclear weaponry, rather than trees. Now you will make this statement to counterbalance this, in the middle of Kassel. Can you describe this enterprise more precisely?

Beuys I will start in very difficult places in the centre of the town. There the places are very difficult because there is already coatings of asphalt and stone slabs with infrastructures of electrical things and the German post office. In the centre of the town the planting of trees is most necessary for the people that live there within an urban context. There the planting of the trees will also be most expensive. The whole thing I guess will cost about three million German marks.

Demarco And who will provide this money? You will have to work with the city fathers.

Beuys Yes, but they will not give money ... the city will co-operate in so far as they will support our activities with tools.

Demarco ... and gardeners ...

Beuys ... and vehicles sometimes, but principally I took the responsibility for all of the money problems. I will fulfil this thing and ask many different people for support. I have received already help for the start of this thing, so for this year I have enough money to buy the stones – because every tree is marked with a basalt stone. It's a natural form which need not be worked on as a sculpture or by stonemasons. The stone is similar to what you will find in the basalt columns of the Giant's Causeway, but more triangular in shape with five, six or seven angles or irregular angled stones which come from the volcanoes ...

Demarco Will they come from the volcanoes around Kassel?

Beuys It is very organic because the nearest volcano to Kassel is only thirty kilometres from the centre of the town. It is very natural to take the stone to the place where I will plant the trees.

Demarco What will be the date of the first planting?

Beuys It is already done.

Demarco It is already done ...

Beuys I planted the first symbolic tree in the centre of the Friedrichsplatz. This is on the axis of the main building for the Documenta exhibitions and on the right side of this tree there is one stone already deposited. When the last of the seven thousand stones will disappear from this place it will say that the last of the seven thousand oaks is planted.

That will be maybe in three years...

Demarco That will be for three years and so that will last until the next Documenta.

Beuys That's true ...

Demarco Can you tell me, Joseph, just before we finish, how this tree project will allow you to continue your work on a new and wider dimension ... this is a new dimension ... it is a new step for you.

Beuys It is a new step in this working with trees. It is not a real new dimension in the whole concept of the metamorphosis of everything on this earth and of the metamorphosis of the understanding of art. It is about the metamorphosis of the social body in itself to bring it to a new social order for the future in comparison with the existing private capitalistic system and state-centralized communistic system. It has a lot to do with a new quality of time. There is another dimension of time involved, so it has a lot to do with the new understanding of the human being in itself.

It has to make clear a reasonable, practical anthropology. It is also a spiritual necessity which we have to view in relation to this permanent performance. This will enable it to reach to the heart of the existing systems – especially to the heart of economics – since the wider understanding of art is related to everybody's creative ability. It makes it very clear and understandable to everybody that the capital of the world is not the money as we understand it, but the capital is the human ability for creativity, freedom and self-determination in all their working places. This idea would lead to a neutralization of the capital and would mean that money is no longer a commodity in the economy. Money is a bill for law, for rights and duties you know ... it will be as real and will lead to a democratic bank system...

Demarco It will, in fact, bring employment...

Beuys In fact it will organically prohibit every kind of unemployment, and organically it will stop inflation and deflation. This is because it deals with the rules of organic money-flow. This makes clear that all these interpretations of the future, especially the interpretations of time, have a lot to do with a new understanding of the human being as a spiritual being. If you have the spirit in focus, you have also another concept of time ... you see time on earth is a physical reality. It takes place in space so it is the space/time relation which Einstein is speaking about. This already gives a kind of allusion to another dimension, but I think this other dimension is something we have still to detect ... When I say we have still to detect it, it has already been detected. It is there as one dimension in my work which I show in the Anthony d'Offay Gallery. This is the warmth quality ...

Demarco The quality of warmth.

Beuys The quality of warmth. This dimension is, in fact, another dimension that has nothing to do with the space and time relation. It is another dimension which comes to exist in a place and which goes away again. This is a very interesting aspect of physics, since until now most physicists are not prepared to deal with the theory of warmth. Thermodynamics was always very complicated stuff.

Love is the most creative and matter-transforming

power. You see in this context it is very simply expressed. Now it is not shown in very interesting diagrams which one could also bring to this discussion ... But to promote this interest for all these necessities to the real anthropology and not this fashionable way of speaking about anthropology ... in this relationship I start with the most simple-looking activity, but it is a most powerful activity; it is planting trees.

Joseph Beuys 'Interview with Richard Demarco, 1982', *Energy Plan for the Western Man, Joseph Beuys in America, Writings by and Interviews with the Artist*, compiled by Carin Kuoni, Four Walls Eight Windows, New York, 1990, pp. 109-16

Bonnie SHERK
Crossroads Community [The Farm] [1977]

[...] As an artist, I have tried to expand the concept of art to include and even be life, and to make visible, connections among different aesthetics, styles and systems of knowledge. The most recent and devotional vehicle for this coming together is a multicultural, agricultural collaborative art work called *Crossroads Community* (*The Farm*), or more simply, *The Farm*. This life-scale environmental, performance sculpture, which is also a non-profit public trust, and a collage of local, State and Federal sources, exists on a multitude of levels including cartoon, metaphor, contradiction and action.

Physically, *The Farm* is a series of simultaneous community gathering spaces, a farmhouse with earthy, funky and elegant environments; a theatre and rehearsal space for different art forms; a school without walls; a library; a darkroom; unusual gardens; an indoor/outdoor environment for humans and other animals; and a future cafe tearoom, and nutrition/healing centre. Within these places many people of different ages, backgrounds and colours come and go, participating in and creating a variety of programmes which richly mix with the life processes of plants and animals. All of these life elements are integrated and relate holistically with fascinating interfaces. It is these interfaces which may indeed be the sources of emerging new art forms.

The Farm, as a life frame, is particularly unusual, however, because it juxtaposes, symbolically and actually, a technological monolith with an art/farm/life complex. *Crossroads Community* sits adjacent to a major freeway interchange on its southern side where four high-need neighbourhoods and three creeks converge. On its northern boundaries, *The Farm* edges on a 5.5-acre open space of land which the City of San Francisco has just acquired for a neighbourhood park. (*The Farm* was instrumental in calling attention to the availability of this land and convincing the City to buy it.)

Part of *The Farm*'s dream is to uncover the natural resources of the earth, like the water which flows underneath, and to recycle the concrete which currently covers the land to create rolling hillsides, meadows, gardens, windmills, ponds, play and performing spaces,

etc. This lush, green environment would connect *The Farm* with the public elementary school that borders the future park on the north.

The potential for this project which involves the creative integrity of its surrounding neighbours and school children is astounding – as a model for other places and as a possible series of solutions for the many urban errors specific to this site. Another aspect for the future is to blur the boundaries between land parcels and act on new possibilities for fluid interchange [...]

Bonnie Sherk, 'Crossroads Community (The Farm)', Center for Critical Inquiry Position Paper, 1st International Symposium, San Francisco Art Institute, 1977

Buster SIMPSON
Hudson Headwater Purge [1996]

The installation *Hudson Headwaters Purge* (1991, New York) is part of a continuing series, dating back to 1983. The limestone sculpture is a populist environmental agitprop, working both metaphorically and pharmaceutically. As metaphor, it dramatizes the crisis of person and planet as one; acid indigestion, acid rain – a connection the media picked up on when they coined the titles 'River Rolaids' and 'Tums for Mother Nature'. The numerous disks used in the *Hudson Headwaters Purge* are of soft chalk limestone measuring 24 inches diameter (61 cm) by 3 inches (8 cm) thick (formerly exhibited in the Hirshhorn Museum Fountain, Washington DC, 1989). Pharmaceutically, limestone neutralizes or 'sweetens' pH acidic waters. The process of adding limestone to acidic rivers is now a standard practice with environmental agencies. Yet the source of the problem persists; power and combustion. We remain resigned to the stop gap solution, 'the bigger the problem, the bigger the pill'.

Buster Simpson, 'Hudson Headwater Purge', 1996, unpublished artist's statement

Betty BEAUMONT
Script from the film *The Journey* [1980]

[...] At the end of the 1970s, I was working on a project at Gateway National Park in the New York area and heard of a group of scientists doing research on potential uses for coal-waste from hydro-electric plants. It seemed that for every 100 railroad cars of coal that go into these plants, thirty carloads become waste material. At this time, there was also an interest in converting oil power plants to coal because of the supposed 'oil shortage'. If this were to happen there would be a tremendous proliferation of coal-waste material. The scientists working on the research project were investigating the stabilization of coal-waste so that it would not pollute.

I was interested in doing an underwater project that combined metaphor with underwater farming. While investigating the use of the Atlantic continental shelf, a dream emerged: to build an underwater 'oasis' that would be a productive, flourishing site in the midst of an area of urban blight caused by ocean dumping. For the next year I followed the scientists' research and watched a test site before I proposed using their coal-waste materials to build the *Ocean Landmark Project* in the Atlantic Ocean. The project then developed through the participation and co-operation of biologists, chemists, oceanographers, engineers, scuba divers, industry and myself. We dove for a season and found a site just off Fire Island National Seashore about 40 miles (64.3 km) from New York City's harbour. This site was selected because it was close enough to shore that it could be fished. An important part of this reef project is its ability to help feed people.

The scientists wanted to find a way of eliminating the wastes from a coal burning factory. A considerable amount of time and energy went into the shape and form of the blocks and how to handle the material. Initially we built metre by metre blocks which were much too large and heavy. Then we built foot by foot blocks which, being hand-made, were very time-consuming and not at all workable. Finally we decided on a standard, available process and utilized a block-making factory in Pennsylvania. From 500 tons (510 tonnes) of material, we made 17,000 blocks for this project [...]

The *Ocean Landmark Project* establishes the co-evolution of technology, humanity and nature.

I see my work as an arc between nature and industry. I view nature as a circular system, industry as a linear system and my work as a curved element that overlaps industry and nature. It comes from an eco-consciousness and a concern for future generations. The *Ocean Landmark Project* can theoretically last forever and never be completed.

Betty Beaumont, 'Script from the Film *The Journey*', unpublished artist's statement, 1980

Smadar GOLAN
To Raise the World [1987]

'I don't care what they call it – art, or anti-art. The problem is the society we live in.' He says, 'We've got to a point of such contamination, such deterioration, that we have to stop, and to start again, in a different way'. He was in a quandary whether to see Arik Sharon as the chief enemy of the State of Israel, or to concentrate on struggle within his own movement – including the Kibbutz movement – which too had become petrified and contaminated bodies. More power, impressiveness, effectiveness had become the product everyone was interested in. 'I felt that the problem was becoming more and more internal. That I had to conduct the struggle in my own home, my own quarter-acre.'

Greenhouses in the heart of Ein-Shemer. The idea was born ten years ago, at the Kibbutz's fiftieth anniversary celebrations. Avital Geva, 'We asked ourselves if we are

Art too has a chance,
if the museums open
themselves to the
electrician who
makes the fuse-board
and the metalworker
who makes the screw.
Wonderful things
happen outside art,
and the galleries
should be opened
to these things.

Smadar GOLAN To Raise the World, 1987

capable of going back and learning how to grow tomatoes. The tomato is a symbol. We estimated that growing tomatoes and cucumbers for our own kitchen was a kind of act of return, return to the soil, to simple work. And it satisfies very many interests of co-operation, experimentation and renewal.'

Renewal, in his view, begins in the smallest cell, the home. He defines the experimental area he would occupy himself with in the following years as a socio-agricultural domain. This project involves the youngsters of the Kibbutz. Each team is responsible for a crop, an experiment. 'Kibbutz Ein-Shemer', says Geva, 'has often faced the question of where to place the greenhouses – at the outskirts of the Kibbutz or in the centre. If you value experiments, give them an appropriate place, give them a power! A social experiment in the centre of the Kibbutz, that's like a synagogue. A synagogue is built in the centre of a settlement. It is close to the heart, where the friction is. At the Faculty of Agriculture and the Vulcani Institute, out of hundreds of researchers, we found several people who were willing to try out ideas which perhaps could not be tried out in any other place. We set up a grouping, we found a plant in Tel Aviv that produces industrial control systems. This plant, "Ardan", adopted our youngsters, they went to work there, and it supplied us with industrial control systems for free. Once every two weeks someone from the plant comes to the Kibbutz, and teaches the youngsters. If there were more companies who would devote a tenth or a hundredth of their budget to a school in their vicinity, we would become a Japan here within five years. We would surpass the Japanese!'

Avital Geva's model is co-operation. A person alone, he says, will not get anywhere. There is only one hope, grouping. We must make changes from the base up, in every social cell and in every plant. Co-operation between different people from different spheres. To open everything up, and to try everything. And without pretensions. Without expecting quick results. To investigate, to examine, to observe and to relate to every single thing as a work of art.

'Art too has a chance', says Avital Geva, 'if the museums open themselves to the electrician who makes the fuse-board and the metalworker who makes the screw. Wonderful things happen outside art, and the galleries should be opened to these things.'

'My question, about what goes in the museums today, is: are we touching upon the painful questions […]? Or are we going on sleeping well at nights and putting on shows and curiosities? Conceptual Art did not learn to adapt itself to life. Like any social or political movement that does not renew itself, art is wilting.'

The focus, he claims, has moved from work in the actual field, to some field that no one sees, to perpetuation in catalogues. Many artists have become dazzled and gone commercial. 'What is the tragedy? That everybody produces in his own little hut and wants his painting to reach Tel Aviv. The people who conduct the art schools are artists who have dedicated themselves to small factories that produce small artists. They teach the pupils to produce art that can be hung on the wall. The great dream is to get to some gallery, at the most to an exhibition at the Tel Aviv

Museum. The great dream is a catalogue. If it says in the catalogue – "has participated in this or that number of exhibitions" – the artist's stocks rise. He gets more points.

'That game is over. It's boring, stupid, a waste of energy. Nothing new or interesting happens to raise questions for Tel Aviv's bohemians. Nothing. It's silly to waste time in museums. They're cemeteries of art. What's a museum? A factory for the preservation of fish or pickled cucumbers …'

Smadar Golan, 'To Raise the World', *Dvar Hashavua*, Israel, January 1987; reprinted in *Greenhouse*, The Israeli Pavilion, Venice Biennale, 1993, pp. 51-52

Avital GEVA
Vital Principles for the Greenhouse [1993]

1. It is vital for the greenhouse to be in an autonomous and social learning environment. The greenhouse must be an autonomous body – a. *vis-à-vis* the institution (the 'Mevo'ot Eiron' high school); b. in terms of how the pupils see themselves and their project.
The first educational goal: to educate towards self-directedness, and hence the framework has to make this possible. If our framework does not make possible a sense of autonomy, it will lose its most important source of attraction.
2. In the greenhouse there must always be an element of perpetual development, and each year to start from the beginning […] If there is development, there is a momentum. This is not a place just for final theses. The main thing: this is a place where people build, and create.
3. The pupils and the crew will strive to base the project upon an economic balance […]
4. The institution's directors will decide if the institution will cover the additional expenses accruing to the greenhouse's special educational methods […]

Avital Geva, 'Vital Principles for the Greenhouse', *Greenhouse*, The Israeli Pavilion, Venice Biennale, 1993, p. 54

Stephen Jay GOULD
The Golden Rule: A Proper Scale for Our Environmental Crisis [1992]

THE GOLDEN RULE

[…] The issue of scale underlies the main contribution that my profession of paleontology might make to our larger search for an environmental ethic. This decade, a prelude to the millennium, is widely and correctly viewed as a turning point that will lead either to environmental perdition or stabilization. We have fouled local nests before and driven regional faunas to extinction, but we were never able to unleash planetary effects before this

century's concern with nuclear fallout, ozone holes and putative global warming. In this context, we are searching for proper themes and language to express our environmental worries.

I don't know that paleontology has a great deal to offer, but I would advance one geological insight to combat a well-meaning, but seriously flawed (and all too common), position and to focus attention on the right issue at the proper scale. Two linked arguments are often promoted as a basis for an environmental ethic:
1. We live on a fragile planet now subject to permanent derailment and disruption by human intervention;
2. Humans must learn to act as stewards for this threatened world.

Such views, however well intentioned, are rooted in the old sin of pride and exaggerated self-importance. We are one among millions of species, stewards of nothing. By what argument could we, arising just a geological microsecond ago, become responsible for the affairs of a world 4.5 billion years old, teeming with life that has been evolving and diversifying for at least three-quarters of this immense span. Nature does not exist for us, had no idea we were coming and doesn't give a damn about us. Omar Khayyam was right in all but his crimped view of the earth as battered, when he made his brilliant comparison of our world to an eastern hotel:
'Think, in this battered caravanserai
Whose portals are alternate night and day,
How sultan after sultan with his pomp
Abode his destined hour, and went his way.'
This assertion of ultimate impotence could be countered if we, despite our late arrival, now held power over the planet's future. But we don't, despite popular misperception of our might. We are virtually powerless over the earth at our planet's own geological timescale. All the megatonnage in all our nuclear arsenals yields but one ten-thousandth the power of the ten kilometre asteroid that might have triggered the Cretaceous mass extinction. Yet the earth survived that larger shock and, in wiping out dinosaurs, paved a road for the evolution of large mammals, including humans. We fear global warming, yet even the most radical model yields an earth far cooler than many happy and prosperous times of a prehuman past. We can surely destroy ourselves, and take many other species with us, but we can barely dent bacterial diversity and will surely not remove many million species of insects and mites. On geological scales, our planet will take good care of itself and let time clear the impact of any human malfeasance.

People who do not appreciate the fundamental principle of appropriate scales often misread such an argument as a claim that we may therefore cease to worry about environmental deterioration, just as Copeland argued falsely that we need not fret about extinction. But I raise the same counter-argument. We cannot threaten at geological scales, but such vastness has no impact upon us. We have a legitimately parochial interest in our own lives, the happiness and prosperity of our children, the suffering of our fellows. The planet will recover from nuclear holocaust, but we will be killed and maimed by billions, and our cultures will perish. The earth will prosper

if polar icecaps melt under a global greenhouse, but most of our major cities, built at sea level as ports and harbours, will founder, and changing agricultural patterns will uproot our populations.

We must squarely face an unpleasant historical fact. The conservation movement was born, in large part, as an elitest attempt by wealthy social leaders to preserve wilderness as a domain for patrician leisure and contemplation (against the image, so to speak, of poor immigrants traipsing in hordes through the woods with their Sunday picnic baskets). We have never entirely shaken this legacy of environmentalism as something opposed to immediate human needs, particularly of the impoverished and unfortunate. But the Third World expands and contains most of the pristine habitat that we yearn to preserve. Environmental movements cannot prevail until they convince people that clean air and water, solar power, recycling and reforestation are best solutions (as they are) for human needs at human scales — and not for impossibly distant planetary futures.

I have a decidedly unradical suggestion to make about an appropriate environmental ethic — one rooted, with this entire essay, in the issue of appropriate human scale vs. the majesty, but irrelevance, of geological time. I have never been much attracted to the Kantian categorical imperative in searching for an ethic — to moral laws that are absolute and unconditional, and do not involve any ulterior motive or end. The world is too complex and sloppy for such uncompromising attitudes (and God help us if we embrace the wrong principle and then fight wars, kill and maim in our absolute certainty). I prefer the messier 'hypothetical imperatives' that invoke desire, negotiation and reciprocity. Of these 'lesser', but altogether wiser and deeper principles, one has stood out for its independent derivation, with different words but to the same effect, in culture after culture. I imagine that our various societies grope towards this principle because structural stability (and basic decency necessary for any tolerable life) demand such a maxim. Christians call this principle the 'golden rule'; Plato, Hillel and Confucius knew the same maxim by other names. I cannot think of a better principle based on enlightened self-interest. If we all treated others as we wish to be treated ourselves, then decency and stability would have to prevail.

I suggest that we execute such a pact with our planet. She holds all the cards, and has immense power over us — so such a compact, which we desperately need but she does not at her own timescale, would be a blessing for us and an indulgence for her. We had better sign the papers while she is still willing to make a deal. If we treat her nicely, she will keep us going for a while. If we scratch her, she will bleed, kick us out, bandage up and go about her business at her own scale. Poor Richard told us that 'necessity never made a good bargain', but the earth is kinder than human agents in the 'art of the deal'. She will uphold her end; we must now go and do likewise.

Stephen Jay Gould, 'The Golden Rule: A Proper Scale for Our Environmental Crisis', *Eight Little Piggies; Reflections in Natural History*, 1992, Penguin Books, London, pp. 48-51

IMAGINING

For all its involvement with the physical aspects of the landscape, Land Art is also a conceptual movement. This group of excerpts highlights aspects of art making which, while touching on a wide array of issues involved with natural settings and actualized artworks, stress landscape as idea rather than material. If the artists created actual 'things' at all, they tended to be peripheral to the land, addressing aspects of space, time, distance, geography, astronomy, migration or meteorology through gallery artefacts in written, photographic or diagrammatic formats. Such speculative endeavours were an important part of the Land Art programme, expanding its theoretical context while carrying on the conceptual tradition from which it was born. Another strand included here is that which draws on the metaphoric and symbolic aspects of the land as framed by the conventions of the garden.

Douglas HUEBLER
Location Piece no. 14, Global Proposal* [1969]

During a given twenty four-hour period twenty four photographs will be made of an imagined point in space that is directly over each of twenty four geographic locations that exist as a series of points 15 longitudinal degrees apart along the 45° Parallel North of the Equator.

The first photograph will be made at 12:00 Noon at 0° Longitude near Coutras, France. The next, and each succeeding photograph, will be made at 12:00 Noon as the series continues on to 15° Longitude East of Greenwich (near Senj, Yugoslavia) ... on to 30°, 45°, 60°, etc., until completed at 15° Longitude West of Greenwich. 'Time' is defined in relationship to the rotation of the Earth around its axis and as that rotation takes twenty four-hours to be completed each 'charge' of time occurs at each 15° of longitude (Meridian); the *same* virtual space will exist at 'Noon' over each location described by the series set for this piece. The twenty four photographs will document the same natural phenomenon but the points from which they will be made graphically describe 8,800 miles (14,159 km) of linear distance and 'fix' twenty four hours of sequential time at one instant in real time.

The twenty four photographs, a map of the world and

this statement will join altogether to constitute the form of this piece.

* The owner of this work will assume the responsibility for fulfilling every aspect of its physical execution.

Douglas Huebler, 'Location Piece no 14, 1969', ed. Ursula Meyer, *Conceptual Art*, E.P. Dutton & Co., New York, 1972, p. 140

John BALDESSARI
CALIFORNIA Map Project
[1969]

Part 1: CALIFORNIA
The following are photographs of letters that spell CALIFORNIA and of the map used for locating the site for each letter. The letters vary in scale from 1 inch (2.5 cm) to approximately 100 inches (250 cm), and in materials used. The letters are located as nearly as possible within the area occupied by the letters on the map.

C. Off Jones' Valley Road. 9 miles (14.5 km) from Highway 299 leading from Redding. On bank of finger of Shasta Lake. Materials: found logs.
A. On road to Paradise. 7 miles (11 km) from intersection of Paradise Road and Highway 99 (near Chico). Materials: paint on rock.
L. 3.6 miles (2 km) from Newcastle on California 193. Materials: telephone pole and faked shadow.
I. 5 miles (8 km) from San Andreas on Highway 49. (near Angel's Camp). Materials: non-toxic colour in creek.
F. Ben Hur Road. South of Mariposa. 3.4 miles (5.5 km) from California 49. Materials: scattered bits of red cloth.
O. 3.4 miles (5.5 km) on Reed Road from junction 180 (near Minkler). Materials: red yarn.
R. 14 miles (22.5 km) north of Kernville in Sequoia National Forest. In Kern River. Materials: found rocks.
N. 4.10 miles (7 km) from Highway 395 on Death Valley Road. 6 miles (10 km) on south side of road. Materials: rocks and dry colour.
I. Outside Lucerne. 11.8 miles (19 km) from Lucerne fire station. 2 miles (3 km) off Old Womans Spring Road. Turn at sign reading 'Partin Limestone Products'. Materials: white dry colour. (The letter is nearly invisible.)
A. In Joshua Tree National Monument. 15 miles (24 km) from Twenty-nine Palms Visitors Center on road to Cottonwood. Materials: dry colour, rocks, desert wildflower seed.

The idea was to see the landscape as a map and to actually execute each letter and symbol of the map employed on the corresponding part of the earth. It was an attempt to make the real world match a map, to impose language on nature and vice versa.

John Baldessari, 'California', *Works 1966-1981*, Van Abbemuseum, Eindhoven, Museum Folkwang, Essen, 1981

Gordon MATTA-CLARK
Interview with *Avalanche*
[1974]

[…] *Avalanche* I've always thought of you as working within an architectural context.

Gordon Matta-Clark Not architectural in the strict sense. Most of the things I've done that have 'architectural' implications are really about non-architecture, about something that's an alternative to what's normally considered architecture. The Anarchitecture show at 112 Greene Street last year – which never got very strongly expressed – was about something other than the established architectural vocabulary, without getting fixed into anything too formal.

Avalanche Do you see the Humphrey Street building as a piece of anarchitecture?

Matta-Clark No. Our thinking about anarchitecture was more elusive than doing pieces that would demonstrate an alternate attitude to buildings, or, rather to the attitudes that determine containerization of usable space. Those attitudes are very deep-set … Architecture is environment too. When you're living in a city the whole fabric is architectural in some sense. We were thinking more about metaphoric voids, gaps, left-over spaces, places that were not developed.

Avalanche What's a metaphoric void?

Matta-Clark Metaphoric in the sense that their interest or value wasn't in their possible use …

Avalanche You mean you were interested in these spaces on some non-functional level.

Matta-Clark Or on a functional level that was so absurd as to ridicule the idea of function … For example, the places where you stop to tie your shoe-laces, places that are just interruptions in your own daily movements. These places are also perceptually significant because they make a reference to movement space.

When I bought those properties at the New York City Auction the description of them that always excited me the most was 'inaccessible'. They were a group of fifteen micro-panels of land in Queens, left-over properties from an architect's drawing. One or two of the prize ones were a foot strip down somebody's driveway and a square foot of sidewalk. And the others were kerbstone and gutterspace. What I basically wanted to do was to designate spaces that wouldn't be seen and certainly not occupied. Buying them was my own take on the strangeness of existing property demarcation lines. Property is so all-pervasive. Everyone's notion of ownership is determined by the use factor […]

Gordon Matta-Clark 'Interview with Avalanche', *Avalanche*, New York, December 1974, p. 34

George BAKER
Christian Philipp Müller, A Balancing Act [1997]

THE RETROPERSPECTIVE

One of the more melancholic, at times devastating, laws of history lies in the fact that it is only with the decay of a given object – with the ruination of an institution, the break-up of a cultural formation, the obsolescence of a concept – that its history becomes visible for the first time, that it becomes available for historical contemplation. What then are we to make of a Documenta exhibition defined by its curator as a 'retroperspective', as an exhibition that will look back upon its predecessors to more clearly define the cultural situation of the present?

ETERNITY

Following a suggestion by Catherine David, Müller's project for Documenta X began with a simple question, what physical traces have been left in the city of Kassel after nine Documentas? Noticing during the course of 1996 that the Friedrichsplatz had been disfigured for the construction of an underground car park, Müller became interested in the two site-specific sculptures still to be seen there: Walter De Maria's *The Vertical Earth Kilometer* and the first and last trees from Joseph Beuys' *7,000 Oaks* project. Before the opening of Documenta 6, on May 6, 1977, construction began on De Maria's work, a sculpture that involved the drilling of a hole one kilometre into the earth; a solid brass circular rod, two inches in diameter and one kilometre long, was dropped into the hole. The sculpture's placement originally marked the centre crossing of the pathways that bisect the Friedrichsplatz. Joseph Beuys' Documenta 7 proposal was to plant 7,000 oak trees throughout the city of Kassel; Beuys planted the first of the oak trees with a basalt stone marker in the Friedrichsplatz on March 16, 1982. After Beuys' death in 1986, the last of the 7,000 trees was finally planted next to the first by Beuys' widow and his son to mark the opening of the next Documenta in 1987.

In their different ways, both projects had evidently left the physical frame of the museum, opting for placement in the urban space of Kassel. But had they truly escaped their institutional frame? On the Friedrichsplatz, De Maria's earthwork and the first and last of Beuys' trees seem to act as little more than logos for the museum building standing directly behind them.

While participating in the permanence implicit in many site-specific projects, these works push that definition onto a qualitatively different level: they aim to be eternal both in their material embodiment and artistic implications. The sovereign desire upon the part of both Beuys and De Maria to mark the face of the city permanently was a desire eventually deflated by the city of Kassel itself. With its construction of a car park completed during 1996, the city literally pulled the rug out from beneath both works by redesigning the very face of the Friedrichsplatz. De Maria's *Vertical Earth Kilometer* no longer marks the centre of the place today; it has been shunted off to one side, almost forgotten in the grand sweep and new symmetries of the plaza. Beuys' trees and basalt stones are also now placed in a completely illogical proportion to the path system.

A split between the site and the art – a split that echoes the long emerging one between Documenta and Kassel –

now registers physically on the skewed face of the Friedrichsplatz.

A DIALECTICAL IMAGE

With the *Vertical Earth Kilometer* and the key trees from *7,000 Oaks* squarely facing each other upon the Friedrichsplatz, it is as if the internal history of the Documenta exhibitions had concretized what Walter Benjamin has called a 'dialectical image', an idea he clarified as 'dialectics at a standstill'.[1] For the projects of Beuys and De Maria seem to represent the two poles between which art in the twentieth century has always oscillated, the irreconcilable 'torn halves' that the entire avant-garde project of the twentieth century has not yet been able to bridge: the aesthetic and the social spheres, art that defines itself as a pure aesthetic construct and avant-garde projects that aim at pure social effectivity.

A CIRCUS ACT

And what of the contemporary artist today, presented to an international audience at Documenta X in 1997? One could see Christian Philipp Müller's 'exhibition within an exhibition' as a retreat. Müller chooses to withdraw into the museum itself, occupying a space within it that frames a vista back onto the Friedrichsplatz. A space is thus provided for contemplation of the current state of the urban space, the skewed *Vertical Earth Kilometer*, and Beuys' oak trees – a space resolutely within the frame of the museum, one that attempts to provide a contemplative distance within which to regard the recent and seemingly irreconcilable difficulties that plague the attempt to create a truly public art. In this space, a brief history of the Friedrichsplatz is presented; documents relevant to the funding of the two sculptures are displayed. Finally, Müller places a six-metre long balancing rod upon a sculptural base, a bar constructed half in brass, half in oak (loosely pastiching De Maria's *The Beginning and End of Infinity* [1987]). The placement of this sculpture punctuates the vista's continuation into the room within the museum.

1 See Walter Benjamin, 'Re the Theory of Knowledge, Theory of Progress', Konvolut N of the *Passagen-Werk*, translated in ed. Gary Smith, *Benjamin: Philosophy, Aesthetics, History*, University of Chicago Press, Chicago, 1989, p. 49

George Baker, 'Christian Philipp Müller, A Balancing Act', Documenta X, Kassel, 1997, leaflet, n.p.

Terry ATKINSON and Michael BALDWIN
Some Notes [1967]

'Other maps are such shapes, with their islands and capes!
But we've got our brave Captain to thank'
(So the crew would protest) 'that he's bought *us* the best –
A perfect and absolute blank!'

In contrast, a map in Carroll's *Sylvie and Bruno Concluded*, Chapter 11, has *everything* on it. The German Professor explains how his country's cartographers experimented with larger and larger maps until they finally made one with a scale of a mile to the mile. 'It has never been spread out, yet', he says. 'The farmers objected: they said it would cover the whole country, and shut out the sunlight! So now we use the country itself, as its own map, and I assure you it does nearly as well.'
— Martin Gardiner, 'The Annotated *Snark*'

1.MAP TO NOT INDICATE…

The map is designed to indicate 'not indicating'. Iowa and Kentucky are indicated in one mode – delineated sub-areas labelled 'Iowa' and 'Kentucky' within the whole map area, the size of which, obviously, is dependent upon the scale used, and the shape of which, obviously, is dependent upon which area is mapped. The second mode is a list of proper names succeeding the phrase 'map to not indicate'. This list of names indicates the relevant areas not indicated on the map above it. Thus these two modes might be summarized as follows:

(1) The area where indication is indicated (the map area).
(2) The area where 'non-indication' is indicated (the list area).

Mode (1) uses mode (2), i.e., there is an act of naming in both modes, but mode (2) derives its significance through its relationship to mode (1), whereas mode (1) could function simply as a 'map to indicate Iowa and Kentucky'. If there were no delineated area distinct from the delineated sub-areas, there would be no 'map to not indicate'.

There are other possibilities here. Consider, for example, a map of the same geographical area, this time with all the States, areas, etc., delineated upon the map-area, again the areas normally named Arizona, New Hampshire, Tennessee, etc., are labelled 'Not Arizona', 'Not New Hampshire', 'Not Tennessee', etc. This would be a map to indicate 'Not Arizona' etc. Such a map would be 'nonsense' of a kind because the negative particle is either false, or it invites the production of another name. Yet such a scheme would be correct if, for example, the delineated area normally named Arizona was labelled 'Not New York' and so on throughout the whole map synopsis. Only this time the map would be a map to indicate what was not where rather than the conventional what is where. Where there is no road in a certain place we do not conventionally indicate this fact upon the relevant map by labelling it 'There is no road at this point'.

2. MAP OF A THIRTY-SIX SQUARE MILE SURFACE AREA OF THE PACIFIC OCEAN WEST OF OAHU

The map is one where there is nothing to indicate within the context of a normal land and sea configuration map. By mapping the surface one eliminates questions relating to the depth of the ocean, and as there is no land within the area chosen, there is nothing to indicate within the frame of reference of a conventional map. But strictly speaking the map cannot achieve what it says it does because the surface of the Pacific Ocean is not completely flat – the waves 'have height' and are constantly in motion. (The only technique we can tentatively suggest as one which might prove an adequate one for mapping an area such as the surface of an ocean is a laser three-dimensional kinetic projection involving temporal correlation as opposed to our normal map-making convention of spatial correlation.)

3. MAP OF ITSELF

This map maps the area it is and consequently ceases to be a map. A map by definition is a representation where the spatial organization is such that each point on the 'drawing' corresponds to a geographical, celestial, etc., position according to a definite scale or projection. This 'map' has no correspondence with anything else but itself in terms of the spatial indices. It is 'the country itself'.

Terry Atkinson and Michael Baldwin, 'Some Notes', 1967, unpublished notes

Anne-Marie SAUZEAU BOETTI
Introduction to Classifying the Thousand Longest Rivers in the World [1977]

Classifying in order of size is the most common method of organizing information within a given category. In the case of rivers, size can be expressed in the first, second or third power, that is in km, km² or m³ (length, drainage area or run off). The criterion of length is the most arbitrary and ingenuous but still the most usually applied. Yet it is impossible to measure the length of a river, because of the thousand perplexities raised by its flowing existence (because of its meandering and going through lakes, because of its branching around islands and shifting in its delta area, because of man's interference along its course, because of the elusive boundary between fresh and salty waters). Many rivers have never been measured because their banks or their waters cannot be reached, even water spirits sometimes join the flora and fauna to keep men away. As a result, some rivers flow without a name, either unnamed on account of their untouched reality or unnamable on account of some superstitious prohibition. (A few months ago, a pilot who was flying low above the Brazilian forest discovered a 'new' tributary to the Amazon.) Other rivers cannot be measured because they do have a name, a casual name given by men (a single name along the whole course whenever the navigable river is a carrier of human communication, different names whenever the awe-inspiring river merely visits isolated groups): now, the entity of a river can be established either in relation to its name (a trace of human adventure) or to its hydrographic entirety (the adventure of the water from its most remote headspring down to the sea, without any record of the names given to the various segments). The problem is that the two adventures rarely coincide. Usually the explorer's adventure goes against the stream, starting from the sea; on the contrary the river's adventure ends in it. The explorer who proceeds upstream has to toss his way at each branching since above each confluence everything becomes rarefied: the water, at times the air, but always his own certainty; whereas the river that flows down towards the sea gradually condenses its waters and the certainty of its ineluctable way. Who can say whether it is better to follow the man or the water? The water, say modern geographers, objective and humble. And they start to recombine the identity of the rivers. An example: the Mississippi of New Orleans is not properly the extension of the Mississippi which rises from Lake Itasca in Minnesota, as you may learn at school, but of a brook that rises in Western Montana under the name of Jefferson Red Rock River and becomes the Missouri lower down. This is so because, at the Mississippi-Missouri confluence in St. Louis, the number of kilometres above the junction is greater on the Missouri side. But it is a fact that this 'scientific method' is actually applied only to the large prestigious rivers, those liable to compete for records of length. Such methodological readjustment is not wasted on minor rivers (less than 800 km in length). They will continue to be called (and measured) according to their only baptismal name, though when they have two headstreams (corresponding to two other names) the major might rightly be included within the course of the mainstream. The present classification mirrors this double method, it follows both the law of the water and the law of men, since such is the state of information at disposal. In a word it mirrors the partial game of information rather that the fluid life of water. This classification was started in 1970 and concluded in 1973. Some data were transcribed from famous publications, many un-edited data were elaborated from communications with non-European geographical institutes and study centres, governments, universities and single scholars all over the world. This convergence of documentation is both the substance and the meaning of the work. The innumerable asterisks contained in these thousand files raise innumerable doubts and work as a counterpoint to the stiff classifying method. The partial information available regarding rivers, the linguistic problems connected to their identity, and the very elusive nature of the waters, mean that the present classification – like all preceding or following ones – will always be provisional and illusory.

Anne-Marie Sauzeau Boetti, 'Introduction', *Classifying the Thousand Longest Rivers in the World*, edition of 500 artist's books, Ascoli Piceno, Italy, 1977

Ian Hamilton FINLAY
More Detatched Sentences on Gardening in the Manner of Shenstone [1985]

Gardening activity is of five kinds, namely, sowing, planting, fixing, placing, maintaining. In so far as gardening is an Art, all these may be taken under the one head, composing.

Take a small grove of pine trees and dry-pave the ground with common brick. Now sweep the fallen pine-needles around the base of each tree.

Where the viewer is solitary, imagination is the scale.

In our climate, why should we not provide some of our garden features at least with shadow – formed, say, of brick – in lieu of the sun?

Et in Arcadia ego: the cool root of stone, pleasing to the earthworm, renders the classical (as opposed to the plant) garden very vulnerable to the mole.

Strawberries grown in hollow logs stood upright are not inferior to small orchards in the pleasure given by the bark, and leaves, and fruit.

Formal gardens are (as it were) statues of Nature.

It is permissible, in the *Art* of gardening, to substitute a mooring-post for a boat.

What an extraordinary apparition is a tree in leaf!

People who say that there are three dimensions have never practised the art of bricklaying. They should read Duns Scotus: 'Every quantity has extension in three dimensions: length, width and depth. These three dimensions in turn are extended to the number six, for length extends upward and downward, width to the right and to the left, and depth frontward and backward.' – And that is only the beginning.

The small caves formed by Meadowsweet should now and then be inhabited by a comprehensible fragment of light-coloured stone.

Prefabricated – that is, reconstituted stone – columns etc. have a low standing with present taste, but a justification in Plato.

Better than truth to materials is truth to intelligence.

The dull necessity of weeding arises, because every healthy plant is a racist and an imperialist; every daisy (even) wishes to establish for itself an Empire on which the sun never sets.

The most singular aspect of old formal gardens is that one cannot put a name to the *stuff* – sand, gravel, pine needles, last year's leaves? – which forms the body of the paths.

When the *Shepherdperson* came in, surely Pan was out.

The opinions of the *angry* gardeners, Robinson, Blomfield, Payne Knight, etc. are always the most diverting, if not the most practical.

Nut. n. an Arcadian atom: an emblem of unostentatious country integrity: the shepherd's snack; the squirrel's dict; a thought of autumn in May.

Weather is the chief content of gardens; yet it is the one thing in them over which the gardener has no control.

If war-galleys were a main subject of sculpture in Roman gardens, why should not stone aircraft carriers – representations of our modern Imperial Navies – be thought proper in ours?

... Yet, harmony is a content ... And yet, what is the content of harmony?

The inscription seems out of place in the modern garden. It jars on our secularism by suggesting *the hierarchies of the word*.

The sundial's true content is Time, the clock's is *the* time.

The pagan sundial tells the hour by a beam, the Christian by a shadow.

In the proper categorising of things, the sundial is to be found with the statue and the urn, rather than with the clock.

Sundials only appear to tell the time; rather, they tell old cottages, silence, cumulus clouds, elm trees, steeples and moss. Likewise, weathercocks tell forests, bird flocks, scarecrows, seaports and ships.

Bird-dropping. n. (if before The Berry Season), an antique highlight.

The presence of the straight line is dominant in the serpentine, whose undulations are so many departures from the *idea* of the straight. One cannot see an undulating line without forming the thought of a straight line, whereas the straight line does not produce the thought of the serpentine, but appears complete in itself. This applies to the conceptual line, as well as to the line of a lawn, flowerbed or trees.

A lawn is by no means mere short grass.

Detached lawn: a very small area of clipped grass, the size of a napkin or a tablecloth, occurring outwith the bounds of the formal garden.

The obelisk is a very self-convinced formal element.

Brown made water and lawns (etc.) Palladian elements, as much as Lord Burlington did, his columns and porticos.

Brown made water appear as Water, and lawn as Lawn.

It is the case with gardens as with societies: some things require to be *fixed* so that others may be *placed*.

The Weed Garden has elevated the stinging nettle from an emblem of sloth – i.e. human sloth – to one of high moral integrity.

It is a fact, at present overlooked, that the disorder of Weed Gardens stops short in the weeds themselves.

The Weed Garden, or, Indolence Justified.

A dark proverb: The more compost heaps, the fewer teaspoons.

Artificial gardens – as Lamb describes them – now strike us as not at all artificial, since they have been made 'natural' by time.

One visitor will abbreviate the garden, another enlarge it. To one, it is the entertainment of ten minutes, to another the meditation of a day.

Wind benefits a lake, a pond or pool is entirely spoiled by it.

The garden pool teaches what the Presocratics knew, that land wishes to be water and water, land.

Composition is a forgotten Art.

Bark is to boat as panzer is to tank.

As public sex was embarrassing to the Victorians, public classicism is to us.

In this age, a frog in the garden pond is of more interest than a budding water-lily. And a water-lily is of much more interest than an inscription or a sculpture.

The most singular and pleasing aspect of water – strange to say – is its flatness.

Both the garden style called 'sentimental', and the French Revolution, grew from Rousseau. The garden trellis, and the guillotine, are alike entwined with the honeysuckle of the new 'sensibility'.

The main division of gardens is into art gardens and botanical gardens. Compared to this division all the others – 'The Garden as Music', 'The Garden as a Poem' – etc. – are superficial.

The gardens of Kent and Brown were mistakenly referred to the Chinese aesthetic, just as today's thoughtful gardens are considered to be Japanese. 'Japanese garden' has come to signify no more than 'art garden'. The contemporary 'sculpture park' is not – and is not considered to be – an art garden, but an art gallery out-of-

doors. It is a parody of the classical garden native to the West.

Seeing the first wild flower in spring is not as memorable as picking the last gooseberry in autumn.

Used tools moralise.

In Britain, ideal landscape is coloured silver, in Italy, gold.

Ian Hamilton Finlay, 'More Detached Sentences on Gardening in the Manner of Shenstone', printed in Yves Abrioux, *Ian Hamilton Finlay: A Visual Primer*, Reaktion Books, London, 1985, p. 38

William FURLONG

Time Garden [1993]

Time Garden is a new site-specific work for outdoor installation at Killerton Park, Devon. Its concerns extend those of the *Radio Garden* made in 1988 for the Tyne International, Gateshead.

Time Garden is structured according to twelve of the world's time zones and comprises twelve trays, each 8 feet × 2 feet (244 × 61 cm), planted with grass seeds from one of the zones. The composition of the growing medium in each of the trays also relates to that found in one of the zones.

At the end of each tray, a clock is set to a one hour time difference thus creating a chronological atlas.

The trays were installed as low tables on the wind-swept approach to Killerton House, during the months June to October.

In some trays the grasses will thrive, whereas in others seed will fight for germination and survival. The growth will also be affected and determined by the British climate and weather conditions.

Like the *Radio Garden*, the work explores the process of 'remapping' the world not based on political borders and boundaries or geographical landmass, but in the *Time Garden* through vertical divisions, dissecting the earth's latitude.

Other themes in the work refer to the practice of earlier occupants of Killerton house who collected seeds and plants from far-flung outposts of the British Empire during trading visits. The results can be clearly observed in the artificially constructed landscape of Killerton Park.

The work could also be described as a series of 'time-tables' which embody the indexing of time, both chronologically as well as through the time scales of natural growth.

'Timeless', 'time warp', 'time scale', 'time frame' and 'time running out' come to mind at Killerton as do the inescapable relationships between the fertile and productive environment of the park and surrounding areas, and other locations around the world where human survival and existence depend on fragile and often hostile socio-ecological balances.

William Furlong, 'Time Garden', *Ha-Ha: Contemporary British Art in the 18th Century*, University of Plymouth, Devon, 1993

Guy TORTOSA

A Seasoned Garden [1995]

Lothar Baumgarten explains that the name of the garden he has conceived for the Fondation Cartier refers to the medieval compendia in which the monks, with legendary patience, inventoried and classified all the species known to them at the time: primarily medicinal plants but also aromatic ones intended for the kitchen. This was a time when the West was rebuilding itself. People were reading Aristotle, Theophrastes, Dioscurides and of course the Bible. Like Noah, the monks were counting living creatures in order to lay the foundations of a new world.

Despite the fact that it looks like an untamed meadow, Baumgarten's garden is thus quite cultivated. Its roots go back to a distant European past in which France as a nation-state with its present borders, whether artificial or natural, did not yet exist, but where there was already a whole vegetation of flowers (columbines, daisies, poppies, lilies, cornflowers) and trees, those of the plains and the mountains, the South and the North (pines, chestnuts, birches, poplars, alders, oaks, olives). All that was already there, like new, singular and yet similar to the vegetation of other countries where learned monks – those of St. Gall, Canterbury or Reichenau, for example – were working in their common language, Latin, to give names to both the most sophisticated of flowers, such as the mandrake or the orchid, and the most modest of plants, the rue, the clover or the dandylion.

Like the gardens of the Middle Ages, those of the fortified castles and abbeys, *Theatrum Botanicum* is enclosed. By glass on the boulevard Raspail side, by stone on the south, and by the walls and fences that hem it in and protect its most remote section [...]

The plan of the garden is based at once on the rectangle, the circle, the oval and the triangle. Each of these geometric figures is embedded in another. The ellipse of the fountain is the smallest. An immense isosceles triangle appears to contain all the others, and particularly the rectangle that Nouvel's building traces on the ground. At the far end of the garden, a chestnut tree and a walnut tree occupy a right angle. At certain points, their fruits reach over the wall to touch those of an old fig tree on the neighbouring property thus offering passers-by the possibility of a gourmet snack. In May, the ground is covered with the little white and pink blossoms that fall from the chestnut tree. In its shadow, there is also an elder, fallen branches and lilies-of-the-valley, lungworts and different varieties of hellebore. Going back down towards the boulevard, in the northern part but with full southern exposure, there are the herbs of the South, thyme, sage, balm and mint, and farther on, strawberry plants, Aaron's rods and red campion swaying over a carpet of moist grass, horsetails, fritillaries, gunneras and cow parsnips whose stems and flowers can be nine feet long by the time the gardener's shears make them disappear in autumn.

This is an urban garden, an art garden, a garden of memory, a sensual garden. There is no end to the definitions that can be applied. Indeed, gardens are

difficult to categorize. Nature contains everything – space, time, life, movement, sight, smell – to such an extent that we can never understand it in its entirety. For this reason, the art of gardens is probably the most complete and the least abbreviated of all arts. Aesthetic theory cannot exhaust it. To such an extent that the theories of sensation, of the total artwork, of the work in progress, of the 'well done, badly done' that was so dear to Robert Filliou, or of the 'social sculpture' dear to Joseph Beuys can all find in it a form of realization that the so-called visual arts, seemingly more lasting, often attain only imperfectly.

Theatrum Botanicum is urban in the same sense as the great public parks which have constituted indispensable breaths of greenery and calm in the heart of polluted cities since the nineteenth century. Its environment is hardly friendly. Boulevards and buildings surround it on all sides. Which makes it easy to understand why this is a garden that privileges the vegetal and the animal and not, as might be the case in certain less urban environments, the mineral. This conception is radically different from that of the French garden, which advanced in an organic, omnipresent nature, while *Theatrum Botanicum* attempts to house nature once again in the centre of a geometricized form from which it has gradually been excluded. André Le Nôtre, gardener to Louis XIV, was commissioned to open vistas; he created highways before their time. The avenue that was to connect the Tuilleries to the height of Saint-Germain-en-Laye was to have measured over nine miles. In the inorganic city, the contemporary garden gives nature a place once again. It is enclosed like the medieval garden because what surrounds it is voracious, and the inhabitants are afraid that they cannot protect themselves. The classic garden confounds inside and outside; through its design, humans express the feeling that they can have power over what surrounds it. The other garden cultivates the inside against an outside perceived as confused or hostile.

But the urban character of this garden depends also on its urbanity, its 'social' composition. Its guests are numerous. Baumgarten has inventoried some 150 indigenous or immigrant varieties of vegetation. Some of them, especially a few tall trees with their majestic bearing, have been there for a long time; others had disappeared and were reintroduced. A certain number were brought by the artist and his assistants in the form of seeds or young shoots, while others, impossible to count with any precision, will be carried by the wind, insects, animals or visitors and move in without warning. The list that Baumgarten has made of the inhabitants of his garden includes the bedbug, the dragonfly, the bumblebee that settles between the stones of the walls, the blue titmouse, the ladybird that devours aphids, the prattling magpie, the nocturnal owl, the peacock butterfly, the pied woodpecker, the blackbird, the moth, the oak jay, the mole with its soft, mottled fur, the nuthatch that makes its way head first down the tree trunks, the cricket, the ringdove that is the most urban of all the animals in this garden, the thrush, the fly, the sparrow, the wasp, the mouse that is not just found in laboratories, the wagtail, the robin, the warbler, the ant. More open-ended than a register of births, marriages and deaths, this list is like the credits of an

infinite film in which the actors who are the inhabitants and passing guests of this botanical theatre are going to offer each stroller curious enough to perceive it the spectacle of nature's fortunes and misfortunes. This garden is thus urban not only because it lies in the heart of the city but also because it constitutes a city.

If, as Plato, Aristotle and many authors after them have written, it is true that there can be no happy republic without a great diversity of statuses, genders, intelligences and origins (certain trees that are perfectly assimilated here nonetheless lay claim to remote origins: Japan for the sephora, America for the plane tree and the locust), *Theatrum Botanicum* has every chance of being a happy city. People will doubtless argue there, love each other there, work there, exchange friendly and unfriendly services. The tiger moth's caterpillar will settle on the leaves of the comfrey; the mayflower, alias *cardamine pratensis*, will welcome the orange tip butterfly under the name of *anthocaris cardimines*; the nettle will take care of the peacock butterfly's caterpillar whether he likes it or not, while under the bark of the tree, the typographer bark beetle will make drawings, and maybe one day soon, when the pied woodpecker will have done his job, an owl will make his home in the trunk of a walnut or chestnut tree.

Theatrum Botanicum is also an art garden. Baumgarten has not conceived it differently. The trees, the flowers, the fountain, the animals, the strollers and even the sky will serve as sculptures here. The creation of a garden always begins with the composition of the ground. Poor and dry in one place, moist and rich in another, the ground, like the background of a painting, determines the garden's outside appearance. Similarly, in the strict sense of the word, the work of the artist is invisible here. As is the garden itself. *Theatrum Botanicum* is invisible because it is new, because it does not resemble any of the most common models of a garden. Indeed, it is neither a classical French garden (like Versailles) nor an English landscape garden (like the park at the old Fondation Cartier in Jouy-en-Josas). It is a contemporary garden. We will look at it with our bodies as we stroll through, we will discover it over the course of time and the seasons, and as is the case in front of some of Monet's canvases which have taught us to look at snow differently than through the filter of our preconceptions (which is to say, a snow that is alternately blue, pink, yellow or green), we will learn to appreciate the beauty of what we do not usually see. The weeds, for example.

Guy Tortosa, 'A Seasoned Garden', Fondation Cartier pour l'art contemporain, Paris, May, 1995

Robert SMITHSON
An Interview with Bruce Kurtz [1972]

[...] *Bruce Kurtz* Do you see the whole moon thing as another kind of ownership, another kind of currency ...
Robert Smithson I described the moon shot once as a very expensive Non-site. It keeps people working, you know. To

an extent I thought that after they got to the moon there was a strange demoralization that set in that they didn't discover little green men, or something. It's on that level. I was watching the one last night, and there was kind of a forced exuberance. There was this attempt to try to confer some meaning onto it, and to me it's quite banal.
Kurtz One thing that amazed me about the first moon shot was that you saw Mission Control in Houston with all those incredible computer stations, that incredible technology, with hundreds of people facing toward a kind of altar, like at the movies, and above the altar was a picture of Snoopy. There had to be some way in their minds of attaching a mascot to the whole experience, in other words to symbolize the experience to make it more comprehensible, and the image was so regressive that it denatured the experience. There was no awareness of the meaning.
Smithson That's what I was saying before about the computer thing, it's sort of like they're so abstracted that they ... their imagery would draw from Snoopy, or Porky Pig, or something.
Kurtz The idea that we can completely control the environment, nature, is, I think, what creates the interest in the moon shot, and it's something like Disneyland. You can make your environment however you want to make it, but the way it's made is another kind of cultural control.
Smithson Actually, I think Disney World is more of a Dream World than Documenta. In other words, it's more aggressive. And its also a big money-making operation. So these dream worlds start proliferating [...]

Robert Smithson, 'An Interview with Bruce Kurtz', The Writings of Robert Smithson, ed. Nancy Holt, New York University Press, New York, 1979, pp. 200-4

J. G. BALLARD
Robert Smithson as Cargo Cultist [1997]

What cargo might have berthed at the Spiral Jetty? And what strange caravel could have emerged from the saline mists of this remote lake and chosen to dock at this mysterious harbour? One can only imagine the craft captained by a rare navigator, a minotaur obsessed by inexplicable geometries, who had commissioned Smithson to serve as his architect and devise this labyrinth in the guise of a cargo terminal.

But what was the cargo? Time appears to have stopped in Utah, during a geological ellipsis that has lasted for hundreds of millions of years. I assume that the cargo was a clock, though one of a very special kind. So many of Smithson's monuments seem to be a potent amalgam of clock, labyrinth and cargo terminal. What time was about to be told by *Broken Circle*, and what even stranger cargo would have landed here?

The *Amarillo Ramp* I take to be both jetty and runway, a proto-labyrinth that Smithson hoped would launch him from the cramping limits of time and space into a richer and more complex realm.

Fifty thousand years from now our descendants will be mystified by the empty swimming-pools of an abandoned southern California and Côte d'Azur, lying in the dust like primitive time machines or the altars of some geometry-obsessed religion. I see Smithson's monuments belonging in the same category, artefacts intended to serve as machines that will suddenly switch themselves on and begin to generate a more complex time and space. All his structures seem to be analogues of advanced neurological processes that have yet to articulate themselves.

Reading Smithson's vivid writings, I feel he sensed all this. As he stands on the *Spiral Jetty* he resembles Daedalus inspecting the ground plan of the labyrinth, working out the freight capacity of his cargo terminal, to be measured in the units of a neurological deep time. He seems unsure whether the cargo has been delivered.

His last flight fits into the myth, though for reasons of his own he chose the wrong runway, meeting the fate intended for his son. But his monuments endure in our minds, the ground-plans of heroic psychological edifices that will one day erect themselves and whose shadows we can already see from the corners of our eyes.

J.G. Ballard, 'Robert Smithson as Cargo Cultist', Robert Smithson: a Collection of Writings on Robert Smithson on the occasion of the installation of Dead Tree at Pierogi 2000, Pierogi Gallery, New York, 1997

Mark DION
The Tasting Garden [1997]

The goal of *The Tasting Garden* is to produce a complementary addition to the Harewood Estate, which would take into consideration not only the historical purpose of the walled garden, but would also embody one of the most powerful principles of the contemporary ethos – that of the conservation of biological diversity. *The Tasting Garden* would harmoniously blend Harewood's commitment to both historical preservation, as represented by the house and grounds, with that of biological protection, as exemplified by the bird garden. However, the solutions featured in this new project would not be characterized by a historical reconstruction, but rather a bold contemporary design based on the contributions of the artful science of arbourculture.

The Tasting Garden is to occupy the vast and abandoned western half of the walled garden. The archway in the dividing wall of the two derelict grounds would suffice as an entrance and link to the conceptually supportive arrangement of Christian Philipp Müller.

From the slightly elevated position of the entrance, the viewer overlooks an enormous branching pathway: essentially a network of paths forming a tree-like structure. The main path constitutes the tree trunk and the side paths its branches. These also deviate into smaller paths which terminate in semi-circular areas. In this area one encounters a rectangle of stone set into the ground and inscribed with the name of a fruit tree variety, followed with an odd and anachronistic description of the qualities of the fruit, particularly the taste. Behind this inlaid tablet

stands a short (4 foot, 122 cm) concrete column bearing a bronze plate, upon which sits an oversized bronze fruit. Immediately behind the column and a short distance off the pathway is the tree itself. These trees come in three forms: a newly planted sapling, an adult tree or a withered and bare bronze trunk.

The tree forms the central metaphor of the work: the tree of life, the tree of knowledge, the family tree, the phylogenetic tree of evolutionary development. The main branches of the tree pathway represent the major northern fruit crop trees: apples, quinces, pears, plums, peaches and cherries. The terminal nodes are distinct varieties. Each of these varieties is marked by the status of rare, threatened, endangered or extinct. These are agricultural plants which have become extirpated or endangered by the general shift to monoculture agricultural production or other trends which result in the production of higher yields of marketable fruit but less diversity of species. Large scale agri-business privileges only a handful of plants which exhibit desirable traits, such as long shelf-life, large yields, sweeter taste, and pest-resistance. Long neglected have been a number of breeds which not only demonstrate a more expansive and challenging taste spectrum, but also make up an important reservoir of genetic material.

When coming to the end of one of the pathway branches, the visitor encounters a description of the taste of one of these rare fruits. Humans, being creatures which favour sight over all other senses, have merely a few impoverished adjectives for taste. Descriptions confronting the viewer of the stones are derived from mostly eighteenth and nineteenth century sources and they seem to strain acrobatically in an attempt to translate objectively the sense of taste. The next element evokes the notion of the monument, or even the grave marker. The scale of the ridiculously oversized fruit exemplifies its status as the representative of the entire breed or variety. The shapes of the fruit will of course speak of the variety of tradition. Finally, there is the tree itself, standing a short distance off the path. Where possible, adult trees transplanted from other parts of the grounds should be used. Young nursery trees fill in where mature trees are not available. It may take a decade before the garden can be optimally viewed. The extinct breeds shall be represented by dark macabre casts of dead trunks. These grim surrogates will most powerfully speak when the living trees bare fruit or blossoms.

Beyond the massive diagonal wall which bisects the western half of the garden a separate but equally important feature of The Tasting Garden is located. An orchard maintained to propagate and preserve those agricultural varieties most threatened with extinction will function as an agricultural equivalent to the aims of the endangered species breeding programme of the bird garden. Visitors can stroll through the orchard unguided.

A critical aspect of both the tree walkway and the orchard enjoyed by guests is the ability to pick and eat fruit. The public will be encouraged to sample ripe fruit directly from the trees, or fruit could be made available through the restored kitchen or other already established outlets at Harewood. The Tasting Garden makes available rare and challenging flavours and textures, normally inaccessible to all but a handful of expert cultivators. It demonstrates the loss of genetic diversity succinctly through the activation of one of the most under-utilized senses in art. Whatever fruit remains uneaten due to over-abundance of late maturity could be put to the service of Harewood's livestock farmers.

Completing the composition of The Tasting Garden is an element best described as a folly. The Arborculturist's Work Shed is a diminutive monument acknowledging the grand achievements and skills of the men and women who laboured in the walled garden to feed the estate, as well as those today who maintain the grounds and gardens. Highlighted in this tribute are the tools of the trade: spades, books, watering cans, chemicals, horticulturalist shears etc. Indeed, it is not as much the alchemist's studio as it is a functioning work shed. Not obvious to the visitor is the fact that this structure is a carefully conceived and composed installation. While each inch of the interior can be viewed through the many windows, the building can not be entered. The arrangement of objects within the structure constructs an elaborate narrative, foregrounding the romance of horticulture as a profession bridging art and science. The work emphasizes the human aspect of an endeavour as monumental and seemingly timeless as the construction of the Harewood landscape. Included within The Arborculturist's Work Shed are drawings, photographs and other artefacts of the garden staff, past and present.

Mark Dion, 'The Tasting Garden', Mark Dion, Phaidon Press, London, 1997, pp. 140-43

ILLUMINATION

Whether working in the Western deserts or the Maine woods, along country paths or deep in the wilderness, with metaphorical or utilitarian ambitions, all Land and Environmental Artists eventually contend with the complex issues surrounding the presentation and dissemination of what are fundamentally non-portable artworks. Few admirers of works such as the *Spiral Jetty* or *The Lightning Field* have actually visited these sites. Furthermore, temporary actions or incursions are durational and subject to natural forces of degradation. What are the roles of the artefacts and media through which they are presented? The excerpts in this final section explore issues of mediation and representation, of the contributions of text and image to our understanding and apprehension of Land Art projects. As Susan Sontag notes of photography, that most complex of mediative vehicles and the primary means of displaying the evidence of Land Art projects, 'Reality has always been interpreted through the reports given by images. Our irrepressible feeling that the photographic process is something magical has a genuine basis. No one takes an easel painting to be in any sense co-substantial with its subject; it only represents or refers. But a photograph is not only like its subject, a homage to the subject. It is part of, an extension of that subject; and a potent means of acquiring it, of gaining control over it.'

John BEARDSLEY
Art and Authoritarianism: Walter De Maria's *Lightning Field* [1981]

It is perhaps an outmoded conviction of mine that art criticism should take as its point of departure the specific characteristics of a work of art or a group of works. In the case of Walter De Maria's *The Lightning Field*, however, this is virtually impossible. The measure of control exercised by the artist and his sponsor, the Dia Center for the Arts, over the viewer's approach to the work, his physical experience of it, his access to information and documentation about it, forecloses an independent appraisal of the work. It thereby renders problematic any discussion of the work as such, for its inhibits an effective dissociation between what one sees and what one is expected to see, between what one believes and what one is led to believe.

Although it is an open question to what extent the *The Lightning Field* would ever involve an experience of lightning for the average viewer, it is nevertheless a seriously conceived work, and it is therefore regrettable that it cannot be discussed on its own merits. But the directive posture assumed towards the viewer by De Maria and Dia suggests that both artist and patron lack confidence in either the quality of the work or the discernment of the viewer. They are therefore being defensive or condescending, neither posture positively predisposing the viewer to the work. Unwilling to have *The Lightning Field* or even photographs of it seen in circumstances other than those absolutely dictated and controlled by them, they are responsible for obscuring the work with extra-art issues, and ultimately for eliciting a criticism that is bound to be distasteful to them.

Although it is a long way from almost anywhere to Quemado, New Mexico, the town is neither economically disenfranchised nor culturally remote. Representative of a region now politically and economically on the ascendant, Quemado is the scene of continuing, if not quite flourishing, cattle ranching, and it is not far from the massive open-pit copper mines of Santa Rita and Clifton-Morenci. In addition, uranium deposits are thought to underlie the region. Quemado is served by the federal

highway system, making it about four hours away from Albuquerque, six from Phoenix. And now, Quemado even has contemporary art.

The coincidence of a relatively high number of lightning days per year with the availability of purchasable, flat, semi-arid, sparsely populated range land brought De Maria and the Dia Center for the Arts to Quemado in the mid seventies. De Maria had already tested his ideas for *The Lightning Field* in a pilot project constructed near Flagstaff, Arizona, in 1974. Now he wanted a final project which would be considerable larger, whose permanence would be guaranteed by ownership of the land. The Dia Center for the Arts, which is principally supported by Philippa Pellizzi, heiress to the De Menil oil fortune, came to De Maria's assistance. On his behalf, the foundation acquired five or more sections (a section is a square mile, or 640 acres) north-east of Quemado. Here De Maria erected his grid of 400 stainless steel poles with pointed tips. The grid measures a mile east to west and slightly over a kilometre north to south; the east-west rows contain twenty-five poles, the north-south, sixteen. They are spaced 220 feet (67 m) apart, 331 feet (101 m) on the diagonal. Despite fluctuations of ground level, they are installed in such a way that their tips form a continuous plane at an average height of 20 feet 7.5 inches (6 m 19 cm) above ground.

In the town of Quemado, Dia meanwhile bought and renovated a building for the local administrative office of *The Lightning Field*. It also houses what they call a mini-museum of De Maria's work, where a selection of the *Silver Meters* and the circle and square *Equivalents* are on view. This, then, is a counterpart to the permanently installed, Dia-supported *Earth Room* and *Broken Kilometer* at locations in New York City.

It is to this office in Quemado that a prospective viewer must write for an appointment to see *The Lightning Field*. The appointment procedure insures that no more than a few people are on the *Field* at any given time, since it is believed that the work is best experienced in these uncrowded conditions. If the appointment is granted, the viewer reports for his visit to the Quemado office, surrenders his unauthorized photographic equipment, and signs a release freeing De Maria and Dia of liability should injury or death occur while visiting the work. Next, a 'contribution' of thirty dollars is made to Dia to help them defray expenses for the visitor's food and lodging. Then, like a neophyte in a new order, the visitor is driven off for a minimum twenty-four-hour initiation into the mysteries of *The Lightning Field*. The lodging on the location is a renovated homesteader's cabin. Food is pointed out and canteens are issued. The visitor is then left alone until the same time the following day, when he is returned to Quemado, his camera and his car.

Given the complexities of this procedure, one might rightfully expect some revelation during residence at *The Lightning Field*. Instead, there is an unprepossessing array of poles in what is admittedly a very beautiful landscape. In the bright light of midday, the poles of the *Field* are barely visible. They are seen to good advantage only at dawn and dusk, when fully illuminated by raking light. And, of course, since lightning storms pass over the *Field*

approximately three days a month during the lightning season, from late May through early September, the likelihood of seeing dramatic lightning strikes is remote.

There is, then, an enormous disparity between the actual sculpture, which is a minimalist understatement, and the promotion it receives, which is anything but. The necessity of making an appointment, signing a release against a danger which seems more imagined than real, and of being delivered to the *Field* rather than allowed to drive, all conspire to induce a feeling of awe, to insure that one will fully expect to see God at *The Lightning Field*. Needless to say, He doesn't appear. No artwork could live up to this hype, least of all one that involves the dematerializing effects of sunlight and the subtle interrelationship of sculpture and landscape.

There is no question but that those who administer *The Lightning Field* have carefully considered the manner in which they control access to and, indirectly, perception of the work. A conversation with a representative of Dia elicited several reasons for such extreme control, including the insurance that the viewer is alone, or nearly so, with the work, and protection of the fragile semi-arid environment in which it is situated. These concerns may be legitimate, but certainly many other works — Nancy Holt's *Sun Tunnels*, Smithson's *Spiral Jetty*, Heizer's *Double Negative*, not to mention such urban works as Robert Morris' *Grand Rapids Project* — all stand unprotected in the landscape and are in no worse condition than *The Lightning Field*. In my various visits to other artworks in relatively remote areas, I have never encountered other visitors, so it seems doubtful that the number of potential visitors to *The Lightning Field*, were access unimpeded, would ever be great enough to endanger the work or the surrounding environment. Restrictions, in this case, seem more an expression of the willful cultivation of mystery.

De Maria's and Dia's efforts to control the viewer's response to the work extend even beyond the circumstances of the visit to include manipulation of information about the work, especially photographs. I have been obliged for several years to play an elaborate game of cat and mouse with De Maria to obtain photographs: photographs for publication were repeatedly going to be available 'sometime soon'. When asked about the possibility of obtaining photographs for this particular essay, the Dia representative inquired about its point of view. When told, she explained that it was 'doubtful that De Maria would want to put his stamp of approval' on it by supplying photographs. While it is true that an artist has full discretion over a work that is not in the public domain, such a demonstration of insecurity about an independent point of view suggests a complete misunderstanding of the nature of criticism, which is never simply intended to parrot the opinions of the artist. Are De Maria and his sponsors so uncertain of the quality of *The Lightning Field* that they cannot let it stand on its own merits? Is it so vulnerable that it cannot withstand the independent opinions of writers?

When De Maria did release photographs for publication in *Artforum,* he exerted considerable control over the way they were used. Working closely with the

magazine's staff and photographer John Cliett, De Maria produced what *Artforum* publisher Amy Baker describes as 'an artist's work' – i.e., pages designed specially by the artist. Acknowledging that it was 'a generous, expensive lay-out', Baker explained that the staff felt that the work was of sufficient interest to warrant an unusual amount of space and expense, and that the publication of the work on the artist's terms seemed essential to the dissemination of the work.

The number of photographs, the exculsive use of colour, the number of editorial pages – De Maria was given the cover plus five pages at the centrefold – is unusual, to say the least, for *Artforum's* artists' pages. But particularly offensive was the use of blank grey pages separating De Maria's photographs from the thereby implied dross of the remainder of the issue. Evidently caught between their desire to see the work published and the artist's excessive demands, *Artforum's* staff was complicit in the mystification of *The Lightning Field* and the exaggerated claims made for it.

Matters of control and access to *The Lightning Field* would be of little concern if they remained limited to this one instance. However, they are of consequence to all artworks in the landscape, for which this work could conceivably become a model. The Dia Center for the Arts, which is, of course, tax exempt and therefore indirectly supported by every taxpayer, has recently received financial support for two projects from the National Endowment for the Arts. A condition of these grants, awarded through the Art in Public Places programme, is that the public have 'free and unimpeded access' to the artwork. One of these projects is Jim Turrell's *Sun and Moon Space*, to be installed in Arizona. Given the stipulations of Endowment support, one hopes that access to the work will not be established on the model of *The Lightning Field*. From a critical perspective, as well, the management of *Lightning Field* is no trivial matter. Not only do the machinations of the artist and his sponsors in this case reveal contempt for the enterprise of criticism, but, more importantly, they call into question the very possibility of a criticism that seeks independence from the controlling factors of any artwork's context.

I wish to acknowledge the support of the National Endowment for the Arts, a federal agency, which provided funds necessary to research this essay through the Art Critics' Fellowships programme.

John Beardsley, 'Art and Authoritarianism: Walter De Maria's *Lightning Field*', *October*, no 16, Cambridge, Massachusetts, Spring 1981, pp. 35-38

Lawrence ALLOWAY
Site Inspection [1976]

This is an article based on visits to the sites of earthworks in Arizona, Novada, Texas and Utah. I am not an enemy of the culture of reproductions, but the documentation of large outdoor sculpture, intimately bound to the landscape, presents exceptional difficulty to photographs. They have their own conventions, for one thing, and for

15. Michael Heizer and Robert Smithson

another, some of the works I suspected were being embalmed in single images. This turned out to be the case. The photographs of Robert Smithson's *Amarillo Ramp* that are usually reproduced were taken when the creek it stands in was dammed up. In fact it belongs half in the water, for Smithson allowed for seasonal variations in the state of his sculptures. He assumed multiple states, not just one. The sculptures by Walter De Maria, Michael Heizer and Smithson that I visited are all site-specific, in that they have been located by the artists in places that are unique to each work. The form of the sculpture cannot be separated from the terrain it occupies (it has zero mobility), and the distances that have to be travelled are a part of the content also. In what follows I shall have to indicate the topography as part of the system of the sculpture.

The discrepancy between site and documentation is inherent in the medium, but it can be used purposefully. For example, to compare Smithson's film the *Spiral Jetty* with the *Spiral Jetty* as it lies in the Great Salt Lake is to experience a startling divergence. Part I of the film deals with the construction of the jetty, but of course what we see in Utah is the end-state of the work. Part II concentrates on vertical views of the jetty, shot from a helicopter which, taken with cues on the soundtrack, emphasize the spiral as a solar form expanding out to spiral nebulae. The movement of the camera is frequently vertiginous, and as the helicopter goes higher and the spiral shrinks, its crystalline structure becomes evident. Thus the film presents us with a disquisition on the morphology of the spiral.

What is it like at Rozel Point? The 15 foot (4.5 m) wide jetty winds its two-and-a-half turns out into the lake for 1,500 feet (450 m), and when you stumble along it on ankle-wrenching loose rock, you feel very close to the water. The ridge behind is low and as the spiral stretches out from the beach, it echoes the far-off line of mountains across the lake. On site, the prevailing impression is of a vast lateral plane expanding from the jetty, embracing miles of water and rock. Thus the film and the object exist in a complementary not an explanatory relationship. (Still photographs of horizontal views are misleading too, because they tend to exaggerate the rockiness of the foreground.)

And there is another factor, not given in the documentation. There have been attempts to drill oil in the area and not far from the jetty are ruined oil rigs, which led Smithson to comment, 'This site gave evidence of a succession of man-made systems mired in abandoned hopes'. On the way to Rozel Point you pass the Golden Spike Monument where, out in a lonely landscape, two locomotives confront one another, face-to-face, on a single track. This stand-off, as it appears to be, actually commemorates the meeting of the rails, built from East and West, of the first transcontinental railroad [...]

The full development of earthworks is inseparable from monumentality, and it is only on this basis that the core works of the movement can be understood. Smithson, Heizer and De Maria have all created large works of long duration and slow use which are the opposite of brief or expendable works.

The problem of monumental art is that in cities it is never big enough. When Barnett Newman's *Broken Obelisk* was set in front of the Seagram Building on Park Avenue it became a twenty-six-foot (793 cm) high small sculpture. This despite the fact that Newman was using well-rehearsed public forms, the pyramid and the obelisk. Earthworks, even at their present scale, would not work in cities either; there is just too much interference from a lively and complex environment. Hence the only place to realize large works is not in the country, exactly, but in Continental America, which is to say in places where there is no prior cultivation, or very little. What is needed is thinly populated states with low real-estate values. Hence the placing of earthworks in Nevada, Utah, Arizona and Texas where, incidentally, the land is usually of no value and can be leased from the government.

Of course, convenience is never the decisive factor, and the fact that the frontier was more recently in the Southwest than in the Northeast is important. To make art on a large scale out of doors it is necessary to command survey procedures and construction techniques. The artist experiences the development of the work as practical control and social co-operation in contrast to the supposed isolation of the city-based 'line' artist. The earthworks artists preserve the purity of their inspiration no less than their specialized peers, but they realize it in terms of engineering. The romanticism of the frontier finds expression in an ethic of physical labour. (Heizer and Smithson have both talked of the satisfactions of work in these terms. Apart from present geological and topographical problems, there is the sanction of the American past, such as the Indian burial mounds; one, the Serpent Mound in Adams County, Ohio, is 1.254 feet [38 cm] long, 20 feet [610 cm] wide on an average, and between 4 and 5 feet [122 and 152.5 cm] high. These long-running, low, indigenous works are certainly a part of the background of ideas that made earthworks possible.)

Heizer, in making *Double Negative*, removed rock and earth, but did not introduce materials from off-site as part of the structure. Smithson, in the *Spiral Jetty* and *Amarillo Ramp*, created finely articulated forms; but he did so with what was at hand, material collected on the shore and carried out into the water. De Maria's *Las Vegas Piece* disturbs the landscape scarcely at all and though the poles of his *First Lightning Field* are imported to the site, they form a fine screen, not a bulky object. Smithson's interest in containing and intersecting forms, Heizer's in the displacement of large masses, and De Maria's in illusive space are each absolutely different, but all are highly responsive to the given terrain. This is because of their realization on that duration and scale are in themselves expressive, and that they are best achieved by works of art that do not compete materially with the landscape. The clear air, the aridity, the absence of trees, the erosional contours, all convey a geological sense of the uncovered landscape, the wilderness to which the sculpture is attuned.

Solitude characterizes the *Spiral Jetty* and the *Double Negative* and *Las Vegas Piece*. Although the works are big, they are in no sense social. They are best experienced singly by spectators; only in that way can there be a proper

acknowledgement of the sense of being alone that these works induce. The remoteness of the sites as well as the scale of the landscape contribute to this effect. Earthworks communicate a cisatlantic sense of the resonantly empty. It is possible that the theme of the American Sublime, associated with Clyfford Still, Newman and Mark Rothko, which certainly has no descendants in current abstract painting, may be present in the tie of earthworks to the land. Though the landscape references of field painting can be over-stressed, the Sublime was assuredly linked to landscape painting in the eighteenth and nineteenth centuries. And it was associated precisely with the kind of sites – mountain, desert, lake – where the earthworks are, and with such states of feeling as solitude [...]

Lawrence Alloway, 'Site Inspection', *Artforum*, New York, October 1976, pp. 49–52

Craig OWENS
Earthwords [1979]

[...] What I am proposing, is that the eruption of language into the aesthetic field – an eruption signalled by, but by no means limited to, the writings of Smithson, Morris, Andre, Judd, Flavin, Rainer, LeWitt – is coincident with, if not the definitive index of, the emergence of Postmodernism. This 'catastrophe' disrupted the stability of a modernist partitioning of the aesthetic field into discrete areas of specific competence; one of its most deeply felt shocks dislodged literary activity from the enclaves into which it had settled only to stagnate – poetry, the novel, the essay – and dispersed it across the entire spectrum of aesthetic activity. Visual artists thus acquired a mine of new material, and the responses ranged from Morris' language *File* and the linguistic conceits of Art & Language and Conceptual Art, to the autobiographical perambulations of narrative or 'story' art and the fundamentally linguistic concerns of performance art, such as that of Laurie Anderson (also an artist who writes). And it is within this massive return of language that Smithson's writings – and his art – are to be located.

It might be objected that artists, and modernist artists in particular, have always written, produced texts which explain their work, expound theoretical positions, engage in discussion or debate with other artists. And that, especially within modernist quarantine, these texts are indeed secondary, appended to and dependent upon visual production. The texts of modernist artists do read more often that not as responses to what had been eliminated from visual practice. They testify to a mounting sense of loss; as painting became more 'pure', the desire for a supplement increased. For the modernist artist, however, writing was not an alternative medium for aesthetic practice; through it, work might be explained, but never produced. So that even if we maintain that these complements to work are essential to its understanding, Malevich's *The Non-Objective World*, Mondrian's *Plastic Art and Pure Plastic Art*, Kandinsky's *Concerning the Spiritual in Art* ... remain statements and not *texts*: 'a text is not a line of words releasing a single "theological"

meaning (the "message" of the Author-God), but a multi-dimensional space in which a variety of writings, none of them original, blend and clash'.¹

Smithson's writings, on the other hand, are indeed texts, dazzling orchestrations of multiple, overlapping voices; as such, they participate in that displacement of literature by the activity of *writing* which also occurs with Barthes, Derrida, Lacan ... This is not, however, the only value of these texts, for they also reveal the degree to which strategies which must be described as *textual* have infiltrated every aspect of contemporary aesthetic production. In his 1973 review of a Frederick Law Olmsted exhibition at the Whitney Museum, Smithson observes that 'the maps, photographs, and documents in catalogue form ... are as much a part of Olmsted's art as the art itself' – which might be applied with equal validity to Smithson's art. I have already mentioned that the Non-site, a 'course of hazards, a double path made up of signs, photographs and maps', is a text. Not only does this complex web of heterogenous information – part visual, part verbal – challenge the purity and self-sufficiency of the work of art; it also upsets the hierarchy between object and representation, 'Is the Site a reflection of the Non-site (mirror), or is it the other way around?'

Significantly, these remarks, which reveal the textuality of the Non-site, occur in a footnote appended to Smithson's text on the *Spiral Jetty*, itself a graphic document inscribed on the surface of the Great Salt Lake. Like the Non-site, the *Jetty* is not a discrete work, but one link in a chain of signifiers which summon and refer to one another in a dizzying spiral. For where else does the *Jetty* exist except in the film which Smithson made, the narrative he published, the photographs which accompany that narrative, and the various maps, diagrams, drawings, etc., he made about it?² Unintelligible at close range, the spiral form of the *Jetty* is completely intuitable only from a distance, and that distance is most often achieved by imposing a *text* between viewer and work. Smithson thus accomplishes a radical dislocation of the notion of point-of-view, which is no longer a function of physical position, but of the *mode* (photographic, cinematic, textual) of confrontation with the work of art. The work is henceforth defined by the position it occupies in a potentially infinite chain extending from the site itself and the associations it provokes – 'in the end I would let the site determine what I would build' – to quotations of the work in other works.

That Smithson thus transformed the visual field into a textual one represents one of the most significant aesthetic 'events' of our decade; and the publication of his collected writings constitutes a challenge to criticism to come to terms with the textual nature of his work, and of Postmodernism in general. That challenge is formidable, since it requires the jettisoning of most of our received notions about art; it can only be acknowledged here. I would however in conclusion like to sketch briefly the critical significance of one issue raised by Smithson's texts, and his work, and that is the allegorical impulse which shapes both. Smithson was not unaware of this impulse. His allegorical reading of the suburban New Jersey industrial landscape begins with a visual epigraph,

Samuel Morse's *Allegorical Landscape*. In a previously unpublished text, 'From Ivan the Terrible to Roger Corman, or Paradoxes of Conduct in Mannerism as Reflected in the Cinema', Smithson acknowledged this impulse, as well as its heretical nature:

'The very word allegory is enough to strike terror into the hearts of the expressive artist; there is perhaps no device as exhausted as allegory. But strangely enough Alan Kaprow has shown interest in that worn-out device. Jorge Luis Borges begins his *From Allegories to Novels* by saying, "For all of us, the allegory is an aesthetic error".'
It was, however, from its exhaustion, its 'erroneous' status, that allegory, for Smithson, derived its aesthetic potential.

I have already described the way in which allegory motivates Smithson's perception of language as material. But it is also manifest in his involvement with entropy and entropic systems; his attraction to both prehistoric and post-industrial ruins; his recognition of the forces which erode and eventually reclaim the work of art, for which the rust on Smith's and Caro's steel sculpture and the disorder of Central Park were taken as emblems. As Benjamin writes:

'The allegorical physiognomy of the nature-history ... is present in reality in the form of the ruin. In the ruin history has physically merged into the setting. And in this guise history does not assume the form of the process of an eternal life so much as that of irresistible decay. Allegory thereby declares itself to be beyond beauty. Allegories are, in the realm of thoughts, what ruins are in the realm of things ... In the process of decay, and in it alone, the events of history shrivel up and become absorbed in the setting.'³

Thus Smithson's desire to lodge his work in a specific site, to make it appear to be rooted there, is an allegorical desire, the desire for allegory. All of Smithson's work acknowledges as part of the work the natural forces through which it is reabsorbed into its setting. When the Great Salt Lake rose and submerged the *Spiral Jetty*, the salt deposits left on its surface became yet another link in the chain of crystalline forms which makes possible the description of the *Jetty* as a text.

This desire to embed a work in its context characterizes Postmodernism in general and is not only a response to the 'homelessness' of modernist sculpture;⁴ it also represents and explains the strategic importance of allegory at this moment in history. For in the arts allegory has always been acknowledged as 'a crossing of the borders of a different mode', an advance of the plastic arts into the territory of the rhetorical arts ... Its intrusion could therefore be described as a harsh disturbance of the peace and a disruption of law and order in the arts'.⁵ Thus allegory marks the dissolution of the boundaries between the arts; by proposing the interchangeability of the verbal and the visual, the integrity of both is compromised. This is why it is an aesthetic 'error', but also why it appears, at present, as the organizing principle of advanced aesthetic practice.

This is not simply a claim that may be made for allegory, but a structural fact. Allegory is traditionally defined, following Quintillian, as a symbol introduced in continuous series, the temporal extension of metaphor. It

is useful to recast this definition in structuralist terms, for then allegory is revealed as the projection of the metaphoric, or static, axis of language onto its metonymic, or temporal, dimension. Although Roman Jakobson defined this projection of metaphor (the synchronic system of differences that defines the structure of a language) onto metonymy (the activity of combination in which structure is actualized in time), as the poetic principle:

'... and while Jakobson goes on to associate metaphor with verse and romanticism, as opposed to metonymy which he identifies with realism and prose, allegory would cut across and subtend all such stylistic categorizations, being equally possible in either verse or prose, and quite capable of transforming the most objective naturalism into the most subjective expressionism, or the most determined realism into the most surrealistically ornamental baroque'.⁶

Yet this capacity to 'cut across and subtend' all aesthetic categories is due to the fact that allegory implicates the two poles, spatial and temporal, according to which the arts were distinguished at the advent of Modernism.

Following the logic of allegory, then, Smithson's work stands as an investigation into what occurs when structure is actualized in time: the *Spiral Jetty*, for example, takes a particular mythic structure – the fiction of an enormous whirlpool at the Lake's centre – and projects it as a temporal experience. This aspect of his practice coincides with the techniques of post-structuralist theory – Derrida's deconstructive reading, for example, or Foucault's archaeology. This correspondence is not simply the result of contemporaneity, for Smithson's activity was a thoroughly *critical* one, engaged in the deconstruction of an inherited metaphysical tradition, which he perceived as more or less ruined. And the success of his enterprise may be measured by the critical rigour with which his relation to inherited concepts is thought in these texts. Yet the failure of contemporary theory, which too often operates in a vacuum, to see its own realization in Smithson's practice is, and remains, a scandal.

1 Roland Barthes, 'The Death of the Author',
 Image/Music/Text, trans. Stephen Heath, Hill and Wang,
 New York, 1977, p. 146

2 See my discussion of Smithson's photographic
 'documentation' of his work in 'Photography *en abyme*',
 October, no 5, Summer 1978, pp. 86-88

3 Walter Benjamin, *The Origin of the German Tragic Drama*,
 trans. John Osborne, NLB, London, 1977, pp. 177-78

4 Rosalind Krauss, 'Sculpture in the Expanded Field',
 October, no 8, Spring 1979, pp. 33-36

5 Carl Horst, 'Barockprobleme', quoted in Benjamin, op.
 cit., p. 208

6 Joel Fineman, 'The Structure of Allegorical Desire',
 unpublished manuscript. Throughout, I am extremely
 indebted to Fineman's psychoanalytic reading of
 allegory.

Craig Owens, 'Earthwords', *October*, no 10, Cambridge,
Massachusetts, Fall 1979, pp. 126-30

Gerry SCHUM

Introduction to the Television-Exhibition: Land Art [1969]

More and more artists today are exploring the possibilities of the relatively new media of film, television and photography. These artists are not concerned primarily with exploiting the possibilities of communication offered by the mass media. A more important consideration, I think, is that the greater part of our visual experience is induced by way of reproduction, with cinematic and photographic representations.

Take Jan Dibbets' *Perspective Correction*, it can only be seen and understood as a photograph. Dibbets drew the outline of a trapezium in the landscape; the shape was constructed according to the laws of photographic perspective, so that on the photograph the trapezium looks like a perfect square. Here the work of art has transferred its existence from a real object as point of departure to the photographic representation. The photograph becomes the actual art object. The objects of Mike Heizer and Walter De Maria, to name just two artists, can only be observed in their entirety, in other words by seeing the film from beginning to end.

The Land Art artists are looking for expressive possibilities which go far beyond the traditional limits of painting. It is no longer the painted view of a landscape but the landscape itself, i.e. the landscape marked by the artist himself, that becomes the art object. The landscape isn't just a decorative background for traditional sculptures any more (the term landscape is broadly interpreted): it has come to mean, here, cityscapes and industrial views as well as nature landscapes. Dr. H. Szeemann, who mounted the 'Live in Your Head' show in the Bern Kunsthalle, refers to a 'consciousness art'.

We live at a time in which the world, i.e. our environment, can be experienced from new dimensions. Satellites enable us to observe the earth from an extra-terrestial viewpoint directly or indirectly via a photographic reproduction. A highway seen from a height of 3,000 metres loses its purely functional character, it becomes a human intervention in the landscape. It is now time that we realize that every grave that is dug, every road that is constructed, every field that is converted into a building-site, represents a formal change in our environment, whose implications transcend by far their purely practical, functional meaning [...]

Gerry Schum, 'Introduction to the Television-Exhibition: Land Art', *Gerry Schum*, Stedelijk Museum, Amsterdam, 1979. Originally broadcast on television 15 April 1969

Walter BENJAMIN

The Work of Art in the Age of Mechanical Reproduction

[1936]

[...] Even the most perfect reproduction of a work of art is lacking in one element: its presence in time and space, its unique existence at the place where it happens to be. This unique existence of the work of art determined the history to which it was subject throughout the time of its existence. This includes the changes which it may have suffered in physical condition over the years as well as the various changes in its ownership.[1] The traces of the first can be revealed only by chemical or physical analyses which it is impossible to perform on a reproduction; changes of ownership are subject to a tradition which must be traced from the situation of the original.

The presence of the original is the prerequisite to the concept of authenticity. Chemical analyses of the patina of a bronze can help to establish this, as does the proof that a given manuscript of the Middle Ages stems from an archive of the fifteenth century. The whole sphere of authenticity is outside technical — and, of course, not only technical — reproducibility.[2] Confronted with its manual reproduction, which was usually branded as a forgery, the original preserved all its authority; not so *vis-à-vis* technical reproduction. The reason is twofold. First, process reproduction is more independent of the original than manual reproduction. For example, in photography, process reproduction can bring out those aspects of the original that are unattainable to the naked eye yet accessible to the lens, which is adjustable and chooses its angle at will. And photographic reproduction, with the aid of certain processes, such as enlargement or slow motion, can capture images which escape natural vision. Secondly, technical reproduction can put the copy of the original into situations which would be out of reach for the original itself. Above all, it enables the original to meet the beholder halfway, be it in the form of a photograph or a phonograph record. The cathedral leaves its locale to be received in the studio of a lover of art; the choral production, performed in an auditorium or in the open air, resounds in the drawing room.

The situations into which the product of mechanical reproduction can be brought may not touch the actual work of art, yet the quality of its presence is always depreciated. This holds not only for the artwork but also, for instance, for a landscape which passes in review before the spectator in a movie. In the case of the art object, a most sensitive nucleus — namely, its authenticity — is interfered with whereas no natural object is vulnerable on that score. The authenticity of a thing is the essence of all that is transmissible from its beginning, ranging from its substantive duration to its testimony to the history which it has experienced. Since the historical testimony rests on the authenticity, the former, too, is jeopardized by reproduction when substantive duration ceases to matter.

And what is really jeopardized when the historical testimony is affected is the authority of the object.[3]

One might subsume the eliminated element in the term 'aura' and go on to say: that which withers in the age of mechanical reproduction is the aura of the work of art. This is a symptomatic process whose significance points beyond the realm of art. One might generalize by saying: the technique of reproduction detaches the reproduced object from the domain of tradition. By making many reproductions it substitutes a plurality of copies for a unique existence. And in permitting the reproduction to meet the beholder or listener in his own particular situation, it re-activates the object reproduced [...]

1 Of course, the history of a work of art encompasses more than this. The history of the *Mona Lisa*, for instance, encompasses the kind and number of its copies made in the seventeenth, eighteenth and nineteenth centuries.

2 Precisely because authenticity is not reproducible, the intensive penetration of certain (mechanical) processes of reproduction was instrumental in differentiating and grading authenticity. To develop such differentiations was an important function of the trade in works of art. The invention of the woodcut may be said to have struck at the root of the quality of authenticity even before its late flowering. To be sure, at the time of its origin a medieval picture of the Madonna could not yet be said to be 'authentic'. It became 'authentic' only during the succeeding centuries and perhaps most strikingly so during the last one.

3 The poorest provincial staging of *Faust* is superior to a Faust film in that, ideally, it competes with the first performance at Weimar. Before the screen it is unprofitable to remember traditional contents which might come to mind before the stage — for instance, that Goethe's friend Johann Heinrich Merck is hidden in Mephisto, and the like.

Walter Benjamin, 'The Work of Art in the Age of Mechanical Reproduction', *Illuminations*, ed. Hannah Arendt, Harcourt Brace, New York, 1968, pp. 222-23. Originally published in *Zeitschrift für Sozialforschung*, no 1, New York, 1936

Joseph MASHECK

The Spiral Jetty Movie [1984]

Robert Smithson's film about the making of his *Spiral Jetty*, 1970, in the Great Salt Lake, informatively conveys a sense of what that magnificent sculpture, difficult of access, is like.[1] But it is also, in itself, a beautiful thing. Smithson's geo-poetic commentary accompanies images of a road, dinosaur skeletons, maps of Atlantis, crusty landscapes and construction equipment, especially dump trucks dumping their loads, in such a natural rhythm that the sculpture seems gradually to grow forth, almost by some developmental necessity on the earth's part.

As a film the movie belongs to the ill-defined category of the 'artistic' documentary, meaning that it demonstrates something and conveys information, but that it does this with a fictive, poetic concreteness, and beautifully. Iconographically, it relates to that

16. Robert Smithson

We live at a time in which the world, i.e. our environment, can be

experienced from new dimensions. Satellites enable us to observe the

earth from an extra-terrestial viewpoint directly or indirectly via a

photographic reproduction. A highway seen from a height of 3,000

metres loses its purely functional character, it becomes a human

intervention in the landscape. It is now time that we realize that

every grave that is dug, every road that is constructed, every field

that is converted into a building-site, represents a formal change in

our environment, whose implications transcend by far their purely

practical, functional meaning.

Gerry SCHUM Introduction to the Television-Exhibition: Land Art, 15 April 1969

contemporary version of the theme of Sisyphus, the dump-truck movie, C. Raker Endfield's practically Greek-tragic *Hell Drivers* (1957; 1961) as well as Clouzot's more famous *The Wages of Fear* (1953), about trucking dynamite, being the memorable examples. In fact, the Sisyphus theme surfaces in a shot where, after the jetty is finished, we follow Smithson from behind (this is the only time we see a person in the film) as he runs its full length, stops, turns around, and jogs back; meanwhile, of course the whole enterprise of laying the heavy stone rubble, load after load, seems Sisyphean, at least until it is seen that Smithson's labours are not in vain after all, that what might have been a massive delusion is really only a 'folly' in the technical sense of landscape-architectural history, with even *that* monumentalized. I say this not to circumscribe the film or limit its meaning, only to provide a mode of entrance into its independent significance.

Towards the beginning of the film Smithson says of the site, 'nothing has changed since I have been here'. The point is not that that surprises him – he was familiar with the geomorphology of the locale, and with geomorphology in general long before – but that it surprises us. Today, when it seems that you cannot be certain that your train will arrive, when the telephone may very well not work, when even the trivial mechanics of life become occasions of chronic anxiety, Smithson stands back calmly and shows us the puny anthill that we are. Even his fascination with the interchangeability of scale in space (as well as in time) only serves to reveal the pacific fact that whether the jetty is as 'big' as a diatom or as 'small' as some nebula might be ultimately incidental, though not because it is only matter of 'pure' form (hardly). And what tough little optimists crystals are – they seem just to grow, pop, and then to stay and stay and stay. Perhaps what the superficial landscape is to sentiment, Smithson's geologic landscape is to the intelligence.

It is particularly appropriate that Smithson's great *Spiral Jetty*, the sculpture itself, I mean, is confronted this way, on film, because one particular film, Antonioni's *The Red Desert* (1964) has had probably more than any other single work of art the effect of awakening an appreciation of the unnoticed decadent beauty of a kind of raw and drab landscape that is really more characteristic of the earth, whether 'virgin' or abused, than we tend, romantically, to imagine. But Antonioni's attitude is quite different from Smithson's: his landscape was made so raw, if not so drab, by the decadent irresponsibility of industrialism, and to share his fascination with the possible picturesqueness of wrecked nature is problematic in a morally different way (finding aesthetic charm in the dilapidation of the human setting, a possibility that haunts Jacob Riis's slum photographs, traces back at least to Whistler's print *The Unsafe Tenement*). Smithson's landscape may look similarly raw and drab, but in its vast geo-historical calm, it leaves Antonioni's North Italian slag-heap world with an aspect of hectic absurdity, of a frantic human scramble that leads back, whatever else we think, to 'square one', whereas Smithson is always sublimely conscious of square one.

The film is inescapably good *qua* film. There is a particularly skillful handling of visual form and structure, especially of visual-verbal analogy. The formal strength

shows in vivid and sustained analogies between the long takes of roadway, early in the film, as the camera charges straight ahead towards what one feels as a real and urgent goal, namely the *site*, then, after a long time, takes a welcome and thrilling bend – between such initial experiences of the road and the subsequent experience of the jetty, with its long, straight approach and the commencement of its curve. All along, and on several planes of time, a counterpoint between the gradually emerging spiral of the jetty and Smithson's verbal commentary manifests the coming-into-being of the sculpture and the film alike, the sculpture being the film's emerging motif, and the film, as it were, the sculpture's 'consciousness'. So much so that even what is not true – for instance, a persistent folk myth that there is a whirlpool in the lake at the mouth of the subterranean river linking it to the Pacific – becomes indispensably significant to the narration. I find these cinematographic strengths significant also in a circumstantial way, to the extent that photography and film are extensions of 'graphic art'. Since the relation between sculpture and printmaking was already discussed by Alberti, in the Renaissance, it is all the more interesting to find Smithson, the sculptor, making a film with true cinematographic strength (meanwhile, some doubt that the *Jetty* itself is sculpture).

It is possible, even likely, that we were not ready for the art of Robert Smithson until we had seen how the earth looks from outer space. This new slant on the earth's puniness and grandeur necessitated adaptations incredibly more severe than the starling aspect of the landscape when first seen from the airplane in the time of Cubism – which the helicopter sequence in this film can be said to recapitulate. As yet only Smithson's art has sufficient sweep and yet also enough contemplative calm to deal with matters of such immensity as they enter the sphere of our real, earthly experience for the first time.

1 For Smithson's account of the making of the film, as well as the *Jetty* itself, see 'The Spiral Jetty', *Arts of the Environment*, 1972; reprinted in *The Writings of Robert Smithson*, ed. Nancy Holt, New York University Press, New York, 1979, pp. 109-16

Joseph Masheck, 'The Spiral Jetty Movie', *Artforum*, no 5, New York, pp. 73-74, revised from an earlier version published in *Artforum*, January 1971; reprinted in *Historical Present: Essays of the 1970s*, UMI Research Press, Ann Arbor, Michigan, 1984, pp. 137-39

Jean BAUDRILLARD
The Hyperrealism of Simulation [1988]

[…] Reality itself founders in hyperrealism, the meticulous reduplication of the real, preferably through another, reproductive medium, such as photography. From medium to medium, the real is volatilized, becoming an allegory of death. But it is also, in a sense, reinforced through its own destruction. It becomes *reality for its own sake*, the fetishism of the lost object: no longer the object

of representation, but the ecstasy of denial and of its own ritual extermination: the hyperreal.

Jean Baudrillard, 'The Hyperrealim of Simulation', *L'Echange symbolique et la mort*; reprinted in *Jean Baudrillard: Selected Writings*, ed. M. Poster, Stanford University Press, Palo Alto, California, 1988

Kate SOPER
Nature/'nature' [1996]

In considering the future of nature, it is difficult not to be struck by the conjuncture at the present time of two influential critiques of modernity whose political prescriptions and agendas are in some ways complementary and overlapping, but which are talking to us about nature in very different ways. I am speaking here of ecology on the one hand and what might broadly be termed 'postmodernist' cultural theory and criticism on the other. Both have denounced the technocratic Prometheanism of the Enlightenment project, and inveighed against its 'humanist' conceptions: ecology on the grounds that this has encouraged an 'anthropocentric' privileging of our own species which has been distorting of the truth of our relations with nature and resulted in cruel and destructive forms of dominion over it; postmodernist theory on the grounds that it has been the vehicle of an ethnocentric and 'imperializing' suppression of cultural difference. Both, moreover, have emphasized the links between the dominion of 'instrumental rationality' and the protraction of various forms of gender and racial discrimination.

Yet while the ecologists tend to invoke 'nature' as an independent domain of intrinsic value, truth or authenticity, postmodernist cultural theory and criticism emphasizes its discursive status, inviting us to view the order of 'nature' as existing only in the chain of the signifier. Nature is here conceptualized only in terms of the effects of denaturalization or naturalization, and this deconstructivist perspective has prompted numerous cultural readings which emphasize the instability of the concept of 'nature', and its lack of any fixed reference […]

In sum, while the ecologist refers to a pre-discursive nature which is being wasted and polluted, postmodernist theory directs us to the ways in which relations to the non-human world are always historically mediated, and indeed 'constructed', through specific conceptions of human identity and difference. Where the focus of the one is on human abuse of an external nature with which we have failed to appreciate our affinities and ties of dependency, the other is targeted on the cultural policing functions of the appeal to 'nature' and its oppressive use to legitimate social and sexual hierarchies and norms of human conduct. Where the one calls on us to respect nature and the limits it imposes on cultural activity, the other invites us to view the nature-culture opposition as itself a politically instituted and mutable construct […]

Let us begin by noting some of the problematic aspects of two prescriptive positions on nature that are often present in the argument of ecological critics.

285

The first is that which invites us to think of 'nature' as a wholly autonomous domain whose so-called 'intrinsic' value has been necessarily and progressively depreciated as a consequence of the intrusive and corrupting activities of the human species. One problem with this rhetoric is that it tends to obscure the fact that much of the 'nature' which we are called upon to preserve or conserve (most obviously the so-called 'natural' landscape) takes the form it does only in virtue of centuries of human activity, and is in an important material sense a product of cultivation or 'cultural construct'. Indeed some would question whether there are any parts of the earth – even its remoter arctic regions and wildernesses – which are entirely free of the impact of its human occupation. If nature is too glibly conceptualized as that which is entirely free of human 'contamination', then in the absence of anything much on the planet which might be said to be strictly 'natural' in this sense of the term, the injunction to 'preserve' it begins to look vacuous and self-defeating [...]

Much that the preservationist and heritage impulse speaks of as 'natural' landscape or seeks to conserve as the encapsulation of a more harmonious order in time – as a more natural past way of living – is the product of class, gender and racial relations whose social origins and sources of discord are disregarded in these retrospections. It is easy, moreover, to be sceptical of such nostalgia for the supposedly more organic and 'natural' order of the past, given how regularly it has figured in the laments of the critics of 'progress'. When, after all, it might be asked, has historical reflection on the present not sought to contrast this to a more fortunate moment in time – to a prelapsarian time-space of 'nature' whether conceived directly in mythical-theological terms as an absolute origin in Eden or Arcadia, or more mundanely and relatively as the utopia of the erstwhile rural stability which has been displaced by modernity? And when has the appeal to 'nature' in this sense not tended to legitimate social hierarchies which needed to be challenged?[1] [...]

There is elitism and phony organicism associated with the urge to environmental and heritage preservation, and one cannot deny the extent to which it is caught up in the same mythologies about 'our' heritage and the 'common land' which have helped to sustain the power and property of those most directly responsible for ecological destruction. Yet, no serious analysis of the contemporary environmentalist impulse can stop short at exposing the ideological dimensions of this response, which is clearly witness to insecurities and dissatisfactions which cannot be dismissed as ecologically irrelevant [...]

Certainly there is no beauty to be had in that blind forgetting of the past which would simply celebrate the incursion of a new motorway as another instance of 'progress', man's mastery over nature, and so on. My point is only that the historical remembrance involved here also requires us not to expunge the record of the human relations which went into the making of the countryside which we now seek to preserve from the destruction of the motorway. Nor should we forget the extent to which our conceptions of the aesthetic attractions and value of the natural world have themselves

been shaped in the course of our interaction with it and must be viewed, at least in part, as reactive responses to its effects. To offer but one very obvious example here, the shift from the aesthetic of the cultivated to that of the sublime landscape, and the Romantic movement into which it subsequently fed, have clearly to be related to the impact of Enlightenment science and industry in knowing and subduing a 'chaotic' nature. Untamed nature begins to figure as a positive and redemptive power only at the point where human mastery over its forces is extensive enough to be experienced as itself a source of danger and alienation. It is only a culture which has begun to register the negative consequences of its industrial achievements that will be inclined to return to the wilderness, or to aestheticize its terrors as a form of foreboding against further advances upon its territory. The romanticization of nature in its sublimer reaches has been in this sense a manifestation of those same human powers over nature whose destructive effects it laments.

Our conceptions, then, of the value and pleasures of the natural world have clearly changed in response to actual human transformations of the environment. They have also been continuously mediated through artistic depictions and cultural representations whose perception of nature has often been partial and politically inflected.[2] We should note, therefore, that the relationship between the aesthetic experience of landscape and its portrayal in art or literature is not one way but mutually determining; and that the political meanings embedded in the latter are both reflective of the actual inscription of social relations within the environment and refracted back into the aesthetic responses to it. Those who refer us to the unmediated aesthetic value of nature should bear in mind how far preferences in nature have, in these senses, been the 'construct' of cultural activity and of its particular modes of artistic representation [...]

If we are to give full due both to the actual history of the making of the environment, and to the contemporary tailoring of 'nature' to modern needs and perceptions, we must inevitably recognize the conceptual difficulty of simply counterposing nature and culture as if they were two clearly distinguishable and exclusive domains. Much which ecologists loosely refer to as 'natural' is indeed a product of culture, both in a physical sense and in the sense that perceptions of its beauties and value are culturally shaped [...]

Ecological argument also needs to be cautious in accepting the classic genderization of nature as feminine, as it does whenever it simply inverts an Enlightenment devaluation of both women and nature as, by association, the exploitable objects of a masculine instrumental rationality in favour of a celebration of the 'maternal' and/or 'virginal' nature which has been rejected and/or violated by her rapacious human son or suitor. This is in part because it reproduces the woman-nature coding which has served as legitimation for the domestication of women and their confinement to the nurturing role (and may overlook the extent to which iconic associations of 'woman' with the land and earth-bound values have served as the prop for national cultures whose actual policies towards women, land ownership and the division

of labour are deeply conservative). It is in part because in the process of symbolic identification it tends to repeat the exclusion of women from 'humanity' and 'culture'. Any eco-politics, in short, which simply reasserts the claims of a feminized space/being of nature against its human dominion is at risk of reproducing the implicit identification of the human species with its male members in its very denunciations of 'human' abuse of 'nature' [...]

We have also, however, to question the coherence of the 'constructivist' rhetoric associated with much postmodernist theory of gender and sexuality – that which refuses, for example, to recognize any extra-discursive natural determinations and seeks to present all supposably natural aspects of human subjectivity as the artefact of culture. This rhetoric informs a good deal of rather glib reference to the 'culturality' of nature, but is perhaps most evident in the argument of those who insist that there is no 'natural' body; that even needs, instincts and basic pleasures must be viewed as the worked-up effects of discourse; and that everything which is presented as 'natural' must be theorized as an imposed – and inherently revisable – norm of culture[3] [...]

Constructivists clearly dislike any reference to 'nature' for fear of lending themselves to biological determinism and its political ideologies. But to take all the conditioning away from nature and hand it to culture is to risk entrapping ourselves again in a new form of determinism in which we are denied any objective ground for challenging the edict of culture on what is or is not 'natural' [...]

Just as some forms of ecological rhetoric about nature can be charged with being too ready to abstract from the political effects of its cultural representation, so the constructivist rhetoric can be accused of being too ready to deny the nature which is not the creation but the prior condition of culture. This is what might be termed nature in the realist sense: the nature whose structures and processes are independent of human activity (in the sense that they are not a humanly created product) and whose forces and causal powers are the condition of and constraint upon any human practice or technological activity, however Promethean in ambition (whether, for example, it be genetic engineering, the creation of new energy sources, attempted manipulations of climatic conditions or gargantuan schemes to readjust to the effects of earlier ecological manipulations). This is the 'nature' to whose laws we are always subject, even as we harness it to human purposes, and whose processes we can neither escape nor destroy [...]

It is an error to suppose that in defending the possibility of an objective knowledge of natural process one is committed to an uncritical acceptance of the 'authority' of science or bound to endorse the rationality of the modes in which its knowledge has been put to use. It is, on the contrary, to seek to further the rational disenchantment with those forms of scientific wisdom and technological expertise which have proved so catastrophic in their impact on the environment. Likewise to pit a religious or mystical conception of nature against these forms of technological abuse is less to undermine

than to collude in the myth of the omnipotence of science: it is to perpetuate the very supposition which needs to be challenged – that because science *can* achieve results which magical interactions with nature cannot, it is always put to work to good effect [...]

What is really needed, one might argue, is not so much new forms of awe and reverence of nature, but rather to extend to it some of the more painful forms of concern we have for ourselves. The sense of rupture and distance which has been encouraged by secular rationality may be better overcome, not by worshipping this nature that is 'other' to humanity, but through a process of re-sensitization to our combined separation from it and dependence upon it. We need, in other words, to feel something of the anxiety and pain we experience in our relations with other human beings in virtue of the necessity of death, loss and separation. We are inevitably compromised in our dealings with nature in the sense that we cannot hope to live in the world without distraining on its resources, without bringing preferences to it which are shaped by our own concerns and conceptions of worth, and hence without establishing a certain structure of priorities in regard to its use. Nor can we even begin to reconsider the ways in which we have been too nonchalant and callous in our attitudes to other life-forms, except in the light of a certain privileging of our own sense of identity and value. All the same, we can certainly be more or less aware of the compromise, more or less pained by it, and more or less sensitive to the patterning of the bonds and separations which it imposes [...]

1 See Raymond Williams' discussion of the relativism of the nostalgia for a lost time/space of 'nature' and of the tendencies of the literary pastoral tradition to 'cancel history', in *The Country and the City*, Hogarth Press, London, 1973, especially pp. 9-45

2 One relevant instance is the way in which a distinction between different types of landscape, and the taste in them, served in the 'civic humanist' aesthetic of the eighteenth century to map - and hence politically legitimate - a supposed difference between social strata. A distinction between the 'panoramic', ideal landscape, and representations of occluded, enclosed landscapes without much depth of field, figured a difference between a refined capacity for thinking in general terms, and a vulgar (and supposedly also female) incapacity to do so, with the taste in the former being associated with the powers of abstraction essential to the exercize of political authority. See John Barrell, 'The public prospect and the private view' in *Landscape, Natural Beauty and the Arts*, ed. Salim Kemal and Ivan Gaskell, Cambridge University Press, Cambridge, 1993, pp. 81-102. See also Barrell's *The Dark Side of the Landscape*, Cambridge University Press, Cambridge, 1980.

3 The major influence on this line of argument has been Foucault, though Foucault is not entirely consistent in what he says about the 'body', and it is debatable how far his account supports those who have drawn on it to deny it any 'naturality' (see, for example, Susan Bordo, 'Anorexia nervosa: psychopathology and the crystallization of culture', in *Feminism and Foucault: Reflections on Resistance*, ed. I. Diamond and L. Quinby,

Northeastern University Press, Boston, 1988, pp. 87-117; M.E. Bailey, 'Foucauldian feminism: contesting bodies, sexuality and identity' in *Up Against Foucault*, ed. C. Ramazanoglu, Routledge, London, 1993, pp. 99-122). The fullest and most sophisticated defence of the 'contructivist' account of the body is to be found in the argument of Judith Butler (see *Gender Trouble: Feminism and the Subversion of Identity*, Routledge, London, 1990; *Bodies that Matter: On the Discursive Limits of Sex*, Routledge, London, 1993).

Kate Soper, Nature/'nature', *Future Natural*, ed. Robertson, Mash, Tickner, Bird, et al., Routledge, London, 1996, pp. 22-34

ARTISTS' BIOGRAPHIES

Carl ANDRE [b. 1935, Quincy, Massachusetts] is best known as a minimalist sculptor and poet. A student of Frank Stella, Andre radically disrupted traditional sculptural practices. Andre's materials included metal plates or ribbon, brick and wood. Works such as *Lever* [1966], composed of a single row of unattached firebricks – Andre described as 'Brancusi's *Endless Column* on the ground instead of in the air'- addresses the relationship of sculpture to the gallery and, by extension, to the environment. For him the 'ideal piece of sculpture is a road': unexpressionistic and without the anti-gravitational illusion of much twentieth-century sculpture. His work was first exhibited in 'Eight Young Artists', Hudson River Museum, Yonkers, New York [1964]. Amongst the many group shows in which Andre has participated is 'Unitary Forms: Minimal Sculpture', the San Francisco Museum of Art [1970]. A major retrospective exhibition of his work was presented at the Solomon R. Guggenheim Museum, New York [1970] and at the Museum of Modern Art, Oxford [1996].

ANT FARM a San Francisco-based group working in architecture, art and media, was founded in 1968 by architects Chip Lord [b. 1944, Cleveland, Ohio] and Doug Michels [b. 1943, Seattle, Washington]; it later expanded to include Hudson Marquez [b. 1946, New Orleans, Louisiana] and other artists and designers. In 1972 they created *House of the Century*, Texas; in 1975 they presented the performances *Media Burn* and *The Eternal Frame*. In *Media Burn* a Cadillac was sent crashing through a wall of burning TV sets; *The Eternal Frame* was a re-enactment of the Kennedy assasination. These works set out to challenge the ideologies of post-war American culture and mass media. Sculptural works include *Citizen's Time Capsule 1975-2000* [1975] and the seminal *Cadillac Ranch* [1974], ten upended Cadillacs half buried in a field alongside Route 66 near Amarillo, Texas. This work, which has been described as a 'requiem for the golden age of the American automobile', has subsequently been featured in advertisements, film and museum shows. '2020 Vision' at the Contemporary Art Museum, Houston, Texas [1973-74] was a site specific survey of their work and influences.

ART & LANGUAGE [Michael Baldwin, b. 1945, Chipping Norton, Oxfordshire; Mel Ramsden, b. 1944, Ilkestone, Derbyshire] was the name given in 1968 to the various collaborative practices developed by Michael Baldwin and Mel Ramsden, with input from Charles Harrison. The name is derived from the journal *Art&Language*, first published in Coventry in 1966, which originated from the work and conversation of Baldwin and Atkinson, together with Harold Hurrell and David Bainbridge. Art & Language was used subsequently to identify the joint works of these four in an effort to reflect the conversational basis of their activity which, by late 1969, already included contributions from Joseph Kosuth, Ian Burn and Mel Ramsden. Amongst their group exhibitions are 'Language II', Dwan Gallery, New York [1968] and 'Knowledge: Aspects of Conceptual Art', Santa Barbara University Art Museum [1992]. Solo exhibitions include Musée Nationale Jeu de Paume, Paris [1993] and Lisson Gallery, London [1994].

Alice AYCOCK [b. 1946, Harrisburg, Pennsylvania] is a New York-based sculptor and installation artist. She has been exhibiting since the early 1970s and is primarily known for large-scale semi-architectural and machine-like projects which address the interaction between structure, site, materials and viewers' responses. Aycock has continuously worked on outdoor sculptures and installations, many of which are permanently sited. For *A Simple Network of Underground Tunnels* [1975] Aycock built six wells connected by underground tunnels just wide enough to crawl through. Once inside the underground structure a person is completely surrounded by concrete and it is impossible to see out. The underground structure is demarcated by a 12 inch wall. In 1996 she created a work for the Sacramento Convention Centre in California, a 200 foot long suspended sculpture with moving parts. Aycock has shown at Documenta 6 [1977] and 8 [1987] and the Venice Biennale [1978, 1980 and 1982]. A solo show of her work was held at Salvatore Ala, Milan [1987] and a retrospective of her work, 'Complex Visions', was held at the Storm King Art Center in Mountainville, New York [1990].

John BALDESSARI [b. 1931, National City, California] trained as a painter but turned towards photography, film, video and artist's books in the mid 1960s. Often appropriating media images or expanding the notion of photo-collage, Baldessari addresses the physical and conceptual limits of the canvas and of the photograph. His works explore, with some irony, how the art 'frame' determines our way of looking at art objects and images. Known for his statement, 'I will not make boring art', his works include *Throwing Three Balls in the Air to Get a Straight Line* [Best of 36 Attempts], a conceptual photopiece also published in book form [1973]. Baldessari's earliest show was 'Uncommon Denominator: 13 San Diego Painters', La Jolla Art Centre, California [1960]. A solo exhibition of his work began touring internationally in 1989 and has been presented, among other venues, at the Museum of Contemporary Art, Los Angeles [1990], the Whitney Museum of American Art, New York [1990] and the Serpentine Gallery, London [1995].

Lothar BAUMGARTEN [b. 1944, Rheinsberg, Germany] is a sculptor and installation artist who draws heavily on archaeology and ethnography. He explores Western systems of classification which identify objects through culturally determined categories and which are often accepted as 'objective truth'. Baumgarten's work is concerned with the relationships between cultures, and how cultures can be displaced through language and alien environments. This was addressed in *AMERICA Invention*, his solo exhibition at the Solomon R. Guggenheim Museum, New York [1993]. *Theatrum Botanicum* [1995] is the garden Baumgarten created for the Fondation Cartier, Paris. Surrounding Jean Nouvel's glass gallery, the garden provides space for nature within an urban environment. The diverse architectural elements and plants which have been introduced into this 'botanical theatre' offer visitors 'the spectacle of nature's fortunes and misfortunes'. Baumgarten's group exhibitions include Documenta 5 [1972], IX [1992] and X [1997] and the Venice Biennale [1978]. Baumgarten has had numerous solo exhibitions such as 'Guyana', Konrad Fischer Gallery, Dusseldorf [1977] and 'Tierra Firme', Instituto Valenciano de Arte Moderno, Valencia [1992].

Herbert BAYER [b. 1900, Haag, Austria, d. 1985, Santa Barbara, California] was an American painter, designer, photographer, typographer and architect. He taught for a brief period at the Bauhaus and then worked as a commercial artist in Berlin. After emigrating to New York in 1938, Bayer was included in a number of important exhibitions at The Museum of Modern Art, New York, amongst them 'Fantastic Art, Dada and Surrealism' [1936] and 'Art and Advertising' [1943]. A forefather of Land Art, Bayer moved to Aspen, Colorado in 1946, where he began working for the Aspen Development Corporation as architect and designer. In 1955 he created two environmental works, *Marble Garden*, a composition of roughly-hewn geometric forms placed around a square pool and fountain, and *Earth Mound*, a conical depression, a small mound and a solitary stone ringed by a low grass ridge. *Mill Creek Canyon Earthworks*, completed in 1982, is a group of earthworks designed as an artwork, drainage system and community gathering place.

Betty BEAUMONT [b. 1946, Toronto] is an artist, environmental planner and feminist whose practice encompasses installation, film, video, photography, environmental projects, text and electronic imaging. She has lived and worked in New York since 1973. Her work is marked by social and ecological concerns, and has been exhibited since the early 1970s. In *Ocean Landmark Project* [1980] Beaumont created an underwater garden [and active fishing ground] which was deposited 40 miles (64 km) outside New York harbour consisting of 17,000 bricks cast from recycled coal fly-ash. In 1989 she made *A Night in Alexandria … The Rainforest … Whose Histories Are They Anyway …*, a 35 foot-long wall of warehouse shelving with a rolling library ladder, the charred remains of over 200 burnt books and an LED text about genetic loss in the rainforest. Her many group exhibitions include 'Fragile Ecologies' at the Queens Museum of Art, New York [1992] and 'Mapping', American Fine Arts Co., New York [1994]. Beaumont has held several solo exhibitions, including 'Toxic Imaging', 55 Mercer Gallery, New York [1987] and 'Changing Landscapes: Art in an Expanded Field', Rochdale Art Gallery, Lancashire [1989].

Joseph BEUYS [b. 1921, Krefeld, Germany, d. 1986, Dusseldorf, Germany] was arguably the most influential figure in the artistic revival of post-war Germany. Promoting a conception of art as integral to everyday life, his practice focused on meetings and discussions as much as on the production and staging of performances, sculptures and installations. Beuys used discarded and found materials in his work as well as his trademark felt and fat; his paintings and drawings are characterized by the use of 'Braunkreutz', a mixture of hare's blood and rust, invented by the artist. One of Beuys' most noted installations is *Eichnen 7,000 (7,000 Oaks)* at Documenta 7 [1982], where the collective planting of 7,000 trees was performed. Between 1961 and 1975 Beuys taught sculpture in Dusseldorf and Hamburg, and in the same period set up two political parties, the German Students' Party [1967] and the Non-Voting Free Referendum Party for Direct Democracy [1970]. Beuys was included in 'When Attitudes Become Form', Kunsthalle, Bern [1969]. He appeared in Documenta 3 [1964], 4 [1968], 5 [1975] and 7 [1982], held performances in galleries both in Europe and America, and represented Germany in the Venice Biennale [1976]. He had numerous solo exhibitions at Galerie Rene Block, Berlin; a major retrospective of his work was held at the Solomon R. Guggenheim Museum, New York [1979].

Doris BLOOM [b. 1954, Vereeningen, South Africa] emigrated from South Africa to Denmark in 1976, where she now lives and works. Her desire to assimilate both European and African influences informs part of her work as a painter and graphic artist. Bloom constructs her work using cultural symbols and language, and often explores landscapes which contain diverse elements in differing scales. Colour, materials and the traces left by the texture of different materials are central to her paintings. Group exhibitions include the National Art Gallery, Beijing, China [1995] and the Johannesburg Biennial [1995]. Bloom's solo exhibitions include Galeria Stefania Miscetti, Rome [1995] and 'Snakes and Ladders', DCA Gallery, New York [1996].

Alighiero BOETTI [b. 1940, Turin, d. 1994, Rome] was an installation and Conceptual Artist associated with the group of Arte Povera artists in Italy. He was particularly interested in collaborative projects and the realization of his pieces often involved other people. Boetti was fascinated by systems of classification and the relationship between chance and necessity, order and disorder. Group exhibitions include 'Arte Povera - Im spazio', Bertesca gallery, Genoa [1967] and an installation with Frédéric Bruly Bouabré at Dia Center for the Arts, New York [1995]. Boetti has had numerous solo exhibitions, the first being in 1967 at the Christian Stein gallery, Turin. A major retrospective of his work was held at Galleria Civica d'Arte Moderna e Contemporanea, Turin [1996].

CAI Guo-Qiang [b. 1957, Quanzhou City, Fujian Province, China] studied Stage Design at Shanghai Drama Institute. From 1986 he lived and worked in Japan, before moving to New York in 1995. He has used a wide range of unconventional materials in his work, most notably gunpowder and Chinese medicine. He creates large-scale outdoor events and indoor installations. His work is richly informed by his Chinese heritage both materially and philosophically. He is also concerned with fundamental questions of our role and place within the infinite expanse of the universe of which the Earth is but a tiny entity. Group exhibitions include 'The Shanghai and Fujian Youth Modern Art Joint Exhibition', Fuzhou City Museum, China [1985] and 'Future, Past, Present' at the Venice Biennale [1997]. Amongst his solo exhibitions are 'Primeval Fireball - The Project for Projects', P3 Art and Environment, Tokyo [1991] and 'Cultural Melting Bath: Projects for the 20th Century', Queens Museum of Art, New York [1997].

Mel CHIN [b. 1951, Houston, Texas] lives and works in New York. Chin's early, highly political sculptures were presented in 'The Operation of the Sun Through the Cult of the Hand' at the Loughelton Gallery, New York [1989]. His political concerns developed to include environmental issues; his first work to address this was *The Condition for Memory*, a series of sculptures commissioned by the New York City Department of Parks and Recreation for the exhibition 'Noah's Art' [1989]. *Revival Field*, begun in 1993 in St. Paul, Minnesota, is an on-going project of land reclamation dependent on the capacity of certain plants to absorb heavy metals through their vascular systems. Chin's ecological and aesthetic concerns have become inseparable and his energies are focused on finding solutions to environmental problems. Chin's work has featured in group exhibitions such as 'Fragile Ecologies', Queens Museum of Art, New York [1992] and 'Fifth Biennial of Havana', National Museum of Fine Arts, Havana [1994]. Solo exhibitions include 'Degrees of Paradise', Storefront for Art and Architecture, New York [1991].

CHRISTO [b. Christo Javacheff, 1935, Gabrovo, Bulgaria] and **JEANNE-CLAUDE** [b. Jeanne Claude de Guillebon, 1935, Casablanca] have been based in New York since 1964. They have worked together since 1961, producing their signature, giant-scale outdoor sculptures, wrapped buildings and natural sites. Works such as *Wrapped Coast* [1969], *Valley Curtain* [1970-72], *Surrounded Islands* [1980-83], *The Pont-Neuf Wrapped* [1975-85], *The Umbrellas* [1991] and *Wrapped Reichstag* [1995] have gained worldwide notoriety. Addressing the obsession with packaging and the transformation of the known into the unknown, Christo and Jeanne-Claude are also recognized for their political and administrative skill in bringing their massively scaled, international projects to light. Their work [then only under Christo's name] has been included in exhibitions such as Documenta 4 [1968] and 'monumenta: Biennale of outdoor sculpture', Newport, Rhode Island [1974]. Solo exhibitions include The Museum of Modern Art, New York [1968] and the Stedelijk Museum, Amsterdam [1973].

Walter DE MARIA [b. 1935, Albany, California] has been associated with Conceptualism, Minimalism, Land Art and installation art since the 1960s. His sculptures and objects confront the viewer's most basic assumptions about art and life, evoking the tension between serenity and anxiety, mathematic order and chaos. His most expansive work, *Lightning Field* [1977], is located on a high plain in southwestern New Mexico, an area with the highest density of lightning in North America. The sculpture is composed of 400 pointed stainless steel rods, spread 220 feet apart and extending one mile by one kilometre. As lightning strikes, the rods ignite, creating a vast net of visible electrical charges. Other major works include *Vertical Earth Kilometer*, Kassel [1977], *New York Earth Room* [1977] and *Broken Kilometer*, New York [1977]. De Maria's first group exhibition was the seminal 'Earthworks' exhibition, Dwan Gallery, New York [1968]. He participated in Documenta 6 [1977] and the Venice Biennale of the same year. He has held solo exhibitions at the Kunstmuseum, Basel [1972] and the Moderna Museet, Stockholm [1989].

herman de vries [b.1931, Alkmaar, The Netherlands] lives and works in Eschenau, Germany. He trained as a horticulturalist and sees his role as a witness to nature. It was the creation of abstract, white and random works in the 1960s which established his association with 'Zero' art. His work is often presented in the form of collections, the largest being *natural relations* [1989] - a collection of several hundred herbs purchased around the world or gathered in the countryside around the artist's home in Bavaria. His exhibitions include 'natural relations with the locked paradise', Karl Ernst Osthaus Museum, Hagen and 'documents of a stream the real works, 1970-1992', Royal Botanic Garden, Edinburgh [1992].

Agnes DENES [b. 1938, Budapest, Hungary] grew up in Stockholm and was educated in New York. Exhibiting since the late 1960s, Denes deals with ecological, social and cultural issues in work which is often monumental in scale and which produces long-term environmental benefits. Denes is perhaps best known for *Wheatfield - A Confrontation* [1982], a two acre wheat field she planted and harvested in downtown Manhattan. 'My decision to plant a wheat field in Manhattan instead of designing just another public sculpture grew out of a longstanding concern and need to call attention to our misplaced priorities and deteriorating human values.' In *Tree Mountain: 10,000 Trees, 10,000 People, 400 Years* [1982], Denes uses the tree as a symbol of community as well as a means to integrate nature and culture; 10,000 silver fir trees were planted by 10,000 people. Her earliest exhibition was at Columbia University, New York [1965]. Group exhibitions include Documenta 6 [1977] and the Venice Biennale [1978, 1980]. Solo exhibitions include 'Perspectives', Corcoran Gallery of Art, Washington, DC [1975]. In 1992 the Herbert F. Johnson Museum at Cornell University presented a retrospective of her work.

Jan DIBBETS [b. 1941, Weert, The Netherlands] is a Conceptual Artist who, since 1967, has produced mainly photo-based work. His work explores the relationship between the eye, the sight of the camera and nature. Exploring what the eye and the

camera can see, Dibbets disturbs conventional belief in the photographic image. In series such as *Perspective Corrections* [1967-69] and *Dutch Mountains* [1971], Dibbets introduced geometric or other recognizable forms into nature which were then photographed as subtly manipulated, natural landscapes. Major group exhibitions have included the seminal group show 'When Attitudes Become Form', Kunsthalle Bern [1969] and Documenta 8 [1982]. Solo exhibitions of Dibbets' work have been held at the Stedelijk Museum, Amsterdam [1972, 1988] and the Solomon R. Guggenheim Museum, New York [1988].

Mark **DION** [b. 1961, New Bedford, Massachusetts] has been based in New York since moving there to study art in 1982. Much of his art practice, whether it takes the form of installation, sculpture, performance or film and video, is an investigation into issues around the representation of nature. Dion questions the history of the natural sciences. In 'On taking a normal situation … ' at MUHKA, Antwerp, Dion presented one of his many site-specific investigations into the notion of biological diversity, *Library for the Birds of Antwerp* [1993]. In a large white circular room of the museum, Dion created a temporary home for eighteen African finches.This work addresses the conflicting interactions between humans and the natural world. An essential aspect of Dion's work has been his frequent collaboration with other artists, scientists and non-art institutions. Dion participated in 'The Fairy Tale: Politics, Desire and Everyday Life', Artists Space, New York [1986] and in Documenta 8 [1987]. Solo exhibitions include 'Frankenstein in the Age of Biotechnology', Galerie Christian Nagel, Cologne [1991] and 'Mark Dion: The Museum of Natural History and Other Fictions', Ikon Gallery, Birmingham [and tour, 1997].

Toshikatsu **ENDO** [b. 1950, Takayama, Gifu Prefecture, Japan] lives and works in Japan. Much of his work consists of circles, squares, cubes and rectangles. These simple forms are reminiscent of Minimalism, but Endo's work does not follow in this tradition. He uses wood, fire and water in many of his works. Fire is often used to burn works in ceremonial events, or it is used in contrast to water contained in hollows in the soil. Endo's work is based on inner ideology bound up with history, mythology and human existence. Amongst his group exhibitions are 'Paper Memorial (Toshikatsu

Endo and Fujio Ngashima)', Tokiwa Gallery, Tokyo [1974] and 'Zones of Love - Contemporary Art from Japan', Museum of Contemporary Art, Sydney [1992]. Solo exhibitions include 'Code of Water I', Lunami Gallery, Tokyo [1975] and 'Earth, Air, Fire, Water - The Sculpture of Toshikatsu Endo', Institute of Contemporary Arts, London [1992].

Harriet **FEIGENBAUM** [b. 1939, New York] began creating site-specific landscape forms using natural materials whilst periodically living on working farms in Italy from 1969 to 1976. Her work, inspired by vernacular architecture, historical overlay and agrarian landscape tradition, culminated in such projects as *Cycles (the haying process)* [1976] at Nassau County Museum of Fine Arts, Roslyn, New York, and *Land Structures Built Where the Petroglyphs are Made by Children*, Artpark, Lewiston [1977]. From 1980 to 1988 Feigenbaum developed reclamation art projects for Pennsylvania's mine-scarred land, an area she first explored in 1965. At Storrs Pitt, Feigenbaum designed three projects - *Serpentine Vineyard* [1982], *Black Walnut Forest* [1983] and *8000 Pines* [1983]. These were conceived of as artworks which would restore fertility to the soil, prevent erosion and restore an ecosystem which had been damaged by the now-abandoned mines. Feigenbaum's work featured in 'The Presence of Nature', Whitney Museum of American Art, New York [1978]. Solo exhibitions include the Pennsylvania Academy of Fine Arts, Philadelphia [1986] and Watson Gallery, Wheaton College, Norton, Massachusetts [1997].

Peter **FEND** [b. 1950, Ohio] is a New York-based artist who founded Ocean Earth Development Corporation in 1980 to produce architectural components and services. The firm pioneered civil satellite monitoring [for the mass media] chiefly of crisis spots and of city-land dynamics for planning. His best-known works include *Earth Net: An Economic System*, exhibited at Caltech [1978] which was later re-made in site-specific form in stone and metal models as *Eurasian Scenario* [1994]. Fend's installation for the Venice Biennale [1993] consisted of an offshore rig suspended above a corridor. On the floor, on both sides, were aeronautical charts indicating where Ocean Earth would introduce an 'Oil-Free Corridor' stretching from Somalia to Iceland. Video monitors running down the centre of the corridor displayed satellite

monitoring of sites along this potentially oil-free, post-fossil fuel region. Ocean-based development projects are being prepared in Montenegro, Tokyo, Genoa, Denmark, Iceland, New Zealand and - based on satellite-derived analysis - Chernobyl. Ocean Earth has participated in Documenta IX [1992] and the Venice Biennale [1993]. Amongst Ocean Earth's solo exhibitions are 'Earth Net, An Economic System', Baxter Art Museum, California [1978] and 'Room Spin', Galerie Roger Pailhas, Paris [1992].

Ian Hamilton **FINLAY** [b. 1925, Nassau, Bahamas] was one of the principal British exponents of concrete poetry in the early 1960s. In 1967 he moved to a croft in the Lanarkshire hills, called Stonypath, which he later named Little Sparta. There Finlay has built a garden which combines texts, often inscribed on stones, with constructions such as sundials and columns, indicating the poet/artist's continual interaction with the garden. Finlay's interests - which range from the French revolution to Greek pre-Socratic philosophers - are expressed in prints, books, cards, sculpture and garden commissions for various sites worldwide. One of Finlay's earliest exhibitions was the 'Cambridge International Exhibition of Concrete Poetry' [1964]. He took part in Documenta 8 [1987] and major solo exhibitions include Deichtorhallen, Hamburg [1995] and Institute of Contemporary Arts, London [1992].

Richard **FLEISCHNER** [b. 1944, New York] creates installations which respond to the particularities and needs of each different environment for which the work is made. *Sod Maze* [1974] was made for 'Monumenta', an outdoor sculpture exhibition in Newport, Rhode Island. A low, mounded turf maze, conceived specifically for the exhibition, this work relates to ancient maze forms once used for penance and purification. In both *Baltimore Project* [1980], created for the densely wooded grounds of the Social Security Administration Centre, Woodlands, Maryland, and a project for the MIT building, Cambridge, Massachusetts [1980-85], Fleischner activates the natural environment through the relationships between individual elements introduced into it. Group exhibitions include 'monumenta: Biennale of outdoor sculpture', Newport, Rhode Island [1974] and 'Earthworks: Land Reclamation as Sculpture', Seattle Art Museum [1979].

Hamish **FULTON** [b. 1946, London] trained as a sculptor, but is known as a photographer and Conceptual Artist. His black and white photographs record his physical and emotional response to the landscape, usually taken during long-distance walks which last from one day to several weeks. The photographs are generally accompanied by a text, which can be mundane, recording the duration or date of the walk or weather conditions - such as *Standing Coyote* [1981] - or more poetic, evoking an emotional response in the viewer. Fulton sees his work as being closely related to the tradition of British landscape painting. Group shows include 'Konception/Conception' at the Stadtisches Museum, Germany [1969] and 'Information' at The Museum of Modern Art, New York [1970]. Solo exhibitions include 'Selected Works 1969-1989', National Gallery of Canada, Ontario [1990] and John Weber Gallery, New York [1996].

William **FURLONG** [b. 1944, Woking, Surrey] is the creator of *Audio Arts*, an audio magazine whose activities include interviews and art events. Furlong's work explores the relationships between objects, space and human meanings. *Objects for Spaces*, selected for 'The Sculpture Show' at the Hayward Gallery, London [1983], in a sense defined *Audio Arts* as falling within the categories of sculpture. *Time Garden* [1993] is made up of twelve trays; the grass seeds and soil in each tray relate to one of the world's twelve time zones. There is a clock on each tray also relating to each time zone. 'The work represents a series of "time tables" which embody the indexing of time, both chronologically as well as through the time scales of natural growth.' *Audio Arts* has been included in Documenta 6 [1977] and IX [1992], and 'HA HA, Contemporary British Art in an Eighteenth Century Landscape', Killerton Park, Devon [1993]. Solo presentations of *Audio Arts* include those at Riverside Studios, London [1980] and the Museum of Modern Art, Oxford [1989].

Avital **GEVA** [b. 1941, Ein-Shemer Kibbutz, Israel] lives and works on the Ein-Shemer Kibbutz in Israel. Geva trained as a painter, but his work has always been closely linked to the land and landscape in which he lives and works. The first exhibition of his paintings [1969] was hung in a citrus orchard; this awareness of his presence in the environment set the tone for all his subsequent projects. In 1970 Geva

set up the Metser-Messer Operation, which organized a group of artists to work in the area between Kibbutz Metser and the neighbouring Arab village, Messer, forging links between local artists, residents and factories. Geva continued to combine political activities with performance and object-based work until 1980 when he devoted himself to the research and development of the greenhouse at Ein-Shemer in collaboration with scientists and young people of the kibbutz. Group shows include 'Art-Society-Art' at the Tel Aviv Museum of Art [1978] and 'Borders' at the Israel Museum, Jerusalem [1980]. In 1993 he represented Israel at the Venice Biennale.

Andy **GOLDSWORTHY** [b.1956, Cheshire] makes ephemeral sculptures in the landscape which he then captures in colour photographs. Goldsworthy's sculptures are made of natural materials such as twigs, leaves, feathers and stones. Changes in season and weather as well as growth and decay are an integral part of the work as the artist responds to nature in a state of flux. 'The photograph does not replace but comes out of the working process and can be as much part of an artist's vocabulary as recorded sound is of a musician's.' Amongst other group exhibitions Goldsworthy has participated in 'Landscape: 10 Exhibitions of Contemporary Landscape in Greater Manchester', Manchester City Art Gallery [1983] and 'Landscape: Place, Nature, Material', Kettle's Yard Gallery, Cambridge [1986]. Solo shows include 'Mountain and Coast: Autumn into Winter, Japan 1987', Gallery Takagi, Nagoya [1987] and 'Hanging Stone', Michael Hue-Williams Fine Art, London [1994].

Hans **HAACKE** [b. 1936, Cologne, Germany] moved to New York in 1965. During the 1960s Haacke was concerned with physical and biological processes; these concerns can be seen in works such as his condensation containers, sealed glass boxes in which trapped water condensed [1963-65]. Later Haacke turned his attention to the forces that shape society and culture, for example his research into property ownership in Manhattan. In 1972 Haacke created *Rhine-Water Purification Plant* at the Museum Haus Lange, Krefeld. Extremely polluted Rhine water was pumped into an acrylic basin; the water was then treated so that the pollutants formed a sediment. The purified water was fed into a large tank containing goldfish; the overflow was pumped into the garden where it joined the ground water

level. Working in a wide variety of media, he has exhibited internationally, including several times at Documenta [1972, 1982, 1987, 1997], where his work has on occasion been censored due to its political nature, and the Venice Biennale [1993]. Solo exhibitions include the Tate Gallery, London [1984] and the Centre Georges Pompidou, Paris [1989].

Helen Mayer **HARRISON** [b. 1929, New York] and Newton **HARRISON** [b. 1932, New York] are both Professors Emeriti at the University of California, San Diego. Their collaborative projects since the early 1970s have often addressed what they call 'left-over spaces and invisible places' through environmentally and socially engaged work. For the Harrisons, the earth is both their material and their medium, although not as a purely aesthetic form. Projects include a conceptual design for the reclamation of Devil's Gate Basin in Pasadena [1987] and *A Wetland Walk for Boulder Creek*, a tertiary treatment for the sewage outfall in Boulder, Colorado, in the early 1990s. The Harrisons' work examines site and terrain-specific problems, often developed alongside ecologists, landscape architects and engineers. In 1993 the Harrisons formed the Harrison Studio with the architectural designers Vera Westergaard and Gabriel Harrison. The Harrisons were included in Documenta 8 in Kassel [1987] and participated in 'Terra Incognito: New Directions in Contemporary Landscape', Rhode Island School of Design, Providence [1990]. Their work has been presented at the Museum of Contemporary Art, Chicago [1980] and the Los Angeles County Museum of Art [1987].

Michael **HEIZER** [b. 1944, Berkeley, California] lives and works in New York and Nevada. Heizer began working as a sculptor, painter and printmaker in the late 1960s, but his most important works are those in the vast deserts of the American west. Many of his early land pieces consisted of moving vast but precise quantities of soil. *Double Negative*, executed in a remote area of the Nevada desert [1969-70], cut two chasms into the rock on either side of a natural valley. Heizer's interventions in the landscape act as mediations between natural and man-made environments. A later series of works, *Effigy Tumuli* [1983-5], reveal a shift in his work, away from his chief concern with geometry to the use of semi-abstract shapes. Heizer's work featured in 'When Attitudes Become Form', Kunsthalle

Berne [1969] and Documenta 6 [1977]. Solo exhibitions include Heiner Friedrich Galerie, Munich [1969] and the Museum of Contemporary Art, Los Angeles [1984].

Nancy **HOLT** [b. 1938, Worcester, Massachusetts] lived and worked in New York City between 1960 and 1995, when she moved to Galisteo, New Mexico. Holt makes films, video tapes and installations as well as site-specific public sculpture. Her sculptures focus primarily on perception, space and ecology and are connected to the typography, psychology and history of each place. Using concrete, brick, stonemasonry, earth and steel, Holt creates structures that simultaneously surround and enclose viewers, whilst also creating a sense of expansiveness through layers of openings and tunnels. Patterns of sunlight and moonlight, astronomical alignments and/or water reflections are intrinsic to many of Holt's sculptures. Among her numerous public art projects are *Sun Tunnels* [1973-6] in the Utah desert, *Catch Basin* [1982] in Toronto, and *Sole Source* [1983] in Dublin. Group exhibitions include 'Language III', Dwan Gallery, New York [1969] and 'Architectural Sculpture', Los Angeles Institute of Contemporary Art [1980]. Holt has had numerous solo exhibitions at John Weber Gallery, New York.

Douglas **HUEBLER** [b. 1924, Ann Arbor, Michigan, d. 1997, Truro, Massachusetts] exhibited paintings for many years. From 1964-67 he produced minimal sculpture which was included in 'Primary Structures' at the Jewish Museum, New York [1966]. During that time he was developing ideas which were resolved in work expressed through a combination of language and image (maps, photographs and drawings). Elements of time, location and social/political systems are the subject matter of this work. In 1981 Huebler embarked on the impossible task of 'photographically documenting the existence of everyone alive', a piece that became an umbrella for a variety of other projects. Group exhibitions include 'Information', The Museum of Modern Art, New York [1970] and 'Reconsidering the Object of Art, 1965-1975', the Museum of Contemporary Art, Los Angeles [1995]. Solo exhibitions include the Boston Museum of Fine Art [1972] and the Palais des Beaux-Arts, Brussels [1994].

Peter **HUTCHINSON** [b. 1930, London] lives and works in Provincetown, Massachusetts. In the late 1960s Hutchinson began

photographing his work made in the landscape and adding descriptive texts to the photographs; the artist refers to these pieces as 'documentations'. Later, in *Paricutin Project* [1970], a volcano piece, and *Foraging* of the same year, the text began to expand until, in the *Narrative* pieces which began in 1972, the texts became more personal and were more obliquely and subtly connected to the photographs. Hutchinson is interested in exploring the relationship between the photographs and texts; looked at separately they convey quite different meanings. Amongst other venues, Hutchinson has exhibited in 'Two Ocean Projects', The Museum of Modern Art, New York [1969] and Museum Haus Lange, Krefeld [1972]. Solo exhibitions include 'Earth, Air, Fire, Water: Elements of Art', Museum of Fine Arts, Boston [1971]. Retrospectives have been held at the Holly Solomon Gallery, New York [1995] and Mayor Gallery, London [1996].

Patricia **JOHANSON** [b. 1940, New York] produced large minimal paintings and sculptures during the 1960s, including the 1600-foot environmental sculpture *Stephen Long* [1968]. Her later work characteristically combines public sculpture with functional infrastructure, such as highways, sewage, garbage and water-treatment plants. *Fair Park Lagoon*, Dallas [1981-6] is one of her projects which combines functional art and ecology. Sculptural paths and bridges provide access to micro-habitats and wildlife, prevent erosion and enhance a flood-control basin. Later projects such as those in the Nairobi River Park and Korean Dragon Park both employ sculptural images filled with wetland plants to filter polluted water and integrate indigenous culture and environments with public landscapes. Johanson has featured in 'Sculpture for Public Spaces', Marisa del Re Gallery, New York [1986] and 'Different Natures', La Defense Art Galleries, Paris [1993]. Solo exhibitions include 'Patricia Johanson: Some Approaches to Landscape, Architecture and the City', Montclair State College, New Jersey [1974] and 'Patricia Johanson: Public Landscapes', Painted Bride Art Centre, Philadelphia [1991].

William **KENTRIDGE** [b. 1955, Johannesburg] originally studied Politics and African Studies at the University of the Witwatersrand, Johannesburg, before becoming involved with theatre and, eventually, visual art. His practice covers

film and video as well as drawing - whether in the landscape, on paper or on black boards. Kentridge is concerned with both physical geography and the geography of experience in his work, which is inextricably bound up with his country and its politics. 'I am interested in political art, that is to say an art of ambiguity, contradiction, uncompleted gestures and uncertain endings.' Group exhibitions include Documenta X [1997] and the Havana Biennale [1997]. Solo exhibitions include Goodman Gallery, Johannesburg [1994] and Stephen Friedman Gallery, London [1998].

Richard **LONG** [b. 1942, Bristol] is a sculptor, photographer and Conceptual Artist. Much of his work consists of the activity of walking; these walks often last many days and take him to remote parts of the world, places unmarked by human presence. His maps and black and white photographs are a visual record of these walks. In many of his early pieces Long left ephemeral marks on the landscape, making sculptures with natural materials found in the environment. *A Line Made by Walking* [1967] is a photograph of a line left in the grass by repeatedly walking back and forth in a straight line. During the 1970s, with pieces such as *Slate Circle* [1979], Long started to produce sculptures in gallery spaces, bringing his experience of nature back into the museum or gallery. He also started to make mud paintings with his hands directly onto the gallery walls. Although his work is strongly linked to the British landscape tradition, the work's meaning lies in the visibility of his actions rather than representations of a landscape. Long distinguished himself from American artists working in the landscape by the lightness of his intervention in environment, both an ethical and aesthetic principle. Long participated in 'Earth Works', Virginia Dwan Gallery, New York [1968] and was included in Documenta 5 [1972]. Solo exhibitions include Museum of Modern Art, Oxford [1971] and 'Walking in Circles', Hayward Gallery, London [1991].

Gordon **MATTA-CLARK** [b. 1942, New York, d.1978, New York] was the son of the Surrealist painter Roberto Matta and grew up in the company of Marcel Duchamp, Max Ernst and the group of Abstract Expressionists in New York. A former student of architecture at Cornell University, New York, he became known for his 'cuttings', interventions he carried out on buildings. His work was not an

attempt to re-animate ruins, but to allow them to function in a different way by opening them up to the urban space. He was not concerned with turning the buildings into monumental sculpture, but in revealing aesthetic, philosophical and social problems. In order to document his work, he became a highly innovative photographer and experimental filmmaker. Solo exhibitions include 112 Greene Street Gallery, New York [1972] and Staadtische Kunsthalle, Dusseldorf [1979]. Group exhibitions include Documenta 5 [1972] and X [1997] and the Venice Biennale [1980].

Cildo **MEIRELES** [b. 1948, Rio de Janeiro, Brazil] creates installations using a variety of materials, combining spectacle with issues of mortality and cultural difference. His installation *How to Build Cathedrals* [1987], consisted of a floor covered with 60,000 coins, a column of communion wafers and a roof of bones. Solo exhibitions include IVAM, Valencia, Spain [1995] and the Institute of Contemporary Arts, Boston [1997]. His work has been seen in numerous group exhibitions including 'Magiciens de la Terre', Centre Georges Pompidou, Paris, and '20 Anos de Arte Brasileira', Museu de Arte Moderna, São Paulo [1994].

Ana **MENDIETA** [b. 1948, Havana, Cuba, d. 1985, New York] was sent to the United States in 1961 as part of the ill-fated Operacion Peter Pan for Cuban exiles. This forced separation from her homeland and her family had a fundamental impact on her work. While still studying at the University of Iowa she started making performance pieces which combined ritual, performance and spiritual references. Mendieta's *Silueta* series, carvings and earthworks made in natural landscapes, developed an original formal and sculptural language informed by the artist's specific culture and autobiography, but which transcended these to express fundamental human concerns. From 1980 to 1985 she started to develop a three-dimensional sculptural vocabulary using leaves, tree trunks, mud and sand in stylized figurative woks. Mendieta's work featured in 'Latin American Artists of the XXth Century' at The Museum of Modern Art, New York [1993] and was also included in 'Feminin-masculin, le sexe de l'Art', Centre Georges Pompidou, Paris [1993]. Retrospective exhibitions include the New Museum of Contemporary Art, New York [1987] and Fondacio Antoni Tapies, Barcelona [1997].

Mary **MISS** [b. 1944, New York] is a sculptor, draughtsman, filmmaker and environmental artist who lives and works in New York. Since the 1970s she has played a leading role in redefining public sculpture and the possibilities for sculptures sited in the landscape. Her work explores the relation of constructed forms to landscape, in terms of both the physical and the cultural settings. In 1987 she completed *South Cove*, an architectural landscape design on a piece of landfill at Battery Park City, New York. The work draws on natural and historical aspects of the cove. In 1996 she started working on renovating the 14th Street Union Square Subway Station in New York, and the La Brea Tar Pit site in Los Angeles. Also in 1996 Miss constructed a collaborative project, *Greedwood Pond: Double Site*, a demonstration wetland in Des Moines, Iowa, in the grounds of the Des Moines Art Center. Amongst her group exhibitions are 'Sitings', La Jolla Museum of Contemporary Art, California [1986] and 'More than Minimal: Feminism and Abstraction in the '70s', Rose Art Museum, Brandeis University, Waltham, Massachusetts. Solo exhibitions include the Architectural Association, London [1987] and 'Mary Miss: Photo Drawings', Des Moines Art Center, Des Moines, Iowa [1996].

Robert **MORRIS** [b. 1931, Kansas City, Missouri] lives and works in New York. His oeuvre covers a wide range of different practices, including performance, painting, sculpture and earthworks. From 1965 Morris exhibited large, conceptually inspired pieces such as *Untitled*, wooden cubes faced with Plexiglas mirror. Moving away from the constraints of conventional media, Morris created experimental anti-form works using ephemeral materials such as felt, mirrors, textile and waste products, steam and dirt. He also started to work directly in the landscape, creating his first earthwork, *Observatory*, in 1971. Morris' primary concerns were the physical and psychological conditions of viewing; the scale of his land pieces provoke an awareness of the viewing experience as both spatial and temporal. *Sculpture off the Pedestal*, in Belknap Park, Michigan [1973-74] continued Morris' exploration of art which responds to the landscape in which it is sited rather than simply set arbitrarily into it. During the 1980s Morris returned to drawing and painting, moving away from his concerns with the phenomenology of the work of art. Group exhibitions include 'Sculpture, American Directions

1945-1975', Smithsonian Institution, Washington DC [1975] and the Venice Biennale [1980]. A solo show at Dilexi Gallery, San Francisco [1957] was one of Morris' earliest exhibitions. Other solo exhibitions have been held regularly at Leo Castelli Gallery, New York.

Christian Philipp **MÜLLER** [b. 1957, Biel, Switzerland] lives and works in New York. He makes both installations and performance works, using historical references to question the conditions of artistic production and reception. In his work *A Balancing Act* [1997], Muller commented on the transformation of the Friedrichsplatz in Kassel, the square in front of Documenta's main building, the Friedericianum, by the construction of an underground car park. This has permanently altered Beuys *7,000 Oaks* [1972] and De Maria's *Vertical Earth Kilometer* [1967]. Group exhibitions include 'Theatregarden Bestiarium', P.S. 1, New York [1989] and Documenta X, Kassel [1997]. Solo exhibitions include 'Kleiner Fuhrer durch die Ehem', Kunstakademiegebaude, Dusseldorf [1984] and 'Was nahe liegt ist doch so fem', Kunstverein Hamburg [1997].

Viet **NGO** [b. 1952, Vietnam] came to the United States in 1970 to study civil engineering and studio arts. He began making large-scale sculptures in granite, marble and wood in 1983, but subsequently turned to environmental art and art in public spaces. Ngo founded a company to promote a 'green' wastewater treatment technology, the Lemna System, which he helped develop; this system allowed him to put into practice his ideas about infrastructure and art. 'The Lemna facilities are designed as green corridors, or punctuation marks, in the general urban landscape.' His best-known work, *Devils Lake Wastewater Treatment Plant* [1990], located in Devil's Lake, North Dakota, is a functioning treatment facility purifying 3.5 million gallons of wastewater a day through serpentine channels covered with a bright green mat of duckweed plants. Ngo's group exhibitions include 'Public Interventions', Institute of Contemporary Arts, Boston [1994] and 'Both Sides', Smithsonian Institution, Washington DC [1996]. Solo exhibitions include 'Sewage and Sculpture: The Lemna Project', Steenslund Gallery, College of St Olaf, Northfield, Minnesota [1990] and 'Viet Ngo: Large Scale Sculptures', Forum Gallery, Minneapolis, Minnesota [1989].

Isamu NOGUCHI [b. 1904, Los Angeles, California, d. 1988, New York] grew up in Japan and travelled extensively, settling in numerous cities around the world at various stages in his life. Noguchi is known primarily for his carved abstract sculptures of stone, marble and aluminium. His work draws on both Eastern and Western aesthetics to create an individual vocabulary. He has worked on a number of murals - *History of Mexico*, Mexico City [1936] - and reliefs - Associated Press Building, New York [1940]. After designing the famous paper lamps for Knoll in the 1940s, Noguchi designed theatre sets for Martha Graham, George Balanchine, Merce Cunningham and John Gielgud. He also worked on a number of garden plans - UNESCO Gardens, Paris [1956-58] - and playground facilities - United Nations Playground, plans rejected [1952-53]. Noguchi participated in '14 Americans', The Museum of Modern Art, New York [1946] and represented the US at the 1986 Venice Biennale. He has held a number of retrospective exhibitions, including The Museum of Modern Art, New York [1947] and the Whitney Museum of American Art, New York [1968 and 1980]. In 1986 his studio in Long Island City, New York became the Noguchi Garden Museum.

Dennis OPPENHEIM [b. 1938, Electric City, Washington] has lived and worked in New York since 1967. His artistic output has encompassed Land and Conceptual Art as well as Body Art; there is often a performative element to his pieces. He has been exhibiting his conceptual, site-specific and installation work since the late 1960s. *Directed Seeding - Cancelled Crop* [1969] was a field of wheat planted according to a specified pattern: a huge cross shape was harvested out of the grown crop. 'Planting and cultivating my own material is like mining one's own pigment [for paint] - I can direct later stages of this development at will.' In 1979 Oppenheim started making what he called Factories, machine constructions similar to the work of Jean Tinguely. He has exhibited at Documenta 6 [1977] and the Venice Biennale [1980]. Solo shows have been presented at The Museum of Modern Art, New York [1969] and the Rijksmuseum Kroller-Muller, Otterlo [1996].

PLATFORM, founded in 1983, is a London-based interdisciplinary group dedicated to provoking desire for an ecological and just society. Bringing together artists and people from specific communities and specialists from other disciplines, PLATFORM aims to enable a creative collaboration which will open the door to a change of perception. *Still Waters* [1992] raised the question of unearthing London's lost rivers; *Homeland* [1993] brought together live interview, drawing, photography and video to test connections between those who produce and those who consume. *Delta* [1993] engaged a hydro-engineer, a sculptor and an economist with the local community to place a micro-hydro turbine in the very degraded river Wandle to act as a reminder that the valleys of London were once self-sufficient. *90% CRUDE* [begun in 1996] is a project investigating the implications of the world's continuing oil dependency.

Richard SERRA [b. 1939, San Francisco, California] is a sculptor who lives and works in New York. In the late 1960s Serra produced a number of works which centred on the manipulation of lead generated by his *Verb List* [1967], a series of verbs that served as a simple task list. The works, such as *Splash Piece* [1968], are the result of self-evident processes. These sculptural pieces and Serra's austere films of the same period indicate his obessession with the performance of tasks within a real space-time continuum. In the 1970s Serra's work was increasingly directed towards contingency; by using mass-produced industrial materials the artist could divest the art object of the aura of uniqueness and timelessness. His minimal and site-specific works, many of which are permanently sited, also draw on the vocabulary of landscape and architecture. Group exhibitions include the early 'From Arp to Artswager I', Bellamy/Goldowsky Gallery, New York [1966] and 'Maximal Implications of the Minimal Line', Bard College, Annandale-on-Hudson, New York [1985]. Serra's solo exhibitions include Galleria La Salita, Rome [1966] and Kunsthalle, Basle [1988].

Bonnie SHERK [b. New Bedford, Massachusetts] lives and works in New York and San Francisco. She is an environmental designer, educator and artist who was a pioneer in bringing the experience of nature to an urban population. Sherk is perhaps best known for *Crossroads Community (The Farm)*, an urban farm and community environmental education and arts centre, which Sherk founded in 1974 and directed until 1980. Located on nearly seven acres adjacent to the intersection of several motorway overpasses in San Francisco, *The Farm* featured domestic animals and vegetable and flower gardens. It also included a pre-school and facilities for performance events, dances and community gatherings. Sherk has expanded ideas first developed in *The Farm* through collaborations with architects and engineers to design large and interactive Life Frames™, also known as Living Libraries® of cultural and ecological diversity. These works aim to bring about an understanding that 'culture and technology are also a part of nature'. Group exhibitions include 'The Four' at De Saisset Museum, Santa Clara, California [1973] and 'Out of Action: Between Performance and the Object', Museum of Contemporary Art, Los Angeles [1998]. A solo exhibition of Sherk's work, 'Projects and Plans', was held at the Civic Center, San Francisco [1996].

Kazuo SHIRAGA [b. 1924, Amagasaki City, Hyogo Prefecture, Japan] lives and works in Japan. Shiraga was a member of the Gutai group, an experimental art group founded in Osaka in 1954. Shiraga experimented with many different forms of painting, using diverse implements: fingers, nails, the palms of his hands, pieces of wood. In 1954 he began making 'action paintings' by scattering paint on the canvas with his feet. From 1965 he consistently applied two methods in his work: one consisted of rapidly tracing the outline of a circle with a piece of wood; the other consisted of perfecting his pictorial technique with his feet. His desire to open up new possibilities through the integration of body and spirit led him to enter the Buddhist priesthood at Enryaku Temple, Mt Hiei in 1971. Amongst his group exhibitions are 'Exhibition of International Contemporary Art', Bridgestone Museum, Tokyo [1957] and 'Gutai Group', Gallery of Modern Art, Rome [1990]. Shiraga has held many solo exhibitions, amongst them Galerie Stadler, Paris [1962] and Galerie Nothelfer, Berlin [1992].

Charles SIMONDS [b. 1945, New York] lives in New York. He began working in the streets of New York's Lower East Side in the early 1970s, creating dwelling places for an imaginary civilization of 'Little People'. Much of his work has a strongly fantastical character, but the histories of these little people are Simonds' evocation of twentieth-century man. Simonds became a member of the Lower East Side Coalition for Human Housing and worked with community groups on park playlots and Sweat Equity housing projects. Simonds has created hundreds of minature landscapes, often made of clay, in cities throughout the world, from New York to London, Berlin, Shanghai, Paris, Genoa, Zurich and Los Angeles. Simonds constructed a large-scale circular dwelling of earth and seeds which converted from shelter to food as the plants matured, as well as participating in the development of inner city parks. Simonds participated in the '8e Biennale de Paris' [1973] and in Documenta 6 [1977]. He has had solo exhibitions at the Solomon R. Guggenheim Museum, New York [1983] and the Musée Nationale Jeu de Paume, Paris [1995].

Buster SIMPSON [b. 1942, Saginaw, Michigan] has made mixed and multi-media projects, performances and site-specific installations. Since the 1970s Simpson has focused on publicly sited projects, addressing ecology and society, often bringing environmental issues to an urban context. Simpson's projects can be found on public sites throughout the United States. For *Host Analogue*, at the Oregon State Convention Center, Simpson placed a windfall fir trunk in the midst of an otherwise immaculately ordered landscape. This trunk acts as a 'nurse log', slowly decomposing and simultaneously becoming a host for newly sprouted seedlings. Amongst Simpson's group exhibitions are 'Flint Area Exhibition', Flint Institute of Arts, Michigan [1963] and '2-D/3-D', Seattle Art Museum [1989]. Solo exhibitions include the Centre for the Visual Arts, Portland and the Hirshhorn Museum, Washington, DC [1989].

Robert SMITHSON [b. 1938, Rutherford, New Jersey, d. 1973, Amarillo, Texas] worked primarily as a painter until 1964 when he began to write and sculpt. His early sculptures bore close affinities to Minimalist works; *The Eliminator* [1964] made of mirrors and neon lights, plays with an illusion of space. From 1966 Smithson regularly visited urban, industrial and quarry sites in New Jersey, and in 1968 he began a series of Non-site works which marked his involvement with Land Art, of which he became one of the leading exponents. After Non-sites, Smithson turned to a series of large-scale outdoor projects. *Spiral Jetty*, on the shore of the Great Salt Lake, Utah [1970], is the best known of these works. *Spiral Hill* [1971] in an old quarry at Emmen, Holland, was the

only work of Smithson's to combine reclamation and art. Smithson participated in the seminal exhibition 'When Attitudes Become Form', Kunsthalle Berne [1969] and in Documenta 5 [1972]. Solo exhibitions include Dwan Gallery, New York [1970] and John Weber Gallery, New York [1976].

Alan SONFIST [b. 1946, New York] lives in New York. In all his work Sonfist's concerns are related to humankind's interaction with and preservation of the environment. From the early 1960s Sonfist developed the idea of Time Landscape™, which reintroduces indigenous flora and fauna into a reclaimed urban site. Incorporating an area's natural and cultural histories, these landscapes are monuments to nature, commemorating the heritage of nature just as the history of heroes and events is commemorated. Sonfist has created many of these landscape works, including *Time Landscape*™, Greenwich Village, New York [1978], *Timeline*, Duisberg, Germany [1981] and *Natural/Cultural Landscape of Tampa*, Florida [1995]. Sonfist participated in 'Invisible Image', School of Visual Arts, New York [1969] and Documenta 6 [1977], amongst other group exhibitions. He held a retrospective at the National Collection of Fine Arts, Washington DC [1978]; other solo exhibitions include the Diane Brown Gallery, New York [1986].

James TURRELL [b. 1943, Los Angeles, California] initially studied psychology and mathematics. In his first installation works he used cross-projected halogen lights, creating illuminated geometric shapes which interacted with the bare interior of the space and with the world outside. Using light as material, Turrell creates perceptual experience rather than representations of the artist's experience. He exploits the physical characteristics of the environments in which he works, both in terms of the symbolic and emotional qualities, and in terms of the natural contours and materials of the site. The infinite scale and duration of nature is addressed in much of his work. Turrell has participated in '3D into 2D', New York Cultural Center [1973] and 'American Exhibition', Art Institute of Chicago [1982]. Solo exhibitions include Stedelijk Museum, Amsterdam [1976] and Kunsthalle Basel [1987].

Mierle Laderman UKELES [b. 1939, Denver, Colorado] has dedicated her art practice to reclaiming both waste materials and waste environments in an effort to create a new relationship with our material world. Her work consists of the activities of selecting, performing and maintaining. From 1973 to 1979 she performed a series of works in SoHo, New York, in which she cleaned pavements and museum floors and performed duties of museum guards. In 1977 she became affiliated with the New York City Department of Sanitation, a residency which led to a series of works which include both permanent sites and performances. *Flow City* is an ongoing project begun in 1983 at a recycling plant on West 59th Street and the Hudson River. *A Blizzard of Release* and *Agitated Materials in Flux* [1993], Taejon, Korea, are permanent installations created out of an assortment of discarded materials. Amongst other exhibitions Ukeles has featured in 'Maintaining NYC in Crisis: What Keeps NYC Alive?', Whitney Museum of American Art, New York [1976] and 'Uncommon Sense', Museum of Contemporary Art, Los Angeles [1997]. Solo exhibitions include 'Mikva Dreams', Franklin Furnace, New York [1977] and 'Garbage! The History and Politics of Trash in New York', New York Public Library, New York [1994].

Meg WEBSTER [b. 1944, San Francisco, California] is a leading American sculptor. She is best known for her elegant, geometric earthworks that extend the minimalist tradition by incorporating materials such as tree branches, dirt, flowers, water, straw, salt, moss, stones and wax. Her work is an exploration of humankind's relationship with the natural world, and more specifically the desire to 'tame' or 'capture' it. Webster's career was launched through an early exhibition, 'Two Walls: Meg Webster', organized by Donald Judd in New York in 1983. Webster participated in the Whitney Biennale, Whitney Museum of American Art, New York [1989] and 'The Material Imagination', Solomon R. Guggenheim Museum, New York [1995]. Amongst her solo exhibitions are 'Three Sculptures in Three Materials', Mattress Factory, Pittsburg [1984] and 'Blue Sky', Morris Healy Gallery, New York [1997].

AUTHORS' BIOGRAPHIES

Lawrence **ALLOWAY** [1926-90] was a writer and critic. During the early 1950s he organized exhibitions and discussions at the Institute of Contemporary Arts in London where he was involved in the formation of the Independent Group in 1952, whose members are generally credited with the establishment of British Pop Art. Alloway was critical of the idea of autonomous, disinterested artworks oriented around an exclusive notion of aesthetic quality. He was interested in the implications of new mass media and its products in terms of both general culture and art practice. His publications include *Abstract Expressionists* [1954] and *American Pop Art* [1974].

George **BAKER** is a critic, theorist and historian of twentieth century art. He is a regular contributor to *Artforum*, *October*, *Texte zur Kunst*, *TRANS* and the *Performing Arts Journal*. He did his PhD work in the art history department at Columbia University, New York.

J.G. **BALLARD** is an English novelist. He spent the early years of his life in China, where his father was a businessman. After the attack on Pearl Harbor in 1941, he was placed with his family in a civilian prison camp. Returning to England in 1946, he read medicine at Cambridge University. After working on a number of scientific journals, he published his first novel, *The Drowned World* in 1961. Other works include *High-Rise*, *Crash* and the semi-autobiographical novel, *Empire of the Sun* which won the 1984 Guardian Fiction Prize and was later filmed by Stephen Spielberg.

Stephen **BANN** is Professor of Modern Cultural Studies at the University of Kent. His publications include *Interpreting Contemporary Art* [1991] and numerous studies on Ian Hamilton Finlay.

John **BARRELL** is a Professor of English at the University of Sussex. He has written on the representation of landscape in art and literature including *The Idea of Landscape and the Sense of Place, 1730-1840* [1972].

Jean **BAUDRILLARD** lives and works in Paris and is a leading philosopher of Postmodernism. Baudrillard's first published writings appeared in Sartre's *Les Temps Modernes*. He has also contributed

regularly to *Libération* and has published many books on cultural theory, including *The Object System* [1968] and *Simulations* [1981].

John **BEARDSLEY** is a critic, curator and teacher based in Washington, DC. He has been a consultant to the Corcoran Gallery of Art and to the Visual Arts programme of the National Endowment for the Arts in America. Amongst his published works are *Probing the Earth: Contemporary Land Projects* [1977] and *Earthworks and Beyond* [1989].

Walter **BENJAMIN** [1892-1940] is a key figure in twentieth-century cultural theory. His influential texts include 'The Author as Producer' [1934] and 'The Work of Art in the Age of Mechanical Reproduction' [1936]. The numerous essays which he wrote throughout his life have been published in collections including *Illuminations* [1928].

Guy **BRETT** is a London-based critic and curator and has been writing on art and organizing exhibitions since the early 1960s. Brett was art critic for *The Times* of London from 1964-75 and Visual Arts Editor for the London weekly *City Limits* in the early 1980s. His published work includes *Through Our Own Eyes: Popular Art and Modern History* [1986], *Exploding Galaxies: The Art of David Medalla* [1995] and *Mona Hatoum* [Phaidon Press, 1997]. He has curated numerous exhibitions including 'Helio Oiticia', Whitechapel Art Gallery, London [1969] and 'Transcontinental: Nine Latin American Artists' at Ikon Gallery, Birmingham and Cornerhouse, Manchester [1990].

Julia **BROWN** is a Senior Curator at the Museum of Contemporary Art, Los Angeles. Her publications include *Michael Heizer, Sculpture in Reverse* [1984].

Edmund **BURKE** [1729-97] was an Irish statesman, essayist and philosopher. His greatest contribution to philosophy was his *Philosophical Inquiry into the Origin of Our Ideas of the Sublime and the Beautiful* [1756]. Later in his career Burke turned more towards politics, lending his support to both the American and Irish wars for independence.

Jack **BURNHAM** [b. 1931] is Associate Professor of Art at Northwestern University. He has written extensively on contemporary art in such articles as 'Real Systems of Art', *Artforum* [1968]. He is the author of *Beyond Modern Sculpture* [1968], *The Structure of Art* [1971] and *Great Western Salt Works: Essays on the Meaning of Post-Formalist Art* [1974]. He has also written on Duchamp and the narrative structure of Western art.

Rachel **CARSON** [1907-64] was an American naturalist and writer. She published many articles on natural history in the *New Yorker* and in many other journals. She also published novels, amongst them *Silent Spring* [1963] and *The Sea Around Us* [1989].

John **COPLANS** co-founded and edited *Artforum* from 1962, first in Los Angeles, then in New York, and also founded *Dialogue* [1971]. He was a curator and director at the Pasadena Art Museum, California [1967-71] and the Akron Art Museum, Ohio [1978]. Coplans wrote art criticism between 1962 and 1981, publishing articles, interviews and catalogue introductions, his subject matter ranging from *Brancusi* [1980] to Pop Art – he was also a contributer to *Andy Warhol* [1970]. He has carried out continuous research into photography and is himself an artist who works with self-portraiture and photography.

Guy **DEBORD** [1931-94] was a French cultural theorist and filmmaker, part of the Situationist International group. His seminal work is *Society and the Spectacle* [1967], in which he argued that the economic system by which we live has produced a false image of itself in order to dominate society; the consumer is seduced by imagery. Debord wished to achieve a total critique of art, through which he hoped to see art integrated into everyday life.

Richard **DEMARCO** is Professor of European Cultural Studies at Kingston University, London. Formerly based in Edinburgh, where he ran the Demarco Gallery, he was also involved with the Edinburgh Festival. Demarco introduced Britain to Joseph Beuys in the 1960s, before the artist was well-known outside Germany.

Michael **FEHR** is the director of the Karl

Ernst Osthaus-Museum of the city of Hagen, a post he has held since 1987. He has worked and published widely on contemporary art, the culture of worker-emigrants, city planning and the theory of museums. His books include *Umbau der Stadt: Beispiel Bochum* [1975] and *Das Deutsche Museum fur Kunst in Handel und Gewerbe* [1977].

Michel **FOUCAULT** [1926-84] was a French philosopher, social scientist and historian of ideas. He wrote frequently for French newspapers and magazines and published several books which profoundly influenced contemporary thought, including *The Order of Things* [1966] and *The History of Sexuality* [Volume 1, 1981, Volume 2, 1990].

Sigmund **FREUD** [1856-1939] was the founding father of psychoanalysis. He was a founding member of the International Association of Psychoanalysis and established a number of psychoanalytic journals. Freud, who spent his life in Vienna, was instrumental in defining the modern understanding of human nature and motivation, and his theories have been widely used in relation to the interpretation of art, in particular *The Interpretation of Dreams* [1900] and his analyses of Leonardo da Vinci and Michelangelo.

Michael **FRIED** was one of a group of American art critics close to Clement Greenberg in the early 1960s who used Greenberg's theories of Modernism as a point of departure for their own work. Fried has published widely in journals and catalogues. His most famous essay is 'Art and Objecthood', published in *Artforum* in 1967, in which Fried argued that the painting and sculpture of Minimalism were made using techniques and effects not in the domain of art, with the result that the artist became more concerned with considerations of presentation and address, resulting in objects which were not pure 'art'. Books include *Courbet's Realism* [1990] and *Absorption and Theatricality: Painting and the Beholder in the Age of Diderot*.

Kenneth **FRIEDMAN** is an artist who has written numerous essays for art magazines and journals. He also makes artist's books, amongst them *The Aesthetics* [1972] and

After Fluxus [1991].

Stephen Jay GOULD is Professor of Geology and Zoology at Harvard University, Cambridge, Massachusetts. He is primarily a palaeontologist and evolutionary biologist, but also teaches geology and the history of science. His publications include *Ever Since Darwin: Reflections in Natural History* [1980] and *Eight Little Piggies* [1994].

Donna HARKAVY is an independent curator based in New York. Amongst the exhibitions she has curated is 'Sculpture Inside Outside', Walker Art Center, Minneapolis [1988]. She has contributed regularly to *Arts Magazine* and has written numerous essays for exhibition catalogues, including an essay on plants in *Alan Rath: Plants, Animals, People, Machines* [1995].

Alanna HEISS has been Director of P.S. 1 Museum, New York, since 1976, and is also President of the New York Institute for Contemporary Art. Her publications include the exhibition catalogue *Dennis Oppenheim, Selected Works 1967-90* [1990].

Dave HICKEY [b. 1937] is an Associate Professor of Art Criticism and Theory at the University of Nevada, Las Vegas. He has served as Executive Editor of *Art in America* magazine in New York, and as Staff Songwriter for Glaser Publications in Nashville, Tennessee. He has contributed to most major American cultural publications. Publications include *The Invisible Dragon: Four Essays on Beauty* [1993]; *Prior Convictions* [1989], a volume of his short fiction; *Air Guitar: Essays on Art & Democracy* [1997]; and a collection of cultural essays *Simple Hearts* [1997].

John Brinckerhoff JACKSON [1909-96] taught at the University of California, Berkeley. His teaching centred on an understanding of the American people in relation to their environment. A writer and scholar, he founded *Landscape*, a journal of human geography, in 1951.

Jack KEROUAC [1922-69] was an American novelist. After his first novel, *The Town and the City* [1950], he turned from conventionally structured writing to 'spontaneous prose'. His principal works are quasi-autobiographical. Following publication of *On the Road* [1957], Kerouac emerged in public consciousness as the spokesman of the Beat Generation.

Rosalind KRAUSS [b. 1940] is Professor of Art History at the City University of New York, and co-editor of the journal *October*; she is also an independent curator. Krauss did much to introduce Clement Greenberg's modernist criticism to a more academic environment, as well as developing the premises of that criticism. However, by the early 1970s Krauss was increasingly aware of the inability of Greenbergian Modernism to address the growing diversity of contemporary culture. She is the author of numerous reviews, articles and catalogue essays including *Passages in Modern Sculpture* [1977], *The Originality of the Avant Garde and Other Modernist Myths* [1985] and *The Optical Unconscious* [1993].

Bruce KURTZ is an art critic and Professor of Fine Arts at Hartwick College. He is especially known for writing articles and essays on video art which have appeared in publications such as *Art in America* and *Arts Magazine*. Kurtz also authored *Spots: The Popular Art of American Television Commercial Directors* [1977].

Kate LINKER is an independent critic based in New York. She contributes frequently to *Artforum* and *Flash Art* as well as other international art journals. She is author of *Love for Sale: The Words and Pictures of Barbara Kruger* and *Vito Acconci* [1994].

Lucy R. LIPPARD [b. 1937] is a freelance writer, curator and activist currently based in New Mexico. She is the author of seventeen books on contemporary art, and has published many articles, reviews and catalogue essays. Lippard has curated exhibitions internationally – among them 'Issue: Social Strategies by Women Artists', Insitute of Contemporary Arts, London [1980] – made political art and performances, and written on a variety of subjects including Conceptual Art, Feminist Art, public art, multiculturalism, land and place. Through her writings Lippard has brought attention particularly to women artists working within the discourses of Land and Body Art. Her books include *Six Years: The Dematerialization of the Art Object* [1973] and *The Lure of the Local* [1997].

Thomas MCEVILLEY [b. 1939] teaches at Rice University, Houston, Texas. He is a contributing editor of *Artforum* and has published articles, catalogue essays and reviews in the field of contemporary art. He has also written monographs on Yves Klein,

Jannis Kounellis and Anish Kapoor; theoretical texts include *Art and Discontent: Theory at the Millennium* [1991] and *Art and Otherness: Crisis and Cultural Identity* [1992].

Joseph MASHECK teaches at Hofstra University, New York. He was an editor of *Artforum* in the late 1970s. Publications include *Marcel Duchamp in Perspective*. He has also written on the subject of flatness in art, particlarly in relation to the work of Robert Ryman and Michelangelo.

Fumio NANJO [b. 1949] is an independent Japanese curator and critic and a lecturer at Keio University, Tokyo. He has served as a juror for the Carnegie International, Pittsburgh [1991]; the Guggenheim's Hugo Boss Award, New York [1996]; and the Turner Prize at the Tate Gallery, London [1998]. He is also the 1998 Commissioner of the Taipei Biennale. Nanjo's articles have been published in numerous art publications including *Les Cahiers* [Centre Georges Pompidou], *Flash Art* and *Art Asia-Pacific*.

Claes OLDENBURG [b. 1929] is one of the principal artists of Pop Art and lives and works in New York. Beginning in 1961 with *The Store*, he set up, in succession, *Home*, *Electrical and Mechanical Objects* and *the Car*; for each of these themes Oldenburg created an environment in his studio of giant objects and soft sculptures. He has featured in group exhibitions such as 'New Forms/New Media I', Martha Jackson Gallery, New York [1960] and 'American Art in the Twentieth Century', Martin-Gropius-Bau, Berlin [1993]. His solo exhibitions include 'Claes Oldenburg: An Anthology', National Gallery of Art, Washington DC [1995].

Craig OWENS [1950-90] was an American critic whose theories are crucial to the critical debate surrounding Postmodernism. From 1979-80 he was Associate Editor at *October* and during the 1980s was Editor of *Art in America*. His seminal text, 'The Allegorical Impulse: Towards a Theory of Postmodernism', was originally published in *October* in 1980. A book of his collected writings, *Beyond Recognition*, was published in 1992.

Uvedale PRICE [1747-1829] was an English landowner and writer. He was a leading exponent of the Picturesque, a quasi-aesthetic theory of landscaped nature. Price argued that the Picturesque described

a category not contained within the polarities of the Sublime and the Beautiful established by Edmund Burke earlier in the century. In 1810 Price's collected writings were published in three volumes.

Harold ROSENBERG [1906-78] was an American critic and teacher. A contemporary of Clement Greenberg, Rosenberg's theory of modernist painting ran in opposition to the Greenbergian line. Rosenberg's argument that the aesthetic became subordinate to the event in action painting coloured the reception of Abstract Expressionism, especially in Europe. He was art critic for the *New Yorker* magazine, and edited *Locations* during the 1960s and 1970s. He wrote numerous catalogue texts on Barnett Newman and books including *The Anxious Object* [1966] and *Art on the Edge: Creators and Situations* [1976].

Anne-Marie SAUZEAU BOETTI married Alighiero Boetti in 1964 and collaborated with him for over twenty years. She is a teacher, writer and curator who has contributed to magazines and reviews such as *Il Manifesto* and *Data*.

Simon SCHAMA [b. 1945] is a historian, writer and broadcaster. He is Old Dominion Foundation Professor of the Humanities at Columbia University, New York. He has published widely; his books include *Citizens* [1989] and *Landscape and Memory* [1998]. Schama also makes television documentaries.

Gerry SCHUM [1938-73] was a critic and pioneer in the realm of video art in Germany. His *Ferrisehgalerie* [Television Gallery] worked with artists to make works for television and broadcast the television-exhibition 'Land Art' on 15 April 1969. Featuring eight works by eight artists, this was the first 'exhibition' titled 'Land Art'. The second exhibition, 'Introduction to TV Exhibition II: Identifications', was broadcast by Sudwestfunk Baden-Baden on 30 November 1970. An exhibition catalogue, *Gerry Schum*, was published by the Stedelijk Museum, Amsterdam [1979].

Willoughby SHARP [b. 1938] was the co-founder and editor of *Avalanche* in the early 1970s, and curator of the seminal 'Earth Art' exhibition at the Andrew Dickson White Museum, Cornell University, New York [1969], one of the first exhibitions to use this term. *Avalanche* featured interviews

Fujiko **SHIRAGA** [b. 1928, Osaka, Japan] is an artist who lives and works in Japan. She was a member of the avant-garde Japanese Gutai group until 1961.

Kate **SOPER** is a Senior Lecturer in Philosophy at the University of North London, and has worked as a journalist and translator. She has published widely in the field of cultural history.

Nancy **SPERO** is an artist who lives and works in New York. She is a vocal advocate of feminism and has published articles in magazines and journals. Like her art, Spero's writings are markedly political, confronting such issues as the Vietnam war and feminism. Spero's many exhibitions include a retrospective at the Institute of Contemporary Arts, London [1987].

Henry David **THOREAU** [1817-62] was an American essayist and poet whose work centred on the study of nature. He published several books, including the American classic *Walden* [1854], as well as a collection of poetry, *Poems of Nature* [1869].

Sidney **TILLIM** is a painter and writer living in New York. A contributing editor to *ARTS Magazine* and *Artforum*, he also curated 'The Work of Art After the Age of Mechanical Reproduction' [1992]. In 1996 he co-curated 'Photographs in Ink', an exhibition which surveyed the history and aesthetics of the photomechanical processes of reproduction.

Jane **TOMKINS**, Professor of English at Duke University, is a writer and editor. She is author of *Sensational Designs: The Cultural Work of American Fiction, 1790-1860* [1985].

Guy **TORTOSA** played a key role in French cultural decentralization during the 1980s. As Senior Visual Arts Officer at the Ministry of Culture in France, he is responsible for public art. He has been particularly concerned with instigating important monumental art projects.

Diane **WALDMAN** was the Deputy Director of the Solomon R. Guggenheim Museum, New York [1965-96]. She curated over thirty exhibitions ranging from de Kooning to Ryman and wrote many catalogue essays, the most recent being on Jenny Holzer [1989].

Octavio **ZAYA** is a critic, editor and curator based in New York. He is Associate Editor of *Atlantica*, published by the Museum Centro Atlantico de Arte Moderno, Canary Islands; Consulting Editor of *NKA Journal of Contemporary African Art*, New York; and a US correspondent of *Flash Art*. Exhibitions he has curated include 'Black Looks, White Myths', Africa Museum, 1st Johannesburg Biennale [1995], and 'In/Sight: African Photographers, 1940-present', Solomon R. Guggenheim Museum, New York [1996].

BIBLIOGRAPHY

Adrian, Dennis, 'Walter De Maria: Word and Thing', *Artforum*, no 5, New York, January 1967, pp. 28-29

Aldiss, Brian, *Earthworks*, Doubleday and Co., New York, 1966

Alloway, Lawrence, 'Site Inspection', *Artforum*, no 15, New York, October 1976, pp.49-55

_____, 'Robert Smithson's Development', *Artforum*, no 11, New York, November 1972, pp. 52-61

Anderson, Wayne, *American Sculpture in Process: 1930-1970*, New York Graphic Society, Boston, 1975

Andrews, Malcolm, *The Search for the Picturesque*, Stanford University Press, Stanford, 1989

Ashton, Dore, 'Exercises in Anti-Style: Six Ways of Regarding Un, In and Anti-Form', *Arts Magazine*, no 43, New York, April 1969, pp. 45-47

Auping, Michael, 'Hamish Fulton: Moral Landscapes', *Art in America*, no 71, New York, February 1983, pp. 87-93

_____, 'Michael Heizer: The Ecology and Economics of Earth Art', *Artweek*, Oakland, California, no 8, June 18, 1977, p. 1

_____, *Common Ground: Five Artists in the Florida Landscape*, John and Mable Ringling Museum of Art, Sarasota, 1982

Bachelard, Gaston, *The Poetics of Space*, Beacon Press, Boston, 1969

Baker, Elizabeth, 'Artworks on the Land', *Art in America*, no 64, New York, January-February 1976, pp. 92-96

Barrell, John, *The Idea of Landscape and the Sense of Place, 1730-1840*, Cambridge University Press, Cambridge, 1972

Battcock, Gregory, ed., *The New Art: A Critical Anthology*, E.P. Dutton Inc., New York, 1966

_____, *Minimal Art: A Critical Anthology*, E.P. Dutton Inc., New York, 1968

_____, *Idea Art*, E.P. Dutton and Co., New York, 1973

Bateson, Gregory, *Mind and Nature: A Necessary Unity*, Bantam, New York, 1980

Baudrillard, Jean, *For a Critique of the Political Economy of the Sign*, Telos Press, St.Louis, 1980

_____, *Selected Writings*, ed. Mark Poster, Stanford University Press, Stanford, 1988

Bear, Liza; Nancy Holt, 'Robert Smithson's Amarillo Ramp', *Avalanche*, no 8, New York, Summer-Fall 1973, pp. 16-21

Beardsley, John, 'Art and Authoritarianism: Walter De Maria's Lightning Field',

October, no 16, Cambridge, Massachusetts, Spring 1981, pp. 35-38

_____, *Probing the Earth: Contemporary Land Projects*, Hirshhorn Museum and Sculpture Garden, Smithsonian Institution Press, Washington, DC, 1977

_____, *Earthworks and Beyond: Contemporary Art in the Landscape*, Abbeville Press, New York, 1989

_____, 'James Pierce and the Picturesque Landscape', *Art International*, no 23, New York, November-December 1979, pp. 6-15

_____, 'Charles Simonds: Extending the Metaphor', *Art International*, no 22, New York, February 1979, pp. 14-19; 34

Benjamin, Walter, *Illuminations*, trans. Henry Zohn, Harcourt, Brace and World, New York, 1968

Berger, John, *About Looking*, Pantheon, New York, 1980

Berger, Maurice, *Labyrinths: Robert Morris, Minimalism and the Sixties*, Harper & Row, New York, 1989

Berry, Wendell, *The Gift of Good Land: Further Essays Cultural and Agricultural*, North Point, San Francisco, 1981

Bongartz, Roy, 'It's Called Earth Art - And Boulderdash', *The New York Times Magazine*, February 1, 1970, pp. 16-17; 22-30

Borden, Lizzie, 'Three Modes of Conceptual Art', *Artforum*, no 10, New York, June 1972, pp. 68-71

_____, 'The New Dialectic', *Artforum*, no 12, New York, March 1974, pp. 44-51

Borges, Jorge Luis, *Selections*, Dutton, New York, 1981

Bourdieu, Pierre, *Outline of a Theory of Practice*, trans. Richard Nice, Cambridge University Press, New York, 1977

Bourdon, David, 'Walter de Maria: The Singular Experience', *Art International*, no 12, New York, December 20, 1968, pp. 39-43; 72

_____, *Christo*, Harry N. Abrams, New York, 1972

_____, *Designing the Earth: The Human Impulse to Shape Nature*, Harry N. Abrams Inc., New York, 1995

Bourgeois, Jean Louis, 'Dennis Oppenheim: A Presence in the Countryside', *Artforum*, no 2, New York, October 1969, pp. 77-82

Burnham, Jack, *Great Western Salt Works*, George Brazillier, New York, 1974

_____, 'Robert Morris: Retrospective in Detroit', *Artforum*, no 8, New York, March 1970, pp. 67-75

Cameron, Eric, 'Drawing Lines in the Desert: A Study of North American Art', *Studio*

International, no 180, London, October 1970, pp. 150-55

Carson, Rachel, *Silent Spring*, Houghton Mifflin, Boston, 1962

Castle, Ted, 'Art in its Place', *Geo 4*, New York, September 1982, pp. 64-75

_____, 'Nancy Holt: Siteseer', *Art in America*, no 70, New York, March 1982, pp. 84-91

_____, 'Charles Simonds: The New Adam', *Art in America*, no 71, New York, February 1983, pp. 94-103

Causey, Andrew, 'Space and Time in British Land Art', *Studio International*, no 193, London, March-April 1977, pp. 122-30

Celant, Germano, *Arte Povera*, Praeger, New York, 1969

Chipp, Herschel B, ed., *Theories of Modern Art: A Source Book by Artists and Critics*, University of California Press, Berkeley and Los Angeles, 1969

Clark, Kenneth, *Landscape into Art*, rev. ed., Harper & Row, New York, 1976

Clay, Grady, 'Earthworks Move Upstage', *Landscape Architecture*, no 70, Washington DC, January 1980, pp. 55-57

Collingwood, R.G., *The Idea of Nature*, Oxford University Press, New York, 1945

Compton, Michael; David Sylvester, *Robert Morris*, The Tate Gallery, London, 1971

Cohen, Arthur, *Herbert Bayer: The Complete Work*, MIT Press, Cambridge and London, 1984

Coomaraswamy, Ananda K., *The Transformation of Nature in Art*, Dover, New York, 1937

Coplans, John 'Robert Smithson: The Amarillo Ramp', *Artforum*, no 12, New York, April 1974, pp. 36-45

Crandell, Gina, *Nature Pictorialized: 'The View' in Landscape History*, Johns Hopkins University Press, Baltimore, 1993

Damisch, Hubert, *The Origin of Perspective*, trans. John Goodman, MIT Press, Cambridge and London, 1994

Davis, Douglas, 'The Earth Mover', *Newsweek*, New York, No 84, January-February 1976, pp. 92-96

_____, 'Last Flight', *Newsweek*, no 82, New York, August 1973, p. 52

De Certeau, Michel, *The Practice of Everyday Life*, The University of California Press, Berkeley and Los Angeles, 1984

De Maria, Walter, 'Statement', *Minimal Art: A Critical Anthology*, ed. Gregory Battcock, E.P. Dutton and Co., New York, 1968

_____, 'Conceptual Art', *Arts Magazine*, no 46, New York, May 1972, pp.39-43

_____, 'The Lightning Field', *Artforum*, no

18, New York, April 1980, pp. 51-59

De Tocqueville, Alexis, *Journey to America*, trans. George Lawrence, Yale University Press, New Haven, 1960

Dillard, Annie, *An American Childhood*, Picador, London, 1989

Driscoll, Edgar J, 'Back to Nature', *Artnews*, no 73, New York, September 1974, pp. 80-81

Eagleton, Terry, *Ideology: An Introduction*, Verso, London, 1991

'Earth', *Progressive Architecture*, no 48, New York, April 1967, entire issue

Ehrenzweig, Anton, *The Hidden Order of Art*, University of California Press, Berkeley and Los Angeles, 1967

Evernden, Neil, *The Social Creation of Nature*, Johns Hopkins University Press, Baltimore and London, 1992

Fein, Albert, *Frederick Law Olmstead and the American Environmental Tradition*, George Braziller, New York, 1972

Fernsehgalerie, *Gerry Schum: Land Art*, Fernsehgalerie Gerry Schum, Hannover, 1970

Field, Simon, 'Touching the Earth: Simon Field Examines the Work of Richard Long', *Art and Artists*, no 8, London, April 1973, pp. 14-19

Fineberg, Jonathan, 'Theater of the Real: Thoughts on Christo', *Art in America*, no 67, New York, December 1979, pp. 92-99

Foote, Nancy, 'Drawing the Line', *Artforum*, no 14, New York, May 1976, pp. 54-57

_____, 'The Anti-Photographers', *Artforum*, no 15, New York, September 1976, pp. 46-54

_____, 'Long Walks', *Artforum*, no 18, New York, Summer 1980, pp. 42-47

Fowkes, William, *A Hegelian Account of Contemporary Art*, UMI Research Press, Ann Arbor, 1981

Frankenstein, Alfred, 'Christo's "Fence", Beauty or Betrayal?', *Art in America*, no 64, New York, November-December 1976, pp. 58-61

Friedman, Bruce Jay, 'Dirty Pictures', *Esquire*, no 75, New York, May 1971, pp. 112-17; 142

Fry, Edward, 'Robert Morris: The Dialectic', *Arts Magazine*, no 49, New York, September 1974, pp. 22-24

Gasset, Ortega y, *Revolt of the Masses*, W.W. Norton, New York, 1957

_____, *The Dehumanization of Art*, Doubleday and Co., New York, 1956

Giedion, Siegfried, *The Eternal Present: The Beginnings of Architecture*, Pantheon Books, New York, 1964

Gilbert-Rolfe, Jeremy; Johnston, John, 'Gravity's Rainbow and the Spiral Jetty', Part 1,

October, no 1, Cambridge, Massachusetts, Spring 1976, pp. 65-85; Part 2, *October*, no 2, Cambridge, Massachusetts, Summer 1976, pp. 71-90; Part 3, *October*, no 3, Cambridge, Massachusetts, Spring 1977, pp. 90-101

Gilpin, William, *Three Essays: On Picturesque Beauty; on Picturesque Travel; and on Sketching Landscape*, London, 1803

Glueck, Grace, 'Danger on 57th Street', *The New York Times*, New York, April 13, 1969, p. D33

Goldberg, Roselee, *Performance Art: From Futurism to the Present*, Harry N. Abrams, Inc., New York, 1988

Grand Rapids Project: Robert Morris, Grand Rapids Art Museum, Grand Rapids, Michigan, 1975

Gruen, John, 'Michael Heizer: You Might Say I'm in the Construction Business', *Artnews*, no 76, New York, December 1977, pp. 96-99

Gunter, Virginia, ed., *Earth, Air, Fire, Water: Elements of Art*, Museum of Fine Arts, Boston, 1971

Guthrie, Woody, *Bound for Glory*, E. P. Dutton, New York, 1943

Haraway, Donna, *Primate Visions: Gender, Race, and Nature in the World of Modern Science*, Routledge, New York, 1989

Harrison, Charles, 'Some Recent Sculpture in Britain', *Studio International*, no 177, London, January 1969, pp. 26-33

Harrison, Helen Mayer and Newton, *The Lagoon Cycle*, Herbert F. Johnson Museum of Art, Cornell University, Ithaca, 1985

Heidegger, Martin, *The Question Concerning Technology and Other Essays*, trans. William Lovitt, Harper & Row, New York, 1977

Heizer, Michael et al., 'Discussions with Heizer, Oppenheim, Smithson', *Avalanche*, no 1, New York, Fall 1970, pp. 48-71

_____, 'The Art of Michael Heizer', *Artforum*, no 8, New York, December 1969, pp. 32-39

_____, Michael Heizer, Museum Folkwang, Essen; Rijksmuseum Kroller Muller, Otterlo, 1979

_____, *Michael Heizer/Actual Size*, Detroit Institute of Arts, Detroit, 1971

Henri, Adrian, *Total Art*, Oxford University Press, New York and Toronto, 1974

Herrera, Hayden, 'Michael Heizer Paints a Picture', *Art in America*, no 62, New York, November-December 1974, pp. 92-94.

Herrera, Hayden, 'A Way of Thinking Out Loud: The Drawings of Robert Smithson', *Art in America*, no 62, New York, September-October 1974, pp. 98-99

Hobbs, Robert, ed., 'Earthworks: Past and Present', special issue *Art Journal*, no 42, New York, Fall 1982, pp.192-233

Hobbs, Robert, ed.; Lawrence Alloway, John Coplans and Lucy R. Lippard, et al., *Robert Smithson: Sculpture*, Cornell University Press, Ithaca, 1981

Holt, Nancy, 'Hydra's Head', *Arts Magazine*, no 49, New York, January 1975, pp. 57-59

_____, 'Nancy Holt: Pine Barrens', *Avalanche*, no 11, New York, Summer 1975, p. 6

_____, 'Sun Tunnels', *Artforum*, no 15, New York, April 1977, pp. 32-37

_____ *The Writings of Robert Smithson*, New York University Press, New York, 1979

Howett, Catherine, 'New Directions in Environmental Art', *Landscape Architecture*, no 67, Washington DC, January 1977, pp. 38-46

Hunt, John Dixon, *Gardens and the Picturesque: Studies in the History of Landscape Architecture*, MIT Press, Cambridge and London, 1992

Hutchinson, Peter, 'Earth in Upheaval: Earth Works and Landscapes', *Arts Magazine*, no 43, New York, November 1968, 19-21

Jackson, John Brinckerhoff, *Discovering the Vernacular Landscape*, Yale University Press, New Haven, 1984

_____, *A Sense of Place, a Sense of Time*, Yale University Press, New Haven, 1994

Johnson, Ellen H, *Modern Art and the Object*, Harper & Row, New York, 1976

Johnston, John; Jeremy Gilbert-Rolfe, 'Gravity's Rainbow and the Spiral Jetty', Part 1, *October*, no 1, Cambridge, Massachusetts, Spring 1976, pp. 65-85; Part 2, *October*, no 2, Cambridge, Massachusetts, Summer 1976, pp. 71-90; Part 3, *October*, no 3, Cambridge, Massachusetts, Spring 1977, pp. 90-101

Jussim, Estelle; Elizabeth Lindquist-Cock, *Landscape as Photograph*, Yale University Press, New Haven, 1985

Kant, Immanuel, *Observations of the Feeling of the Beautiful and the Sublime*, 1764, trans. John T. Goldthwait, University of California Press, Berkeley, 1989

Kardon, Janet, 'Janet Kardon Interviews Some Modern Maze Makers', *Art International*, no 20, New York, April-May 1976, 64-68

Kelley, Jeff, ed., *Allan Kaprow: Essays on the Blurring of Art and Life*, University of California Press, Berkeley and Los Angeles, 1993

Kepes, Gyorgy, *The New Landscape in Art and Science*, Paul Theobald and Co., Chicago, 1956

_____, *Structure in Art and Science*, George Brazillier, New York, 1965

Kepes, Gyorgy, ed., *Arts of the Environment*, George Brazillier, New York, 1972

Kingsley, April, 'Six Women at Work in the Landscape', *Arts Magazine*, no 52, New York, April 1978, pp. 108-12

Kolodny, Annette, *The Lay of the Land: Metaphor as Experience and History in American Life and Letters*, University of North Carolina Press, Chapel Hill, 1975

Kozloff, Max, 'The Box in the Wilderness', *Artforum*, New York, October 1975, pp. 54-55

Knabb, Ken, ed., *Situationist International Anthology*, trans. Ken Knabb, Bureau of Public Secrets, Berkeley, 1981

Krauss, Rosalind, *Passages in Modern Sculpture*, Viking, New York, 1977

_____, 'Sculpture in the Expanded Field', *October*, no 8, Cambridge, Massachusetts, Spring 1979, pp. 31-44

Kubler, George, *The Shape of Time*, Yale University Press, New Haven, 1962

Kurtz, Bruce; Robert Smithson, 'Conversation with Robert Smithson on April 22nd, 1972', *The Fox*, no 2, New York, 1975, pp. 71-76

Kuspit, Donald, 'Charles Ross: Light's Measure', *Art in America*, no 66, New York, March-April 1978, pp. 97-98

'Landscape Sculpture: The New Leap', *Landscape Architecture*, no 61, Washington DC, July 1971, entire issue

LeFebvre, Henri, *The Production of Space*, Basil Blackwell, Cambridge, Massachusetts, 1991

Leider, Philip, 'How I Spent My Summer Vacation or, Art and Politics in Nevada, Berkeley, San Francisco and Utah', *Artforum*, no 9, New York, September 1970, pp. 40-49

_____, 'For Robert Smithson', *Art in America*, no 61, New York, November-December 1973, pp.80-82

Levin, Kim et al., special section of *Arts Magazine*, no 52, New York, February 1978, pp. 126-34

Lindquist-Cock, Elizabeth; Estelle Jussim, *Landscape as Photograph*, Yale University Press, New Haven, 1985

Linker, Kate, 'Charles Simonds' Emblematic Architecture', *Artforum*, no 17, New York, March 1979, pp. 32-37

Lippard, Lucy R., *Changing: Essays in Art Criticism*, E.P. Dutton and Co., New York, 1971

_____, 'Interview with Charles Simonds: Microcosm to Macrocosm/Fantasy World to Real World', *Artforum*, no 12, New York, February 1974, pp. 36-39

_____, *Six Years: The Dematerialization of the Art Object*, Prager, New York, 1973

_____, 'Complexes: Architectural Sculpture in Nature', *Art in America*, no 67, New York, January-February 1979, pp. 86-97

_____, Gardens: Some Metaphors for a Public Art', *Art in America*, no 69, New York, November 1981, pp. 136-50

_____, *Overlay: Contemporary Art and the Art of Prehistory*, Pantheon Books, New York, 1983

Lippard, Lucy R. et al., 'Art Outdoors', special issue *Studio International*, no 193, London, March-April 1977, pp. 82-131

Long, Richard, 'Nineteen Stills from the Work of Richard Long', *Studio International*, no 179, London, March 1970, 106-11

_____, 'Richard Long', *Avalanche*, no 1, New York, Fall 1970, pp. 40-47

_____, 'Richard Long', *Studio International*, no 181, London, May 1971, pp. 224-25

Lopez, Barry, *Desert Notes*, Andrews and McNeel Inc., Fairway, Kansas, 1976

Marmer, Nancy, 'James Turrell: The Art of Deception', *Art in America*, no 69, New York, May 1981, pp. 90-99

Marx, Leo, *The Machine in the Garden: Technology and the Pastoral Ideal in America*, Oxford University Press, New York, 1964

Masheck, Joseph, 'The Panama Canal and Some Other Works of Work', *Artforum*, no 9, New York, May 1971, pp. 38-41

Mason, Peter, *Deconstructing America: Representations of the Other*, Routledge, New York, 1990

McConathy, Dale, 'Keeping Time: Some Notes on Reinhardt, Smithson and Simonds', *Artscanada*, no 32, Toronto, June 1975, pp. 52-57

McFadden, Sarah, 'Going Places, Part II: The Outside Story of Opus 40', *Art in America*, no 68, New York, Summer 1980, pp. 52-54

McLuhan, Marshall; Harley Parker, *Through the Vanishing Point: Space in Poetry and Painting*, Harper Colophon, New York, 1968

McShine, Kynaston L., ed., *Information*, The Museum of Modern Art, New York, 1970

Merchant, Carolyn, *The Death of Nature: Women, Ecology, and the Scientific Revolution*, Harper and Row, San Francisco, 1980

Messer, Thomas, 'Impossible Art-Why It Is', *Art in America*, no 57, New York, May-June 1969, pp. 30-31

Michelson, Annette, *Robert Morris*, the Corcoran Gallery of Art, Washington DC, 1969

Mitman, Gregg, *The State of Nature: Ecology, Community and American Social Thought, 1900-1950*, University of Chicago Press, Chicago, 1992

Morris, Robert, 'Notes on Sculpture', Part I, *Artforum*, no 4, New York, February 1966, pp. 42-44; Part II, *Artforum*, no 5, New York, October 1966, pp. 20-23; Part III, *Artforum*, no 6, New York, Summer 1967, pp. 24-29; Part IV, 'Beyond Objects', *Artforum*, no 7, New York, April 1969, 50-54

_____, 'Some Notes on the Phenomenology of Making: The Search for the Motivated', *Artforum*, no 8, New York, April 1970, pp.

62-66

_____', Place and Process', *Avalanche*, no 1, New York, Fall 1970, pp. 12-13

_____, *Robert Morris*, Marcia Tucker, et al., Whitney Museum of American Art, New York, 1970

_____, 'Observatory', *Avalanche*, no 3, New York, Fall 1971, pp. 30-35

_____', Some Splashes in the Ebb Tide', *Artforum*, no 11, New York, February 1973, pp. 42-49

_____, *Robert Morris/Projects*, Institute of Contemporary Art, University of Pennsylvania, Philadelphia, 1974

_____. 'Aligned With Nazca', *Artforum*, no 14, New York, October 1975, pp. 26-39

_____, 'The Present Tense of Space', *Art in America*, no 66, New York, January-February 1978, pp. 70-81

_____, 'Notes on Art as/and Land Reclamation', *October*, no 12, Spring 1980, pp. 87-102

_____, *Robert Morris: Selected Works, 1970-1981*, Contemporary Arts Museum, Houston, 1981

Morris, Robert et al., *Earthworks: Land Reclamation as Sculpture*, Seattle Art Museum and King County Arts Commission, Seattle, 1979

Mueller, Gregoir, *The New Avant-Garde: Issues for the Art of the Seventies*, Praeger, New York, 1972

Novak, Barbara, 'The Double Edged Axe', *Art in America*, vol 64, no 1, New York, January-February 1976, pp. 44-50

Novak, Barbara, *Nature and Culture: America Landscape Painting, 1825-1875*, Oxford University Press, New York, 1980

Onorato, Ronald J., 'The Modern Maze', *Art International*, no 20, New York, April-May 1976, pp. 21-25

Packer, William, 'Artists Over Land', *Studio International*, no 190, London, November 1975, pp. 252-53

Panofsky, Erwin, *Perspective as Symbolic Form*, trans. Christopher S. Wood, Zone Books, New York, 1992

Parker Harley; Marshall McLuhan, *Through the Vanishing Point: Space in Poetry and Painting*, Harper Colophon, New York, 1968

Perlmutter, Elizabeth, 'Art in Landscape', *Artnews*, no 75, New York, April 1976, pp. 66-67

Phelan, Peggy, *Unmarked: The Politics of Performance*, Routledge, London, 1993

Pollan, Michael, *Second Nature: A Gardener's Education*, Atlantic Monthly Press, New York, 1991

Prinz, Jessica, *Art Discourse/Discourse in Art*, Rutgers University Press, New Brunswick, New Jersey, 1991

Prown, Julius David, et al., *Discovered Lands, Invented Pasts: Transforming Visions of the American West*, Yale University Press, New Haven, 1992

Robbin, Anthony, 'Smithson Non-Site Sights', *Artnews*, no 68, New York, February 1969, pp. 50-53

Rorty, Richard, *Philosophy and the Mirror of Nature*, Princeton University Press, Princeton, 1979

Rosen, Nancy, 'A Sense of Place: Five American Artists', *Studio International*, no 193, London, March-April 1977, pp. 115-21

Rosenberg, Harold, *The De-definition of Art: Action Art to Pop to Earthworks*, Horizon Press, New York, 1972

_____, *Art on the Edge: Creators and Situations*, Macmillan Publishing Co., New York, 1975

Russell, John, 'Art: Heizer's Sculptural World', *The New York Times*, May 14, 1976, p. C16

Sandler, Irving, *American Art of the 1960s*, Harper & Row, New York, 1988

Schjeldahl, Peter, 'Robert Smithson: He Made Fantasies as Real as Mountains', *The New York Times*, August 12, 1973, p. 21

Scully, Vincent, *The Earth, The Temple and The Gods*, Yale University Press, New Haven, Connecticut, 1962

Szeeman, Harald, *When Attitudes Become Form*, Kunsthalle, Berne, 1969

Shabecoff, Philip, *A Fierce Green Fire: The American Environmental Movement*, Hill and Wang, Farrar Strauss Giroux, New York, 1993

Sharp, Willoughby, et al., *Earth Art*, Andrew Dickson White Museum, Cornell University, Ithaca, 1970

Sheffield, Margaret, 'Natural Structures: Michael Singer's Sculpture and Drawings', *Artforum*, no 17, New York, February 1979, pp. 48-51

Shepard, Paul, *Man in the Landscape*, Alfred A. Knopf, New York, 1967

Steinberg, Leo, *Other Criteria: Confrontations with Twentieth-Century Art*, Oxford University Press, Oxford and New York, 1972

Shirley, David L., 'Impossible Art - What It Is', *Art in America*, no 57, New York, May-June 1969, pp. 32-47

Sky, Alison; Robert Smithson, 'Entropy Made Visible', *On Site 4*, Fall 1973, pp. 26-30

Slotkin, Richard, *The Fatal Environment: The Myth of the Frontier in the Age of Industrialization, 1800-1890*, Harper & Row, New York, 1986

Smith, Henry Nash, *Virgin Land: The American West as Symbol and Myth*, Harvard University Press, Cambridge, 1950

Smithson, Robert, 'Toward the Development of an Air Terminal Site', *Artforum*, no 5, New York, June 1967, pp. 36-40

_____, 'Ultra-Moderne', *Arts Magazine*, no 42, New York, September-October 1967, pp. 31-33

_____, 'Some Void Thoughts on Museums', *Arts Magazine*, no 42, New York, November 1967, p. 41

_____, 'The Monuments of Passaic', *Artforum*, no 7, New York, December 1967, pp. 48-51

_____, 'A Museum of Language in the Vicinity of Art', *Art International*, no 12, New York, March 1968, pp. 21-27

_____, 'Minus Twelve', *Minimal Art: A Critical Anthology*, ed. Gregory Battcock, E.P. Dutton and Co., New York, 1968, pp. 402-6

_____, 'Aerial Art', *Studio International*, no 177, London, April 1969, pp. 180-18

_____, 'Incidents of Mirror Travel in the Yucatan', *Artforum*, no 8, New York, September 1969, pp. 28-33

_____, 'Cultural Confinement', *Artforum*, no 11, New York, October 1972, p. 39

_____, 'The Spiral Jetty', *Arts of the Environment*, ed. Gyorgy Kepes, George Braziller, New York, 1972, pp. 222-32

_____, 'Frederick Law Olmsted and the Dialectical Landscape', *Artforum*, no 11, New York, February 1973, pp. 62-68

Smithson Robert; Bruce Kurtz, 'Conversation with Robert Smithson on April 22nd, 1972', *The Fox*, no 2, New York, 1975, pp. 71-76

Robert Smithson, *Arts Magazine*, no 52, New York, May 1978, special issue, pp. 96-144

Stegner, Wallace, *American West as Living Space*, University of Michigan Press, Ann Arbor, 1987

Sylvester, David; Michael Compton; *Robert Morris*, The Tate Gallery, London, 1971

Tiberghein, Giles, *Land Art*, trans. Caroline Green, Princeton Architectural Press, New York, 1995

Tillim, Sidney, 'Earthworks and the New Picturesque', *Artforum*, no 7, New York, December 1968, pp. 42-45

Tomkins, Calvin, 'Onward and Upward with the Arts: Running Fence', *New Yorker*, no 53, New York, March 28, 1977, pp. 43-46

Tuan, Yi-Fu, *Space and Place: The Perspective of Experience*, University of Minnesota Press, Minneapolis, 1977

_____, 'Realism and Fantasy in Art, History, and Geography', *Annals of the Association of American Geographers*, no 80, 1990, pp. 435-46

Van der Marck, Jan, *Herbert Bayer: From Type to Landscape - Designs, Projects and Proposals, 1923-73*, Dartmouth College Museum and Galleries, Hanover, New Hampshire, 1977

Van Bruggen, Coosje, *John Baldessari*, Rizzoli, New York, 1990

Waldman, Diane, 'Holes Without History', *Artnews*, no 70, New York, May 1971, pp. 44-48; 66-68

White, John, *Birth and Rebirth of Pictorial Space*, Faber and Faber, London, 1959

Williams, Raymond, *Problems in Materialism and Culture*, Verso, London, 1980

Williams, William Carlos, *A Recognizable Image*, New Directions, New York, 1978

Wortz, Melinda, 'Walter De Maria's Lightning Field', *Arts Magazine*, no 54, New York, May 1980, pp. 170-73

Youngblood, Gene, 'World Game: The Artist as Ecologist', *Artscanada*, no 27, Toronto, August 1970, pp. 42-49

INDEX

Entries in italics refer to images. Entries in inverted commas refer to titles of texts.

304 For Samuel and Audrey

PUBLISHER'S ACKNOWLEDGEMENTS

We would like to thank all those who gave their kind permission to reproduce the listed material. Every effort has been made to secure all reprint permissions prior to publication. However, in a small number of instances this has not been possible. The editors and publisher apologize for any inadvertent errors or omissions. If notified, the publisher will endeavour to correct these at the earliest opportunity.

We would like to thank the following for their help in providing images: American Fine Arts Co., New York; Ant Farm Archives, San Francisco; Art & Language, Middleton Cheney, Oxfordshire; John Baldessari, Santa Monica, California; Barnaby's Picture Library, London; Family of Herbert Bayer, Denver, Colorado; Betty Beaumont, New York; Doris Bloom and William Kentridge, Copenhagen and Johannesburg; Boetti Archive, Rome; Bridgeman Art Library, London; Cai Guo Qiang, New York; Fondation Cartier, Paris; Leo Castelli Gallery, New York; Paula Cooper Gallery, New York; Mel Chin, New York; Christo and Jeanne-Claude, New York; Comstock, London; Walter De Maria, New York; herman de vries, Knetzgau, Germany; Agnes Denes, New York; DIA Center for the Arts, New York; Jan Dibbets, Amsterdam; Documenta Archive, Kassel; Mary Beth Edelson, New York; Toshikatsu Endo, Saitama, Japan; Harriet Feigenbaum, New York; Ronald Feldman Fine Arts, New York; Peter Fend, New York; FRAC Poitou Charentes; William Furlong, London; Barbara Gladstone Gallery, New York; Andy Goldsworthy, Thornhill, Dumfriesshire; Marian Goodman Gallery, New York; Greenpeace International, Amsterdam; Robert Morris Archive, Solomon R. Guggenheim Museum, New York; Hans Haacke, New York; Ian Hamilton Finlay, Dunsyre, Lanarkshire; Helen and Newton Harrison, Del Mar, California; Morris Healy Gallery, New York; Michael Heizer, Hiko, Nevada; Susan Hiller, London; Nancy Holt, Galisteo, New Mexico; Estate of Douglas Huebler, Valencia, California; Peter Hutchinson, Provincetown, Massachusetts; Hyogo Prefectural Museum of Modern Art, Kobe; Patricia Johanson, Buskirk, New York; Annely Juda Fine Art, London; Carl A. Kroch Division of Rare and Manuscript Collections, Cornell University Library, Ithaca, New York; Galerie Lelong, New York; Lemna Corporation, St. Paul, Minnesota; Richard Long, Bristol; Gordon Matta-Clark Trust, Weston, Connecticut; Estate of Ana Mendieta and Galerie Lelong, New York; Cildo Meireles, Rio de Janeiro; Mary Miss, New York; Christian Philipp Müller, New York; N.A.S.A., Houston, Texas; David Nash, Blaenau Ffestiniog, Gwynedd; Isamu Noguchi Foundation, Inc., New York; Dennis Oppenheim, New York; PLATFORM,

London; The Preservation Society of Newport County, Rhode Island; Edward Ruscha, Venice, California; Bonnie Sherk, San Francisco; Buster Simpson, Seattle, Washington; Michael Singer, Wilmington, Vermont; Robert Smithson Estate, New York; Holly Solomon Gallery, New York; Alan Sonfist, New York; Charles Simonds, New York; Sperone Westwater Gallery, New York; Stedelijk Museum, Amsterdam; James Turrell, Flagstaff, Arizona; Waddington Galleries, London; John Weber Gallery, New York; Donald Young Gallery, Seattle.

COMPARATIVE ILLUSTRATIONS

John Constable, *The Haywain*, 1821, National Gallery, London, p. 24; Kenneth Noland, *Gift*, 1962, Tate Gallery, London, p. 25; Casper David Friedrich, *The Wreck of the Hope*, 1824, Kunsthalle, Hamburg, p. 191; Nicolas Poussin, *Landscape with Traveller Washing His Feet*, 1648, National Gallery, London, p. 191; Claude Lorrain, *Landscape with Sacrifice to Apollo*, 1662, Anglesey Abbey, Cambridgeshire, p. 191; Anthony Caro, *Early One Morning*, 1962, Tate Gallery, London, p. 191; Albert Bierstadt, *The Rocky Mountains*, 1863, Metropolitan Museum of Art, New York, p. 192

PHOTOGRAPHERS

Hervé Abadie p. 186; Gunter Beer p. 164; John Cliett pp. 2–3, 108, 109; Peter Davenport p. 174; D. James Dee pp. 144, 146, 154; Hilmer Deist p. 165; Daniel Dutka pp. 39, 155; Virginia Dwan p. 31; Dr. G. Gerster p. 58; Gianfranco Gorgoni pp. 47, 56–57, 59, back cover; Martyn Greenhalgh p. 182; Werner J. Hannappel pp. 175, 183 (middle, bottom); Nancy Holt pp. 4, 32, 192; C. Johnson p. 33; Yukio Koyabashi p. 129; Gerard Martron pp. 170, 171; Robert McElroy p. 117; Morgan p. 21; Peter Namuth p. 157; Nathanson p. 120; Dave Patterson p. 183 (top); Paola Pellion p. 184; Eric Pollitzer p. 79; Jon Reis p. 145 (bottom); John Riddy p. 191; Walter Russell p. 24 (right); David Schneider p. 168 (top); Photostudio Schneyer pp. 162–63; Fred Scruton pp. 128, 130, 131; Harry Shunk pp. 80–81, 82; Oren Slor p. 165; Soichi Sunami p. 45; Nic Tenwiggenhorn p. 107; Caroline Tisdall p. 35 (right); Tom Vinetz pp. 29, 54, 55; Wolfgang Volz pp. 37, 72, 73, 83, 84, 85; Tadasu Yamamoto p. 113 (right).

AUTHOR'S ACKNOWLEDGEMENTS

I would like to thank those friends, colleagues and institutions whose guidance and assistance helped make this project possible.

Thanks to the many galleries and museums who cooperated with picture research requests, as well as those which allowed me personal access to their archives, especially Ronald Feldman Gallery, John Weber Gallery and its director John Weber, and the DIA Center for the Arts, New York.

To the many public and university librarians who have put up with my repeated requests, particularly those affiliated with the Boston Public Library System at the Newton Free Library, the Brookline Public Library and the Boston Copley Library; the Bapst Library at Boston College; the Widener and Loeb Libraries at Harvard University; the New York Public Library; and the Brooklyn Public Library.

To my friends Marjory Jacobson, Patricia Fuller and Ed Levine, who discussed the project with me at the outset and regularly let me plunder their personal libraries for original texts, catalogues and books unavailable anywhere else.

The editorial team at Phaidon, particularly Iwona Blazwick, who helped to draw the book's blueprint with me, and Gilda Williams, my kind and patient editor. And the superb team of editors and researchers who held the project together against the odds: indefatigable picture hunter Clair Joy; Clare Manchester, who compiled the extended captions and biographies and steered the book through its most complicated phase; project editors Audrey Powell and John Leslie; John Stack; reader Alison Sleemann; Clare Stent, without whose expertise and equanimity this book would not exist; designer, Stuart Smith; and production controller Veronica Price.

Other individuals also made contributions both large and small to the process: Patricia Bickers, Peter Boswell, Robin Cembalest, Martin Friedman, Eric Gibson, Chantal and Mike Hasselmo, Nicola Kearton, Barbara and Alfred MacAdam, Malcolm Miles, Susan and Thomas Plagemann, David Walters, and Nell and Jack Wendler. Finally for my wife, Mona Marquardt, who always sees the light at the end of the tunnel.

THEMES AND MOVEMENTS The development of modern and contemporary art has been dominated by fundamental, revolutionary movements and recurring themes. The Themes and Movements series is the first fully to examine post-war art by combining expert narrative, key works and original documents. Each book is introduced by a comprehensive Survey by a distinguished scholar who provides a thorough analysis of the theme or movement. The second section is dedicated to numerous images of the Works themselves. Every key artwork is illustrated and accompanied by an extended caption describing the principal ideas and the process behind it, as well as exhibition history. Finally, with the Documents section, the series also offers direct access to the voice of the artist and to primary texts by critics, historians, curators, philosophers and theorists. A unique archive of the innovations, discourses and controversies that have shaped art today, these books are as exhaustive as a full-scale museum overview, presenting every significant work of art associated with a particular tendency.